W9-BBR-808

1000 Sculptures of
Genius

Authors: Joseph Manca, Patrick Bade, Sarah Costello.
Translation: Sofya Hundt, Nick Cowling and Marie-Noëlle Dumaz.

Designed by: Baseline Co Ltd, 61A-63A Vo Van Tan Street, 4th Floor
District 3, Ho Chi Minh City, Vietnam

ISBN: 978-1-84484-215-5

Publisher's note: The asterisks (*) at the end of the captions signal a commented work at the end of each chapter.

1000 Sculptures of
Genius

PARKSTONE
INTERNATIONAL

CONTENTS

INTRODUCTION

The Classical World

The ancient Greeks, at first an isolated and provincial people among many population groups in the Mediterranean basin, rose to cultural, military, and political prominence, but they stood on the shoulders of giants and learned from the traditions of other ancient Mediterranean and Near Eastern civilisations. In the sphere of the arts, the Egyptians, in particular, had already developed a culture of idealised, well-proportioned human figures, a narrative tradition in painting and relief sculpture, and temple architecture that incorporated the display of a variety of sculptural elements. Yet the Greeks, in altering the static forms of the Egyptians, sought to craft sculptural figures that expressed life, movement, and a more fundamental and humane sense of moral potential. This development is seen in its early phase in the growing naturalism and subtlety of facial expression in sculpture produced in the Archaic period of the seventh and sixth centuries B.C.E. greater freedom of invention appeared during that time in vase painting, but sculptors, restrained by the intractability of stone and by convention, lagged somewhat behind. Reflecting a philosophical search for the ideal, the sculptors aimed at achieving timeless beauty. Just as Greek philosophers considered the nature of the ideal republic, perfect justice, or the ideal Good itself, artists brought forth a host of perfected forms. In their subject matter, sculptors often favoured the naked, youthful male body, a reflection of the Greek penchant for athleticism and military prowess, and an indication of the fluid boundaries of their range of sexual appreciation. A widespread and important form was the *kouros*, a free-standing male figure often placed at tombs in honour of the deceased. *Kore*, female equivalents of the *kouroi*, were clothed, following the convention of the time, but equally focused on youth, charm, and ideal beauty.

During the fifth century B.C.E. a mood of great confidence developed among the Athenian people, spawned by their victory over the Persians in 490-479 B.C.E. and by continued Athenian leadership among the collected Greek city-states. Indeed, the Athenian leader Perikles, in his famous oration (431 B.C.E.) for soldiers fallen in the Peloponnesian War, affirmed the superiority of Athens in cultural affairs, stating that their dedication to citizenship, sacrifice, and intellect formed the moral core of Athenian greatness. This was a moment of revolution in artistic style. Ever more explicitly based on the ideals of the perfect body, sculptured figures expanded in movement and emotion, but always with a moderating balance of weight, proportion, and rhythm. Equally important was the sense of palpable reality; sculpture, rather than being made of unadorned marble or bronze, was often enhanced by details in other media to achieve, in restrained fashion, an extra degree of naturalism. In later eras, a belief in the "purity" of the art of the Greeks led critics to overlook these additions, but the Greeks themselves gave life to their figures by painting on the marble key parts such as lips or eyes; in bronze sculpture, the highest and most enduring form of artistic technique, one found such additions as glass eyes and silver eyelashes. Later Greeks and Greek colonists would make a specialty of coloured terracotta figurines. The realm of ancient Greek sculpture was a lively and at times colourful world.

In Classicism, beauty bears a numerical component. Just as musical intervals and chords could be defined proportionally through the ratio of numbers, and

geometry and mathematics informed planetary movements, similar proportional aspects found a place in Greek sculptural and architectural design. Polykleitos' *Canon*, or *Spear-bearing Youth*, was only the most prominent of many works informed by proportional ideals: the ratio of lengths of fingers, hands, arms, legs, and heads were adjusted to stand in relationship to other parts and the whole. We know of his system in part from a description by Galen, a medical doctor who lived in the second century A.D. Galen discussed Polykleitos' artistic system, and seemed to accept the idea that the human body truly comprises a set of ideal proportions. This principle would endure throughout the history of art; Classicism in the Renaissance and neoclassical periods would also incorporate some kind of mathematical or numerical system of proportionality.

The Greek city-states were weakened by warfare during the fourth century B.C.E., although striking developments in their sculptural traditions continued unabated, the works of that time were enhanced by a new sense of elegance and spatial play. By the end of the century, faced with powerful opposition, the Greek city-states had lost their independence and were united by the Macedonians under Philip II and Alexander the Great. Greek citizens were incorporated into a far-flung empire that occupied lands from Italy to the edge of India, and even after the division of this empire into various kingdoms, the various Greek city-states remained parts of larger political entities. Such dramatic changes could only lead to a changed perception of one's place in the universe, and it is hardly surprising that novel artistic results occurred in all of the visual arts. One new strain was a pragmatic, realistic attitude that seemed to respond to the new *Realpolitik* of changing conditions, in which the ideal of local democracy was shattered. In the new state of things, the individual had to get by in a difficult, changing, and dynamic world. The Hellenistic period saw the diffusion

of genre scenes, some of which were of great pathos: an old woman struggling to walk to market, tired boxers, children tussling, dwarves dancing. New expressionistic details can be found in Hellenistic figures, particularly in the distinctive muscular types with large muscles, thick proportions, deep-set eyes, and thick, curling, moving hair. The older types of sculptural projects – frieze reliefs, tympanum sculpture, and free-standing figures – continued, but new settings and types arose. In the great Altar of Zeus at Pergamon (see nos. 110-111), rather than a narrow frieze set above, there is a large-scale relief scene below, bringing the gigantic battle scene down to the viewer's own level. The size of public sculpture increased over earlier periods of Greek art, and the Colossus of Rhodes, dominating the harbour, became an early tourist site.

The Greek colonies in the Italian peninsula had set the stage for the advance of the figural arts there. The Etruscans, a still relatively mysterious people, adopted some of the figural modes learned from the Greeks. The spectacular rise of the Romans started out as one of military and political triumph. The story is well known of how a small city-state grew to dominate the peninsula, and then came to create a great empire that stretched from Scotland to North Africa to Mesopotamia. The most striking of the Roman sculptural products during the centuries before the Empire were in portraiture; the unflinching realism of Roman republican portraiture reveals the character and moral fibre of those who were developing a political and social system of great strength and promise.

Iconographic change in sculpture followed the political development and expansion of the Empire. The establishment by Augustus (died 14 A.D.) of an imperial regime called for a new manner of imperial portraiture, and the changing styles and approach of these images of rulers stand at the core of the development of Roman portraiture. The divine status of the emperor and the propagandistic display of his likeness in public spaces

provided opportunities for Roman sculptors and designers of coins and medals. There arose a vast new array of new monument types, and sculpture appeared on triumphal arches, on towering columns, and at the baths, *fora*, and elsewhere. The Romans were willing, when they were not relying on their own inventions, to erect copies of Greek works, or to proudly display the originals themselves that had been purchased or plundered from Greece. These Greek copies and originals in turn served as artistic inspirations and helped maintain a high standard of quality in Roman sculpture. Some Roman emperors, such as Marcus Aurelius, consciously appropriated Greek ideals; he sported a beard in the Greek fashion and adopted Stoic philosophy, and his sculptors responded with idealising and classicising works, the most memorable being the equestrian monument placed on the Capitoline Hill. This work is in bronze, a favoured material of the Greeks that also became highly desirable to the Romans.

Roman people of all social classes were surrounded by high-quality sculptural originals, as the Roman state wanted to leave its stamp on public sites, including provincial ones. The baths (*terme*) were a frequent location for sculptures, many of them free-standing figures on athletic themes. The exterior of the Colosseum was adorned with sculptural figures standing in its open arches and a colossal statue of the Emperor Nero adjacent to the amphitheatre (later turned into a sun god by Nero's unadmiring successors). The rediscovery of the buried cities of Pompeii and Herculaneum in the eighteenth century led to an increase in knowledge of the placement and type of sculptural figures used in Roman cities, and confirmed the literary evidence that much statuary was displayed in the *atria* of urban homes, as it was in the villas and vast country gardens of the aristocratic classes. Cicero, like other cultured contemporaries, formed what were essentially small museums in his villas, inside and out, and these served as places of retreat and philosophical contemplation. Emperors, too, populated their villas with grottoes, fountains, and reflecting pools that were surrounded by sculpture. Knowledge of these villas from ruins and from verbal descriptions was vital in shaping the gardens of Europe in the Renaissance and later. The Romans developed a vigorous sculptural tradition surrounding the rituals of death and mourning, and their funerary portraits and sarcophagus reliefs provide a rich legacy of artistic history.

During the last centuries of its existence, the Roman Empire slowly went into decline militarily, economically, culturally, and morally. The amphitheatres and their bloody games gained in popularity, while traditional athletics (running, javelin throwing, discus throwing) fell into desuetude. Dramatic theatre in the traditional sense all but disappeared, and poetry and prose lost much in the way of refinement. For its part, Roman sculpture of the second to the fifth centuries showed a gradual decline, and figural ideals and proportions ultimately handed down from the Greeks gave way to blunt, mundane, and stocky types that conveyed stature and power. Constantine the Great (died 337 A.D.) was the first Roman emperor to accept Christianity, which had hitherto, with varying degrees of intensity, been persecuted in the empire. The early Christians generally shared the artistic materials and style of the secular Romans, while introducing religious imagery.

The Collapse of Rome and the Rise of Medieval Culture

The destruction of the civilisation of the Roman Empire at the hands of the tribal Visigoths, Ostragoths, Vandals, and others in the fifth and sixth centuries brought an end to long cultural traditions. Some of the migratory peoples brought with them a kind of art based on small scale, intertwining, and animal motifs, with only a rather stylised human presence. The Vikings, no less than the

others, practised a style alien to ancient Mediterranean traditions. For its part, the Roman tradition, which remained dormant for over two centuries before being revived by Charlemagne (Charles the Great; died 814), who consciously brought back ancient Roman styles of script, architecture, sculpture, and manuscript illumination, all in what seems to us as provincial variant at best, and hardly taking a new direction. The Ottonian style of a century or so later was less linked to Roman models, but perhaps equally vigorous and forcible in attempting new narrative force and figural presence.

Although Europe was weakened by invasions from Vikings, Magyars and others towards the end of the first millennium after Christ, a great stabilisation of European society took place toward the year 1000, and civilisation began to flourish. The feudal system was well established, and Christianity had become mature in its institutions and was leading the way in education and in shaping the codification of both civil and canon law. Society was secure enough that trade could take place on land and sea, and the faithful could take long pilgrimages to distant sites. Places where holy relics were located – blood from the body of Christ, pieces of the True Cross, the mantle of the Virgin, bones of a saint – became pilgrimage destinations, and the internationalisation of culture grew as pilgrims travelled the continent. The holy destinations for these religious tourists called for a new manner of sculptural presentation, and there was a re-adaptation of the ancient Roman system of using abundant sculptural decoration on exteriors, as occurred early in the Romanesque period at the Cathedral at Modena. Builders turned also to a utilisation of Roman architectural ideas, including the construction of thick masses of wall and the use of rounded arches and barrel-vaults, and thus the later word "Romanesque" is used to indicate this use of ancient Roman ideas in a new context. For their part, certain sculptors made very close copies of Roman works, or even (with architectural sculpture) re-used Roman "spoils", that is, items salvaged from the rubble and prized for their beauty. At the church of SS Apostoli, the Florentines used one ancient capital found in local Roman ruins and made faithful copies to create a nave in the antique taste. This was a rebirth of the arts, if not a Renaissance, but the movement was international and there was a recognisable similarly of style, despite local variations, from Spain to England.

The Gothic period in the arts continued under many of the same social and cultural conditions as the Romanesque. The Church increased its strength, economies continued to grow, and the aristocratic feudal class continued to exert dominance. A number of artistic forms did change, however. Now rejecting antiquity as a model, the builders of this new age came up with their own solutions, an *ars nova* that differed from the heavier, stable Romanesque style. The development of the pointed arch, ribbed vaulting, flying buttresses, and great masses of fenestration in ecclesiastical architecture was in response to the desire for light, to create a jewel-studded Heavenly Jerusalem in the interiors. Abbot Suger (died 1151) of Saint-Denis (outside the walls of medieval Paris) led the way intellectually with his architectural patronage, and over time the new style swept Europe. Another ecclesiastical institution that gained in stature during the Gothic period was the monastery. Fairly powerful in earlier times, monasteries made even greater gains in moral and economic influence. The growth of monasteries, built with orderly planning and hierarchical and sensible arrangement of buildings, was one of the striking developments of the period, although this is often overlooked because the material remains of these great establishments have survived in rather poor or fragmentary state. Throughout this period the monarchies of Europe continued to strengthen, and the fabulous wealth achieved by the French kings and their relations, such as Jean, Duc de Berry, found an outlet in ambitious artistic commissions.

The Church continued to have a dominant role in education, and it oversaw the development of the universities. There was a growing voice for nominalism, in which the primacy of the senses and the priority of material existence played a leading role, and this philosophy is ideologically linked to a growing naturalism in the visual arts. The softening of the features of carved figures and the rendering of ease of posture show a new sharpness of vision and a willingness to consider the real as well as the ideal aspects of the visual world. The Church's assertive role included the moral leadership during the Crusades, the raising of armies to occupy the Holy Land. Despite the Crusades, and in part because of them, the medieval period saw the introduction of ideas in philosophy and science from Islamic thinkers, enriching Western thought. The revival of formal types located in the Holy Land, especially as found in the church of the Holy Sepulchre in Jerusalem, left a lasting mark on medieval and Renaissance architectural iconography.

The later Middle Ages played out against a backdrop of great drama: the Black Death, the plague that destroyed much of the population of Europe, occurred between 1348-1351, and in many places it threw society into upheaval. The ruling feudal class survived, but the labouring class gained some social strength, and the growth of cities and the clout of the bourgeoisie accelerated. This power of the merchant classes was especially strong in Italy, where the city-states flourished and feudal and agricultural power waned, and Italian cities saw the rise of a new secular and urban class of leaders. This was accompanied also by a secularisation of society, which took place in the growth of vernacular Italian literature (Dante, Petrarch, Boccaccio) and by explorers and travellers such as Marco Polo. This was the proto-Renaissance that would explode in the fifteenth century into a powerful surge of secular and classical revival ideas.

Renaissance and Baroque Europe: Naturalism and the Revival of Antiquity

The world of Renaissance Europe was dominated by the spirit of humanism. Humanists, that is, scholars interested in the moral and literary values found in ancient Greek and Roman literature, turned their attention to rediscovery of ancient texts, useful not only for the study of good grammar and writing, but newly valued for the content itself, throwing light on the past experiences and thoughts of an elevated, lost civilisation. Renaissance critics regarded the Gothic style as a corruption, and gave us the word *Gothic* itself, which is historically inaccurate but reflected the belief that those who developed the pointed arch and the "barbarous" accretion of ornaments on the exteriors of the great northern European cathedrals were of the same low calibre as those who had earlier destroyed the Roman Empire.

Following the lead of the humanists themselves, others – businessmen, lawyers, political rulers, and eventually church leaders and clerics – rediscovered the marvels of antiquity. For certain fields of endeavour, such as medical science and painting, there were scant remains from ancient societies, but sculpture was one field where the remains were plentiful, from triumphal arches to sculpture fragments, from sarcophagi to small bronzes. Fifteenth-century sculptors who wanted to turn to antiquity for inspiration could easily do so. To their credit, nearly all Renaissance artists, in whatever medium they worked, tended to re-interpret and re-use material from the past rather than slavishly copy. There were isolated instances where artists repaired (and therefore matched the style of) ancient works, and some artists made close versions of them, as did the aptly named Antico (Pier Jacopo Alari-Bonacolsi), a sculptor in the employ of Isabella d'Este, or as did the young Michelangelo, who made certain youthful pieces close enough to antiquity to deceive connoisseurs. And it was

not only antiquity that served as a model: many artists turned to nature itself for inspiration, as recommended by contemporary humanists, and they also benefited from knowledge of other European artistic traditions closer to their time. Many sculptors, in fact, kept alive to some extent the spirit of the Gothic style, as did Luca della Robbia and Andrea del Verrocchio, whose art possesses a sweetness and elegant turn of line that owes something to late Gothic traditions.

The Renaissance was the age of investigation, travel accounts, map-making, history writing, and nature poetry, among other new secular trends, part of what the historian Jacob Burckhardt called the "rediscovery of the world and of Man". In the sphere of the sculptor, life models, careful observation of human movement, and anatomical study all helped the artistic cause. That a sculptured figure appeared alive and ready to speak was what gained the highest praise from critics of the time. Contemporary humanists recommended that artists look at nature, but look at it in its best forms: sculptors and painters were asked to choose the finest parts of different sources to create a beautiful work of art. Nor should good proportions be overlooked; as in antiquity, the harmony between part and part was an essential goal of a sculptor. Leon Battista Alberti, whose small treatise *On Sculpture* was the first of its kind since antiquity, set out in detail how to create a finely-proportioned sculptural figure.

There were different phases of the Renaissance, and the kind of classical art that inspired and was re-utilised differed according to the times and the interpreters. In the early Renaissance, the art of Roman republican sculpture was admired. Donatello and Nanni di Banco liked the details and the tough moral character of these prototypes and re-interpreted this in their sculptures. Later in the Renaissance, Michelangelo turned to Hellenistic Greece and its broad, muscular figures and extravagant theatricality. When the *Laocoön*, one of the prime works of antiquity, was rediscovered in 1506, Michelangelo sketched it, and soon incorporated the serpentine twists and anguished expressions into his Judeo-Christian subject matter. Other Renaissance sculptors were interested in the calm, classical style invented in the fifth century B.C.E. and its later variants from antiquity.

An important aspect of the social and artistic fabric of Renaissance Europe was formed by the papacy. During the later Middle Ages the papacy was divided. This was the Great Schism of the western Church, and at times multiple popes were recognised; the Palais des Papes in Avignon superseded the Vatican in Rome as a papal site. In 1417 the schism was healed and Martin V brought the papacy back to Rome. For centuries, strong papal leaders – Niccolo V, Innocent VIII, Julius II, with Leo X perhaps chief among these as art patrons – became leaders in art patronage. Later in the baroque period this rebuilding would continue, and the popes continued to act like secular rulers, with large incomes to spend on art works, distribute to favourites, or divert to military campaigns. In the fields of sculpture, the bronze doors of St Peter's by Filarete, the tomb of Innocent VIII by Antonio Pollaiuolo, and the commissioning of medals and other figures by Benvenuto Cellini were part of this papal re-establishment in Renaissance Rome.

The Mannerist style, the stylised art made in Italy in the sixteenth century, was unthinkable without the idealising lead of the high Renaissance masters, but the goals of the Mannerists were somewhat different. Fostered especially by connoisseurs and by courtly patrons, the Mannerist sculptors achieved a cool elegance and sometimes an icy formalism rather different from the more emotive and effectively passionate works from earlier in the sixteenth century. Giambologna experimented with the creation of sculpture meant to be seen from multiple directions, whereas most earlier sculptors had concentrated one's

attention on a single effective viewing point, or a constricted range of viewing stance. Along with the Mannerist artistic attitude went a social attitude that favoured variety, extravagance, inventiveness, grace, and self-consciousness. The autobiography of Benvenuto Cellini, filled with colourful events, bravado, and bragging, is the perfect complement to his artistic career. The line between Mannerism and the high Renaissance is not easy to draw, and the "Mannerists" themselves were not always aware of their place in the artistic scheme later codified by modern art historians. The Mannerists thought that they were surpassing nature with idealising, well-studied and varied figures, goals also shared by earlier artists.

The seventeenth century, the age of the baroque, was marked by a number of social changes: the struggles between religions led to the Counter-Reformation, the spread of Catholic missions around the world, scientific exploration of the heavens and into the particulars known from microscopes, and continued discovery of the peoples and places of the earth, all of which increased mankind's sense of its own potential. The expansive and new investigative mentality was echoed by an underlying naturalism in sculpture and a rejection of the artificialities of Mannerism, which were swept away by dramatic baroque figures in action, sometimes realistically "staged" in grand palatial, urban, or ecclesiastical settings. Gian Lorenzo Bernini dominated the sculptural scene in baroque Rome with his sculptures of swooning saints, complex fountains, and army of saints at the piazza of St Peter's, a project carried out by Bernini and his large workshop. Throughout Europe, Mannerist niceties and clever details were replaced by the broader and more emotional new style.

As in politics, Louis XIV of France had a major impact on the arts. The Sun King, who effectively ascended to power in 1661, fancied himself the paragon or spiritual heir of Apollo and Alexander the Great, and he favoured Classicism in the arts; this was reflected in his sculptural commissions as well as those for architecture and painting. Louis favoured a rather bombastic and heavy version of Classicism, as evinced by the extant architecture, interior decoration, and garden design at Versailles, a glorified hunting lodge that he turned into a centre of power. When Louis died, a certain relief set in among the aristocrats of France. Courtiers moved from Versailles to newly-constructed *hôtels particuliers* in Paris. A smaller-scale taste took over, and decorations became lighter and airier, the style of the so-called rococo. This word, which was coined later by, it seems, pupils in the circle of the neoclassicist Jacques-Louis David, indicates that the art was a cross between *barocco*, the baroque, and *rocaille*, or pebble (or shell) work, and was a light version of the baroque. Practised by Clodion (Claude Michel) and an army of craftsmen who formed the interiors of the period, the rococo flourished particularly in noble country houses, city dwellings, and – perhaps most memorably – in church interiors. Born in France, the style flourished across Europe, and achieved its zenith in the Catholic church interiors of Austria and southern Germany.

The eighteenth century was an age of scientific advancement and discovery, and it turned out that the frilly rococo was not suited to every locale and patron. It never took root in England or America, where the taste in sculpture was leaning heavily towards copies of the antique, a taste gained from Englishmen's exposure to antiquity while on the Grand Tour. Copies after the Italian Renaissance sculptors were also quite in vogue in England, and when the native genius expressed itself it was, not surprisingly, in forms reminiscent of antiquity, as in the art of John Flaxman. The English made a specialty of forming natural and apparently spontaneous gardens, and sculptures after the antique often found their place in these landscape gardens.

The Modern Age: From Neoclassicism to the Twentieth Century

The emphasis on virtue in the eighteenth century was hardly compatible with the delights of the rococo, and eventually something had to change. As it turned out, Classicism was once again seen as the salvation of Western art. Neoclassicism became widespread, inspired in part by the rediscovery of Herculaneum and Pompeii, and fostered by the thirst for Virtue, which was deemed to be embodied in the calm and moderate sculpture of antiquity. The neoclassical movement was ripe for success, and it swept across Europe and America and beyond. It was fed and fostered by a number of events and movements: the Grand Tour, the rediscovery of buried Roman cities, an education system that put an emphasis on the study of the antique, the sheer exhaustion with the late baroque and rococo... all of this nurtured a movement that dominated in architecture, sculpture, and the decorative arts, and had a major impact on painting.

A number of political regimes utilised the classical style to garner public support. This was hardly a new practice, as a number of Italian Renaissance rulers had done the same. Such a practice linked the new regimes to a long-standing tradition that was enlightened, virtuous, steeped in democratic values, favourable to education, and stood at the apex of secular culture among world civilisations. The French revolutionaries immediately embraced the developing neoclassical style, and Napoléon continued to do so, linking himself to Roman imperial iconography. The American Revolution and its aftermath led to an adoption of classical reference to the Greek and Roman form of government, but the English themselves provided the background for this and had already incorporated the new classical ideas into their sculptural traditions and other art forms.

Every country or regime, in somewhat nuanced versions, shared in this Neoclassical style. The international character of it was the product of the exchange of artistic ideas and the mining of the same ancient sources.

Another international style, Romanticism, unfolded during the nineteenth century against a backdrop of growing industrialism, democracy, and disillusionment by some with the results of those economic and political developments. The romantics explored the world of the irrational, the distant, and the bizarre, and their art often appealed to those disenfranchised by the societal progress and change being experienced in Western culture. Some of this thinking continued later in the century and beyond, and one can argue that romanticism continued – and continues – to inform modern thinking and artistic solutions.

The late nineteenth-century world of thought put forth a number of attempts to explain the world, and the recognition of the power of irrational or hidden forces, whether in Freud, Nietzsche, Jung, or Marx, gave rise to artistic manifestations. Paul Gauguin, who explored (and exploited) the stylistic and iconographic world of the South Pacific islands, is an example of this anti-bourgeois trend. Even before Darwin, the world of animals had great appeal among the romantics. Darwin, in his *On the Origin of Species* (1859), linked *homo sapiens* to the animal world genealogically, and during his time and earlier one could read of the importance of animals and animals' spirits in the works of Romantic poets and prose writers; animals were recognised as knowing and passionate, and their emotions linked to those of humans, a theme already explored by Leonardo da Vinci, Charles Le Brun, and other artists. The sculpture of Antoine-Louis Barye express this interest in the passions of the animal world, in a vivid trend also explored by painters such as George Stubbs, Eugène Delacroix, and Henri Rousseau.

The late nineteenth century was a time of great cultural and societal change, and some artists seemed to respond to this and produce an art as revolutionary as the new ideas in science, philosophy, and psychology.

Auguste Rodin, for example, moved in the direction of modernism in the later nineteenth century, but many sculptors in different countries favoured a more studied, academic, and traditional approach. Throughout Europe and America, traditional, academic sculpture found an admiring public, and many of these works still dominate their public sites, from the so-called *Eros* by Alfred Gilbert in London's Piccadilly Circus, via Edvard Eriksen's *Little Mermaid* in the harbour of Copenhagen, to New York's *Statue of Liberty* by Frédéric-Auguste Bartholdi (see no. 725). This last colossal work is a remarkable specimen of academic Classicism, produced at a time when even the less avant-garde American school was ready to explore a variety of manifestations of early modernism.

The twentieth century was marked by a new subjectivity of thought, and old paradigms gave way to new. Einstein's theory of relativity overthrew more static beliefs in physics. The atonalist musical composers overthrew the old common system alive for four hundred years and shifted aural attention away from the keynote and musical scale. Psychoanalytical thinkers continued to undermine confidence in conscious thought and reason.

Even economists introduced new ideas of subjectivity into economic thinking, and saw prices as the result of shifting sentiment of supply and demand rather than based in firm factors such as the costs of production.

All of this was part of a new mentality that saw a dynamic universe, and artists shared in this new vision. Cubism is the most obvious participant of this novel thinking, and the focus on fragmentation, changing view point, and the re-assessment and re-evaluation of traditional artistic ideals continued to be widespread in the twentieth century.

From the abstractions of Umberto Boccioni and Jacques Lipschitz to the work of David Smith and Donald Judd, there was a nearly unbroken line of shared modernist taste. Yet such modernism was not without opposition in the twentieth century.

Indeed, even early in the century, in the midst of paradigm shift away from academic art and towards modernist solutions, the tragedy of World War I occurred, with tremendous loss of life bringing little change in advantage for either side. The war left a generation disillusioned, and the artistic movements of Dada and even Surrealism can be traced to this fall in confidence and darker vision. They even questioned the value of modernism itself, a challenge that would continue to the end of the century in the work of the post-modernists, who found in Dada a spiritual forerunner.

The abstract features of modernist thinking were also challenged by the Pop Artists in the 1950s and 1960s, who used everyday objects (or facsimiles of them) to comment on, among other things, modern consumer society.

Indeed, today's sculpture often finds expression in the form of ephemera that are raised to the level of high art: the found object of the early twentieth century is being renewed in the art of contemporary installations.

What is needed now is for architectural sculpture to return. Long banished by most modern architects, sculptural ornamentation has all but disappeared, to the detriment of society. The sense that form should follow function leaves little room for sculptural ornamentation, which had long been the jewel in crown of architectural construction. Perhaps a new generation of architects will once again embrace the use of carved or moulded ornament as a way to convey a sense of grace, beauty, and nobility.

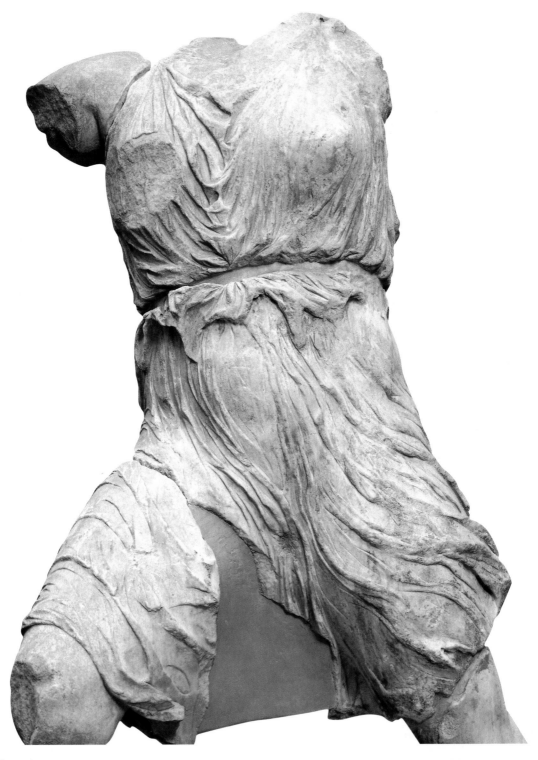

ANTIQUITY

s the ancient Greek city-states grew and evolved, the literary arts developed somewhat in advance of painting and sculpture. At about the time Homer was creating his epics, Greece saw the flourishing of the stylistic era identified as the Geometric period, lasting from about 950 to 750 B.C.E., a style dominated by rigid forms and in which the fluidity of the human figure was only just beginning to show itself. As the Greeks were increasingly exposed to foreign customs and material culture through trade, they were able to adapt and alter other artistic styles. The art of the Near East and of the Egyptians helped to shape Greek art of the Archaic period (c. 750 B.C.E. to 480 B.C.E.). During this time the Greeks began to infuse their figures with a greater sense of life, as with the famous "archaic smile" and with a new subtlety of articulation of the human body.

The remarkable evolution of Greek sculpture during the fifth century B.C.E. is unparalleled in artistic history. Innovations achieved during that time shaped stylistic development for thousands of years, and belong not to a people in one moment but to all of humankind. The development of weight-shift in a single standing figure and the concomitant torsion and subtlety of bodily stance were major aspects of this new style, but equally significant were the perfection of naturalistic forms, the noble calm, the dynamic equilibrium of movement, the harmony of parts, and the regulated proportions. All of this came to characterise the art of what we know as Classicism. The sculptors Polykleitos, Phidias (the sculptural master of the Parthenon project), and Myron worked in slightly divergent but compatible modes to achieve an art of moderation and perfection.

The fourth century B.C.E. saw an expansion of the artistic goals of the previous generations of Greek sculptors. Lysippos and Praxiteles softened the human form, and a nonchalant grace informs their figures. Artists in this period humanised the gods and added an element of elegance to their movement and expression. Sculptors of the fourth century B.C.E. increased the spatial complexity of the viewing experience: arms sometimes protrude into our space, groups are more dynamic in arrangement, and we benefit from walking around these sculptures and taking in the varied viewpoints.

The changes of the fourth century B.C.E. can hardly prepare us for the explosion of styles that occurred in the Hellenistic period, a time of exaggerations: extreme realism in rendering details and in capturing moments of daily life; great elegance of the female form, as we see in the memorable *Venus de Milo* (see no. 117) and *Nike of Samothrace* (see no. 106); and extreme muscularity of male figures in action. The beauty and refinement of the *Belvedere Apollo* (see no. 90), now in the Vatican collection, stand as a refined continuation of the earlier Greek ideals. On the other hand, the high relief figures from the altar of Pergamon, showing the battle of the gods and giants, are powerful in physique and facial expression, with deep-set eyes, thick locks of waving hair, and theatrical gestures. Later, Michelangelo and Bernini would draw inspiration from the Hellenistic works known to them from Greek originals and Roman copies.

The Romans always remained to some extent under the sway of the Greeks, but developed their own modes of sculptural expression. The most striking

of their early modes, not uninfluenced by Hellenistic models, was during the Republican period (until the second half of the first century B.C.E.). In an unforgettable development of the portrait type, Roman sculptors rendered searing details of facial particulars and created works conveying a strong sense of moral character, representing such virtues as wisdom, determination, and courage.

Around the time of Augustus a new kind of idealisation entered into Roman art, exemplified by the harmonious and flowing compositional arrangement of the reliefs on the Ara Pacis Augustae (see no. 126). A marble, standing figure of Augustus, the *Augustus Prima Porta* (see no. 121), is a Romanised version of Greek tradition, with the *contrapposto* (weight-shift) stance and the idealised, youthful face of the ruler. Less Greek in conception are the details of his armour and the heavy drapery style. Through the rest of the duration of the Roman Empire, there was a continuous artistic struggle, without resolution, between idealism and realism. The background to this battle was formed by the flood of Greek originals and Roman copies of them that filled the gardens, courtyards, and *fora* of the Romans, and these works ranged in style from the archaic to the Hellenistic.

Aside from any dependence on the Greeks, the Romans developed their own traditions, and were especially inventive in arriving at new stylistic expressions in their public monuments. The vigorous narrative and variety of the reliefs on the Arch of Titus still impress, and it is not surprising that they inspired Renaissance artists. No less remarkable are the intricate reliefs on the Column of Trajan and Column of Antoninus Pius. With scroll-like compositions, hundreds of figures adorn these columns in reliefs, showing military and – even more prominently – technological feats of the Roman armies. The figures seem large compared to their architectural surroundings, and the beginning of the "medieval" relationship of the figure to its spatial circumstances begins here.

The decline and fall of the Roman Empire formed a dramatic backdrop to the change of artistic style, including sculpture itself. By the late Empire of the third and fourth centuries A.D., at the time of the short-lived barracks emperors and during the experience of a host of troubles, portraiture achieved an extreme expression, sometimes capturing fear or cunning, and corresponding to the tenor of the times. The subjective question of the decline in style arises in a consideration of the Arch of Constantine (see no. 166): the side-by-side placement of earlier reliefs alongside those of the fourth century is telling in the squat proportions and repetitions of type and stance of the latter. Thus, even before the advent of Christianity, a decline in style and taste was present. This is no more evident than in the art of portraiture; the noble facial expression and the bodily idealism and harmony of the classical style have disappeared, and one sees instead nude figures with smaller heads and flat, broad chests.

The Christians, whose rise altered the character of Roman life, inherited the sculptural styles of the late Romans. Even some iconographic types were re-utilised; for example, Apollo-like features were given to Christ. Characteristic sculptural materials included an expansion of working in ivory, which remained a widespread medium in the Middle Ages. The Early Christian iconographic innovations were substantial, and a whole new range of subjects appeared in art. In the Eastern half of the fallen Roman Empire, the Byzantine Empire would survive and persevere. Its sculptors retained features adapted from the late Roman style, and eventually the Byzantines would help to re-introduce some of the ancient Mediterranean artistic ideas into late medieval and proto-Renaissance Italy.

See next page:
2. **Anonymous**.
Portrait of Julius Caesar, c. 30-20 B.C.E.
Marble, 56 x 19 x 26 cm.
Musei Vaticani, Vatican City (Italy). Roman Antiquity. (*)

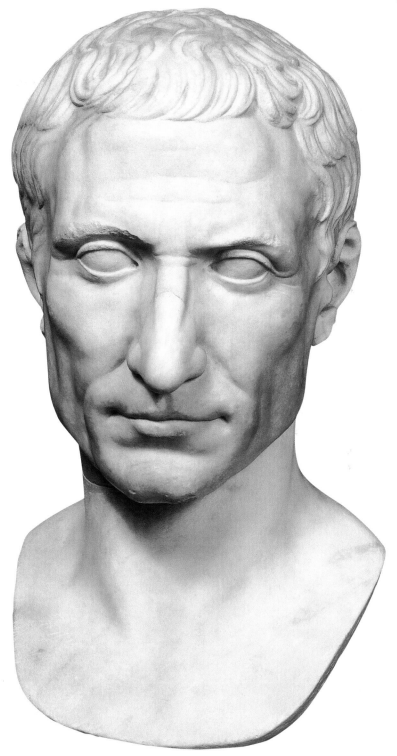

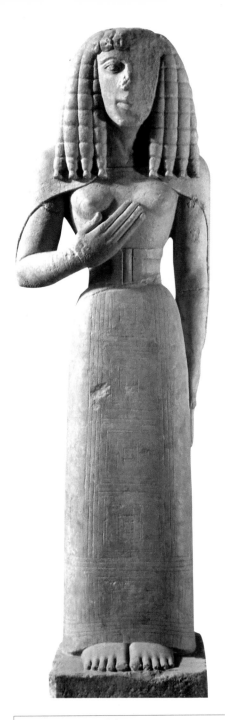

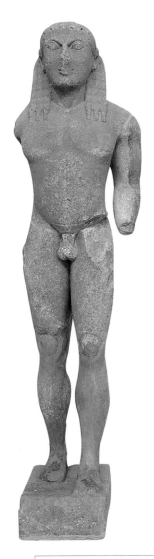

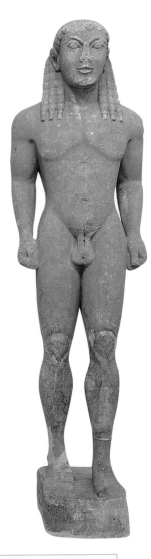

4. **Anonymous.**
Kleobis and Biton, Apollo Sanctuary, Delphi (Greece),
c. 610-580 B.C.E. Marble, h: 218 cm.
Archaeological Museum of Delphi, Delphi (Greece). Greek Antiquity. (*)

3. **Anonymous.**
The "Auxerre Kore", c. 640-630 B.C.E.
Limestone, h: 75 cm.
Musée du Louvre, Paris (France). Greek Antiquity. (*)

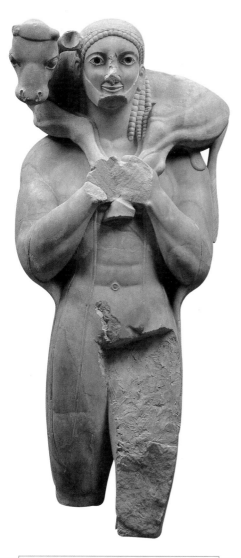

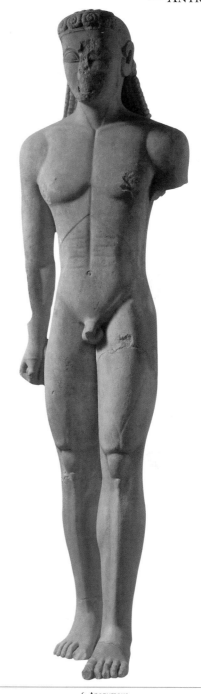

5. **Anonymous.**
Moschophoros, called the *"Calf Bearer"*, Acropolis, Athens
(Greece), c. 570 B.C.E.
Marble, h: 164 cm.
Acropolis Museum, Athens (Greece). Greek Antiquity.

6. **Anonymous.**
The Sounion Kouros, Temple of Poseidon,
Cape Sounion (Greece), c. 600 B.C.E. Marble, h: 305 cm.
National Archaeological Museum of Athens, Athens (Greece).
Greek Antiquity.

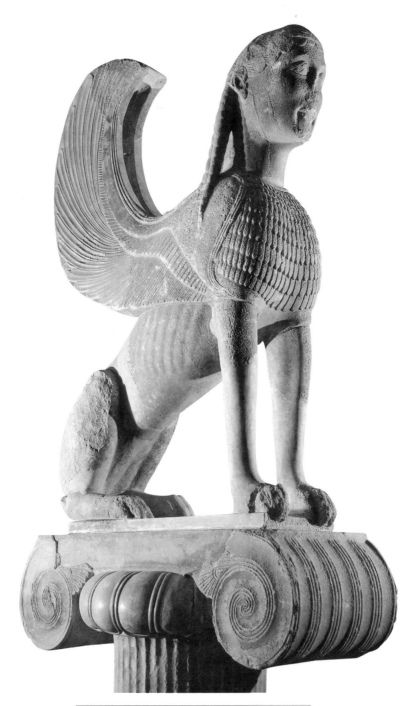

7. Anonymous.
The Naxian Sphinx, Earth Sanctuary, Delphi (Greece), c. 560 B.C.E.
Marble, h: 232 cm.
Archaeological Museum of Delphi, Delphi (Greece). Greek Antiquity. (*)

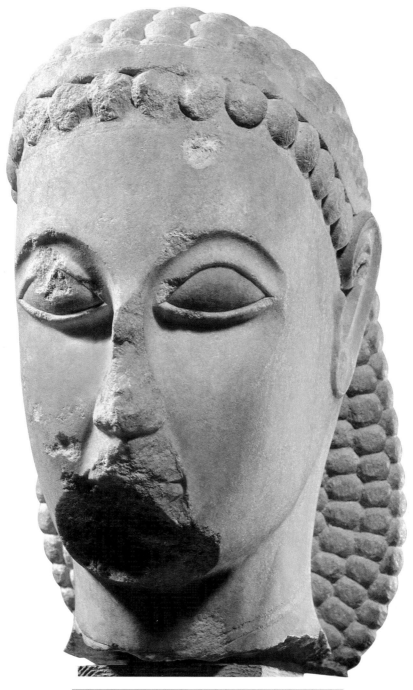

8. **Anonymous.**
Dipylon Head, Dipylon, Athens (Greece), c. 600 B.C.E.
Marble, h: 44 cm.
National Archaeological Museum of Athens, Athens (Greece). Greek Antiquity. (*)

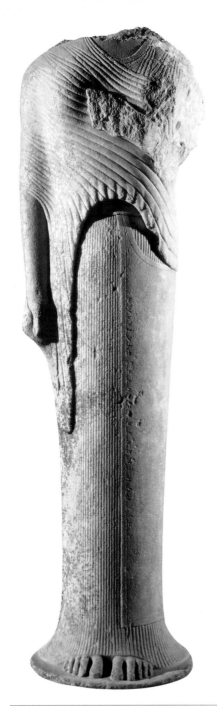

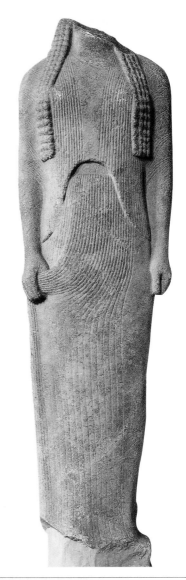

10. **Anonymous.**
Ornithe, Geneleos Group, Heraion of Samos, Samos (Greece),
c. 560-550 B.C.E. Marble, h: 168 cm.
Staatliche Museen zu Berlin, Berlin (Germany). Greek Antiquity.

9. **Anonymous.**
Kore dedicated to Hera by Cheramyes of Samos, c. 570-560 B.C.E.
Marble, h: 192 cm.
Musée du Louvre, Paris (France). Greek Antiquity. (*)

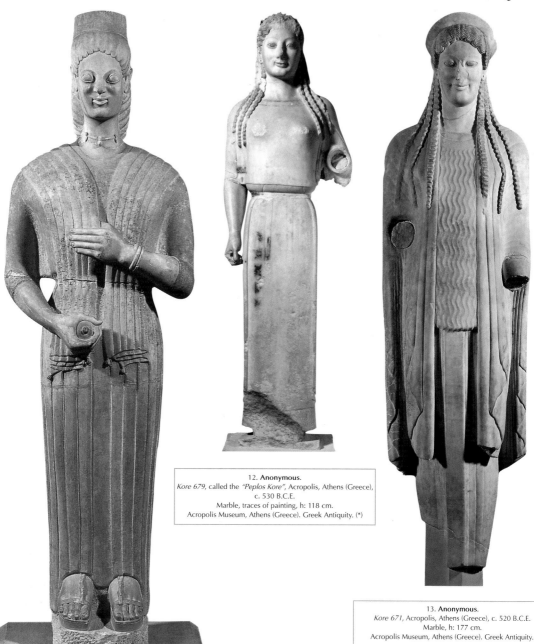

12. Anonymous.
Kore 679, called the *"Peplos Kore"*, Acropolis, Athens (Greece),
c. 530 B.C.E.
Marble, traces of painting, h: 118 cm.
Acropolis Museum, Athens (Greece). Greek Antiquity. (*)

13. Anonymous.
Kore 671, Acropolis, Athens (Greece), c. 520 B.C.E.
Marble, h: 177 cm.
Acropolis Museum, Athens (Greece). Greek Antiquity.

11. Anonymous.
Kore, Keratea, c. 570-560 B.C.E.
Marble, h: 193 cm.
Staatliche Museen zu Berlin, Berlin (Germany). Greek Antiquity.

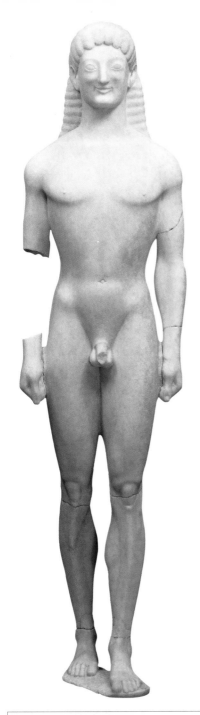

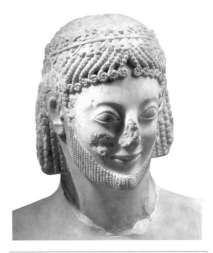

15. **Anonymous.**
Head of a Cavalier called the *"Cavalier Rampin"*, Acropolis, Athens (Greece), c. 550 B.C.E.
Marble, traces of painting, h: 27 cm.
Musée du Louvre, Paris (France). Greek Antiquity. (*)

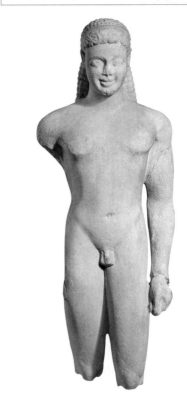

14. **Anonymous.**
Kouros, called the *"Apollo from Tenea"*, c. 560-550 B.C.E.
Marble, h: 153 cm.
Glyptothek, Munich. Greek Antiquity.

16. **Anonymous.**
Kouros, Asclepieion, Paros, c. 540 B.C.E.
Marble, h: 103 cm.
Musée du Louvre, Paris (France). Greek Antiquity.

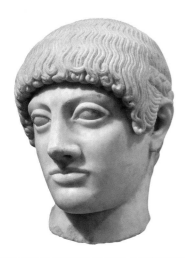

17. **Anonymous**.
Head of a Blond Youth, c. 485 B.C.E.
Marble, h: 25 cm.
Acropolis Museum, Athens (Greece). Greek Antiquity.

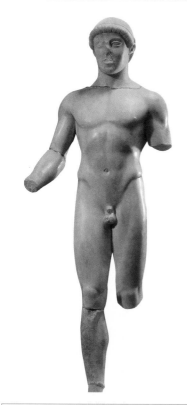

18. **Anonymous**.
Kouros, Agrigento, c. 500-480 B.C.E.
Marble, h: 104 cm.
Archaeological Museum, Agrigente (Italy). Greek Antiquity.

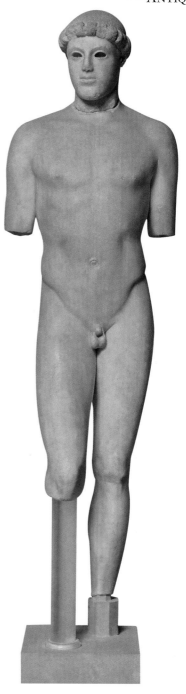

19. **Anonymous**.
The Kritios Boy, Acropolis, Athens (Greece), c. 480-470 B.C.E.
Marble, h: 116 cm.
Acropolis Museum, Athens (Greece). Greek Antiquity.

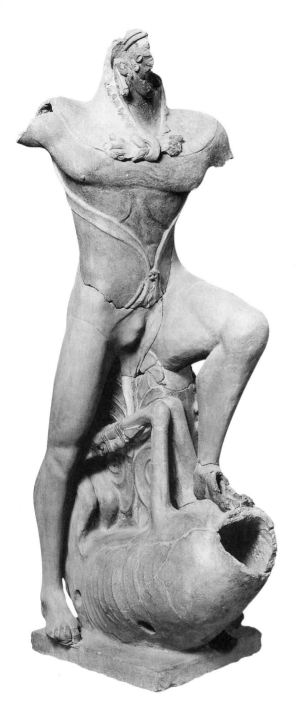

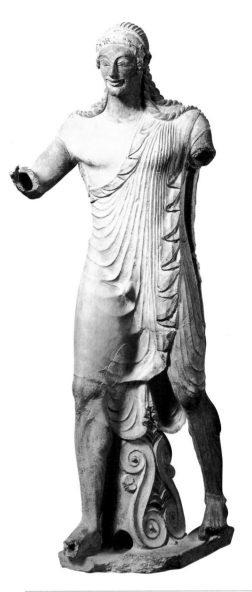

21. Anonymous.
Apollo, Temple of Portonaccio, Veii (Italy), c. 510 B.C.E.
Terracotta, h: 180 cm.
Museo Nazionale Etrusco di Villa Giula, Rome (Italy). Etruscan Antiquity.

20. Anonymous.
Heracles, Temple of Portonaccio, Veii (Italy), 510-490 B.C.E.
Terracotta.
Museo Nazionale Etrusco di Villa Giula, Rome (Italy). Etruscan Antiquity. (*)

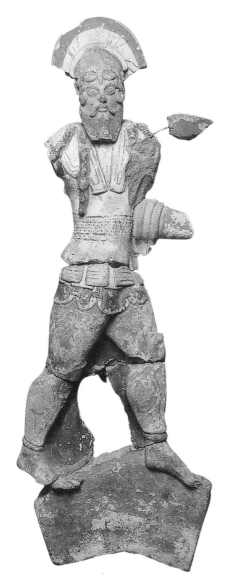

22. **Anonymous.**
Warrior from Cerveteri, c. 530-510 B.C.E.
Terracotta.
Ny Carlsberg Glyptotek, Copenhagen (Denmark). Etruscan Antiquity.

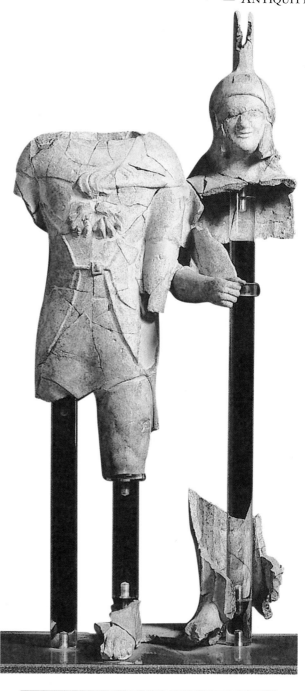

23. **Anonymous.**
Athena introducing Heracles on Mount Olympus, c. 530-520 B.C.E.
Terracotta.
Museo Nazionale Etrusco di Villa Giula, Rome (Italy). Etruscan Antiquity.

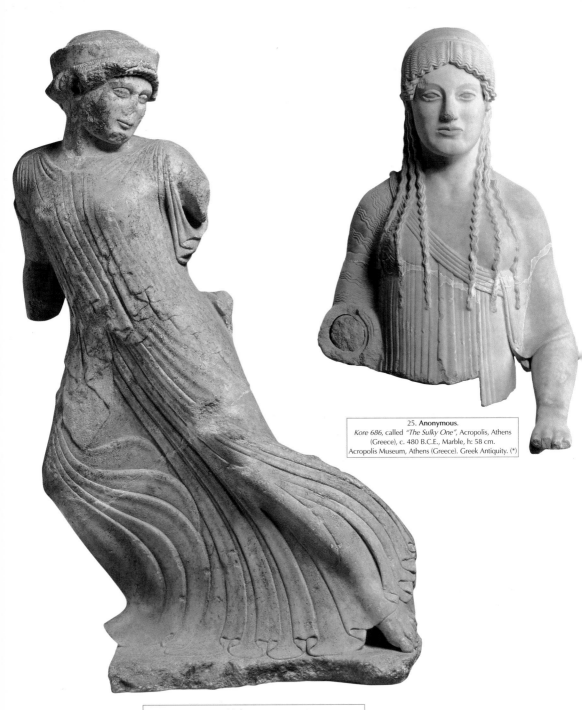

25. Anonymous.
Kore 686, called *"The Sulky One"*, Acropolis, Athens
(Greece), c. 480 B.C.E., Marble, h: 58 cm.
Acropolis Museum, Athens (Greece). Greek Antiquity. (*)

24. Anonymous.
Young Girl running, pediment, Temple of Eleusis, Eleusis (Greece),
c. 490-480 B.C.E. Marble, h: 65 cm.
Archaeological Museum, Eleusis (Greece). Greek Antiquity.

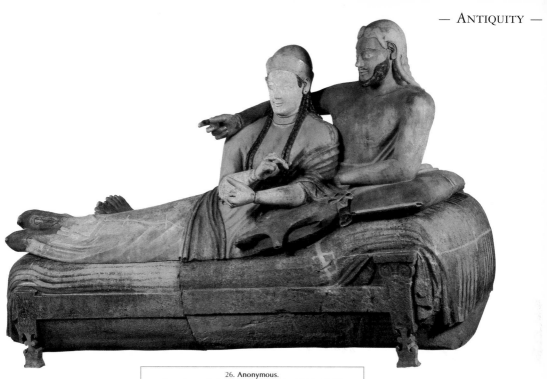

26. Anonymous.
Sarcophagus of a Couple from Cerveteri, c. 520-510 B.C.E.
Painted terracotta, 111 x 194 x 69 cm.
Musée du Louvre, Paris (France). Etruscan Antiquity. (*)

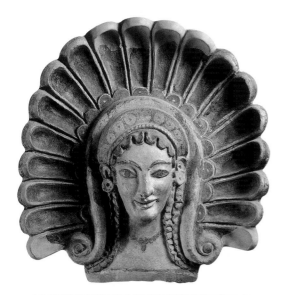

27. Anonymous.
Antefixe, 500 B.C.E.
Terracotta.
Etruscan Antiquity. (*)

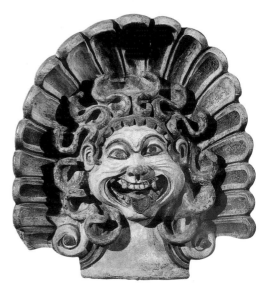

28. Anonymous.
Antefixe with the Head of a Gorgon, 500 B.C.E.
Terracotta.
Etruscan Antiquity.

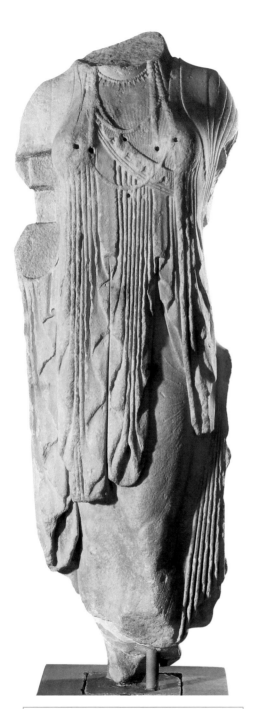

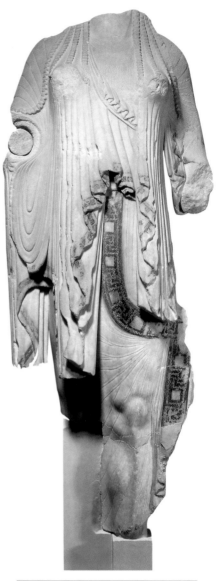

30. **Anonymous.**
Kore 594, Acropolis, Athens (Greece), c. 500 B.C.E.
Marble, h: 122 cm.
Acropolis Museum, Athens (Greece). Greek Antiquity. (*)

29. **Anonymous.**
Kore, Delos (Greece), c. 525-500 B.C.E.
Marble, h: 134 cm.
National Archaeological Museum, Athens (Greece). Greek Antiquity.

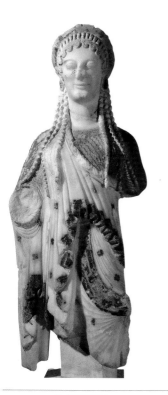

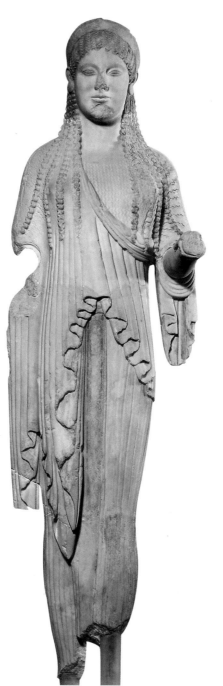

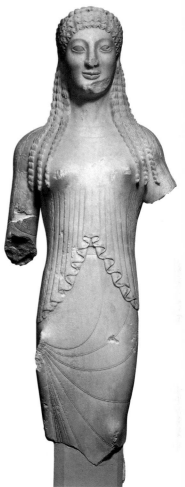

31. Anonymous.
Kore 675, Acropolis, Athens (Greece), c. 520-510 B.C.E.
Marble, h: 54.5 cm.
Acropolis Museum, Athens (Greece). Greek Antiquity.

33. Anonymous.
Kore 678, Acropolis, Athens (Greece), c. 530 B.C.E.
Marble, h: 96.4 cm.
Acropolis Museum, Athens (Greece). Greek Antiquity.

32. Anonymous.
Kore 685, Acropolis, Athens (Greece), c. 500-490 B.C.E.
Marble, h: 122 cm.
Acropolis Museum, Athens (Greece). Greek Antiquity.

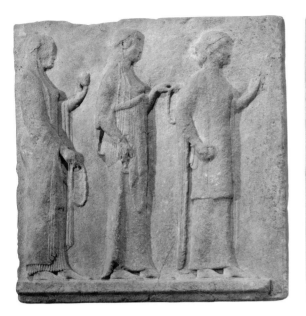

34. **Anonymous.**
Graces with Offerings, Passage of the Theores, Thasos (Greece), c. 480 B.C.E.
Marble, 92 x 92 x 33 cm.
Musée du Louvre, Paris (France). Greek Antiquity.

35. **Anonymous.**
Hermes and a Grace, Passage of the Theores, Thasos (Greece), c. 480 B.C.E.
Marble, 92 x 92 x 33 cm.
Musée du Louvre, Paris (France). Greek Antiquity.

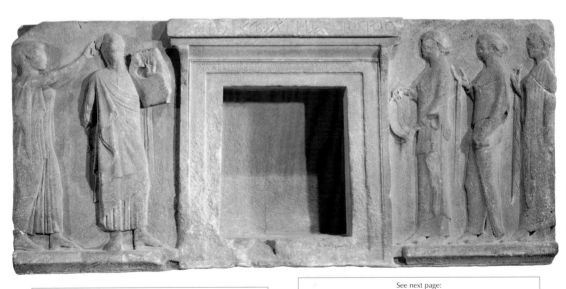

36. **Anonymous.**
Apollo and the Nymphs, Passage of the Theores, Thasos (Greece), c. 480 B.C.E.
Marble, 92 x 209 x 44 cm.
Musée du Louvre, Paris (France). Greek Antiquity.

See next page:
37. **Anonymous.**
Leda and the Swan, copy after a Greek original created during the first half of
the 5th century B.C.E. by **Timotheus**. Marble, h: 132 cm.
Musei Capitolini, Rome (Italy). Greek Antiquity.

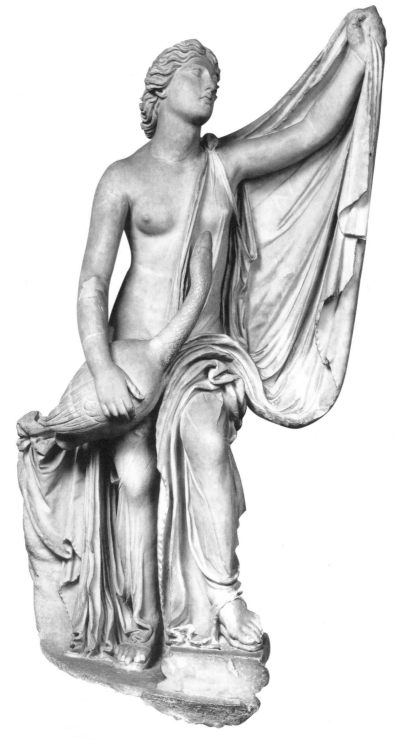

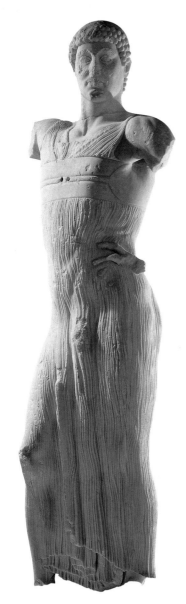

38. Anonymous.
Youth Clad in Tight Long-Fitting Tunic,
called the *"Charioteer of Motya",*
c. 470 B.C.E. Marble, h: 181 cm.
Museo Joseph Whitaker, Motya (Italy). Greek Antiquity.

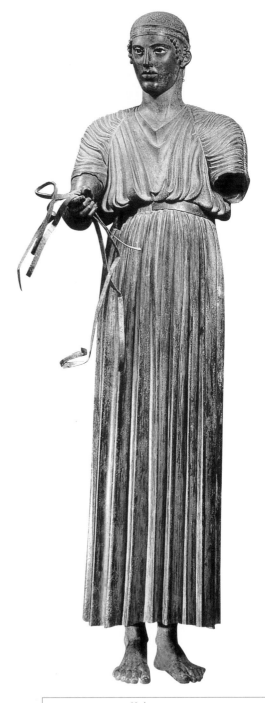

39. Anonymous.
The Charioteer of Delphi, c. 475 B.C.E.
Bronze, h: 180 cm.
Archaeological Museum of Delphi, Delphi (Greece). Greek Antiquity. (*)

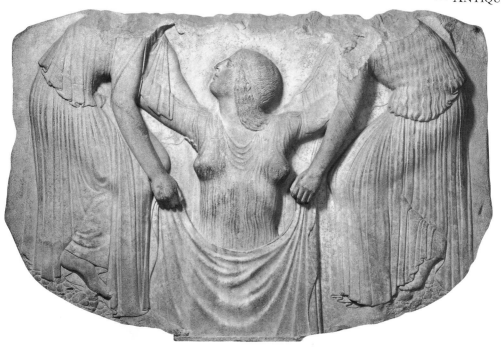

40. Anonymous.
Birth of Aphrodite, detail of the *"Ludovisi Throne"*,
c. 470-460 B.C.E. Marble, h: 90, l: 142 cm.
Museo Nazionale Romano, Rome (Italy). Greek Antiquity.

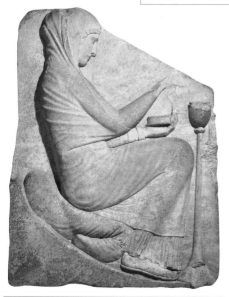

41. Anonymous.
Youth making an Offering, detail of the *"Ludovisi Throne"*,
c. 470-460 B.C.E. Marble, h: 84 cm.
Museo Nazionale Romano, Rome (Italy). Greek Antiquity.

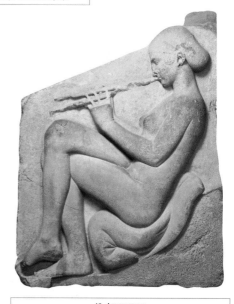

42. Anonymous.
Nude playing the Double Flute, detail of the *"Ludovisi Throne"*,
c. 470-460 B.C.E. Marble, h: 84 cm.
Museo Nazionale Romano, Rome (Italy). Greek Antiquity.

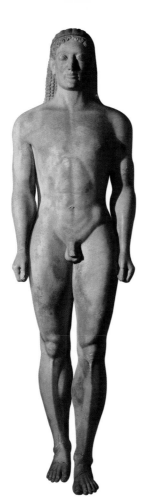

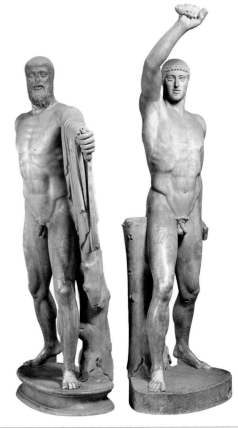

44. **Anonymous.**
The Tyrannicides Harmodius and Aristogeiton, roman copy after a Greek
original created around 477 B.C.E. by **Critios**. Marble, h: 195 cm.
Museo Archeologico Nazionale, Naples (Italy). Greek Antiquity. (*)

43. **Anonymous.**
Kroisos, Anavysos, c. 525 B.C.E.
Marble, h: 193 cm.
National Archaeological Museum, Athens (Greece). Greek Antiquity.

45. **Anonymous.**
Dying Warrior, corner figure, east pediment, Temple of Aphaia, Aegina (Greece),
c. 500-480 B.C.E. Marble, l: 185 cm.
Glyptothek, Munich (Germany). Greek Antiquity. (*)

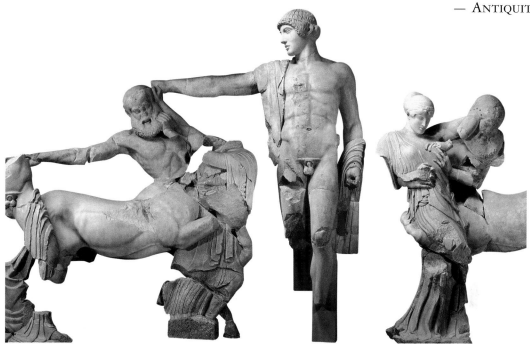

46. **Anonymous.**
The Battle between the Lapiths and the Centaurs,
west pediment, Temple of Zeus, Olympia (Greece), c. 470-456 B.C.E.
Marble, height of Apollo: 330 cm.
Archaeological Museum, Olympia (Greece). Greek Antiquity.

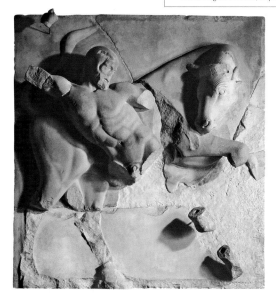

47. **Anonymous.**
Heracles fighting the Cretan Bull, west metope, Temple of Zeus, Olympia (Greece),
c. 470-456 B.C.E. Marble, h: 160 cm.
Musée du Louvre, Paris (France). Greek Antiquity.

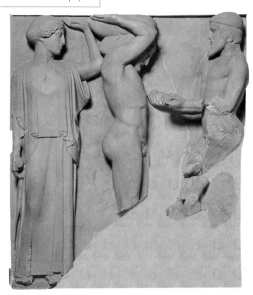

48. **Anonymous.** *Heracles receiving the Golden Apples of the Hesperides from the Hand of Atlas, while Minerva rests a Cushion on his Head,* east metope, Temple of Zeus, Olympia (Greece), c. 470-456 B.C.E. Marble, h: 160 cm. Archaeological Museum, Olympia (Greece). Greek Antiquity. (*)

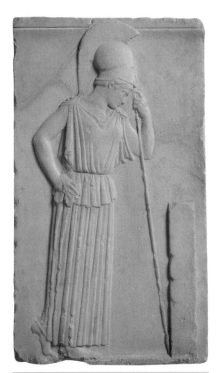

49. **Anonymous**.
Pensive Athena, Acropolis, Athens (Greece),
c. 470-460 B.C.E. Marble, h: 54 cm.
Acropolis Museum, Athens (Greece). Greek Antiquity. (*)

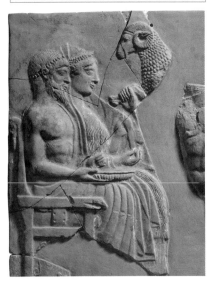

50. **Anonymous**.
Hades and Persephone, pinax relief (fragment),
c. 470-450 B.C.E. Terracotta, h: 255 cm.
Museo Nazionale, Reggio Calabria (Italy). Greek Antiquity. (*)

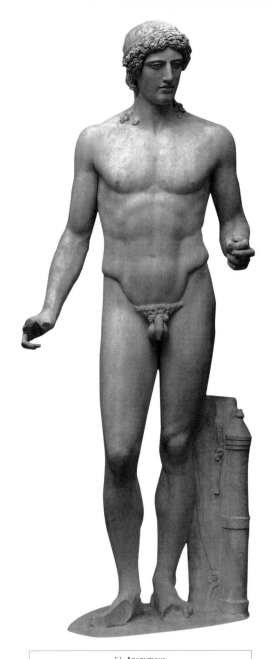

51. **Anonymous**.
Apollo, called the *"Apollo Parnopios"*, copy after a Greek original
created around 450 B.C.E. by **Phidias**.
Marble, h: 197 cm.
Staatliche Museen, Kassel (Germany). Greek Antiquity. (*)

See next page:
52. **Anonymous**.
Bust of Perikles, copy after a Greek original
created around 425 B.C.E. Marble, h: 48 cm.
The British Museum, London (United Kingdom). Greek Antiquity.

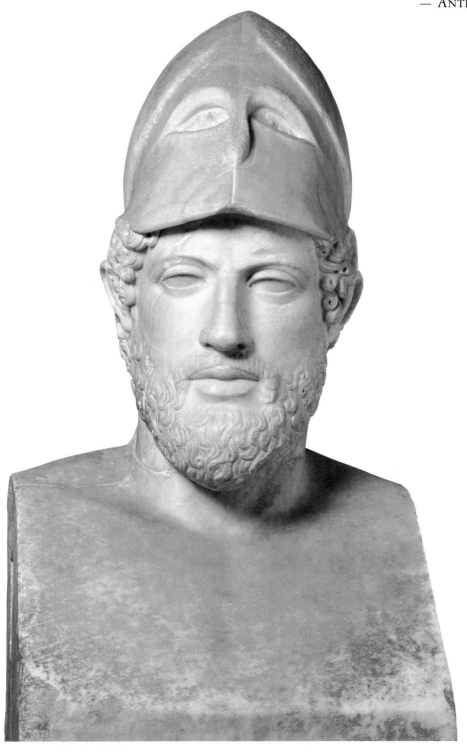

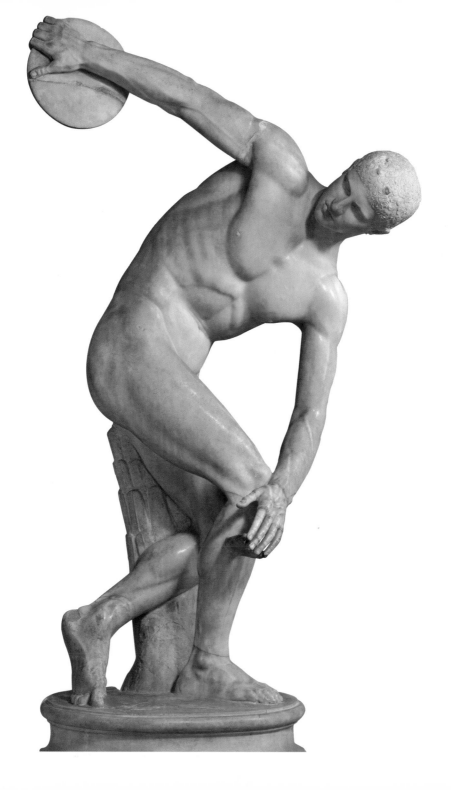

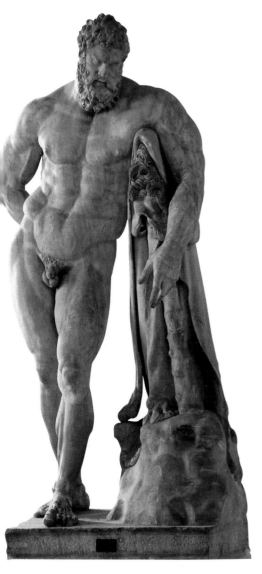

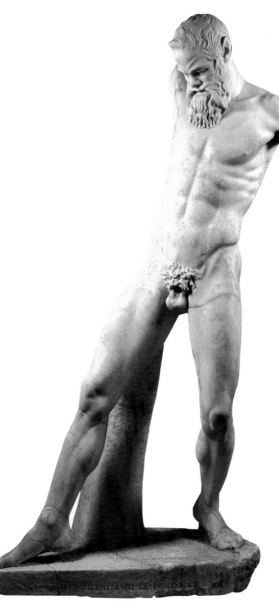

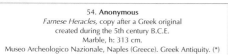

54. Anonymous
Farnese Heracles, copy after a Greek original
created during the 5th century B.C.E.
Marble, h: 313 cm.
Museo Archeologico Nazionale, Naples (Greece). Greek Antiquity. (*)

See previous page:
53. Anonymous.
Discobolus, copy after a Greek original created around 450 B.C.E. by **Myron**.
Marble, h: 148 cm.
Museo Nazionale Romano, Rome (Italy). Greek Antiquity. (*)

55. Anonymous.
Marsyas, copy after a Greek original created around 450 B.C.E. by **Myron**.
Marble.
Museo Gregoriano Profano, Vatican (Italy). Greek Antiquity. (*)

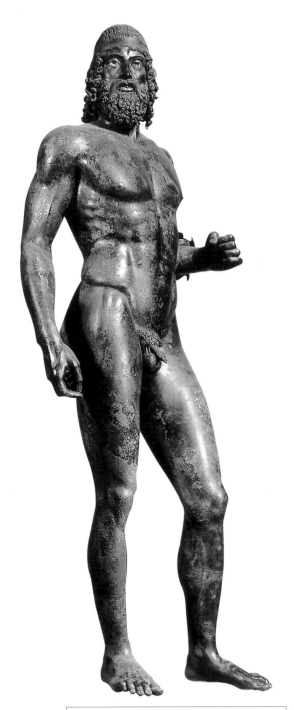

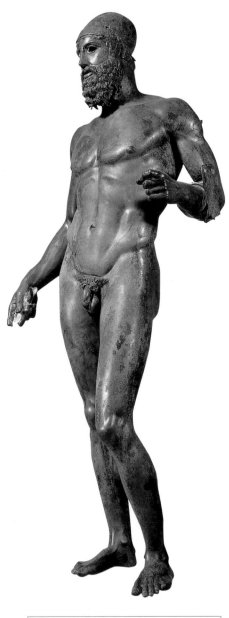

57. **Anonymous**.
Riace Bronze B, Roman copy after a Greek original
created around 450 B.C.E. by **Phidias**.
Bronze, h: 197 cm.
Museo Nazionale, Reggio Calabria (Italy). Greek Antiquity. (*)

56. **Anonymous**.
Riace Bronze A, Roman copy after a Greek original
created around 450 B.C.E. by **Phidias**.
Bronze, h: 198 cm.
Museo Nazionale, Reggio Calabria (Italy). Greek Antiquity.

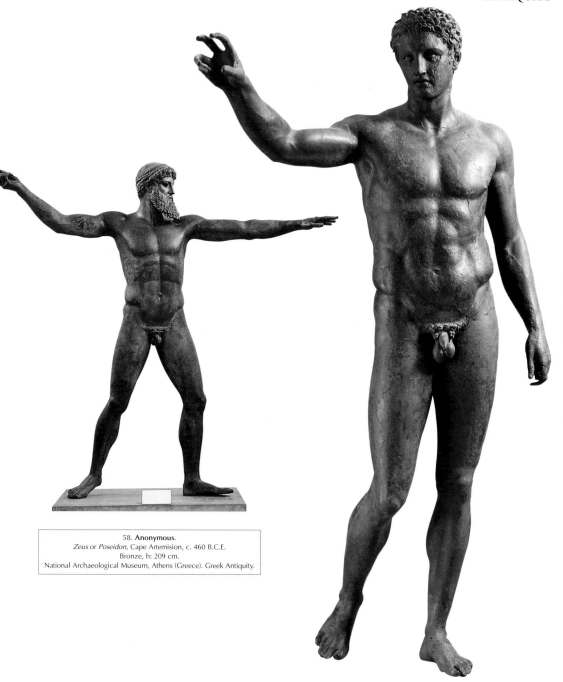

58. **Anonymous.**
Zeus or *Poseidon*, Cape Artemision, c. 460 B.C.E.
Bronze, h: 209 cm.
National Archaeological Museum, Athens (Greece). Greek Antiquity.

59. **Anonymous.**
Youth of Antikythera, middle of the 4th century B.C.E.
Bronze, h: 194 cm.
National Archaeological Museum, Athens (Greece). Greek Antiquity.

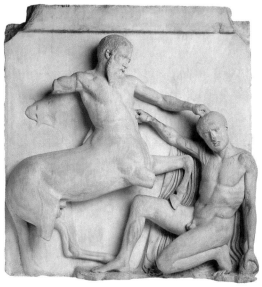

60. Anonymous.
Battle of the Lapiths and the Centaurs, south metope No.29,
Parthenon, Athens (Greece), c. 446-438 B.C.E. Marble, h: 134 cm.
The British Museum, London (United Kingdom). Greek Antiquity.

61. Anonymous.
Battle of the Lapith and the Centaurs, south metope No.30,
Parthenon, Athens (Greece), c. 446-438 B.C.E. Marble, h: 134 cm.
The British Museum, London (United Kingdom). Greek Antiquity.

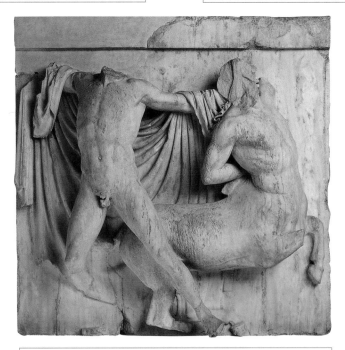

62. Anonymous.
A Lapith tackles a Fleeing Centaur and prepares to Strike a Decisive Blow, south metope No.27,
Parthenon, Athens (Greece), c. 446-438 B.C.E. Marble, h: 135 cm.
The British Museum, London (United Kingdom). Greek Antiquity. (*)

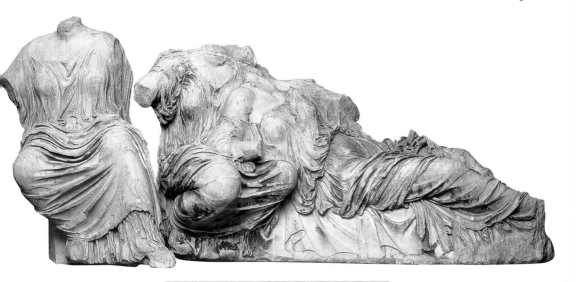

63. **Anonymous**.
Goddesses, east pediment, Parthenon, Athens (Greece),
c. 438-432 B.C.E. Marble, h: 130 cm.
The British Museum, Athens (Greece). Greek Antiquity. (*)

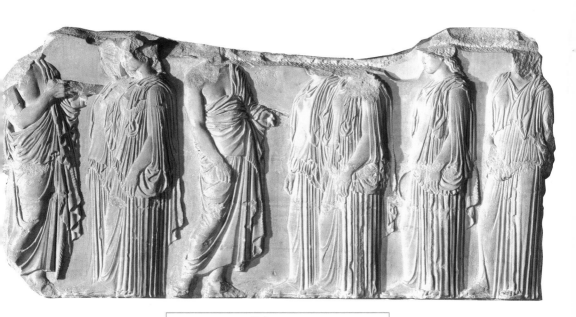

64. **Anonymous**.
Head of the Pan-Athenaic Procession, slab No.7, east frieze, Parthenon,
Athens (Greece), 445-438 B.C.E. Marble, h: 96 cm, l: 207 cm.
Musée du Louvre, Paris (France). Greek Antiquity.

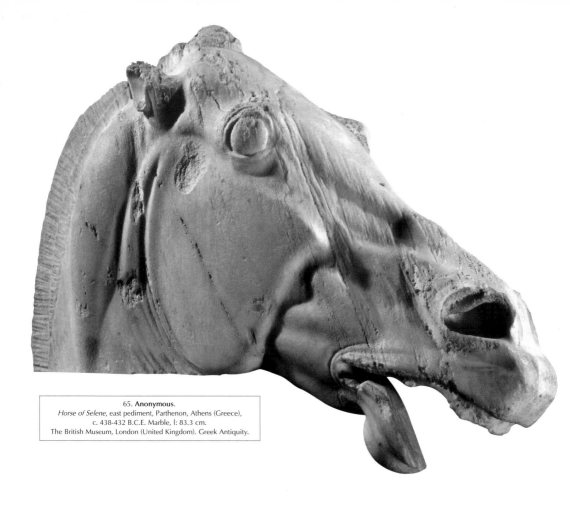

65. Anonymous.
Horse of Selene, east pediment, Parthenon, Athens (Greece),
c. 438-432 B.C.E. Marble, l: 83.3 cm.
The British Museum, London (United Kingdom). Greek Antiquity.

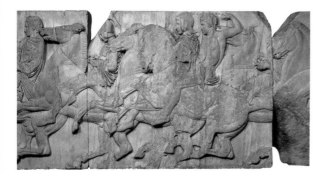

66. Anonymous.
Mounted Riders, slab No.38, north frieze, Parthenon, Athens (Greece),
c. 438-432 B.C.E. Marble, h: 106 cm.
The British Museum, London (United Kingdom). Greek Antiquity. (*)

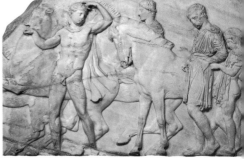

67. Anonymous.
Horse Men, slab No.42, north frieze, Parthenon, Athens (Greece),
c. 438-432 B.C.E. Marble, h: 106 cm.
The British Museum, London (United Kingdom). Greek Antiquity.

68. **Anonymous**.
Diomedes, c. 430 B.C.E. Marble, h: 102 cm.
Glyptothek, Munich (Germany). Greek Antiquity.

69. **Anonymous**.
Male Torso, the *"Diadoumenos"*,
copy after a bronze original created around 430 B.C.E. by
Polykleitos. Marble, h: 85 cm.
Musée du Louvre, Paris (France). Greek Antiquity.

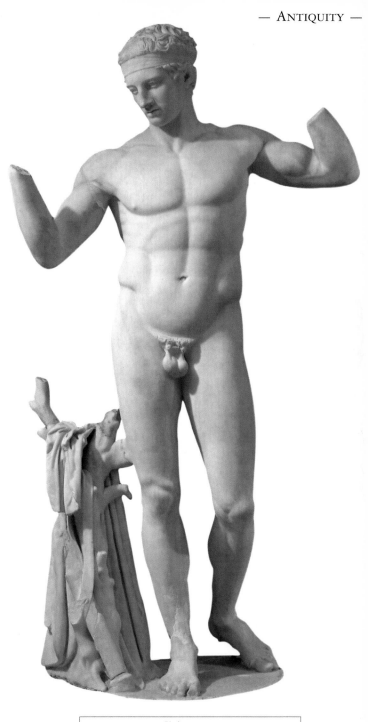

70. **Anonymous**.
Diadoumenos, the Young Athlete, copy after the bronze original
created around 430 B.C.E. by **Polykleitos**. Marble, h:186 cm.
National Museum, Athens (Greece). Greek Antiquity. (*)

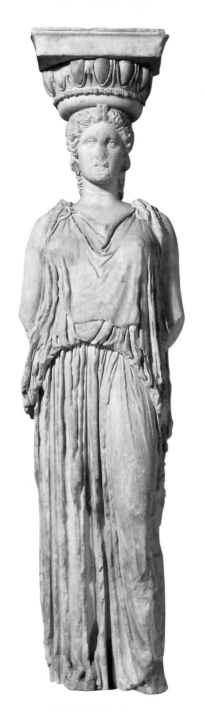

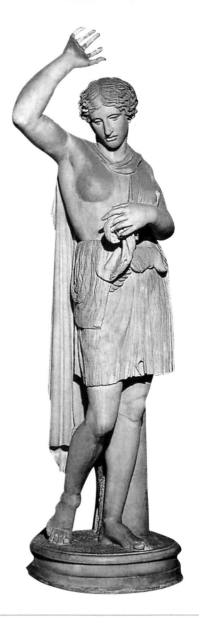

72. **Anonymous.**
Wounded Amazon, Roman copy after a Greek original created around
440-430 B.C.E. by **Polykleitos**. Marble, h: 202 cm.
Musei Capitolini, Rome (Italy). Greek Antiquity. (*)

71. **Anonymous.**
Caryatid, Erechtheum, Acropolis, Athens (Greece),
c. 420-406 B.C.E. Marble, h: 231 cm.
The British Museum, London (United Kingdom). Greek Antiquity. (*)

73. Anonymous.
Artemis, east frieze, Parthenon, Athens (Greece),
c. 438-432 B.C.E. Marble, h: 100 cm.
The British Museum, London (United Kingdom). Greek Antiquity.

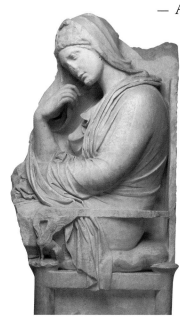

74. Anonymous.
Draped Woman Seated, tombstone (fragment),
c. 400 B.C.E. Marble, h: 122 cm.
The Metropolitan Museum of Art, New York (United States). Greek Antiquity.

75. Paionios of Mende, Greek.
Nike, c. 420 B.C.E. Marble, h: 290 cm.
Archaeological Museum, Olympia (Greece).
Greek Antiquity.

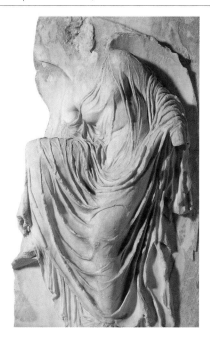

76. Anonymous.
Nike, balustrade, Temple of Athena Nike, Athens (Greece),
c. 420-400 B.C.E. Marble, h: 101 cm.
Acropolis Museum, Athens (Greece). Greek Antiquity. (*)

77. Anonymous.
Capitoline She-Wolf (Romulus and Remus), 5th century B.C.E.
Bronze, h: 75 cm.
Musei Capitolini, Rome (Italy). Etruscan Antiquity. (*)

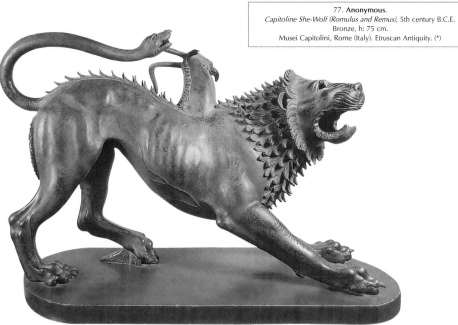

78. Anonymous.
Chimera of Arezzo, c. 380-360 B.C.E.
Bronze, h: 80 cm.
Museo Archeologico di Firenze, Florence (Italy). Etruscan Antiquity. (*)

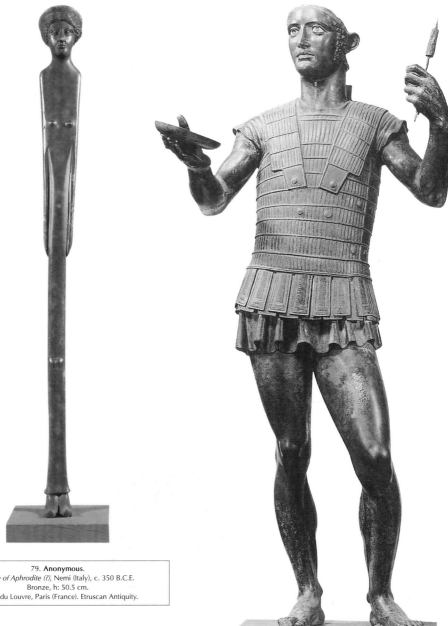

79. **Anonymous.**
Statue of Aphrodite (?), Nemi (Italy), c. 350 B.C.E.
Bronze, h: 50.5 cm.
Musée du Louvre, Paris (France). Etruscan Antiquity.

80. **Anonymous.**
Mars from Todi, end of the 5th century B.C.E.
Bronze.
Musei Vaticani, Vatican City (Italy). Etruscan Antiquity. (*)

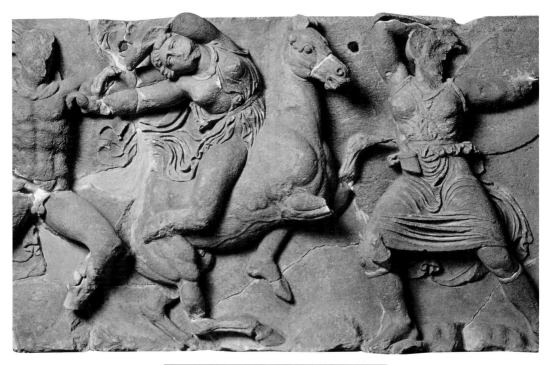

81. Anonymous.
Battle between the Greeks and the Amazons, east frieze, Temple of
Apollo Epikourios, Bassae (Greece), c. 420 B.C.E. Marble, h: 70 cm.
The British Museum, London (United Kingdom). Greek Antiquity.

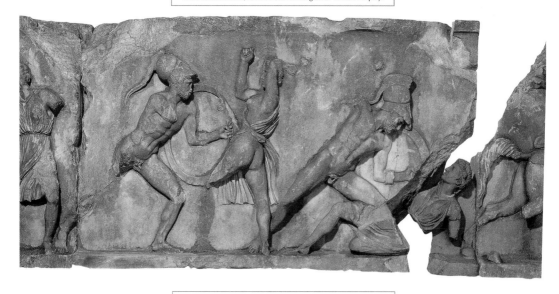

82. Anonymous.
Amazon Frieze, Mausoleum of Halicarnassus, Bodrum (Turkey),
c. 360-350 B.C.E. Marble, h: 90 cm.
The British Museum, London (United Kingdom). Greek Antiquity.

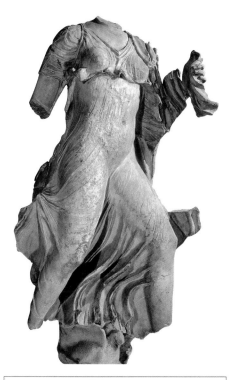

83. **Anonymous.**
Nereid 909, Nereid Monument, Xanthos (Turkey),
c. 400 B.C.E. Marble, h: 140 cm.
The British Museum, London (United Kingdom). Greek Antiquity. (*)

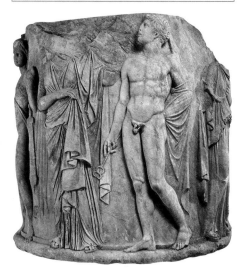

84. **Anonymous.**
Thanatos, Alceste, Hermes and Persephone, drum of column,
Artemision, Ephesus (Turkey), c. 350-300 B.C.E. Marble, h: 155 cm.
The British Museum, London (United Kingdom). Greek Antiquity. (*)

85. **Anonymous.**
Maenad, copy after a Greek original created around c. 370-330 B.C.E.
by **Skopas**. Marble, h: 45 cm. Skultpturensammlung, Staatliche
Kunstsammlungen Dresden, Dresden (Germany). Greek Antiquity. (*)

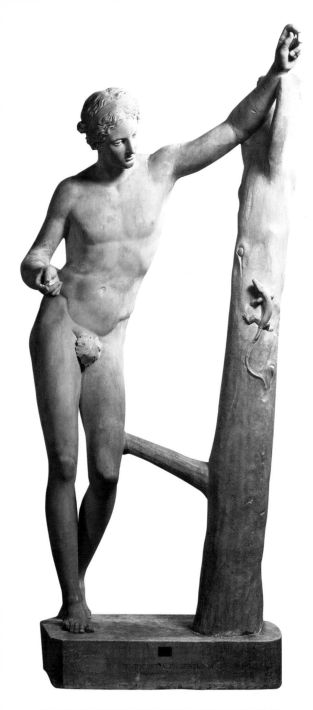

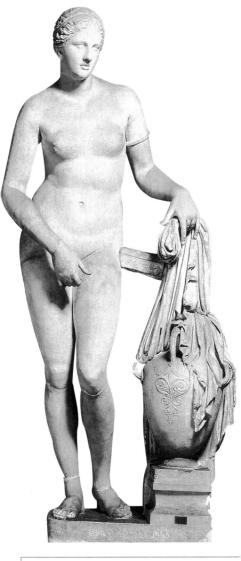

87. **Anonymous.**
Aphrodite of Knidos, copy after a Greek original created around 350 B.C.E. by **Praxiteles**. Marble.
Museo Pio Clementino, Vatican (Italy). Greek Antiquity. (*)

86. **Anonymous.**
Apollo Sauroktonos, Hellenistic copy after a Greek original created during the 4th century B.C.E. by **Praxiteles**. Marble.
Museo Pio Clementino, Vatican (Italy). Greek Antiquity.

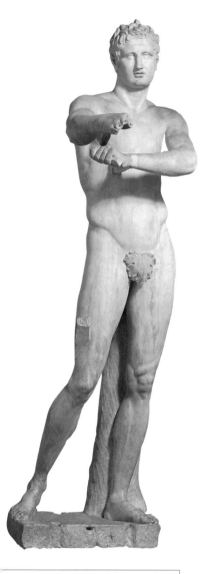

88. **Anonymous.**
Apoxyomenos, copy after a bronze original created around 330 B.C.E. by **Lysippos**. Marble, h: 205 cm. Museo Pio Clementino, Vatican (Italy). Greek Antiquity. (*)

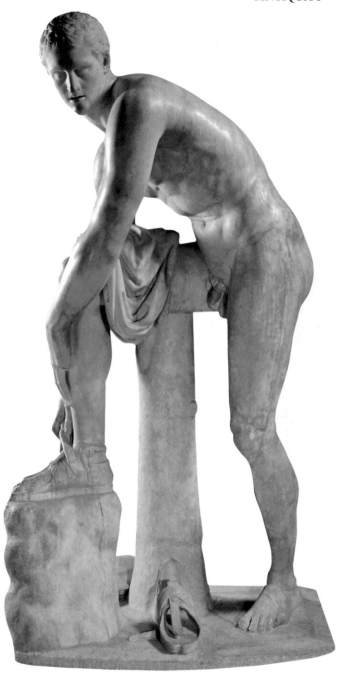

89. **Anonymous.**
Hermes tying his Sandal, Roman copy after a Greek original created during the 4th century B.C.E. by **Lysippos**. Marble, h: 161 cm. Musée du Louvre, Paris (France). Greek Antiquity.

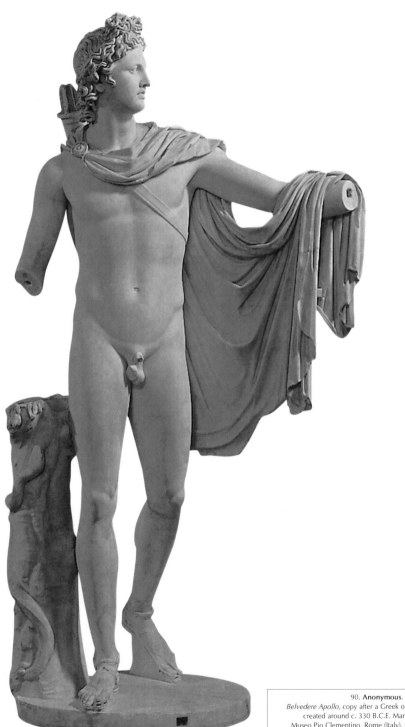

90. **Anonymous.**
Belvedere Apollo, copy after a Greek original by **Leochares**
created around c. 330 B.C.E. Marble, h: 224 cm.
Museo Pio Clementino, Rome (Italy). Greek Antiquity. (*)

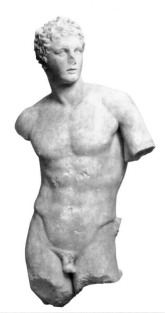

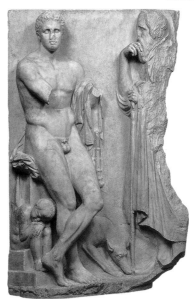

91. **Anonymous.**
Meleager, copy after a Greek original created around c. 340 B.C.E. by **Skopas.**
Marble, h: 123 cm.
Arthur M. Sackler Museum, Harvard (United States). Greek Antiquity.

92. **Anonymous.**
Athenian Tombstone, c. 340 B.C.E.
Marble, h: 168 cm.
National Archaeological Museum, Athens (Greece). Greek Antiquity.

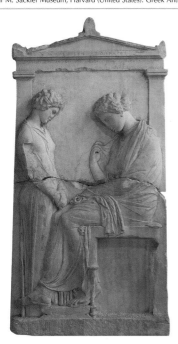

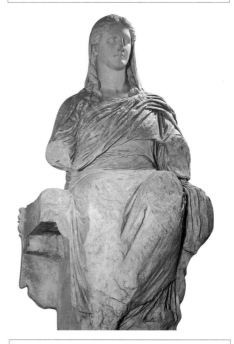

93. **Anonymous.**
Tombstone from Mnesarete, c. 380 B.C.E.
Marble, h: 166 cm.
Glyptothek, Munich (Germany). Greek Antiquity.

94. **Anonymous.**
Demeter of Knidos, c. 340-330 B.C.E.
Marble, h: 153 cm.
The British Museum, London (United Kingdom). Greek Antiquity.

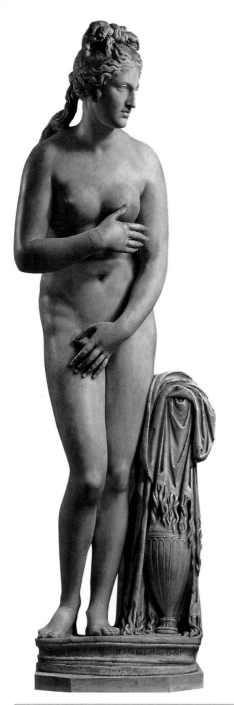

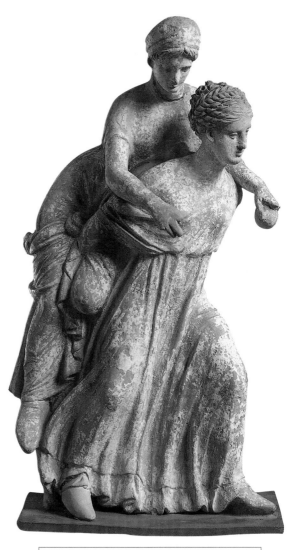

96. **Anonymous.**
Playing Girls, end of the 4th century-beginning of the 3rd century
B.C.E. Terracotta, h: 26 cm.
The State Hermitage Museum, St Petersburg (Russia). Greek Antiquity.

95. **Anonymous.**
Capitoline Venus, Roman copy after a Greek original created around
the 3rd century B.C.E. by **Praxiteles**. Marble, h: 193 cm.
Musei Capitolini, Rome (Italy). Greek Antiquity.

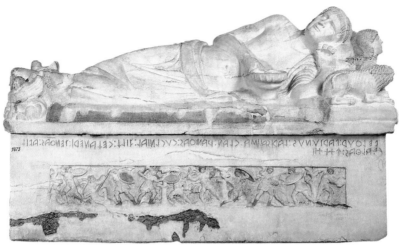

97. Anonymous.
Sarcophagus of Velthur Partunus, so-called "Magnate",
third quarter of the 4th century B.C.E. Painted marble and limestone,
Museo Archeologico di Tarquinia, Tarquinia (Italy). Etruscan Antiquity.

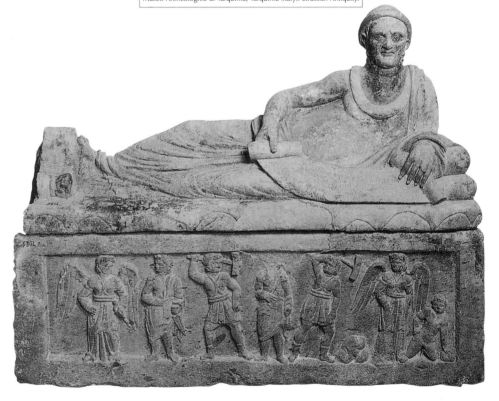

98. Anonymous.
Sarcophagus of Laris Pulenas from Tarquinia, 3rd century B.C.E. Nenfro.
Museo Archeologico di Tarquinia, Tarquinia (Italy). Etruscan Antiquity.

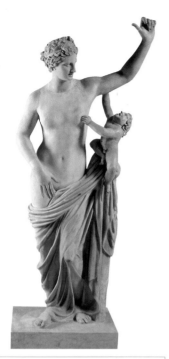

99. **Anonymous.**
Venus and Cupid, Roman copy after a Greek original created at
the end of the 4th century B.C.E., restored at the end of the 17th
century by **Alessandro Algardi**. Marble, h: 174 cm.
Musée du Louvre, Paris (France). Greek Antiquity. (*)

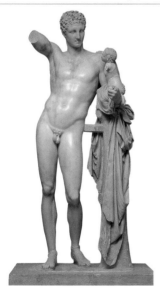

100. **Anonymous.**
Hermes with the Infant Dionysos, copy after an original created
at the end of the 4th century B.C.E. by **Praxiteles**.
Marble, h: 215 cm.
Archaeological Museum, Olympia (Greece). Greek Antiquity.

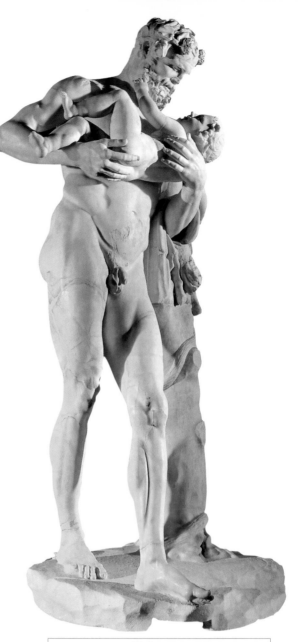

101. **Anonymous.**
Silenus with the Infant Dionysos, Roman copy after a Greek original
created during the 4th century B.C.E. Marble, h: 190 cm.
Musée du Louvre, Paris (France). Greek Antiquity.

See next page:
102. **Anonymous.**
Artemis with a Hind, called *"Diane of Versailles"*,
Roman copy after an original created around 330 B.C.E. by **Leochares**.
Marble, h: 200 cm.
Musée du Louvre, Paris (France). Greek Antiquity. (*)

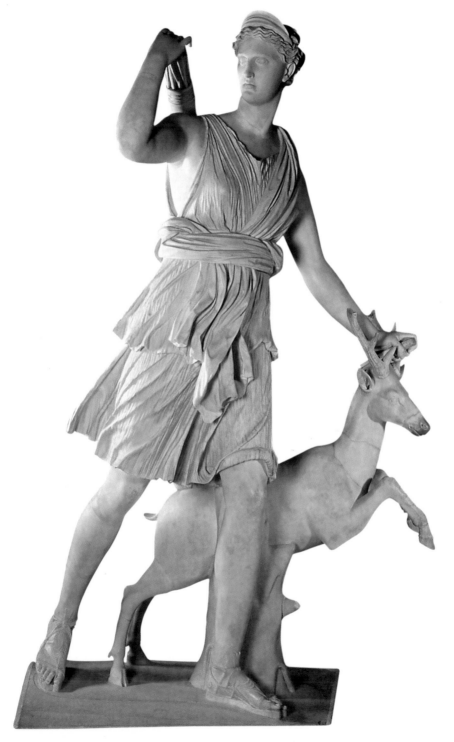

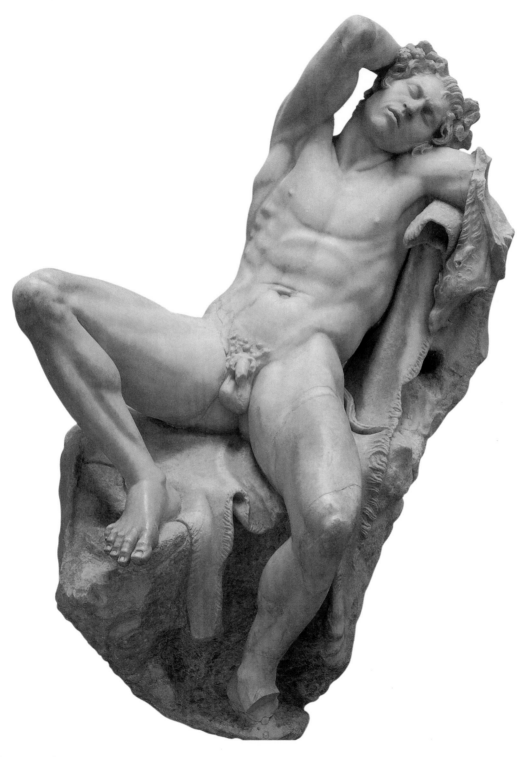

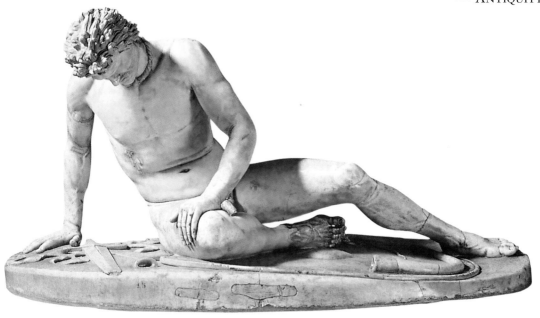

See previous page:
103. **Anonymous.**
The Barberini Faun, c. 220 B.C.E. Marble, h: 215 cm.
Glyptothek, Munich (Germany). Greek Antiquity. (*)

104. **Anonymous.**
Dying Gaul, Roman copy after a bronze original erected by the kings of
Pergamon Attalus I and Eumenes II around 240 B.C.E. Marble, h: 93 cm.
Musei Capitolini, Rome (Italy). Greek Antiquity.

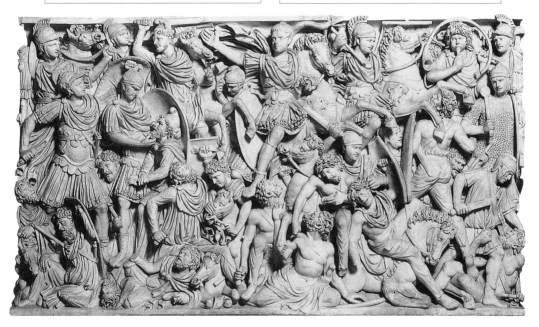

105. **Anonymous.**
Battle between the Romans and the Germans, Ludovisi Sarcophagus,
3rd century B.C.E. Marble.
Museo Nazionale Romano, Rome (Italy). Roman Antiquity.

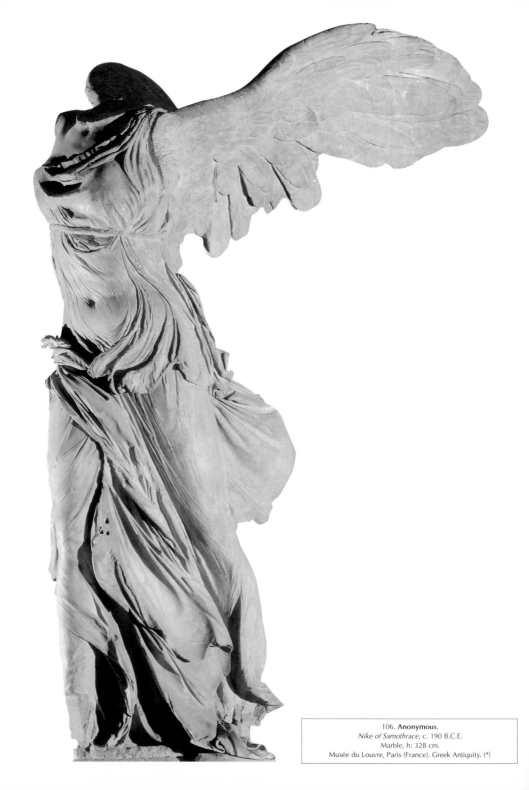

106. **Anonymous.**
Nike of Samothrace, c. 190 B.C.E.
Marble, h: 328 cm.
Musée du Louvre, Paris (France). Greek Antiquity. (*)

107. **Anonymous.**
Crouching Aphrodite, Roman copy after a Greek original
Created during the 3rd (?) century B.C.E. Marble, h: 71 cm.
Musée du Louvre, Paris (France). Greek Antiquity.

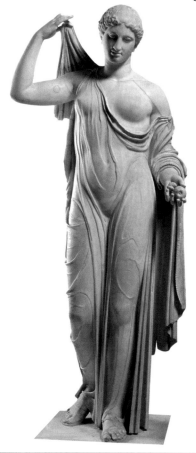

108. **Anonymous.**
Aphrodite, type *"Venus Genetrix"*, Roman copy after a Greek
original created at the end of the 5th century B.C.E. by **Callimachus** (?).
Marble, h: 164 cm.
Musée du Louvre, Paris (France). Greek Antiquity.

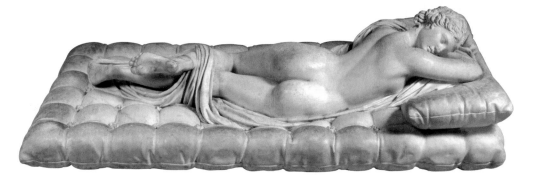

109. **Anonymous.**
Sleeping Hermaphrodite, Roman copy of a Greek original of the 2nd century B.C.E. (?).
Marble, 169 x 89 cm (the mattress was carved in 1619 by **Gian Lorenzo Bernini**).
Musée du Louvre, Paris (France). Greek Antiquity. (*)

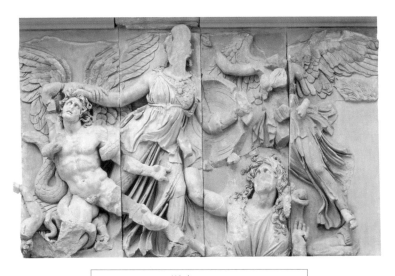

110. **Anonymous.**
Athena fighting with the Son of Gaea the Earth Goddess,
pedestal frieze, Great Altar of Zeus, Pergamon (Turkey), c. 180 B.C.E.
Marble, h: 230 cm.
Pergamonmuseum, Berlin (Germany). Greek Antiquity. (*)

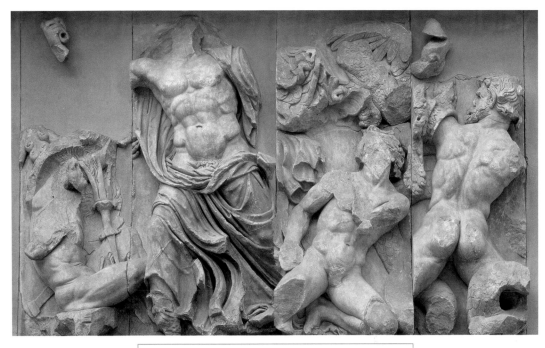

111. **Anonymous.**
Zeus and Porphyrion during the Battle with the Giants,
pedestal frieze, Great Altar of Zeus, Pergamon (Turkey), c. 180 B.C.E. Marble, h: 230 cm.
Pergamonmuseum, Berlin (Germany). Greek Antiquity.

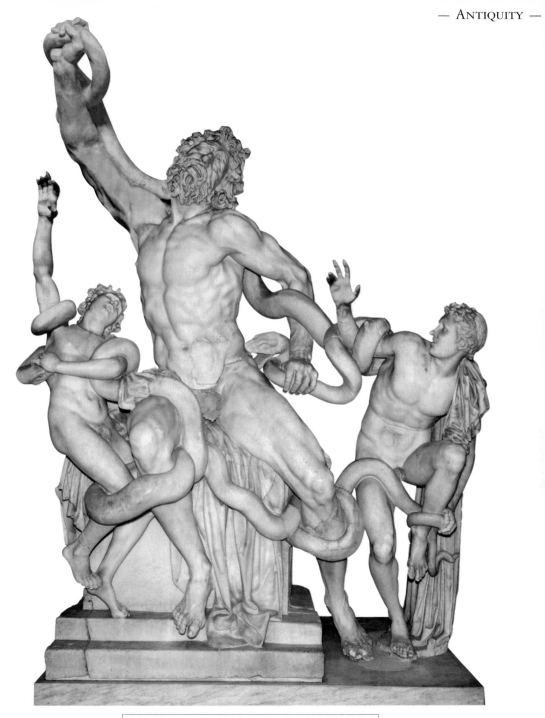

112. **Anonymous.**
Laocoön, Roman copy after a bronze original created in Pergame (Turkey) by
Agesander, **Athenodoros** and **Polydorus** around 150 B.C.E. Marble, h: 242 cm.
Museo Pio Clementino, Vatican (Italy). Greek Antiquity. (*)

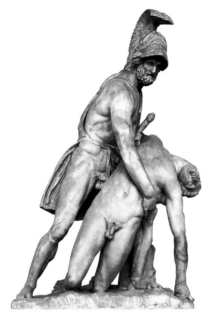

113. **Anonymous.**
Menelaos with the Body of Patroklos,
Roman copy of a Greek original created during the 3rd century B.C.E.,
restored during the 17th century. Marble, h: 253 cm.
Loggia dei Lanzi, Florence (Italy). Greek Antiquity.

114. **Anonymous.**
Ludovisi Group, Roman copy after a bronze original erected by
the kings of Pergamon (Turkey), Attalus I and Eumenes II,
around 240 B.C.E. Marble, h: 211 cm.
Museo Nazionale Romano, Rome (Italy). Greek Antiquity.

115. **Anonymous.**
Statue of Antinous, Favourite of Emperor Hadrian,
c. 130-138 A.D. Marble, h: 199 cm.
Archaeological Museum of Delphi, Delphi (Greece). Roman Antiquity.

See next page:
116. **Anonymous.**
The Punishment of Dirce, called the *"Farnese Bull",*
Roman copy of an original created during the 2nd century B.C.E.
by **Apollonius of Tralles** and his brother Tauriscus. Marble, h: 240 cm.
Museo Archeologico Nazionale, Naples (Italy). Greek Antiquity. (*)

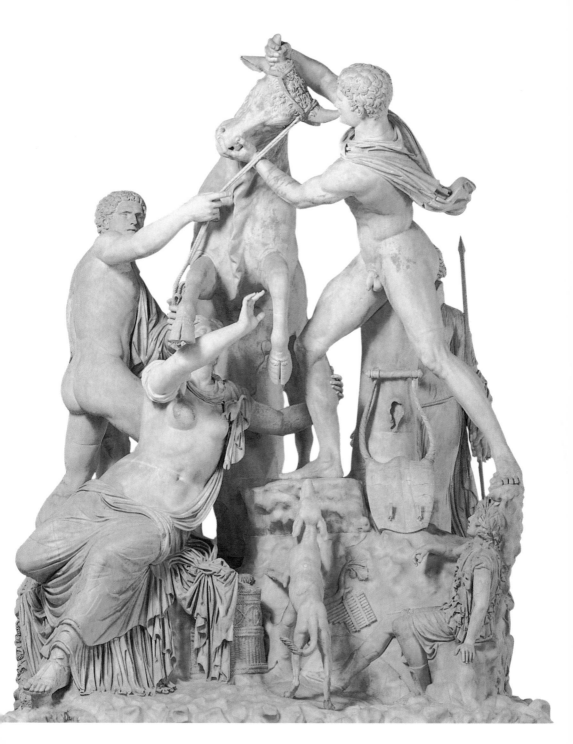

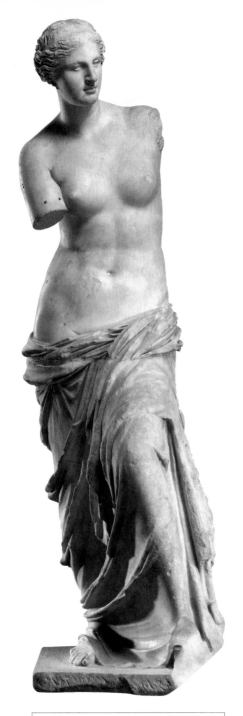

118. **Anonymous.**
Aphrodite, called the *"Venus of Arles"*,
end of the 1st century B.C.E. Marble, h: 194 cm.
Musée du Louvre, Paris (France). Roman Antiquity.

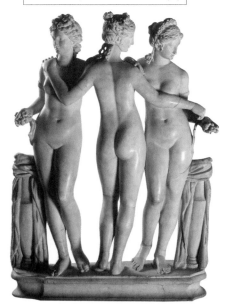

117. **Anonymous.**
Aphrodite of Melos, called the *"Venus de Milo"*,
c. 100 B.C.E. Marble, h: 202 cm.
Musée du Louvre, Paris (France). Greek Antiquity. (*)

119. **Anonymous.**
The Three Graces, Roman copy of a Greek original created during
the 2nd century B.C.E., restored in 1609. Marble, 119 x 85 cm.
Musée du Louvre, Paris (France). Greek Antiquity. (*)

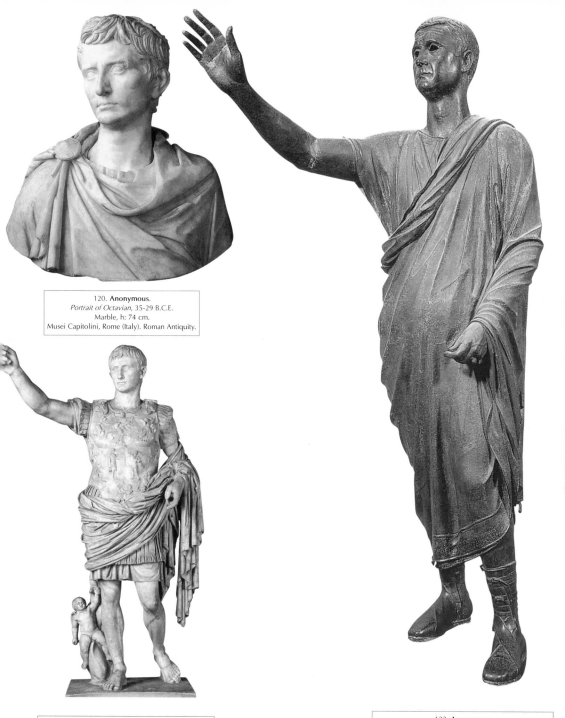

120. **Anonymous.**
Portrait of Octavian, 35-29 B.C.E.
Marble, h: 74 cm.
Musei Capitolini, Rome (Italy). Roman Antiquity.

121. **Anonymous.**
Augustus Prima Porta, 50 B.C.E. Marble, h: 104 cm.
Musei Vaticani, Vatican City (Italy). Roman Antiquity. (*)

122. **Anonymous.**
The Orator (L'Arringatore), Funerary Statue of Aulus Metellus,
2nd-1st century B.C.E. Bronze, h: 179 cm.
Museo Archeologico, Florence (Italy). Roman Antiquity.

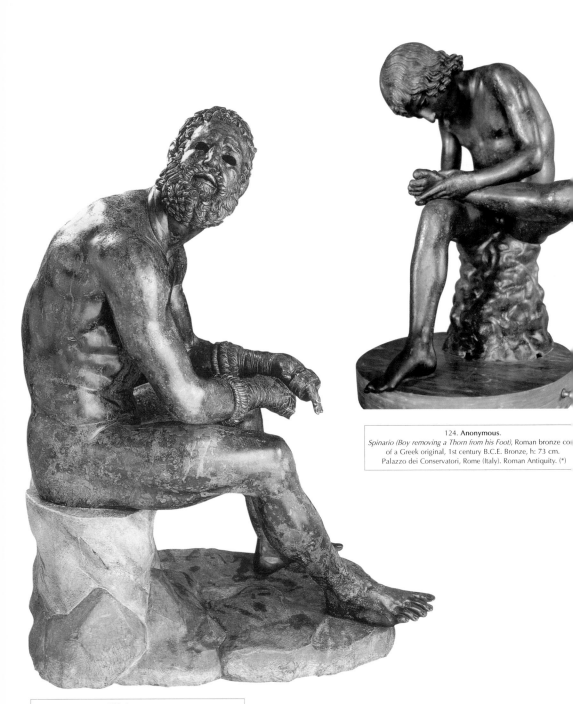

124. **Anonymous.**
Spinario (Boy removing a Thorn from his Foot), Roman bronze co[py]
of a Greek original, 1st century B.C.E. Bronze, h: 73 cm.
Palazzo dei Conservatori, Rome (Italy). Roman Antiquity. (*)

123. **Anonymous.**
Seated Boxer, 100-50 B.C.E.
Bronze, h: 128 cm.
Museo Nazionale Romano, Rome (Italy). Roman Antiquity. (*)

125. **Agasias of Ephesus**, Greek.
The Fighting Warrior, called the *"Borghese Gladiator"*,
c. 100 B.C.E. Marble, h: 199 cm.
Musée du Louvre, Paris (France). Roman Antiquity. (*)

See next page:
126. **Anonymous**.
Tellus Relief, panel, east facade, Ara Pacis Augustae,
13-9 B.C.E. Marble, height of the enclosure: 6 m.
Rome (Italy). In situ. Roman Antiquity. (*)

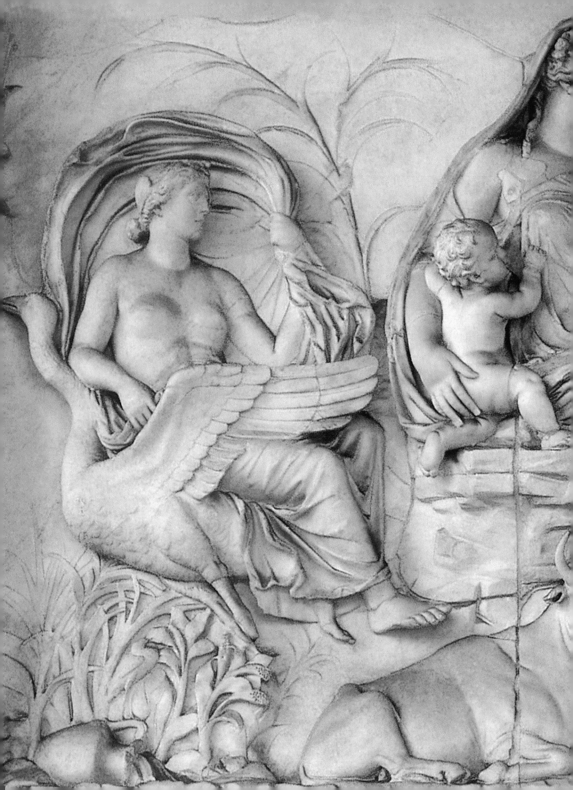

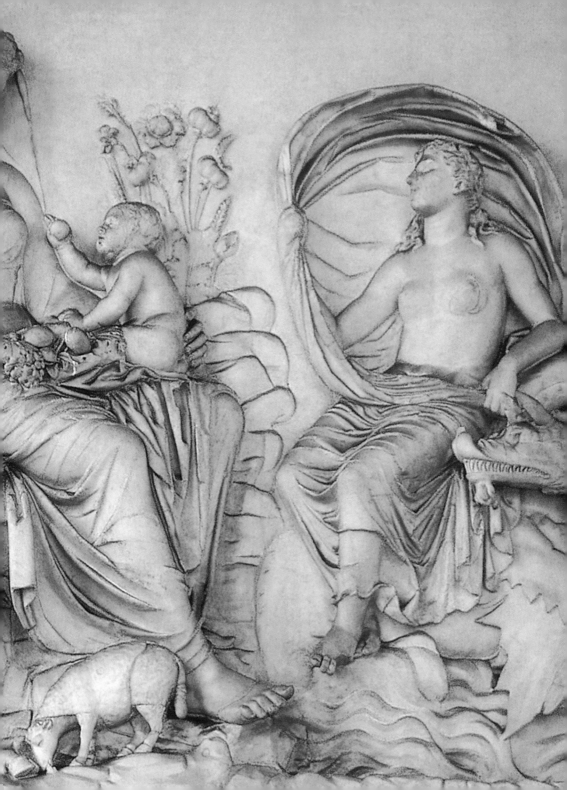

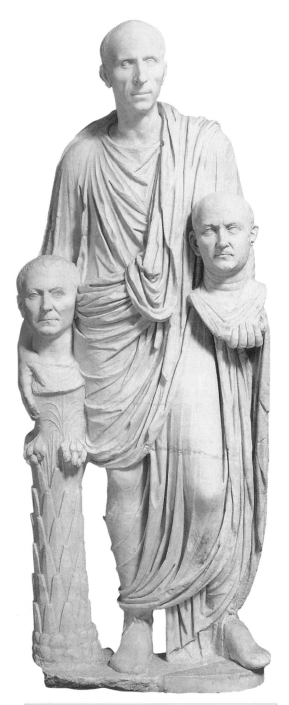

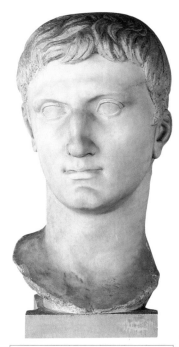

128. **Anonymous.**
Head of Emperor Augustus, 27 B.C.E.-14 A.D.
Marble.
Roman Antiquity.

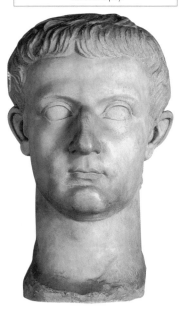

127. **Anonymous.**
Roman Aristocrat with Heads of his Ancestors,
first quarter of the 1st century B.C.E. Marble.
Musei Capitolini, Rome (Italy). Roman Antiquity. (*)

129. **Anonymous.**
Portrait of Emperor Tiberius, 14-37 A.D. Marble.
Roman Antiquity.

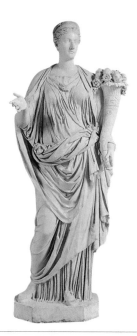

130. **Anonymous**.
Julio-Claudian Princess, 41-54 A.D.
Marble, h: 200 cm.
Musée du Louvre, Paris (France). Roman Antiquity.

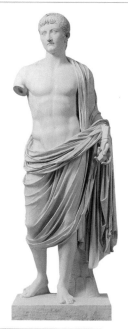

131. **Anonymous**.
Germanicus, Brother of Emperor Claudius,
41-54 A.D. Marble, h: 180 cm.
Musée du Louvre, Paris (France). Roman Antiquity.

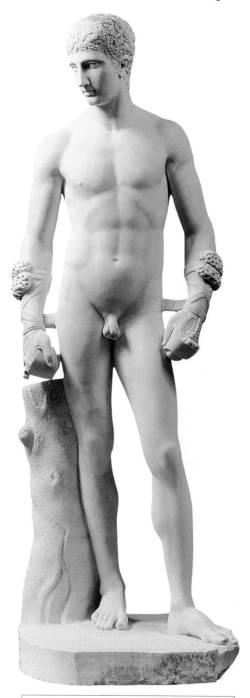

132. **Anonymous**.
Winner Athlete, 1st century A.D.,
restored in 1781 by **Vincenzo Pacetti**. Marble, h: 148 cm.
Musée du Louvre, Paris (France). Roman Antiquity.

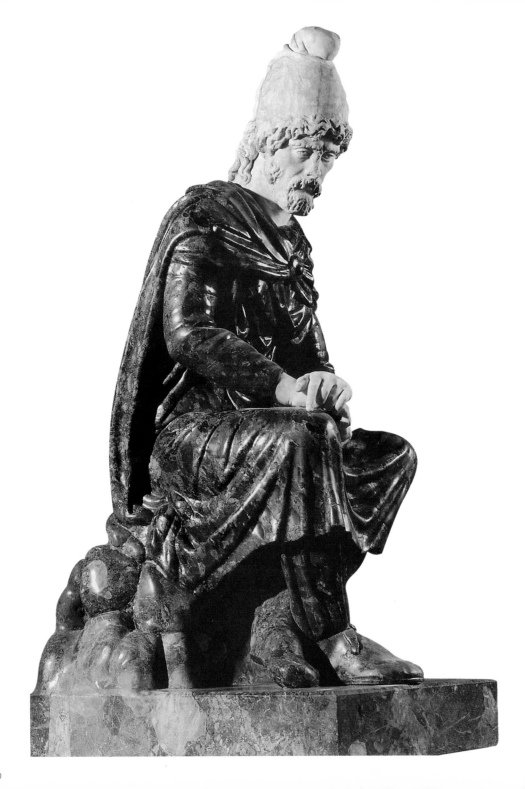

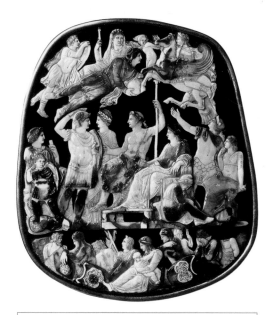

134. **Anonymous.**
Cameo, called the *"Grand Camée de France"*,
c. 23-29 A.D. Five-layered sardonyx, 31 x 26.5 cm.
Bibliothèque nationale de France, Paris (France). Roman Antiquity.

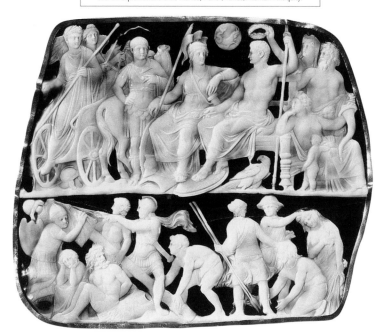

See previous page:
133. **Anonymous.**
Prisoner Seated, first century A.D. (body), second century A.D. (head).
Green breccia and marble, h: 163 cm.
Musée du Louvre, Paris (France). Roman Antiquity. (*)

135. **Anonymous.**
Gemma Augustea, after 10 A.D.
Two-layered onyx, h: 19 cm.
Kunsthistorisches Museum, Vienna (Austria). Roman Antiquity. (*)

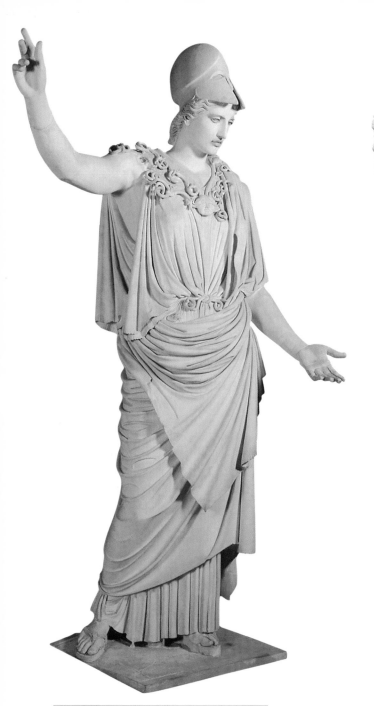

137. Anonymous.
Bust of Woman, called *"Bust Fonseca"*, beginning of the second century A.D. Marble, h: 63 cm.
Musei Capitolini, Rome (Italy). Roman Antiquity. (*)

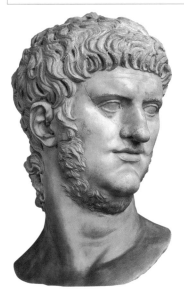

136. Anonymous.
Athena, also called *"Pallas of Velletri"*, Roman copy of a Greek original in bronze created around 470 B.C.E. and attributed to
Cresilas, 1st century A.D. Marble, h: 305 cm.
Musée du Louvre, Paris (France). Roman Antiquity.

138. Anonymous.
Bust of Emperor Nero, 54-68 A.D. (face), seventeenth century (head and bust). Marble, h: 66 cm.
Musei Capitolini, Rome (Italy). Roman Antiquity.

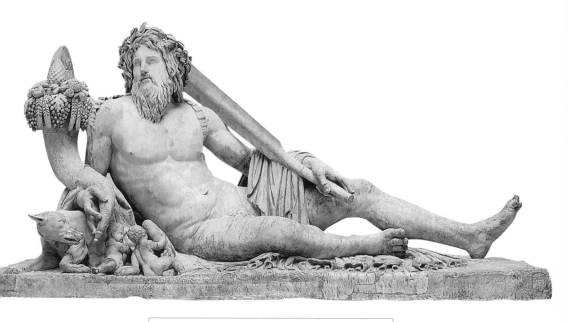

139. **Anonymous.**
The Tiber, adaptation of an original created around 250-200 B.C.E.
in Alexandria (Egypt), c. 90-140 A.D. Marble, h: 165 cm.
Musée du Louvre, Paris (France). Roman Antiquity.

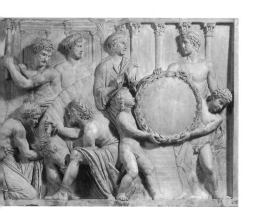

140. **Anonymous.**
Relief Figuring a Bull Sacrifice,
69-96 A.D. Marble.
Galleria degli Uffizi, Florence (Italy). Roman Antiquity.

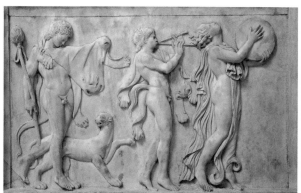

141. **Anonymous.**
Procession of the Followers of Bacchus, 1st century A.D.
Marble.
The British Museum, London (United Kingdom). Roman Antiquity.

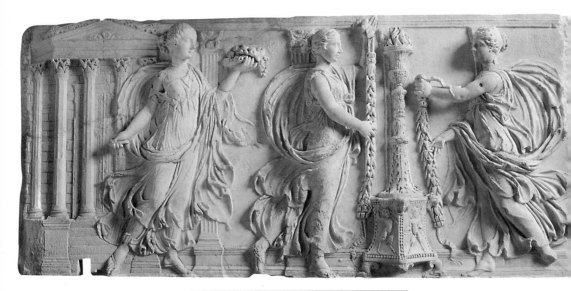

142. **Anonymous.**
Relief, called *"The Sacrificing"*,
2nd century A.D. Marble, 68 x 150 cm.
Musée du Louvre, Paris (France). Roman Antiquity.

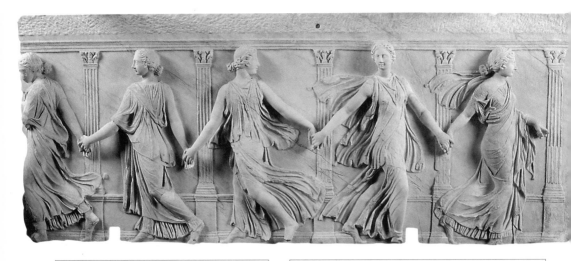

143. **Anonymous.**
Relief, called *"The Borghese Dancers"*,
2nd century A.D. Marble, 73 x 185 cm.
Musée du Louvre, Paris (France). Roman Antiquity. (*)

See next page:
144. **Anonymous.**
Atalanta, 2nd century A.D., restored during the 17th century. Marble, h: 122 cm.
Musée du Louvre, Paris (France). Roman Antiquity.

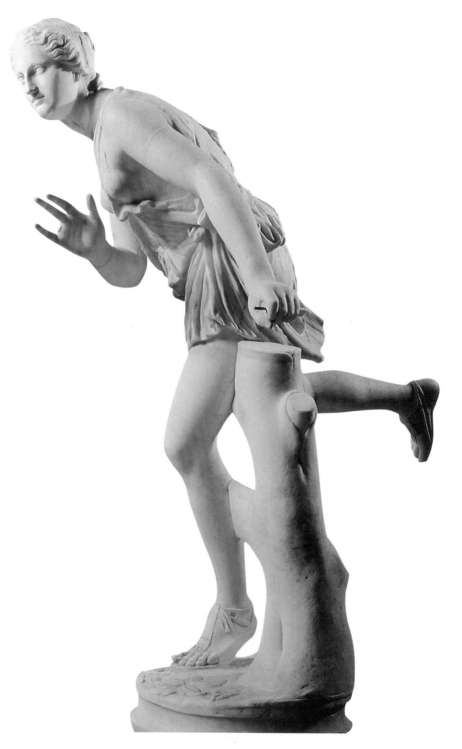

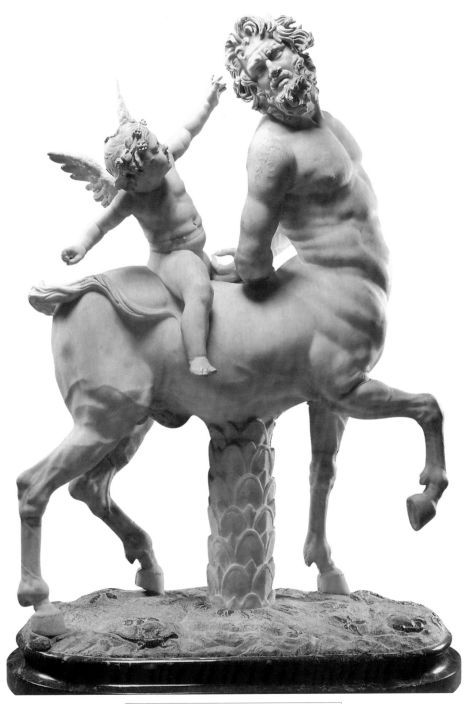

145. Anonymous.
Centaur being ridden by Cupid, 1st-2nd century A.D.
Marble, 147 x 107 x 52 cm.
Musée du Louvre, Paris (France). Roman Antiquity.

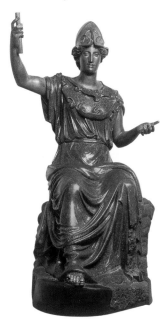

146. **Anonymous.**
Minerva, also called *"Roma"*, 2nd century A.D.,
restored during the 18th century.
Red porphyry and gilded bronze, h: 147 cm.
Musée du Louvre, Paris (France). Roman Antiquity.

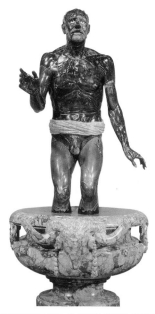

147. **Anonymous.**
The Elderly Fisherman, or *"The Death of Seneca"*,
2nd century A.D.
Black marble and alabaster, h: 121 cm.
Musée du Louvre, Paris (France). Roman Antiquity.

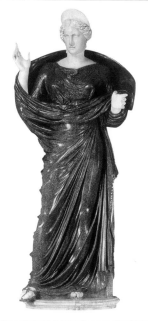

148. **Anonymous.**
Praying Woman (Orans), 2nd century A.D., restored during
the 16th century by the workshop of the family **della Porta**.
Porphyry, red, white and green marble, h: 204 cm.
Musée du Louvre, Paris (France). Roman Antiquity.

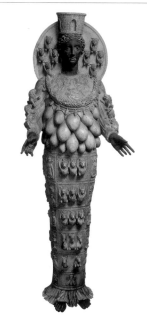

149. **Anonymous.**
Artemis of Ephesus, 2nd century A.D.
Bronze and alabaster.
Museo Archeologico Nazionale, Naples (Italy).
Roman Antiquity.

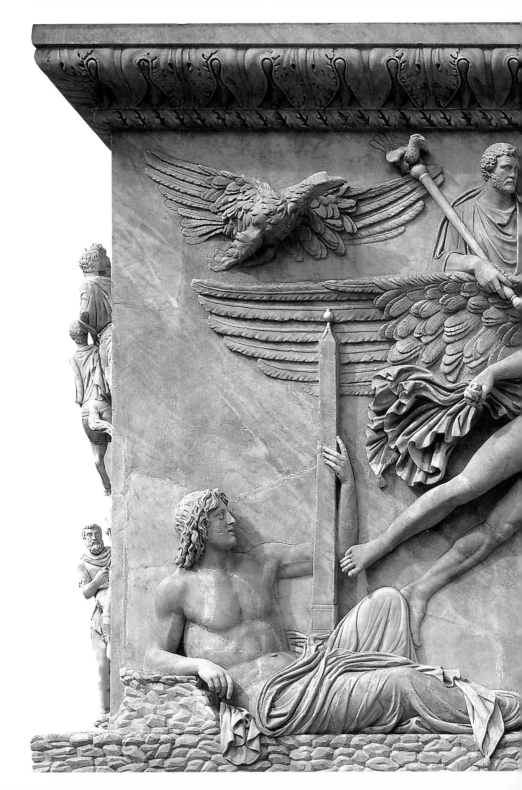

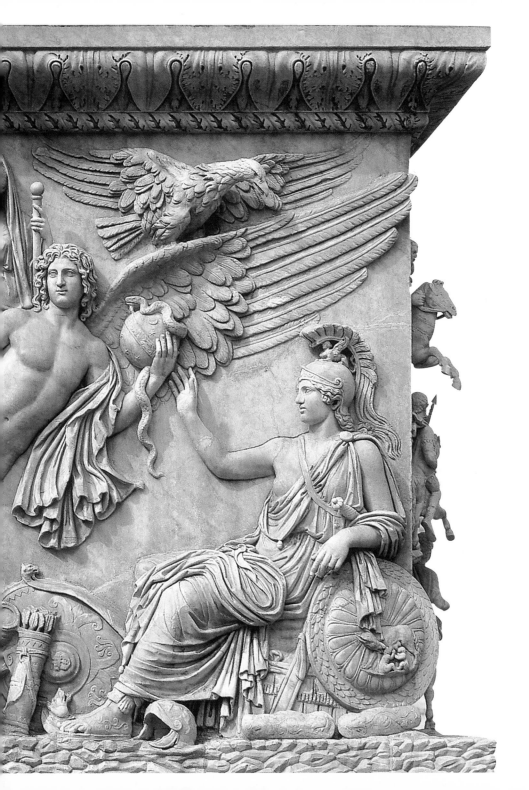

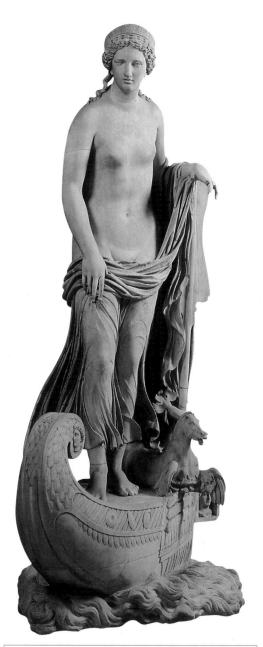

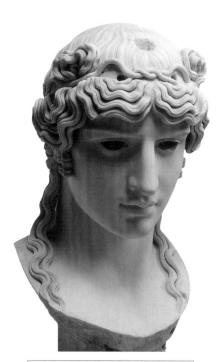

152. **Anonymous.**
Bust of Antinous, called *"Antinous Mondragone"*,
c. 130 A.D. Marble, h: 95 cm.
Musée du Louvre, Paris (France). Roman Antiquity.

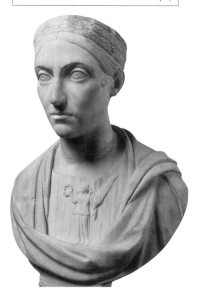

151. **Anonymous.**
Thetis Albani, 2nd century A.D., restored during the 18th century.
Marble, h: 211 cm.
Musée du Louvre, Paris (France). Roman Antiquity.

See previous page:
150. **Anonymous.**
Apotheosis of Antoninus Pius and Faustina, column base,
Temple of Antoninus and Faustina, c. 141 A.D. Marble.
Musei Vaticani, Vatican City (Italy). Roman Antiquity.

153. **Anonymous.**
Bust of Poet, called *"Sabine Richelieu"*, c. 120 A.D.
Marble, h: 65 cm.
Musée du Louvre, Paris (France). Roman Antiquity.

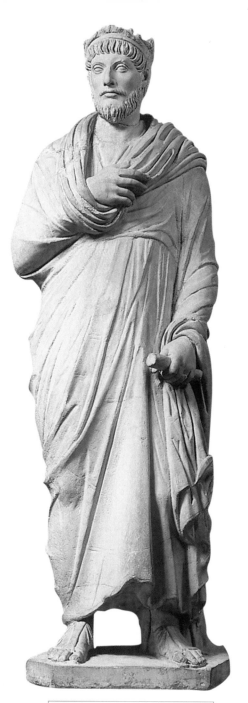

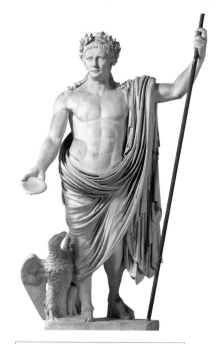

155. **Anonymous.**
Emperor Claudius as Jupiter,
41-54 A.D. Marble.
Museo Pio Clementino, Vatican (Italy). Roman Antiquity.

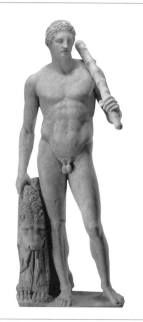

154. **Anonymous.**
Statue called *"Julian Apostate"*, 2nd century A.D.
Marble, h: 180 cm.
Musée national du Moyen Age – Thermes et hôtel de
Cluny, Paris (France). Roman Antiquity.

156. **Anonymous.**
The Lansdowne Heracles, c. 125 A.D.
Marble, h: 193.5 cm.
J. Paul Getty Museum, Los Angeles (United States).
Roman Antiquity.

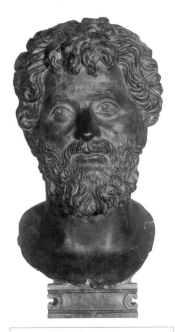

157. **Anonymous.**
Portrait of Emperor Septimius Severus,
194-211 A.D. Marble.
Roman Antiquity.

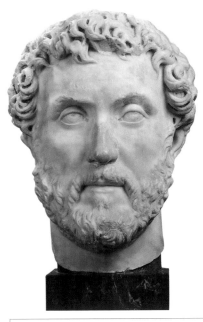

158. **Anonymous.**
Portrait of Emperor Antoninus Pius,
c. 150 A.D. Marble. Skultpturensammlung, Staatliche
Kunstsammlungen Dresden, Dresden (Germany). Roman Antiquity.

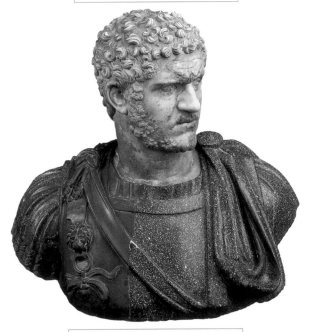

159. **Anonymous.**
Portrait of Emperor Caracalla,
215-217 A.D. Marble, h: 72 cm.
Musei Capitolini, Rome (Italy). Roman Antiquity. (*)

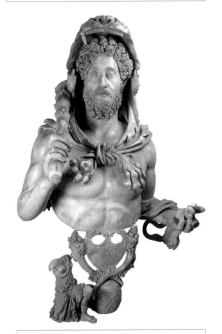

160. **Anonymous.**
Bust of Commodus as Heracles,
180-193 A.D. Marble, h: 133 cm.
Musei Capitolini, Rome (Italy). Roman Antiquity. (*)

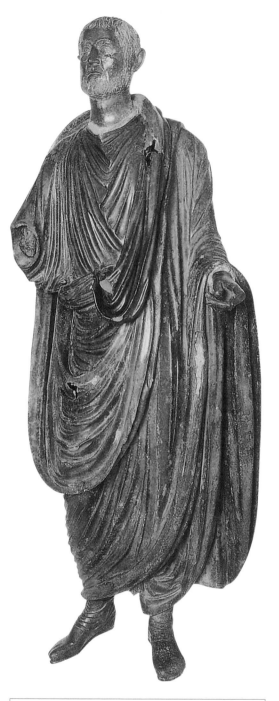

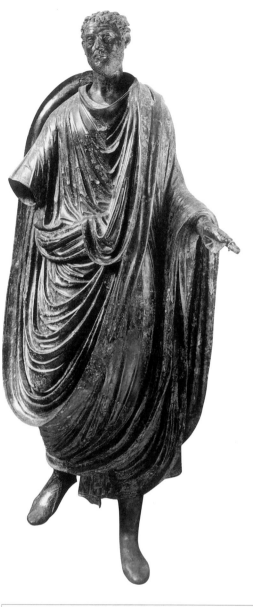

162. **Anonymous.**
Portrait of Caius Julius Pacatianus, end of the 2nd century A.D. – beginning of the
3rd century A.D. Bronze, h: 210 cm.
Musée des Beaux-Arts et d'Archéologie, Vienne (France). Roman Antiquity. (*)

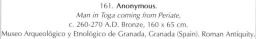

161. **Anonymous.**
Man in Toga coming from Periate,
c. 260-270 A.D. Bronze, 160 x 65 cm.
Museo Arqueológico y Etnológico de Granada, Granada (Spain). Roman Antiquity.

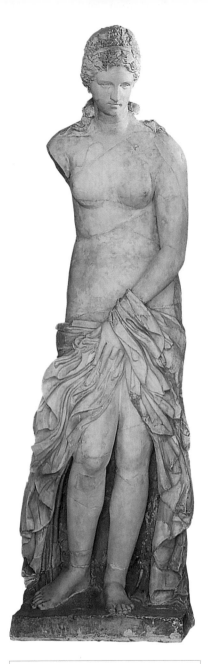

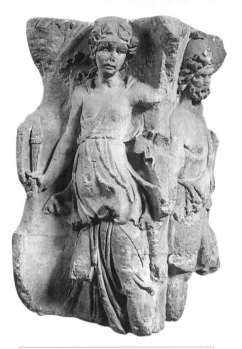

164. **Anonymous.**
The Pillar of St Landry: Goddess Holding a Torch,
second half of the 2nd century A.D. Limestone.
Musée national du Moyen Age – Thermes et hôtel de Cluny,
Paris (France). Roman Antiquity.

163. **Anonymous.**
Venus of Nîmes,
3rd-4th century A.D. Marble.
Musée archéologique, Nîmes (France). Roman Antiquity.

See next page:
166. **Anonymous.**
Arch of Constantine, 312-315 A.D. Marble, 21 x 25.7 x 7.4 m.
Rome (Italy). In situ. Roman Antiquity. (*)

165. **Anonymous.**
Nautes Pillar (discovered on the Ile de la Cité, Paris),
14-37 A.D. Stone, original height: more than 250 cm.
Musée national du Moyen Age – Thermes et hôtel de Cluny,
Paris (France). Roman Antiquity. (*)

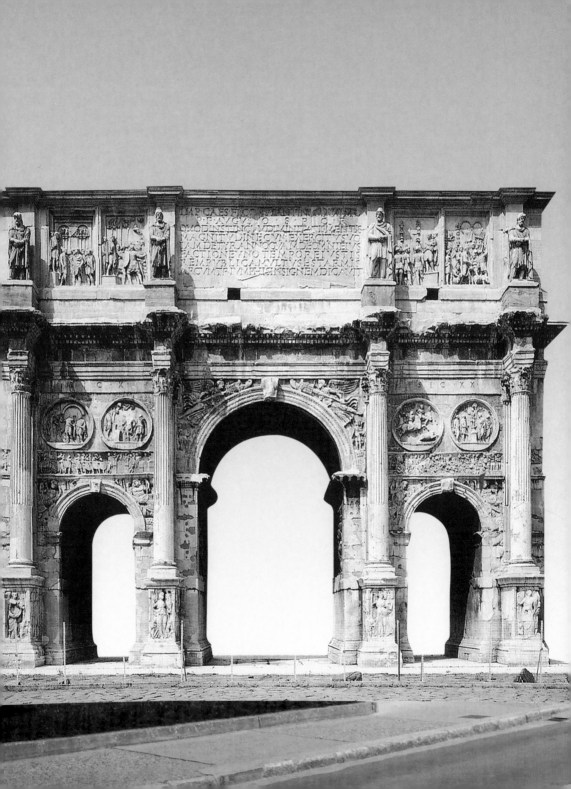

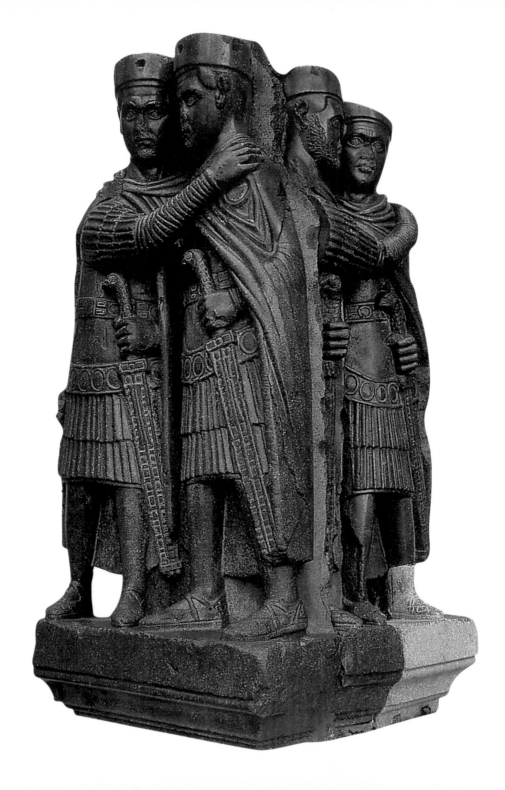

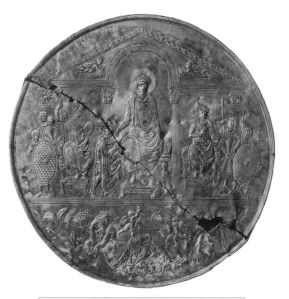

168. **Anonymous**.
Missorium of Theodosius I, 387-388 A.D.
Silver partly gilted, diameter: 74 cm.
Real Academia de la Historia, Madrid (Spain). Early Christian. (*)

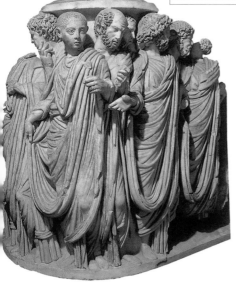

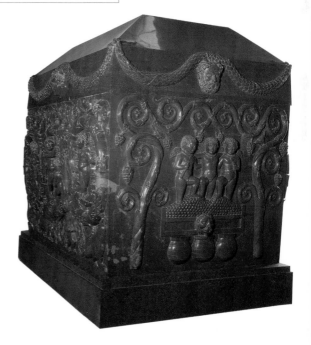

169. **Anonymous**.
Sarcophagus from Acilia,
260-270 A.D. Marble.
Palazzo Massino, Rome (Italy). Roman Antiquity.

See previous page:
167. **Anonymous**.
The Tetrarchs: Diocletian, Maxentius, Constantius Chlorus and Galerius,
4th century A.D. Porphyry.
uth facade of the San Marco basilica in Venice (Italy). In situ. Byzantine. (*)

170. **Anonymous**.
Sarcophagus of Constantina,
second third of the 4th century A.D. Porphyry.
Museo Pio Clementino Vatican (Italy). Roman Antiquity. (*)

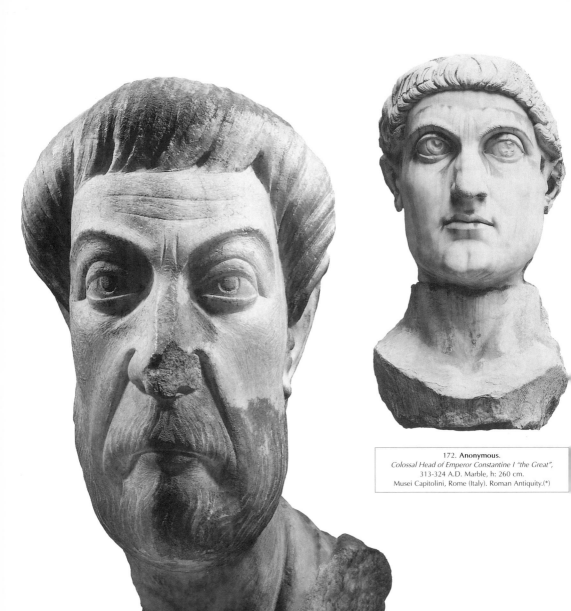

171. **Anonymous.**
Portrait Bust of Eutropios,
second half of the 5th century A.D. Marble, h: 32 cm.
Kunsthistorisches Museum, Vienna (Austria). Byzantine.

172. **Anonymous.**
Colossal Head of Emperor Constantine I "the Great",
313-324 A.D. Marble, h: 260 cm.
Musei Capitolini, Rome (Italy). Roman Antiquity.(*)

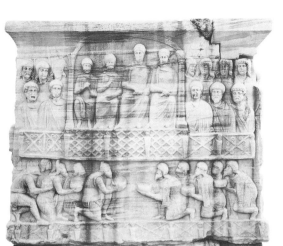

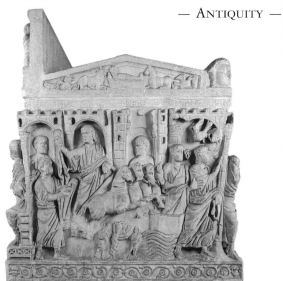

173. **Anonymous**.
Theodosius receiving the Tribute of the Barbarians,
detail of the base of the Obelisk of Theodosius,
390-393 A.D. Marble, h: 430 cm.
Hippodrome, Istanbul (Turkey). In Situ. Roman Antiquity/Byzantine. (*)

174. **Anonymous**.
Sarcophagus with Biblical Scenes,
c. 390 A.D. Marble (moulding).
Basilica Sant'Ambrogio, Milan (Italy). Early Christian.

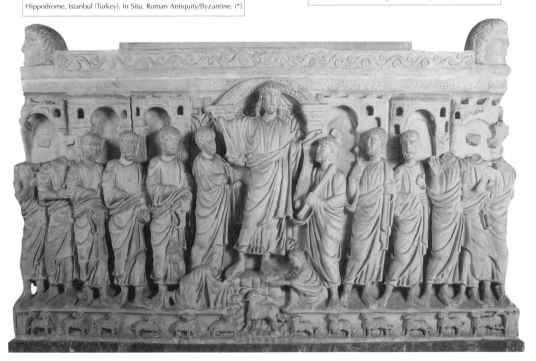

175. **Anonymous**.
Sarcophagus of Traditio Legis, Christ Handing the Law to St Peter,
c. 390 A.D. Marble (moulding).
Basilica Sant'Ambrogio, Milan (Italy). Early Christian.

176. **Anonymous.**
Sarcophagus with Symbolic Decoration,
c. 500 A.D. Marble.
Basilica Sant'Apollinare in Classe, Ravenna (Italy). Early Christian.

177. **Anonymous.**
Sarcophagus said "of St Barbatian",
second quarter of the 5th century A.D. Marble.
Cathedral, Ravenna (Italy). Early Christian.

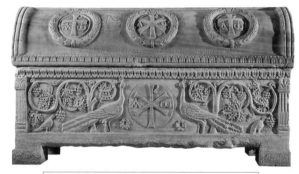

178. **Anonymous.**
Sarcophagus, called "Sarcophagus of Archbishop Theodore",
end of the 5th century, beginning of the 6th century A.D. Marble.
Basilica Sant'Apollinare in Classe, Ravenna (Italy). Early Chirstian (*)

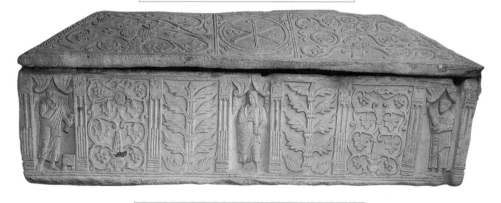

179. **Anonymous.**
Sarcophagus with Mixed Decoration,
4th century A.D. Marble, 47 x 200 x 72 cm.
Musée Lapidaire, Nîmes (France). Early Christian.

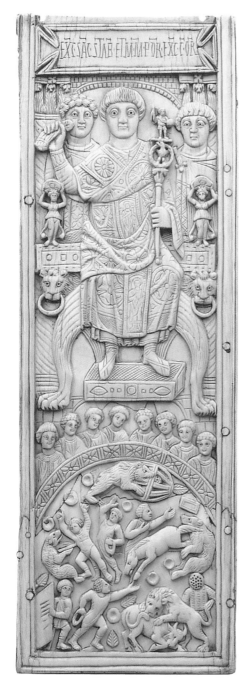

180. **Anonymous.**
Plaque from the Diptych of Consul Areobindus,
c. 506 A.D. Ivory, 39 x 13 cm.
Musée national du Moyen Age – Thermes et hôtel de Cluny, Paris (France). Early Christian (*)

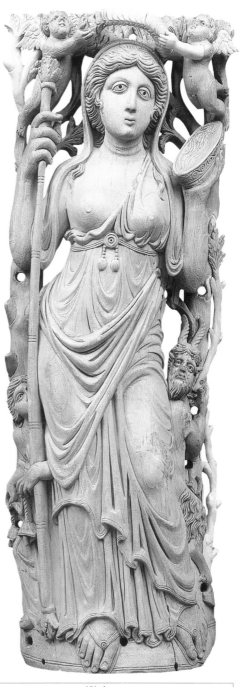

181. **Anonymous.**
Ariadne and her Cortege,
beginning of the 6th century A.D. Ivory, 40 x 14 cm.
Musée national du Moyen Age – Thermes et hôtel de Cluny, Paris (France).
Byzantine.

Masterworks Commented

2. Anonymous, *Portrait of Julius Caesar*.

Julius Caesar began his political leadership as the head of the traditionally Republican government of Rome, but ended it as a murdered dictator. Caesar had taken control over the vast empire of Rome, eschewing the practice of sharing power with the Senate. He was both revered for his strong leadership and resented for his tyranny. It was that resentment that led to his assassination on the Ides of March, 44 B.C.E. This portrait expresses not only Caesar's likeness, but also his character. We sense his strength, intelligence and nobility. The bust follows the Republican tradition of veristic portraiture.

3. Anonymous, *The "Auxerre Kore"*.

In the seventh century B.C.E., Greek sculptors first began to create large-scale sculpture in stone. The tradition grew out of the production of small bronze and terracotta figurines, produced in Greece as early as the tenth century B.C.E. With this piece, the artist changed the conception of sculpture, from small, portable figurines to large, free-standing sculpture, of the type so well-known in later Greek art. In this early example, which stands less than a metre high, the influence of Egypt can be seen in the patterned, wig-like hairstyle and the stiff, frontal stance. She is modestly dressed in a long, patterned gown and shawl, simply adorned with a broad belt. Her hand is raised to her chest in a reverent gesture. Most likely created for placement in a sanctuary, this "Kore," or female figure, would have represented either a devout young woman, or a goddess to whom a prayer was offered.

4. Anonymous, *Kleobis and Biton*.

Kleobis and Biton are life-size statues that were found in the sanctuary at Delphi. An inscription identifies the artist as coming from Argos, on the Peloponnesus. The sculptures' origin in Argos links them to the mythical twins Kleobis and Biton. These young men from Argos were said to pull a cart a full five miles in order to bring their mother to a festival dedicated to the goddess Hera. In return, Hera granted the men what was seen as a great gift: a gentle death while sleeping. The brothers fell asleep after the festival and never woke up. Their great strength, devotion to their mother, and their early deaths were memorialised in dedicatory statues offered at the great sanctuary at Delphi, according to the historian Herodotus. These statues, which may be those described by Herodotus, are close in date to the *Dipylon Head* (see no. 8) and share the same Egyptian style and decorative, incised details.

7. Anonymous, *The Naxian Sphinx*.

This graceful creature is a composite of a lion, an eagle, and a woman. The grace and beauty of the sphinx emphasises its strength: this fierce creature was intended to protect all that it could oversee from its position atop a high column. The column and sphinx were erected as a votive offering by the people of Naxos at the sanctuary of Delphi. Such votive offerings, which could also include figurines and statues, reflect the "quid pro quo" nature of the Greeks' relationship with their gods. They would ask a god for something, promising a votive gift if they got what they asked for. The sanctuary at Delphi was a popular location for this sort of prayer; people from all over Greece would go there to consult the oracle of the Temple of Apollo before they undertook any important act. If they received favour from Apollo, they would leave a votive offering.

8. Anonymous, *Dipylon Head*.

This fragment is a rare early example of the "kouros", or standing male statue. Its name comes from the Dipylon Cemetery in Athens where it was found. There, in the sixth century B.C.E., statues were sometimes used as grave markers. While female statues were modestly dressed, the male versions were nude, perhaps indicating a god or a hero. Like the *Auxerre Kore* (see no. 3), these statues developed both from a local tradition of small figurines, and from the Egyptian tradition of large stone sculpture. The early date of this piece is revealed through the style, which is more decorative than realistic. The eyes and eyebrows are deeply-incised, the contours of the face

are flat, and shape of the ear is indicated with concentric, curved lines. The hair is patterned in an Egyptian manner and held back with a band. Over the course of the sixth century, Greek sculpture would lose this patterned, decorative quality and become increasingly realistic and lifelike.

9. Anonymous, *Kore dedicated to Hera by Cheramyes of Samos*.

This *kore* is best understood through comparison to the earlier *Auxerre Kore* (see no. 3). It continues the tradition sculpting the standing female in stone, but shows the development in the art form. This *kore*, like the earlier example, is modestly draped in a long gown and a shawl, but the form of her body is more visible underneath, especially the curves of her shoulders, breasts, and belly. The sculptor has drawn attention to these forms by showing how the clothing gathers, pleats and falls as it drapes over the woman's body. Instead of the heavy, patterned woollen peplos worn by the *Auxerre Kore* (see no. 3), this kore wears a chiton, a tightly pleated, lightweight garment made of linen. The pleats are shown in detail, creating a vertical pattern that contrasts with the diagonal drapery of the shawl. This attention to the patterns of drapery would continue to characterise female sculpture in Greece over the coming centuries.

12. Anonymous, *Kore 679*, called the "*Peplos Kore*".

Known as the *Peplos Kore*, this piece was another victim of the Persian invasion, found buried in the ruins of the Acropolis in Athens. While her heavy garment hangs straight over her body, the sculptor has taken care to show the curves of her shoulders, breasts, and hips underneath. Underneath the straight skirt, she wears the lightweight, crinkly linen chiton. Her full face has more life and realism in it than earlier *korai*. The vitality of the piece is heightened, for the modern viewer, by the remains of paint on the statue, and also through the very slight movement shown through the upraised arm and the left leg, which steps very slightly forward.

15. Anonymous, *Head of a Cavalier* called the *"Cavalier Rampin"*.

When the Persians attacked Athens in 480 B.C.E., they destroyed the Acropolis, setting fire to the great temples it held. The scorched and broken relics of statuary were buried like victims of war by the Athenians. Archaeologists have since recovered the buried statues, and so we have a rich array of sculptural examples from Greece's "Archaic" period. The examples include a number of *korai*, or standing females, but also this rare example of a figure on horseback. Like the earlier small bronze figurines of men on horseback, this life-size stone sculpture evokes a heroic figure. The rich patterns of the hair and beard are characteristic of Near Eastern art, a style presumably brought to Athens via the Greek colonies in Asia Minor. The name of the statue comes from the French diplomat who purchased the head, separated from the rest of the piece, in the nineteenth century. The head remains in Paris, in the Louvre, while the other fragments are housed on the Acropolis in Athens.

20. Anonymous, *Heracles*.

Unlike Greek temples, Etruscan, or Tuscan, temples were traditionally decorated with large terracotta sculptures balanced on the roof, along the ridgepole. One of the most important temples in Etruria was in the city of Veii. The temple at Veii, called the Portonaccio temple, featured a group of figures sculpted out of baked clay, or terracotta, along the ridge of the temple's roof. The two principle figures of the group are Apollo (see no. 21) and Heracles. Heracles, shown here, is controlling a hind, a deer sacred to the goddess Artemis. The task of capturing the hind was one of the twelve labours of Heracles, a penance he was ordered to perform by the Oracle of Delphi as punishment for killing his family. The pose of Heracles as he rests his foot on the hind (the head of the animal is not preserved) is typical of the dynamism of Etruscan statuary. While Archaic Greek statues were still and static, this Archaic Etruscan example is frozen in motion, engaged in restraining the animal, showing the strength and power of Heracles.

25. Anonymous, *Kore 686,* called *"The Sulky One".*

Kore 686, from the Athenian Acropolis, shows elements both from the Archaic style and from the Severe, or Early Classical, style that followed. Her long locks of hair and complex layers of clothing are familiar elements of Archaic sculpture. However, the serious, or "severe," expression on her face, as well as the strict, vertical folds of her chiton are more typical of the new, more serious aesthetic of the Severe style. Her ornamentation has been reduced; she wears no necklace or bracelets, and her gown has none of the decorative patterning seen on earlier pieces. The head and torso fragment probably belong with a base that is inscribed "Euthydikos, the son of Thaliarchos, dedicated (it)." The statue can thus be understood as a votive offering by Euthydikos, representing a goddess, or perhaps Thaliarchos, his mother.

26. Anonymous, *Sarcophagus of a couple from Cerveteri.*

Though their civilisation flourished alongside that of the Greeks, our limited understanding of Etruscan language and culture has left a veil of mystery over the people who lived in Italy before the Roman Republic. Their art was strongly influenced by that of the Greeks, as evidenced by this terracotta sarcophagus with its echoes of the style of the Greek Archaic period. In Etruscan sculpture, however, we find more lively subjects, like this couple, animated in their easy affection for each other. Like so much of Etruscan art, this is a funerary piece, designed for placement in one of the elaborate tombs the Etruscans carved out of the soft volcanic bedrock of central Italy. It reveals the Etruscan view of the afterlife: an eternal party, where men and women would lounge at a banquet, enjoying good food, drink, and the company of their loved ones.

27. Anonymous, *Antefixe.*

The soft, porous volcanic stone found in Etruria was not suitable for building or carving. Etruscan temples were therefore made mainly out of wood. The wooden structure of the temple was protected by terracotta tiles and ornaments. While wood does not survive the ravages of time, terracotta does, and these small terracotta decorations are often all that remains of the great Etruscan temples of the past. The terracotta pieces on the temples were both functional and decorative. The piece shown is an antefix, an ornament placed at the end of the roofline, hiding the edge of the roof tiles and protecting the wooden framework underneath. Antefixes were often decorated. This one shows the head of a maenad, a woman who worshipped the wine god, Dionysus. Her slight smile and long plaits of hair show the influence of Greek Archaic sculpture.

30. Anonymous, *Kore 594.*

Kore 594 is another of the large group of statues of maidens from the Athenian Acropolis, buried after the destruction of the Acropolis by the Persian army. While the head is not preserved, the piece retains an air of regal elegance, due mainly to the complex folds of richly decorated clothing. Her right arm would have extended outwards, perhaps holding an offering to Athena. While the male statues of this period were completely nude, the female versions were not only clothed, but accessorised with an elaborate array of robes and fancy jewellery. The many patterns, drapes, and folds the sculptor has carved on her garments lend a rich, decorative quality to the piece, heightened by the effect of bright paint, much of which is preserved on her hair and gown.

39. Anonymous, *The Charioteer of Delphi.*

Delphi was a pan-Hellenic sanctuary, a place where people from all over the Greek world would gather to worship, consult the oracle, and participate in the Pythian games, held every four years. The games were comprised of music and sporting events, including chariot racing. This sculpture was part of a group dedicated to commemorate a victory in a chariot race, we are told by the inscription preserved on the piece. In addition to the chariot driver,

there were horses, a chariot, and a groom. The lavish expenditure on the life-size monument would have represented not only the victory in the race, but also the great wealth of the donor. The bronze figure was enlivened with inlay of silver, copper, and stone in the teeth, headband, and eyes. The deep, straight folds of the drapery are in keeping with the Early Classical, or Severe, style of sculpture.

44. Anonymous, *The Tyrannicides Harmodius and Aristogeiton.*

Harmodius and Aristogeiton Metal was a valuable commodity in the ancient world, so sculptures made of bronze or other metals were often eventually melted down by a conquering nation or a successive ruler who did not care for the art of his predecessor. For that reason, few large-scale bronze sculptures survive from antiquity. Romans, however, had a taste for Greek art, and copied many of their bronze sculptures in stone, the material preferred by Romans. Often, the bronze original has since been lost, and the Roman copies are all that survive. Such is the case with this group, Roman copies in marble of two Greek sculptures in bronze. The subjects are Harmodius and Aristogeiton, lovers who together conspired to murder the political tyrant, Hippias. They lost their nerve and killed his brother instead, but were revered as heroes by Athenians who believed them to have murdered the tyrant. Statues of the two were erected in their honour in the Athenian Agora.

45. Anonymous, *Dying Warrior.*

Greek temples often featured large sculpture decorating the pediment, the triangular space under the eave of the roof. The first examples of pedimental sculpture show that the early artists were not adept at filling the awkward triangular space with a cohesive composition; the figures in the corners were shrunk to a diminutive scale in comparison to the central figures. However, in this pediment group from the end of the Archaic period, the sculptors showed new skill in conceiving the composition. The central figures, not shown, engage in lively battle, lunging and parrying with swords and shields. One archer crouches to take aim, his low position allowing him to fit into the smaller space toward the corner of the pediment. The *Dying Warrior* next to him fills that corner, the angle of his falling body perfectly fitting into the smallest part of the pediment. A single, cohesive narrative is thereby created across the triangular space, telling the story of a battle fought by local heroes.

48. Anonymous, *Heracles receiving the Golden Apples of the Hesperides from the Hand of Atlas, while Minerva rests a Cushion on his Head.*

This metope, or square component of the frieze of the temple, is from the Temple of Zeus at Olympia, the largest and most important structure of the first half of the fifth century. Together, the metopes of the Temple of Zeus told the story of the twelve labours of Heracles. Each metope showed one of his labours, or tasks. This metope shows the eleventh labour, the apples of the Hesperides. Heracles was told he had to steal apples belonging to Zeus. He met up with Atlas, who had to hold up the world for all of time. Atlas said he would get the apples for Heracles if Heracles would hold the earth for him. In the scene shown, Atlas has returned with the apples, and Heracles must figure out how to get Atlas to take back the weight of the world. Athena stands behind Heracles, gently helping him hold his burden.

49. Anonymous, *Pensive Athena.*

Athena was the patron goddess of Athens, worshipped by Athenians on the Acropolis, and honoured in special events such as the Panathenaic festival. For her part, Athena aided the Athenians in battle and brought them prosperity through the cultivation of the olive tree. In this relief, we are meant to see the depth of her affection for the Athenians. She reads a list of Athenian soldiers killed in war, and mourns them sorrowfully, her head bowed, her body resting heavily against her spear. The melancholy mood of the piece is characteristic of Severe style sculpture. That style is also seen in the heavy, straight folds of Athena's dress, or peplos, and the still, heaviness of her pose.

In comparison to earlier Archaic sculpture, however, in this piece we see a fleshed, realistic person in a natural pose, expressing real emotion. These qualities reveal the increasing skill of the artists from the sixth to the fifth century B.C.E.

50. Anonymous, *Hades and Persephone*.

This terracotta plaque shows Hades, the god of the underworld, with his bride, Persephone. Hades abducted Persephone and brought her to the underworld; in her grief, Persephone's mother, Demeter, made the world infertile. Zeus had to intervene, demanding that Hades let Persephone spend half the year with her mother. The cycle of Persephone's annual passage from her mother to the underworld is reflected in the seasons, with the cold, frozen winter the result of her time in the underworld, and Demeter's grief. On this plaque, Hades and Persephone are shown ruling the underworld. Their stiff, regal poses indicate their status as rulers, but also reflect the style of the early fifth century B.C.E., the Severe style. The stillness of the figures, the straight folds of drapery, and the serious facial expressions are all characteristic of the Severe style.

51. Anonymous, *Apollo* called the *"Apollo Parnopios"*.

Apollo was the god of music, poetry, medicine, archery, and prophecy, and was always shown as young and beautiful. Here, he has the idealised body of a young male athlete. The naturalism of his anatomy, with its sculpted muscles and graceful movement, is expressed through the relaxed, *contrapposto* stance. His expression is thoughtful but emotionless. This classic fifth-century B.C.E. statue type is transformed into Apollo by the addition of the elaborately curled long hair, and his attributes, the bow and laurel wreath, which he would have held in each hand.

53. Anonymous, *Discobolus*.

In Myron's *Discobolus*, we see the human form freed from the standing, frontal pose of earlier statues. Here, the artist is clearly interested not only in the body of the athlete, but in the movement of the discus thrower. His muscles tense and strain in preparation for his throw, his face focused on his activity. While the pose, with the arms forming a wide arc, is revolutionary, the piece is still meant to be viewed from the front. It would not be until the following century that artists began to conceive of sculpture that could be viewed from all sides.

54. Anonymous, *Farnese Heracles*.

Here, Heracles rests after obtaining the apples of the Hesperides, which he holds in his right hand. The sculpture is a Roman copy in marble of a Greek bronze original, usually attributed to Lysippos, a sculptor of the fourth century B.C.E. The weight of the figure is borne almost completely by Heracles' right leg and by the club, covered with his signature lion skin, on which he leans. The exaggerated *contrapposto*, or shift in weight, that results is typical of fourth-century B.C.E. sculpture. However, the heavy, muscled form is not. The uncharacteristic weightiness of the figure may be due to the subject, the notoriously strong Heracles. Or, it may be an exaggeration created by the Roman copyist, in response to the aesthetic ideals of the Roman audience. The weighty realism of this piece inspired artists of the Italian Renaissance and later periods after it was discovered in the ruins of the Baths of Caracalla in Rome in the sixteenth century.

55. Anonymous, *Marsyas*.

Like Myron's *Discobolus* (see no. 53), his *Marsyas*, pictured here, is shown in a dramatic stance that marks an important departure from the stiff, frontal poses of Archaic statues. The Roman copy in marble requires a strut for support, but the bronze original would have appeared even more dynamic, delicately balanced on the balls of his feet. The subject has been identified as *Marsyas*, a satyr, who at the moment shown, has spotted a reed instrument upon the ground, discarded by Athena. He is poised in motion, recoiling in surprise at his good luck, but momentarily fearful of taking the precious item. He will pick it up and become of a master of the instrument,

but in the way of Greek tragedy, his gift will be his downfall. Hubris, or pride, leads him to challenge the god of music, Apollo, to a contest. He loses, of course, and is flayed alive as punishment.

57. Anonymous, *Riace Bronze B*.

A sunken treasure, this bronze statue was pulled from the sea, having been lost in a shipwreck in antiquity. Ironically, its loss in the sea resulted in it being one of the few bronze statues to survive from antiquity, since it was never melted down for its valuable metal. The warrior is one of a pair that has been attributed to the fifth century B.C.E., or High Classical Period. In this piece we can see the ideals of High Classical period sculpture fully realised. At the same time realistic and idealistic, the sculpture shows a lifelike, perfect, body, each muscle articulated, the figure frozen in a relaxed, life-like pose. The solid, athletic body reflects the ideal of a young athlete, although this figure represents an older warrior, who once would have held a spear and a shield. The nudity of the figure also alludes to the athlete, who in Greece would have practised or competed in the nude, and also to the mythical hero, a reminder that the man represented here was no ordinary warrior, but a semi-divine hero, an appropriate offering for one of the great sanctuaries of the Greek world.

62. Anonymous, *A Lapith tackles a Fleeing Centaur and prepares to Strike a Decisive Blow*.

The Parthenon, part of the Acropolis sanctuary to Athena in Athens, is seen as a paradigm of classical architecture and the pinnacle of classical architectural sculpture. Its sculptural program included two pediments, an interior Ionic frieze and exterior Doric frieze, with sculpted metopes on all four sides, each showing a mythical battle. This metope is from the south side, which illustrated the Centauramachy, or battle between the Centaurs and Lapiths. Here, a Lapith man wrestles a Centaur. Both figures are shown actively straining, pulling in opposite directions, creating a strong sense of dynamism in the piece. That dynamic force is emphasised by the folds of the Lapith's robe that spills out behind him, also enlivening the background of the piece. Dramatic movement, and patterning such as that created by the folds of cloth, along with the addition of paint, would make the metope more visually arresting to the viewer far below on the ground.

63. Anonymous, *Goddesses*.

Most of this pediment was lost when the temple was converted into a Christian church and an apse was added to the east end. This group of goddesses survives, however, and illustrates why the Parthenon's decoration is seen as the pinnacle of Greek architectural sculpture. The triangular shape of the pediment can be seen in this group, which would have occupied most of one of the corners. The problem of how to fill a triangular space has been solved with mastery here: the three goddesses lounge together, sitting, squatting, and reclining in a relaxed group, their poses naturally filling the angled space. A far cry from the straight, frontal figures of the Archaic period, these bodies bend, twist, reach and lean, their sheer drapery serving only to accentuate the curves of their bodies.

66. Anonymous, *Mounted Riders*.

The Parthenon in Athens is a Doric-style building, but has the distinction of including an Ionic-style, continuous frieze around the cella, and the structure inside the exterior ring of columns. The Ionic frieze, wrapping unbroken around the cella, provided sculptors with the perfect opportunity to depict a long procession. The procession shown is the Panathenaic festival, the annual religious celebration of Athena, during which Athenians would climb to the Acropolis to present a new gown, or *peplos*, to the goddess's cult statue. The long line of the frieze is kept visually interesting by varying the members of the procession: some are shown walking, some leading animals, and some on horseback. On this fragment of the frieze, a line of horsemen are shown overlapping, at varying levels of relief. Some of the horses rear, some buck their heads, further varying the scene. Originally, the frieze would have been painted, increasing its visibility to the viewer forty feet below.

70. Anonymous, *Diadoumenos, the Young Athlete.*

Polykleitos is one of the best-known sculptors of the fifth century B.C.E., known especially for his athletic dedications, such as this one. The figure binds his hair with a tie in preparation for sport. His clothes rest next to him on a low branch, since Greek athletes exercised in the nude. Polykleitos' *Doryphoros*, or *Canon*, sought to illustrate the ideal male figure. In the piece shown, we see the same proportions the sculptor established with his *Canon*, and the same attention to anatomical realism. The Polykleitan ideal is a heavy, muscled, somewhat stocky body, especially in comparison to the more gracile figures of the next century.

71. Anonymous, *Caryatid.*

In the caryatid, the column takes its most ornate form, replaced entirely by the statue of a woman. It decorates the porch of the Erechteion, a temple to Athena on the Acropolis in Athens, built to replace one destroyed by the Persians. In its form and decoration, this temple deviates from tradition, including not only the unusual caryatids, but also an asymmetrical plan on varying ground levels, with two porches jutting out of the main building. This atypical plan was due to the multiple shrines incorporated into the temple, and also to its placement on an uneven rocky outcrop, home to the original olive tree given to the city by Athena. The six caryatids supported the south porch, one of the unusual additions to the regular temple plan. The caryatid figures have all the solidity of form we find in other fifth-century sculpture, and therefore seem up to the task of supporting a roof. The exaggerated shift in weight, and the clinginess of the drapery, are typical of sculpture of the end of the fifth century B.C.E.

72. Anonymous, *Wounded Amazon.*

The Amazons are known from Greek mythology as great warriors. Like the flipside of the Greek world, in Amazon society it was the women who hunted and fought wars; in some versions of the myth no men were allowed in their society, in other versions, men were present, but charged with domestic duties. In Greek art, Amazons are usually shown in battle against the Greeks. Since the women warriors represented a reversal of the norms of Greek society, it is thought that the images of Amazons may have been metaphors of the Persians, enemies of the Greeks, inhabitants of the east, and "others" in the same way the mythological Amazons were unknown, mysterious enemies of the Greeks.

76. Anonymous, *Nike.*

The *Nike*, or winged victory, was a companion to Athena, often shown following the goddess, or held in her hand. This figure is from the Temple to Athena Nike, from a frieze along the balustrade, or low wall surrounding the temple. Along this long frieze, the Nike figure was shown repeatedly in a variety of poses, setting up trophies and offering sacrifices. This fragment captures Nike in an unguarded moment, adjusting her sandal. This casual action is indicative of how the Greeks saw their gods – humanlike, imperfect, and subject to foibles and folly. Here, her movement also provides the sculptor with the opportunity to emphasise the elaborate folds of drapery that gather over her arm and across her bent legs.

77. Anonymous, *Capitoline She-wolf (Romulus and Remus).*

Rome emerged into greatness from a history as a small city within an Italy largely controlled by Etruscans. This historical past was not glorious enough for the Romans, however, who preferred a mythological tale of the founding of the city. In that story, two brothers, Romulus and Remus, descendents of the heroes of the Trojan War & of the god Mars, were abandoned near the Tiber River. They were suckled by a she-wolf and therefore survived. Later, they founded the city of Rome, but they quarrelled; Romulus killed Remus, and went on to rule Rome. In this piece, two babies are shown suckling at the teats of a she-wolf. The babies were added during the Renaissance, so we cannot identify the piece with certainty as a depiction of Romulus and Remus. It does, however, date to the very early years of the Roman Republic, so it may be an image of that founding myth. Ironically, the piece is the work of an Etruscan artist, reflecting the very heritage that the Romans wished to deny.

78. Anonymous, *Chimera of Arezzo.*

The Chimera was a mythical creature, a composite of a lion's head and body, a snake for a tail, and a second head, of a goat, emerging from its back. A powerful monster, it was thought to bestow evil upon anyone who saw it. Its origin was Lycia in Asia Minor, but this depiction of the monster comes from Etruria in Italy, which had been greatly influenced by the cultures of the Near East via trade and exchange. It showcases the metalworking talent of the Etruscans. The artist has captured the animal in a fierce roar, writhing in pain as it attacks itself, the snake-tail biting the goat-head, blood pouring from the wound. The realism of the lion's body, with its tensed muscles and ribcage jutting through the skin, is contrasted by the decorative quality of the lion's mane and tufted back, the fur forming a textured pattern along its body.

80. Anonymous, *Mars from Todi.*

The Etruscans were a native people of Italy, living in the area that today still bears their name: Tuscany. They enjoyed prosperity, in part because of access to rich metal resources. Their expertise in working with metal is attested by this bronze statue of a warrior in his armour, performing a libation, or liquid offering, before the battle. In his right hand he holds a shallow pouring vessel, and with his left hand he was originally leaning on his spear. A helmet would have completed the figure. In the naturalism of the rendition of the warrior, and his contrapposto stance, we see the influence of fifth-century Greece. A Greek statue would have been nude, however; the modestly-clad warrior is clearly a product of an Etruscan artist. The statue was found in Todi at the site of an ancient sanctuary dedicated to Mars. It was buried between slabs of travertine stone, lost in a collapse of some sort, which accounts for its rare state of preservation.

83. Anonymous, *Nereid 909.*

In Greek mythology, the Nereids were a set of fifty sisters, sea-nymphs who were helpful to sailors in the Mediterranean Sea during storms. The Nereid Monument was a temple-tomb erected in Xanthos, on the coast of Asia Minor. It was a small, Ionic-style building with a carved relief on a frieze wrapping around it. Above, between the columns of the colonnade, were statues of numerous Nereids clothed in sheer chitons. The tomb was built by the local Lycian elite, but the sculpture reflects the international culture of the Hellenistic Period. In the typically dramatic style of the Hellenistic, the chiton worn by this nymph is blown by the wind and the sea, and clings to her body. Each nymph was in a different pose, seemingly captured in movement, frozen perpetually in the wind blowing off the sea.

84. Anonymous, *Thanatos, Alceste, Hermes and Persephone.*

This is the only remaining sculpted column drum from the Temple of Artemis, or Artemision, at Ephesus. The temple was one of the wonders of the ancient world, renowned both for its majestic size and for its decorative program. It was built around 550 B.C.E., then rebuilt in the fourth century, the period from which this column drum dates. The temple exemplified the Ionic order of architecture, which was the temple style of the Greek colonies of Asia Minor, where the Artemision was located. Much larger than a typical Doric temple such as the Parthenon, it measured 115 metres in length. The central building, or cella, was surrounded by a double ring of columns, and had additional rows of columns at the front and back, creating the effect of a "forest of columns". The columns were very large, and much more ornate than those of the Doric order. The lowest drum of each column, just above the column base, was sculpted in low relief. These works of art would have been at eye level, providing a rich array of decorative narratives to surround the visitor. The overall effect of the temple must have been one of overwhelming scale and lavish decoration. Sadly, though the temple stood for hundreds of years, it is now almost completely lost. This single remaining sculpted drum stands as a testament to the skill of the artisans commissioned to build and decorate the great temple.

85. Anonymous, *Maenad.*

Skopas was one of the great sculptors of the fourth century B.C.E. He was known for the deeply-carved, expressive eyes of his subjects, and the resulting sense of emotionality in his works. In this dancing *Maenad*, thought to be a copy of a work of Skopas, we see one of Skopas' important innovations: the movement conveyed by the piece. Far more than a gesture or a weight-shift, the maenad's movement is a violent, swirling dance, shown especially in the twist of her neck and the swirl of her gown. Maenads were worshippers of Dionysos, the god of wine. His followers were thought to engage in drunken, orgiastic rituals, dancing in an ecstatic frenzy.

87. Anonymous, *Aphrodite of Knidos.*

Aphrodite, goddess of love, beauty, and sex, was renowned for her own beauty. The *Aphrodite of Knidos* was one of the first nude female sculptures in the Greek world, and caused quite a stir. It portrays Aphrodite as the epitome of female beauty: a goddess, but rendered accessible to mere mortals through her vulnerability. That vulnerability, expressed through the combination of her nudity and her shy stance, was emphasised through the placement of the statue in an outdoor shrine in a place where it could be directly approached and seen up close. The nude Aphrodite became a common subject for sculpture in the fourth century B.C.E. and following, in part due the popularity of this piece. It is also likely that Aphrodite provided sculptors with the opportunity to showcase the female form in a sensual and erotic manner under the guise of a reverential image of a god.

88. Anonymous, *Apoxyomenos.*

In the fourth century, standing male statues of idealised athletes remained a popular subject for sculpture. The poses became more varied, however, as sculptors experimented with forms that could be viewed from multiple angles. The *Apoxyomenos*, or *Man scraping Himself*, is an example of innovation of pose. His right arm extends forward, reaching out of the plane in which the rest of his body lies. Before exercising, a Greek athlete would apply oil to his body. He would then return to the bath house, after engaging in sport, and scrape the oil off himself. The subject of the *Apoxyomenos* is in the process of scraping himself clean.

90. Anonymous, *Belvedere Apollo.*

The *Belvedere Apollo* has long enjoyed fame, known as the prototypical work of Greek art. This fame springs from its rediscovery during the Renaissance of the fifteenth century. At that time, wealthy Italian nobles began to collect ancient sculpture that was being discovered in the ruins of Roman Italy. The *Belvedere Apollo* went to the collection of the Pope, and was displayed in the courtyard of the Belvedere villa in the Vatican. There, it was seen by countless visitors and visiting artists, who sketched the piece. Copies were made for various courts of Europe. The proud, princely bearing of the figure, along with the delicate beauty of Apollo's face, had great appeal among the aristocratic classes of the sixteenth and seventeenth centuries, and to the Romantics of the eighteenth and nineteenth centuries.

99. Anonymous, *Venus and Cupid.*

Aphrodite became a common subject for Greek sculptors in the fourth century B.C.E. and later, because her renowned beauty provided an acceptable excuse for an erotic representation of the female body. She is sometimes shown, as here, with her son Eros, known to the Romans as Cupid, and in later art as "putti," the winged babies symbolising earthly and divine love. In Roman art and mythology, Aphrodite became Venus, goddess of love. To the Romans she had a more elevated status, seen as the progenitor of the line of Caesar, Augustus, and the Julio-Claudian emperors, and by extension as an embodiment of the Roman people. This playful depiction of Aphrodite and Eros, or Venus and Cupid, is more suggestive of the Greek view of Aphrodite, who saw her not only as the symbol of sensual beauty, but also as occasionally silly and humorous.

102. Anonymous, *Artemis with a Hind,* called *"Diane of Versailles".*

This depiction of a strong, striding Artemis hunting with a deer by her side is thought to derive from a Greek original of the fourth century B.C.E. Artemis was one of the virgin goddesses, a huntress and protector of the wild and of fertility; her association with fertility made her also the goddess of childbirth. She was a twin to the god Apollo, and copies of this statue are often paired with copies of the *Belvedere Apollo* (see no. 90). Her dual role as a hunter and a protector of animals is seen in this piece. Although she is hunting, she is accompanied by a deer, or hind, which is under her protection. With one hand, she reaches for an arrow. The other hand has been restored and may have originally held a bow. Her energetic stride, and the movement of her short dress as she walks, is typical of the new variety of poses seen in statues of the fourth century and later.

103. Anonymous, *The Barberini Faun.*

The wealth of the Hellenistic period meant that many people could afford sculpture for their private houses and gardens. Consequently, more profane, even erotic, subjects were introduced to the repertoire of Greek art. Here, a sleeping, and probably drunk, satyr lounges sprawled out on an animal skin. The pose is unabashedly erotic, the figure's nudity no longer signalling simply that he is a hero, athlete, or god, but rather suggesting his sexual availability. The naturalistic and idealised manner of depiction of the body of the satyr is a legacy of High Classical sculpture.

106. Anonymous, *Nike of Samothrace.*

Following the conquest of Greece, the Near East, and Egypt by Alexander the Great towards the end of the fourth century B.C.E., Greek art entered a new cosmopolitan age, when the wealth and exotic tastes of great foreign kingdoms brought new flair to Greek sculpture and architecture. One of the most dynamic examples of this Hellenistic art is the *Nike of Samothrace*, which was part of a large installation at a sanctuary on the island of Samothrace in the northern Aegean Sea. In its original setting, the Nike was alighting on the prow of a warship, signalling victory. The prow, carved out of stone, served as the base for the dramatic figure. The whole piece was set into a landscape with a running fountain suggesting the waves of the sea. This combination of landscape, art and drama was characteristic of the Hellenistic period. The figure herself calls to mind the earlier Nike of the fifth century (see no. 76), whose movement caused her robes to drape and fold elegantly around her. Here, however, the viewer can almost feel the wind whipping her garment from all sides. The movement of the fabric, pulling simultaneously in both directions around her legs, gives the piece a dynamism not previously seen in sculpture.

109. Anonymous, *Sleeping Hermaphrodite.*

A young naked woman lying on a bed seems to be resting. But when seen from a different angle, she appears somewhat masculine. We are indeed facing the representation of Hermaphrodite. He was the son of Hermes and Aphrodite, and found himself with both sexes after a nymph he had rejected asked Zeus to fuse them both in one single body. This ambiguous subject was strongly appreciated at the end of the Hellenistic period because of the surprise it created upon the viewer. This Roman copy of a Greek original of the second century B.C.E. continued to fascinate the collectors among which the cardinal Scipione Borghese who commissioned Bernini to sculpt the mattress upon which the Hermaphrodite lays.

110. Anonymous, *Athena fighting with the Son of Gaea the Earth Goddess.*

The greater-than-life-size figures of this relief adorned the Pergamon altar, a structure at the highest point of the city of Pergamon in Turkey, capital of one of the Hellenistic kingdoms. The sculpture filled the frieze, which wrapped around the outside of the building and along its great staircase. It depicted the battle between the gods and giants. The giants are shown with wings on their backs and snakes emerging from them, in contrast to the gods, shown in typical Greek-style robes. In this fragment, Athena, the central figure, battles with a giant, on the left. She is pulling back his head as he pulls in the opposite direction, trying to escape. At the

same time, he struggles to hold onto the hand of his mother, Gaia, the earth and mother of all giants. She is shown at the bottom of the scene, as though emerging from the earth itself. Gaia was the source of all power for the giants, and as long as they touch her they cannot be killed. But this giant has lost his grip, and the winged victory figure already swoops in behind Athena, ready to crown her victor. For Athena, the battle is one. This dramatic battle plays out around the entire frieze, with the same kind of violent struggle seen here. The scene is in high relief, with deeply cut shadows accentuating the drama, and figures spilling off of the wall and onto the staircase.

112. Anonymous, *Laocoön*.

Laocoön was a Trojan priest. When the Achaeans, who were holding Troy under siege, left the famous Trojan horse on the beach, *Laocoön* tried to warn the Trojan leaders against bringing it into the city, fearing it was a trap. Athena, acting as helper and protector of the Greeks, punished *Laocoön* for his interference. She had him and his two sons attacked by giant snakes. In this famous sculpture group, probably a Roman copy of the Hellenistic original, one son breaks free of the snakes, looking back to see his father and brother being killed. The baroque style of the piece ties it to the Pergamon school. It exhibits the same drama, seen in the straining muscles and the faces contorted in pain. In fact, the pose of *Laocoön* seems to echo that of the giant who battle Athena on the Pergamon Altar (see nos. 110, 111).

116. Anonymous, *The Punishment of Dirce*, called the *"Farnese Bull"*.

One of the largest pieces of sculpture created in antiquity, this piece was made during the second century B.C.E., in the Hellenistic period. It has all the hallmarks of Hellenistic sculpture: an elaborate assemblage of multiple figures, dramatic action, and a pyramid-shaped composition. It was made by artists from the Greek island of Rhodes for a Roman politician. This copy decorated the Baths of Caracalla in the later Roman empire. It was there that it was rediscovered in the sixteenth century and placed in the Farnese Palace, a residence of the Pope. The scene depicted is from the story of Antiope and Dirce. Antiope was the mother of twin boys, whom she was forced to abandon. They survived, but her punishment was to be the slave of her aunt, Dirce. She escaped and went to find her sons. Dirce found her and ordered her tied to a bull and trampled. Antiope was rescued by her sons, who instead inflict the punishment on Dirce. Here, the boys tie Dirce to a raging bull; her fate is clear.

117. Anonymous, *Aphrodite of Melos*, called the *"Venus de Milo"*.

The *Aphrodite of Melos*, or *Venus de Milo*, is an original Greek sculpture dating to the Hellenistic period. It was discovered in a field along with other sculptural fragments, including a separate arm holding an apple, which belongs with this figure. The apple is probably a reference to the mythical "Judgment of Paris". In that tale, the goddess of Discord tossed a golden apple inscribed "for the loveliest" towards the goddesses Aphrodite, Athena, and Hera. The young Trojan prince, Paris, was asked to decide which goddess should be awarded the apple. Each tried to bribe Paris but he chose Aphrodite, who offered him the love of the most beautiful mortal woman in the world. That woman, of course, was Helen of Sparta, already married to the Greek king. Her abduction by Paris started the Trojan War. While Aphrodite is criticised by Homer for her role in starting the conflict, she is celebrated here as the purveyor of true love.

119. Anonymous, *The Three Graces*.

The Graces, or Charities, were three goddesses named Beauty, Mirth, and Cheer. They oversaw happy events such as dances and banquets. They were companions to Aphrodite, providing the happiness that accompanies love. Like Aphrodite, they were often depicted in the nude, and often, as in this example, dancing in a circle. In each, we see the familiar shift in weight, or contrapposto, developed in the fifth century. However, the composition of this piece is far more elaborate than any High Classical sculpture. It was not until the Hellenistic period that complex groups of multiple figures were depicted in free-standing sculpture. The figures are tied together by their embrace, unifying the piece, yet they face different directions, so that the sculpture would be interesting from any angle from which it was viewed.

121. Anonymous, *Augustus Prima Porta*.

Augustus, the first emperor of Rome, transformed the way art and image were used by the Romans. He rejected the "veristic" style of Roman portraiture, preferring instead to emulate the High Classical style of fifth-century Greece. In this portrait, found at the villa of his wife Livia at Prima Porta, Augustus is shown in a pose that directly quotes Polykleitos' *Doryphoros*, the best-known statue of the fifth century. In doing so, Augustus called upon all the associations the High Classical period carried: empire and power, but also democracy. Augustus was trying to appease those who might resent his absolute rule and the end of the Republic. He was at once advertising his strength, and also his role as a fair, democratic leader who would represent the senate and the people of Rome.

123. Anonymous, *Seated Boxer*.

A rare bronze statue that survived from antiquity, this powerful image of a tired boxer is likely an original Hellenistic work, dated perhaps to the first century B.C.E. The seated pose of the boxer invites the viewer to look down at the figure, as he in turn looks up, perhaps to discover the verdict of the judge. He still wears his boxing gloves, and is badly bruised and bleeding, his face and ears swollen from the fight. Despite these wounds, he does not appear defeated. He has all the exaggerated musculature of other Hellenistic works, such as the *Laocoön* and the *Belvedere Torso*. His mouth and the cuts on his face are copper additions to the bronze statue, and the eyes would have likewise been made of a different material.

124. Anonymous, *Spinario (Boy removing a Thorn from his Foot)*.

This piece is one of the rare bronze works to survive from antiquity. Created by a Roman artist of the Hellenistic-Roman period, it reflects both the interests of Hellenistic artists as well as the tastes of Roman collectors. The sculptors of the Hellenistic and Roman world drew from a much wider range of subjects than did earlier Greek artists. Their commissions came from private citizens and towns rather than only temples. As Rome became the dominant power in the eastern Mediterranean, the interests of both collectors and artists began to shift. The "canons" or rules established by Greek artists of earlier periods no longer constrained what artists could do. This representation of a boy removing a thorn from his foot is an example of these innovations, showing a boy in a mundane, everyday act, yet idealised to suit Roman taste. After the statue's rediscovery in the Middle Ages it became quite influential, and was widely reproduced during the Renaissance.

125. Agasias of Ephesus, *The Fighting Warrior*, called the *"Borghese Gladiator"*.

This Roman copy of a Greek original dating, perhaps, to the fourth century B.C.E., was rediscovered in the early seventeenth century and acquired by Cardinal Borghese. A wealthy relative of Pope Paul V, he collected hundreds of statues, many of which were ancient, some of which were contemporary pieces in the style of antiquity. Pieces in the Borghese collection often suffered from unfortunate restorations, though this piece seems to have escaped unmarred. It was later purchased by Napoléon Bonaparte, a relative by marriage of the Borghese family. In that way it made its way to Paris. It was long thought to represent a gladiator, but more recently it has been acknowledged that it could as easily be an athlete or warrior. Much has been made of the ideal musculature and anatomy of the subject. The artist clearly sought to emulate as realistically as possible the form, stance, and sinews of the lunging figure.

126. Anonymous, *Tellus Relief*.

With the *Ara Pacis Augustae*, the Emperor Augustus makes a complex ideological statement. The building was a monument to the lasting peace Augustus achieved by securing the borders of the empire. Carved in relief

inside and out, it depicted an array of symbols, each signalling a component of his message. Inside the altar, bucrania and fruit-bearing garlands suggested the fecundity of Rome and the perpetuity of Rome's sacrificial offerings to the gods. Outside, the ceremonial dedication of the monument itself was depicted, with a procession that calls to mind the Parthenon frieze. In addition, the exterior has four panels with mythological scenes. Like the procession, it is done in the classicising style of Greek art, adopted by Augustus to suggest a long historical basis for his rule of Rome, and also to call to mind democratic ideals, belying his imperial authority. In this panel, the central female figure probably represents Tellus, or Mother Earth. She holds two babies, representing the fertility of Rome and of the Roman people. The theme of fertility and fecundity is emphasised by the plants and animals at her feet.

127. Anonymous, *Roman Aristocrat with Heads of his Ancestors.*

In Roman tradition, figural sculpture was not intended to portray a young, athletic ideal, as it was for the Greeks. Instead, it represented the ideal of Roman society: the wise, elder statesman, patriarch of a family, part of a distinguished lineage. Sculptures were portraits of individuals and included all their flaws – wrinkles, warts, funny noses and knobbly knees. This style is called "verism," meaning truth. It was the dominant style during the Roman Republic. Here, and elderly man holds portrait busts of his ancestors, showing his respect for them, and at the same time drawing attention to his lineage. Such portraits would be prominently displayed in the atrium of the home.

133. Anonymous, *Prisoner Seated.*

Images of the barbarian enemies of Rome were common. Often, they are shown as defeated, or as captives of the empire. Many were found in Trajan's Forum, and are therefore thought to be representations of Dacians, a people of Eastern Europe who were conquered by Trajan. Trajan depicted the defeat of the Dacians in much of the imagery of his reign, because that victory brought great wealth to Rome. Dacia was rich in mineral wealth, including large amounts of gold and silver. That wealth flowed into Rome after the conquest, and allowed Trajan to undertake a major building campaign, including his great Forum and the famous Markets. He also devoted some of the riches to alleviate the suffering of Rome's poor, providing food for impoverished children. In this image, whose hat and clothing suggest he is a king of Dacia, the enemy is portrayed defeated, but strong and proud. The strength and nobility of Rome's enemies made her victory over them that much greater.

135. Anonymous, *Gemma Augustea.*

This cameo pendant is carved out of a multi-veined onyx, a stone with variegated layers of dark blue and white running through it. The white layer has been carved into a figured design, partially revealing the underlying dark blue layer, which provides a background colour. It is remarkable for its size, since it is rare to have such a large stone with enough consistency in its layers to produce a piece of this scale (23 cm wide). The scene is carved in two registers. The lower register shows the end of a battle, with Roman soldiers erecting triumphal trophies near several enemy prisoners. Above, the Emperor Augustus is shown seated next to Roma, the female embodiment of Rome. Augustus is crowned with a laurel wreath. To the left, the stepson and successor of Augustus, Tiberius, arrives in a chariot. The piece asserts the power of Augustus while affirming his support for Tiberius as successor. The military scene at the bottom is a reminder of Tiberius' success on the battlefield, a reminder of his qualification as the next emperor.

137. Anonymous, *Bust of Woman,* called *"Bust Fonseca".*

While Roman male portraiture often retained elements of the veristic style of the Roman Republic, portraying realistic images of rulers and aristocrats, female portraits were usually of the idealised, classicising style. In this portrait, the woman's face is delicate and softly contoured, perpetually youthful. The gentle modelling of the face is accentuated by the intricate

patterning of her hair, carved into an elaborate pile of curls that was the style at the time. The artist has used the hairstyle to exhibit his skill, employing a fine drill to carve deeply into each ringlet of hair.

143. Anonymous, *Relief,* called the *"Borghese Dancers".*

This is an example of a low-relief panel, a scene whose elements rise from the background in differing levels of relief. The lowest level, barely emerging from the background, is a Corinthian colonnade. Centred under each column is a female figure, whose flowing drapery forms the next level of relief. The figures themselves are in much higher relief, with arms fully freed from the background panel. The dancers move in opposite directions, hands clasped, their tunics billowing behind them as they move. It is not known where the panel was originally placed; it was rediscovered in the Renaissance and displayed in the Villa Borghese.

159. Anonymous, *Portrait of Emperor Caracalla.*

Caracalla was part of a lineage of emperors that took over after the cruel Commodus was murdered. Several military leaders tried unsuccessfully to rule Rome, until Caracalla's father, Septimus Severus, a popular general, was declared emperor. Severus tried to legitimise his rule by declaring himself part of the previous dynasty, the Antonines. His portraits therefore intentionally resemble those of the earlier rulers. Caracalla, however, is portrayed in a more realistic manner, one that expresses his own cruel nature. In this portrait, his critical, angry expression and pugnacious visage reveal both his physical appearance and his personality. He has eschewed the drilled, corkscrew style hair and beard of his predecessors in favour of a shorter style. His portrait reveals that he had no use for links to a dynastic past; his power would come from his own strength and vengeful acts.

160. Anonymous, *Bust of Commodus as Heracles.*

This portrait of the Roman Emperor Commodus shows him in the guise of Heracles, the great hero of myth. Commodus was one of the more deranged and tyrannical emperors, and one of his follies was to imagine himself as Heracles. He changed his name to Heracles Romanus and forced the Senate to declare him a god. This portrait is in some ways typical of the portraiture of the time. It shows the emperor as young and bearded, which was the standard style since Hadrian. His face is given a classicising, elegant appearance, yet the hooded eyes were particular to Commodus and show this to be, at least to some degree, a likeness. The emperor's hair and beard have finely-drilled curls (see no. 137). Otherwise, however, the portrait is rather unusual. Commodus is draped in the lion skin worn by Heracles, held in place by the knotted front legs of the beast. He holds Heracles' club in one hand, and the apples of the Hesperides, from the mythical labours of Heracles, in the other. Other than the lion skin, he is bare-chested, another sign of his supposed divinity.

162. Anonymous, *Portrait of Caius Julius Pacatianus.*

Continuing the tradition established by the Etruscans many centuries earlier, this bronze portrait statue represents an elder male, perhaps a statesman. Most likely meant for display in family's home, or villa, this piece commemorates the *"pater familias,"* or high-ranking male family member. By the third century, the toga, worn by this figure, was not generally a quotidian garment. Instead, it was worn for ceremonial purposes, and signified the citizenship and importance of the wearer.

165. Anonymous, *Nautes Pillar.*

This monument comes from Roman Gaul, from soon after the Romans had taken control of Paris. The pillar, dating to the early first century A.D. was originally erected in a Gallo-Roman temple. A Christian cathedral was built on the site in the sixth century, later replaced by the church of Notre-Dame de Paris. The broken pillar was found within the foundation of Notre-Dame. It speaks to the religious transformation that must have taken place after the Roman takeover of Gaul. It was dedicated to the Roman god Jupiter by Parisian sailors, but also included the names of gods of

Gaul, demonstrating that worship of the old gods was still allowed under Roman rule. This remarkable work preserves not only early Gallo-Roman history, but also a non-imperial style of art that retained Celtic characteristics.

166. Anonymous, *Arch of Constantine.*

Triumphal arches were erected throughout the course of the Roman empire, commemorating the achievements and victories of various emperors. The *Arch of Constantine*, an emperor famous for making Christianity the official religion of the late empire, is interesting because it re-used panels and figures from older Roman monuments. Such re-use is known as "*spolia*". Spoliation was done for several reasons; in part, it was simple economical recycling. Rather than quarrying new stone and paying artisans to carve it, pieces could be taken from older monuments and incorporated into a new one. There was an additional, ideological motivation. In the case of Constantine's arch, he chose reliefs and figures from the greatest moments of the Roman Empire to stress the continuity of his rule with that of past emperors, despite the changes in political structure and religious authority during his rule.

167. Anonymous, *The Tetrarchs: Diocletian, Maxentius, Constantius Chlorus and Galerius.*

The third century was a turbulent time in the Roman Empire, with constant civil war and a series of military leaders vying for power. When Diocletian became emperor in 284, he chose to solidify his rule by sharing power with his rivals. He established a tetrarchy, or rule by four. Diocletian took the title of Augustus of the east, with a corresponding Augustus of the west, and secondary rulers east and west called Caesars. Marriages were arranged among members of the tetrarchs' families to reinforce the relationships. Although this power arrangement was unusual, it was surprisingly effective, and order was maintained until Diocletian retired, at which point the division between east and west fractured the empire for good. This portrait of the four tetrarchs is notably different than earlier portraits of emperors. The classicising style of depiction has been discarded in favour of the native, plebeian style of art, long seen in pieces such as funerary reliefs, but rarely in imperial monuments. Plebeian art is characterised by the stocky proportions and stylised presentation of the body, as seen here. This style was probably introduced to imperial art via the series of military leaders who served as emperor during the third century, and brought with them the plebeian vernacular.

168. Anonymous, *Missorium of Theodosius I.*

On this engraved and chased silver and ceremonial plate, a complex image of imperial power and piety is shown. Commemorating the tenth year of the rule of Theodosius I, the plate shows the emperor enthroned in a Christ-like pose with a halo above his head. Theodosius banned pagan religions, making Christianity the official state religion of the Roman Empire. Under Theodosius, there was a "renaissance" of artistic expression in which the pictorial style of the Late Antique is again imbued with Classicism. Constantinople became the cultural centre of the Empire, replacing Rome.

170. Anonymous, *Sarcophagus of Constantina.*

Beginning in the second century, Romans began to favour inhumation, rather than cremation, as a funerary practice. As a consequence, the stone coffins called "sarcophagi" were produced. Each sarcophagus was decorated with more or less elaborate figural scenes, depending on the taste and the wealth of the deceased. The sarcophagi were usually placed within tombs that were frequently visited by the living relations of the deceased, so the effort spent in carving them was appreciated for many years. Christians living within the Roman Empire also preferred inhumation to cremation; in fact, it is possible that Christian customs influenced the change in funerary practices of the pagans. The sarcophagi for Christian burials were decorated, of course, with Christian symbols such as the cross, but many pagan symbols were also co-opted for used by the Christian religion, and so there is

frequently a combination of both pagan and Christian iconography on early Christian sarcophagi.

This sarcophagus, made out of rich, purple stone called porphyry, may have been the resting place of Emperor Constantine's daughter, Constantina. Constantine is generally known as the first Christian emperor, though in fact his real contribution to the cause of Christianity was to legalise and promote the religion. He seems to have converted to Christianity late in his life; he may or may not have been truly faithful. Adding to the mystery of the faith of the emperor is the imagery on his daughter's sarcophagus. The scenes of winged *putti* figures could be pagan images of a festival for Bacchus, the god of wine. Alternatively, they could be a Christianised version of the motif, in which the imagery of wine represents the blood of Christ.

172. Anonymous, *Colossal Head of Emperor Constantine I "the Great".*

Though only fragments of the colossal statue of Emperor Constantine remain, the impressive head, standing over 2.4 metres, conveys the power the seated portrait must have had. It originally stood in the Basilica of Constantine, a massive structure built of concrete barrel and groin vaults. The ingenious groin vaults allowed light to flood the Basilica, illuminating the richly decorated interior and the apse at the west end, where the statue of Constantine sat. The short, cropped hair and beardless face of the emperor was intended to evoke earlier rulers from the golden age of the empire, such as Augustus and Trajan. The fragments that remain are from the head, hands, and feet of the emperor, the only parts of the statue made of marble. The rest would have been made of less expensive materials, such as wood.

173. Anonymous, *Theodosius receiving the Tribute of the Barbarians.*

This sculpted base was created to hold an obelisk imported to Constantinople, modern Istanbul, from Egypt by the Emperor Theodosius. The obelisk was erected at the ancient Hippodrome, where chariot racing was held. On each side of the base, Theodosius is shown along with members of his family and court, seated at the Hippodrome. Surrounded by a crowd of faces, he watches the races and observes the obelisk as it is raised. The scenes memorialise the accomplishment of obtaining and erecting the obelisk, and also remind all who would see it that Theodosius was responsible. The flat depiction of the figures, the lack of perspective or three-dimensional space, and the varying scale of the figures is more indicative of the art of the Middle Ages than that of the Roman Empire.

178. Anonymous, *Sarcophagus,* called *"Sarcophagus of Archbishop Theodore".*

The peacock was a powerful symbol in early Christianity. It served as a symbol of immortality, since it sheds and renews its feathers annually. It was also believed that the flesh of a peacock will not decompose upon its death, symbolic of the Christian soul. The many colours of the plumage represented the full spiritual spectrum, and the eye-like patterns on its feathers represented the all-seeing power of God. Here, two peacocks flank the superimposed Greek letters *chi* and *rho*, symbolising Christ. The elegance of the carving of this sarcophagus shows the strong classicising style as it continued in Christian art.

180. Anonymous, *Plaque from the Diptych of Consul Areobindus.*

In this ivory relief carving, the flat, descriptive style of the Middle Ages is fully realised. The Consul Areobindus is shown seated on an elaborate throne surrounded by symbols of his office. The patterning of the Consul's robes, and the expressiveness of his face highlight the effectiveness of this style. The Consul is presiding over a spectacle in the Hippodrome in Constantinople, shown below. Men are shown engaged in an animal hunt while a crowd looks on. The lower scene combines a birds-eye view of the sport with a eye-level view of the crowd. This combination of perspectives is part of the descriptive, rather than realistic, style of the Middle Ages. This ivory object was originally part of a hinged diptych. The two pieces, like covers of a book, held a wax rewriteable tablet.

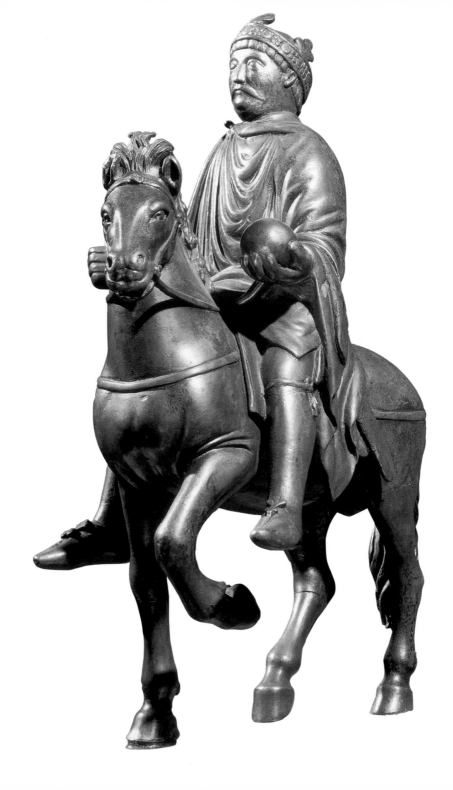

MIDDLE AGES

After the demise of the Roman Empire, all of the art forms declined across western Europe, and a whole set of stylistic and iconographic traditions essentially disappeared. In this political and artistic vacuum, a number of new styles arrived with the cultures that introduced them. The tribal movements in the north brought with them animal art, stylised and small-scale works. The art of such groups as the Vikings and Hiberno-Saxons, who specialised in stylised animal forms and the invention of intricate and abstract knot and weave designs, stands as good examples of the style that succeeded the waning of the heavily figural tradition of the ancient Romans.

In time, some of the core cultures in western Europe turned again to ancient Roman models for guides. Towards the year 800, Charlemagne's writers and artists very consciously set out to revive ancient models in order to suggest his political revival of the Roman Empire, and certain specimens of Carolingian sculpture are based, if somewhat naively, on ancient Roman prototypes. A more broadly-based spirit of revival occurred in the Romanesque style, which was flourishing by 1000 A.D. and left its mark on Europe during the next two centuries or so. Just as Romanesque architects re-utilised the rounded arches, wall masses, and barrel-vaults of the Romans, artists attempted to revitalise sculpture by creating monumental and extensive programmes for ecclesiastical exteriors. As for stylistic particulars, a few Romanesque sculptors looked, sometimes with startling fidelity, to the models of the Roman past, basing their works, whether capitals or portrait heads, on originals from antiquity. These were in something of a minority, however, and more generally the Romanesque figural style was varied and novel, sometimes rendered with great elongation or, on the other hand, with squat proportions.

Many monumental Romanesque works responded to the great movement of pilgrims from site to site, and frightening Last Judgments or memorable images of the Second Coming of Christ served as a reminder of this before the entrance portals, as they did at the cathedrals at Autun and Vézelay. The effective placing of figures in the tympana and in the trumeaux at the entrance doors caught the attention of those entering. Half hidden in the pier of the trumeau at Saint-Pierre Abbey Church in Moissac (see no. 208), the prophet Jeremiah twists and turns, his expressive elongation and thin drapery folds representing a new kind of ecstatic artistry. No less expressive is the Christ figure at Saint-Lazare Cathedral of Autun (see no. 207); his thin and angular body conveying the spiritual sense of his ascension to Heaven. In the tympanum, we have a record of the name of the master, Gislebertus, an early example of the growing status of the artist, who in this case proudly signed his work.

It is impossible to separate the development of Gothic sculpture from the rise of new forms in architecture. The sculptural programmes in Gothic cathedrals exploded in variety and subject matter. There occurred the addition of the numerous jamb figures along the sides of the doors, and overhead a stunning crowd of saints, prophets, angels, and others occupied the ever-deepening plane of the wall. Some of the early Gothic figures, such as the jamb figures at Notre Dame at Chartres (see no. 235),

were linear and columnar, to represent their sustaining role in the Church, but in general, compared to their Romanesque predecessors, the Gothic figures became softer, more realistic, and more sensitively human. Christ over the main portal at Chartres (see no. 233) is forgiving and humane, his body supple and plausibly real.

Even further from the stiff Romanesque style is the courtly Gothic of the later Middle Ages. Here the hip-short stance is an elegant replacement of the antique *contrapposto* stance, and sometimes a rubbery S-curve or arc runs through the figures. The French late Gothic tradition, in particular, was marked by a courtly elegance and suave sophistication. Especially strongly in the last phases of the Gothic style, the gentle smile on the faces and the curving lines were markedly "pretty" rather than incisive in narrative. The late Gothic manner started in France but radiated outwards, and was manifested throughout Europe, and echoes of it are found in Italy, Germany, the Low Countries, and elsewhere. The elaborate late Gothic building style is often echoed in reliquaries of the period, which sculptors crafted using the florid architectural language of the time.

During the Gothic period, some sculptors relied on ancient prototypes. The master of the *Annunciation* group at Reims (see no. 293) was clearly looking at Roman models, and the Italian Nicola Pisano did the same. Indeed, the rebirth of sculpture in Italy began in the 1200s in the hands of Nicola, whose marble pulpits (see nos. 301, 302) and other works drew on both the formal models and the overall spirit of the ancient Roman style as he knew it from sarcophagi in the *camposanto* (cemetery) of Pisa. Like other aspects of the early rebirth of classical culture, Nicola's innovations had only a limited impact, and even his own son Giovanni Pisano turned to an expressive Gothic manner reminiscent of the art of late medieval northern Europe.

If the French developed a witty and decorous courtly Gothic, and the Italians carved their figures in a way at times dependent on grave classical models, the Germans had their own expressive mode. The Röttgen *Pietà* (see no. 318) is emblematic of this, with its clotted blood and tortured body of Christ calling attention to the suffering of Christ rather than his perfection of form. Later the German Veit Stoss, encasing his narrative scenes in intricate Gothic frames, filled the spaces with melancholy figures, their draperies full of emotional movement and spatial clustering. This kind of expressionism was found in late Gothic German painting too, and would have an effect even on German Expressionists of the twentieth century, who looked back at the vigorous traditions of their national past.

We know the names of a few Romanesque sculptors, but the authorship of far more works is established by the Gothic period, so that known artists began to replace the largely anonymous craftsmen of earlier times. This is an aspect of the individualism of modern times. Other characteristics of the late medieval style seemed to mark the end of an era. The historian Johan Huizinga noted the weariness and melancholy embodied in the late Gothic, and he thought the works to be too abundantly endowed with iconographic niceties and disguised symbolism, where apparently everyday objects bore a religious meaning. This incorporation of the vividness of daily life with religious iconography is clearly seen in the development of passion-plays, in which the Passion of Christ was acted out in public plays throughout Europe in the fifteenth century. The elaborate sculptural projects of the Passion were related to this theatrical trend, and there was an obvious visual interplay between the two art forms.

See next page:
183. **Nino Pisano**, 1343-1368, Italian.
La Madonna del Latte, c. 1345.
Polychrome marble, h: 91 cm.
Museo Nazionale di San Matteo, Pisa (Italy). Gothic.

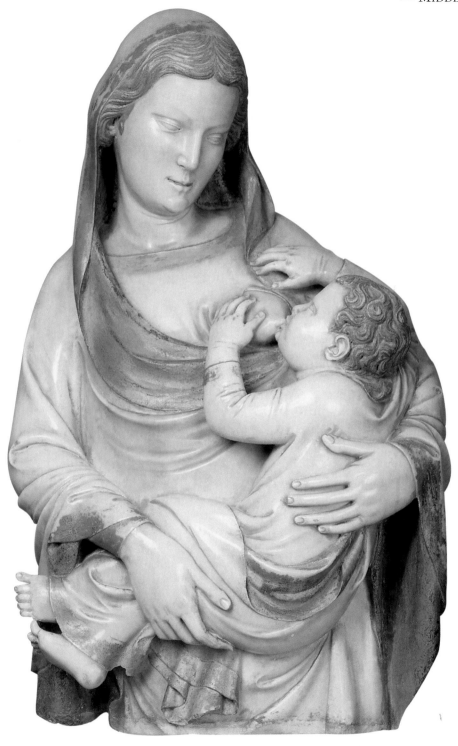

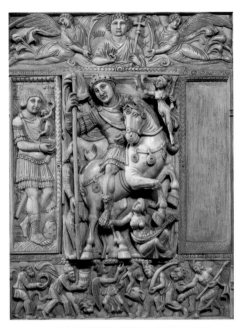

184. Anonymous.
The Emperor Triumphant, Barberini Ivory,
leaf of a diptych, first half of the 6th century.
Ivory and traces of inlay, 34.2 x 26.8 cm.
Musée du Louvre, Paris (France). Byzantian (?).

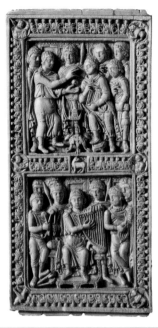

185. Workshop of the Palace of Charlemagne.
David and St Gerome, Dagulf ivory plaques, before 795.
Ivory, 16.8 x 8.1 cm.
Musée du Louvre, Paris (France). Carolingian.

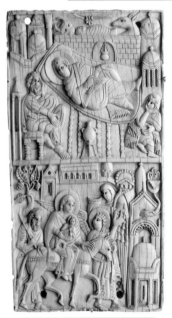

186. Anonymous.
Paliatto, relief from Salerno (Italy), c. 1084.
Ivory and traces of gilding, h: 24.5 cm.
Museo Diocesano, Salerno (Italy).
Early Middle Ages.

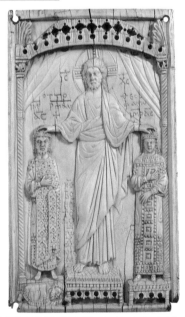

187. Anonymous.
Coronation of Emperor Otto II and Theophanu, 982-983.
Elephant Ivory and traces of polychromy, 18 x 10 cm.
Musée national du Moyen Age – Thermes et hôtel de
Cluny, Paris (France). Early Middle Ages.

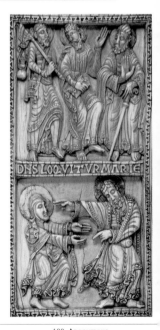

188. Anonymous.
Plaque with the Journey to Emmaus and the Noli M
Tangere, 1115-1120. Ivory and traces of gilding, 27 x 13.
The Metropolitan Museum of Art, New York
(United States). Early Middle Ages. (*)

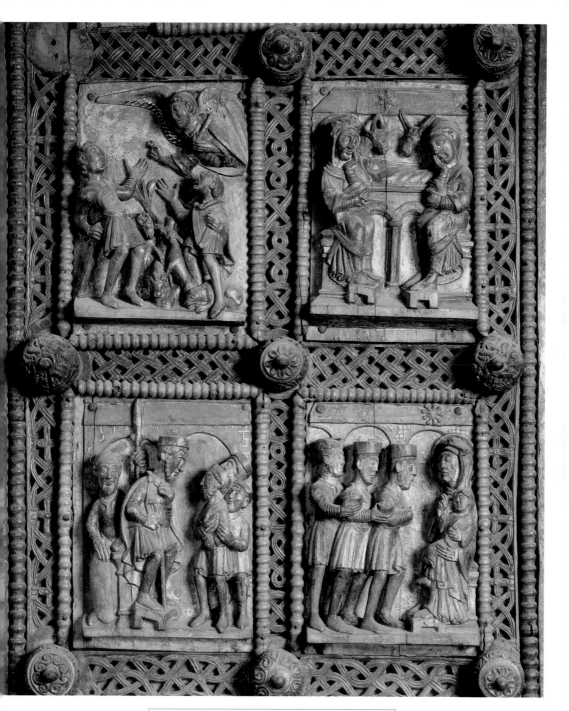

189. Anonymous.
Annunciation to the Shepherds, Birth of Christ, Magi before King Herod and
Adoration of the Magi, west panel of the door, St. Maria im Capitol Church,
Cologne (Germany), c. 1065.
Polychrome wood, h: 474 cm. In situ. Roman.

190. **Anonymous.**
Capital, cloister, former Saint-Pierre Abbey
Church, Moissac (France), 1100.
In situ. Roman.

191. **Anonymous.**
Harpies, capital of the cloister, Santo Domingo
Monastery, Silos (Spain), 1085-1100.
In situ. Roman.

192. **Anonymous.**
Samson and the Lion, capital of the transept cross, La Brède
Church, La Brède (France), 12th century. Stone, h: 55 cm.
Musée d'Aquitaine, Bordeaux (France). Roman. (*)

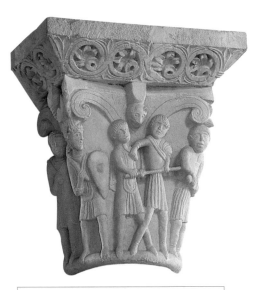

193. **Anonymous.**
Capital, imbedded column, San Martín Church, Frómista (Spain),
last quarter of the 11th century.
In situ. Roman.

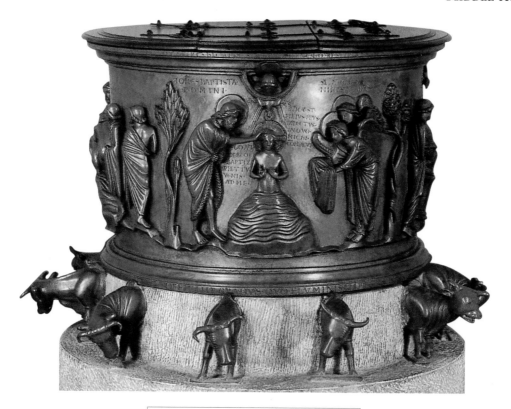

194. **Rénier de Huy**, died 1150, Belgian.
Baptismal Font, Saint-Barthelemy Church, Liège (Belgium),
beginning of the 12th century. Bronze.
In situ. Roman. (*)

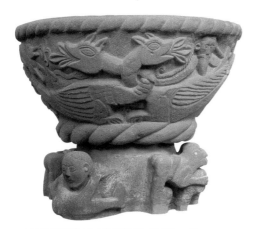

195. **Anonymous.**
Baptismal Font, Evangelical Church, Freudenstadt (Germany),
second half of the 11th century. Sandstone, h: 100 cm.
In situ. Roman.

196. **Anonymous.**
Baptismal Font, Tower of Saint James Church, Avebury
(United Kingdom), beginning of the 12th century.
In situ. Roman.

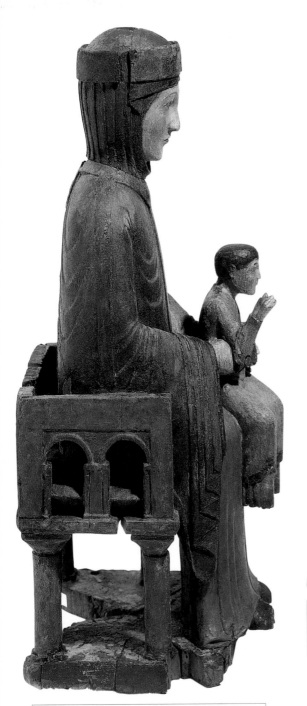

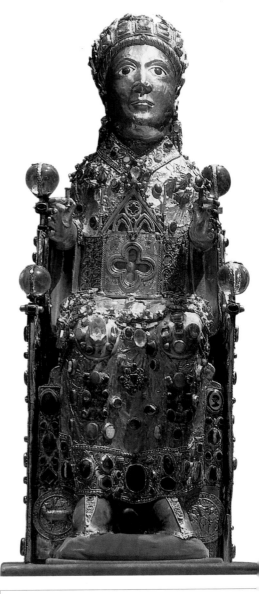

198. **Anonymous.**
Gold Majesty of St Foy, treasure of goldsmithery, Sainte-Foy Abbey Church,
Conques-en-Rouergue (France), 9th-16th century.
Heart made of if wood, gold leaves, silver, enamel and precious stones, h: 85 cm
In situ. Roman. (*)

197. **Anonymous.**
Virgin in Majesty, beginning of the 12th century.
Polychrome wood, h: 73 cm.
Musée Bargoin, Clermont-Ferrand (France). Roman.

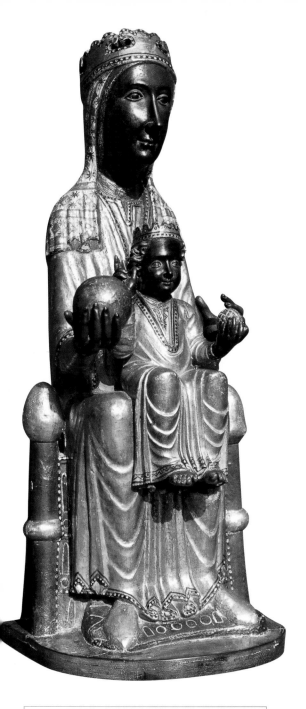

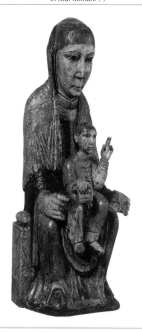

199. **Anonymous.**
Virgin of Montserrat, called *La Moreneta*, sanctuary of the Black Virgin,
Montserrat Monastery, Montserrat (France), beginning of the 12th century.
In situ. Roman.

201. **Anonymous.**
Virgin from Ger, Santa Coloma in Ger Parish Church, Santa Coloma
en Ger (Spain), second half of the 12th century.
Wood carving with polychromy in tempera, 52.5 x 20.5 x 14.5 cm.
Museo Nacional d'Art de Catalunya, Barcelona (Spain). Roman.

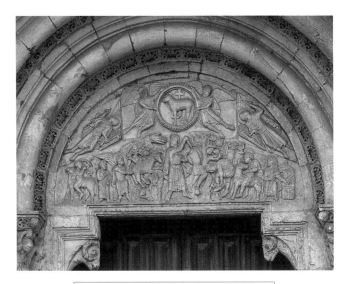

202. **Anonymous.**
Tympanon, Puerta del Cordero, San Isidoro Collegiate, León (Spain),
beginning of the 12th century.
In situ. Roman.

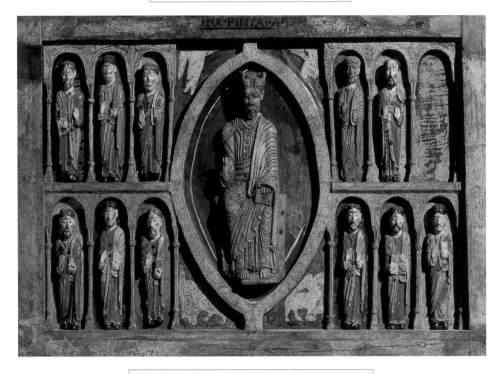

203. **Anonymous.**
Altar, Santa Maria Parish Church, Taüll (Spain), second half of the 12th century.
Pinewood carving with polychromy in tempera, 135 x 98 cm.
Museo Nacional d'Art de Catalunya, Barcelona (Spain). Roman.

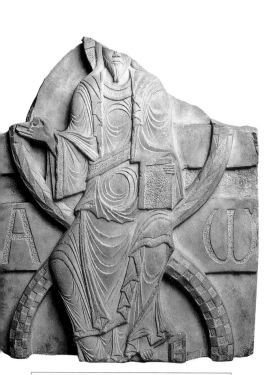

204. **Anonymous.**
Christ in Majesty, Cathedral, Rodez (France), 12th century.
Marble, 53 x 44.5 cm.
Musée Fenaille, Rodez (France). Roman.

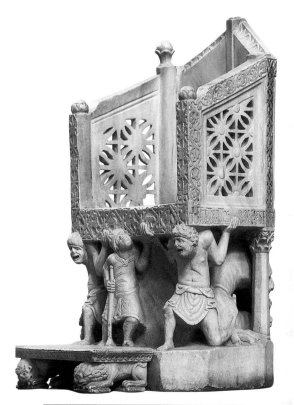

205. **Anonymous.**
Elijah's Episcopal Throne, San Nicola Basilica, Bari (Italy), 1105.
Marble.
In situ. Roman.

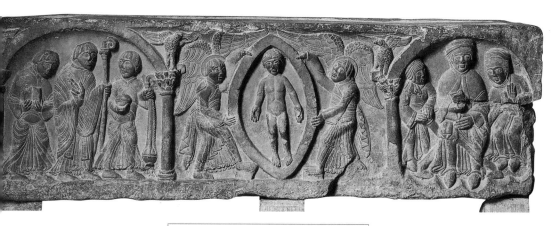

206. **Anonymous.**
Sarcophagus of Infanta Doña Sancha,
San Salvador y San Ginés Church, Jaca (Spain), c. 1100.
In situ. Roman.

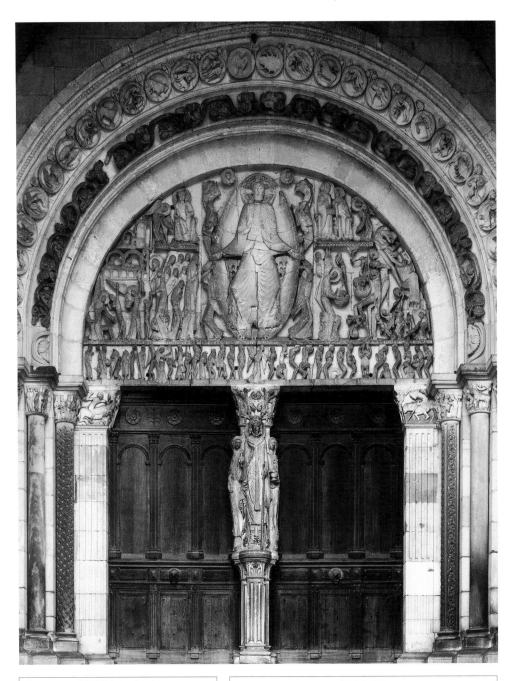

207. **Gislebertus**, French.
The Last Judgment, main portal tympanum,
Saint-Lazare Cathedral, Autun (France), 1130-1145.
In situ. Roman. (*)

See next page:
208. **Anonymous.**
South-Side Portal, former Saint-Pierre Abbey Church, Moissac (France), 1110-1130.
In situ. Roman. (*)

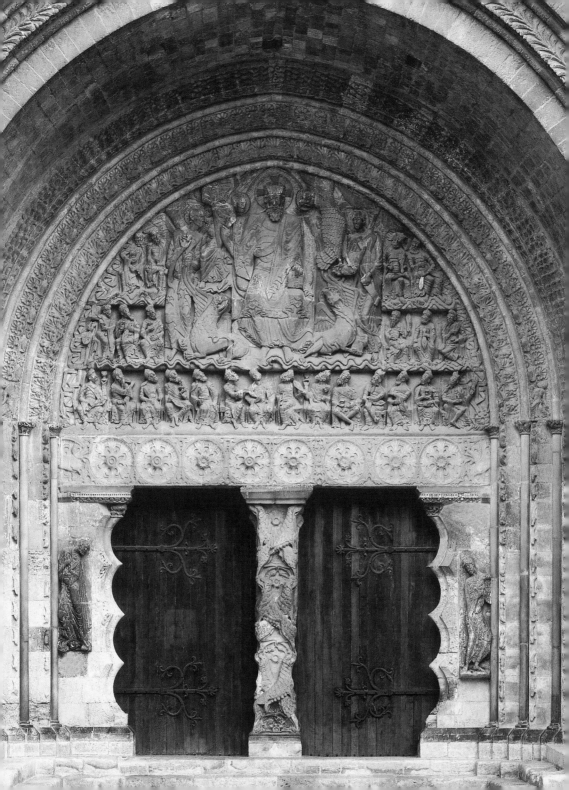

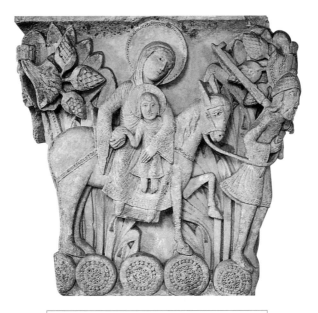

209. **Gislebertus**, French.
Flight into Egypt, capital of the chancel, Saint-Lazare Cathedral,
Autun (France), 1120-1130.
Salle capitulaire de la cathédrale Saint-Lazare, Autun (France). Roman.

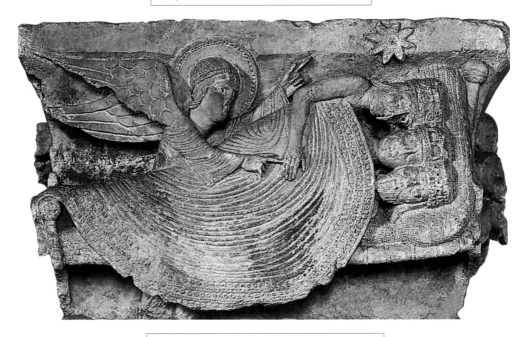

210. **Gislebertus**, French.
The Annunciation to the Magi, upper level of a capital from the chancel
of the Saint-Lazare Cathedral, Autun (France), 1120-1130.
Salle capitulaire de la cathédrale Saint-Lazare, Autun (France). Roman. (*)

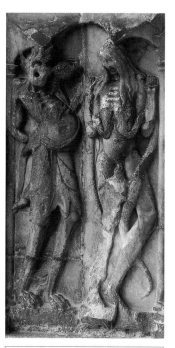

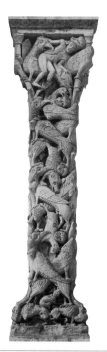

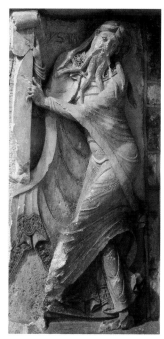

211. Anonymous.
Evil and Hedonism, west wall, south portal porch,
former Saint-Pierre Abbey Church,
Moissac (France), 1120-1135.
In situ. Roman.

212. Anonymous.
Column, reverse of the facade, Sainte-Marie Abbey
Church, Souillac (France), 1120-1135.
In situ. Roman.

213. Anonymous.
Prophet Isaiah, door jamb from the ancient west portal,
Sainte-Marie Abbey Church, Souillac (France),
1120-1135.
In situ. Roman. (*)

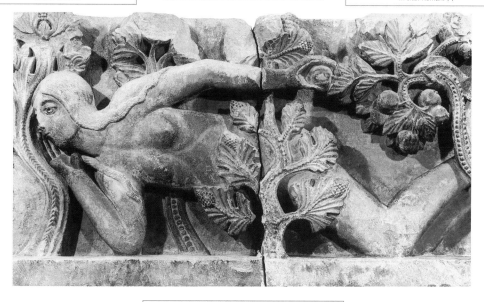

214. Gislebertus, French.
Eve's Temptation, lintel, north portal, Saint-Lazare Cathedral,
Autun (France), c. 1130. Limestone, 72 x 131 cm.
Musée Rolin, Autun (France). Roman.

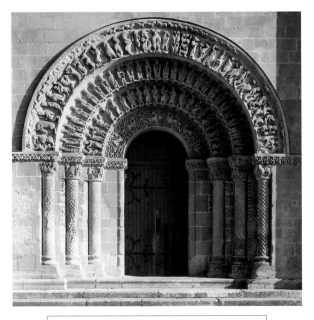

215. **Anonymous.**
Portal, south-side transept, former Saint-Pierre-de-la-Tour Collegiate
Church, Aulnay-de-Saintonge (France), c. 1130.
In situ. Roman.

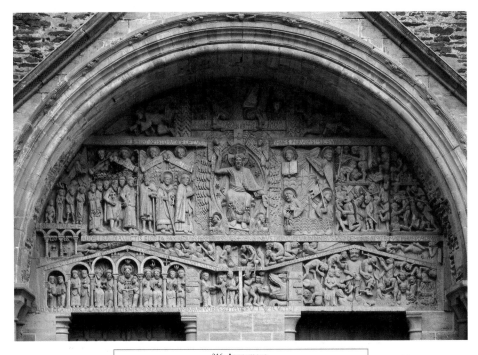

216. **Anonymous.**
The Last Judgment, west portal tympanum, Sainte-Foy Abbey Church,
Conques-en-Rouergue (France), 12th-14th century. 360 x 670 cm.
In situ. Roman.

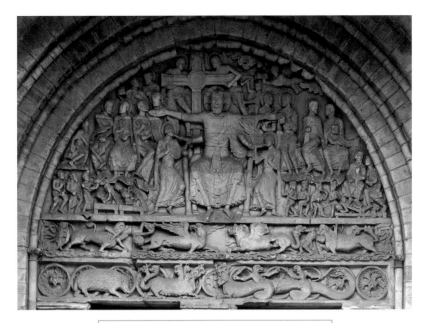

217. **Anonymous.**
The Last Judgment and the Infernals, south portal tympanum, Saint-Pierre
Abbey Church, Beaulieu-sur-Dordogne (France), 1130-1140.
In situ. Roman.

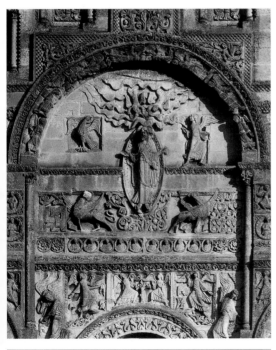

218. **Anonymous.**
The Ascension, central arcade of the upper level of the eastern facade,
Saint-Pierre Cathedral, Angoulême (France), 1110-1128.
In situ. Roman.

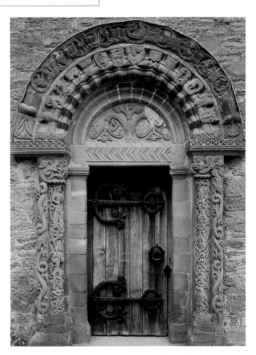

219. **Anonymous.**
South portal with animal columns,
St Mary and St David Church, Kilpeck (United Kingdom), c. 1140.
In situ. Roman.

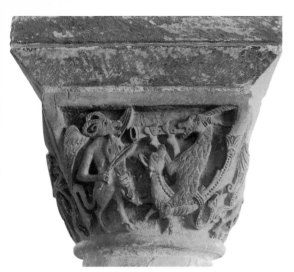

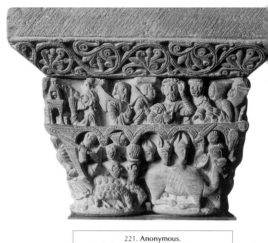

221. **Anonymous.**
The Suffering of Job, capital of the cloister,
Pamplona Cathedral, Pamplona (Spain) c. 1145.
Museo de Navarra, Pamplona (Spain). Roman.

220. **Anonymous.**
Capital, crypt, Canterbury Cathedral,
Canterbury (United Kingdom), 1100-1120.
In situ. Roman.

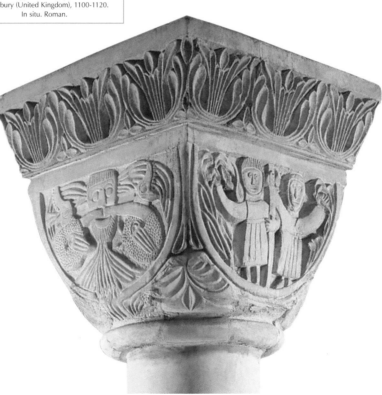

222. **Anonymous.**
Capital Adorned with Figures, St. Servatius Collegiate Church,
Quedlinburg (Germany), c. 1129.
In situ. Roman.

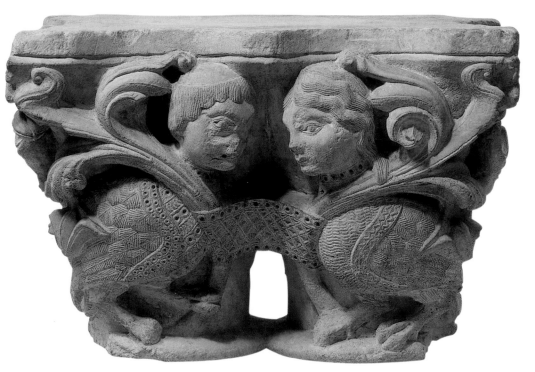

223. Anonymous.
Harpies facing Each Other, double capitals, c. 1140-1145.
Limestone, 26.1 x 41.2 x 30 cm.
Musée national du Moyen Age – Thermes et hôtel de Cluny, Paris (France). Roman.

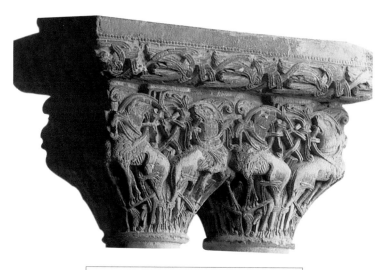

224. Anonymous.
Double Capital, cloister, Santo Domingo Monastery,
Silos (Spain), middle of the 12th century.
In situ. Roman.

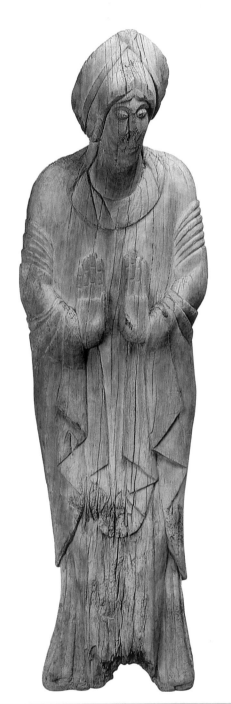

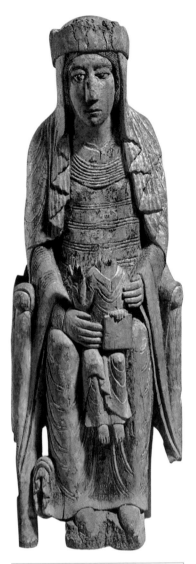

226. Anonymous.
Enthroned Virgin and Child, 1130-1140.
Birch, paint and glass, h: 102.9 cm.
The Cloisters, New York (United States). Roman.

225. Anonymous.
Holy Woman, 1125-1150.
Pear tree wood with traces of paint, h: 133 cm.
Musée national du Moyen Age – Thermes et hôtel de Cluny, Paris (France). Roman.

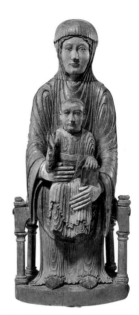

228. **Anonymous.**
Enthroned Virgin and Child, 1150-1200.
Walnut with gesso, paint, tin leaf and traces of linen, h: 68.6 cm.
The Cloisters, New York (United States). Roman.

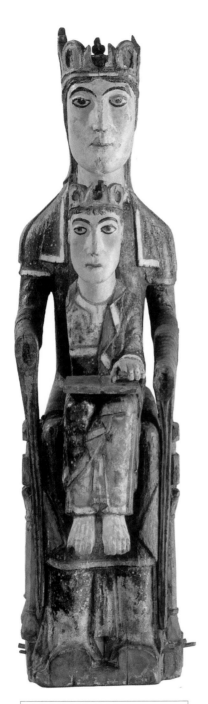

227. **Anonymous.**
Madonna with Child from Rarogne, c. 1150.
Lime wood and paint, h: 90 cm.
Musée national suisse, Zürich (Switzerland). Roman.

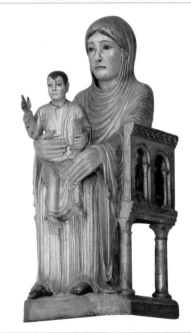

229. **Anonymous.**
Madonna with Child, called *Notre-Dame-la-Brune,*
Saint-Philibert Abbey Church, Tournus (France).
Wood partially gilded and traces of polychromy, h: 73 cm.
In situ. Roman.

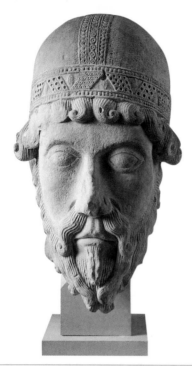

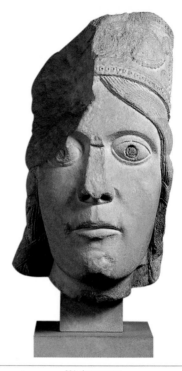

230. Anonymous.
Head of a Prophet, west facade, Saint-Denis Abbey Church, Saint-Denis (France)
c. 1137-1140. Stone, h: 41 cm.
Musée national du Moyen Age – Thermes et hôtel de Cluny, Paris (France). Roman.

231. Anonymous.
Head of an Old Testament Queen (Saba), west facade, Saint-Denis Abbey Church,
Saint-Denis (France), c. 1137-1140. Limestone, h: 36.5 cm.
Musée national du Moyen Age – Thermes et hôtel de Cluny, Paris (France). Roman.

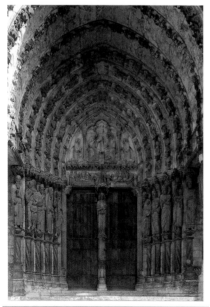

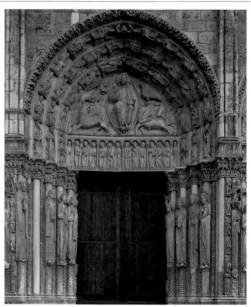

232. Anonymous.
The Coronation of the Virgin, central portal of the northern
transept, Notre-Dame Cathedral, Chartres (France), c. 1145-1155.
In situ. Gothic.

233. Anonymous.
Royal Gate, Notre-Dame Cathedral, Chartres (France),
c. 1145-1155.
In situ. Gothic. (*)

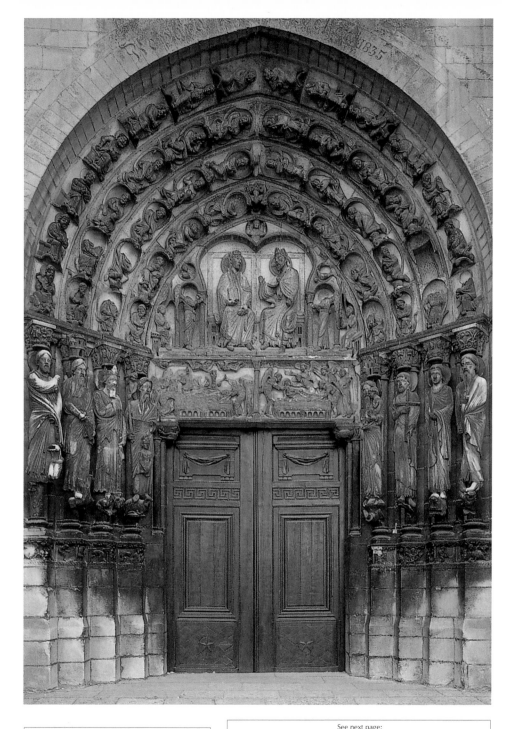

234. **Anonymous.**
Tympanon, Sainte-Anne portal, west facade,
Notre-Dame Cathedral, Paris (France), before 1148.
In situ. Gothic.

See next page:
235. **Anonymous.** *Three Kings and One Queen of the Old Testament*,
jamb figures, right side wall of the west portal called *"Royal Gate"*,
Notre-Dame Cathedral, Chartres (France), c. 1145-1155.
In situ. Gothic. (*)

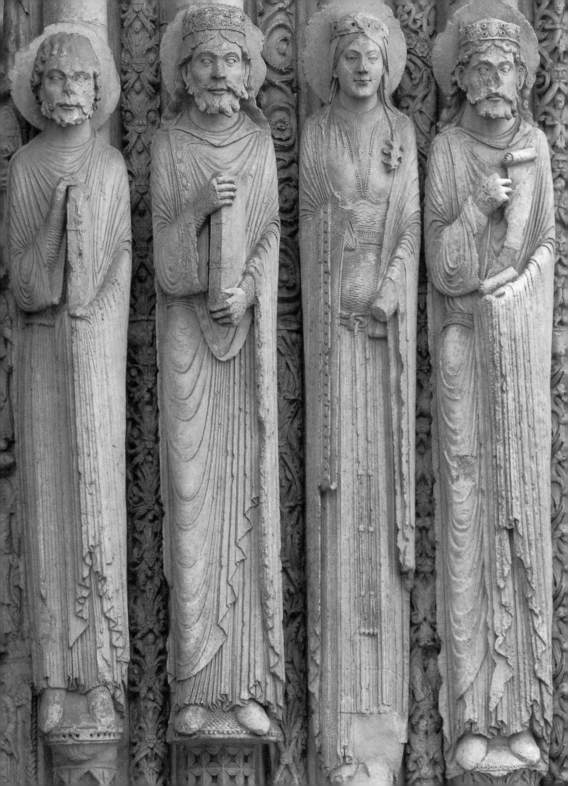

236. Anonymous.
The Descent from the Cross, corner pillar of the cloister, Santo
Domingo Monastery, Silos (Spain), middle of the 12th century.
In situ. Roman.

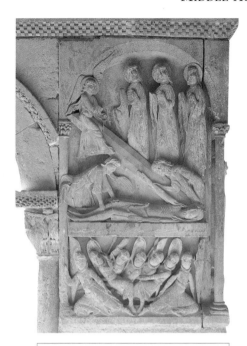

237. Anonymous.
Entombment, corner pillar of the cloister, Santo Domingo
Monastery, Silos (Spain), middle of the 12th century.
In situ. Roman.

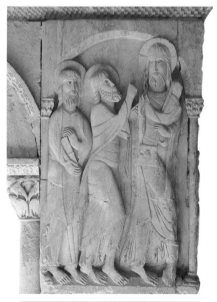

238. Anonymous.
Christ and the Pilgrims of Emmaus, corner pillar of the
cloister, Santo Domingo Monastery, Silos (Spain),
middle of the 12th century.
In situ. Roman.

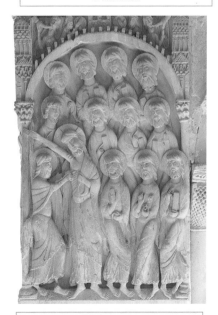

239. Anonymous.
Doubting Thomas, corner pillar of the cloister,
Santo Domingo Monastery,
Silos (Spain), middle of the 12th century.
In situ. Roman.

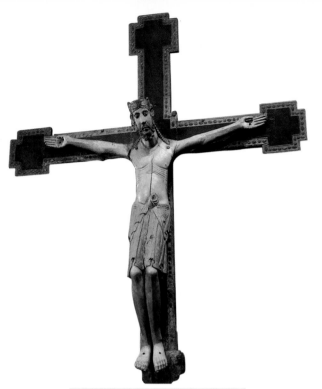

240. **Anonymous.**
Crucifix, c. 1150-1200. Christ: white oak and pine with
polychromy, gilding and applied stones; cross: red pine,
polychromy, 259 x 207.6 cm.
The Cloisters, New York (United States). Gothic.

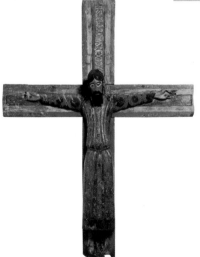

241. **Anonymous.**
Christ in Majesty on the Cross called *Batlló Majesty*, La Garrotxa (Spain),
second half of the 12th century. Woodcarving with polychromy in tempera,
Christ: 94 x 96 x 17 cm; cross: 156 x 120 x 4 cm.
Gift of Enric Batlló, Museo Nacional d'Art de Catalunya, Barcelona (Spain). Roman.

242. **Anonymous.**
Crucifixion, second half of the 12th century.
Wood with traces of paint, h: 181 cm.
Musée national du Moyen Age – Thermes et hôtel de Cluny,
Paris (France). Roman.

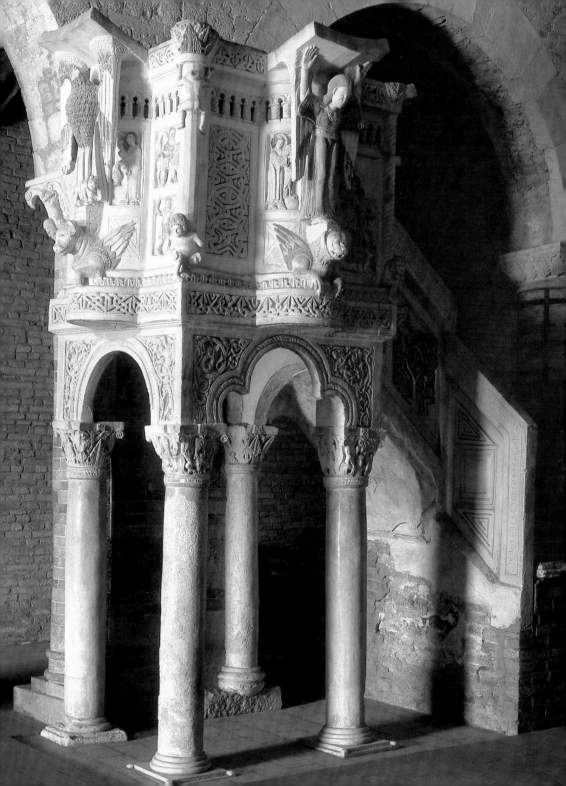

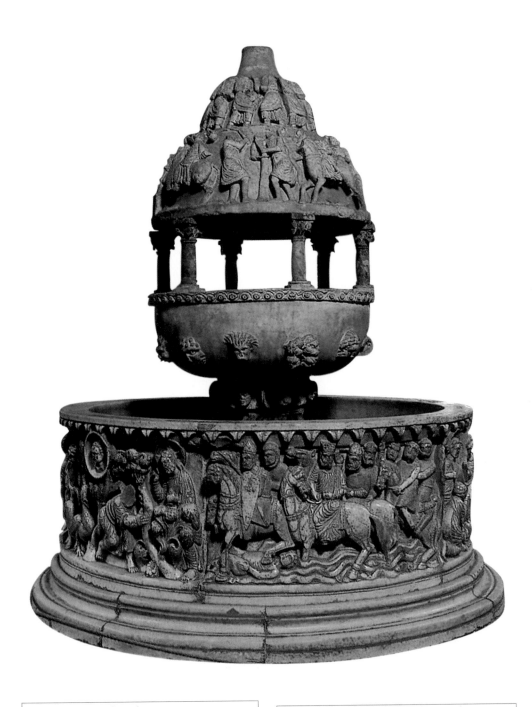

See previous page:
243. **Nicodemus da Guardiagrele**, Italian.
Pulpit, Santa Maria del Lago Abbey Church, Moscufo (Italy), 1159.
Stucco. In situ. Roman. (*)

244. **Master Roberto**, Italian.
Baptismal Font, San Ferdiano Church, Lucca (Italy), c. 1150.
In situ. Roman.

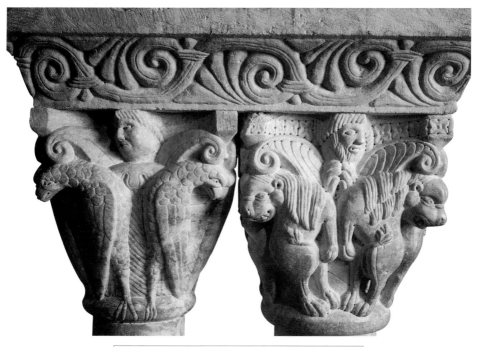

245. Anonymous.
Double Capital, gallery, former priory of Notre-Dame, Serrabone (France),
second half of the 12th century.
In situ. Roman.

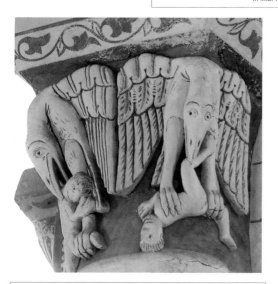

246. Anonymous.
Eagle Taking Away Souls, capital of the ambulatory, former Saint-Pierre Collegiate,
Chauvigny (France), first quarter of the 12th century.
In situ. Roman.

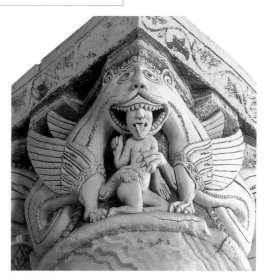

247. Anonymous.
Dragon devouring a Christian, capital, former Saint-Pierre Collegiate,
Chauvigny (France), first quarter of the 12th century.
In situ. Roman.

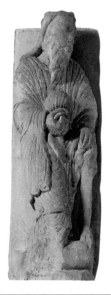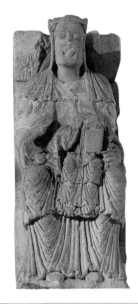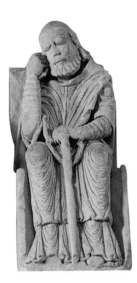

248. **Anonymous.**
The Adoration of the Magi, c. 1175-1200.
Limestone, from left to right: h: 123.8 cm, h: 134 cm, h: 136.5 cm, h: 129.5 cm.
The Cloisters, New York (United States). Gothic.

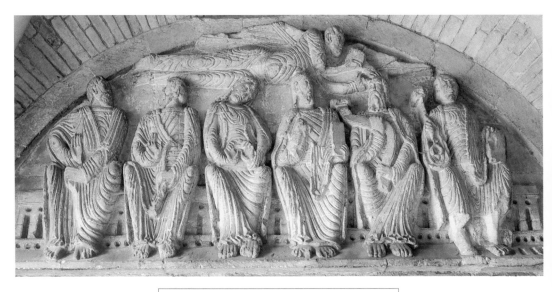

249. **Anonymous.**
Lunette of one of the side walls in the porch of the south-side portal,
St Mary and St Aldhelm Church, Malmesbury (United Kingdom), 1155-1170.
In situ.

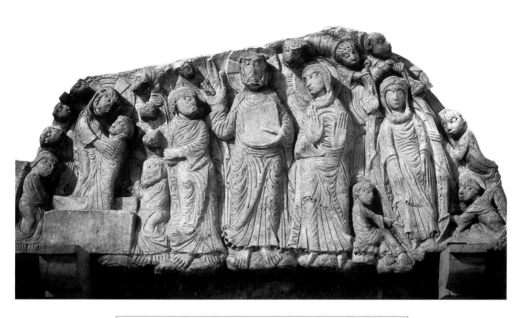

250. **Master of Cabestany**, French.
Ascension and Gift of Mary's Girdle, tympanon, western wall, Notre-Dame-des-Anges Church,
Cabestany (France), second half of the 12th century.
In situ. Roman.

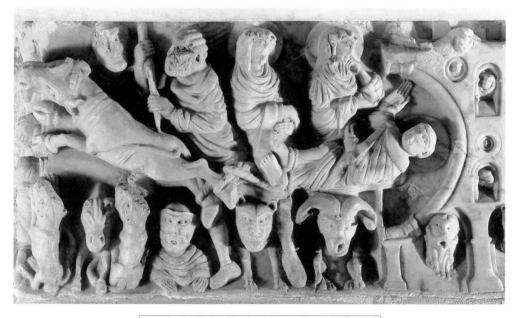

251. **Master of Cabestany**, French.
Death and Martyrdom of St Sernin (detail), second half of the 12th century.
Marble. Ancienne abbaye Sainte-Hilaire, Saint-Hilaire (France).
Roman. (*)

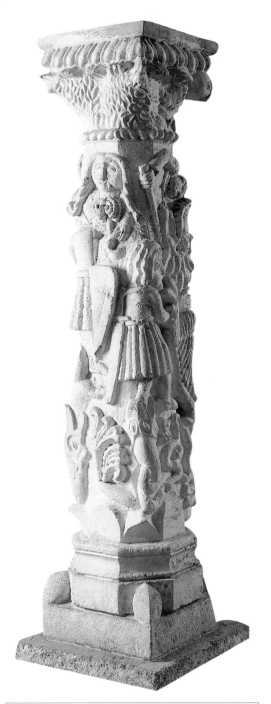

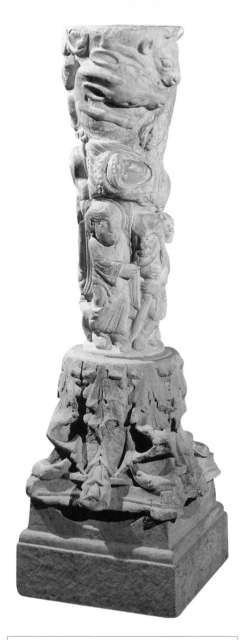

253. **Master of Cabestany**, French.
Scenes from the Birth of Christ, columns of the baptismal font,
second half of the 12th century. Alabaster and limestone, 87 x 58 cm.
Museo di Arte Sacra, Casciano Val di Pesa (Italy). Roman.

252. **Anonymous**.
Beast Column, column of the crypt, St. Maria und St. Korbinian, Freising
(Germany), c. 1200. h: 255 cm.
In situ. Roman.

See next page:
254. **Anonymous**.
Main portal of Sainte-Trophime Church, Arles (France), 12th-15th century.
In situ. Roman.

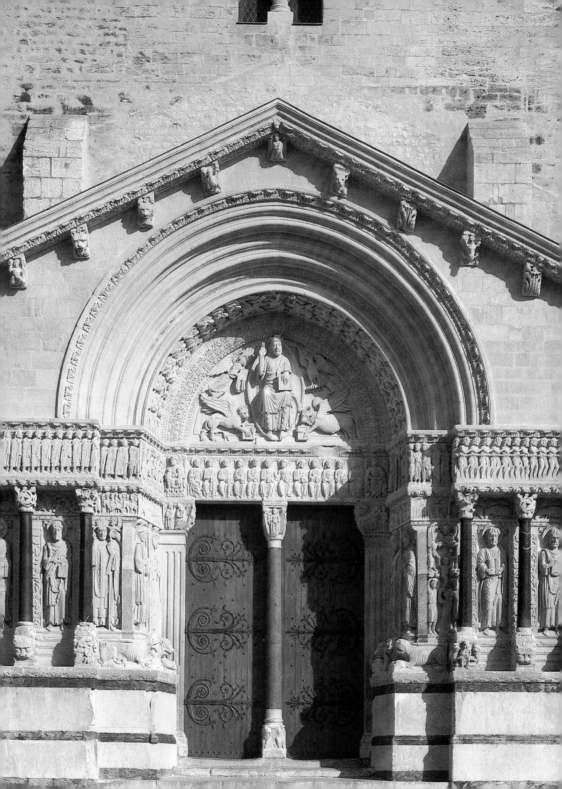

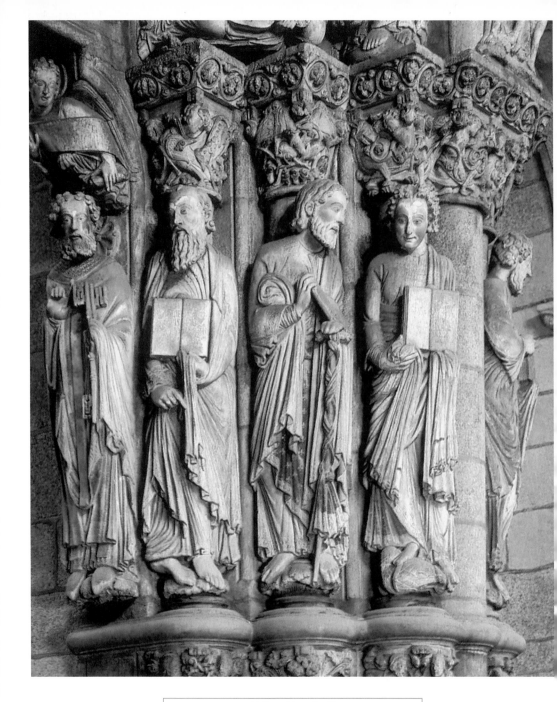

255. **Master Mateo**, Spanish.
The Apostles Peter, Paul, James the Great (Santiago) and John, Portico de la Gloria,
doorpost of the central portal, Santiago de Compostela Cathedral,
Santiago de Compostela (Spain), 1137-1188.
In situ. Roman. (*)

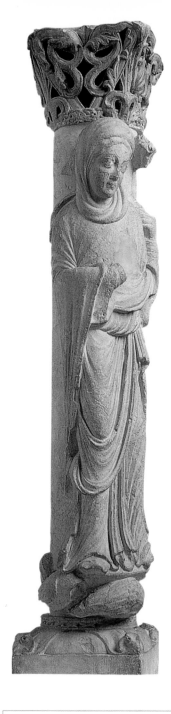

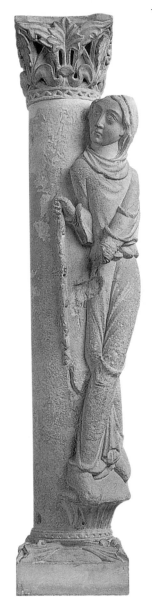

257. Anonymous.
Statue, Châlons-en-Champagne (France), c. 1170-1180. h: 84 cm.
Musée Mayer van den Bergh, Antwerp (Belgium). Gothic.

256. Anonymous.
Statue, Châlons-en-Champagne (France), c. 1170-1180.
h: 82 cm.
Musée Mayer van den Bergh, Antwerp (Belgium). Gothic.

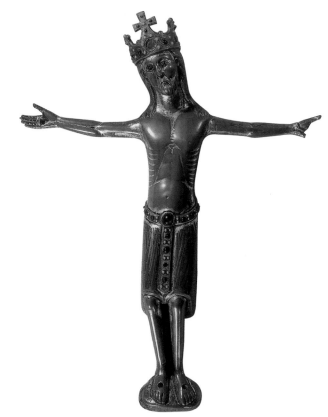

258. **Anonymous**.
Christ the King, Crucified, c. 1210-1220. 39.2 x 32.3 x 4.9 cm.
Musée national du Moyen Age – Thermes et hôtel de Cluny,
Paris (France). Gothic.

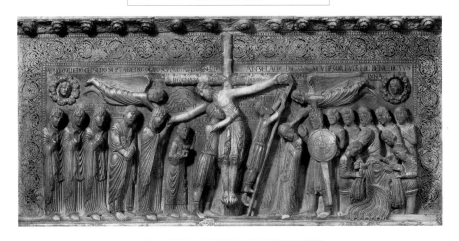

259. **Benedetto Antelami**, 1178-1196, Italian.
Deposition from the Cross, 1178. Marble, 110 x 230 cm.
Cattedrale di Parma, Parma (Italy). Roman. (*)

260. **Anonymous**.
Juggler, third quarter of the 12th century.
Limestone, 60 x 33 x 11 cm.
Musée des Beaux-Arts, Lyon (France). Roman.

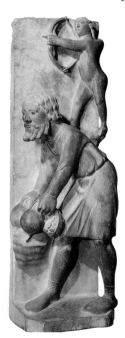

261. **Benedetto Antelami**, 1178-1196, Italian.
The Month of November, c. 1220.
Il Battistero, Parma (Italy). Roman.

262. Alloted to **Master of Samson de Maria Laach**.
Ornemented Chair, c. 1200.
Limestone. Das Bonner Münster, Bonn (Germany). Gothic.

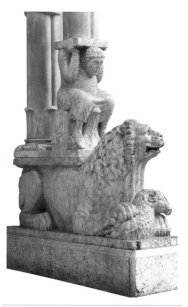

263. **Niccolò**, Italian.
Telamon on a Lion, detail of the baldacchino of the main
portal, San Giorgio Cathedral, Ferrare (Italy). c. 1135.
In situ. Roman.

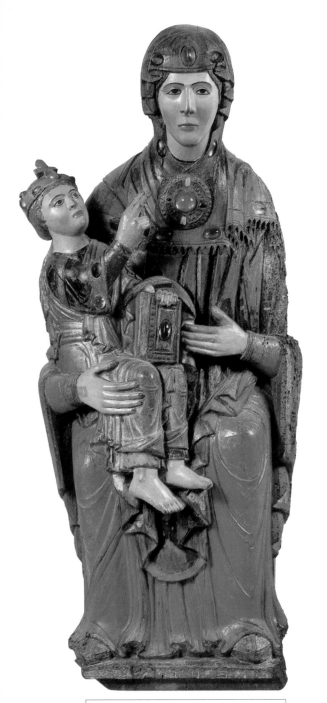

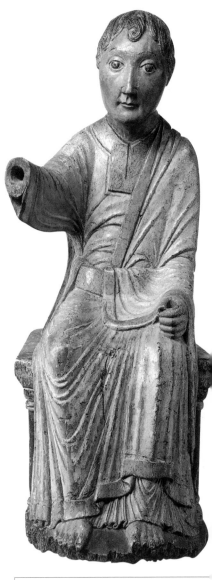

265. **Anonymous.**
Angel (from the decoration of sacred tombs), c. 1180.
Wood, h: 62 cm.
Stiftung Preussischer Kulturbesitz, Berlin (Germany). Roman.

264. **Anonymous.**
Madonna di Acuto, c. 1210.
Polychrome wood with stones, h: 109 cm.
Museo di Palazzo Venezia, Rome (Italy). Roman. (*)

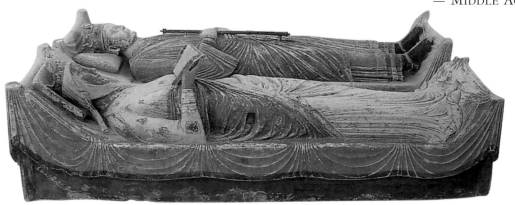

266. Anonymous.
Recumbment Statues of Richard The Lionheart and Alienor from Aquitaine,
beginning of the 12th century.
Ancienne abbaye royale de Fontevraud, Fontevraud-l'Abbaye (France).
In situ. Roman.

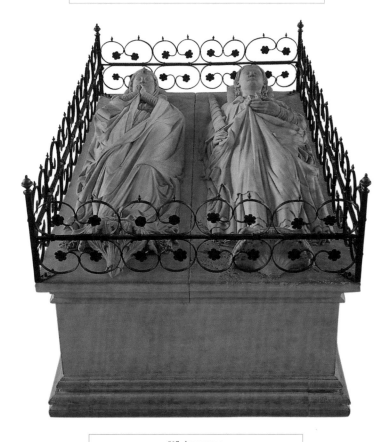

267. Anonymous.
Tomb of Henry the Lion and Mathilda from England, c. 1230-1240.
Dom St. Blasii, Braunschweig (Germany). In situ. Gothic.

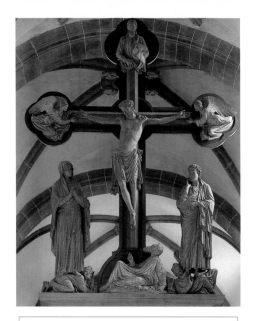

268. **Anonymous.**
Crucifix, c. 1235-1240.
Chorherrenstiftskirche der Augustiner, Wechselburg. In situ. Gothic.

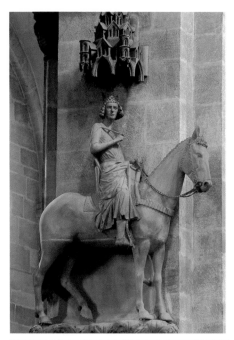

269. **Anonymous.**
King on his Horse called *The Bamberg Rider,*
first pillar on the northen face of the chancel, Notre-Dame Cathedral,
Bamberg (Germany), before 1237. H: 233 cm.
In situ. Gothic. (*)

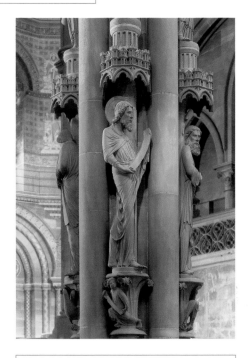

270. **Anonymous.**
The Evangelists, detail of the *"Pillar of the Angel",* Notre-Dame
Cathedral, Strasbourg (France), c. 1225-1230.
In situ. Gothic.

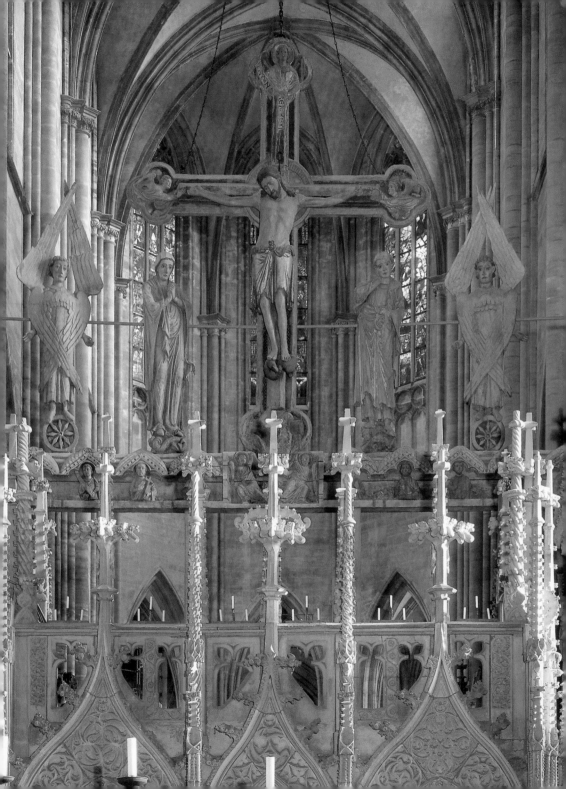

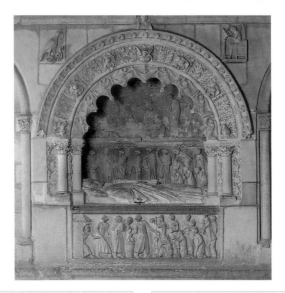

272. **Anonymous.**
Burial of Bishop Martin II Rodriguez, northern side of the transept,
León Cathedral, León (Spain), after 1242.
In situ. Roman.

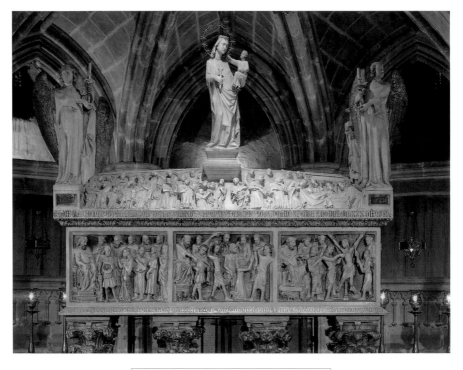

273. **Lupo di Francesco**, Spanish,
Sarcophagus of St Eulalia, crypt, Barcelona Cathedral,
Barcelona, 1327-1339. Marble.
In situ. Gothic.

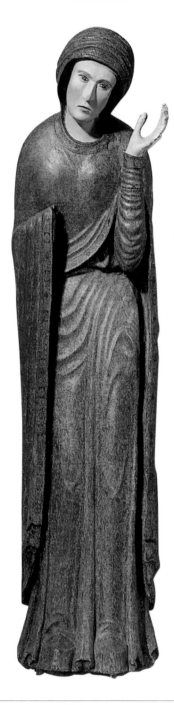

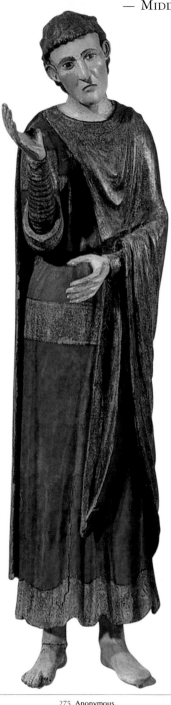

274. **Anonymous.**
Virgin at the Calvary, c. 1220-1230.
Painted wood, h: 170 cm.
Musée national du Moyen Age –
Thermes et hôtel de Cluny, Paris (France). Gothic. (*)

275. **Anonymous.**
St John at the Calvary, c. 1220-1230.
Painted wood, h: 170 cm.
Musée national du Moyen Age –
Thermes et hôtel de Cluny, Paris (France). Gothic. (*)

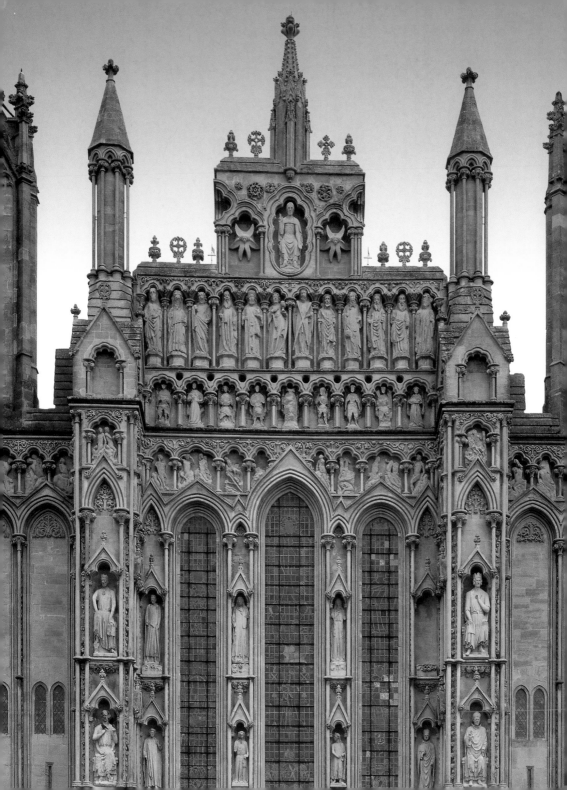

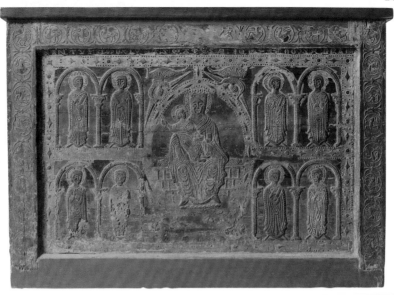

See previous page:
276. **Anonymous.**
Western façade of the Welles Cathedral,
Welles (United Kingdom), c. 1230.
In situ. Gothic.

277. **Anonymous.**
Altar Frontal, c. 1225.
Wood with gesso, canvas, and paint, 95.9 x 147.3 x 7 cm.
The Cloisters, New York (United States). Roman.

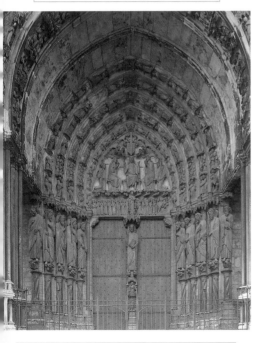

278. **Anonymous.**
The Last Judgment, central portal of the south-side of the transept,
Notre-Dame Cathedral, Chartres (France), c. 1210.
In situ. Gothic.

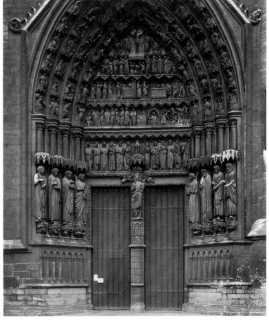

279. **Anonymous.**
Portal of the "Gilded Virgin", south-side of the transept, Notre-Dame
Cathedral, Amiens (France), c. 1240-1245.
In situ. Gothic.

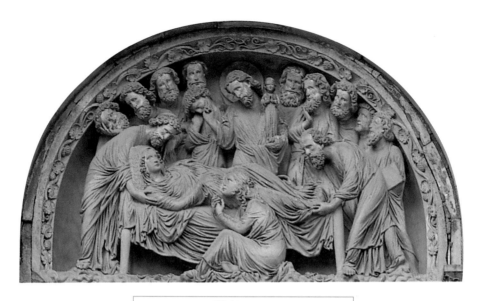

280. **Anonymous.**
Dormition of the Virgin, left tympanon of the double portal,
Notre-Dame Cathedral, Strasbourg (France), c. 1235.
In situ. Gothic.

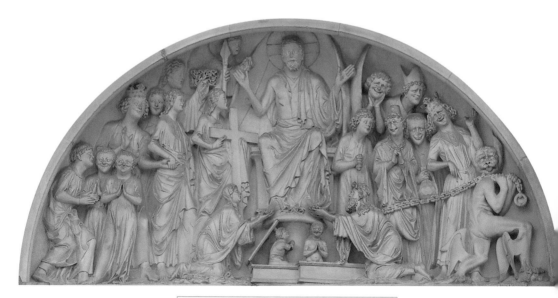

281. **Anonymous.**
The Last Judgment, tympanon of the northern facade portal of the nave,
St. Peter Cathedral, Bamberg (Germany), 1225-1237.
In situ. Gothic.

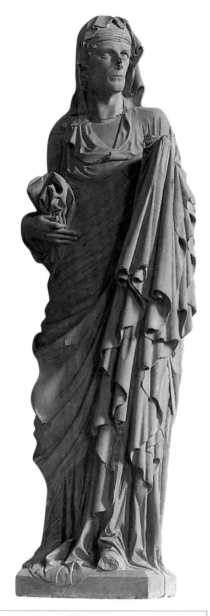

282. **Anonymous.**
Holy Elisabeth, second pillar of northern side of the Saint Georges chancel,
St. Peter Cathedral, Bamberg (Germany), 1225-1237.
In situ. Gothic.

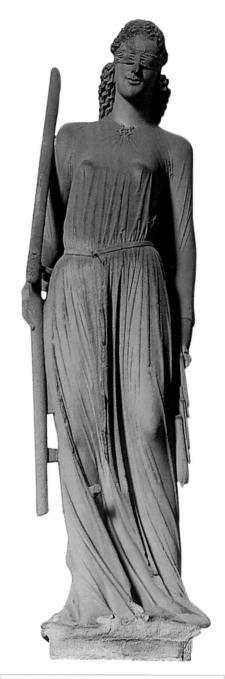

283. **Anonymous.**
Synagoga, second south-side pillar of the Saint Georges chancel,
St. Peter Cathedral, Bamberg (Germany), 1225-1237.
In situ. Gothic. (*)

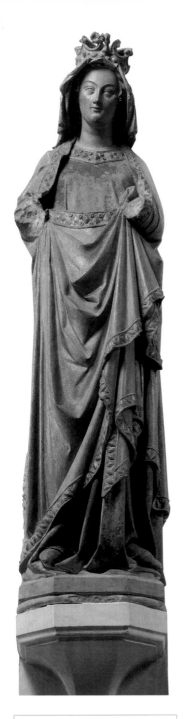

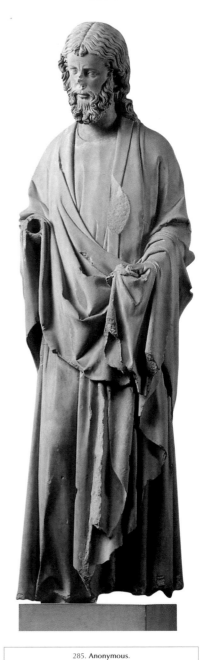

284. **Anonymous.**
Virgin, c. 1250. Sandstone with paint, h: 148.6 cm.
The Cloisters, New York (United States). Gothic.

285. **Anonymous.**
Wistful Apostle, Sainte-Chapelle, Paris (France), 1241-1248.
Stone, h: 165 cm.
Musée national du Moyen Age – Thermes et hôtel de Cluny,
Paris (France). Gothic. (*)

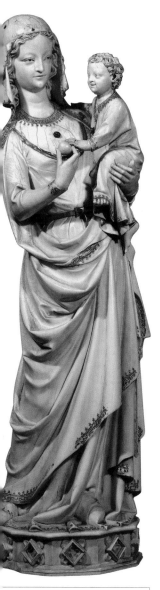

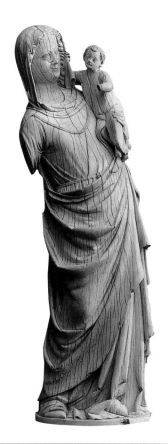

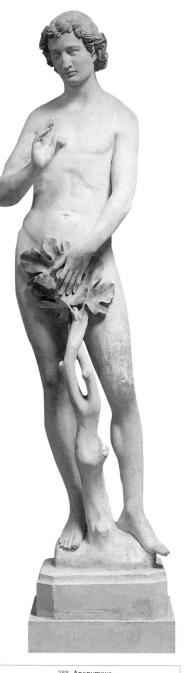

287. **Anonymous.**
Virgin with Child, c. 1250-1260.
Elephant ivory, h: 52 cm.
Musée national du Moyen Age – Thermes et hôtel de
Cluny, Paris (France). Gothic.

286. **Anonymous.**
Madonna and Child, treasury of the Sainte-
Chapelle, Paris (France), c. 1260-1270.
Elephant ivory, traces of gold and paint, h: 41 cm.
Musée du Louvre, Paris (France). Gothic. (*)

288. **Anonymous.**
Adam, south-side of the transept, Notre-Dame Cathedral,
Paris (France), c. 1260.
Polychrome stone, h: 200 cm.
Musée national du Moyen Age – Thermes et hôtel de Cluny,
Paris (France). Gothic. (*)

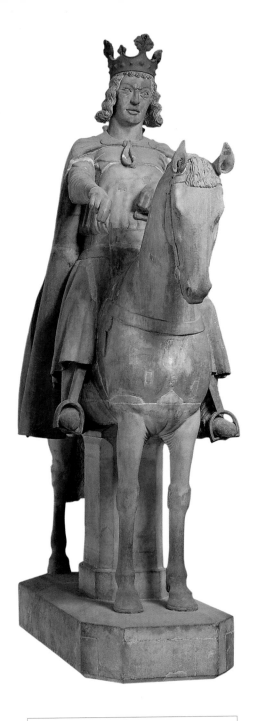

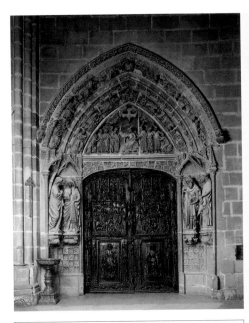

290. **Anonymous.**
Portal of the Cloister, south-side of the transept,
Burgos Cathedral, Burgos (Spain), c. 1270.
In situ. Gothic.

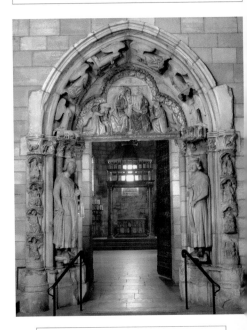

291. **Anonymous.**
Doorway, Moutiers-Saint-Jean (France), c. 1250.
Limestone with traces of polychromy, 469.9 x 383.5 cm.
The Cloisters, New York (United States). Roman.

289. **Anonymous.**
Horseman of the Alter Markt (The Emperor Otto I ?), c. 1245-1250.
Kulturhistorisches Museum, Magdeburg (Germany). Gothic. (*)

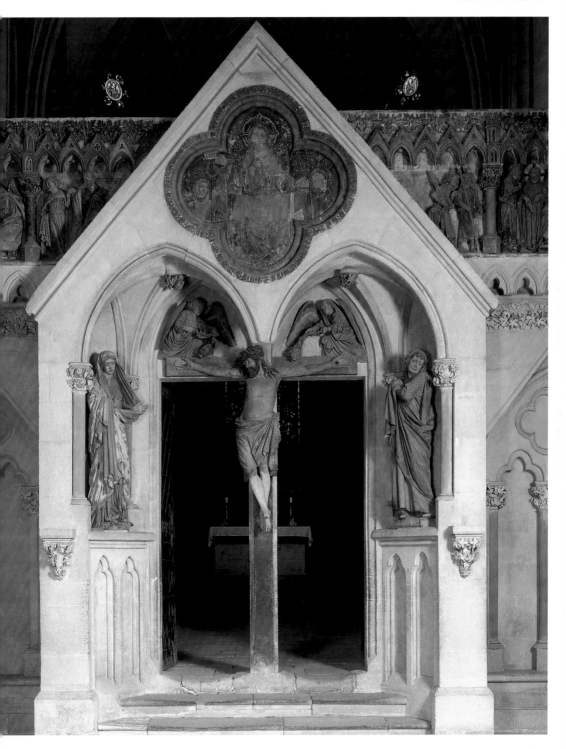

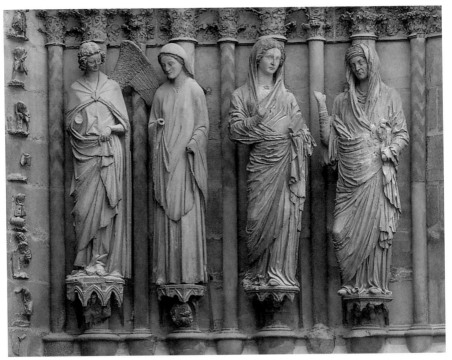

See previous page:
292. **Anonymous.**
Portal of the Western Jube, St. Peter und Paul Cathedral,
Naumburg (Germany), c. 1250.
In situ. Gothic.

293. **Anonymous.**
Annunciation and Visitation, right wall of the central door,
western portal,
Notre-Dame Cathedral, Reims (France), 1252-1275.
In situ. Gothic. (*)

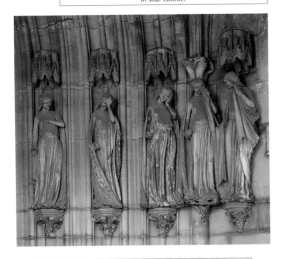

294. **Anonymous.**
The Foolish Virgins, walls of the *"Heaven Portal"*,
St. Mauritius und Katharina Cathedral, Magdeburg (Germany), c. 1245.
In situ. Gothic.

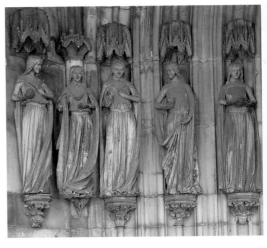

295. **Anonymous.**
The Wise Virgin, wall of the *"Heaven Portal"*,
St. Mauritius und Katharina Cathedral, Magdeburg (Germany), c. 1245.
In situ. Gothic.

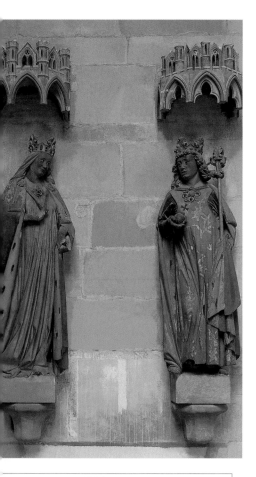

296. Anonymous.
The Emperor Otto I and his Wife Adelaide, northern facade of the chancel,
Meissen Cathedral, Meissen (Germany), c. 1255-1260.
In situ. Gothic.

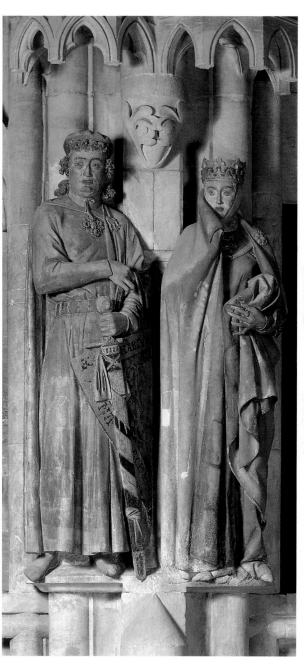

297. Anonymous.
Statues of the Founders Ekkehard and Uta, eastern chancel,
Naumburg Cathedral, Naumburg (Germany), c. 1260-1270.
In situ. Gothic. (*)

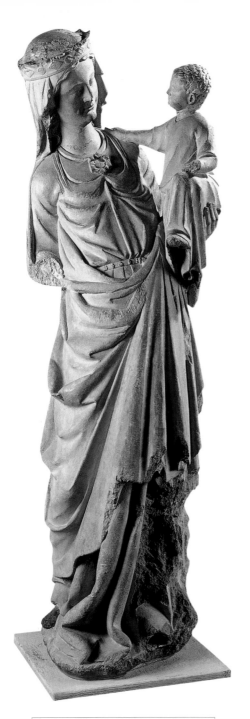

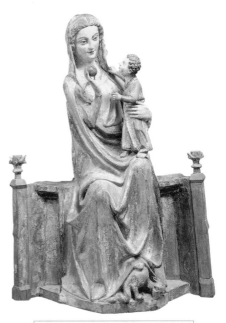

299. **Anonymous.**
Seated Virgin with Child, c. 1270.
Painted wood.
Schnütgen-Museum, Cologne (Germany). Gothic.

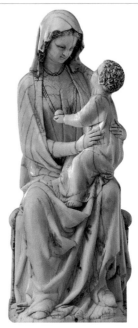

298. **Anonymous.**
Virgin with Child, c. 1270. Stone, h: 150 cm.
Musée municipal Antoine Vivenel,
Compiègne (France). Gothic.

300. **Anonymous.**
Enthroned Virgin and Child, c. 1260-1280.
Elephant ivory with traces of paint and gilding, h: 18.5 cm.
The Cloisters, New York (United States). Gothic.

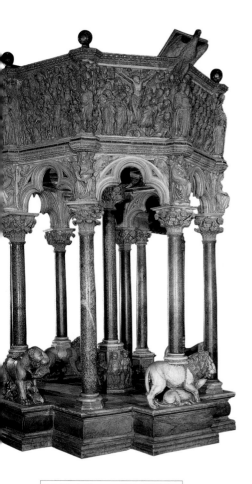

301. **Nicola Pisano**, c. 1206-1278, Italian.
Pulpit, 1265-1268.
Marble, h: 460 cm.
Duomo, Siena (Italy). Gothic.

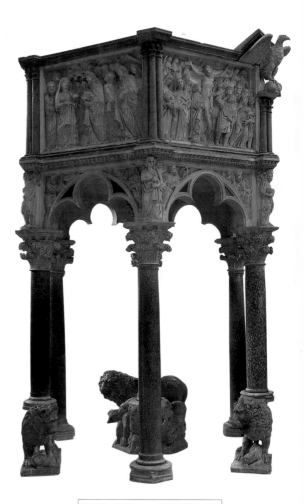

302. **Nicola Pisano**, **c.** 1206-1278, Italian.
Pulpit, 1260.
Marble, h: 465 cm.
Battistero, Pisa (Italy). Gothic. (*)

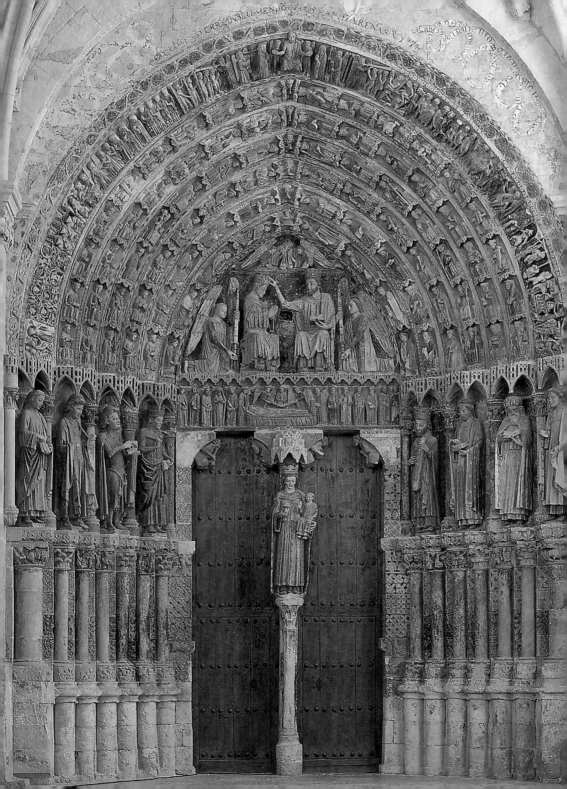

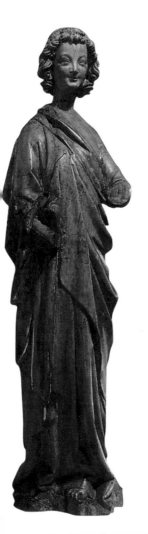

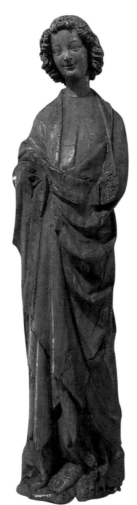

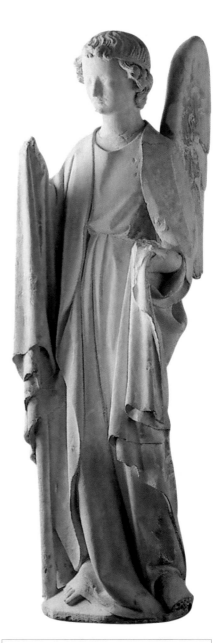

304. **Anonymous.**
Pair of Altar Angels, end of the 13th century.
Oak with traces of polychromy, 75 x 17.8 cm.
The Cloisters, New York (United States). Gothic.

305. **Anonymous.**
Angel, Poissy Collegiate Church, Poissy (France), after 1292.
Stone with traces of polychromy, 103 x 27 x 27 cm.
Musée national du Moyen Age – Thermes et hôtel de Cluny,
Paris (France). Gothic.

See previous page:
303. **Anonymous.**
Majesty Portal, Santa María La Mayor Collegiate,
Toro (Spain), end of the 13th century. Painted stone.
In situ. Gothic.

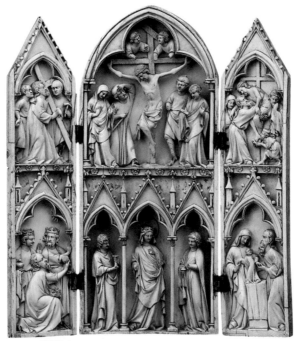

306. **Anonymous.**
Triptych of the Glorious Virgin, c. 1290. Ivory.
Musée national du Moyen Age – Thermes et hôtel de Cluny,
Paris (France). Gothic.

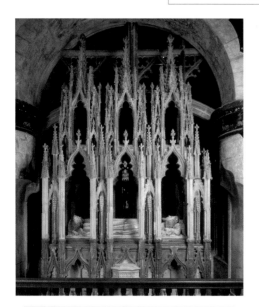

307. **Anonymous.**
Tomb of the King Edward II, c. 1330-1335.
Marble and alabaster.
St Peter and the Holy and Invisible Trinity Cathedral,
Gloucester (United Kingdom). Gothic. (*)

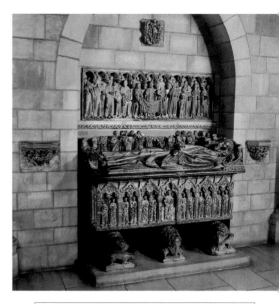

308. **Anonymous.**
Tomb Effigy of Ermengol VII, Santa María de Bellpuiq de las Avellanes
Church, (Spain) 1320-1340.
Limestone and polychromy, 305 x 203 cm.
The Cloisters, New York (United States). Gothic.

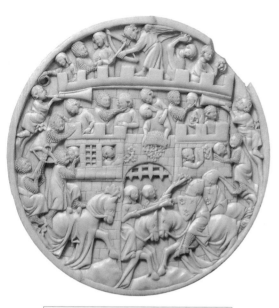

309. **Anonymous**.
The Attack on the Castle of Love, mirror case, c. 1320-1340.
Elephant ivory, diameter: 14.1 cm.
The Cloisters, New York (United States). Gothic.

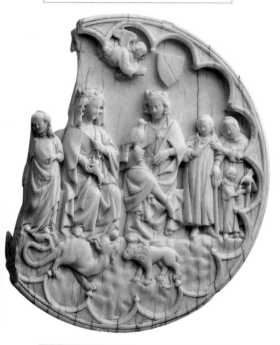

310. **Anonymous**.
The Assembly, mirror case, c. 1300.
Ivory, diameter: 13.8 cm.
Musée national du Moyen Age – Thermes et hôtel de Cluny,
Paris (France). Gothic.

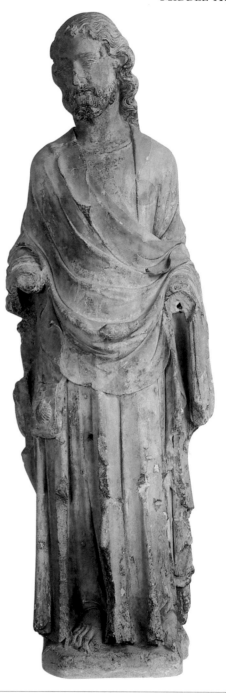

311. **Robert de Lannoy**, died 1356, French.
St James the Great, Saint-Jacques of the Hospital Church, Paris (France),
1326-1327. Stone, 175 x 58 cm.
Musée national du Moyen Age – Thermes et hôtel de Cluny,
Paris (France). Gothic.

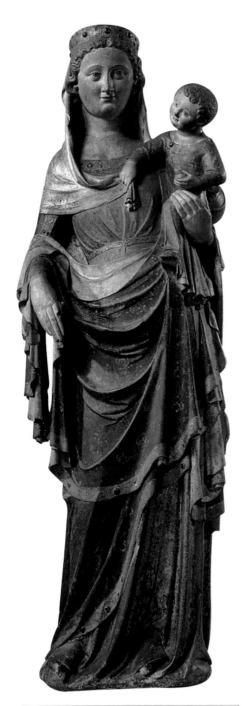

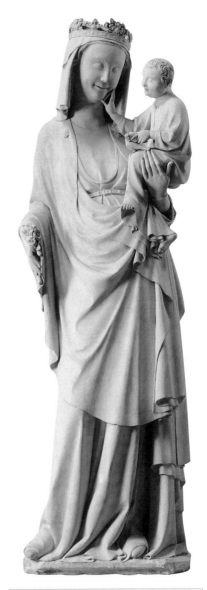

313. **Anonymous.**
Virgin and Child, Blanchelande Abbey Church, first third of
the 14th century. Stone, 175 x 57 x 34 cm.
Musée du Louvre, Paris (France). Gothic.

312. **Anonymous.**
Standing Virgin and Child, 1340-1350.
Limestone, paint, gilding and glass, h: 172.7 cm.
The Cloisters, New York (United States). Gothic.

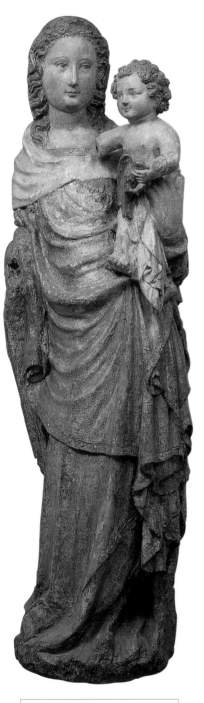

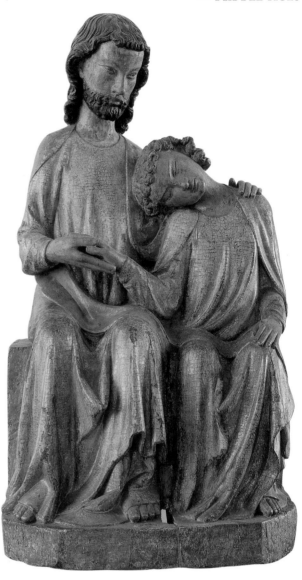

315. **Anonymous.**
Group of Christ and of St John of Sigmaringen, c. 1330.
Polychrome and gilded walnut.
Staatliche Museen zu Berlin, Berlin (Germany). Gothic. (*)

314. **Anonymous.**
Virgin with Child, c. 1370.
Polychrome and gilded walnut. h: 132 cm.
Schnütgen-Museum, Cologne (Germany). Gothic.

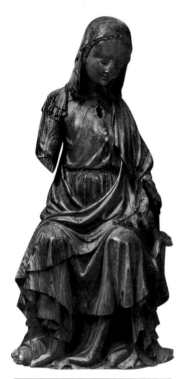

316. Anonymous.
Enthroned Virgin and Child, 1290-1300.
Ivory, 27.3 x 13.5 x 9.6 cm.
The Cloisters, New York (United States). Gothic.

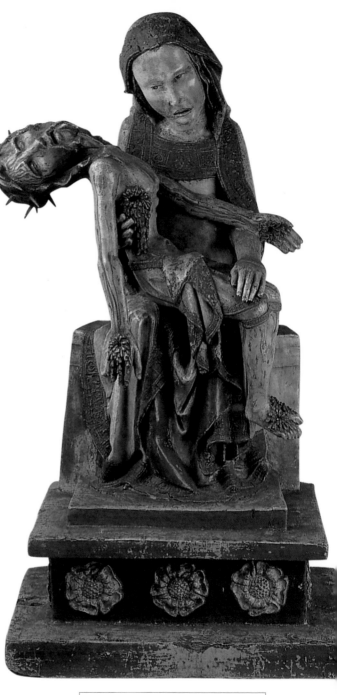

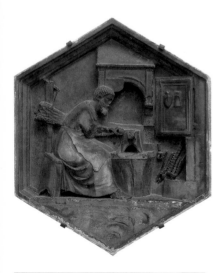

317. **Andrea Pisano** (and **Giotto**), c. 1295-1348, Italian.
Tubal-Cain, the Blacksmith, 1334-1337.
Museo dell'Opera del Duomo, Florence (Italy). Gothic.

318. **Anonymous**.
Röttgen Pietà, c. 1300.
Lime wood and traces of polychromy, h: 88.5 cm.
Rheinisches Landesmuseum, Bonn (Germany). Gothic. (*)

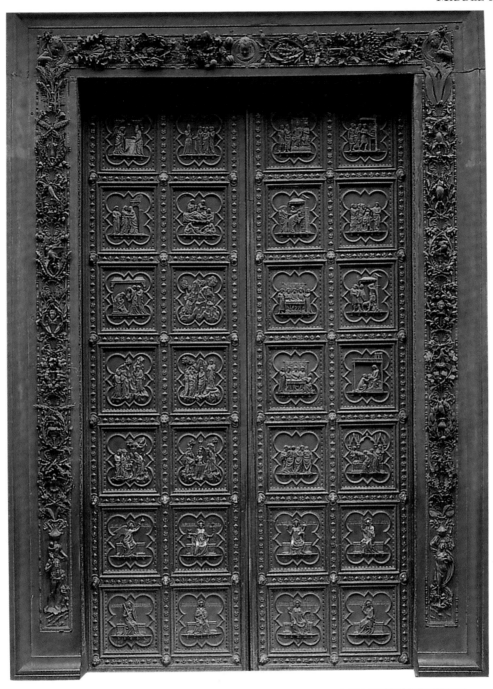

319. **Andrea Pisano**, 1295-1348, Italian.
Door of Southern Portal, Baptistery, Florence (Italy), 1330-1336.
Gilded bronze.
Battistero di San Giovanni, Florence (Italy). In situ. Gothic. (*)

See next page:
320. **Arnolfo di Cambio**, c. 1245-1302, Italian.
Sickman at the Fountain, sculpture fragment. Marble.
Galleria Nazionale dell'Umbria, Perugia (Italy). Gothic.

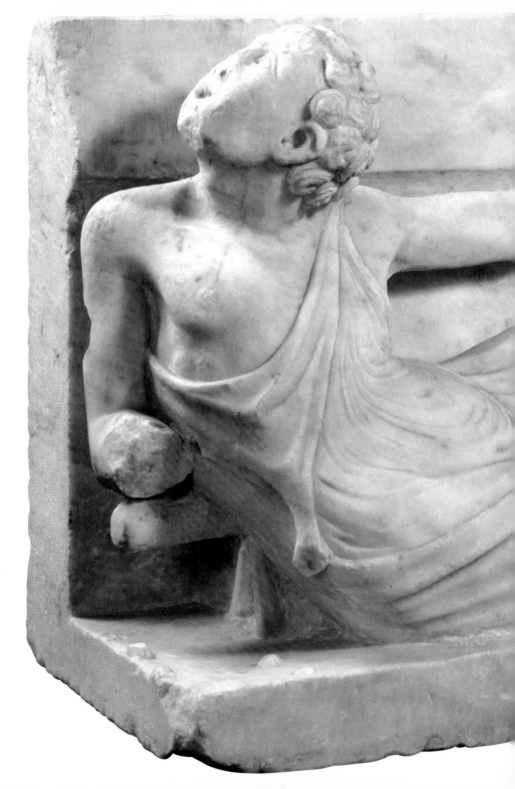

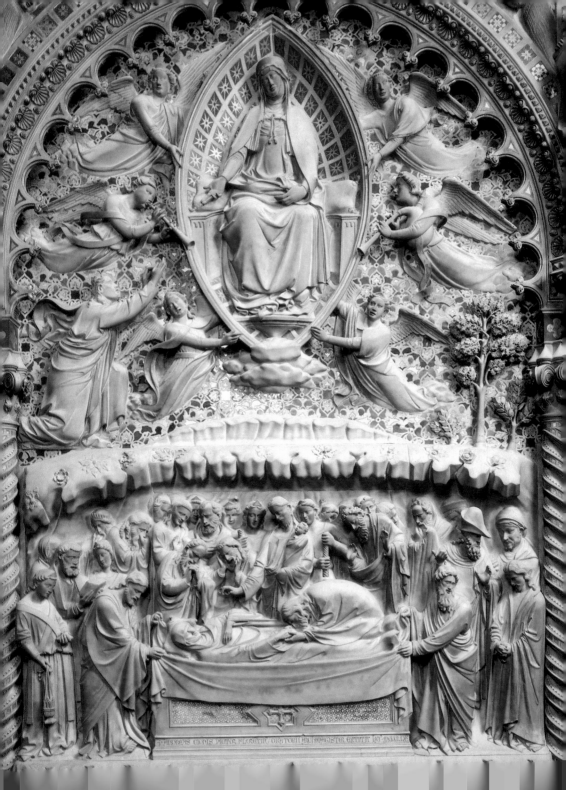

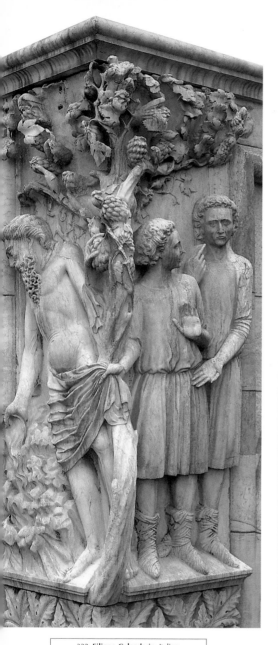

322. **Filippo Calendario**, Italian.
The Drunkenness of Noah, 1340-1355.
Marble.
Palazzo Ducale di Venezia, Venice (Italy). Gothic.

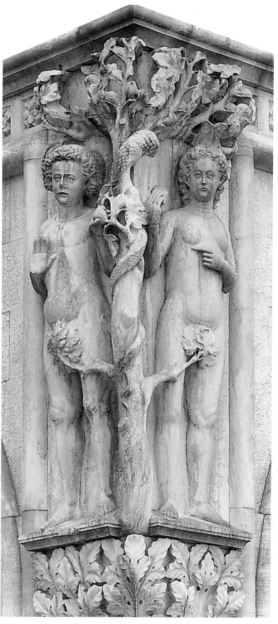

323. **Filippo Calendario**, Italian.
The Original Sin, 1340-1355.
Marble.
Palazzo Ducale di Venezia, Venice (Italy). Gothic.

See previous page:
321. **Andrea di Cione Arcangelo**, called **Orcagna**, c. 1308-1368, Italian.
Dormition and Assumption of the Virgin, detail of the tabernacle of Orsanmichele,
Florence (Italy), 1359. Marble, lapis lazuli, gold and glass inlay.
In situ. Gothic.

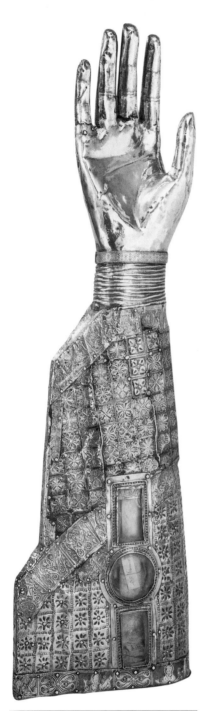

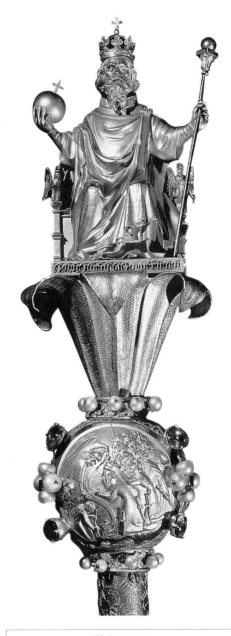

324. **Anonymous.**
Arm Reliquary of St Lawrence, c. 1175.
Cedar wood, silver partially gilted.
Stiftung Preussischer Kulturbesitz, Berlin (Germany). Gothic.

325. **Anonymous.**
Sceptre of King Charles V of France, from the treasure of Saint-Denis
Abbey Church, 1364-1380.
Gold (top), gilded silver (pole), rubis, coloured glass and pearls, h: 53 cm.
Musée du Louvre, Paris (France). Gothic. (*)

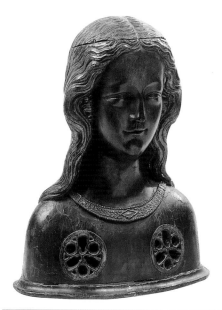

326. **Anonymous**.
Reliquary Head of a Companion of Holy Ursula, c. 1340.
Lime wood and traces of polychromy.
Musée national du Moyen Age – Thermes et hôtel de Cluny,
Paris (France). Gothic.

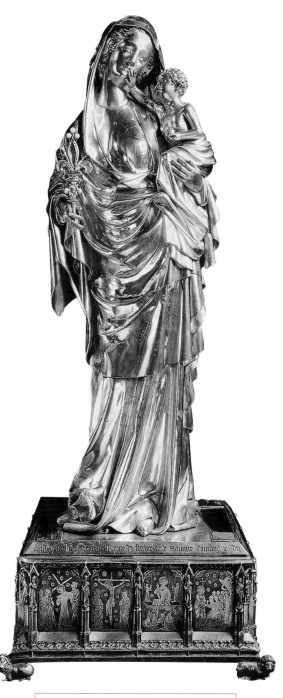

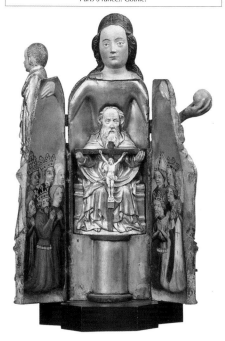

327. **Anonymous**.
Opening Virgin, c. 1400. Polychrome lime wood, h: 20 cm.
Musée national du Moyen Age – Thermes et hôtel de Cluny,
Paris (France). Gothic.

328. **Anonymous**.
Virgin with Child called *Virgin of Jeanne d'Evreux*, 1324-1339.
Gilded silver, enamel, gold, stones and pearls, h: 68 cm.
Musée du Louvre, Paris (France). Gothic.

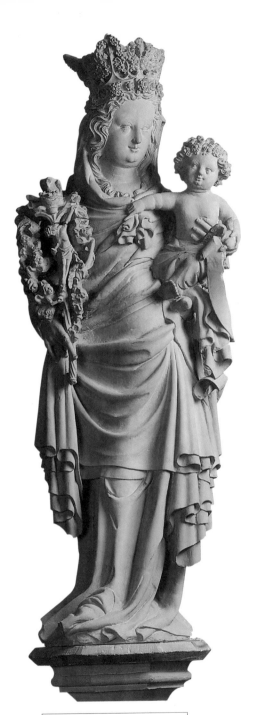

330. **Heinrich IV Parler** (?), German.
Bust of Parler, console. c. 1390.
Polychrome limestone, h: 46 cm.
Schnütgen-Museum, Cologne (Germany). Gothic.

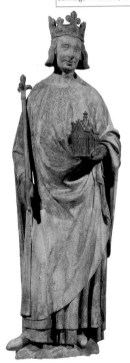
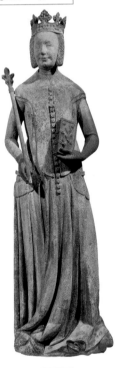

329. **Anonymous.**
Virgin with Child, c. 1390.
Red sandstone, plaster additions, h: 151 cm.
Karmeliterkirche, Mainz (Germany). Gothic.

331. **Anonymous.**
Charles V and Jeanne of Bourbon, 1365-1380.
Stone, 194 x 50 x 44 cm and 195 x 71 x 40 cm.
Musée du Louvre, Paris (France). Gothic.

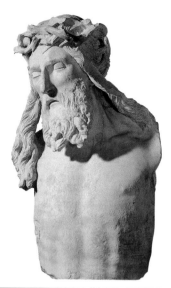

332. **Claus Sluter**, c. 1350 – c. 1406, Flemish.
Bust of Christ Crucified, from the Chartreuse of Champmol,
Dijon (France) 1399. Limestone, h: 61 cm.
Musée archéologique, Dijon (France). Gothic.

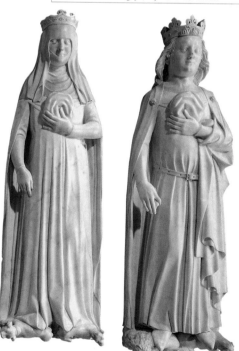

333. **Jean de Liege**, 1361-1381, Flemish.
Recumbment Statues of Charles IV, the Fair, and Jeanne d'Evreux,
second half of the 13th century. Marble, 135 x 36 x 16 cm.
Musée du Louvre, Paris (France). Gothic. (*)

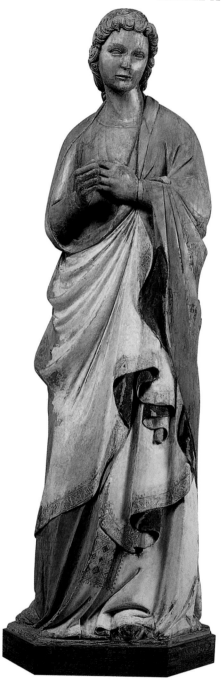

334. **Anonymous**. *Angel of the Annunciation*, third quarter of
the 14th century. Polychrome wood, h: 177 cm.
Musée national du Moyen Age – Thermes et hôtel de Cluny,
Paris (France). Gothic.

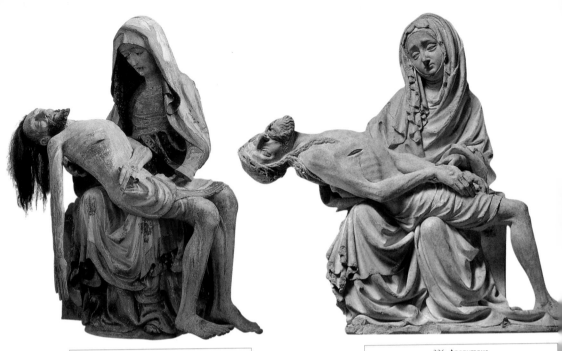

335. **Anonymous.**
Pietà, beginning of the 15th century.
Polychrome wood,
Dom St. Marien, Freiberg (Germany). Gothic.

336. **Anonymous.**
Pietà, c. 1400.
Limestone, 38.1 x 39.1 x 14 cm.
The Cloisters, New York (United States). Gothic.

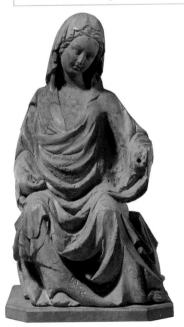

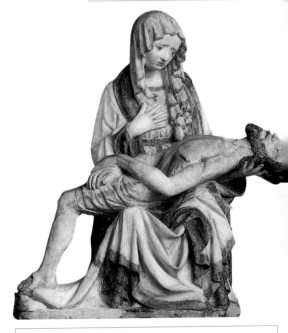

337. **Anonymous.**
Enthroned Virgin, late 14th century. Terracotta, 44.8 x 25.4 x 24.1 cm.
The Cloisters, New York (United States). Gothic.

338. **Anonymous.**
Virgin of Mercy, c. 1400. Polychrome limestone, 39 x 28 x 20 cm.
Musée national du Moyen Age – Thermes et hôtel de Cluny, Paris (France). Gothic.

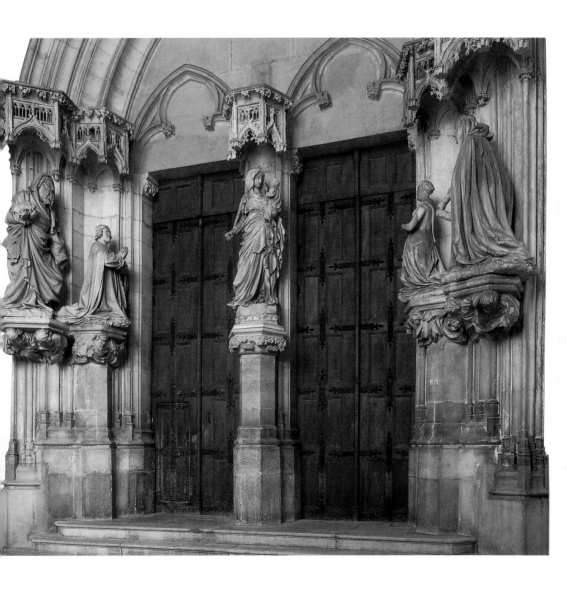

339. **Claus Sluter**, 1350-1406, Flemish.
Portal of Chapel, Chartreuse of Champmol, Dijon (France), 1389-1394.
In situ. Gothic. (*)

MASTERWORKS COMMENTED

182. Anonymous, *Equestrian Statuette: Charlemagne or Charles the Bold.*

A rare example of the art of Carolingian bronze makers, this statue represents a sovereign, Charlemagne, on horseback. Inspired by Antique equestrian statues, it undoubtedly finds its inspiration in works such as the statue of Marcus Aurelius in Rome, in which Carolingian artists saw the Emperor Constantine crushing paganism. This error of attribution would explain the parallel between the two works: Charlemagne, as the emperor of the West (800-814) had to protect and spread the word of the Roman Catholic religion.

This very beautiful example was rediscovered in 1807 by Alexandre Lenoir, creator of the Museum of French Monuments, in the inventory of the cathedral of Metz. It was kept for a long time in his personal collection, then passed into the collection of the City of Paris before becoming part of the Louvre museum's collection.

Cast in three parts (horse, body on the saddle, and head), this group, whose furnishings, globe and sword, have partly disappeared, presented the Charlemagne as a conqueror, a "new Caesar".

188. Anonymous, *Plaque with the Journey to Emmaus and the Noli Me Tangere.*

This small plaque is currently in the Metropolitan Museum of Art in New York. It is of Spanish origin, but its original context is not known. It is assumed to be part of a series of images showing the life of Christ. The two scenes show Christ after his resurrection. At the top he appears to two disciples, who do not recognise him. The men are in the middle of a journey. Their conversation and movement as they walk are conveyed through the gestures of the figures. In the lower scene, Mary Magdalene recognises Christ. He tells her not to touch him, or "Noli me tangere". His broad gestures indicate this, and also indicate his other command, that she pass along the news of his resurrection to the disciples.

192. Anonymous, *Samson and the Lion.*

With the Romanesque sculpture of the eleventh and twelfth centuries there was a revival of stone carving after centuries of dormancy in that art form. Undoubtedly inspired by the fragmentary remains of Roman art still standing in Western Europe, artists of the Romanesque period expressed themselves with a new vivaciousness and spirit. Most of this energy was focused on the architectural details of churches and cloisters, such as the capitals of columns, like the one shown here. Each capital bore a different image, such as a story from the Bible or a mythical creature or demon. The liveliness and imagination expressed in these sculptures were, perhaps, uplifting to those worshipping in the churches or cloisters they decorated. This example shows Samson, a hero of the Israelites, known for his great strength. One of his feats was to fight and kill a lion. He is shown at the moment of the kill, overpowering the great beast. While the proportions make the piece almost like a caricature, the naturalism of the spiralling plants in the background, and the emotional quality of Samson's facial expression lend an honesty and dignity to the work.

194. Rénier de Huy, *Baptismal Font.*

Few sculptors of the Romanesque period are known by name; one is Rainer de Huy, a bronze worker from Belgium. His *Baptismal Font* is remarkable in that, despite its large scale, it was cast in a single piece, demonstrating the skill of the craftsman. The main register on the basin shows the baptism of Christ. The figure of Christ, standing waist-deep in a stylised pool of water, is flanked by John the Baptist on one side and a pair of angels on the other. Below are twelve oxen, on which the weight of the font appears

to rest. The oxen are a reference to the twelve cast oxen of King Solomon's temple in the Book of Kings, seen by Christians as presaging the twelve Apostles. The figures are in high relief, escaping the bounds of the background. That energy is seen especially in the oxen, whose poses and individuality add vitality to the piece.

198. Anonymous, *Gold Majesty of St Foy.*

It became customary in the Middle Ages to preserve the relics of a saint. Relics were any physical remains of the saint, usually bones from the body. The relics were usually kept in jewelled boxes called reliquaries. The desire to see, touch, and pray over the relics of a saint contributed to the popularity of the pilgrimage, in which devout Christians would travel great distances to visit relics of saints. This is the reliquary of St Foy, a young girl put to death by the Romans because she refused to worship pagan idols. The relics of that saint, a fragment of her skull, were acquired by the abbey church of Conques in France, and this beautiful reliquary was created to hold them. The saint was said to perform miracles on behalf of those who visited her relics, and the ensuing popularity of the reliquary made it necessary to rebuild the church to accommodate all the visitors, as Conques became an important church on the pilgrimage route.

200. Anonymous, *Madonna with Child.*

During the Romanesque period, sculpture in the round was rare; the Church opposed icons because devotion to them was seen as worship of a graven image, prohibited by the Ten Commandments of the Old Testament. However, pilgrims and other worshippers filled the churches along the pilgrimage route, and to accommodate the crowd, altars and stations were set up within the naves and ambulatories of the churches. These altars often included a reliquary or statue such as this one, which served as the focal point of prayer.

This statue of the Virgin is made of wood and partially covered in silver and gilded silver plating. The repoussé decoration on the throne and the gown of the Virgin reflects the metalwork traditions of earlier period, on decorated objects such as manuscript covers and reliquaries. The architectural motif on the throne is typical of statues of this type and symbolises the church. The Virgin herself forms a throne for Christ; in this embodiment she is known as the "Throne of Wisdom". Christ holds a Bible in one hand while the other is raised in a gesture of benediction.

207. Gislebertus, *The Last Judgment.*

On the tympanum of the portal of Saint-Lazare in Autun, the details of the Last Judgment are played out in vivid details. Christ is shown in the centre, as judge. The weighing of souls is shown to the right of Christ, and the blessed are then separated from the damned. The torture of the damned is shown in terrifying detail. The blessed, in contrast, are helped by angels to reach heaven. Below, a line of souls await their judgment. Anyone passing through this portal would be faced with a vivid reminder of what the fate of the sinner would be.

208. Anonymous, *South-Side Portal.*

Carving the portals of churches in the Romanesque period was part of a general desire to decorate and beautify a building dedicated to God. The motifs were chosen from the Old and New Testaments, a pictorial art, in opposition to the abstract animal interlace found in the Celtic art of the preceding period. Illustrating the portals with personages from the Bible was done to instruct and inspire a largely illiterate population. The portal at Moissac is typical in terms of what is shown: the Theophany, or end of time

Christ is shown in the centre, surrounded by the symbols of the four Evangelists. Lined up around them in three registers are the Twenty-Four Elders who would stand by Christ on Judgment Day. Moissac is unusual, however, for the style of the carving. The figures represent an ecstatic, metaphysical experience. They are supposed to be imbued with the Holy Spirit, and are therefore shown a dynamic state of movement.

210. Gislebertus, *The Annunciation to the Magi.*

This capital from the church of Saint-Lazare in Autun is masterful in how much it conveys through a simple, effective composition. The three kings, or magi, are shown sleeping. They are identified by their number and their crowns. As they sleep, they have a vision of an angel, only the upper part of whom is shown, the rest hidden behind the blanket of the sleeping magi. The angel gestures to the magi, and to the star above them, and we can almost hear his directions to them. The lines marking the folds of the angel's robes, and of the blanket, add dynamism to the composition that evokes the swirling drapery of the Parthenon's metopes (see nos. 60, 61, 62).

213. Anonymous, *Prophet Isaiah.*

The figure of Isaiah from Souillac is in the same dynamic state of ecstasy as the figures on the Moissac portal. The sculpture decorates the door jamb of the abbey church of Sainte Marie. Showing evidence of the influence of Gaulish art in the elongated proportions of the figure, as well as a classicising influence seen in the movement of the drapery around the figure, this sculpture embodies the developed French school of Romanesque art. No longer flat, frontal and schematic like the art of the Late Antique, this figure is all pose and movement.

233. Anonymous, *Royal Gate.*

The central portal of the west facade at Chartres Cathedral demonstrates the changes in sculpture that mark the transition from the Romanesque to the Early Gothic period. While Romanesque sculpted portals featured an intimidating figure of Christ in Majesty, presiding over the Last Judgment (see no. 207), Early Gothic portals showed a gentler Christ. Here, Christ is shown in majesty, but he is a more human figure, with a softer, more rounded body. The composition is simpler, focused on Christ. The symbols of the four Evangelists fill the rest of the space. The result is a simple image that induces contemplation, as opposed to the elaborate narratives and complex renderings of souls in torment seen on the earlier portals.

235. Anonymous, *Three Kings and One Queen of the Old Testament.*

These still, columnar figures are ranged on either side of each of the three doors of the "Royal Gate" of Chartres Cathedral, as if forming a receiving line, welcoming those who enter the sanctuary. While their elongated proportions and stylised drapery tie them to the sculpture of the Romanesque period (see no. 213), their placement is new. The two churches that revolutionised the Gothic style, Saint-Denis and Chartres, both employed sculpted figures on the columns of the door jambs. These figures do not replace the columns, as did the caryatids of the classical world (see no. 71); instead, they are affixed to the front of the column. Each figure is a king or queen of the Old Testament, and together they give the entryway the name "The Royal Portal".

These gentle-looking kings and queens symbolise the base that was the Old Testament, on which Christ and the events of the New Testament would rest.

243. Nicodemus da Guardiagrele, *Pulpit.*

A treasure within a beautiful Romanesque abbey church in Moscufo, Italy, this carved and painted pulpit is the work of the master sculptor, Nicodemus da Guardiagrele. Four columns with elaborately carved capitals support arches, on which rests a pulpit. The pulpit is decorated with the symbols of the four Evangelists in high relief, two in the centre of the two sides. Beside those, in low relief, are various painted panels, with both narrative scenes and interlace imagery recalling illuminated manuscripts. Interlaced patterns also decorate the spandrels of the arches. Much of the original paint is preserved.

251. Anonymous, *Death and Martyrdom of St Sernin* (detail).

St Sernin was the first bishop of Toulouse in the third century. He was arrested and martyred, the events shown on this sarcophagus, a work of the twelfth century. In this detail, St Sernin is shown being tortured to death, dragged through the streets of Toulouse by a raging bull. Two pious women are shown observing St Sernin's death; they are blessed by the saint, and will bury him after his death. The bull is goaded onwards by the torturer, shown on the left with a staff, and by two dogs. St Sernin was killed by the Romans because he would not worship pagan gods; the pagan temple is alluded to here via the architectural element to the right of the saint. The heads that fill the spaces below the scene are pagans, bulls, and demons, referring to the sinfulness of those that martyred the saint.

255. Master Mateo, *The Apostles Peter, Paul, James the Great (Santiago) and John, Portico de la Gloria.*

These figures adorn the portal to the pilgrimage church of Santiago de Compostela. Said to be the burial place of the apostle St James, Santiago de Compostela was the culmination of one of the great pilgrimage routes of the Middle Ages. The "Portico de la Gloria" is one of the few parts of the Romanesque church still visible today; much of the rest of the Cathedral was rebuilt in ensuing periods. The sculpture on this portal was the work of the great master, Mateo. Like the column figures at Chartres (see no. 235), the columns at Santiago de Compostela include Old Testament kings and prophets. Also included are the apostles, appropriately, given the association to St James. The apostles, shown here, are depicted with their attributes. They show a liveliness and naturalism that would have been made more vivid with the addition of paint, now almost entirely faded.

259. Benedetto Antelami, *Deposition from the Cross.*

This marble panel is from the Cathedral of Parma, Italy. It is signed by the sculptor Benedetto Antelami. A poignant portrayal of the descent from the cross, the panel shows Roman soldiers removing Christ's body as two angels sweep in to comfort Mary and Christ's followers. There is a strong classicising style to the relief, seen especially in the gentle folds of drapery on each figure. Antelami's treatment of the drapery reveals the strong influence that the classical sculpture, still visible in Italy, had on his work. Here, the lines of the drapery add a sense of movement to the otherwise still composition. The figures' unnatural proportions, for example their large, clumsy hands and feet, do not detract from the overall impression of the work; instead, they add a humanistic element to the sombre piece.

264. Anonymous, *Madonna di Acuto.*

Made of wood and decorated with paint and semi-precious stones, this image of the Madonna and Child is a devotional object similar to an icon, yet its large size, over a metre high, distinguishes it from other similar works. Her robe is the traditional blue association with the Virgin. Christ is seated, childlike, in her arms. He raises one hand in blessing and holds the Bible in his other hand.

269. Anonymous, *King on his Horse* called *The Bamberg Rider.*

With *The Bamberg Rider*, Gothic art finally fully realises its classical heritage. The achievement of classical sculptors in creating fully three-dimensional, realistic forms that capture the life and movement of their subjects is once again seen in this figure on horseback, the first equestrian statue in Europe since the sixth century. It is nearly free-standing, attached at the back to the pier of the church. The musculature of the horse, the natural folds of the rider's drapery, and the relaxed pose of the rider all recall the equestrian statues of antiquity. However, the ethereal expression on the face of the rider and the stiff, stylised quality of the horse's head are markers of the piece's Gothic milieu, and in particular of the influence of the Gothic sculptural program at Reims in France. The rider, who wears a crown, has not been identified but may represent a medieval German king.

274 & 275. Anonymous, *Virgin at the Calvary* and *St John at the Calvary.*

These large figures were originally part of a group depicting Christ's descent from the Cross. Early Gothic art displayed more pathos than art of the previous period; the sadness of these figures reflects the human tragedy of the event as well as the divine importance. Virtually life-size and brightly painted, the figures, in their original group, would have lent an intimate immediacy to the Biblical story to anyone viewing the sculptures.

283. Anonymous, *Synagoga.*

Bamberg Cathedral is home to an important group of Gothic sculptures, including this figure, a personification of Synagoga. Synagoga and her counterpart, Ecclesia, stand on opposite sides of the tympanum of the north portal of the church. The pair are in keeping with the tradition of showing Old Testament and New Testament figures together in Last Judgment portal groups. Synagoga is shown blindfolded, representing her blindness to the teachings of Christ. She holds the tablets on which the Ten Commandments are written. She represents the church before Christ. Ecclesia, on the other side, represents the Church as saved by Christ. Above the head of Synagoga is an architectural model on a base of Gothic-style pointed arches. The style of the sculpture at Bamberg is related to the famous program at the cathedral of Reims, seen in the gentleness of the figure. The full-bodied, three-dimensional naturalism of the figure demonstrates the stylistic advances of Gothic art over that of the Romanesque period.

285. Anonymous, *Wistful Apostle.*

This apostle was originally part of a group of the twelve apostles at the Sainte Chapelle in Paris, the court chapel of King Louis IX. Together, they were arranged in a line on either side of the chapel's reliquary, said to contain part of the original Crown of Thorns. Presenting the tranquil, humanistic quality of Gothic sculpture, this example is particularly notable for the figure's melancholy expression, relaxed pose, and the gentle folds of drapery that create a pattern of light and shadow across the body of the apostle.

286. Anonymous, *Madonna and Child.*

This ivory figurine of the Virgin and Child has an accessibility and humanity about it that clearly distinguishes it from the earlier Middle Ages (see no. 200). No longer an image of impenetrable divinity, these figures appear very human. Mary and the infant share a gaze and a touch, their loving relationship at once apparent. The figures are carved with delicacy, especially Mary's girlish face and her slender and elegant hands. Her robes have deep folds that draw attention to the shift in her weight as she leans towards the infant Christ. Mary became an important figure of devotion in the Middle Ages in Western Europe. By the Late Gothic period, the focus of the cult had shifted from the resplendent Mary of the Assumption, Queen of Heaven, to a tender, loving, maternal Mary.

288. Anonymous, *Adam.*

This statue of Adam is one of the rare nudes of medieval art. Larger than life-size, this statue originally decorated the exterior of Notre-Dame in Paris. Paired with Eve, it was part of a Last Judgment scene. The nudity of the figure recalls classical prototypes, and the s-shaped pose and sinuous body of Adam owes a particular debt to fourth-century B.C.E. sculptors such as Praxiteles and Lysippos. The soft, unmuscled body, however, does not reflect the classical ideal. Most of the human sculpture of the Middle Ages was clothed in long robes, and a sculptor would have had little opportunity to study the nude. Despite the lack of precedent, however, the sculptor of this piece has captured the human body in detail, showing the anatomy below the surface, especially on the figure's torso.

289. Anonymous, *Horseman of the Alter Markt (The Emperor Otto I ?).*

In a dramatic departure from earlier Gothic art, such as the Bamberg Rider (see no. 269), this equestrian statue is entirely free-standing. Not intended to decorate a church, the statue was conceived of as a distinct, separate work of art, set up in the city's market. Made of stone, it probably depicts King Otto I, the tenth-century Holy Roman Emperor and founder of the Ottonian dynasty. Otto I lived in Magdebourg and was buried in the city's cathedral, and so is closely associated with Magdebourg's history. In the thirteenth century, when the statue was carved, Magdebourg was still an important city and played a key role in regional trade networks. While it is innovative in its conception as a free-standing sculpture, the horseman lacks the grace and artistry of the Bamberg Rider.

293. Anonymous, *Annunciation and Visitation.*

These jamb figures decorate the elaborate, High Gothic west facade of the Cathedral at Reims, France. Unlike the earlier jamb sculptures at Chartres, where the figures appear to replace the columns (see no. 235), the jamb figures at Reims are removed from the columns so that they appear to be free-standing, each on its own small pedestal. The exaggerated folds of drapery are Hellenistic in style, giving the pieces a very classicising look. Also Hellenistic is the portrait-like quality of the faces of the sculptures, each imbued with a distinct personality. The figures relate to each other, appearing to converse and interact, lending liveliness to the Cathedral's entryway.

297. Anonymous, *Statues of the Founders Ekkehard and Uta.*

The traces of paint and gilding that survive on this sculpted pair add to their lifelikeness. Count Ekkehard stands proudly, covered by a long cloak and carrying a sword and shield. Countess Uta gazes off in the same direction as Ekkehard, her expression strong and noble. She gathers her cape against her face as if to ward off the cold. Through the drape of the cape, the bend of her arm is visible. Her crown sparkles on her head. The pair is affixed to pillars in a chapel in the choir of the Naumburg Cathedral. Ekkehard and Uta were patrons of the Cathedral who lived in the eleventh century, long before these images were carved. Nevertheless, the sculptures have a remarkably portrait-like quality, suggesting that the sculptor carved them to resemble actual models.

302. Nicola Pisano, *Pulpit.*

The *Pulpit* of the Baptistery in Pisa was carved by the sculptor Nicola Pisano. The format of the sculpted relief panels recalls the monuments of ancient Rome, such as the panels of victory arches or the *Ara Pacis Augustae.* The five panels tell the story of the life of Christ. The scenes include the early life of Christ: the Annunciation, Nativity, Adoration of the Magi, and the Presentation in the Temple. The Crucifixion and the Last Judgment complete the cycle. The *Pulpit* is also adorned with personifications of virtues, including Fidelity and Fortitude. The concept of the personification is also drawn from classical sculpture. The Evangelists and their symbols are portrayed in the spandrels, along with the Old Testament prophets. In its content, then, the *Pulpit* is similar to earlier examples, such as that at Santa Maria del Lago (see no. 243). The classicising quality of the pulpit is unmatched by its predecessors, however.

307. Anonymous, *Tomb of the King Edward II.*

Edward II was King of England at the beginning of the fourteenth century. A turbulent time in England, the king was first defeated by Scotland's Robert the Bruce, then removed from the throne by his wife and a rival and imprisoned in Gloucester. It is rumoured that he was murdered in prison. Edward's tomb in Gloucester Cathedral includes an effigy of the king within an elaborate Gothic architectural framework. The tomb was commissioned by Edward's son, King Edward III.

315. Anonymous, *Group of Christ and of St John of Sigmaringen.*

In this emotional piece, Christ is shown with St John the Evangelist. The sculpture is of a type that shows Christ comforting St John, who rests his head on Christ's chest. A number of images of this type were created in the Lake Constance region of Germany in the early fourteenth century. The free-standing sculptures were intended for devotional purposes, placed in chapels within churches and especially in Dominican convents. The emotional, contemplative quality of the piece would have made it well-suited for the devotion of the sisters of the convent.

318. Anonymous, *Röttgen Pietà.*

This piece represents the German Gothic style, removed from French influence. While it retains the humanistic, emotional quality seen in other Gothic art, the delicate, elegant, gentle quality of French Gothic art is not seen in this piece. Instead, the sculptor has captured the raw tragedy of the Pietà, showing a Christ that has suffered in his death, and a Madonna who, in turn, suffers for her son. Christ's body is small, thin, and broken. The wound in his side is large and deep, still gushing blood. The Madonna exhibits the realism that characterises Gothic art, but the Christ figure has become expressionist: the skeletal quality of his body emphasising his suffering and death. At this time, people in Europe were suffering from plague and famine, and the sweet, gentle figures of the preceding centuries no longer spoke to them. This image of pain in their Saviour and his mother would have had a much more powerful effect on those who had likely seen members of their own family die.

319. Andrea Pisano, *Door of Southern Portal.*

These doors are at the south entrance to the Baptistery in Florence. When they were created, they were at the east entrance, which faced the Cathedral.

The doors were designed by the sculptor Andrea Pisano, and cast out of bronze. The art of large-scale casting in bronze had been nearly lost since antiquity, making the doors an impressive technological achievement. The decoration on the door is divided into twenty-eight panels. Each panel consists of an image within a quatrefoil framework. The framing of the panels creates a unified overall appearance for the doors. Twenty of the images within the frames are of the life of St John the Baptist. The lowest eight images are personifications of the Virtues.

In 1400, the doors were moved to the south entrance and a competition was held for the design of the new doors for the eastern entrance.

325. Anonymous, *Sceptre of King Charles V of France.*

This elaborate sceptre originated at the Abbey of Saint-Denis, where French coronations were held for centuries. It was part of the treasure of jewels and regalia used for those coronations. It was entrusted to Saint-Denis by Charles V for the coronation of his son, Charles VI, but may have been used in the coronation of Charles V, as well. The pommel of the sceptre is decorated with relief carvings showing the life of Charlemagne. Jewels and pearls are affixed to the pommel. Above is a lily, originally enamelled in white, representing the French monarchy. The lily supports a throne, on which Charlemagne is seated.

He holds a similar sceptre in one hand and a "sovereign's orb" in the other. The sovereign's orb, a globe surmounted by a cross, represents God's dominion over the earth. Together, the sceptre and orb represent the king's dual role as ruler and head of the church.

333. Jean de Liege, *Recumbment Statues of Charles IV, the Fair, and Jeanne d'Evreux.*

This pair of effigy statues comes from the Cistercian abbey church of Maubuisson in France. Queen Jeanne d'Evreux commissioned the pieces before her death. The statues are only about half life-size; their small size is due to the type of tomb they surmount. Called an "entrail tomb," it was designed to hold only the entrails of the king and queen. Each figure is shown holding a small bag that would have contained the entrails.

In parts of France, such as Normandy and Ile-de-France, there was a long-standing custom among aristocratic families, especially the Royal Family, to have multiple tombs for different parts of the body. The body would be eviscerated upon death, and the entrails, or heart, would be destined for one tomb, the bones for another.

339. Claus Sluter, *Portal of Chapel.*

This portal of the Chartreuse of Champmol, Dijon, was commissioned by Philip II the Bold, Duke of Burgundy, ruler of the Netherlands and regent of France at the end of the fourteenth century. The chapel was a mausoleum for the royal family, associated with the Carthusian monastery of Champmol.

The sculptor he chose to decorate the chapel was Claus Sluter, a Netherlandish sculptor. The figures that decorate the portal are Philip II and his wife, on either side of the doors. They are led by their patron saints, St John the Baptist and St Catherine, towards the Virgin and Child, who adorn the central door post.

The figures have all the grace and humanity of High Gothic art, but with a more dramatic quality provided by the movement of the figures and their drapery. Sluter was influenced by classical sculpture and was able to add the vitality found in ancient art to the developed naturalism of the art of the Gothic age.

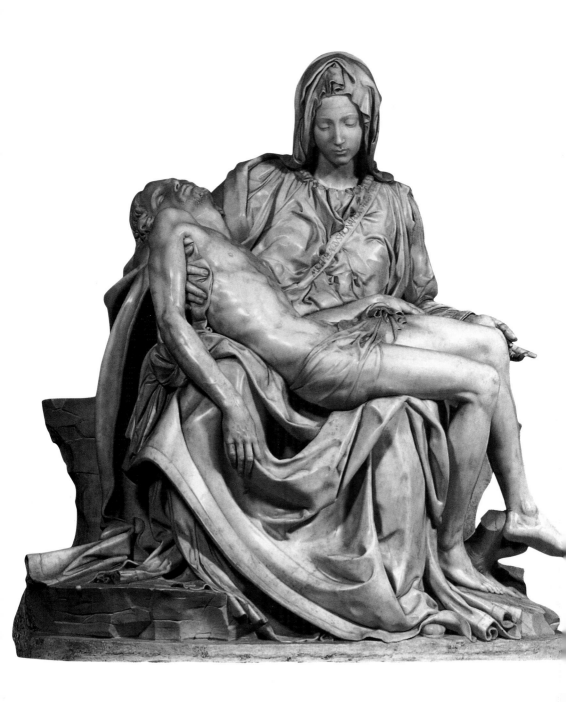

RENAISSANCE

It was not until the fifteenth century that a recognisably Renaissance manner in sculpture first appeared, and it did so in Tuscany. The competition panels for the Florentine baptistery doors, made in 1402, heralded new things to come. Of the seven bronze panels of the *Sacrifice of Isaac*, two have survived, one by Filippo Brunelleschi (see no. 342) and the other by Lorenzo Ghiberti (see no. 343), who was judged the winner. Ghiberti crafted his pieces with some of the delicacy and curving lines of the international Gothic style, but the idealism of the nude figure of the boy Isaac is derived from Greco-Roman Classicism and was calculated to appeal to contemporary humanists. Even more revolutionary was Brunelleschi's panel, with its violent emotions and action, and its realistic renderings based on nature and on classical models, such as the *Spinario* (see no. 124) of Antiquity.

Giorgio Vasari, the sixteenth-century artist and biographer, was enamoured of the works of Donatello, and made him the hero of early Renaissance sculpture. Donatello, relying most heavily on the detailed and realistic model of republican Roman sculpture, breathed life into his figures, and in a sometimes high-pitched emotional style he swept away the elegant traditions of the international Gothic style. Donatello's optical refinements – the creation of sculpture that looked best placed *in situ* but seemed overly rough and inchoate when viewed up close in the studio – represented a departure from the highly finished chasing of medieval sculpture. Few early Renaissance sculptors sought to achieve the vigour and occasional brutality of Donatello's figures. Ghiberti's style

continued to evolve, and his later works are fully Renaissance in manner, with single-point perspective in his reliefs, an increase in the inclusion of classical architecture and figurative models, and a mature style that harked back to the elegance and poignancy of the sculpture of Greece of the fourth century B.C.E., known to him through Roman copies.

Jacopo della Quercia created masterworks in Bologna and Siena; his heavy forms and narrative clarity were to influence Michelangelo a century later. Fifteenth-century Florence continued to produce a great number of outstanding sculptors, who operated substantial workshops and spread their styles through their pupils. The workshops of Luca della Robbia and his son Giovanni della Robbia created a beautifully coloured, glazed terracotta technique that became widely popular in every sense. Their works remain sprinkled around Florence in outdoor sculpture and give a particular character to one's experience of the whole city. Desiderio da Settignano specialised in the rendering of delicate skin and hair and in producing an almost painterly surface to his relief sculpture. His *St John the Baptist* (see no. 375) possesses a delicacy and easy refinement that differ from the vigorous and expressionist sculpture of Donatello. Perhaps the most successful sculptor of the latter part of the *quattrocento* was Andrea del Verrocchio, a versatile master who painted and worked in terracotta, bronze, and marble. Verrocchio's equestrian monument to the military leader Bartolomeo Colleoni in Venice (see no. 387) is unsurpassed for its time in movement, facial expression, and physical presence. His greatest rival

was Antonio Pollaiuolo, trained as a goldsmith and able to render fine details and as well as a strong sense of overall movement. Pollaiuolo was the greatest heir of Donatello in the dry textures and wiry expressionism, features found both in smaller-scale works such as his bronze of *Heracles and Antaeus* (see no. 367), and in his large, compartimentalised tomb of Pope Innocent VIII (Rome, St Peter's).

Northern European sculptors of the fifteenth century retained aspects of the Gothic style, and, as in Italy, the stylistic changes were evolutionary rather than revolutionary. In the case of the German sculptor Tilman Riemenschneider, the jagged lines of drapery and strained facial expressions served effectively the same narrative and emotional ends. With the work of Veit Stoss, an underlying naturalism and more fluid and relaxed draperies indicate a continuation of a less expressive strain of late Gothic art. The Germans continued to favour the use of painted limestone and, in spectacular constructions, large sculptural projects composed of polychromatic wooden figures.

If Donatello was the leader of his generation, Michelangelo Buonarroti was universally recognised as the greatest sculptor of his time. Having first trained as a painter with the competent master Domenico Ghirlandaio, Michelangelo swiftly became the leading sculptor of his generation, under the patronage of the House of Medici. His earliest works, including his relief of the *Battle of the Lapiths and Centaurs*, foretold his lifelong interest in the male nude in vigorous action. Early on, he gave up on the relief format, and concentrated instead on free-standing figures and groups that he "liberated" from the block of marble. Fired by the idea of perfection of neo-platonism, and with formal reliance on the idealism of ancient art, especially the theatrical and exaggerated hellenistic style, he poured out work after work until nearly the

age of ninety. Signing his name *Michelangelo Scultore* (Michelangelo the Sculptor), he long defended the craft as the highest art form and as a window to the divine.

Other sculptors of the time contributed to the excellence of this period in the field of sculpture. Jacopo Sansovino, after a good start in Florence and Rome, dominated the field in Venice, where he even translated into relief sculpture the rough and suggestively painterly finish that characterised contemporary painting in La Serenissima. His works, in a far more classical mode than Michelangelo's, harmonised with the Venetian sensibility for movement and serene beauty.

Adopting the idealism of the high Renaissance style, but in some ways reacting against its essential tenets, were the mannerists, who exaggerated the canons of tradition. Attaining an elegant and polished look in his art, Benvenuto Cellini turned out a variety of works, the most famous being his bronze *Perseus* (see no. 465) for the Piazza della Signora (see no. 465). Giambologna created an art for connoisseurs who knew the rules of tradition and liked to see them broken, and who delighted in variety, gracefulness, and profusion. He developed a type of figural group that could be seen from various points of view, pleasing the connoisseurs who moved around it, as with his *Rape of the Sabine* (see no. 493), which competed for attention in the Piazza della Signora with Cellini's *Perseus* (see no. 465). Giambologna, from the northern city of Bologna, serves an example of the international character of mannerism, as did Adriaen de Vries, a late mannerist who worked in Prague and elsewhere in Europe. The "stylish style" travelled across the continent and was accepted by several artists linked to the "School of Fontainebleau", and the elongations and sophisticated beauty of Mannerism appear memorably in the classicising relief sculpture of the French sculptor Jean Goujon.

See next page:
341. **Anonymous**, French.
Diana with Stag, also called the *"Diana of Anet"*,
c. 1548-1555. Marble, 211 x 258 x 135 cm.
Musée du Louvre, Paris (France). Mannerism. (*)

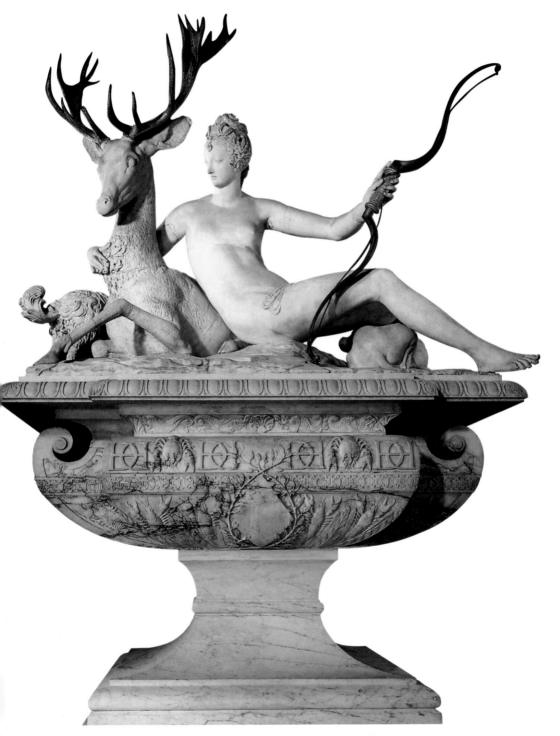

342. **Filippo Brunelleschi**, 1377-1446, Italian.
Sacrifice of Isaac, 1401. Bronze, 47 x 40 cm.
Museo Nazionale del Bargello, Florence (Italy). Early Renaissance. (*)

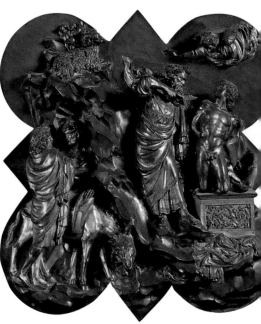

343. **Lorenzo Ghiberti**, 1378-1455, Italian.
Sacrifice of Isaac, 1401-1402. Bronze, 45 x 38 cm.
Museo Nazionale del Bargello, Florence (Italy).
Early Renaissance. (*)

344. **Donatello**, 1386-1466, Italian.
Feast of Herod, baptismal font, c. 1525.
Gilded bronze, 60 x 60 cm.
Battistero, Siena (Italy). In situ. Early Renaissance.

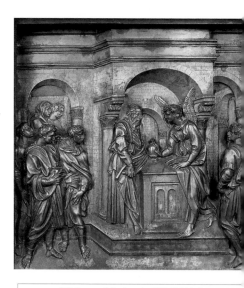

345. **Jacopo della Quercia**, 1371-1438, Italian.
Annunciation of the Birth of John the Baptist to Zachary,
baptismal font, 1428-1430. Gilded bronze, 60 x 60 cm.
Battistero, Siena (Italy). Early Renaissance.

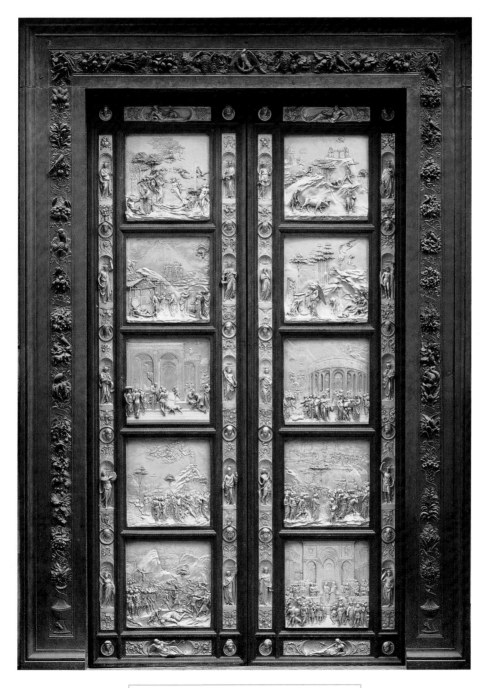

346. **Lorenzo Ghiberti**, 1378-1455, Italian.
The Gates of Paradise, east door, Baptistery, 1425-1452.
Gilded bronze, 506 x 287 cm.
Battistero di San Giovanni, Florence (Italy). In situ. Early Renaissance. (*)

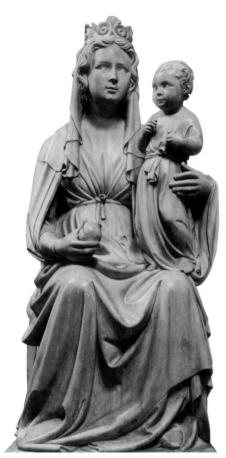

347. **Jacopo della Quercia**, 1371-1438, Italian.
Virgin with The Pomegranate, 1406. Marble.
Museo della Cattedrale, Ferrara (Italy). Early Renaissance.

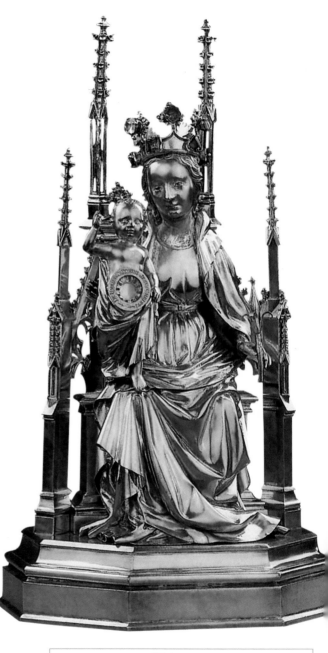

348. **Anonymous.**
Reliquary of Christ's Umbilicus, Paris, 1407.
Gilded silver (modern glass capsule), h: 33.4 cm.
Musée national du Moyen Age – Thermes et hôtel de Cluny, Paris (France). Gothic.

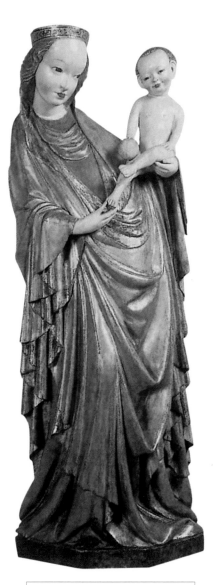

349. **Master of the Krumlov Madonna**, Polish.
Krumlov Madonna, c. 1390-1400.
Stone, h: 112 cm.
Kunsthistorisches Museum, Vienna (Austria). Gothic.

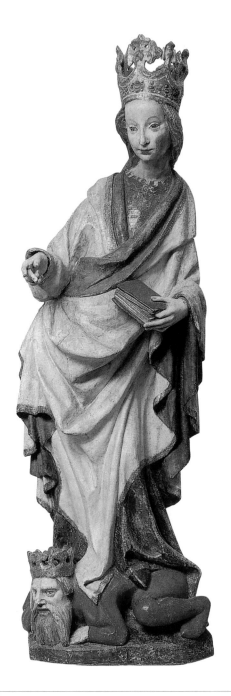

350. **Anonymous**.
St Catherine holding a Book, after 1400. Wood.
Holy Cross Chapel, Karlstejn Castle, Karlstejn (Czech Republic). Gothic. (*)

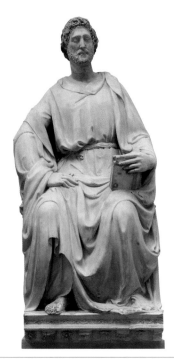

351. **Nanni di Banco**, c. 1375-1421, Italian.
St Luke, 1408-1415. Marble, h: 208 cm.
Museo dell'Opera del Duomo, Florence (Italy).
Early Renaissance.

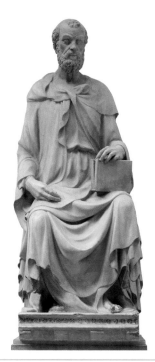

352. **Bernardo Ciuffagni**, 1381-1457, Italian.
St Matthew, 1410-1415. Marble.
Museo dell'Opera del Duomo, Florence (Italy).
Early Renaissance.

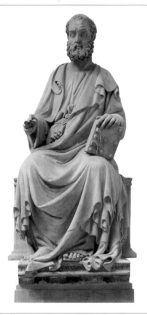

353. **Piero di Niccolò Lamberti**, 1393-1435, Italian.
St Mark, 1410-1412. Marble, h: 240 cm.
Museo dell'Opera del Duomo, Florence (Italy).
Early Renaissance.

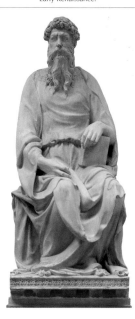

354. **Donatello**, 1386-1466, Italian.
St John the Preacher, c. 1408-1415. Marble, h: 215 cm.
Museo dell'Opera del Duomo, Florence (Italy). Early Renaissance.

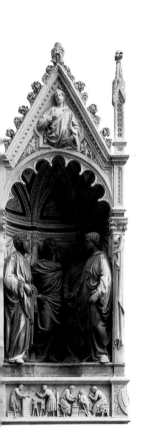

. **Nanni di Banco**, c. 1375-1421, Italian.
anti Quattro Coronati, c. 1408-1413.
Marble, h: 185 cm. Orsanmichele,
rence (Italy). In situ. Early Renaissance.

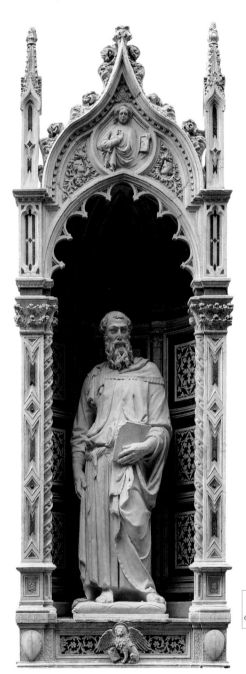

356. **Donatello**, 1386-1466, Italian.
St Mark, 1411. Marble, h: 236 cm.
Orsanmichele, Florence (Italy). In situ. Early Renaissance.

357. **Lorenzo Ghiberti**, 1378-1455, Italian.
St John the Baptist, 1412-1416. Bronze, h: 254 cm.
Orsanmichele, Florence (Italy). In situ. Early Renaissance.

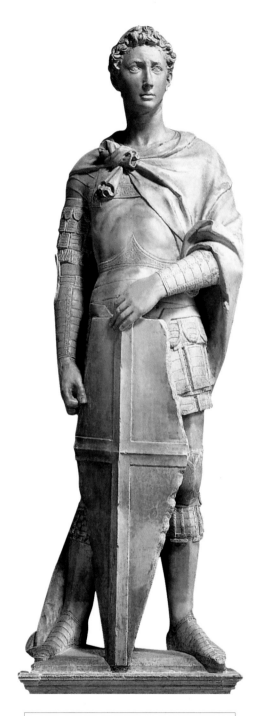

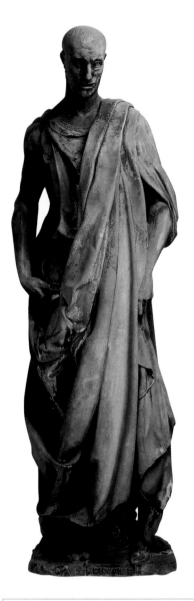

358. **Donatello**, 1386-1466, Italian.
St George, c. 1416-1417. Marble, h: 209 cm.
Museo dell'opera del Duomo, Florence (Italy). Early Renaissance.

359. **Donatello**, 1386-1466, Italian.
Habakkuk (Il Zuccone), 1423-1426. Marble, h: 195 cm.
Museo dell'opera del Duomo, Florence (Italy).
Early Renaissance. (*)

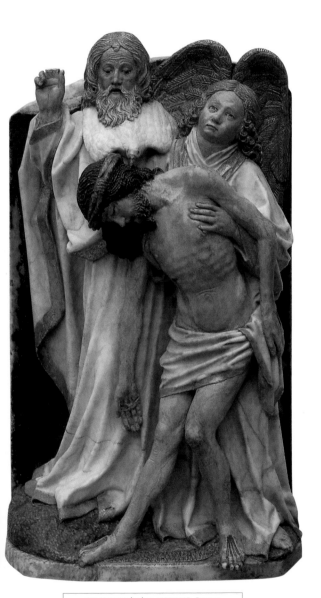

360. **Hans Multscher**, 1400-1467, German.
The Holy Trinity, c. 1400-1467. Alabaster, h: 28.5 cm.
Liebieghaus, Frankfurt am Main (Germany).
Northern Renaissance.

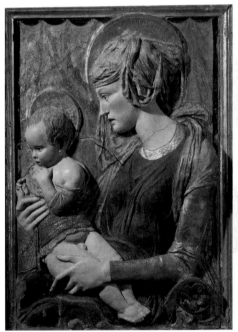

361. **Donatello**, 1386-1466, Italian.
Virgin and Child, 1440. Painted terracotta, 102 x 74 cm.
Musée du Louvre, Paris (France). Early Renaissance.

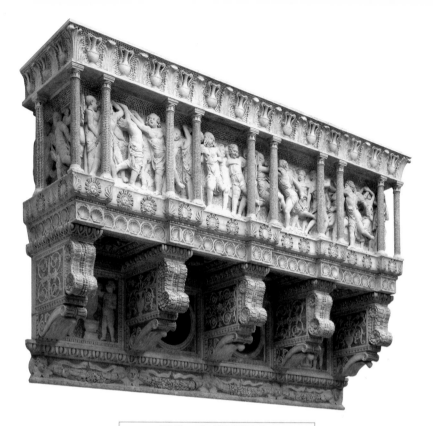

362. **Donatello**, 1386-1466, Italian.
Cantoria, 1439. Marble and mosaic, 348 x 570 cm.
Museo dell'Opera del Duomo, Florence (Italy).
Early Renaissance. (*)

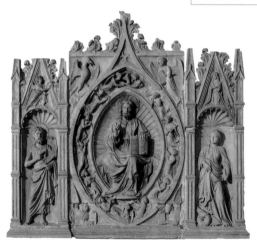

363. **Andrea de Giona**, active mid-15th century, Italian.
Retable with Christ, St John the Baptist and St Margaret, 1434.
Marble, 182.9 x 203.2 x 12.7 cm.
The Cloisters, New York (United States). Early Renaissance.

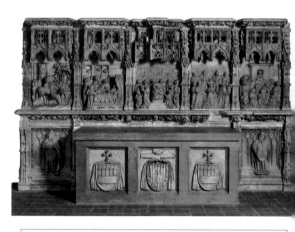

364. **Francí Gomar**, active 1443 – c. 1493, Spanish.
Altar Predella and Socle of Archbishop Don Dalmau de Mur y Cervelló, c. 1456-1458.
Alabaster with traces of paint and gilding, 271.8 x 464.8 x 66.7 cm.
The Cloisters, New York (United States). Early Renaissance.

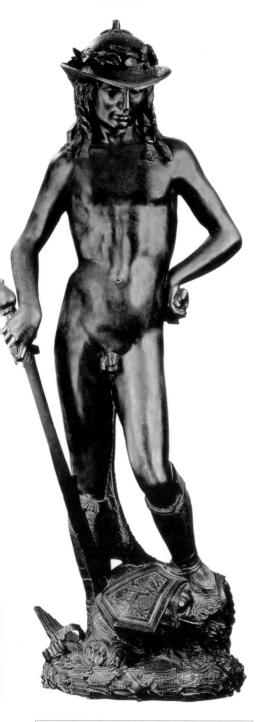

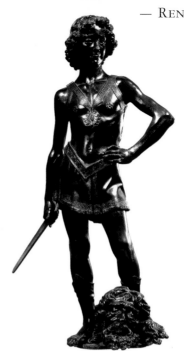

366. **Andrea del Verrocchio**, c. 1436-1488. Italian.
David, c. 1475. Bronze, h: 126 cm.
Museo Nazionale del Bargello, Florence (Italy).
Early Renaissance.

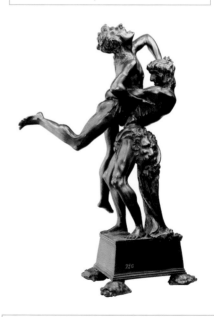

365. **Donatello**, 1386-1466, Italian.
David, c. 1440-1443. Bronze, h: 158 cm.
Museo Nazionale del Bargello, Florence (Italy). Early Renaissance. (*)

367. Antonio di Jacopo Benci, called **Antonio Pollaiuolo**, 1432-1498, Italian.
Heracles and Antaeus, c. 1470. Bronze, h: 46 cm.
Museo Nazionale del Bargello, Florence (Italy). Early Renaissance. (*)

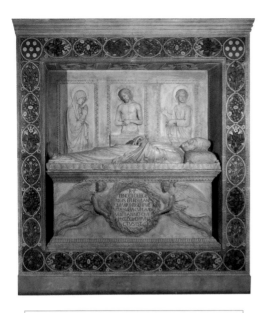

368. **Luca della Robbia**, 1400-1482, Italian.
Tomb of Bishop Benozzo Federighi, 1455-1456. Marble.
Santa Trinità, Florence (Italy). In situ. Early Renaissance.

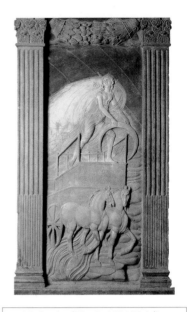

369. **Agostino di Duccio**, 1418-1481, Italian.
The Moon, c. 1450-1457. Marble.
Tempio Malatestiano, Rimini (Italy).
In situ. Early Renaissance. (*)

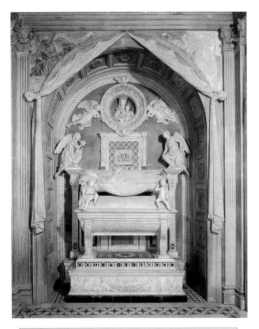

370. **Antonio Rossellino**, 1427-1479, Italian.
Tomb of the Portuguese Cardinal, 1460-1466.
Enamelled terracotta, h: 400 cm.
Cappella del Cardinale del Portogallo, San Minato al Monte,
Florence (Italy). In situ. Early Renaissance.

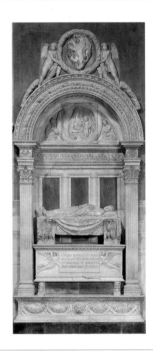

371. **Bernardo Rossellino**, 1409-1464, Italian.
Tomb of Leonardo Bruni, c. 1448-1450.
Marble, partly gilded, h: 715 cm.
Santa Croce, Florence (Italy). Early Renaissance.

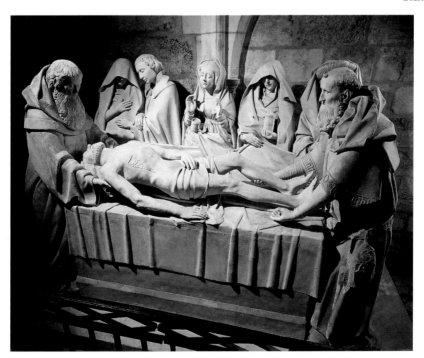

372. **Georges** (and **Michel**) **de La Sonnette**, French.
The Entombment, 1453. Stone from Tonnerre.
Vieil Hôpital Notre-Dame des Fontenilles, Tonnerre (France). Gothic.

See picture below:
373. **Jacques Morel** and **Pierre Antoine Le Moiturier**, French.
Effigies of Charles I of Bourbon and his Wife Agnes, Daughter of John the Fearless, 1453. Stone, Église Saint-Pierre, Souvigny (France). In situ. Gothic.

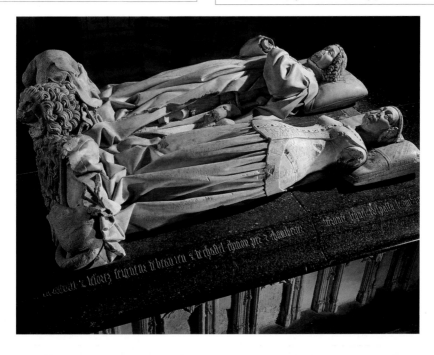

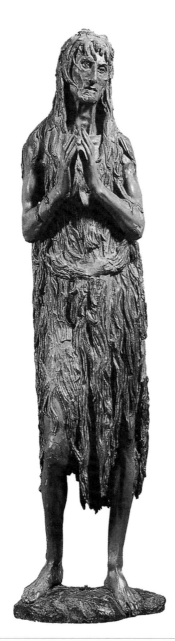

374. **Donatello**, 1386-1466, Italian.
Mary Magdalene, c. 1453-1455. Painted wood with gold, h: 188 cm.
Museo Nazionale del Bargello, Florence (Italy). Early Renaissance. (*)

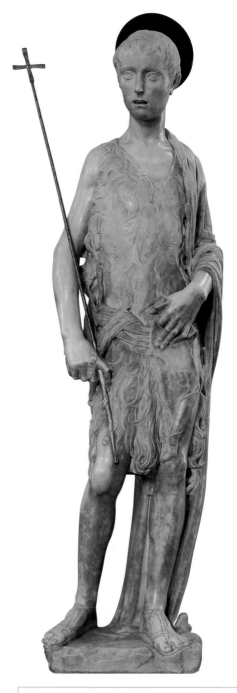

375. **Desiderio da Settignano**, c. 1430-1464 Italian.
St John the Baptist, 1455-1460. Marble, h: 173 cm.
Museo Nazionale del Bargello, Florence (Italy). Early Renaissance. (*)

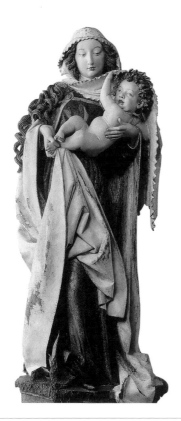

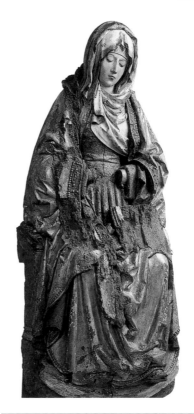

376. Anonymous.
Virgin with Child, called the *"Madonna from Dangolsheim"* (France),
c. 1460. Painted walnut, h: 107 cm.
Staatliche Museen zu Berlin, Berlin (Germany). Gothic.

377. Anonymous.
Virgin in Prayer, c. 1500. Painted wood, 126 x 53 x 27 cm.
Musée de Picardie, Amiens (France). Gothic.

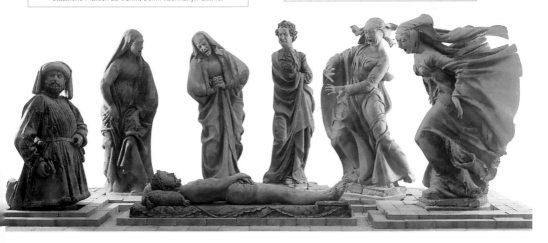

378. Niccolò Dell'Arca, active 1462-1494, Italian.
Deploration of the Dead Christ, c. 1462-1463. Terracotta.
Pinacoteca Nazionale, Bologna (Italy). Early Renaissance. (*)

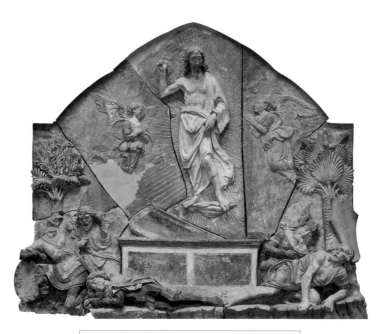

379. **Andrea del Verrocchio**, c. 1435-1488, Italian.
Resurrection, c. 1470. Painted terracotta, 135 x 150 cm.
Museo Nazionale del Bargello, Florence (Italy). Early Renaissance.

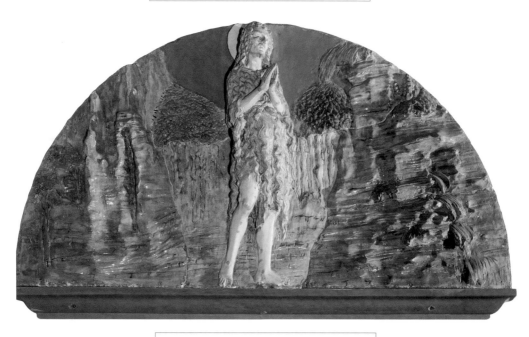

380. **Andrea della Robbia**, 1435-1525, Italian.
St John the Baptist, 1470 (?). Enamelled terracotta.
Museo Nazionale del Bargello, Florence (Italy). Early Renaissance.

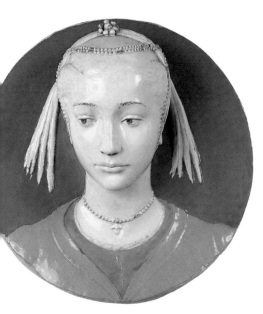

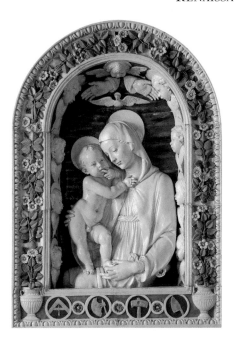

381. **Luca della Robbia**, 1400-1482, Italian.
Tondo Portrait of a Lady, 1465. Glazed terracotta, diameter: 54 cm.
Museo Nazionale del Bargello, Florence (Italy). Early Renaissance.

382. **Andrea della Robbia**, 1435-1525, Italian.
The Madonna of the Stonemasons, 1475-1480.
Glazed terracotta, 134 x 96 cm.
Museo Nazionale del Bargello, Florence (Italy). Early Renaissance. (*)

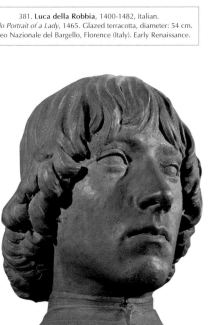

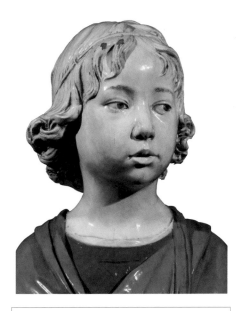

383. Workshop of **Andrea del Verrocchio**, Italian.
Bust of Piero de Cosimo de' Medici, c. 1470. Terracotta, h: 54 cm.
Museo Nazionale del Bargello, Florence (Italy). Early Renaissance.

384. **Andrea della Robbia**, 1435-1525, Italian.
Bust of a Young Boy, c. 1470. Glazed terracotta, h: 33 cm.
Museo Nazionale del Bargello, Florence (Italy). Early Renaissance.

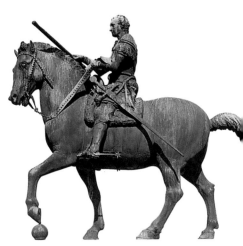

386. **Donatello**, 1386-1466, Italian.
Equestrian Statue of the Gattamelata (Condottiere Erasmo da Narni),
1444-1453. Bronze on marble plinth, h: 340 cm.
Piazza del Santo, Siena (Italy). In situ. Early Renaissance.

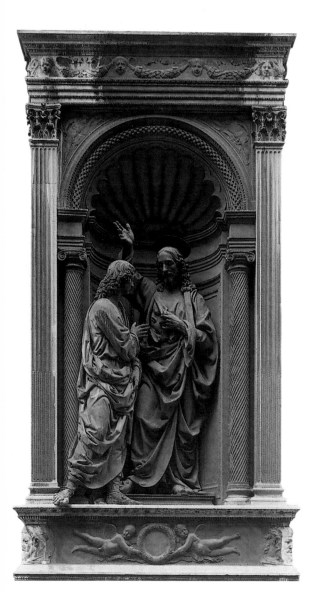

385. **Andrea del Verrocchio**, c. 1435-1488, Italian.
The Incredulity of St Thomas, 1467-1783.
Bronze, Christ h: 230 cm, St Thomas h: 200 cm.
Orsanmichele, Florence (Italy). In situ. Early Renaissance.

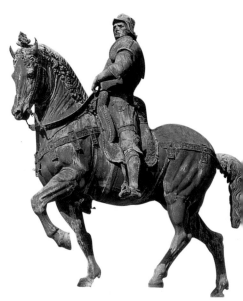

387. **Andrea del Verrocchio**, c. 1435-1488, Italian.
Equestrian Statue of the Colleone (Bartolomeo Colleoni), 1480-1495.
Gilded bronze, h: 395 cm (without base).
Campo di Santi Giovanni e Paolo, Venice (Italy). In situ. Early Renaissance.

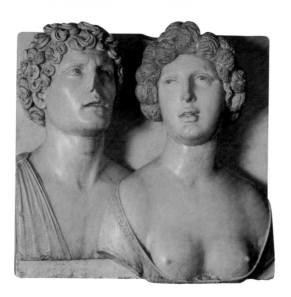

388. **Tullio Lombardo**, 1460-1532, Italian.
Double Portrait, 1490-1510. Marble, 47 x 50.5 cm.
Ca d'Oro, Venice (Italy). High Renaissance. (*)

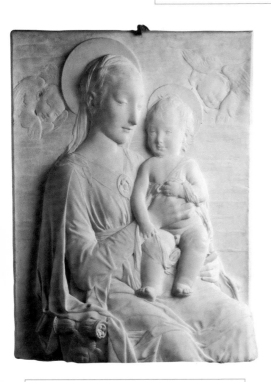

389. **Antonio Rossellino**, 1427-1479, Italian.
The Madonna and Child, c. 1460. Marble, 67 x 51.5 cm.
The State Hermitage Museum, St Petersburg (Russia).
Early Renaissance.

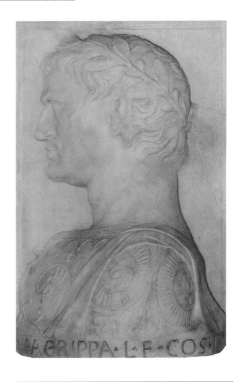

390. **Gregorio di Lorenzo**, Italian.
Profile of Marcus Agrippa, 1472. Marble, 50 x 35 cm.
Casa Romei, Ferrara (Italy). Early Renaissance.

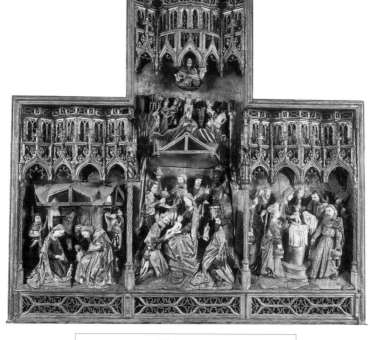

391. **Anonymous.**
Altarpiece of the Virgin, c. 1470. Painted oak and fruit-tree, h: 165 cm.
Musée départemental des Antiquités, Rouen (France). Gothic.

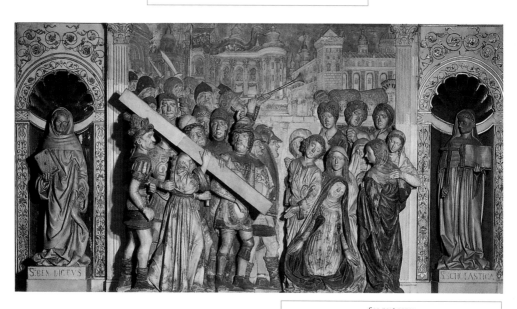

392. **Francesco Laurana**, c. 1430 – c. 1502, Italian.
Christ bearing the Cross, detail from the altar, 1478-1481.
Stone. Église Saint-Didier, Avignon (France).
In situ. Early Renaissance.

See next page:
393. **Veit Stoss**, c. 1447 – c. 1533, German.
Death of the Virgin and Christ receiving the Virgin, central panel,
St Mary altarpiece, interior, 1477-1489. Wood, h: 13 m.
St. Mary, Kraków (Poland). Northern Renaissance. (*)

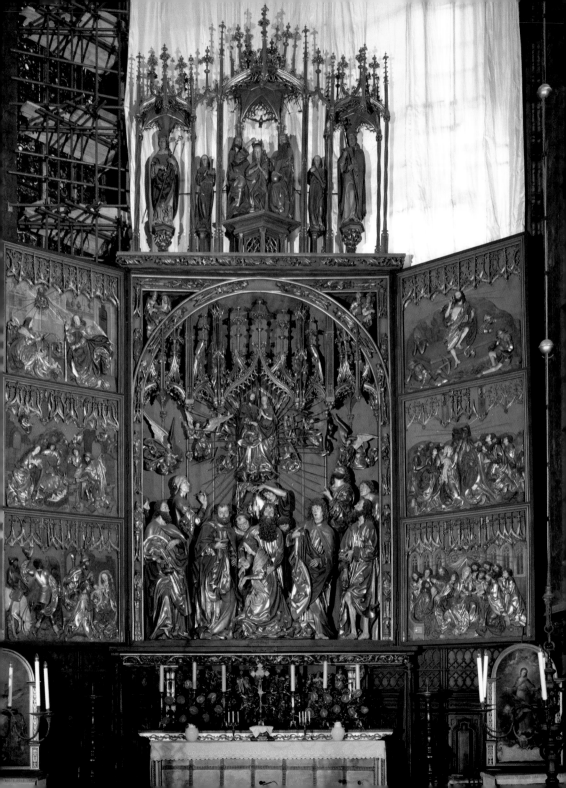

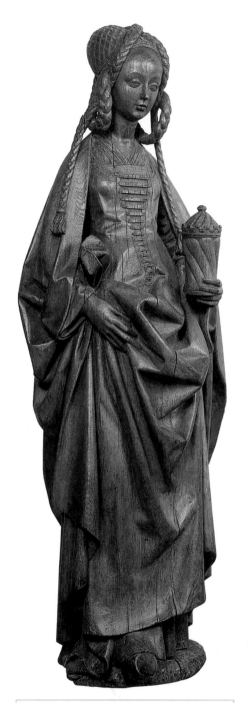

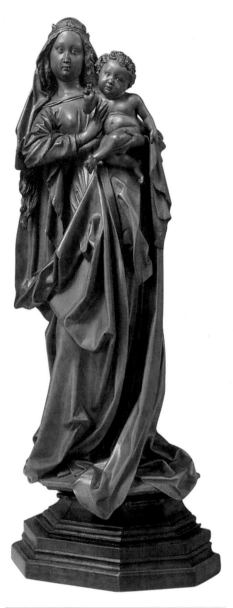

395. Attributed to **Nikolaus Gerhaert von Leiden**, active 1460-1473,
North Netherlandish.
Standing Virgin and Child, c. 1470. Wood, h: 33.6 cm.
The Cloisters, New York (United States). Northern Renaissance.

394. **Anonymous**.
St Mary Magdalene, Brussels (Belgium), c. 1490-1500.
Oak, h: 97 cm.
Musée national du Moyen Age – Thermes et hôtel de Cluny,
Paris (France). Northern Renaissance. (*)

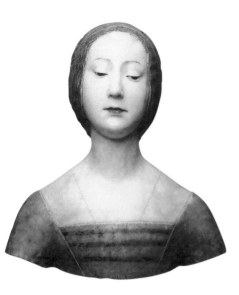

396. **Francesco Laurana**, c. 1430 – c. 1502, Italian.
Bust of a Lady, Isabella di Aragona, Princess of Naples, c. 1487-1488.
Coloured marble, h: 44 cm.
Kunsthistorisches Museum, Vienna (Austria). Early Renaissance. (*)

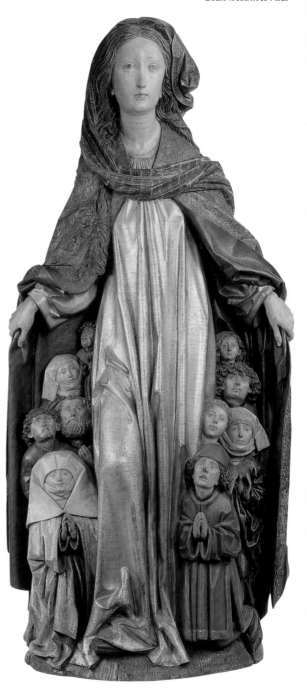

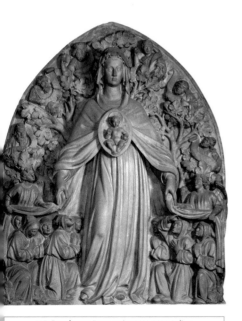

397. **Bartolomeo Buon**, active 1421-1464, Italian.
Virgin and Child with kneeling Members of the Guild of the Misericordia, c. 1445 – c. 1450.
Istrian stone, carved from six blocks, 251.5 x 208.3 cm.
Victoria & Albert Museum, London (United Kingdom). Gothic.

398. **Gregor Erhart**, c. 1460/79-1540, German.
Ravensburg Madonna of Mercy, c. 1480-1490.
Painted linden-wood, h: 135 cm.
Staatliche Museen zu Berlin, Berlin (Germany). Northern Renaissance. (*)

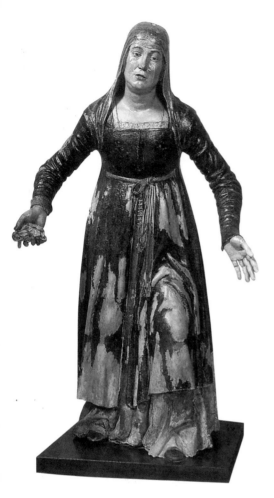

399. **Guido Mazzoni**, 1450-1518, Italian.
Salome, 1480-1485. Terracotta.
Santa Maria della Rosa, Ferrara (Italy). Early Renaissance. (*)

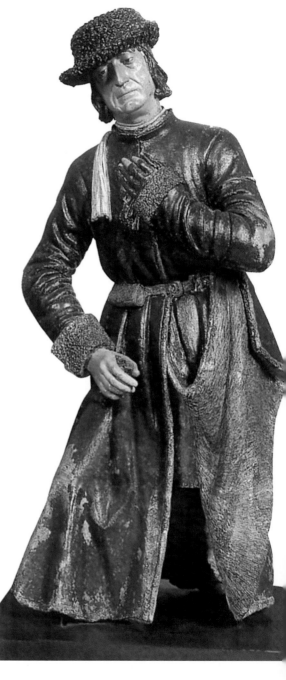

400. **Guido Mazzoni**, 1450-1518, Italian.
Joseph of Arimathea, 1480-1485. Terracotta.
Santa Maria della Rosa, Ferrara (Italy). Early Renaissance.

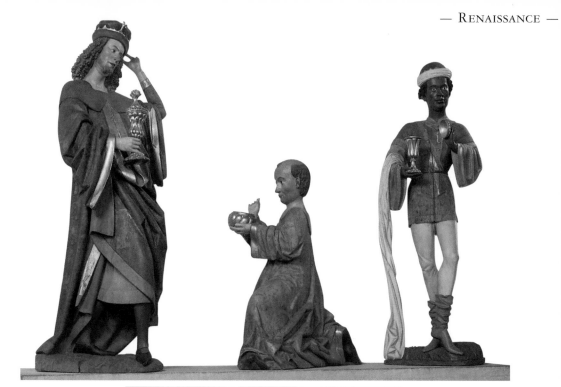

401. **Anonymous**, German.
Three Kings, Adoration Group, high altar, Lichtenthal Cistercian Abbey,
near Baden-Baden (Germany), 1489. Poplar, paint and gilding,
from left to right: h: 163.8 cm, h: 101.6 cm, h: 156.2 cm.
The Cloisters, New York (United States). Gothic.

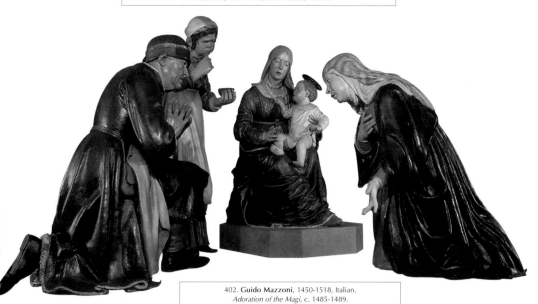

402. **Guido Mazzoni**, 1450-1518, Italian.
Adoration of the Magi, c. 1485-1489.
Painted terracotta. Cattedrale, Modena (Italy).
In situ. Early Renaissance.

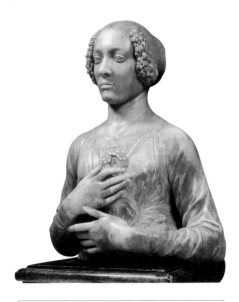

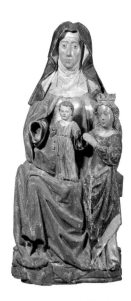

403. **Andrea del Verrocchio**, c. 1435-1488, Italian.
Woman with a Bunch of Flowers (Flora), c. 1480.
Marble, h: 61 cm.
Museo Nazionale del Bargello, Florence (Italy). Early Renaissance.

404. **Anonymous**, French.
St Anne, the Virgin and Child, 15th-16th century (Christ added during the 18th century). Polychrome wood, h: 100 cm.
Musée départemental Dobrée, Nantes (France). Gothic.

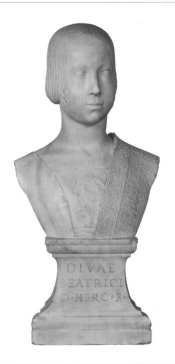

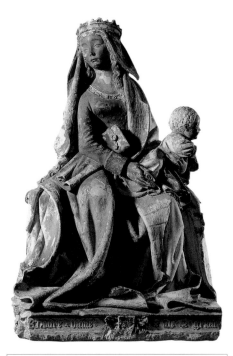

405. **Gian Cristoforo Romano**, 1465-1512, Italian.
Bust of Beatrice d'Este, 1490-1492. Marble, h: 59 cm.
Musée du Louvre, Paris (France). High Renaissance.

406. **Anonymous**.
Nostre Dame de Grasse, c. 1480.
Painted stone, h: 113 cm.
Musée des Augustins, Toulouse (France). Gothic. (*)

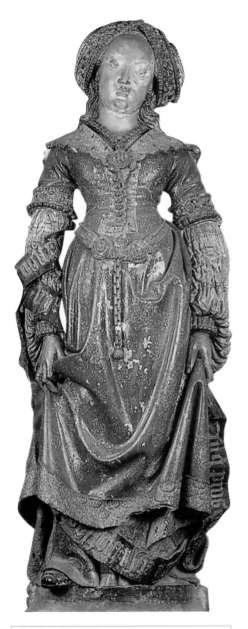

407. **Anonymous**, French.
Statue of Judith, end of the 15th century.
Polychrome stone.
Cathédrale Sainte-Cécile, Albi (France). In situ.

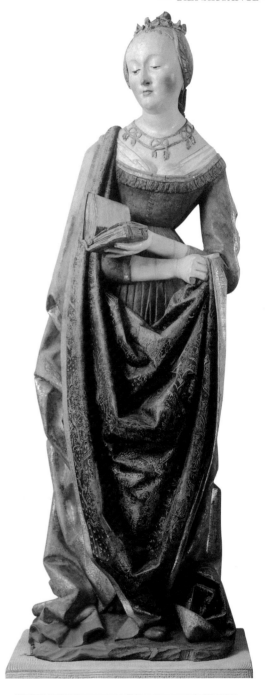

408. **Anonymous**, German.
St Barbara, c. 1490. Lindenwood with paint, h: 127.6 cm.
The Cloisters, New York (United States). Gothic.

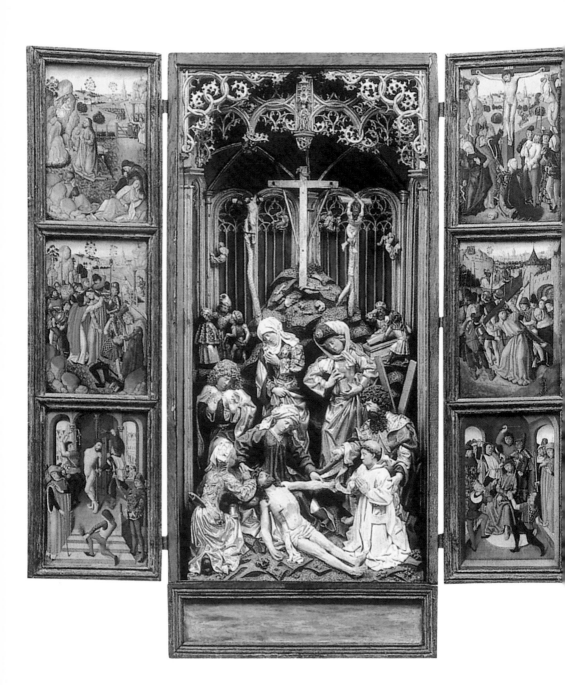

409. **Anonymous.**
The Passion Retable, Germany, c. 1483.
Painted wood, h: 97 cm, w: 45 cm (closed).
Musée national du Moyen Age – Thermes et hôtel de Cluny, Paris (France).

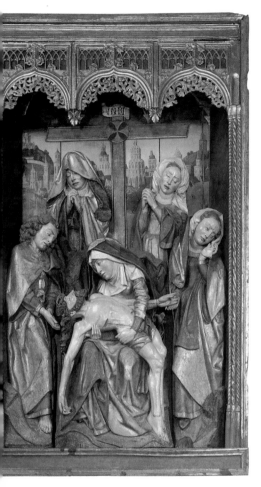

410. **Anonymous**, Spanish.
The Lamentation, c. 1480.
Walnut, paint and gilding, 211 x 123 x 34.3 cm.
The Cloisters, New York (United States). Gothic.

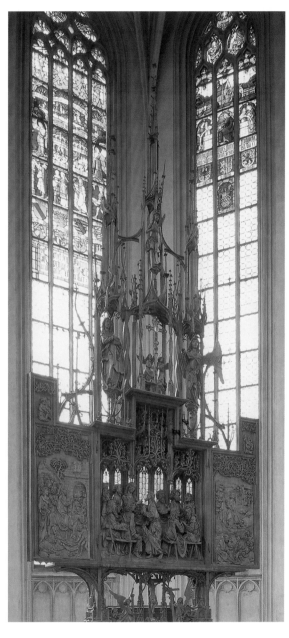

411. **Tilman Riemenschneider**, 1460-1531, German.
Holy Blood Altar, 1499-1504. Linden-wood, h: 900 cm.
St. Jakob Kirche, Rothenburg ob der Tauber (Germany).
Northern Renaissance. (*)

412. **Anonymous.**
Tomb of the Infant Alfonso, Spain, 1489-1493.
Cartuja de Miraflores, Burgos (Spain). In situ. Gothic.

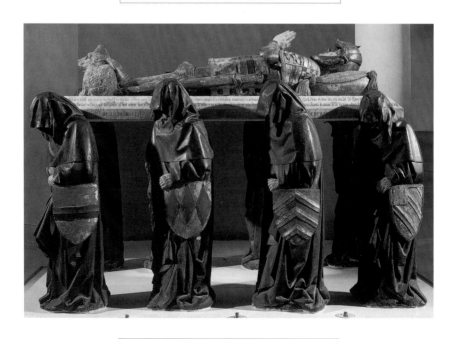

413. **Pierre Antoine Le Moiturier**, active in the 1460s, French.
Tomb of Philippe Pot, end of the 15th century.
Painted limestone, 180 x 260 x 167 cm.
Musée du Louvre, Paris (France). Gothic. (*)

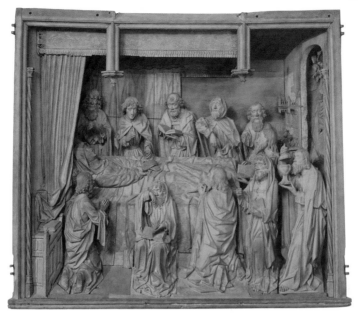

414. Workshop of **Master Tilman**, German.
The Death of the Virgin (The Dormition), late 15th century.
Oak, 160 x 187.3 x 43.8 cm.
The Cloisters, New York (United States). Northern Renaissance.

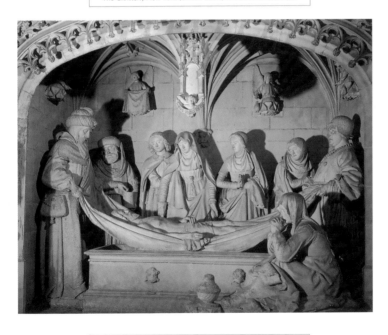

415. Workshop of **Michel Colombe**, French.
The Entombment, 1496. Stone.
Église de l'Abbaye Saint-Pierre, Solesmes (France).
In situ. Gothic.

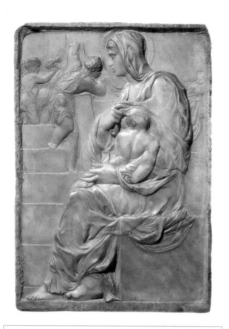

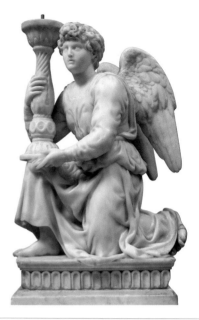

416. **Michelangelo Buonarroti**, 1475-1564, Italian.
Madonna of the Stairs (Madonna della Scala), c. 1490.
Marble, 55.5 x 44 cm.
Casa Buonarroti, Florence (Italy). High Renaissance. (*)

417. **Michelangelo Buonarroti**, 1475-1564, Italian.
Angel with Candlestick, 1494-1495. Marble, h: 58.5 cm.
Chiesa San Domenico, Bologna (Italy). High Renaissance.

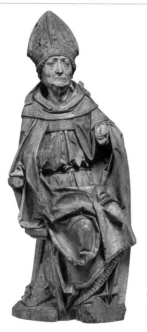

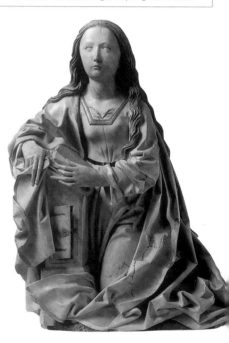

418. **Tilman Riemenschneider**, 1460-1531, German.
Seated Bishop, c. 1495.
Linden-wood, black stain, 90.2 x 35.6 x 14.9 cm.
The Cloisters, New York (United States). Northern Renaissance.

419. **Tilman Riemenschneider**, 1460-1531, German.
Virgin of the Annunciation, c. 1495.
Alabaster with traces of paint, h: 100 cm.
Musée du Louvre, Paris (France). Northern Renaissance. (*)

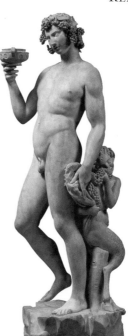

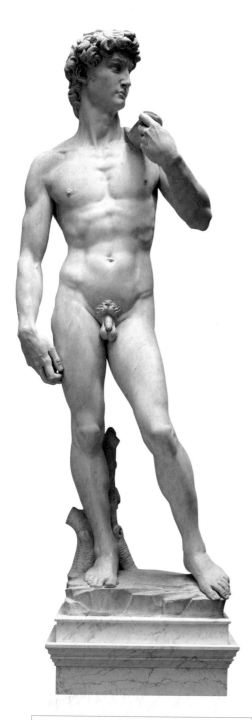

421. **Michelangelo Buonarroti**, 1475-1564, Italian.
Bacchus, 1496-1497. Marble, h: 203 cm.
Museo Nazionale del Bargello, Florence (Italy). High Renaissance.

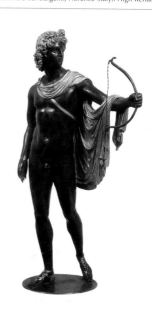

420. **Michelangelo Buonarroti**, 1475-1564, Italian.
David, 1501-1504. Marble, h: 434 cm.
Galleria dell'Accademia, Florence (Italy). High Renaissance. (*)

422. **Pier Jacopo Alari-Bonacolsi**, called **Antico**, 1460-1528, Italian.
Apollo, end of the 15th century. Bronze and silver, h: 54.6 cm.
Ca d'Oro, Venice (Italy). High Renaissance. (*)

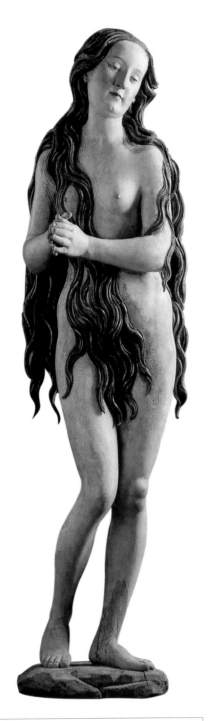

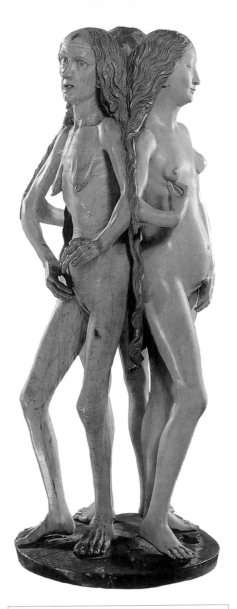

424. **Gregor Erhart**, c. 1460/79-1540, German.
Vanitas, c. 1500. Painted linden-wood, h: 46 cm.
Kunsthistorisches Museum, Vienna (Austria). Northern Renaissance. (*)

423. **Gregor Erhart**, c. 1460/79-1540, German.
St Mary Magdalene, 1510. Painted linden-wood, h: 325 cm.
Musée du Louvre, Paris (France). Northern Renaissance. (*)

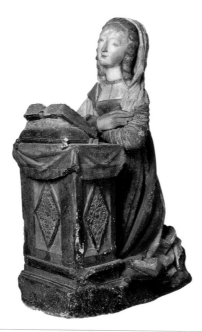

425. **Anonymous.**
Virgin of the Annunciation, beginning of 16th century.
Stone polychrome, h: 78 cm.
Musée Fenaille, Rodez (France). Gothic.

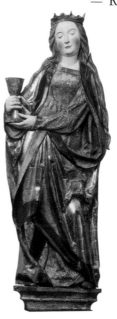

426. **Daniel Mauch**, 1477-1540, German.
St Barbara, c. 1510-1520.
Painted linden-wood, h: 120 cm.
Musée de Picardie, Amiens (France). Gothic.

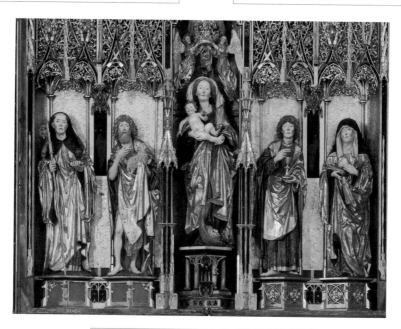

427. **Gregor** (and **Michael**) **Erhart**, 1460/79-1540, German.
Main Altar with Madonna and Saints, 1493-1494. Wood.
Benedictine Abbey Church, Blaubeuren (Germany).
Northern Renaissance.

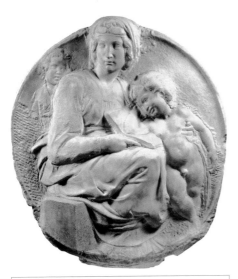

428. **Michelangelo Buonarroti**, 1475-1564, Italian.
Virgin with Child and St John the Baptist as a Child (Tondo Pitti),
1504-1505. Marble, 85 x 82.5 cm.
Museo Nazionale del Bargello, Florence (Italy). High Renaissance. (*)

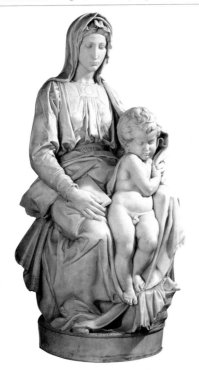

429. **Michelangelo Buonarroti**, 1475-1564, Italian.
Madonna and Child, 1501-1505.
Marble, h: 128 cm.
Notre-Dame, Bruges (Belgium). High Renaissance.

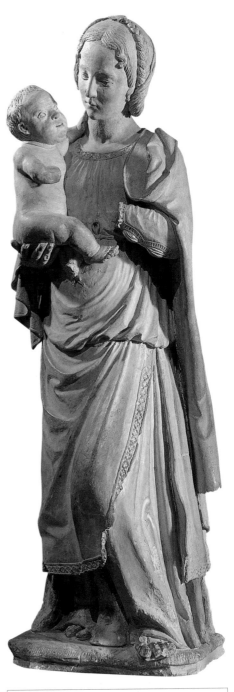

430. **Anonymous**.
The Virgin and Child, beginning of the 16th century.
Terracotta, h: 81 cm.
Musée des Beaux-Arts du château, Blois (France). Gothic.

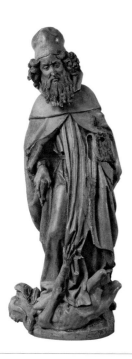

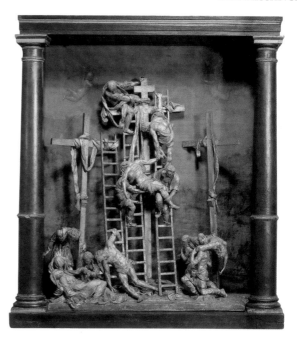

431. Attributed to **Niclaus of Haguenau**, German.
St Anthony the Abbot, c. 1500. Walnut, h: 113.7 cm.
The Cloisters, New-York (United States). Gothic.

432. **Jacopo Sansovino**, 1486-1570, Italian.
The Descent from the Cross, c. 1513.
Wax and wood with gilding, 97.8 x 89.5 cm.
Victoria & Albert Museum, London (United Kingdom). Mannerism.

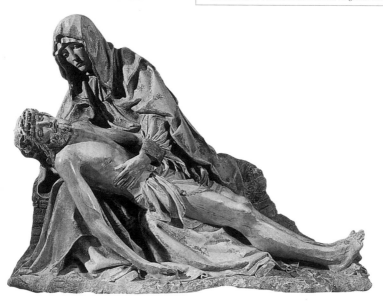

433. **Master of Chaource**, French.
Pietà, 1500-1520. Marble.
Église Saint-Martin, Bayel (France). In situ.

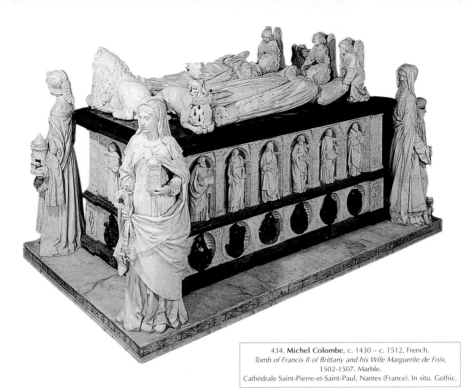

434. **Michel Colombe**, c. 1430 – c. 1512, French.
Tomb of Francis II of Brittany and his Wife Marguerite de Foix,
1502-1507. Marble.
Cathédrale Saint-Pierre-et-Saint-Paul, Nantes (France). In situ. Gothic.

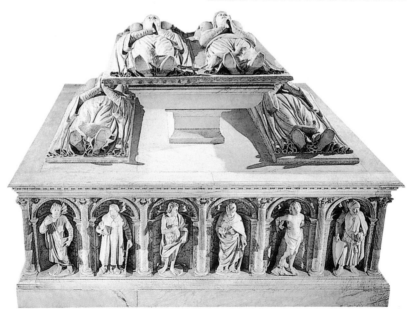

435. **Anonymous**, Italian.
Tomb of the Dukes of Orleans, originally from the Célestins Church,
Paris (France), 1504. Marble.
Basilique Saint-Denis – Nécropole royale, Saint-Denis (France). Gothic.

See next page:
436. **Michelangelo Buonarroti**, 1475-1564, Italian.
The Tomb of Pope Julius II, 1505-1545. Marble, 235 cm.
San Pietro in Vincoli, Rome (Italy). High Renaissance.

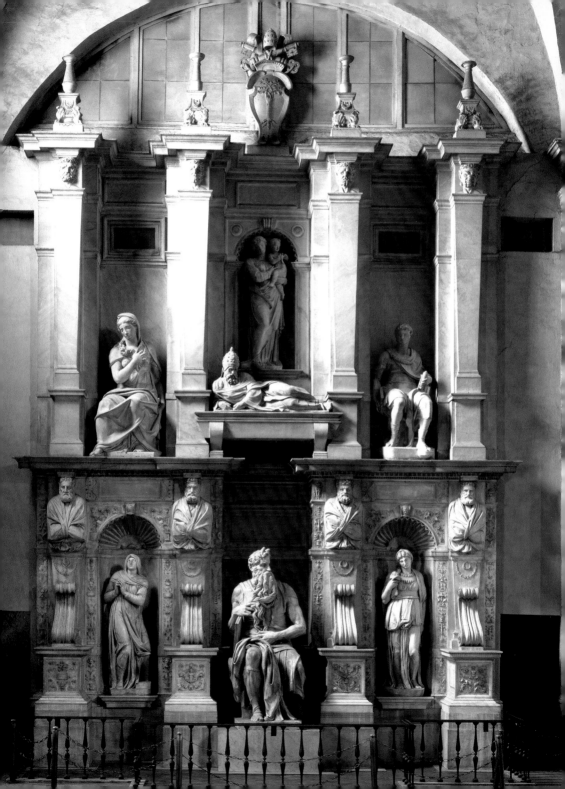

437. **Michel Colombe**, c. 1430 – c. 1512, French.
St George and the Dragon, 1509-1510. Marble, 128 x 182 x 17 cm.
Musée du Louvre, Paris (France). Gothic.

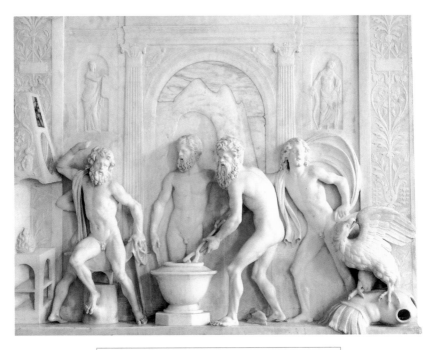

438. **Antonio Lombardo**, 1458-1516, Italian.
The Birth of Minerva, c. 1508-1516.
Marble inset with coloured stone, 83 x 106 cm.
The State Hermitage Museum, St Petersburg (Russia). Early Renaissance.

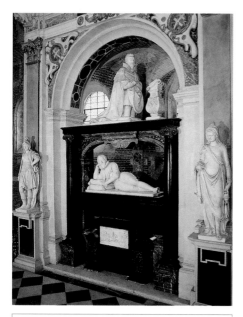

439. **Simon Guillain**, 1589-1658, French.
Tomb of Henri, Duke of Guise and Catherine of Clèves,
beginning of the 16th century.
Collège jésuite, Eu (France). Baroque.

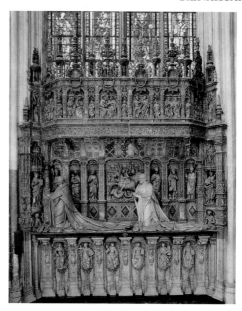

440. **Roullant Le Roux**, died 1527, French.
Tomb of Cardinals Georges I and Georges II of Amboise, 1509.
Stone and marble.
Cathédrale Notre-Dame, Rouen (France). In situ. Baroque.

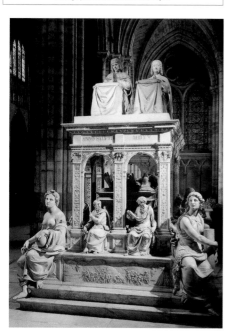

441. **Jean Juste**, 1485-1549, French.
Tomb of Louis XII and Anne of Brittany, 1515-1531. Marble.
Basilique Saint-Denis – Nécropole royale,
Saint-Denis (France). In situ.

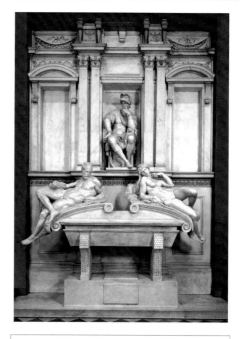

442. **Michelangelo Buonarroti**, 1475-1564, Italian.
Tomb of Lorenzo de' Medici, Duke of Urbino, 1524-1531.
Marble, 630 x 420 cm.
Sagrestia Nuova, San Lorenzo, Florence (Italy). High Renaissance.

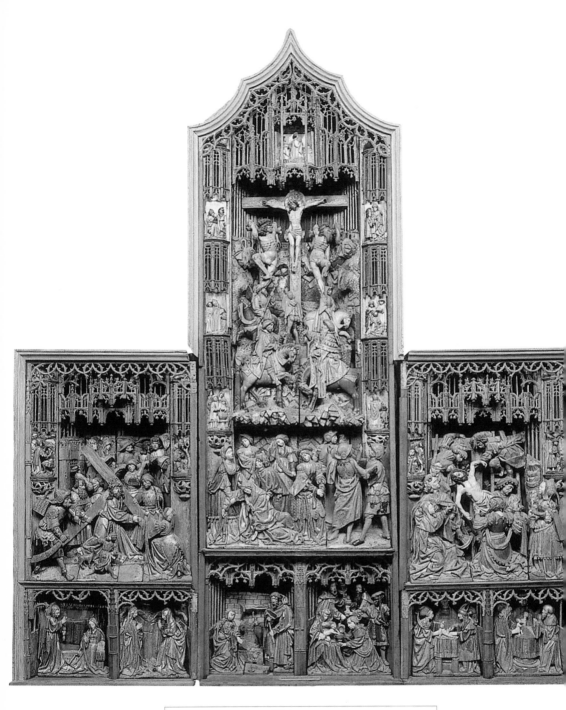

443. **Anonymous.**
Altarpiece of the Passion and of the Childhood of Christ,
Anvers (Belgium), c. 1515-1520. Painted oak, 290 x 258 cm.
Musée national du Moyen Age – Thermes et hôtel de Cluny, Paris (France). Gothic.

444. **Properzia de Rossi**, 1490-1530, Italian.
Joseph and the Wife of Potiphar, c. 1520.
Marble, 550 x 580 cm.
Museo di San Petronio, Bologna (Italy). High Renaissance.

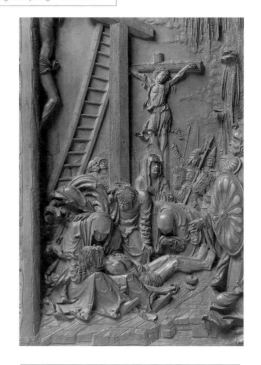

445. **Anonymous**.
Tomb of the Archbishop Uriel von Gemmingen, 1514-1519. Stone.
Mainzer Dom, Mainz (Germany). Northern Renaissance.

446. **Monogrammist I. P.**, Active 1520-1530, Austrian.
Lamentation of Christ, c. 1520-1525. Wood, h: 19.5 cm.
The State Hermitage Museum, St Petersburg (Russia).
Northern Renaissance.

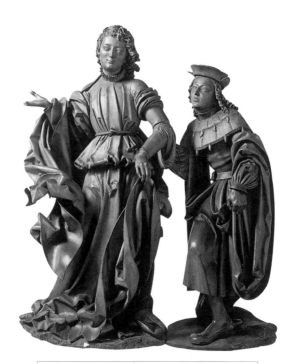

447. **Veit Stoss**, c. 1477 – c. 1533, German.
Raphael and Tobias, c. 1516. Wood, h: 97 cm.
Germanisches Nationalmuseum, Nuremberg (Germany).
Northern Renaissance. (*)

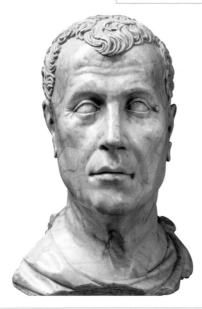

448. **Conrad Meit**, 1480-1550, German.
Head of a Man, c. 1520. Alabaster, 33.2 x 26.5 x 22.9 cm.
J. Paul Getty Museum, Los Angeles (United States).
Northern Renaissance.

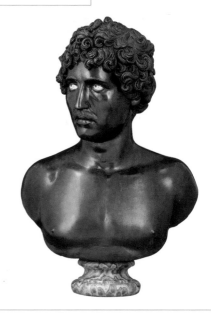

449. **Pier Jacopo Alari-Bonacolsi**, called **Antico**, 1460-1528, Italian.
Bust of a Young Man, c. 1520.
Bronze with silver inlay, 54.6 x 44.3 x 21.5 cm.
J. Paul Getty Museum, Los Angeles (United States). Early Renaissance.

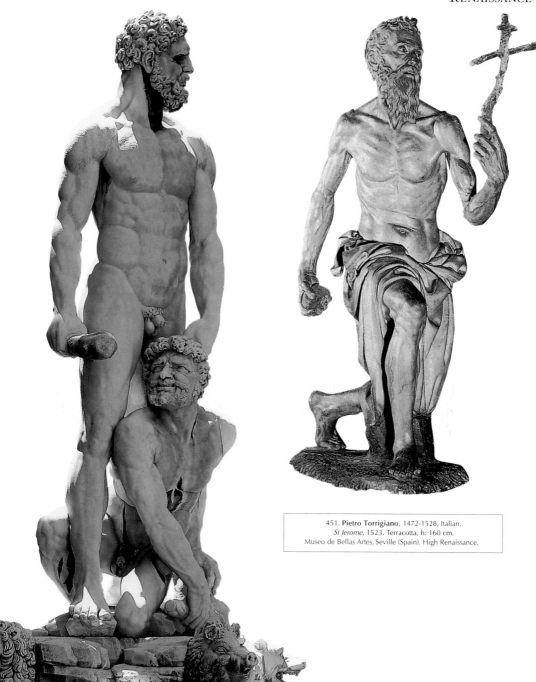

451. **Pietro Torrigiano**, 1472-1528, Italian.
St Jerome, 1523. Terracotta, h: 160 cm.
Museo de Bellas Artes, Seville (Spain). High Renaissance.

450. **Baccio Bandinelli**, 1493-1560, Italian.
Heracles and Cacus, 1525-1534.
Marble, h: 505 cm.
Piazza della Signora, Florence (Italy). In situ. Mannerism.

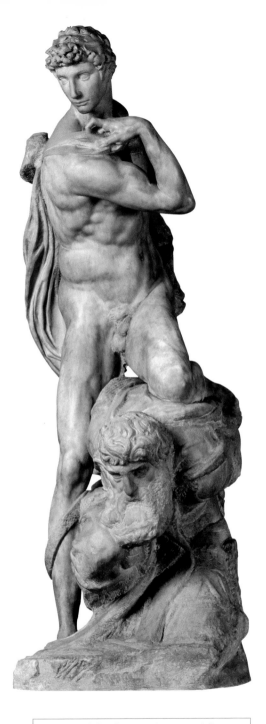

453. **Niccolò Tribolo**, 1500-1550, Italian.
Allegory of Nature, c. 1529. Marble, h: 115 cm.
Musée national du château, Fontainebleau (France). Mannerism.

452. **Michelangelo Buonarroti**, 1475-1564, Italian.
Victory, 1532-1534. Marble, h: 261 cm.
Palazzo Vecchio, Florence (Italy). High Renaissance.

454. **Anonymous.**
Bust of Woman in Medallion, c. 1540.
Stone, h: 60 cm.
Musée des Beaux-Arts, Lyon (France). Mannerism.

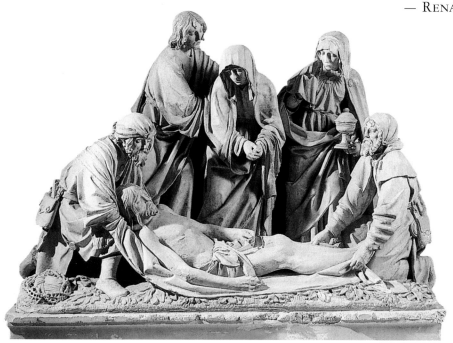

455. **Master of Chaource**, French.
The Entombment, 1528. Stone.
Église Notre-Dame, Villeneuve-l'Archevêque (France).
In situ. Mannerism.

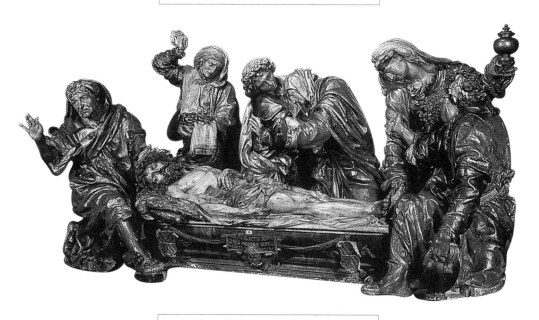

456. **Juan de Juní**, 1506-1577, Franco-Spanish.
Entombment, 1541-1544. Painted wood, 186 x 323 x 155 cm.
Museo Nacional de Escultura, Valladolid (Spain). Mannerism. (*)

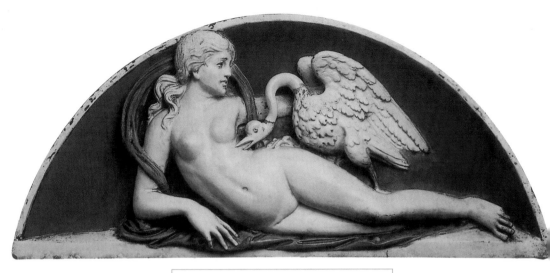

457. **Girolamo della Robbia**, 1488-1566, Italian.
Leda and the Swan, c. 1540. Varnished terracotta, 26 x 66 cm.
Liebieghaus, Frankfurt am Main (Germany).

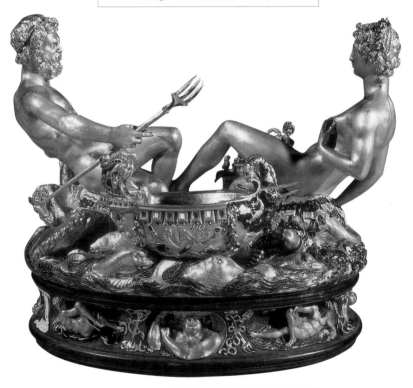

458. **Benvenuto Cellini**, 1500-1571, Italian.
The Salt Cellar of Francis I, 1540-1543.
Ebony, gold, partly enamelled, 26 x 33.5 cm.
Kunsthistorishes Museum, Vienna (Austria). Mannerism. (*)

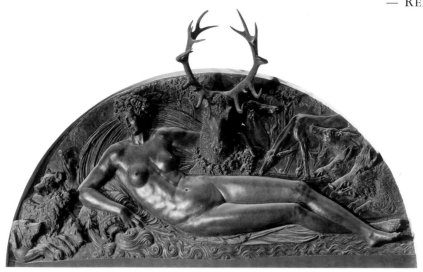

459. **Benvenuto Cellini**, 1500-1571, Italian.
Nymph of Fontainebleau, 1542-1543.
Bronze, 205 x 409 cm.
Musée du Louvre, Paris (France). Mannerism.

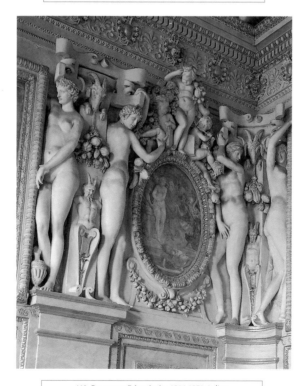

460. **Francesco Primaticcio**, 1504-1570, Italian.
The Room of the Duchesse d'Etampes,
now called the *"Escalier du Roi"*, 1541-1544. Stucco.
Musée national du Château, Fontainebleau (France). Mannerism. (*)

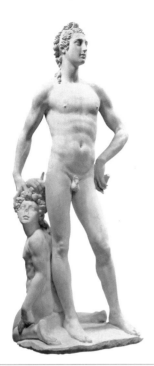

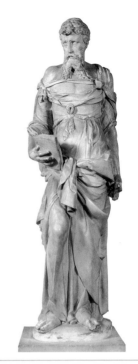

461. **Benvenuto Cellini**, 1500-1571, Italian.
Apollo and Hyacinth, 1545-1548. Marble.
Museo Nazionale del Bargello, Florence (Italy). Mannerism.

462. **François Marchand**, c. 1500-1551, French.
St Paul, c. 1543. Alabaster.
Musée des Beaux-Arts, Chartres (France). Mannerism.

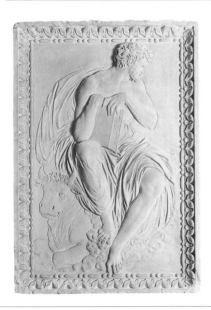

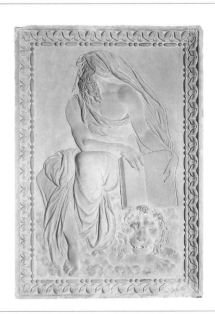

463. **Jean Goujon**, active 1540-1563, French.
St Luke, rood screen, Saint-Germain-l'Auxerrois Church, 1544.
Stone, 79 x 56 cm.
Musée du Louvre, Paris (France). Mannerism.

464. **Jean Goujon**, active 1540-1563, French.
St Mark, rood screen, Saint-Germain-l'Auxerrois Church, 1544.
Stone, 79 x 56 cm.
Musée du Louvre, Paris (France). Mannerism.

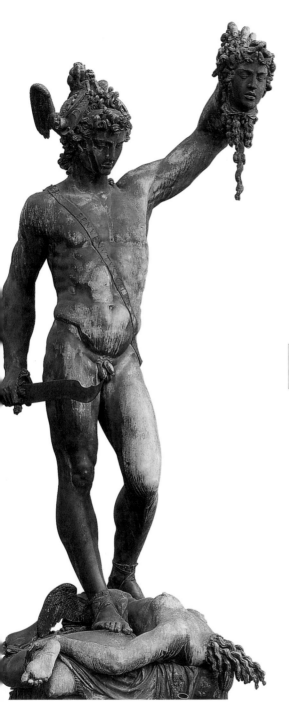

466. **Leone Leoni**, 1505-1590. Italian.
Emperor Charles V in the Armour of the Battle of Muehlberg (1547) against the Protestant Princes under Johann Friedrich of Saxony, 1533. Bronze. Museo del Prado, Madrid (Spain). Mannerism.

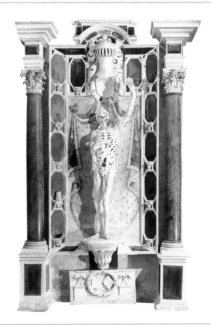

465. **Benvenuto Cellini**, 1500-1571, Italian.
Perseus, 1545-1554. Bronze, h: 548.6 cm.
Loggia dei Lanzi, Florence (Italy). Mannerism. (*)

467. **Ligier Richier**, c. 1500-1567, French.
Flayed or *The Skeleton*,
Tomb of René de Chalon, Prince of Orange, 1547. Stone.
Église Saint-Etienne, Bar-le-Duc (France). Gothic. (*)

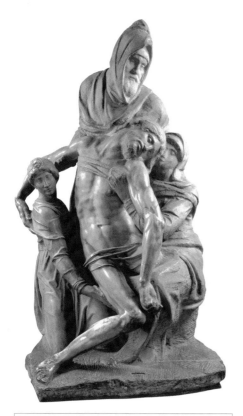

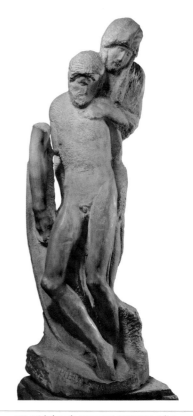

468. **Michelangelo Buonarroti**, 1475-1564, Italian.
Pietà, 1550-1555.
Marble, h: 226 cm.
Museo dell'Opera del Duomo, Florence (Italy). High Renaissance.

469. **Michelangelo Buonarroti**, 1475-1564, Italian.
Pietà Rondanini, c. 1552-1564.
Marble, h: 190 cm.
Museo Civico Castello Sforzesco, Milan (Italy). High Renaissance.

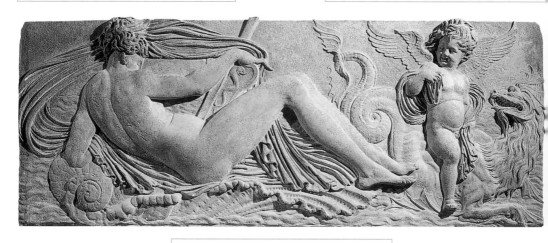

470. **Jean Goujon**, active 1540-1563, French.
Nymph and Spirit, 1549.
Stone, 74 x 195 cm.
Musée du Louvre, Paris (France). Mannerism.

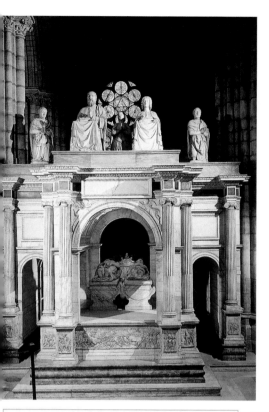

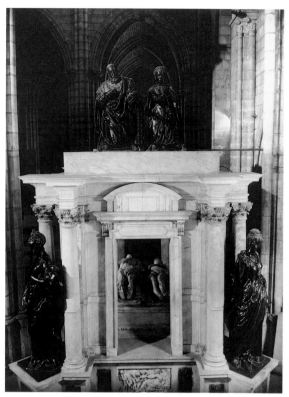

471. **Pierre Bontemps** (and **Philibert de L'Orme**), active 1535-1567, French.
Tomb of Francis I and Claude de France, 1548-1559.
Marble. Basilique Saint-Denis – Nécropole royale,
Saint-Denis (France). In situ. Mannerism.

472. **Germain Pilon** (and **Francesco Primaticcio**), c. 1529-1590, French.
Tomb of Henri II and Catherine de' Medici, 1560-1573. Marble.
Basilique Saint-Denis – Nécropole royale, Saint-Denis (France). Mannerism. (*)

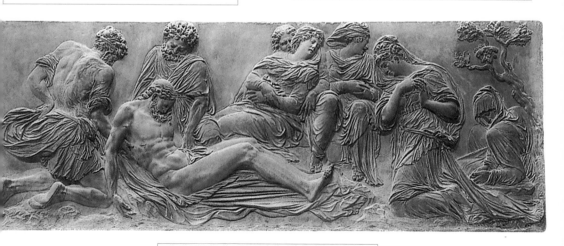

473. **Jean Goujon**, active 1540-1563, French.
The Lamentation of Christ, middle of the 16th century.
Stone, 67 x 182 x 7 cm.
Musée du Louvre, Paris (France). Mannerism.

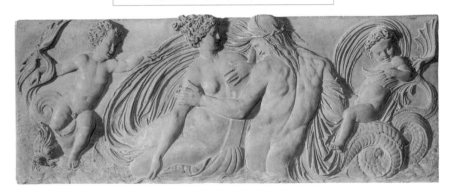

474. **Germain Pilon**, c. 1529-1590, French.
The Resurrection, second half of the 16th century.
Marble, 215 x 188 x 74 cm.
Musée du Louvre, Paris (France). Mannerism.

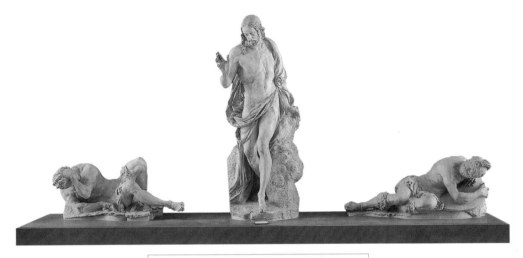

475. **Jean Goujon**, active 1540-1563, French.
Nymph and Triton, middle of the 16th century.
Stone, 73 x 195 x 12 cm.
Musée du Louvre, Paris (France). Mannerism. (*)

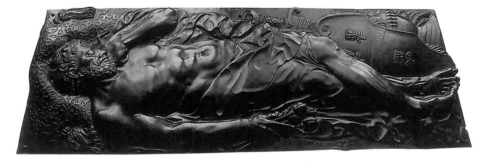

476. **Ponce Jacquiot**, active 1527-1572, French.
André Blondel de Rocquencourt, third quarter of the 16th century.
Bronze, 59 x 173 x 6 cm.
Musée du Louvre, Paris (France). Mannerism.

477. **Domenico del Barbiere**, called **Dominique Florentin**,
c. 1506-1570, Italian.
Charity, 1549. Limestone, h: 140 cm.
Église Saint-Pantaléon, Troyes (France). In situ. Mannerism.

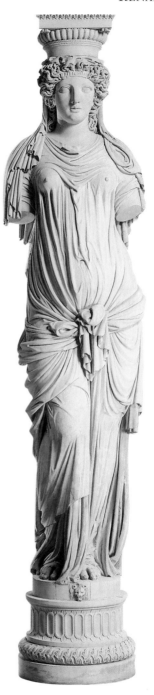

478. **Pierre Bontemps**, active 1535-1567, French.
Urn containing the Heart of Francis I, 1550. Marble.
Basilique Saint-Denis – Nécropole royale, Saint-Denis (France). Mannerism. (*)

479. **Jean Goujon**, active 1540-1563, French.
Caryatid, 1550-1551. Stone.
Musée du Louvre, Paris (France). Mannerism. (*)

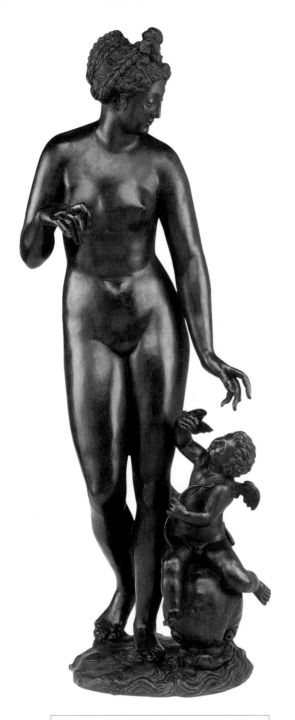

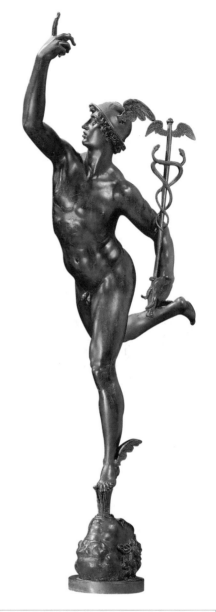

481. **Giovanni Bologna**, called **Giambologna**, 1529-1608,
Flemish/Italian.
Mercury, 1564-1580. Bronze, h: 75 cm.
Museo Nazionale del Bargello, Florence (Italy). Mannerism. (*)

480. **Jacopo Sansovino**, 1486-1570, Italian.
Venus and Cupid, c. 1550. Bronze, h: 88.9 cm.
J. Paul Getty Museum, Los Angeles (United States). Mannerism.

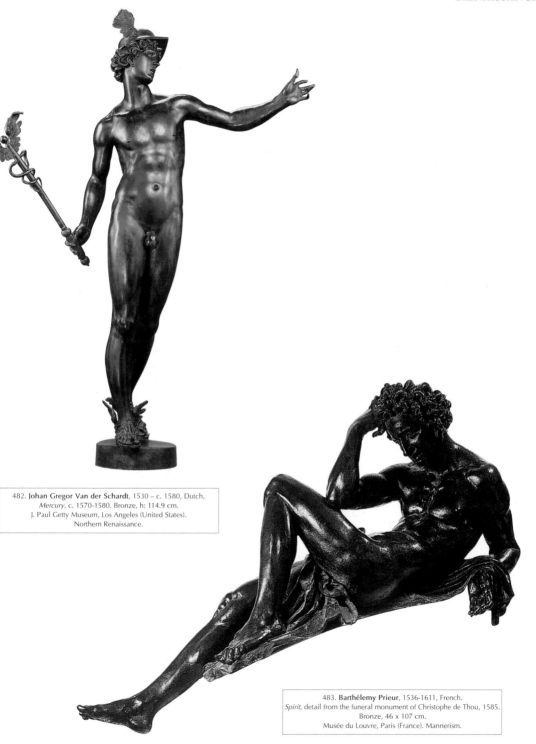

482. **Johan Gregor Van der Schardt**, 1530 – c. 1580, Dutch,
Mercury, c. 1570-1580. Bronze, h: 114.9 cm.
J. Paul Getty Museum, Los Angeles (United States).
Northern Renaissance.

483. **Barthélemy Prieur**, 1536-1611, French.
Spirit, detail from the funeral monument of Christophe de Thou, 1585.
Bronze, 46 x 107 cm.
Musée du Louvre, Paris (France). Mannerism.

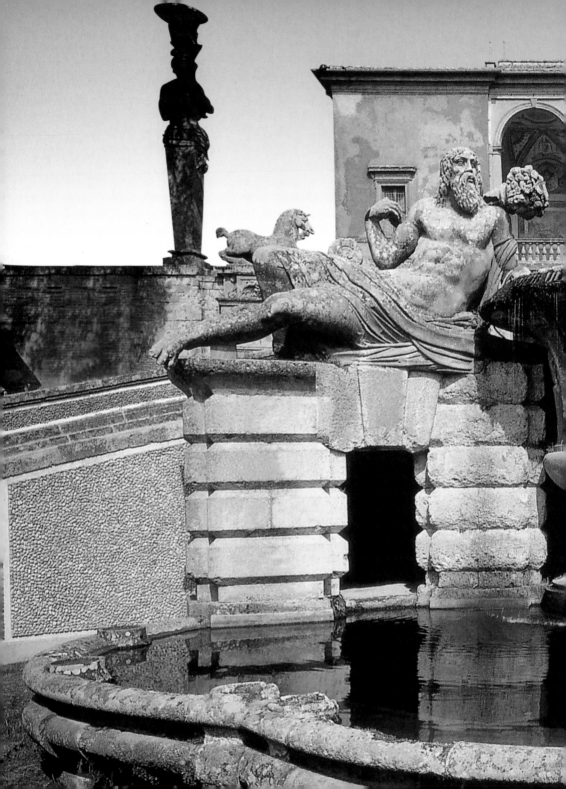

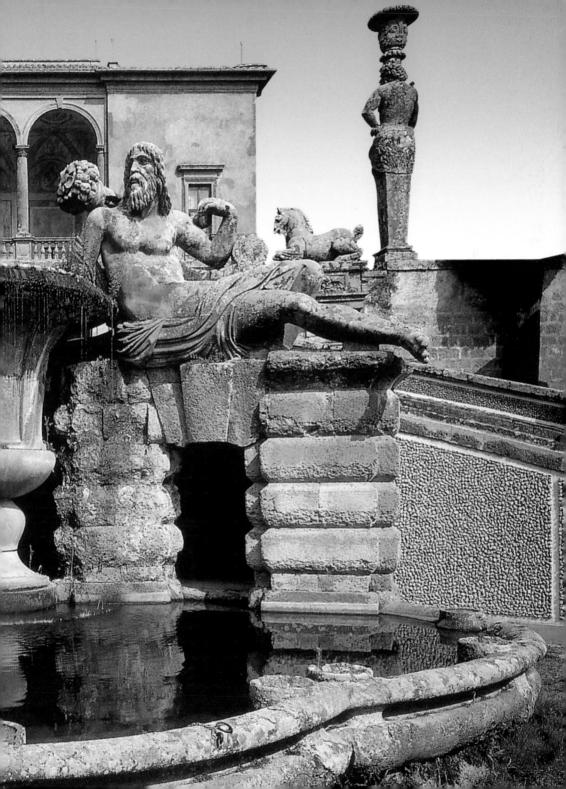

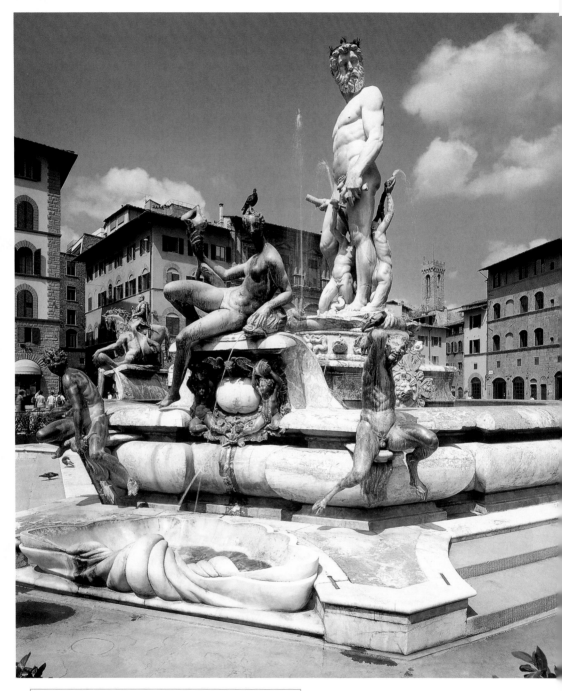

See previous page:
484. **Giacomo** (or **Jacopo**) **Barozzi da Vignola**, called **Vignola**, 1507-1573, Italian.
Fountain with River Gods and *View of the Frontispiece of the Gardens of the Villa Farnese*, c. 1560. Stone.
Villa Farnese, Caprarola (Italy). In situ. Mannerism.

485. **Bartolommeo Ammanati**, 1511-1592, Italian.
Fountain of Neptune, 1559-1575.
Marble and bronze, h: 560 cm.
Piazza della Signora, Florence (Italy). In situ. Mannerism. (*)

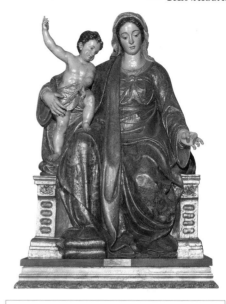

486. **Pablo de Rojas**, 1549-1611, Spanish.
The Immaculate Conception, 1580-1607.
Painted wood with gilding, h: 127 cm.
Cathedral, Granada (Spain). Mannerism.

487. **Jerónimo Hernández**, 1540-1586, Spanish.
The Virgin of the "Rosario", 1577-1578.
Painted wood, h: 142 cm.
Hermandad del Museo, Seville (Spain). Mannerism.

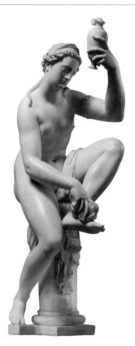

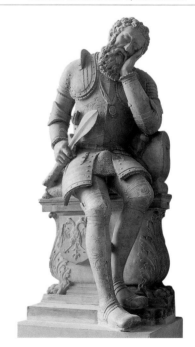

488. **Giovanni Bologna**, called **Giambologna**, 1529-1608,
Flemish/Italian.
Female Figure (possibly Venus, formerly called Bethsheba), 1571-1573.
Marble, h: 114.9 cm.
J. Paul Getty Museum, Los Angeles (United States). Mannerism.

489. **Pierre Bontemps**, active 1535-1567, French.
Tomb of Charles de Maigny, third quarter of the 16th century.
Stone, 145 x 70 x 42 cm.
Musée du Louvre, Paris (France). Mannerism.

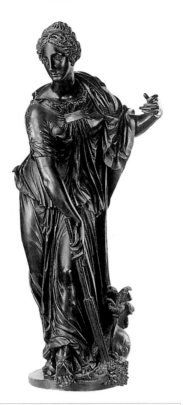

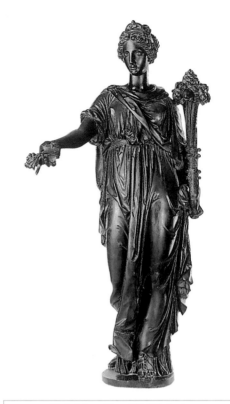

490. **Barthélemy Prieur**, 1536-1611, French.
Peace, detail from the Monument for the urn with the heart of the
Connetable Anne de Montmorency, 1571.
Bronze, h: 128 cm. Musée du Louvre, Paris (France). Mannerism.

491. **Barthélemy Prieur**, 1536-1611, French.
Abundance, detail from the Monument for the urn with the heart of the
Connetable Anne de Montmorency, 1571. Bronze, h: 122 cm.
Musée du Louvre, Paris (France). Mannerism.

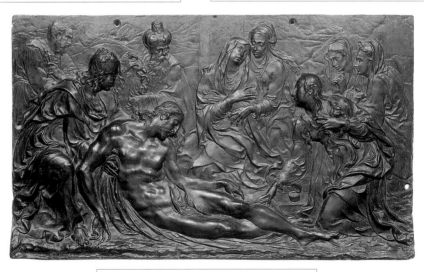

492. **Germain Pilon**, c. 1529-1590, French.
Lamentation over Christ, 1580-1585.
Bronze, 47 x 82 cm.
Musée du Louvre, Paris (France). Mannerism.

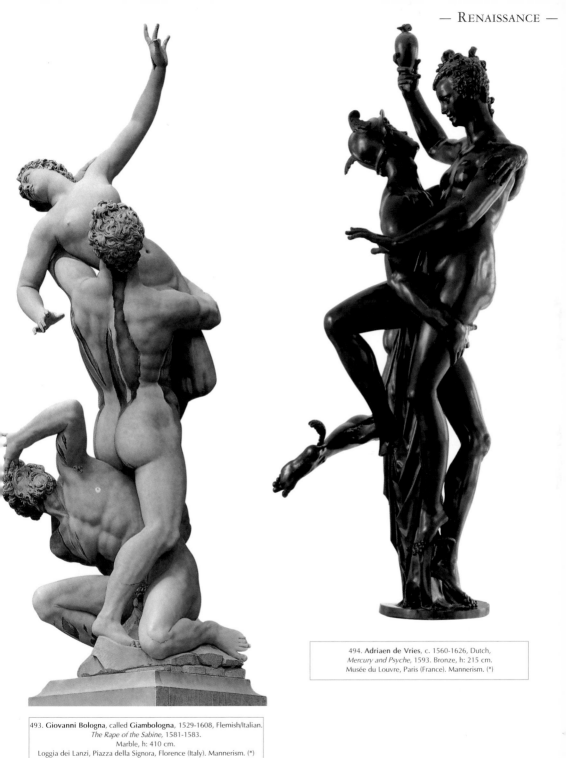

493. **Giovanni Bologna**, called **Giambologna**, 1529-1608, Flemish/Italian.
The Rape of the Sabine, 1581-1583.
Marble, h: 410 cm.
Loggia dei Lanzi, Piazza della Signora, Florence (Italy). Mannerism. (*)

494. **Adriaen de Vries**, c. 1560-1626, Dutch,
Mercury and Psyche, 1593. Bronze, h: 215 cm.
Musée du Louvre, Paris (France). Mannerism. (*)

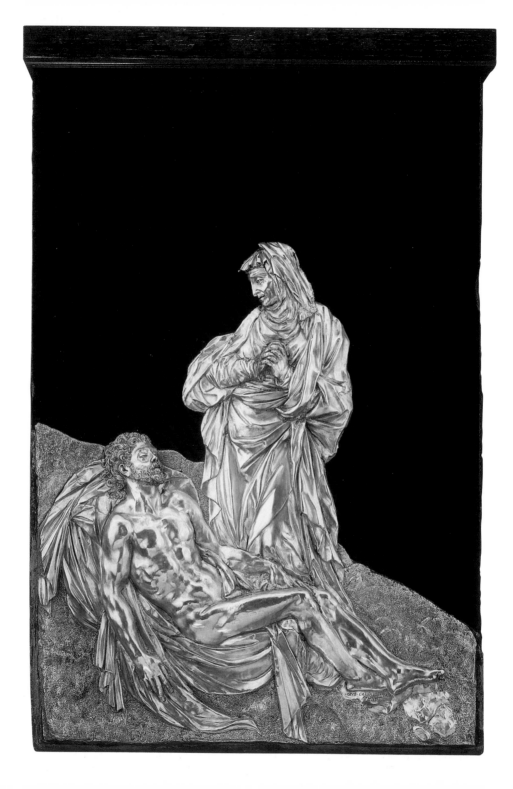

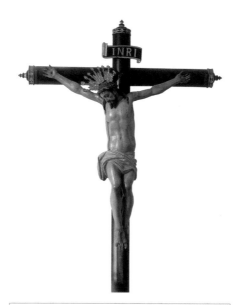

496. **Andrés de Ocampo**, 1555 (?)-1623, Spanish.
Crucifixion, c. 1592-1596.
Painted wood, Convento de Santa Marta, Córdoba (Spain). Mannerism.

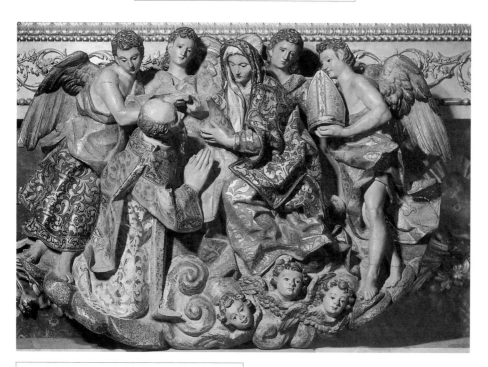

See previous page:
495. **Cesare Targone**, active 1575-1590, Italian.
Virgin Mourning the Dead Christ, 1586-1587.
Finely chased embossed gold on obsidian, 38.4 x 26.5 cm.
J. Paul Getty Museum, Los Angeles (United States). Mannerism.

497. Workshop of **El Greco**, Spanish.
St Ildefonso receiving the Chasuble, 1585. Painted wood.
Sacristy of the cathedral, Toledo (Spain). Mannerism. (*)

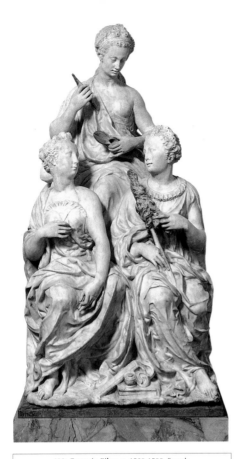

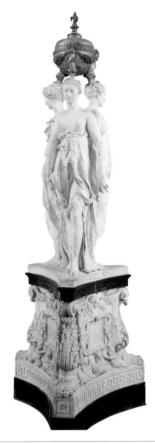

498. **Germain Pilon**, c. 1529-1590, French.
The Three Moirae, fourth quarter of the 16th century.
Marble, 162 x 73 cm.
Musée national de la Renaissance, Ecouen (France). Mannerism.

499. **Germain Pilon** (and **Domenico del Barbiere**), c. 1529-1590, French.
Monument containing the Heart of Henri II, 1561-1566.
Marble, 150 x 75 x 75 cm.
Musée du Louvre, Paris (France). Mannerism. (*)

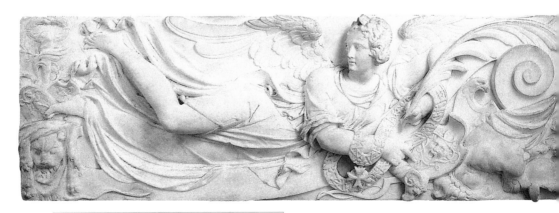

500. **Mathieu Jacquet**, c. 1545 – c. 1611, French.
Victory, detail from the bas-relief *"The Battle of Ivry and the Surrender of Mantes"* from the *"Belle Cheminée"* at Fontainebleau, c. 1611.
Marble, 46.6 x 66.7 x 5.3 cm.
Musée du Louvre, Paris (France). Mannerism.

See next page:
501. **Germain Pilon**, c. 1529-1590, French.
Mater Dolorosa, c. 1585. Terracotta, 159 x 119 x 81 cm.
Musée du Louvre, Paris (France). Mannerism. (*)

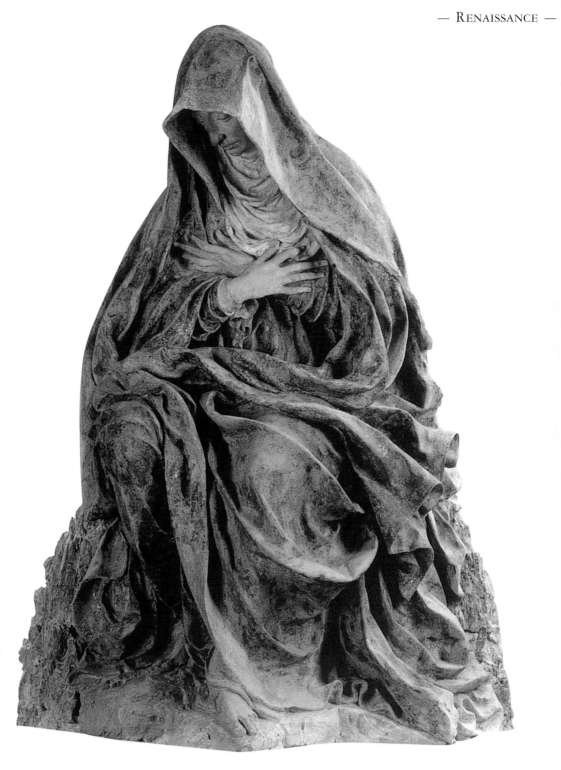

MASTERWORKS COMMENTED

340. Michelangelo, *Pietà.*

In 1498 the *Pietà* was created for St Peter's in Rome. This was Michelangelo's most "pathetic" work to date, and is certainly one of his most popular. At the age of twenty-three Michelangelo received a commission from the French cardinal Jean de Lagraulas for a *pietà* in marble. A Roman gentleman, Jacopo Galli, guaranteed the project and assured that this *Pietà* would be "the most beautiful work in marble ever produced in Rome". Michelangelo completed this majestic sculpture in the two years 1498 and 1499. A work of his youth, this *Pietà* already shows his great mastery of sculpture. Together, the figures form a very balanced pyramid in which the verticality of the Mother and the horizontality of the Son are nevertheless united thanks to the ample clothing of the Virgin. The dead Christ lies in an abandoned position in the arms of his Mother, surprisingly young — too young perhaps to be his mother — thus portraying the original virginity of Mary. Michelangelo created a work of absolute perfection in which the beauty of Christ's body and that of the Virgin's face reflect the divine. However, pain is present and the Virgin is filled with sadness, but she shows resignation and even gentleness towards her son's body lying against her. The *Pietà* of St Peter's in Rome, the only work signed by Michelangelo, is representative of the Golden Age of the Italian Renaissance, where all that mattered was harmony and perfection.

341. Anonymous, *Diana with Stag,* also called the *"Diana of Anet".*

The château of Anet, built by Philibert Delorme from 1547 to 1552 for the favourite mistress of Henri II, Diane de Poitiers, was originally the site for this magnificent statue, the fountain then being placed in the middle of the park. The creator of this masterpiece remains anonymous, though attribution has been made to Cellini, Goujon, and even Jacquiot. Inspired by mythology, this group, apparently representing the chaste Diana embracing Actaeon, whom she transformed into a stag because he had surprised her while bathing, portrays in reality the royal love between Henri II and Diane de Poitiers, the golden antlers of the stag symbolising the royal crown. Another reading could pay homage to the late husband of Diane, Louis de Brézé, a great huntsman of France, because the presence of hounds, an interpretation confirmed by the cenotaph on which the statues are sculpted. The harmony of the line and the balance are perfect. Through the use of a parallel line, Diana's bow balances the diagonal created by the height of the antlers. The sophistication of Diana's hair contrasting with her magnificent and unbowed nakedness gives a particularly intense sensuality to the work. This first great nude of French sculpture is a striking example of French Mannerism in the School of Fontainebleau.

342. Filippo Brunelleschi, *Sacrifice of Isaac.*

In 1401, the city of Florence, Italy, held a competition for the commission of the new bronze doors for the east entrance of the Baptistery. Andrea Pisano designed an earlier set of bronze doors for that entrance (see no. 319); these were moved to the south entrance. The eastern portal was considered very important because it faced the Cathedral. Entrants to the competition were asked to create a panel depicting the sacrifice of Isaac. In this event from the Old Testament, Abraham is asked by God to sacrifice his only son, Isaac. Abraham agrees, and takes Isaac to a mountaintop. There, he draws a knife and prepares to kill his son. God intervenes at the last moment, sending an angel to stop Abraham, who has proven his faith. Of all the entries, only two survive, those of two of the finalists, Filippo Brunelleschi and Lorenzo Ghiberti. Both chose to depict the sacrifice scene within the same quatrefoil framework used by Pisano on his earlier doors. In this panel by Brunelleschi, the moment just before Abraham was to kill Isaac is shown; the angel sweeps in to stop Abraham's knife. In the classicising scene, the robes of the angel and of Abraham are shown whipping around in different directions. Isaac's head is twisted backward in preparation for the cut, as he kneels on a sculpted altar. The scene is dramatic and energetic.

343. Lorenzo Ghiberti, *Sacrifice of Isaac.*

This panel is Ghiberti's entry for the competition. Like Brunelleschi's (see no. 342), it shows the moment just before the sacrifice, enclosed within a similar quatrefoil frame. Also like Brunelleschi's, there is a strong classicising influence in the folds of drapery and the pose of the figures. However, Ghiberti has shown the physicality of the figures more clearly, emphasising their bodies, both the nude torso of Isaac and the form of Abraham's body under his drapery. Landscape figures more prominently in Ghiberti's work, as well. The rocky terrain of the mountaintop breaks the composition diagonally, adding a rough texture that contrasts with the smooth contours of the figures' bodies. Ghiberti's panel on the competition, and represents the new aesthetic of the Renaissance, with its interest in classicising representations of the body and the naturalisation of the landscape.

346. Lorenzo Ghiberti, *The Gates of Paradise.*

Following his success in winning the competition to create the bronze doors for the Baptistery in Florence (see no. 343), in 1424 Ghiberti completed the set consisting of twenty-eight panels of scenes from the New Testament. Immediately, church officials commissioned a second set of panels for the third portal. His first set was moved to the north entrance so that the new panels could grace the important east entrance. These new doors broke from the pattern originally set by Pisano of containing each scene in a Gothic-style quatrefoil frame. Instead, Ghiberti composed each scene within a large square, reducing the number of panels to ten. The resulting doors, cloaked in glimmering gilded bronze, have a more majestic appearance. The larger panels also gave Ghiberti the space to construct more elaborate scenes, in which many figures interact in front of complex architectural and landscape backgrounds. The doors were later praised by Michelangelo as being fit for the gates of Paradise.

350. Anonymous, *St Catherine holding a Book.*

This statue of St Catherine is from Karlstejn Castle in the Czech Republic. The castle was built by Charles IV, Holy Roman Emperor, in the mid-fourteenth century to serve as the treasury for the Imperial crown jewels and the Imperial reliquaries. A later renovation to the castle created the chapel of St Catherine, connected to the main church, dedicated to the Virgin Mary, the daughter of St Catherine. The chapel is known for its Gothic frescos, but this statue also serves as an excellent example of the art of the Late Gothic period from this region. The figure stands in the exaggerated s-curve, typical of Gothic sculpture. The sweet, tender expression shows the heritage of the French High Gothic school.

359. Donatello, *Habakkuk (Il Zuccone).*

Donatello, one of the great sculptors of the Italian Renaissance, created a series of five prophets for niches of the Campanile, the bell tower of the cathedral of Florence. This example is seen as the greatest of the five. Called "Il Zuccone," or the pumpkin, for the bald head of the prophet, the actual identity of the prophet is thought to be Habakkuk, a figure from the Old Testament. In this figure, the sentimentality of Gothic sculpture has been abandoned. The free-standing figure has a full-bodied realism not seen since classical antiquity. The heavy drapery echoes the grave, sombre, emotional quality of the figure. That feeling is expressed most strongly in the prophet's face, a portrait-like image of brooding emotion. The realism of the body as well as the orator-like appearance tie this piece closely to Roman tradition, despite its Christian subject.

362. Donatello, *Cantoria.*

A cantoria is a choir loft, a space for the choir above the nave of the church, which allows for better acoustics. This cantoria was originally in the Duomo, or cathedral of Florence. It is now in the cathedral museum. The carved relief panels depict singing *putti,* or baby angels. This heavenly choir is an unruly, energetic lot of chubby figures draped loosely in robes, contained within an architectural framework. They stand behind a colonnade, the columns of which are decorated with a glass mosaic. Above and below, they are framed by classical motifs such as acanthus leaves, amphorae, and *putti* heads. The background is also decorated with a glass mosaic, creating a shimmering, heavenly effect around the angels. The relief carving of the *putti* is carefully designed so that the figures overlap each other at different levels, creating a greater sense of depth than is actually carved. The piece demonstrates the strong influence the sculpture of antiquity had on the work of Donatello.

365. Donatello, *David.*

Donatello's *David* stands, victorious, over the head of the dead giant. He holds the large sword of the giant and wears a hat and boots. The statue caused a small scandal when it was first displayed because of the nudity of the figure. While nudity was not unknown in sculpture, it seems gratuitous here, not required by the subject, as it would be in a portrayal of Adam, for example. *David's* nudity is also accentuated by his hat and boots, which seem incongruous in the absence of other clothing. The statue is also notable in being cast of bronze, showing the advance in that technology. While the *contrapposto* stance is derived from classical models, the figure is more feminine looking than male sculptures from the Greek or Roman worlds.

367. Antonio di Jacopo Benci, called **Antonio Pollaiuolo,** *Heracles and Antaeus.*

In Greek mythology, Antaeus was a giant, son of Gaia, the mother earth. He was invincible, killing all his opponents, until he challenged the hero Heracles. They wrestled, and Antaeus seemed impossible to beat, growing only stronger as Heracles threw him repeatedly to the ground. Because Antaeus was a son of Gaia, he drew strength from contact with the earth. Once Heracles realised this, he could defeat Antaeus by lifting him high in the air. In this sculpture, Heracles, identified by the lion's skin that hangs from his waist, lifts Antaeus in the air. Heracles' muscles strain and the giant struggles against him. Pollaiuolo, a sculptor and painter, created multiple renditions of this mythological struggle. It gave the artist the opportunity to explore the human body under physical strain, and also represented the accomplishment of faith and the human spirit.

369. Agostino di Duccio, *The Moon.*

This relief sculpture is from the Tempio Malatestiano in Rimini. The Tempio Malatesta is also known as the Church of San Francesco, but it was commissioned by the local tyrant Sigismondo Malatesta to be his mausoleum, and so the building bears his name. The sculptor Agostino di Duccio created the sculptural program for the interior of the church. The low relief panel shows a personification of the moon atop the chariot that drove the moon through the sky. The linear quality of the relief shows the influence of engravings; details such as the drapery sweeping around the figure are shown as line and pattern, rather than form. The device of foreshortening is used on the horses' bodies; this visual technique became common in Renaissance art and gave the illusion of depth to a two-dimensional surface.

374. Donatello, *Mary Magdalene.*

In his *Mary Magdalene* Donatello rejects the classical aesthetic almost entirely, letting the emotional expression of his work, seen also in *Il Zuccone* (see no. 359), take over the piece. Not idealised in any way, this image of *Mary Magdalene* shows her as aged, tired, sick, and suffering. The statue is made of wood and has not survived fully intact; it has been damaged and worn over the centuries. The original would have had a finer finish and painted details. Even disregarding the ravages of time, however, it is clear that no effort was made to idealise *Mary Magdalene*. Her ragged appearance calls forth the sympathy of the viewer and reminds one of the fate of a sinner.

375. Desiderio da Settignano, *St John the Baptist.*

This sculpture of *St John the Baptist* owes its realism to the influence of Donatello, for example, his Prophets from the Campanile (see no. 359). Desiderio da Settignano followed the example of Donatello, and created a figure in a classical pose, but with an emotional quality more fitting for a religious image. The figure's body is also, like Donatello's David, a weaker, more feminine body type than would be found in classical sculpture. For the sacred subjects of early Renaissance art, the spiritual power of the figure was more important than the physical power of the body.

378. Niccolò Dell'Arca, *Deploration of the Dead Christ.*

This group of terracotta figures was placed in the Santa Maria della Vita church in Bologna. The life-sized figure on the right expresses the full desolation of mourning, her mouth open in a cry of horror, her body lunging forward towards the dead Christ. The treatment of drapery established in antiquity is at its most dramatic here, the robes of the woman flying out

behind her. The size of the figures and of the group with its multiple mourners, along with the realism of the figures and their emotional states, would have made this installation a heart-stopping sight for viewers in the church.

382. Andrea della Robbia, *The Madonna of the Stonemasons.*

Andrea della Robbia, along with other members of his family, produced glazed terracotta relief sculptures, most with a signature blue background. *The Madonna of the Stonemasons* is considered his masterpiece. The Madonna is depicted in an idealised, classicising manner, with smooth, delicate features. The infant Christ is a chubby, content baby, and the pair is shown in a tender embrace. Wearing halos and surrounded by *putti*, they are clearly in a heavenly realm. Below are four medallions bearing emblems of the guild of the Stonemasons.

388. Tullio Lombardo, *Double Portrait.*

This double portrait, perhaps representing the artist and his wife, is the most celebrated work by Tullio Lombardo. Also renowned for his architectural work, the style of this artist represents the transition between Humanism and Classicism at the end of the fifteenth century in Venice. In this work Tullio Lombardo mixes the influences of Antique sculpture and painted double portraits from the north of Italy in order to represent an event, a wedding (?) through this commemorative sculpture. The style *all'antiqua* (in the Antique style) of semi-nude characters gives them an idealised and timeless quality similar to mythological representations.

With this work (which is not unique, as the museum of Vienna has one also), Tullio Lombardo prepared his contemporaries and his patrons for the arrival of the individual bust portrait.

393. Veit Stoss, *Death of the Virgin and Christ receiving the Virgin.*

The German sculptor Veit Stoss created this enormous painted wooden altar for the Church of St Mary in Kraków, Poland in the latter half of the fifteenth century. Composed in triptych form, the main scene is flanked by wings that include three registers of panels, each panel depicting a scene from the life of Mary. The narrative scenes are enclosed by elaborate Gothic architectural frameworks. An example of German Late Gothic sculpture, the piece is a powerful expression of the Virgin's life, death, and apotheosis. Its impact comes not only from its size, thirteen metres in height, but also from the rich emotional expression of the piece. The agitated movement of the figures and their drapery is meant to reflect the turbulent mental state of the subjects.

394. Anonymous, *St Mary Magdalene.*

This image of *St Mary Magdalene* stands in stark contrast to the slightly earlier example by Donatello. While Donatello's version is a stark, psychological portrait of suffering, this statue from Belgium retains the Gothic style of elegant, gentle features in the face, and elongated proportions of the body, seen especially in the figure's hands. The folds of her gown reveal the influence of classical sculpture; one hand lifts them slightly allowing the sculptor to depict deeper, more complex folds. Her clothing and hairstyle are more in keeping with the style of the time in which she was created than with the subject's own era. She wears a gown with a full skirt and laced bodice, and wears her hair in an elaborate arrangement of braids. In her hands, however, she holds the object traditionally associated with *St Mary Magdalene*, the bottle of fragrant oil she would use to anoint the body of Christ after his death.

396. Francesco Laurana, *Bust of a Lady, Isabella di Aragona, Princess of Naples.*

Laurana's portraits of women have a highly idealised, classicising appearance. Drawing on the tradition of the Etruscan and Roman portrait busts of antiquity, as well as the revival of the art form in the late Middle Ages, Laurana imbues his work with an ethereal quality that instils the subject with some of the saintliness of the Virgin. The heavily-lidded eyes suggest a transformed psychological state of trance or ecstasy. Traditionally, the sculpted bust is made to commemorate the dead, and some of Laurana's work is certainly done in that convention. Portrait busts were also commissioned for the living, however, as was this example. Here, Laurana has depicted the princess with a slight aristocratic hauteur. He shows particular accomplishment in the realism of the details of the neckline of Isabella's gown.

398. Gregor Erhart, *Ravensburg Madonna of Mercy*.

In this representation, the Virgin stands with her cloak held protectively around the people of Ravensburg. Her blue cape contrasts with the gold drapery of her gown, which falls in natural folds over her slightly raised leg. She is depicted in an idealised manner, with the somewhat elongated proportions accorded to Gothic representations of the Virgin. The people she protects, in contrast, are squat, humble, and very mortal-looking villagers. This was a common type of devotional image, and may relate to a statue of medieval law in which a noblewoman may offer the "protection of the mantle," or refuge, to persecuted people in need.

399. Guido Mazzoni, *Salome*.

Guido Mazzoni was a sculptor and painter in Italy in the late fifteenth century. He was also an accomplished designer for the stage, a background that probably influenced his work in creating life-size terracotta groups of ecclesiastical figures. Among the groups he created was one commissioned by Eleanore of Aragon. The Lamentation group consists of seven figures grouped around a figure of the dead Christ. The figure shown here, *Salome*, is one of these. The sculptures show the realism that marked the work of the late fifteenth century. Each figure in the group expresses their pain and horror at Christ's death, each in an individual way. *Salome* seems to be restraining herself, holding herself back from Christ's body. Together, the group has a dramatic, theatrical effect that draws the viewer into the narrative of the Lamentation.

406. Anonymous, *Nostre Dame de Grasse*.

This statue of the Virgin and Christ is the masterpiece of Late Gothic art from Toulouse. It is thought to come from the church of the Frères Prêcheurs. It includes elements both of the Gothic style and of the art emerging from Renaissance Italy, to the south. The sweet, idealised appearance of Mary, as well as her slender, elongated proportions tie the piece closely to other similar Gothic-period representations of the Virgin in France. The naturalism of the poses of the figures, however, and the relaxed, unaffected gesture of Christ reaching away from Mary tie the piece to the new aesthetic of Renaissance Italy. The painted stone has all the appearance of fabric falling around the body draping across the lap of the Virgin. The piece is inscribed "Nostre Dame de Grasse" or "Our Lady of the Chubby One," referring to the pudgy representation of Christ.

411. Tilman Riemenschneider, *Holy Blood Altar*.

Characteristic of the altarpieces of the time and opened only on certain occasions, this monochrome altarpiece in soft wood represents some fundamental Christian scenes. On the left panel one can see Christ, represented sitting on a donkey, entering Jerusalem in all his glory, while, on the right panel he is shown abandoned on the Mount of Olives, surrounded by his sleeping disciples.

In the centre appears a majestic representation of *The Last Supper*. Judas, recognisable by the purse he holds in his left hand, is unusually situated at the centre of the scene, talking to Christ who, on the contrary, stands in the background. Christ, with bread still in his hand, has just announced that the traitor is among them and will give him up to the Romans. Besides fear and indignation, astonishment is also visible on the faces of the apostles, and St John rests his head against Christ in distress. The draped clothing, slightly rigid still, is elaborate but without exaggeration, without zeal or excess. Riemenschneider, who saw himself as part of the medieval tradition, insisted more on the importance of the message than on the quest for pure aesthetics, underlining his detachment from the Italian Renaissance. Here again, the artist abandons the usual polychromy in order to highlight the beauty of lime wood, often used at the time in northern Europe. This unusual representation of the Last Supper, through the premonitory presence of Judas, is perhaps even more important as it suggests a return to the reading of the Scriptures, possibly foreshadowing the approaching Protestant Reformation.

413. Pierre Antoine le Moiturier, *Tomb of Philippe Pot*.

Philippe Pot was part of the court of the King of France and a member of one of the ranking noble families of France. His depiction in death highlights his piety and his identity in the court, showing him dressed as a knight, his hands clasped in prayer. His lineage is also emphasised, through the coats-of-arms held by the eight mourners, members of Pot's family. Their faces are barely visible under the hoods of their mourning cloaks. The weight of their garments, falling in heavy folds, underscore the lugubrious, sombre tone of the funereal sculpture.

416. Michelangelo Buonarroti, *Madonna of the Stairs (Madonna della Scala)*.

Even if this Madonna from the Casa Buonarroti could have been copied from a bas relief attributed to Desiderio da Settignano, a work of which Michelangelo could have made a drawing, the Donatellian influence is more than evident. This small-sized bas relief evokes the modelling of his elder. The position of the sitting Virgin could have been inspired by a deposition of Donatello situated in San Lorenzo. The face of the Virgin is solemn and she stares straight ahead, unperturbed, reminding us of a sleepless Sibyl. Her destiny is insidiously announced by angels, unseen by her, carrying the shroud of Christ in the middle-ground. Beyond motherhood, Michelangelo, as many other artists before him, alludes to the Passion.

As for the Child, heavily built and huddled against his mother in the foetal position, he seems to be dozing. Only his hand, open like that of Mary, shows a will to communicate with the outside world, like a sign of absolute trust. A tension between fear and trust, represented also by the posture of the Virgin, emerges from this major work in the folds of the draped fabric, sometimes a symbol of protection, sometimes a symbol of death. The grace and perfection of the balance visible in this modelling make this bas relief a magnificent High Italian Renaissance work.

419. Tilman Riemenschneider, *Virgin of the Annunciation*.

An example of late Gothic art, this masterwork in alabaster was composed originally of two independent statues, surprisingly of the same size, of the archangel Gabriel and the Virgin Mary. The instantaneous nature of the announcement is striking: Gabriel still open-mouthed, as if he had just spoken. If the attitude of Mary represented opposite, leaning on the writings of the saints, portrays a certain emotion, the door left ajar in the pulpit is nevertheless a discreet sign of the reception of the divine message and its acceptance. The importance given to the feelings of the characters rather than to studied aesthetics underlines the difference in concerns existing at the same time between late northern Gothic and the Italian High Renaissance. This northern art was above all an art of signs and imagery.

The polychrome highlights that one can see on the Virgin were added afterwards by a third party, certainly with finesse, but the quality of the sculpture was sufficient in itself, with no need for additions. Riemenschneider was indeed one of the first of the leading German sculptors who did not paint his works.

420. Michelangelo Buonarroti, *David*.

In starting this work, the young master committed a serious error: forgetting that only adults can be subject to enlargement, as required for a monolith, he took for his model a young boy incompletely developed. That is why the statue has a certain emptiness which clashes with its colossal dimensions. The posture of the figure is most simple; considering the dimensions of the block, a moving pose and violent gestures would have compromised the balance. Perhaps the state of advancement of the work when Michelangelo took delivery of the monolith did not leave him enough volume to work with either. It was obviously a *tour de force* to have extracted from this mass in the form of an extremely long rectangle, a figure as noble and lively as his *David*.

Upright, the weight of the body is carried on the right leg, in a position called *contrapposto*, the left leg forward, the young hero – or one might perhaps say the young god – lets his right arm hang loose halfway down his thigh, while his left arm is bent to shoulder height. With a bold look but a reflective expression, firm footed, he awaits his adversary, calmly calculating, like a true Florentine, the chances of combat, while preparing for attack. The effect of this first masterpiece, a major icon of the High Renaissance, was startling. Florence had never seen such an explosion of enthusiasm, and still today its success remains the same.

422. Pier Jacopo Alari-Bonacolsi, called **Antico**, *Apollo*.

The sculptor Pier Jacopo Alara-Bonacolsi was called "Antico" because of the references to antique sculpture found in his work. He would have not only seen Greek and Roman statues that had recently been rediscovered and curated, but he also made copies of them and even worked on the

restoration of some pieces. Classical subjects and forms inform his work. He is best known for small bronzes such as this one of the archer Apollo, a god of the Greek pantheon. Like some of the bronze statues that survive from antiquity, Antico's bronze are often accented with other metals, such as silver in the eyes or gilding on details. Here, Apollo's cloak, sandals, and his golden hair are gilded, providing a decorative contrast to the duller bronze of the body. Antico took advantage of the technology of his chosen medium and sometimes cast not only the original figurine, but also copies. There are three known versions of this piece.

423. Gregor Erhart, *St Mary Magdalene*.

Of Medieval inspiration, this unusual statue underlines with force the transition between Gothic art and the Renaissance that occurred at this time.

This Swabian sculpture, inspired by an engraving of Dürer named "the beautiful German", represents Mary Magdalene in her most beautiful attire. Hunted by persecution, walking up the valley of Huveaume, she came to preach in Provence before retiring to become a hermit in a grotto in the forest of Sainte-Beaume. Carried by angels, Mary Magdalene have heard the celestial concert every day for each of the seven times of the canonical prayer, not needing any further nourishment. It was rediscovered in 1279 in the crypt of Saint Maximin by Charles II of Anjou. When opened, the sepulchre emitted an astonishingly sweet smell. The principal evangelist of Provence, Maximin was frequently celebrated in the High Middle Ages.

The artist, true to the oral tradition, therefore represents the naked hermit as she is described to us in scriptural testimony. The sensuality of her figure contrasts strongly with the demeanour of her hands joined in prayer. Originally this statue was supported by angels and suspended in a church; perhaps the Mary Magdalene chapel of the Dominican monastery in Augsburg, the town of the artist's birth. The figure in polychrome lime wood, the proportions and the evident harmony in the line begin to move away from the ethereal Gothic canons of the time and announce the first-fruits of the Renaissance.

424. Gregor Erhart, *Vanitas*.

Composed of two women and a young man, all three linked at their backs, their feet soldered to the base, this group in polychrome lime wood has the purposely chosen title *Vanitas*, an allusion to the Old Testament book Ecclesiastes: *Vanitas vanitatum omnia vanitas* (Vanity of vanities, all is vanity). The "vanities", underlying the theories of knowledge flourishing in the sixteenth and seventeenth centuries, are an allegory of life, the dark mirror of human destiny. If a skull is often present in painting, here the decrepitude of the old woman's body is used as a similar symbol, a symbol of death. Separating itself from religious discourse, death is not seen here as a necessary way to salvation; on the contrary, this genre underlines the vanity of life, the absence of meaning and certain future anguish, death being inescapable. The moral indicates a necessary detachment from the earthly pleasures which are considered vain.

The beauty of this sensual couple, insolent with youth, is in strong contrast to the decaying body of the third figure. The emaciated old woman, used by time, symbolises what awaits every human being.

In Erhart's day wooden statues were often coloured in order to highlight the beauty of the sculpture. Holbein the Elder may be at the origin of the polychromy of this group. Through the workmanship and the line of the three sculpted bodies, one can only observe that the relationship with the body that the Renaissance will borrow from Antiquity has not yet been re-established.

428. Michelangelo Buonarroti, *Virgin with Child and St John the Baptist as a Child* (*Tondo Pitti*).

Michelangelo made rough drafts for two bas reliefs a few years after his *David*. One was destined for Taddeo Taddei and the other was commissioned by Bartolomeo Pitti. In Bargello's medallion, undertaken around 1504, the Virgin sits on a simple block of stone (one can note Michelangelo's dislike of all the inventions of the decorative arts, canopies, thrones, etc.) with her left arm around the infant Jesus, holding in front of her and leaning sleepily on the book that rests on her knees. Mary, curled up in a pose of perfect freedom and grace specific to the Golden Age of the Renaissance, looks at the spectator. Behind her, to the left, in the background, appears the small head of St John the Baptist. The motif is most simple but is both full of charm and strength; it shows a young Michelangelo open to fresh and happy impressions. The workmanship of

the Virgin, who has here a prophetic appearance, also evokes, through its modelling, the link between the characters and the occupation of space, the influence of Leonardo da Vinci, who had just exhibited in 1501 his painting of St Anne in Florence.

447. Veit Stoss, *Raphael and Tobias*.

Tobias is a figure in the deuterocanonical book of Tobit. Son of a blind Judaean, during a voyage he met the archangel Raphael, who helped him find and release a woman from the possession of the devil, and also cure his father of his blindness.

Tobias being a common Christian name in northern Europe, it is not surprising to find this theme in a sculpture by Veit Stoss. Favourable to the creation of a group, the subject of *Tobias and the Angel* was however commissioned by a rich Italian.

If the treatment of the clothing is somewhat rigid, the absence of polychromy differentiates Veit Stoss from the other Gothic sculptors of the time. However, the position of the figures and their standardised gestures place this group in the mainstream of Gothic and Medieval work.

456. Juan de Juní, *Entombment*.

A principal figure of Hispanic Mannerism, Juan de Juní offers us with this *Entombment* a monumental example of the spiritual feeling preached at the time in Spain. Commissioned by Fray Antonio de Guevara, Franciscan bishop of Mondoñedo and chronicler for the Emperor Charles V, this group was discovered in the now disappeared convent of San Francisco in Valladolid.

Under the influence of mystic thinking, sculptural works such as this entombment illustrated the physical experience of pain and suffering, portraying them in an outrageously expressive style using violent movements, torsions and other facial distortions provoked by an immense affliction.

This style, very specific to Spain, finds its roots firstly in the classical statues of the Renaissance and secondly, in the statuary of Burgundy, making this national school a receptacle rich in artistic experience from other regions of Europe.

458. Benvenuto Cellini, *The Salt Cellar of Francis I*.

Cellini, sued for many major misdemeanours, was freed from the Castel Sant'Angelo by the King of France Francis I. He remained in the service of his patron from 1537 to 1545. Stolen in 2003 and recently found again, the salt cellar that Francis I commissioned from the artist is today still his most coveted work. Made of enamelled solid gold on an ebony pedestal, it is principally composed of two statues symbolising the union of Earth and the Ocean, Ceres and Neptune, who overlook an allegory of life, and also of the gods of the four winds who highlight the impassive flow of time. Ceres, whose Horn of Plenty symbolises fertility, is the guardian of the Ionic temple situated to her right and destined to hold the pepper. As for the finely decorated boat to the right of Neptune, easily recognisable by his trident and his shell chariot, it is the receptacle for as much salt as necessary. The position of the two perfectly balanced statues highlights one of the characteristics of Mannerism, the sophistication of poses. The sensuality of the bodies that confront each other, notably Ceres, whose hand caresses her breast, also confirms this point of view. This masterpiece is the most important achievement in goldsmithing that remains from the late Renaissance and the only one to be attributed with certainty to the great Italian smith.

460. Francesco Primaticcio, *The Room of the Duchesse d'Etampes*, now called the *"Escalier du Roi"*.

A perfect combination of stucco, fresco and wood panelling, this piece, which powerfully celebrates the story of Roxanne and Alexander, was constructed according to the wishes of Francis I for his favourite mistress, Mademoiselle d'Etampes, between 1541 and 1544. Transformed thereafter by Gabriel, for Louis XV to give access to his apartments, this work indeed changed names throughout the centuries. The aesthetics of the bodies exulting in sensuality and the harmony of line betray the hand of the master who had, thanks notably to the use of *forma serpentina*, a great influence on decorative arts. Called by Francis I to team up with Fiorentino Rosso, the two artists merged with tautness the Mannerist inspiration and respect for the place, this successful combination giving its name to the "First School of Fontainebleau".

465. Benvenuto Cellini, *Perseus.*

True to the description of Ovidian tales of *Metamorphosis,* this bronze statue was in 1545 a commission from Duke Cosimo I de' Medici to the Florentine goldsmith and sculptor Cellini, the embodiment of Tuscan Mannerism. In response to *Judith* by Donatello, created to celebrate the fall of the Medici, *Perseus,* symbolising the power of the Medici, carries as a sign of victory the decapitated head of Medusa, symbol of the aborted rebellion of the Florentine people. Disconcerting in its resemblance, the finesse of Perseus' face can also strangely be found in that of Medusa, leaving the door open for all sorts of interpretations.

Exalting the beauty of the body in repose, the sensuality of *Perseus* also highlights the sexual ambivalence that was sought at the time, the female nude being then developed strongly. The stylistic quest and the exacerbated torsion of the body, as in Mannerism, incite the spectator to walk around the work as it cannot be taken in from one single point of view. Aesthetics are strongly preferred to expression. *Perseus,* in his provocative but elegant pose, embodies the strong characteristics of Italian Mannerism.

467. Ligier Richier, *Flayed* or *The Skeleton.*

Wrongly called the "skeleton", this *transi* (rotting cadaver) standing on his feet represents René Chalon, Prince of Orange, who at the age of twenty-five died in combat opposing the troops of Charles V and Francis I in 1544.

Commissioned three years later by his wife, Anne of Lorraine, the sculpture by Ligier Richier overlooks the tomb containing the heart and entrails of the prince.

The work represents him as a skinless body, holding his heart in his hand, and numerous interpretations are possible: the superiority of the spirit over the heart or a mark of penance.

Considered a major artist of the late Gothic period, Ligier Richier combines here precision and realism in the rendering of the flayed body, allowing one to imagine that the sculptor had a deep knowledge of anatomy, more perhaps in keeping with the humanist spirit of the Renaissance.

472. Germain Pilon (and **Francesco Primaticcio**), *Tomb of Henri II and Catherine de' Medici.*

Erected originally in the chapel of the Valois, this imposing funeral monument for Henri II and Catherine de Medici was supervised by Primaticcio and sculpted by Ponce Jacquiot and Germain Pilon between 1566 and 1573. Even though there were six sculptors who received commissions, Jacquiot and Pilon were the only ones to honour them, as the others died beforehand. The original instructions for the funeral monument were dictated by the queen herself. Realised in marble and bronze, this monument has four pillars, each composed of eight Corinthian statues. On the platform are statues of Henri II and Catherine de' Medici at prayer, in the angles the cardinal Virtues, and at the centre the recumbent statues of the sovereigns. In superimposing and multiplying the different representations of the king and queen sometimes praying, in full glory, and sometimes lying, inanimate, Primaticcio shatters the conventions of the time. The bodily and human dimension is compensated by the spiritual dimension represented by the praying figures. The recumbent statue of Catherine de' Medici was originally a *transi* (rotting cadaver) commissioned from Della Robbia, but as the idea was too shocking to the sensitivities of her circle, it was replaced at the order of the queen herself by a less frightening recumbent statue sculpted by Pilon, who also oversaw the upper part of the monument.

475. Jean Goujon, *Nymph and Triton.*

This bas relief was part of a fountain, made by Jean Goujon to celebrate the official entry of Henri II into Paris. Re-erected in the form of a kiosk in the centre of the Place des Innocents (a former children's cemetery) in 1787, it was recreated as a fountain at the beginning of the nineteenth century. Later rendered useless because the state of the water piping had been improved under the Empire, this bas relief was extracted from the foundations of the fountain to protect it from deterioration. Sculpted by Jean Goujon, it is of Antique inspiration. The mythology recounts that Triton, god of the salt lake of Tritonis, son of Poseidon and Amphitrite, was defeated because he fell asleep completely drunk after drinking a crate of wine down to the dregs. It is also the name given to his descendants; they have the body of a man and the tail of a fish. The symbols of the Tritons are the conch shell and the trident, and they form, with the Nereids, the

procession of the greatest sea gods. These processions were frequently represented on Antique sarcophagi. In this bas relief, the nymphs and marine volutes fill perfectly the frame of the sculpture, in which Jean Goujon offers us a new approach to space. The fluidity of the line and the aesthetic concerns of the figures highlight the perfect mastery of Mannerist sculpture by the artist. He returns to a point of Antiquity and idealised Hellenistic beauty.

478. Pierre Bontemps, *Urn containing the Heart of Francis I.*

The King Henri II commissioned for his father, Francis I, a sumptuous tomb, conceived by the architect Philibert Delorme and made by the sculptor Pierre Bontemps, in the Abbey of Saint-Denis, the necropolis of the Kings of France, where the urn is still conserved. On the principal platform of the sepulchre can be found five praying statues, Francis I, Claude de France, his wife, daughter of King Louis XII and Anne de Bretagne, and three of their children. However, Bontemps did not sculpt an effigy of the king for the monument of the heart, having made one for his tomb, but decorated it richly instead. The coat of arms, sculpted on the basin, composed of three *fleurs de lys*, represents the arms of the Kings of France. The number of lilies present on the arms was restored to three by Charles V in honour of the Holy Trinity. These lily flowers symbolise purity but also the dynastic succession and the rise of the people. The bas reliefs, sculpted with finesse, celebrate the important patronage of the great king during his reign, as well as the sumptuousness of his court, and testify to the quality of this sculptor who assisted Primaticcio in the decoration of the château of Fontainebleau.

479. Jean Goujon, *Caryatid.*

Reduced to slavery, the women of the town of Karyes (Laconia), whose people were decimated by the Greeks, were condemned to carry heavy loads. The Caryatids therefore became sculptures of hieratic and impassive women which replaced the columns of temples, notably in the porch of the Erechtheion. It is the description of this temple that influenced Jean Goujon in the *Caryatids* he made for the Louvre in 1550. Supporting the musicians' platform in the Swiss Guards' Hall, these monumental statues finally gave their name to this room situated in the west wing of the Louvre, constructed by Pierre Lescot between 1546 and 1550.

The incredible harmony of proportions of these elegant Caryatids highlight the knowledge Goujon had of the texts of Vitruvius. In the French version of *De Architectura* published in 1547 one can find original engravings by the sculptor in the first two books, notably the one devoted to Caryatids. The delicate Mannerism of the drapery, the perfect workmanship of these *porteuses* of stone, make Goujon one of the greatest sculptors of the School of Fontainebleau.

481. Giambologna, *Mercury.*

Around 1560 Giambologna received a commission from Pope Pius IV for a Mercury in bronze, his finger raised in the direction of God, the infinite source of knowledge. Even though the commission was cancelled, this winged god was such a success that it was reproduced in different sizes for some of the most powerful sovereigns of the time, such as Francis I, who ordered two, Ottavio Panese, Duke of Parma, Ferdinand I and even Cosimo I. Five of them can be attributed with certainty to the sculptor. It is therefore easy to understand the incredible influence that Giambologna had throughout Europe, as his works travelled easily.

These small statues were often gifts in order to smooth international affairs and to reinforce alliances. This *Mercury* from the Louvre, reproduced here, was a gift to the Emperor Maximilian II during the diplomatic negotiations regarding the marriage of Francis de' Medici, who became the patron of Giambologna, and Anne of Austria.

The foot of his *Mercury* is resting on the breath of Zephyr, whose head is mounted on a medallion dedicated to Maximilian, a sign of protection.

Nevertheless, this choice was purposely made. The messenger of love, Mercury (or Hermes to the Greeks), has the ambivalence to not only be the messenger of the gods of Mount Olympus, which could be flattering for its recipient, but also of commerce and trade. The body of *Mercury* with its rangy figure astonishingly resembles that of *Perseus* (see no. 465) by Cellini.

The harmony of line is perfect, the stretched right arm in *contrapposto* balancing the position of the body, which rests with grace on the left leg, and also the parallel formed by the caduceus (Mercury's traditional staff or wand) with the arm stretched towards the sky as if in homage. The finesse of execution and the magnificent pose, conceived in a spiral encouraging the spectator to walk around this masterpiece, make this sculpture an admirable example of Mannerism at its height.

485. Bartolommeo Ammanati, *Fountain of Neptune*.

Ammanati had to compete with Cellini and Giambologna to sculpt the Neptune originally commissioned by Cosimo de' Medici from Bandinelli.

Finally, Michelangelo and Vasari, who were commissioned to name the sculptor, chose Ammanati, an experienced stonecutter. A celebration of the marriage of Francis de' Medici to Anne of Austria, this imposing marble and bronze statue also symbolises the power of the Medici sought by Cosimo I, and highlights in filigree the naval power he wanted to give to Tuscany.

For the face of the god of the sea, Ammanati drew his inspiration from his patron, Cosimo I, who is lifted by a base of four horses emerging from the water. It evokes the particular efforts that Cosimo was making to supply the city with water. The baton held by Neptune could be a symbol of his protection. The god of the oceans appears here at the height of his powers, peacefully observing his city. The other gods, the laughing satyrs and other seahorses which he added afterwards, also reinforce the Mannerism of the whole group. When one observes the *Fountain of Neptune* situated in the Piazza della Signora next to a copy of Michelangelo's *David*, one can see the major influence that Michelangelo had on Ammanati.

493. Giambologna, *The Rape of the Sabine*.

The Rape of the Sabine by Giambologna is an outstanding example of this artist's virtuosity. If the allusion to a mythological episode is evident in its name, others see in it an allegory of the three ages of life: the fragile adolescent, the grown man at the height of his physical prowess, and the old man. Beyond the fine use of technique shown in this group of three balanced figures sculpted from one unwanted block of marble, this single sculpture embodies the technique of the *figura serpentina* that found its perfect expression in the work of Giambologna, and in this sculpture in particular. In his work, the artist transforms the comprehension of sculpture itself as the spectator is invited to participate in the work.

This sculpture can and must be seen from all angles with equal emotion and intensity. The complexity of the twisted position of the marble group and the finesse of the bodies make this work one of the most beautiful Mannerist sculptures, and puts Giambologna at the summit of his art. His search for aesthetics seems to be at the height of its powers. For more than three centuries Giambologna's sculptures were preferred to any others, with the exception of Michelangelo, his model. His research on the rendering of movement and lift would influence many of his successors such as Bernini. The history of sculpture recognises him as the evident and necessary link between Michelangelo and Bernini, his style influencing the whole Baroque movement.

494. Adriaen de Vries, *Mercury and Psyche*.

A student of Giambologna, Adriaen de Vries makes here his greatest homage to his master. The sylph-like figure of his *Mercury* is indeed directly inspired by the Mannerist sculpture of Giambologna, as is the spiralling group construction.

Psyche appears victorious, after having solved the last task imposed by Venus due to her jealousy. Therefore she raises proudly the object of her success, a bottle containing the beauty ointment of Persephone which she had stolen from the underworld. Mercury, the messenger of love and of the gods, comes to take her to her lover, Cupid, to celebrate their long-awaited marriage. Through her wanderings, Psyche became the symbol of the deposed soul, uniting the divine love. Promised a renaissance, she is also sometimes represented with the wings of a butterfly. In an erotic and sensual impulse, Mercury here lifts up Psyche in an unbalanced movement characteristic of Mannerism; only the draped fabric re-establishes the stability of the couple. The ascending dynamics, perceptible thanks to the draped clothing and the movement of the figures, highlights the aerial grace of the sculpture. The stretching of the figures, seen in the extremely long fingers, and the slightly provocative postures give to the group a Mannerist style very fashionable

in Florence and Fontainebleau, and in Prague where this work was created. Rudolf II, the recipient of the piece, was a fervent supporter of the arts and sciences, and contributed to the development of this movement in northern Europe, instead of consolidating his political alliances. This sculpture can be considered as homage to the arts, and Mannerism in particular.

497. Workshop of **El Greco**, *St Ildefonso receiving the Chasuble*.

El Greco is known for his paintings but much less for his sculpture. Yet we know that he directed a workshop for which he undertook many sketches, one of them being for this group representing the Virgin giving St Ildefonso his chasuble.

Bishop then Archbishop of Toledo in the middle of the seventh century, St Ildefonso is known for having unified the Spanish liturgies. Author of several books, he wrote a treaty defending the perpetual virginity of Mary and developed the Marian cult. To thank him, the Virgin gave him a chasuble in the presence of a number of angels and saints (Agatha, Anthony, Apolline, Catherine, Leocadia and Lucy).

The sculptural works undertaken by El Greco's workshop are not the most well known examples of Spanish sculpture, but were a source of significant inspiration for artists of the time such as Pedro de Mena and Alonso Cano.

499. Germain Pilon (and Domenico del Barbiere), *Monument containing the Heart of Henri II*.

Following a commission from Catherine de' Medici to preserve the heart of her husband Henri II, Germain Pilon, under the direction of Primaticcio, who was the superintendent of all the royal buildings, sculpted for this monument three graces in white marble. The elongation of the figures, typically Mannerist, accentuates the impression of the circular movement originally given by the position of the arms. The magnificence of these hieratic vestals contrasts with the tumult of the draped fabric whose folds seem to absorb light. This reference to Antiquity, probably to Hecate, the goddess of the moon, often represented with three heads or three bodies, was for a long time controversial.

Nevertheless, the idea of a reference to conjugal fidelity, also symbolised by The Three Graces in Roman times, seems to be preferred today, and is confirmed by the engraved inscriptions on the base. Erected originally in the chapel of the Célestins in Paris, which gave the three women the religious symbol of theological virtues, this work has been exhibited in the Louvre since 1817.

Originally in bronze, the gold wooden vase, conceived by the Italian artist Dominique Florentin, which is held above the three women, contains the heart of the king, Henri II, whose death had been dreamt by his wife the night before, and who succumbed to injuries received in a jousting tournament against Gabriel de Montgomery.

501. Germain Pilon, *Mater Dolorosa*.

It was while working on the funeral commissions of Catherine de' Medici and Henri II that Germain Pilon undertook his *Virgin of Pity*. The original version of the marble statue was meant to decorate the Chapel of the Valois in the royal necropolis, the Basilica of Saint-Denis, but this terracotta was placed during the seventeenth and eighteenth centuries in the lower chapel of the basilica. Originally painted in white, the work was, for an undetermined period, richly polychrome.

In the form of a pyramid – perhaps recalling the Holy Trinity – the work is divided into two parts by the technique of *mise en abîme* (placing into infinity). The sculpted work produces a triangular form in which the acute angle is the face of the Virgin, ending in the line of the draped fabric resting on her knees. Between this line and its parallel, created by the crossed hands, one finds a kind of emptiness, a sort of absence. It is for her Son that this woman cries. The central point of this geometric form seems to be not the face but the hands, excessively conspicuous, crossed on her heart. The hands are in repose, as peaceful as her expressionless face. The contrast of the draped fabric, whose folds simulate movement, seems to reflect the torment that burdens this mother after losing her Son. The emotion of this magnificent work is itself glorified by the constraint and the contemplation of the Virgin whose pain is invisible. The elongation of the hands and the folds of the draped fabric put this work firmly in the Mannerist tradition.

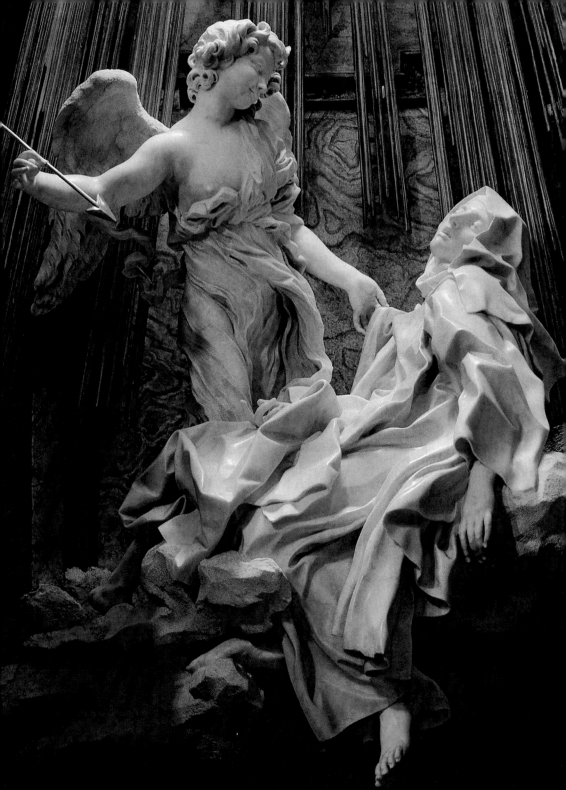

BAROQUE

Baroque sculpture, like painting of the same period, arose from a background of Mannerism. The earlier style was self-conscious, smooth, elegant, and sometimes icy. Baroque masters worked in a manner that was more naturalistic and palpable, and was often genuinely emotional and physically vigorous. The baroque style in sculpture was championed early on with the art of Gian Lorenzo Bernini, whose father Pietro practised a competent, cool, and somewhat fussy version of Mannerism, a style soon rejected by his prodigious son. Gian Lorenzo dominated the art of his time. He achieved particular fame in early manhood with a series of classical and biblical figures – *Apollo and Daphne* (see no. 530), *Pluto and Proserpina* (see no. 527), and *David* (see no. 529) – for Cardinal Scipione Borghese. By the later 1620s Bernini had developed a high baroque style with ecstatic actors, active draperies, and almost rubbery figure types that expressed the intense state of ecstasy, contemplation, conversion, and joy in martyrdom. Bernini, skilled also in painting, architectural design and theatrical staging, unified the visual arts, and he utilised sculpture as part of a larger ensemble. This can be seen in his Cornaro Chapel in Santa Maria della Vittoria, where the ecstatic *St Teresa* (see no. 502) appears surrounded by members of the Cornaro family, skeletons coming alive in the pavement, and a host of angels appearing overhead, one of whom flies down to visit her.

The high baroque manner of Bernini and others had to compete with more classicising strains in the seventeenth century. By the first decade of that century,

Stefano Maderno had established a naturalistic and vigorous manner inspired by the art of antiquity. François Duquesnoy, born and raised in Brussels, furthered his career in Rome in competition with Bernini. Duquesnoy practised a Classicism shared by such artists as the painters Andrea Sacchi and Frenchman Nicolas Poussin. In the crossing of St Peter's, Duquesnoy's *St Andrew* stood in contrast to Bernini's more agitated *St Longinus* (see no. 539). Also embracing more of a classical tendency than Bernini was Alessandro Algardi, whose workshop rivalled Bernini's for commissions in the papal city. Still, Bernini's art stood out, and he employed an army of assistants, who worked in his style in the most visible and important sites in Rome, from the fountains, to the high altars, to portraiture displayed in the private *palazzi* of the city.

Bernini travelled abroad and worked for foreign patrons in Italy, and his style crossed the Alps and left its mark. For Louis XIV he created a marvellous bust, with sweeping drapery and with the implication that the ruler was about to speak and give a command. Bernini's equestrian monument for Louis was less well received, and his architectural projects for the French capital never came to fruition. The French had developed a taste along different lines, favouring instead the classical manner of Charles Le Brun and Poussin in painting, and in sculpture by François Girardon, who for a time dominated the sculptural world of Louis XIV the way classicists Le Brun, Louis Le Vau, and Claude Perrault did in other arts. Girardon's *Apollo tended by Nymphs of Thetis* (see no. 569) at Versailles represents, in essence,

the *Belvedere Apollo* (see no. 90) of antiquity come alive and seated with a royal ease befitting his role as a mirror of Louis XIV, the Sun King himself. The Classicism is reminiscent of the ideal and composed Classicism of Greco-Roman antiquity, and could hardly differ more from the high baroque style of Bernini or of an artist such as the Frenchman Pierre Puget, who turned to Hellenistic antiquity as a model for his emotional and dramatic artistry.

The baroque style was an international style, and manifestations of it appeared across Europe and beyond. In Spain, inspired by the Catholic Counter-Reformation styles of Italy, sculptors such as Alonso Cano developed a naturalistic, serene, and quietly emotional manner. Later Spanish sculptors were more in the high baroque tradition: that style was especially effective on large church facades, and migrated across the Atlantic, as seen in the mission carvings by Pedro Huizar near San Antonio, Texas. Indeed, the Spanish baroque flourished throughout the New World along with the expanding Hispanic culture. Even closer to the Italian high baroque is the work of the German Egid Quirin Asam, whose airborne and illusionistic *Assumption of the Virgin* (see no. 609) dominates the monastery church in Rohr. Very different was the Dutch baroque in sculpture, exemplified by Rombout Verhulst, whose mid-seventeenth century works are of firm design and convincing verisimilitude, worthy counterparts of the painting style of the Dutch Golden Age. In England, a school of sculpture was slow to get started, and the art form was principally known by the architectural sculpture and the carvings in interiors. In the latter respect, the swags of fruit and other elements by Grinling Gibbons have an abundant naturalism that links them to the baroque of continental Europe.

France took a leading role in the visual arts in the eighteenth century, and the death of Louis XIV brought a change in attitude of the French patrons, who now were interested in a less grandiose and weighty style. Rococo art, a light, elegant, and decorative development from the baroque, was ideal for interior decoration, and can be regarded principally as a decorative art in its sculptural manifestations. In Germain Boffrand's Salon de la Princesse in the Hôtel de Soubise in Paris, the artistic team shaped the decoration according to a new feeling for asymmetry and smaller-scale, delicate flourishes. The architect François de Cuvilliés brought this style to south Germany in his Amalienburg for the Elector of Bavaria, where the sculpture works with the architecture to define wall surface with asymmetrical elements, aspects drawn from East Asian design, and fleeting, silvered glimpses of leaves and birds in flight.

In the area of independent sculpture, the rococo artist Claude Michel (Clodion) answered this call with smaller pieces. His works are characterised by their unified terracotta substance, small scale, delicately articulated surfaces, and amorous, or even erotic, subject matter. Some of his works border on the pornographic and were perfect for pleasure-loving aristocrats of the *Ancien Régime*. Such merriment, and the hedonistic attitude that brought it about, came to a crashing halt in the French Revolution. Clodion himself lived through those tumultuous times, but had to alter his style. The events of 1789 put an end to the French rococo, which was already being challenged by a developing taste for the neoclassical.

See next page:
503. **Etienne-Maurice Falconet**, 1716-1791, French.
Flora, c. 1770. Marble, h: 32 cm.
The State Hermitage Museum, St Petersburg (Russia). Rococo.

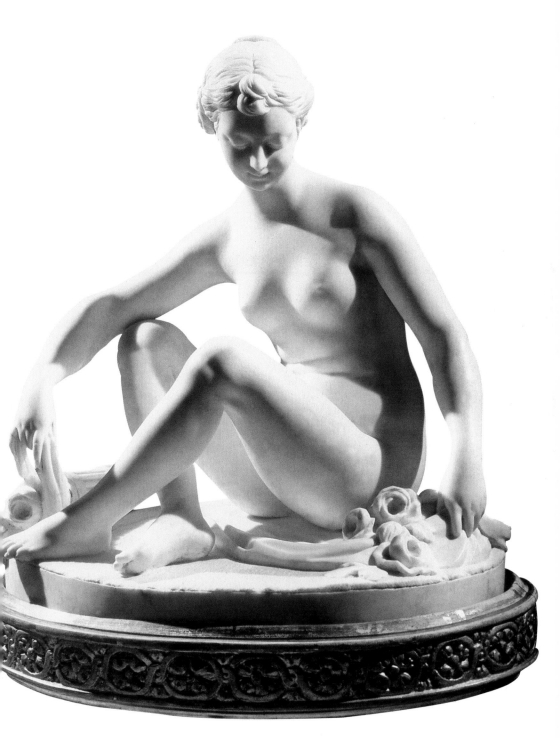

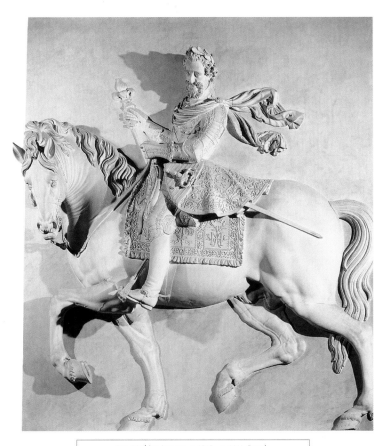

504. **Mathieu Jacquet**, c. 1545 – c. 1611, French.
Equestrian Portrait of Henri IV, Low Relief from the *"Belle Cheminée"*,
1600-1601.
Stone and marble.
Musée national du Château, Fontainebleau (France). In situ. Mannerism. (*)

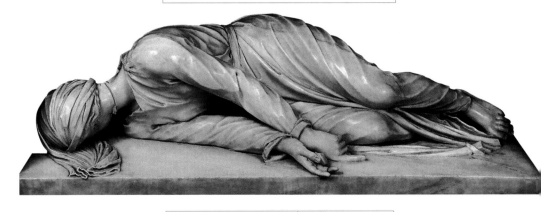

505. **Stefano Maderno**, 1576-1636, Italian.
St Cecilia, 1600. Marble, l: 130 cm.
Santa Cecilia in Trastevere, Rome (Italy). In situ. Baroque. (*)

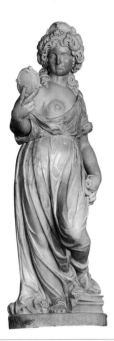

506. **Ippolito Buzio**, 1562-1634, Italian.
Prudence, 1604. Marble, h: 133 cm.
Santa Maria sopra Minerva, Rome (Italy).
In situ. Baroque.

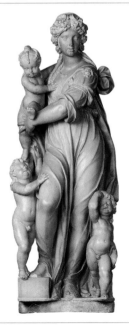

507. **Nicolas Cordier**, 1565-1612, French.
Charity, 1604-1608. Marble, h: 134 cm.
Santa Maria sopra Minerva, Rome (Italy).
In situ. Baroque.

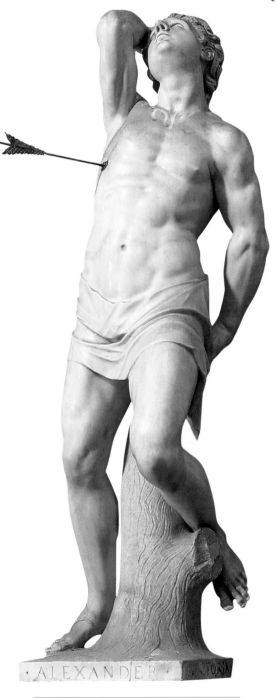

508. **Alessandro Vittoria**, 1525-1608, Italian.
St Sebastian, c. 1600. Marble, h: 170 cm.
San Salvatore, Venice (Italy). Baroque.

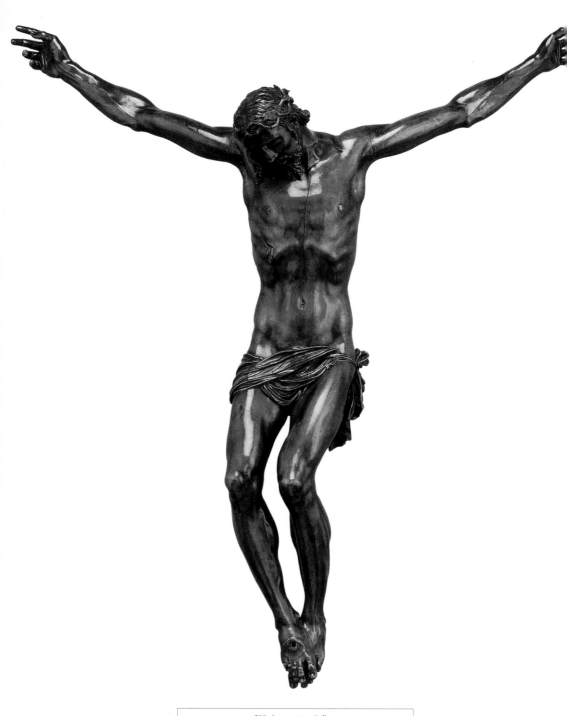

509. **Anonymous**, Italian.
Corpus, c. 1600. Wood, h: 30.5 cm.
J. Paul Getty Museum, Los Angeles (United States). Baroque.

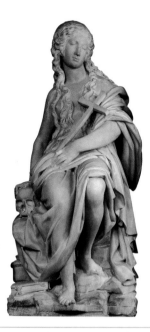

510. **Cristoforo Stati**, 1556-1619, Italian.
St Mary Magdalene, 1609-1612. Marble, h: 210 cm.
Sant'Andrea della Valle, Rome (Italy). In situ. Baroque.

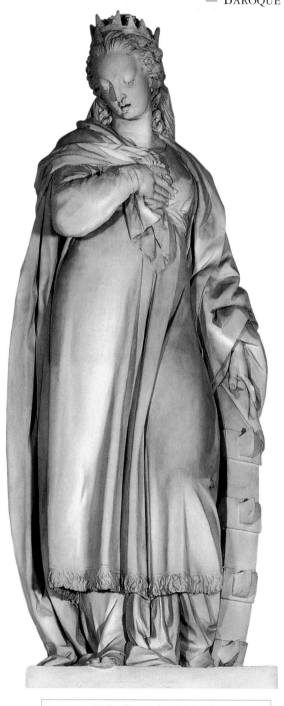

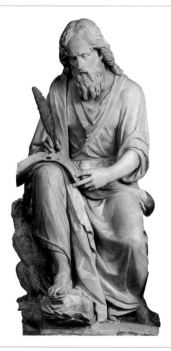

511. **Ambrogio Buonvicino**, 1552-1622, Italian.
St John the Evangelist, 1610-1612. Marble, h: 215 cm.
Sant'Andrea della Valle, Rome (Italy). In situ. Baroque.

512. **Camillo Mariani**, 1565-1611, Italian.
St Catherine of Alexandria, 1599-1600. Stucco, h: 310 cm.
San Bernardo alle Terme, Rome (Italy). In situ. Baroque.

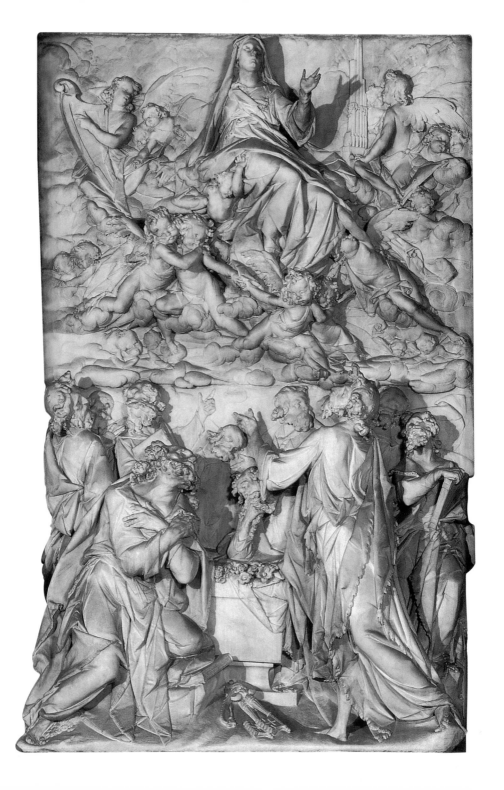

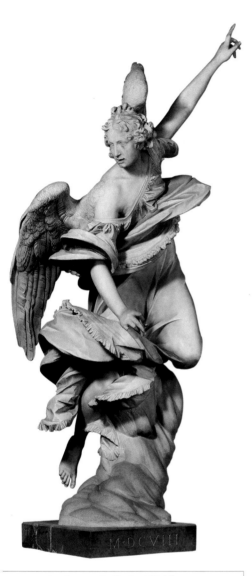

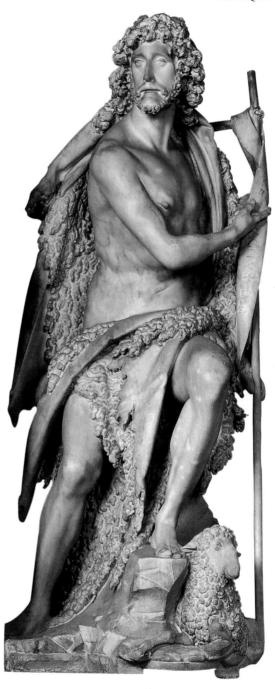

514. **Francesco Mochi**, 1580-1654, Italian.
Angel Annunciate, 1605-1608. Marble, h: 185 cm.
Museo dell'Opera del Duomo, Orvieto (Italy). Baroque. (*)

See previous page:
513. **Pietro Bernini**, 1562-1629, Italian.
The Assumption of the Virgin, 1607-1610. Marble, 245 x 390 cm.
Santa Maria Maggiore, Rome (Italy). In situ. Baroque.

515. **Gian Lorenzo Bernini**, 1598-1680, Italian.
St John the Baptist, 1615. Marble, h: 243 cm.
Sant'Andrea della Valle, Rome (Italy). In situ. Baroque.

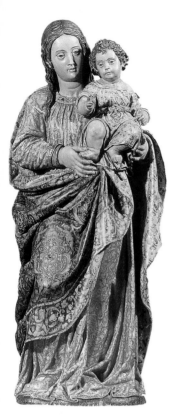

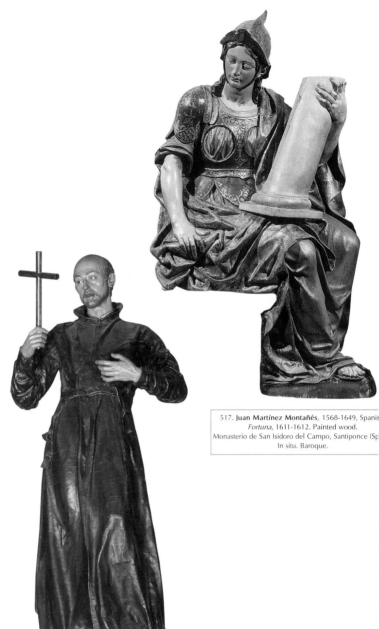

516. **Juan Martínez Montañés**, 1568-1649, Spanish.
Virgin with Child, 1609-1610. Painted wood, h: 78 cm.
Capilla del Reservado, Monasterio de San Isidoro del
Campo, Santiponce (Spain). In situ. Baroque.

517. **Juan Martínez Montañés**, 1568-1649, Spanish.
Fortuna, 1611-1612. Painted wood.
Monasterio de San Isidoro del Campo, Santiponce (Spain).
In situ. Baroque.

518. **Juan Martínez Montañés**, 1568-1649, Spanish.
St Ignatius of Loyola, c. 1610. Painted wood, h: 167 cm.
Iglesia de la Universidad, Seville (Spain).
In situ. Baroque. (*)

See next page:
519. **Jörg Zürn**, 1583-1635/38, German.
Altar of the Virgin, 1613-1616. Spruce and limewood, h: 10 m.
Überlingen Kirche, Überlingen (Germany). Baroque. (*)

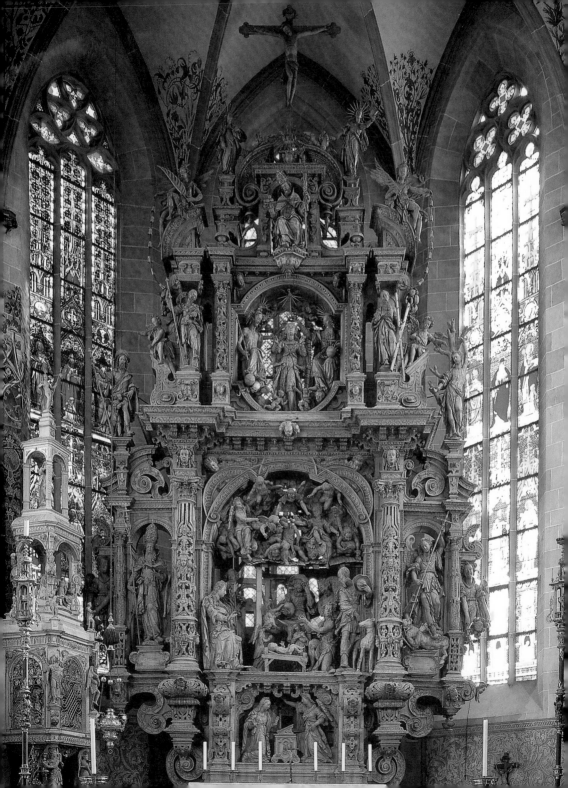

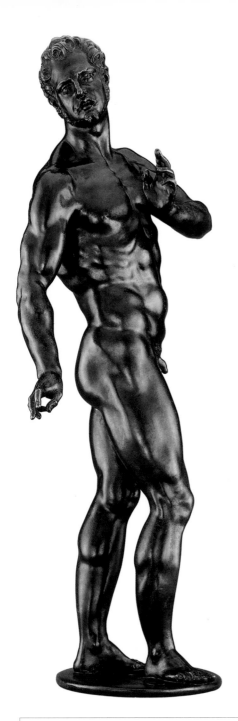

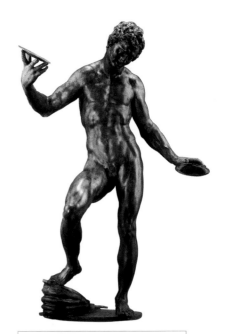

521. **Adriaen de Vries**, c. 1560-1626, Dutch.
Juggling Man, 1610-1615. Bronze, h: 76.2 cm.
J. Paul Getty Museum, Los Angeles (United States).
Mannerism.

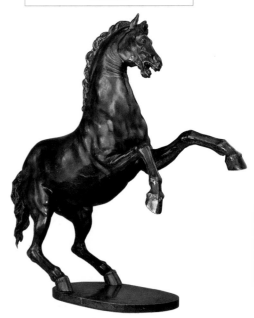

520. **Tiziano Aspetti**, 1559-1606, Italian.
Male Nude, c. 1600. Bronze, h: 73.7 cm.
J. Paul Getty Museum, Los Angeles (United States). Baroque.

522. **Adriaen de Vries**, c. 1560-1626, Dutch.
Rearing Horse, 1610-1615. Bronze, h: 48.3 cm.
J. Paul Getty Museum, Los Angeles (United States).
Mannerism.

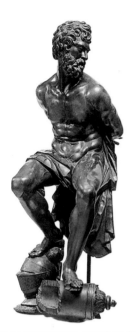

Pierre Francqueville (and Francesco Bordoni), 1548-1615, French.
Figure from the equestrian statue of Henri IV on the Pont-Neuf (Paris),
1614-1618. Bronze, 160 x 64 cm.
Musée du Louvre, Paris (France). Mannerism.

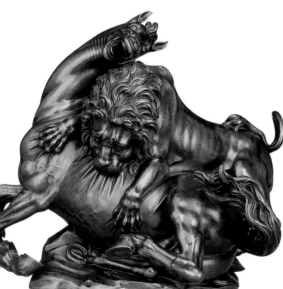

524. Antonio Susini, active 1572-1624, Italian.
Lion attacking a Horse, 1600-1625. Bronze, 22.9 x 28 cm.
J. Paul Getty Museum, Los Angeles (United States).
Baroque.

525. Nicolas Cordier, 1565-1612, French.
Moor, c. 1610. Black marble,
inlays of polychrome stones and gilts, h: 175 cm.
Musée national du château de Versailles, Versailles (France). Baroque.

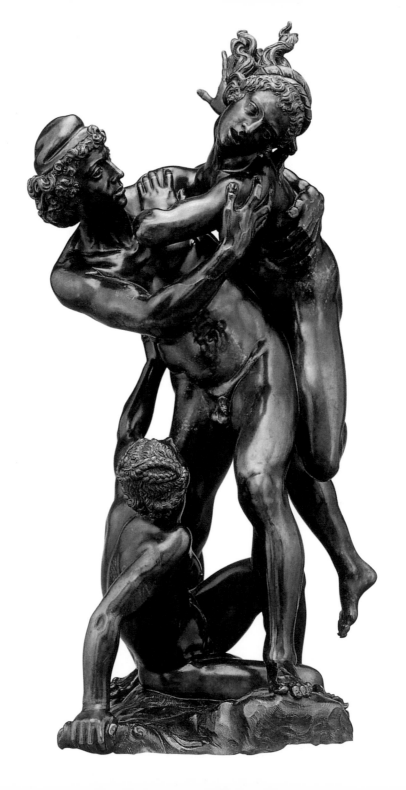

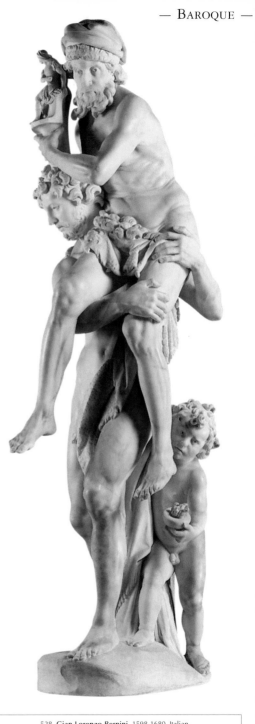

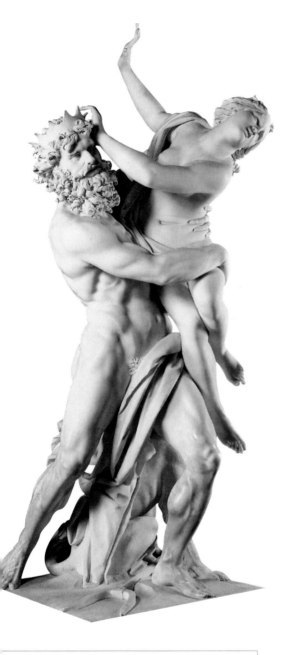

527. **Gian Lorenzo Bernini**, 1598-1680, Italian.
Pluto and Proserpina, 1621-1622. Marble, h: 225 cm.
Galleria Borghese, Rome (Italy). Baroque.

See previous page:
526. **Giovanni Francesco Susini**, 1585-1653, Italian.
The Abduction of Helen by Paris, 1627.
Bronze on a gilt bronze base, h: 68 cm (with base).
J. Paul Getty Museum, Los Angeles (United States). Baroque.

528. **Gian Lorenzo Bernini**, 1598-1680, Italian.
Aeneas and Anchises, 1618-1619. Marble, h: 220 cm.
Galleria Borghese, Rome (Italy). Baroque.

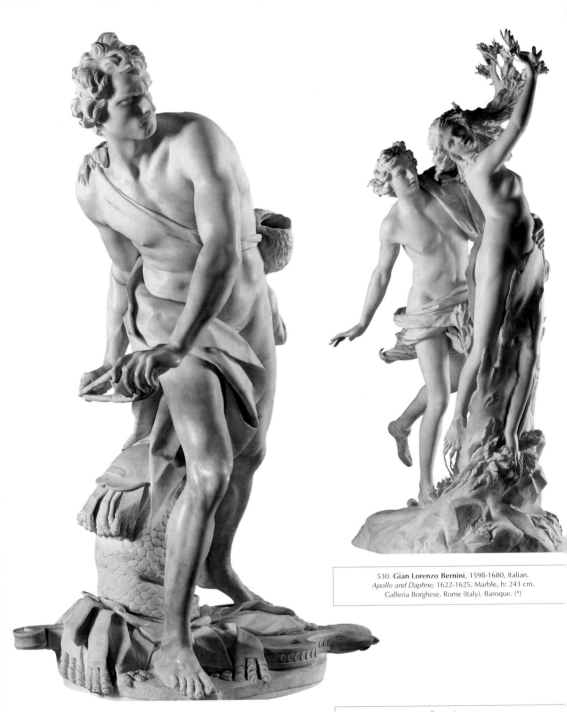

529. **Gian Lorenzo Bernini**, 1598-1680, Italian.
David, 1623-1624. Marble, h: 170 cm.
Galleria Borghese, Rome (Italy). Baroque. (*)

530. **Gian Lorenzo Bernini**, 1598-1680, Italian.
Apollo and Daphne, 1622-1625. Marble, h: 243 cm.
Galleria Borghese, Rome (Italy). Baroque. (*)

See next page:
531. **Gian Lorenzo Bernini**, 1598-1680, Italian.
Monument to Pope Urban VIII, 1627-1647. Golden bronze and marble.
St Peter's Basilica, Vatican (Italy). In situ. Baroque.

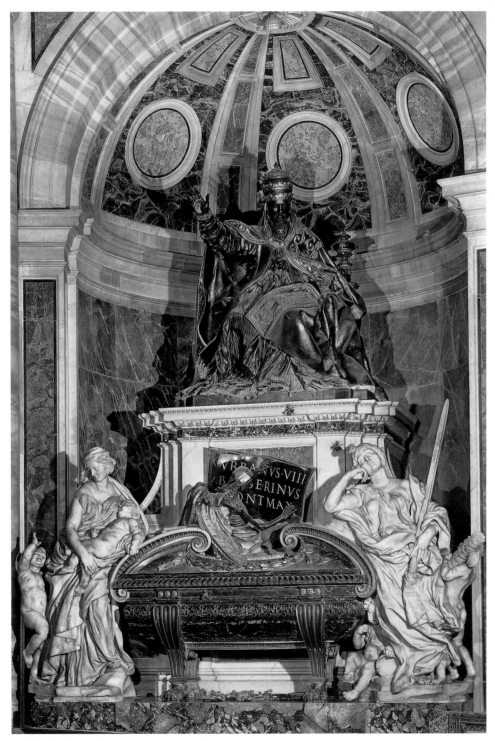

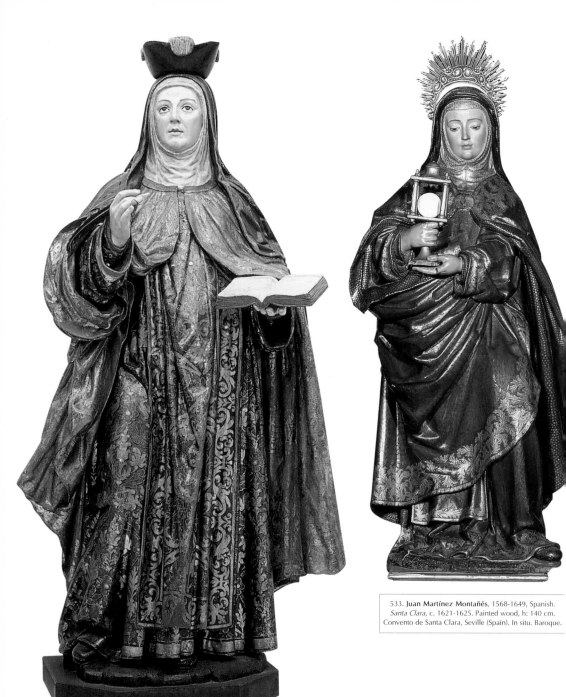

533. **Juan Martínez Montañés**, 1568-1649, Spanish.
Santa Clara, c. 1621-1625. Painted wood, h: 140 cm.
Convento de Santa Clara, Seville (Spain). In situ. Baroque.

532. **Alonso Cano**, 1601-1667, Spanish.
St Teresa of Avila, c. 1629. Painted wood, h: 148.6 cm.
Iglesia del Buen Suceso de la Orden Tercera de PP. Carmelitas, Seville (Spain).
In situ. Baroque. (*)

535. **Alonso Cano**, 1601-1667, Spanish.
St John the Evangelist, c. 1635-1637. Terracotta, h: 38 cm.
Comunidad de las Madres Jerónimas de Santa Paula, Seville (Spain).
In situ. Baroque.

534. **Gregorio Fernandez**, 1576-1636, Spanish.
St Dominic Guzmán, 1626. Painted wood, h: 187 cm.
Iglesia de San Pablo, Valladolid (Spain). In situ. Baroque.

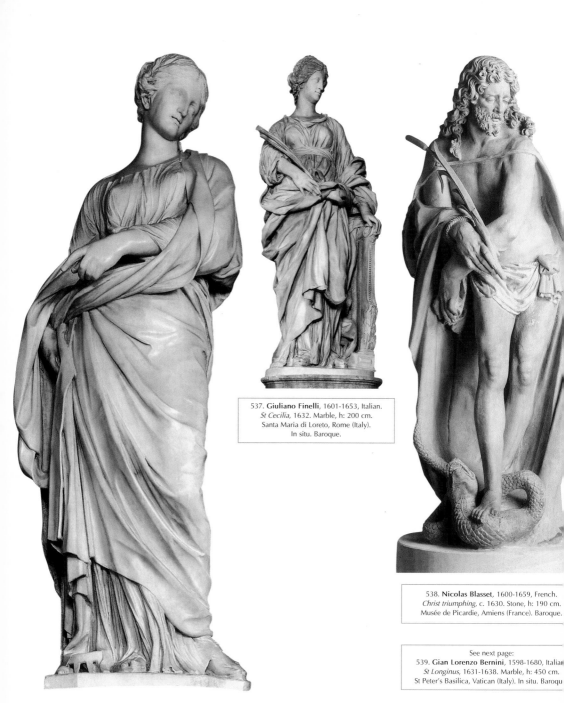

537. **Giuliano Finelli**, 1601-1653, Italian.
St Cecilia, 1632. Marble, h: 200 cm.
Santa Maria di Loreto, Rome (Italy).
In situ. Baroque.

538. **Nicolas Blasset**, 1600-1659, French.
Christ triumphing, c. 1630. Stone, h: 190 cm.
Musée de Picardie, Amiens (France). Baroque.

See next page:
539. **Gian Lorenzo Bernini**, 1598-1680, Italian.
St Longinus, 1631-1638. Marble, h: 450 cm.
St Peter's Basilica, Vatican (Italy). In situ. Baroque.

536. **François Duquesnoy**, 1597-1643, Flemish/Italian.
St Suzanna, 1629-1633. Marble, h: 230 cm.
Santa Maria di Loreto, Rome (Italy). In situ. Baroque.

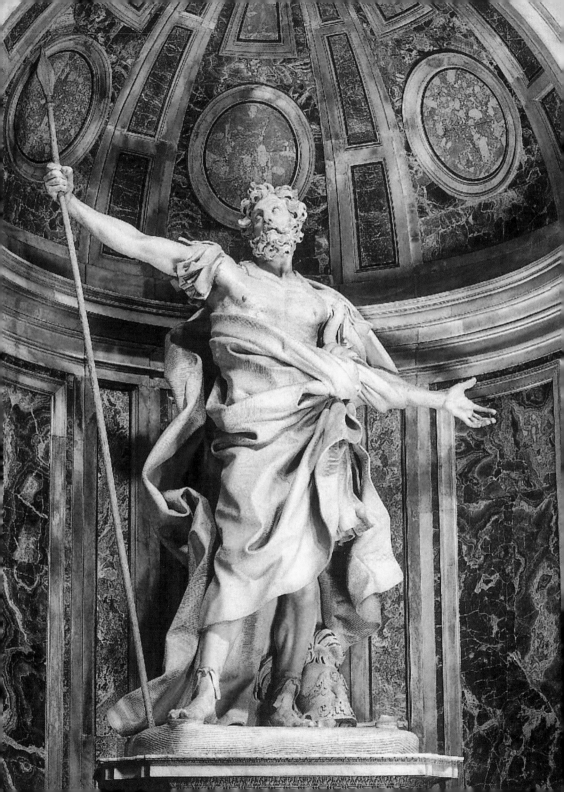

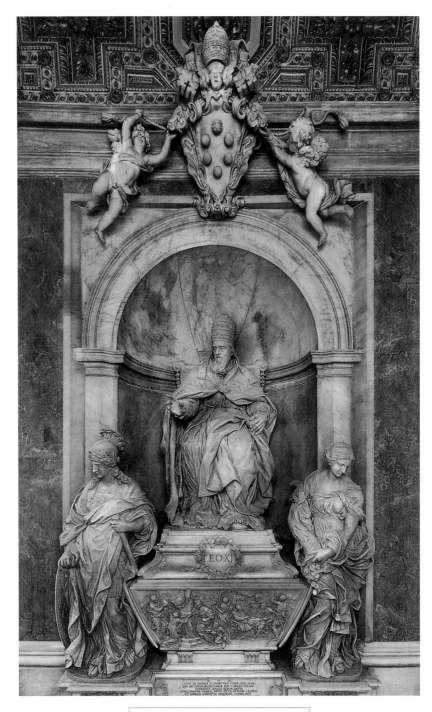

540. **Alessandro Algardi**, 1598-1654, Italian.
Funeral Monument for Pope Leo XI, 1634-1644.
Marble, height of the pope: 290 cm.
St Peter's Basilica, Rome (Italy). In situ. Baroque. (*)

541. **Pedro de Mena**, 1628-1688, Spanish.
St Peter of Alcántara, 1663. Painted wood, h: 78 cm.
Museo Nacional de Escultura, Valladolid (Spain).
Baroque.

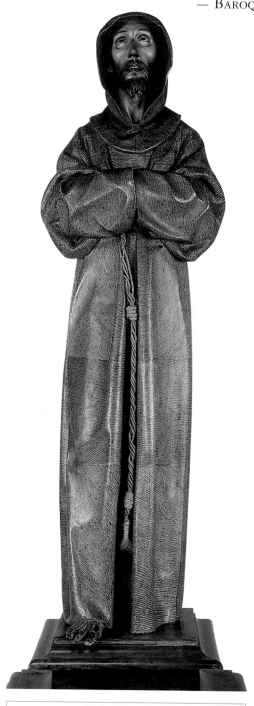

542. **Alonso Cano**, 1601-1667, Spanish.
The Immaculate, c. 1633-1634. Painted wood, h: 141 cm.
Iglesia Parroquial de San Julián, Seville (Spain).
In situ. Baroque.

543. **Anonymous**, Spanish.
Dead St Francis, middle of the 17th century.
Walnut, eyes of glass, teeth of bone, hemp, original polychromy, h: 87 cm.
Musée du Louvre, Paris (France). Baroque.

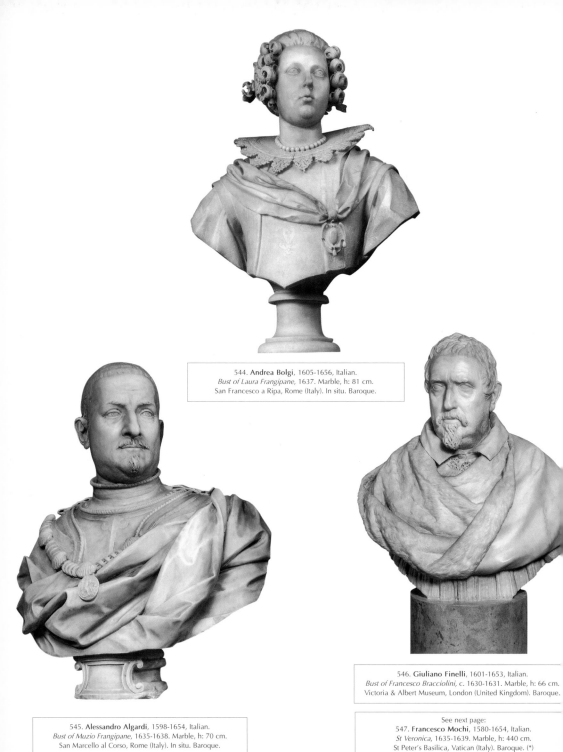

544. **Andrea Bolgi**, 1605-1656, Italian.
Bust of Laura Frangipane, 1637. Marble, h: 81 cm.
San Francesco a Ripa, Rome (Italy). In situ. Baroque.

546. **Giuliano Finelli**, 1601-1653, Italian.
Bust of Francesco Bracciolini, c. 1630-1631. Marble, h: 66 cm.
Victoria & Albert Museum, London (United Kingdom). Baroque.

545. **Alessandro Algardi**, 1598-1654, Italian.
Bust of Muzio Frangipane, 1635-1638. Marble, h: 70 cm.
San Marcello al Corso, Rome (Italy). In situ. Baroque.

See next page:
547. **Francesco Mochi**, 1580-1654, Italian.
St Veronica, 1635-1639. Marble, h: 440 cm.
St Peter's Basilica, Vatican (Italy). Baroque. (*)

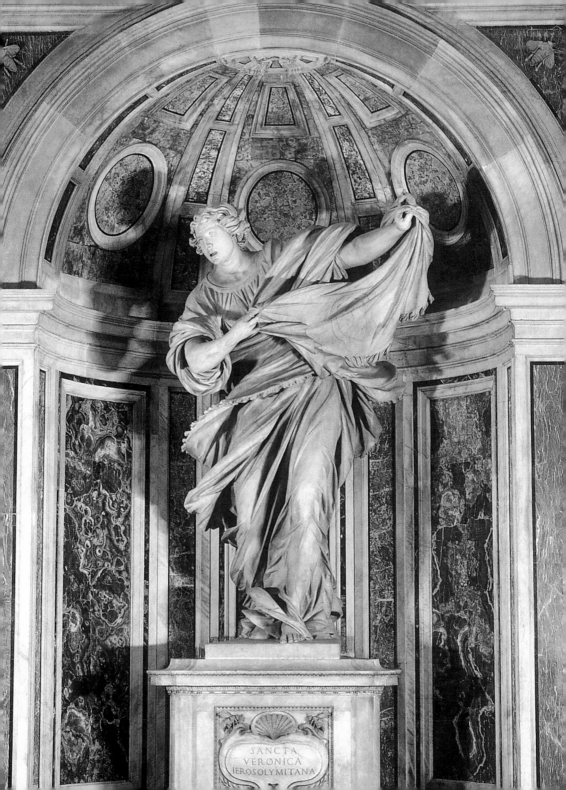

SANCTA
VERONICA
IEROSOLYMITANA

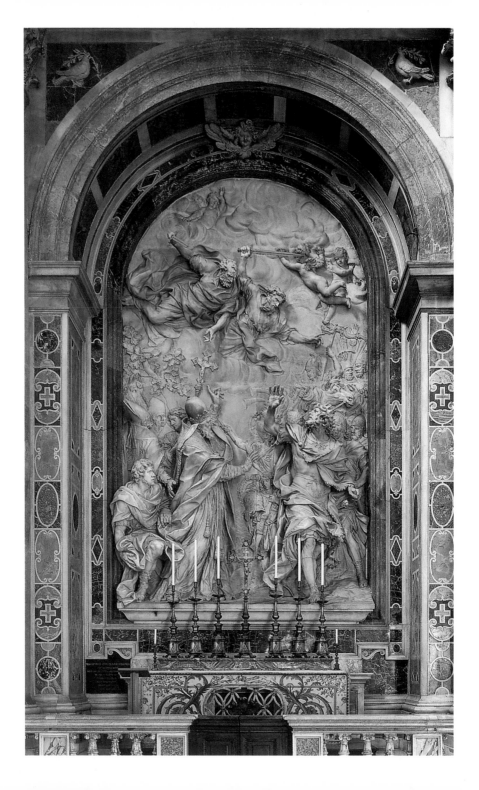

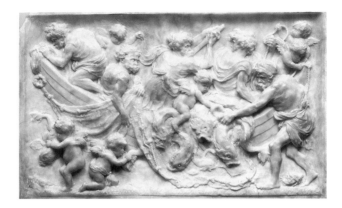

See previous page:
548. **Alessandro Algardi**, 1598-1654, Italian.
Pope Leo I repulsing Attila, 1649-1653. Marble, 858 x 494 cm.
St Peter's Basilica, Rome (Italy). In situ. Baroque.

549. **Gerard van Opstal**, 1594/1604-1668, Flemish.
Marine Scene, c. 1640. Alabaster, 61.9 x 101.6 cm.
J. Paul Getty Museum, Los Angeles (United States). Baroque.

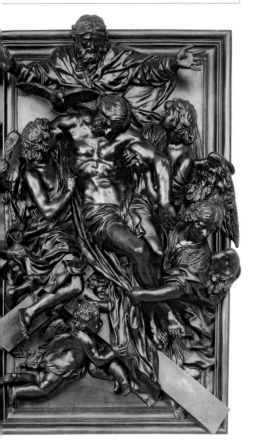

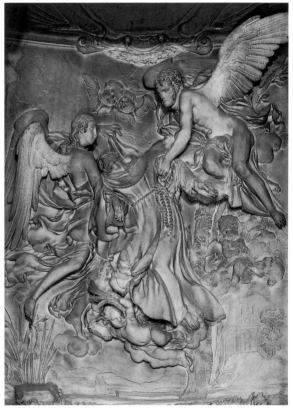

550. **Cosimo Fancelli**, 1620-1688, Italian.
Trinity, 1657. Bronze, 80 x 55 cm.
Santa Maria della Pace, Rome (Italy). In situ. Baroque.

551. **Francesco Baratta**, 1590-1665, Italian.
The Ecstasy of St Francis, 1640-1647. Marble, 290 x 180 cm.
San Pietro in Montorio, Rome (Italy). In situ. Baroque.

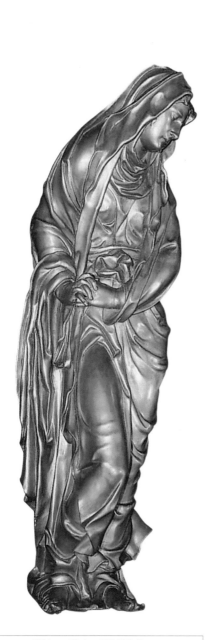

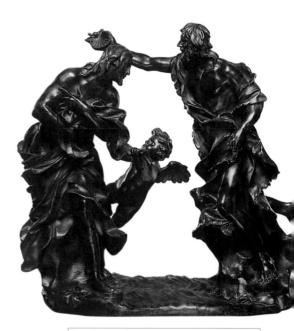

553. **Melchiore Caffà**, 1635-1667, Italian.
The Baptism of Christ, c. 1650. Bronze, h: 46 cm.
Galleria Nazionale d'Arte Antica, Rome (Italy). Baroque.

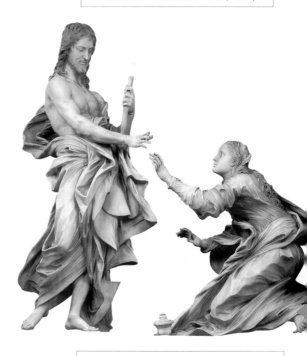

552. **Justus Glesker**, 1610-1678, German.
Mater Dolorosa, from the crucifixion group, 1648-1653. Gilt wood,
Bamberger Dom St. Peter und St. Georg, Bamberg (Germany).
In situ. Baroque.

554. **Antonio Raggi**, 1624-1686, Italian.
Noli Me Tangere, c. 1647. Marble, h: 170 cm.
Santi Domenico e Sisto, Rome (Italy). In situ. Baroque. (*)

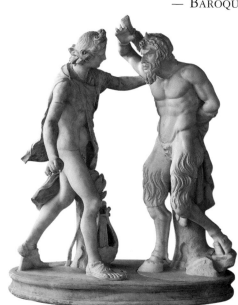

556. **Ercole Buselli**, 1654-1626, Italian.
Apollo and Marsyas, before 1667. Marble and gypsum,
Skultpturensammlung, Staatliche Kunstsammlungen Dresden,
Dresden (Germany). Baroque.

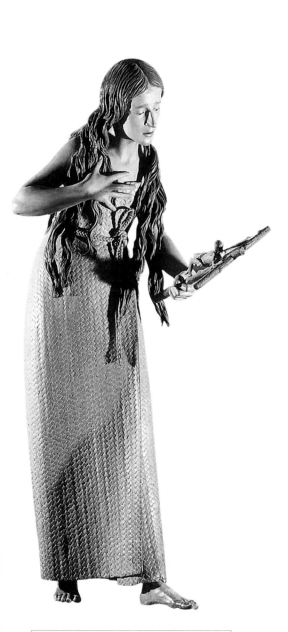

555. **Pedro de Mena**, 1628-1688, Spanish.
The Penitent Mary Magdalene, 1664. Painted wood, h: 165 cm.
Museo Nacional de Escultura, Valladolid (Spain). Baroque. (*)

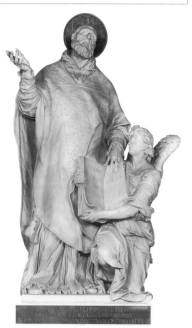

557. **Alessandro Algardi**, 1598-1654, Italian.
The Ecstasy of St Philip Neri, 1636-1638. Marble, h: 300 cm.
Santa Maria in Vallicella, Rome (Italy). In situ. Baroque.

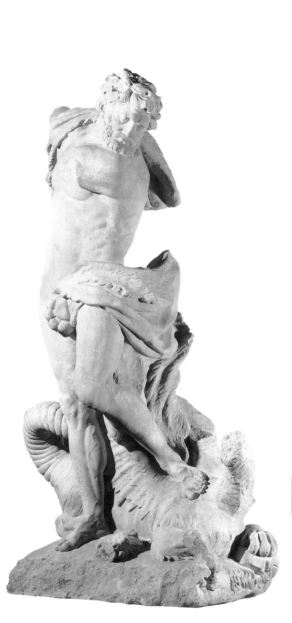

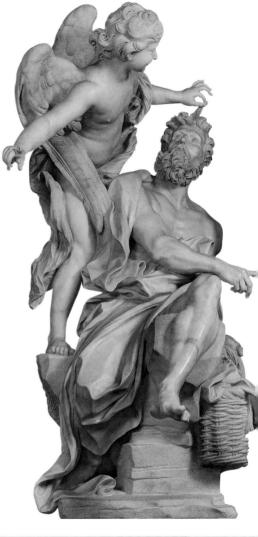

559. **Gian Lorenzo Bernini**, 1598-1680, Italian.
Habakkuk and the Angel, 1655-1661. Marble, h: 180 cm.
Santa Maria del Popolo, Rome (Italy). In situ. Baroque.

558. **Pierre Puget**, 1620-1694, French.
Heracles killing the Hydra of Lerna, 1659-1660. Stone, 266 x 165 x 88.5 cm.
Musée des Beaux-Arts, Rouen (France). Baroque.

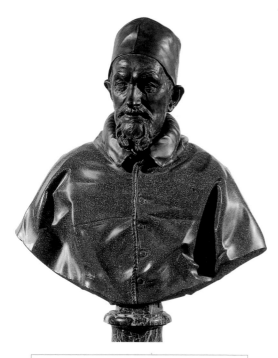

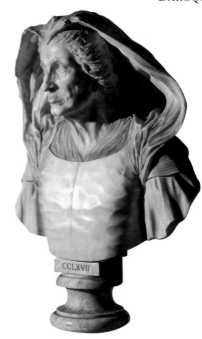

560. **Alessandro Algardi**, 1598-1654, Italian.
Bust of Pope Innocent X, c. 1650. Bronze and porphory, h: 97 cm.
Galleria Doria-Pamphili, Rome (Italy). Baroque.

561. **Domenico Guidi**, 1625-1701, Italian.
Bust of Felice Zacchia Rondinini, c. 1660. Marble, h: 60 cm.
Galleria Borghese, Rome (Italy). Baroque.

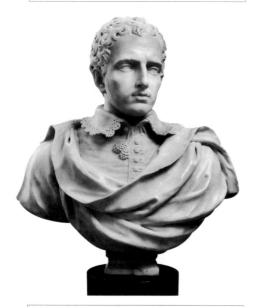

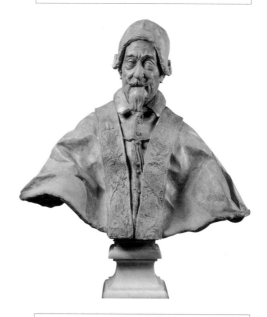

562. **Ercole Ferrata**, 1610-1686, Italian.
Bust of a Young Man, c. 1660. Marble, h: 78 cm.
Stiftung Preussischer Kulturbesitz, Gemäldegalerie, Berlin (Germany).
Baroque.

563. **Melchiore Caffà**, 1635-1667, Italian.
Bust of Pope Alexander VII, 1667. Terracotta, h: 76 cm.
Palazzo Chigi, Ariccia (Italy). Baroque.

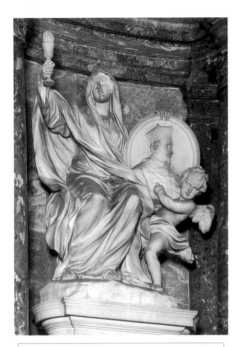

564. **Ercole Ferrata**, 1610-1686, Italian.
Monument to Cardinal Lelio Falconieri with Faith, 1665-1670.
Marble, h: 195 cm.
San Giovanni dei Fiorentini, Rome (Italy). In situ. Baroque.

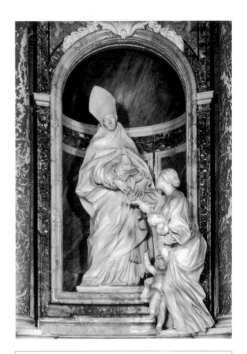

565. **Melchiore Caffà** (and **Ercole Ferrata**), 1635-1667, Italian.
The Charity of St Thomas of Villanova, 1665-1667. Marble, h: 250 cm.
Sant'Agostino, Rome (Italy). In situ. Baroque.

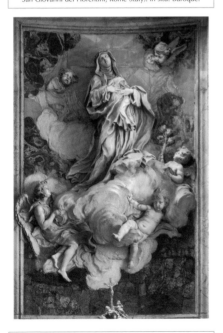

566. **Melchiore Caffà**, 1635-1667, Italian.
The Ecstasy of St Catherine of Siena, 1667. Marble, 310 x 195 cm.
Santa Caterina a Magnanapoli, Rome (Italy). In situ. Baroque.

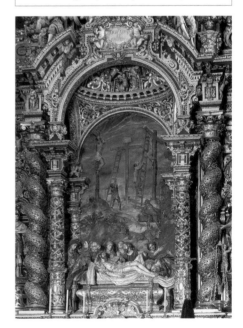

567. **Pedro Roldán**, 1624-1699, Spanish.
Entombment, 1670-1673. Painted wood, h: 310 cm.
Hospital de la Caridad, Seville (Spain). In situ. Baroque.

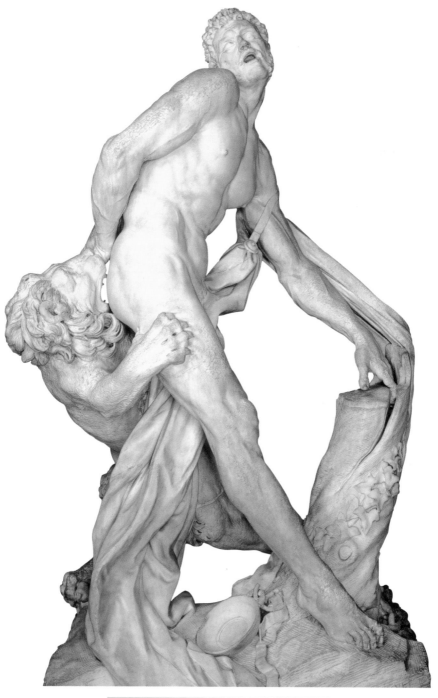

568. Pierre Puget, 1620-1694, French.
Milon of Croton, 1671-1682. Marble, 270 x 140 x 80 cm.
Musée du Louvre, Paris (France). Baroque. (*)

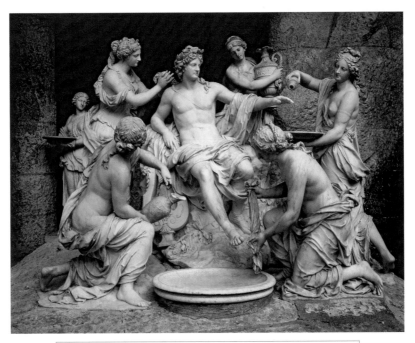

569. **François Girardon**, 1628-1715, French.
Apollo tended by Nymphs of Thetis, Apollo's Bath Grove, 1666-1672. Marble.
Jardins du château, Château de Versailles, Versailles (France). In situ. Baroque. (*)

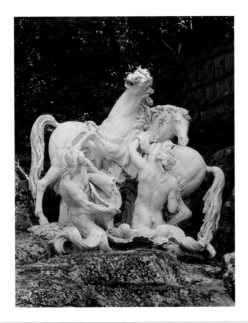

570. **Gaspard** (and **Balthasar**) **Marsy**, 1624-1681, French.
Horses of the Sun, Apollo's Bath Grove,1668-1670. Marble.
Jardins du château, Château de Versailles, Versailles (France). In situ. Baroque. (*)

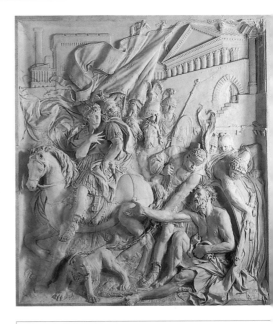

571. **Pierre Puget**, 1620-1694, French.
Alexander and Diogenes, 1671-1689. Marble, 332 x 296 x 44 cm.
Musée du Louvre, Paris (France). Baroque. (*)

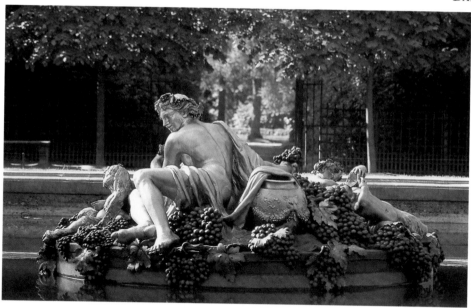

572. **Gaspard Marsy**, 1624-1681, French.
Fountain of Bacchus or the *"Island of Autumn"*, 1672-1679. Bronze and gold.
Jardins du château, Château de Versailles, Versailles (France). Baroque.

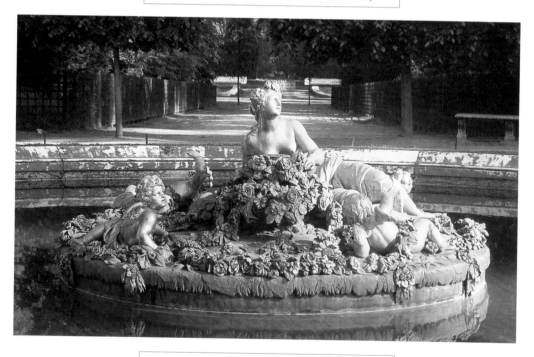

573. **Jean-Baptiste Tuby**, 1635-1700, French.
Fountain of Flora or the *"Island of Spring"*, 1668-1670. Bronze and gold.
Jardins du château, Château de Versailles, Versailles (France). Baroque.

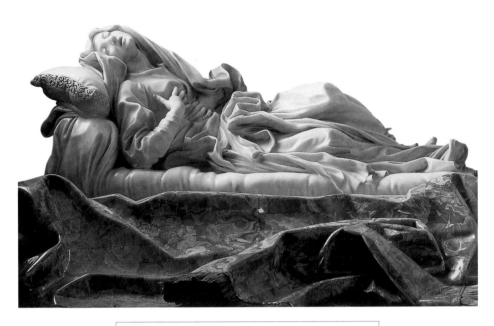

574. **Gian Lorenzo Bernini**, 1598-1680, Italian.
Death of the Blessed Ludovica Albertoni, 1671-1674. Marble and jasper, l: 188 cm.
San Francesco a Ripa, Rome (Italy). In situ. Baroque.

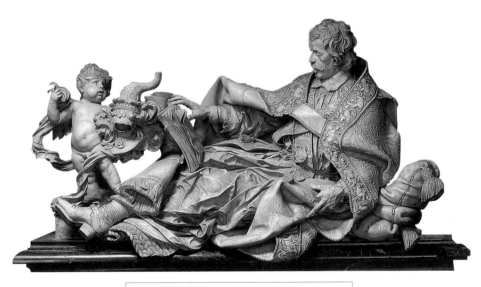

575. **Matthias Rauchmiller**, 1645-1686, Austrian.
Tomb of Karl von Metternich, 1675. Marble.
Liebfrauenkirche, Trier (Germany). In situ. Baroque.

576. **Lorenzo Ottoni**, 1648-1736, Italian.
Bust of Cardinal Antonio Barberini, 1682. Marble, 67 x 73 cm.
Museo di Roma, Rome (Italy). Baroque.

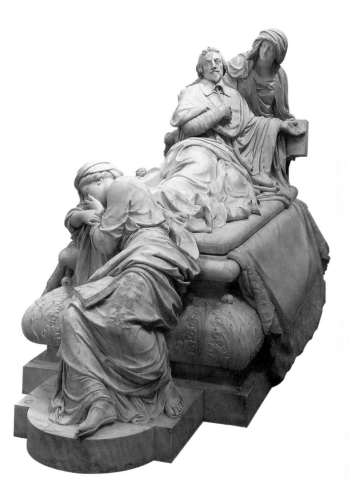

578. **François Girardon**, 1628-1715, French.
Tomb of Armand-Jean du Plessis, Cardinal Richelieu, 1675-1694. Marble.
Chapelle de la Sorbonne, Paris (France). In situ. Baroque.

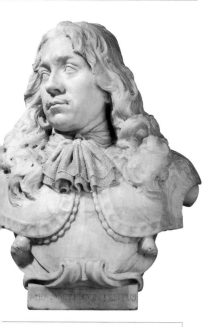

577. **Rombout Verhulst**, 1624-1698, Dutch.
Bust of Jacob Van Reygersberg, 1671. Marble, h: 61 cm.
Paul Getty Museum, Los Angeles (United States). Baroque.

See next page:
579. **Jean-Baptiste Tuby**, 1635-1700, French.
Fountain of Apollo, 1671.
Jardins du château, Château de Versailles, Versailles (France).
In situ. Baroque.

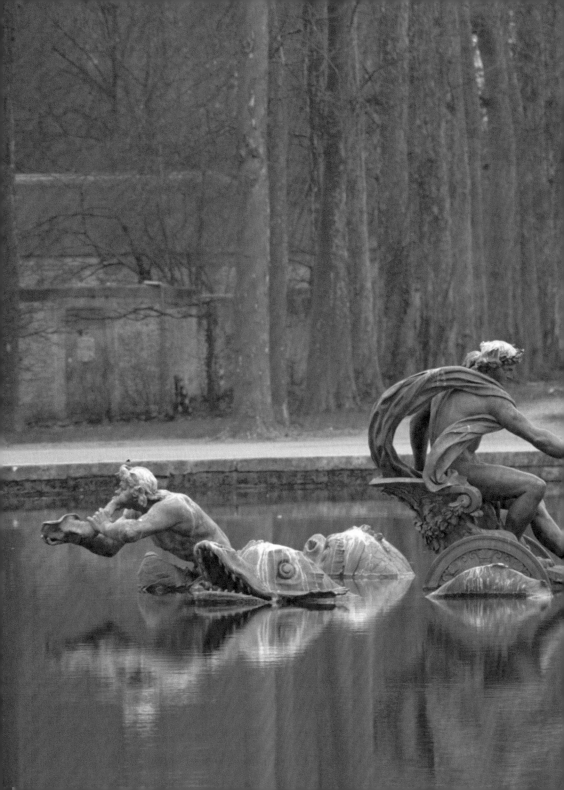

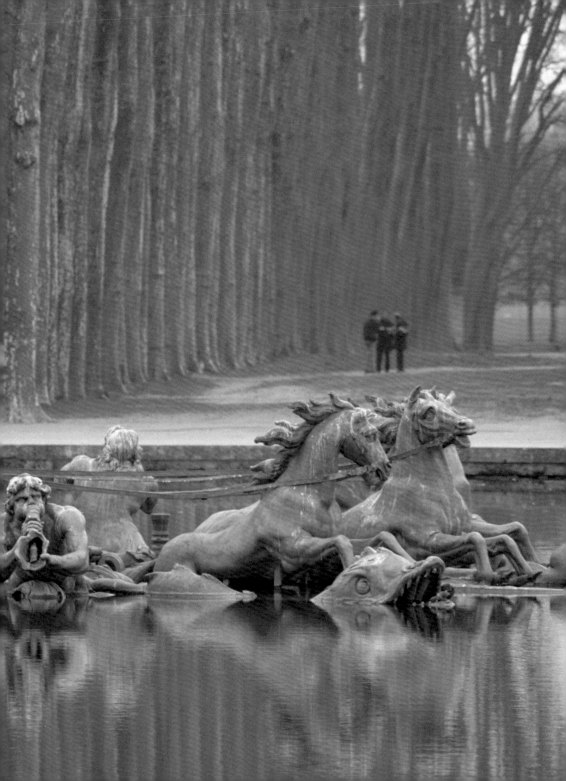

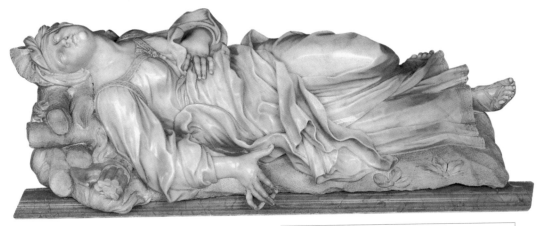

580. **Francesco Aprile**, died 1685, Italian.
St Anastasia, c. 1685. Marble, l: 210 cm.
Sant'Anastasia, Rome (Italy). In situ. Baroque.

See next page:
583. **Christoph Daniel Schenck**, 1633-1691, German.
The Penitent St Peter, 1685. Limewood, 35.5 x 25.4 cm.
J. Paul Getty Museum, Los Angeles (United States). Baroque.

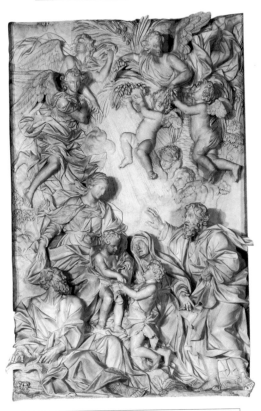

581. **Domenico Guidi**, 1625-1701, Italian.
Holy Family with St Elisabeth, Young John the Baptist and St Zachary,
1677-1687. Marble, 310 x 170 cm.
Sant'Agnese in Agone, Rome (Italy). In situ. Baroque.

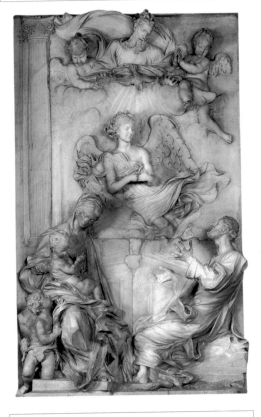

582. **Antonio Raggi**, 1624-1686, Italian.
Angel telling Joseph about the Flight to Egypt, 1675. Marble, 350 x 190 cm.
Sant'Andrea della Valle, Rome (Italy). In situ. Baroque.

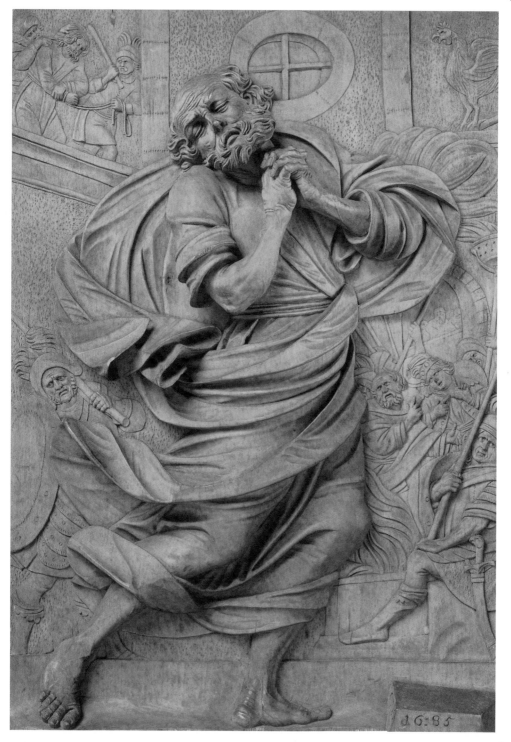

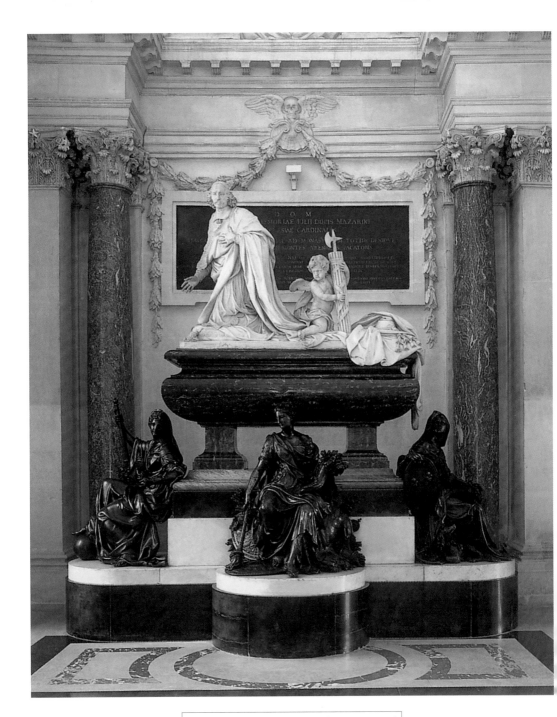

584. Antoine Coysevox (and Jean-Baptiste Tuby), 1640-1720, French.
Tomb of Cardinal Jules Mazarin, 1689-1693. Marble and bronze.
Chapelle de l'Institut de France, Paris (France). In situ. Baroque. (*)

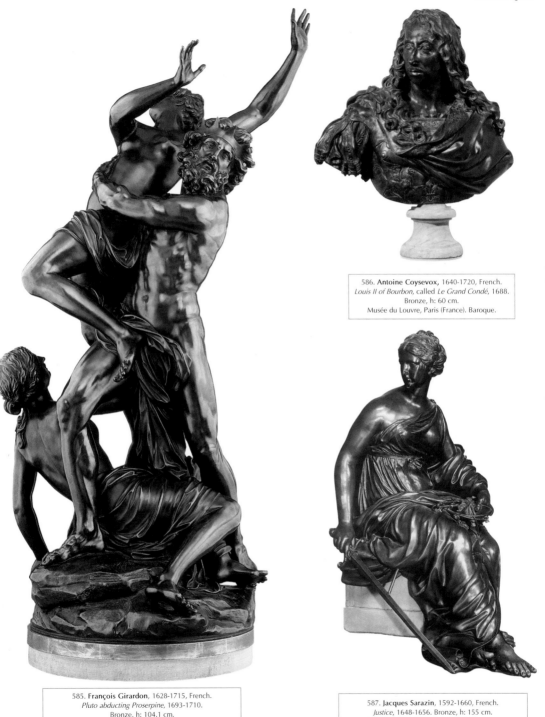

586. **Antoine Coysevox**, 1640-1720, French.
Louis II of Bourbon, called *Le Grand Condé*, 1688.
Bronze, h: 60 cm.
Musée du Louvre, Paris (France). Baroque.

585. **François Girardon**, 1628-1715, French.
Pluto abducting Proserpine, 1693-1710.
Bronze, h: 104.1 cm.
J. Paul Getty Museum, Los Angeles (United States). Baroque. (*)

587. **Jacques Sarazin**, 1592-1660, French.
Justice, 1648-1656. Bronze, h: 155 cm.
Musée Condé, Chantilly (France). Baroque.

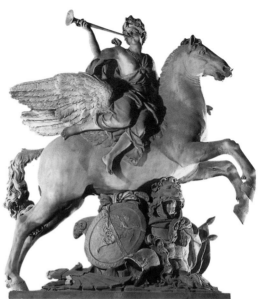

588. **Antoine Coysevox**, 1640-1720, French.
Fame Mounted on Pegasus, 1699-1702. Marble, 315 x 291 x 128 cm.
Musée du Louvre, Paris (France). Baroque. (*)

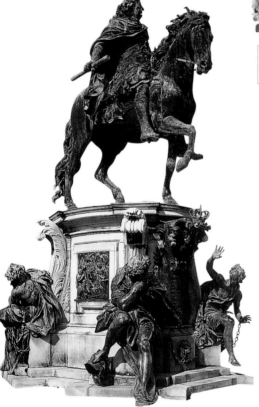

589. **Andreas Schluter**, 1660-1714, German.
Equestrian Statue of Prince Elector Frederick William the Great,
1689-1708. Bronze on stone base, h: 290 cm.
Schloss Charlottenburg, Berlin (Germany). Baroque.

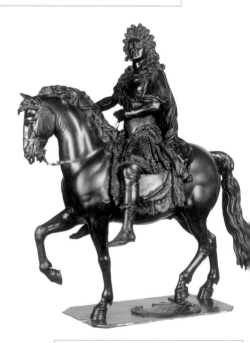

590. **François Girardon**, 1628-1715, French.
Equestrian Statue of Louis XIV, 1685-1692.
Bronze, 102 x 98 x 50 cm.
Musée du Louvre, Paris (France). Baroque.

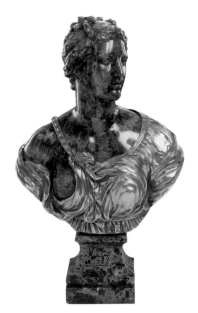

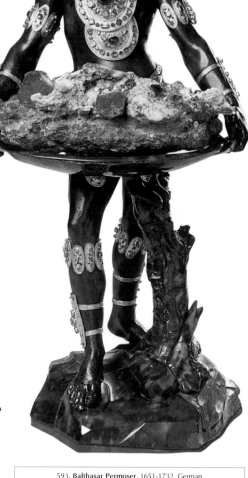

591. **Paul Heermann** (and **Johann Christoph Hübner**),
1673-1732, German. *Female Bust*, 1725-1730.
Amethyst, tuff, gilt bronze, h: 55.5 cm. Skultpturensammlung,
Staatliche Kunstsammlungen Dresden, Dresden (Germany). Baroque.

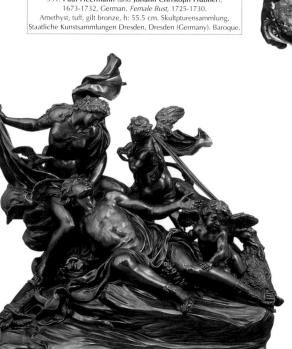

592. **Massimiliano Soldani-Benzi**, 1656-1740, Italian.
Venus and Adonis, c. 1700. Bronze, h: 45.7 cm.
J. Paul Getty Museum, Los Angeles (United States). Baroque.

593. **Balthasar Permoser**, 1651-1732, German.
Moor presenting the Wealth of the New World: a Root of Emerald, 1720.
Lacquered pear wood, gilt silver, emeralds, ruby, sapphires, topaz, garnets,
cinnabar, scale, h: 63.8 cm. Skultpturensammlung, Staatliche
Kunstsammlungen Dresden, Dresden (Germany). Baroque.

594. **Carlo Marcellini** and **Francesco Nuovolone**
after a drawing by **Cir Ferri**, c. 1644-1713, Italian.
Tabernacle, 1682-1684. Bronze.
Santa Maria in Vallicella, Rome (Italy). In situ. Baroque.

595. **Filippo Carcani** after a drawing by **Ludovico Gimignani**,
active 1670-1690, Italian.
Funeral Monument of Agostini Favoriti, 1685. Marble, h: 300 cm.
Santa Maria Maggiore, Rome (Italy). In situ. Baroque.

596. **Paul Strudel**, 1648-1708, Austrian.
Emperor Leopold I and the Allegory of Faith,
detail of the *"Holy Trinity Column"*, 1692. Marble.
Graben, Vienna (Austria). In situ. Baroque.

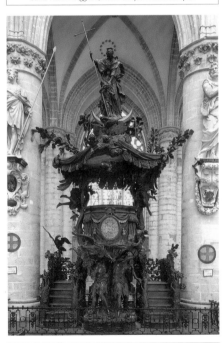

597. **Hendrick Frans Verbruggen**, 1654-1724, Flemish.
Pulpit, 1695-1699. Gilded oakwood, 700 x 350 cm.
Cathédrale Saints-Michel-et-Gudule, Brussels (Belgium).
In situ. Baroque.

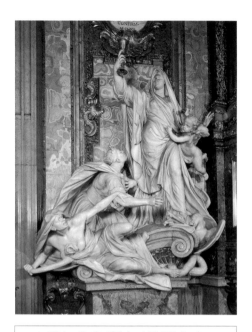

598. **Jean-Baptiste Théodon**, 1645-1713, French.
Faith crushing Idolatry, 1698-1702. Marble, h: 300 cm.
Chiesa del Gesù, Rome (Italy). In situ. Baroque.

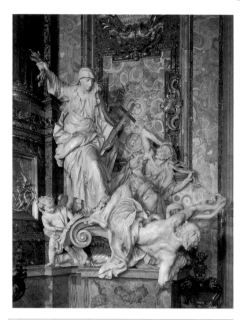

599. **Pierre Legros le Jeune**, 1666-1719, French.
Religion overthrowing Heresy and Hatred, 1695-1699. Marble, h: 300 cm.
Chiesa del Gesù, Rome (Italy). In situ. Baroque. (*)

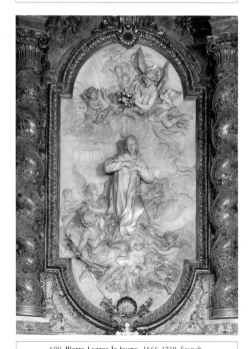

600. **Pierre Legros le Jeune**, 1666-1719, French.
St Aloyzius Gonzaga in Glory, 1698-1699.
Marble, h: 900 cm.
Chiesa del Gesù, Rome (Italy). In situ. Baroque.

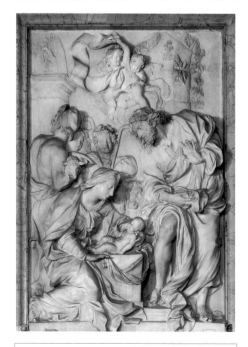

601. **Pierre Etienne Monnot**, 1657-1733, French.
Adoration of the Shepherds, 1696-1699. Marble, 180 x 130 cm.
Santa Maria della Vittoria, Rome (Italy). In situ. Baroque.

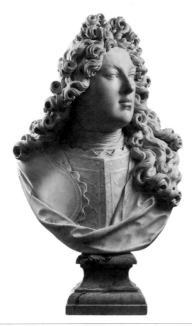

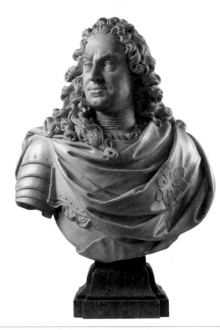

602. **François Coudray**, 1678-1727, French.
Prince Elector Frederick Augustus of Saxony, 1715.
Marble, 84.5 x 51 x 30 cm. Skulpturensammlung, Staatliche
Kunstsammlungen Dresden, Dresden (Germany). Baroque.

603. **Paul Heermann**, 1673-1732, German.
*Prince Elector Frederick Augustus I of Saxony, as Augustus II King of Poland,
called "The Strong"*, 1718. Marble, 92 x 66.5 x 27 cm. Skulpturensammlung
Staatliche Kunstsammlungen Dresden, Dresden (Germany). Baroque.

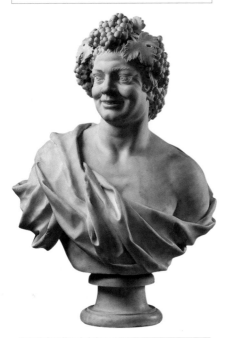

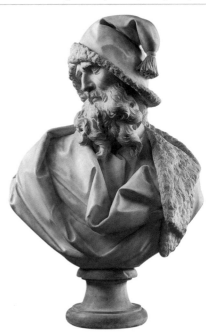

604. **Paul Heermann**, 1673-1732, German.
Autumn, c. 1720. Marble, 73 x 53 x 29 cm.
Skulpturensammlung, Staatliche Kunstsammlungen Dresden,
Dresden (Germany). Baroque. (*)

605. **Paul Heermann**, 1673-1732, German.
Winter, c. 1720. Marble, 76 x 52 x 27 cm.
Skulpturensammlung, Staatliche Kunstsammlungen Dresden,
Dresden (Germany). Baroque.

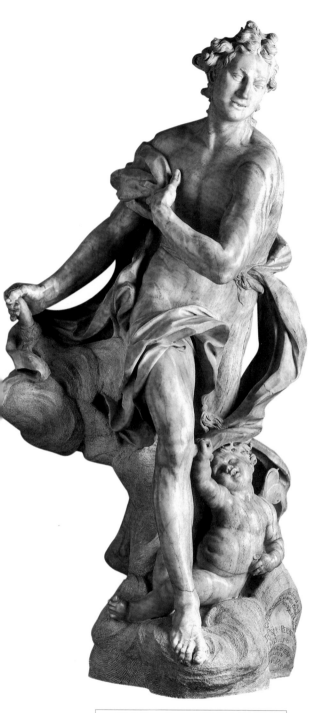

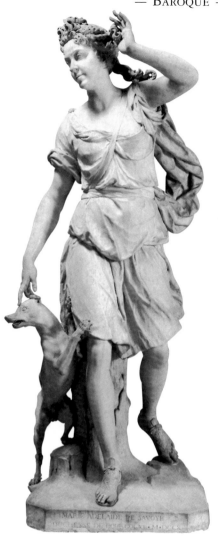

607. **Antoine Coysevox**, 1640-1720, French.
Marie Adelaide of Savoy, Duchess of Bourgogne,
as *Diana the Huntress*, 1710. Marble, 200 x 83 x 80 cm.
Musée du Louvre, Paris (France). Baroque.

606. **Balthasar Permoser**, 1651-1732, German.
Apollo, 1715. Marble, h: 218 cm.
Skultpturensammlung, Staatliche Kunstsammlungen Dresden,
Dresden (Germany). Baroque. (*)

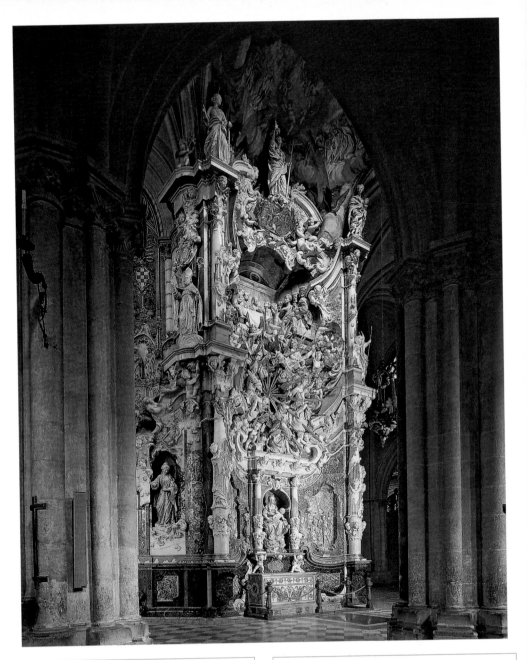

608. **Narciso Tomé**, 1690-1742, Spanish.
Altar "El Transparente", 1721-1732.
Polychrome marble, bronze and stucco, h: 30 m.
Catedral Santa María, Toledo (Spain). In situ. Baroque. (*)

See next page:
609. **Egid Quirin Asam** (and **Kosmas Damian Asam**), 1692-1750, German.
Assumption of the Virgin, 1722-1723. Marble, stucco and gildings.
Kirche Mariahimmelfahrt, Rohr (Germany). In situ. Baroque. (*)

See next page:
610. **Niccolò Salvi** (finished by **Niccolò Pannini**), 1697-1751, Italian.
The Fountain of Trevi, 1732-1762. Marble.
Piazza di Trevi, Rome (Italy). In situ. Rococo. (*)

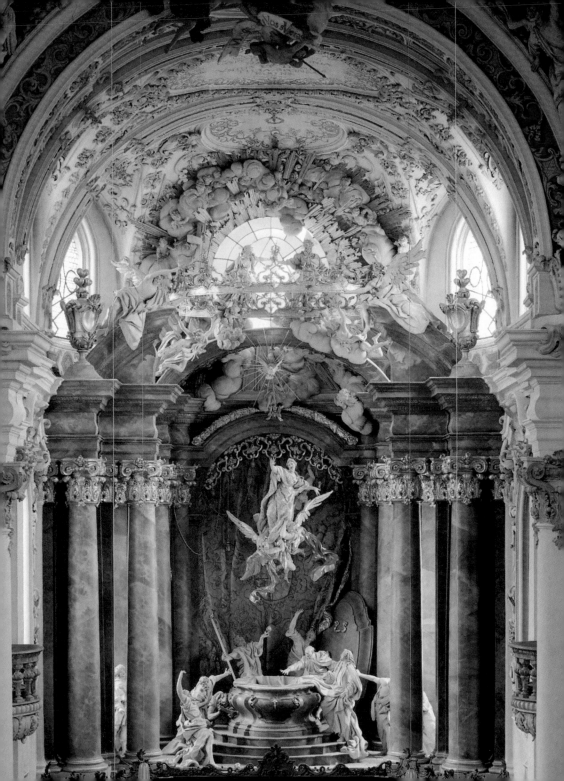

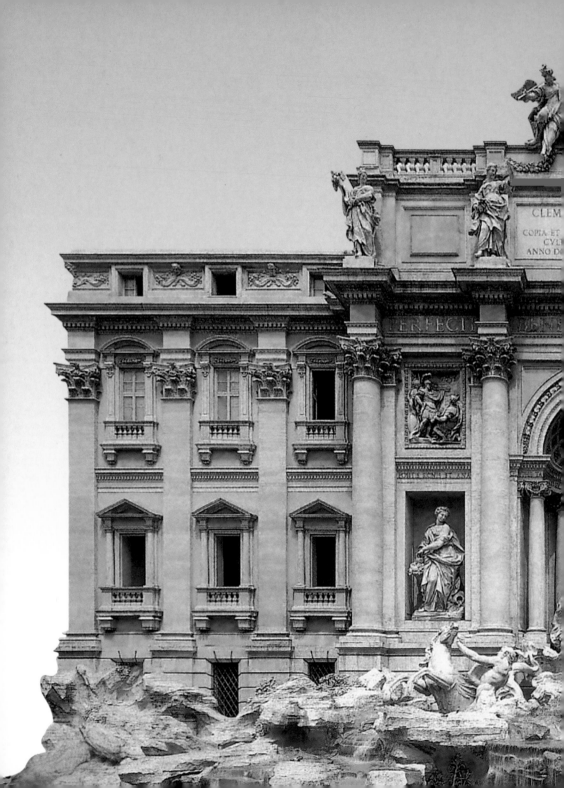

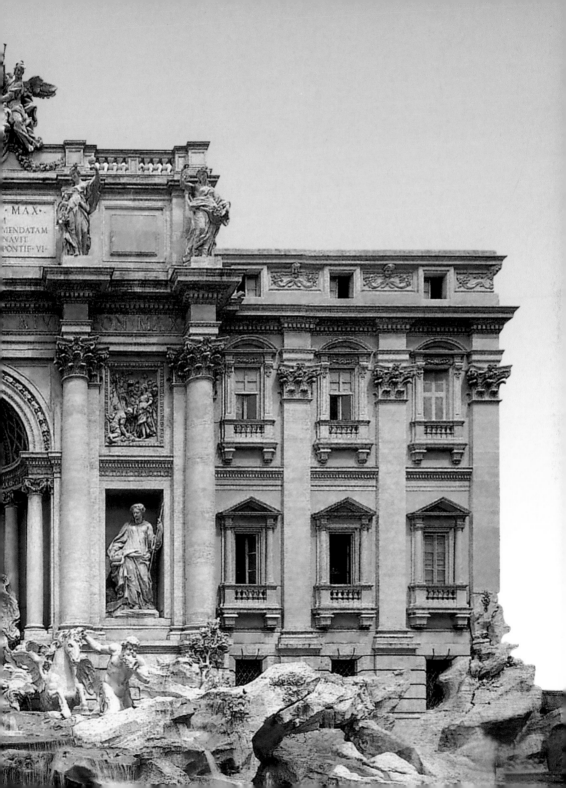

611. **Antonio Corradini**, 1668-1752, Italian.
Bust of a Vestal, c. 1720. Marble, 77.5 x 66 x 27.5 cm.
Skultpturensammlung, Staatliche Kunstsammlungen Dresden,
Dresden (Germany). Rococo.

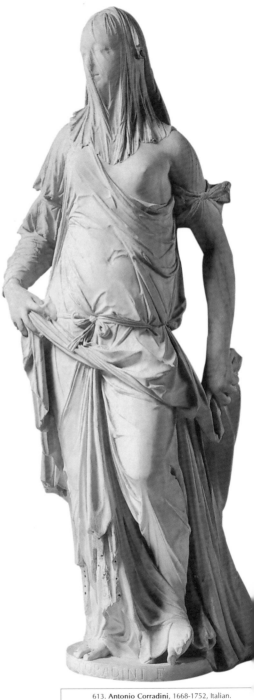

612. **Edme Bouchardon**, 1698-1762, French.
St Bartholomew, c. 1734-1750. Terracotta, h: 55.9 cm.
J. Paul Getty Museum, Los Angeles (United States). Baroque.

613. **Antonio Corradini**, 1668-1752, Italian.
Veiled Woman (Faith?), first half of the 18th century.
Marble, 138 x 48 x 36 cm.
Musée du Louvre, Paris (France). Rococo.

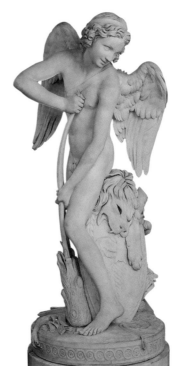

615. **Edme Bouchardon**, 1698-1762, French.
Cupid making a Bow out of the Club of Heracles, 1750.
Marble, 173 x 75 x 75 cm.
Musée du Louvre, Paris (France). Baroque. (*)

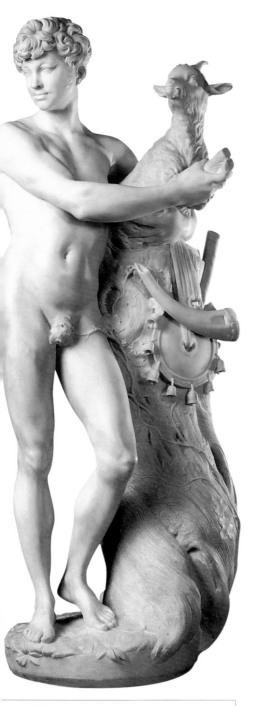

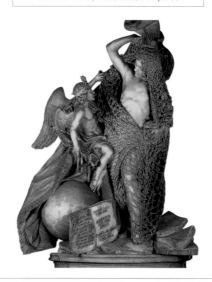

614. **Jacques-François-Joseph Saly**, 1717-1776, French.
Faun holding a Goat, 1751. Marble, h: 83.8 cm.
J. Paul Getty Museum, Los Angeles (United States). Baroque.

616. **Francesco Queirolo**, 1704-1762, Italian.
Disenchantment, 1752-1759. Marble, h: 195 cm.
Cappella Sansevero, Naples (Italy). In situ. Baroque.

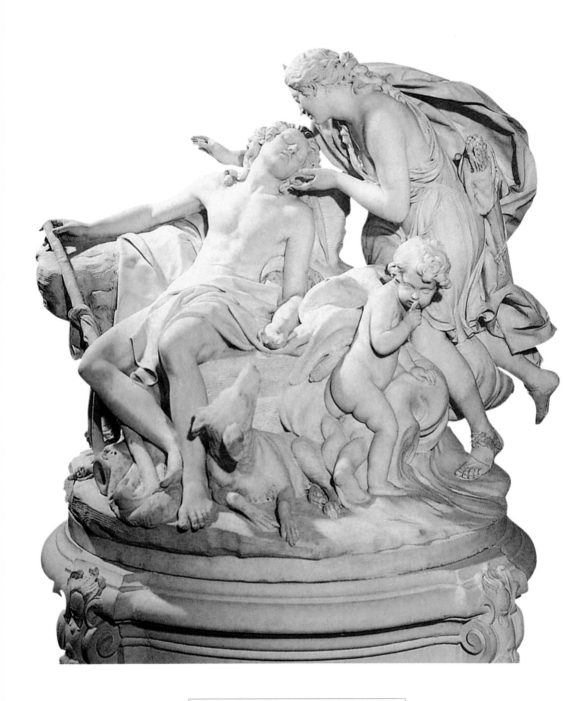

617. **Michelangelo Slodtz**, 1705-1764, French.
Diana and Endymion, c. 1740. Marble, 85 x 100 cm.
Private collection. Baroque. (*)

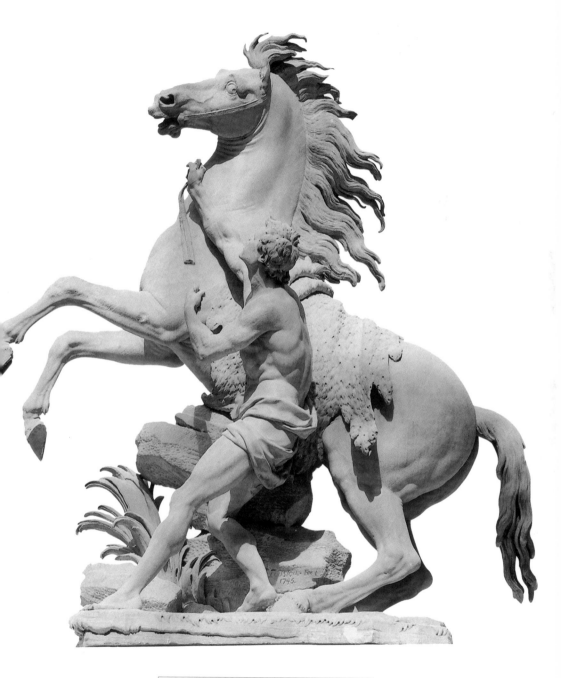

618. Guillaume Coustou, 1677-1746, French.
Horse Restrained by a Groom, called the *"Marly Horse"*,
1739-1745. Marble, 340 x 284 x 127 cm.
Musée du Louvre, Paris (France). Baroque. (*)

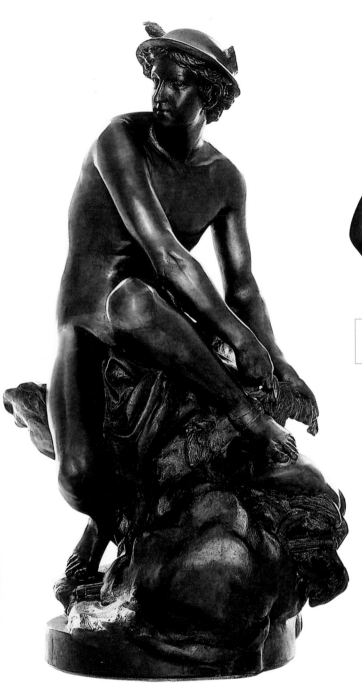

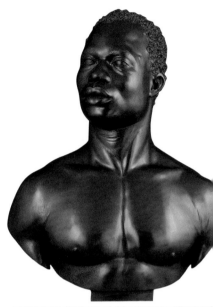

620. **Francis Harwood**, 1748-1783, English.
Bust of a Man, 1758.
Black stone (pietra da paragone), h: 68.6 cm (with base).
J. Paul Getty Museum, Los Angeles (United States). Baroque.

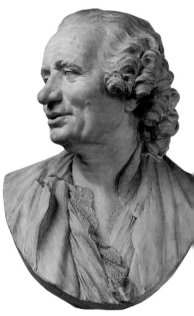

619. **Jean-Baptiste Pigalle**, 1714-1785, French.
Mercury tying his Talaria, 1753. Lead, h: 187 cm.
Musée du Louvre, Paris (France). Rococo.

621. **Jean-Jacques Caffieri**, 1725-1792, French.
Bust of Alexis-Jean-Eustache Taitbout, 1762.
Terracotta, h: 64.5 cm (with base).
J. Paul Getty Museum, Los Angeles (United States). Baroqu

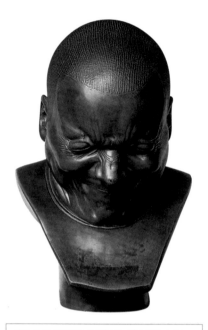

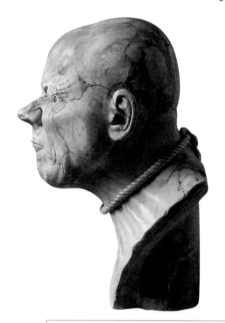

622. **Franz Xaver Messerschmidt**, 1736-1783, Austrian. *An Arch-Villain*, 1770-1783. Tin-lead alloy, h: 38.5 cm. Österreichische Galerie, Vienna (Austria). Baroque. (*)

623. **Franz Xaver Messerschmidt**, 1736-1783, Austrian. *Hanged Man*, 1770-1783. Alabaster, h: 38 cm. Österreichische Galerie, Vienna (Austria). Baroque.

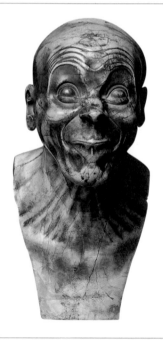

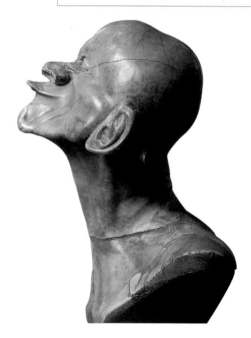

624. **Franz Xaver Messerschmidt**, 1736-1783, Austrian. *The Beaked*, 1770-1783. Alabaster, h: 43 cm. Österreichische Galerie, Vienna (Austria). Baroque.

625. **Franz Xaver Messerschmidt**, 1736-1783, Austrian. *The Lecher*, 1770-1783. Marble, h: 45 cm. Österreichische Galerie, Vienna (Austria). Baroque.

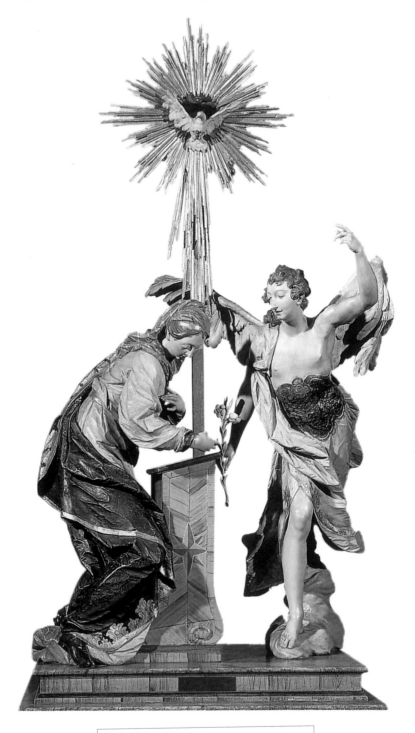

626. **Franz Ignaz Günther**, 1725-1775, German.
Annunciation, 1763. Painted and gilt wood, h: 160 cm.
Augustiner-Chorherren-Stiftskirche, Weyarn (Germany). Baroque. (*)

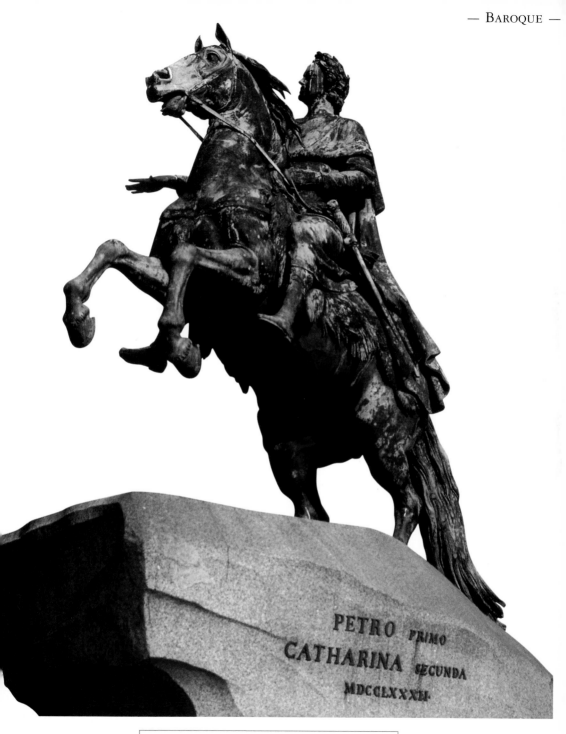

PETRO PRIMO
CATHARINA SECUNDA
MDCCLXXXII

627. **Etienne-Maurice Falconet**, 1716-1791, French.
Monument to Peter the Great, called the *"Bronze Horseman"*, 1766-1778. Bronze.
Decembrist Square, St Petersburg (Russia). In situ. Rococo. (*)

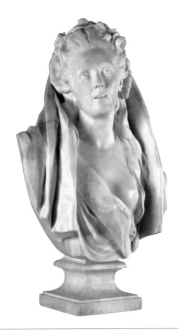

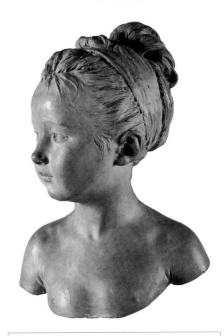

628. **Jean-Antoine Houdon**, 1741-1828, French.
Sophie Arnould, 1775. Marble, 67 x 51 x 29 cm.
Musée du Louvre, Paris (France). Neoclassicism.

629. **Jean-Antoine Houdon**, 1741-1828, French.
Louise Brongniart, 1777. Terracotta, 34.5 x 24 x 18 cm.
Musée du Louvre, Paris (France). Neoclassicism.

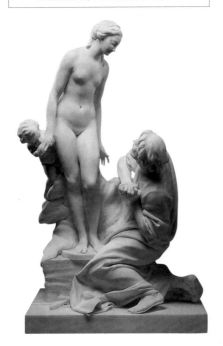

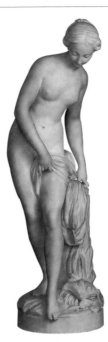

630. **Etienne-Maurice Falconet**, 1716-1791, French.
Pygmalion and Galatea, 1763. Marble, 83 x 48 x 38 cm.
Musée du Louvre, Paris (France). Rococo.

631. **Etienne-Maurice Falconet**, 1716-1791, French.
Bather, 1757. Marble, h: 80 cm.
Musée du Louvre, Paris (France). Rococo.

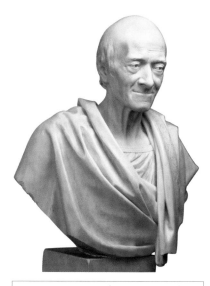

632. **Jean-Antoine Houdon**, 1741-1828, French.
Portrait of Voltaire in a Toga, 1778. Marble, h: 58.5 cm.
The State Hermitage Museum, St Petersburg (Russia).
Neoclassicism.

633. **Jean-Jacques Caffieri**, 1725-1792, French.
Canon Alexandre-Gui Pingré, 1788. Terracotta, h: 51 cm.
Musée du Louvre, Paris (France). Baroque.

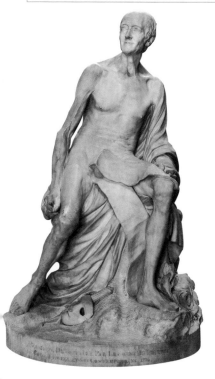

634. **Jean-Baptiste Pigalle**, 1714-1785, French.
Voltaire Nude, 1770-1776. Marble, h: 150 cm.
Musée du Louvre, Paris (France). Rococo.

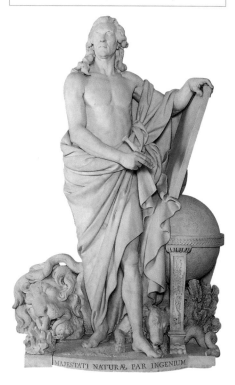

635. **Augustin Pajou**, 1730-1809, French.
Monument to Georges Louis Leclerc de Buffon, 1775-1800.
Marble, h: 290 cm.
Musée national d'Histoire naturelle, Paris (France). Neoclassicism. (*)

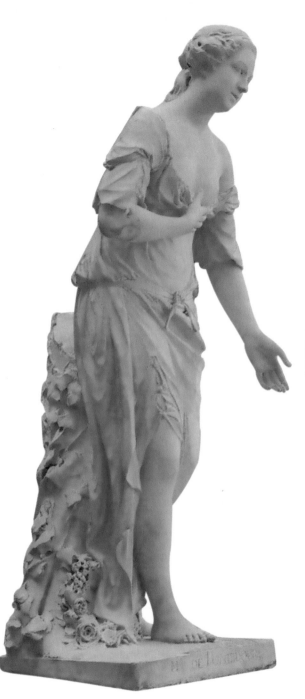

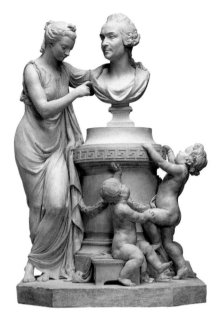

637. **Philippe-Laurent Roland**, 1746-1816, French.
Allegorical Group with the Bust of an Architect (possibly Pierre Rousseau),
c. 1780-1790. Terracotta, h: 67.3 cm.
J. Paul Getty Museum, Los Angeles (United States). Baroque.

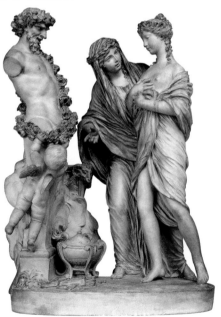

636. **Jean-Baptiste Pigalle**, 1714-1785, French.
Madame de Pompadour as Friendship, 1753.
Marble, 166 cm.
Musée du Louvre, Paris (France). Rococo.

638. **Claude Michel**, called **Clodion**, 1738-1814, French.
Vestal presenting a Young Woman at the Altar of Pan,
c. 1770-1775. Terracotta, h: 43.2 cm.
J. Paul Getty Museum, Los Angeles (United States). Rococo.

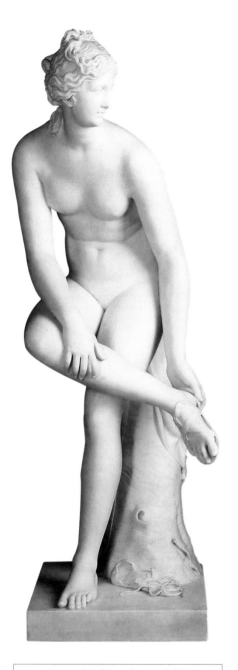

639. **Joseph Nollekens**, 1737-1823, English.
Venus, 1773. Marble, h: 121.9 cm.
J. Paul Getty Museum, Los Angeles (United States). Baroque.

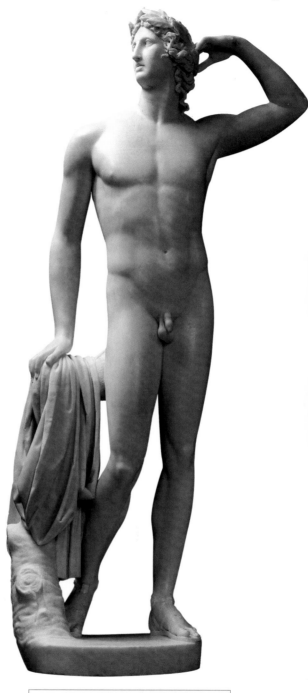

640. **Antonio Canova**, 1757-1822, Italian.
Apollo crowning Himself, 1781. Marble, h: 83.8 cm.
J. Paul Getty Museum, Los Angeles (United States).
Neoclassicism.

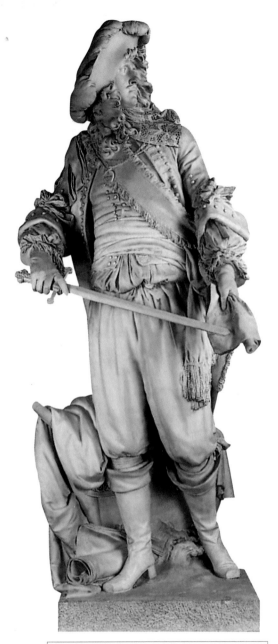

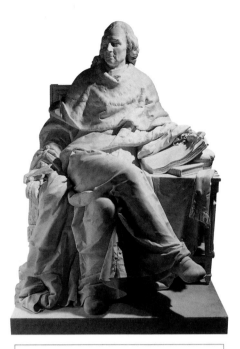

642. **Claude Michel**, called **Clodion**, 1738-1814, French.
Charles de Secondat, Baron de Montesquieu,
1778-1783. Marble, 164 x 122 x 122 cm.
Musée du Louvre, Paris (France). Rococo.

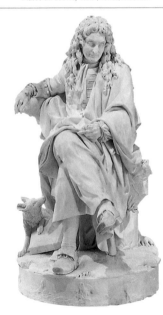

641. **Jean-Antoine Houdon**, 1741-1828, French.
Anne-Hilarion de Costentin, Comte de Tourville, Maréchal de France,
1781. Marble, h: 223 cm.
Musée national du château de Versailles, Versailles (France). Neoclassicism.

See next page:
644. **Jean-Antoine Houdon**, 1741-1828, French.
Seated Sculpture of Voltaire, 1781.
Marble, 133.5 x 78.7 x 103.1 cm.
Comédie-Française, Paris (France). Neoclassicism. (*)

643. **Pierre Julien**, 1731-1804, French.
Jean de La Fontaine, 1785. Marble, h: 173 cm.
Musée du Louvre, Paris (France). Baroque.

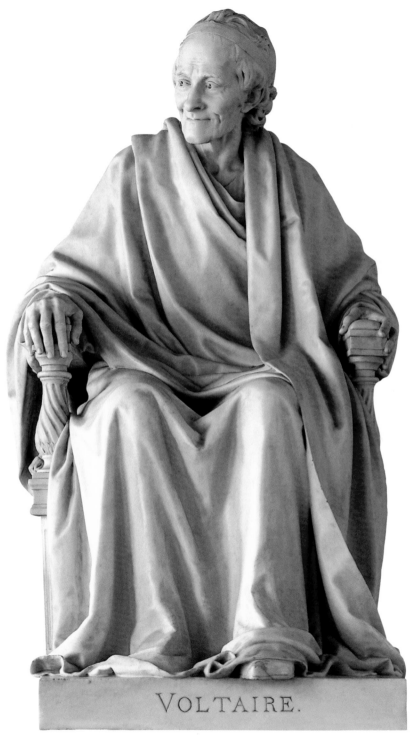

VOLTAIRE.

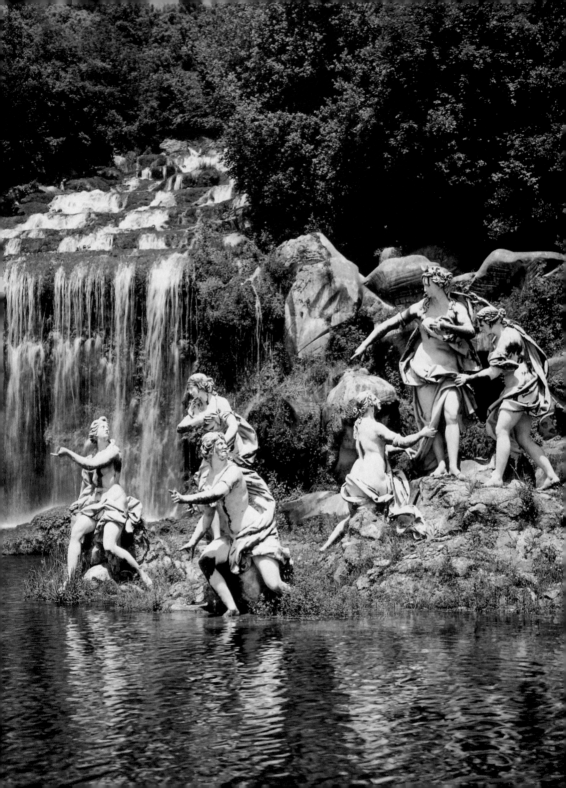

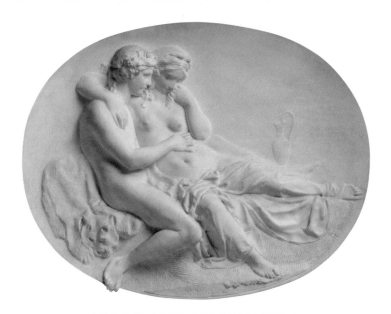

646. **Johann Gottfried Schadow**, 1764-1850, German.
Bacchus comforting Ariadne, 1793. Marble.
Hamburger Kunsthalle, Hamburg (Germany). Neoclassicism.

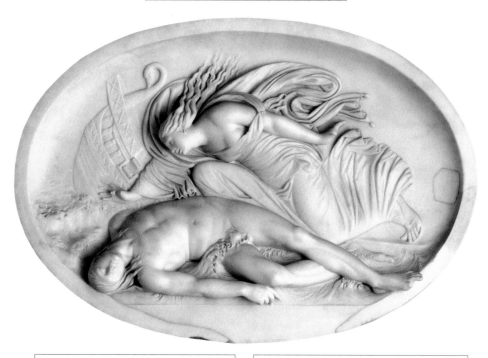

See previous page:
645. **Luigi Vanvitelli**, 1700-1773, Italian.
Diana and Actaeon Basin, 1785-1789. Marble.
La Reggia di Caserta, Caserta (Italy). In situ. Rococo. (*)

647. **Thomas Banks**, 1735-1805, English.
Alcoyne discovering the Body of her Dead Husband Ceyx,
1775-1779. Marble.
Leeds Museums and Galleries, Leeds (United Kingdom). Neoclassicism.

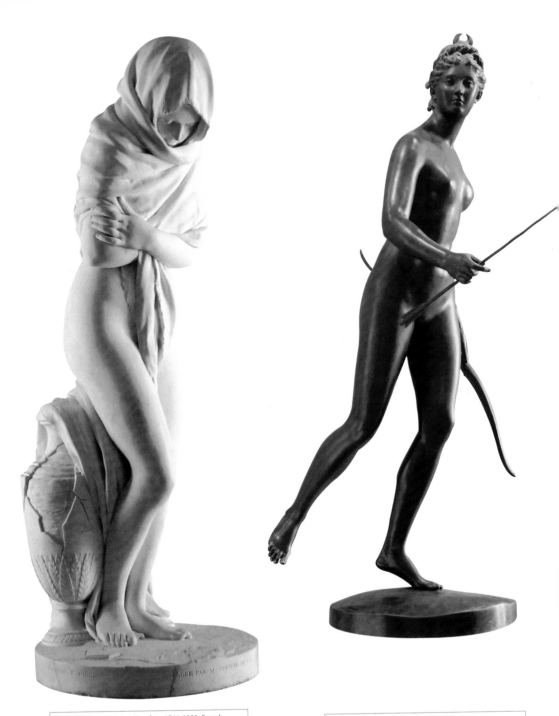

648. **Jean-Antoine Houdon**, 1741-1828, French.
Winter or *The Chilly Woman*, 1783.
Marble, 145 x 50 x 62 cm.
Musée Fabre, Montpellier (France). Neoclassicism. (*)

649. **Jean-Antoine Houdon**, 1741-1828, French.
Diana the Huntress, 1790. Bronze, h: 192 cm.
Musée du Louvre, Paris (France). Neoclassicism. (*)

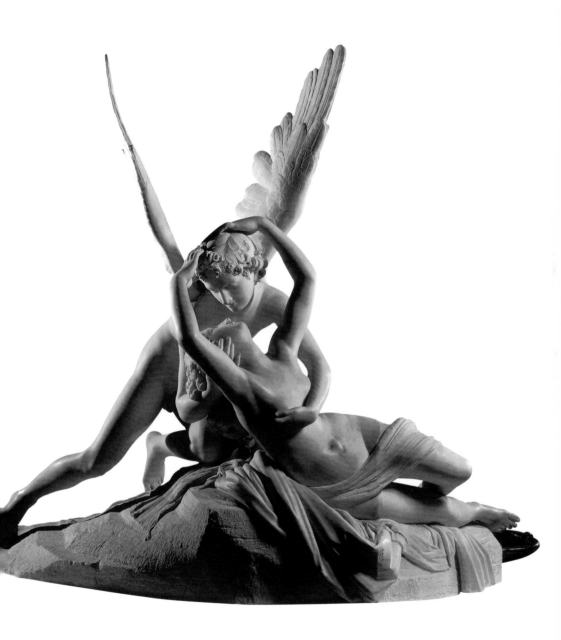

650. **Antonio Canova**, 1757-1822, Italian.
Psyche Awakened by Eros, 1787-1793. Marble, 55 x 68 x 101 cm.
Musée du Louvre, Paris (France). Neoclassicism. (*)

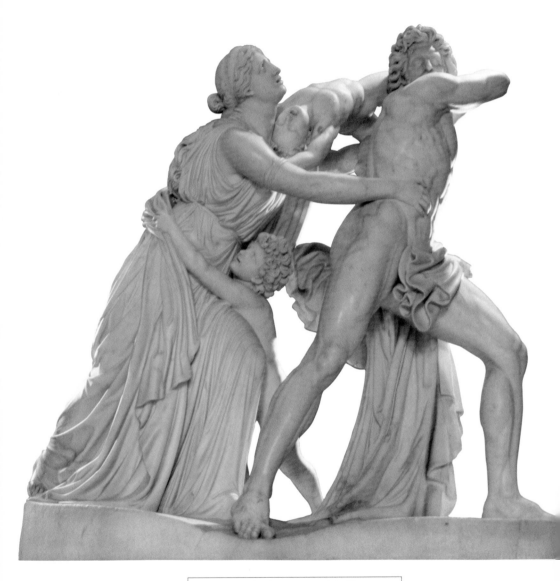

651. **John Flaxman**, 1755-1826, English.
The Fury of Athamas, 1790. Marble.
Ickworth (United Kingdom). Neoclassicism.

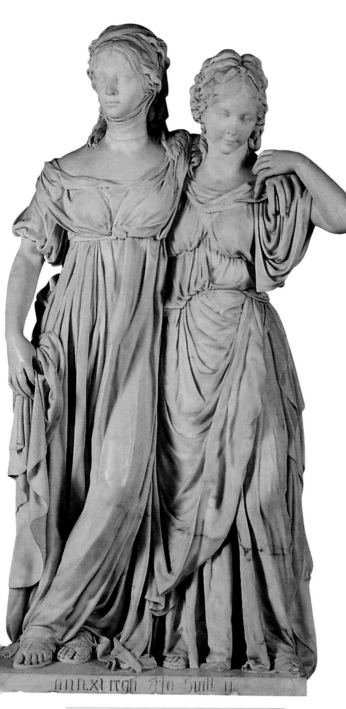

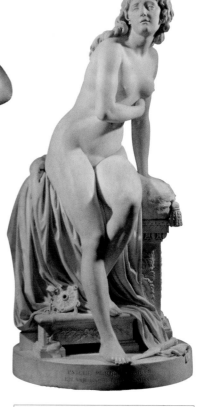

653. **Augustin Pajou**, 1730-1809, French.
Psyche Abandoned, 1785-1790. Marble, h: 177 cm.
Musée du Louvre, Paris (France). Neoclassicism.

652. **Johann Gottfried Schadow**, 1764-1850, German.
The Crown Princesses Louise and Friedrike of Prussia, 1796-1797.
Marble, h: 172 cm.
Alte Nationalgalerie, Berlin (Germany). Neoclassicism. (*)

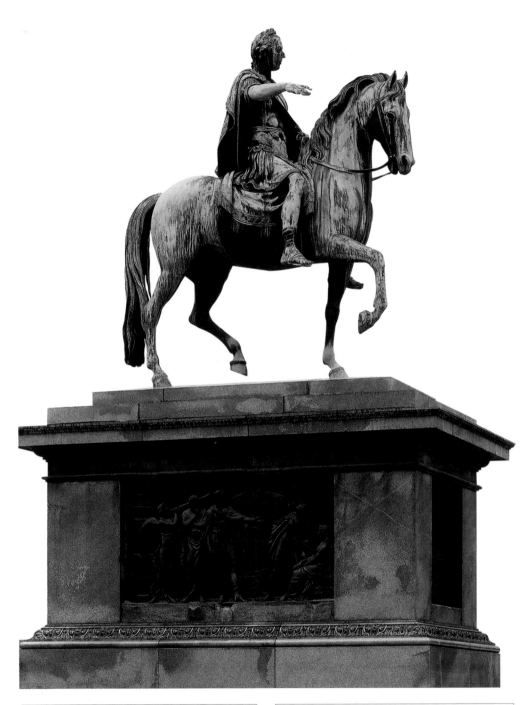

654. **Franz Anton von Zauner**, 1746-1822, Austrian.
Equestrian Statue of Joseph II, Holy Roman Emperor,
1795-1806. Bronze.
Josefsplatz, Vienna (Austria). In situ. Baroque.

See next page:
655. **Antonio Canova**, 1757-1822, Italian.
Tomb of Archduchess Marie-Christine of Austria, 1798-1805. Marble, h: 574 cm.
Augustinerkirche, Vienna (Austria). In situ. Neoclassicism.

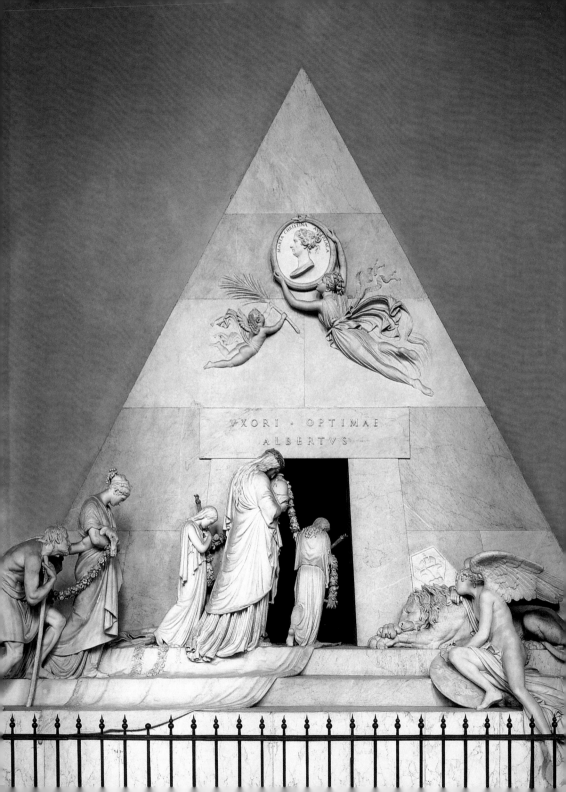

MASTERWORKS COMMENTED

502. Gian Lorenzo Bernini, *The Ecstasy of St Teresa.*

Pushing to excess his quest for composition, Bernini, when undertaking *The Ecstasy of St Teresa*, had a long time before won the public over with *Apollo and Daphne* (see no. 530) created for the Borghese family.

For this group, commissioned by the Cornaro family, Bernini materialises the words of St Teresa of Avila: "I saw the angel with a long spear of gold in his hand, and at the iron's point there seemed to be a little fire. He appeared to me to be thrusting it at times into my heart and to pierce my very entrails [...] The pain was so great, that it made me moan [...] The pain is not bodily, but spiritual [...] It is a caressing love so sweet which now takes place between the soul and God..."

Shown with the angel by her side, the saint in ecstasy expresses a deep sensuality. This work has an intensity that one rarely finds in sculpture, the texture of the draped fabric opposing the purity of the faces of the angel and the saint.

Placed in a chapel conceived by the artist, the group is lit by the natural light falling on the figures from a hidden source above.

504. Mathieu Jacquet, *Equestrian Portrait of Henri IV.*

Moving into the apartments of his predecessors in the château of Fontainebleau, Henri IV commissioned Mathieu Jacquet to create "The Beautiful Fireplace". He was originally employed to decorate the main room of the palace.

The equestrian representation of the sovereign in bas relief is rooted in official Roman art. Like an *imperator* marching in front of his army, the sight of the triumphant king is offered to his visitors, while either side of him two figures in marble represent the benefits that the king wished to establish in his kingdom, Peace and Obedience. Portraying in a sculpture the traits of his sovereign, Jacquet disregards the strict Antique representation in profile to model this three-quarters portrait of Henri IV.

505. Stefano Maderno, *St Cecilia.*

St Cecilia by Maderno can be considered as the work which introduced Roman sculpture into the Baroque period. Commissioned by Cardinal Paolo Emilio Sfondrato, it represents the position in which the body of the martyred St Cecilia was found when her tomb was opened in 1599. The art of Maderno directly addresses the emotions of the spectator, as the works of Bernini and Caravaggio would do later. The body of the young saint seems still warm, while one can perceive on the nape of her neck the fatal mark of the axe. Maderno uses his art to testify of the unwavering religious faith of St Cecilia, who died in the name of Christ. His sculpture gives the impression that the event has just occurred, under the eyes of the incredulous spectator, who, torn between pity and horror, can only be moved.

514. Francesco Mochi, *Angel Annunciate.*

The excessive spiralled accentuation in this angel of the Annunciation by Mochi highlights a new artistic evolution in the history of sculpture. The artist indeed sacrifices the perfection of line, the balance (with the outreached arm of the angel) and the harmony of the work in order to better translate emotion. His sculpture seems to show a sense of rapidity and urgency. He thus renews the sculptural language, the workmanship itself conveying emotion. Yet, despite numerous commissions, Mochi was eclipsed by Bernini. He tried to return to less theatrical sculpture, and the workmanship of the Virgin of his *Annunciation*, counterpart to his Angel Gabriel, is silent testimony to this. Created a few years later, its axis is much more linear and its workmanship more sober. This heir of Mannerism was considered the precursor of the Baroque but died before the birth of the movement, surrendering to Bernini in all his glory.

518. Juan Martínez Montañés, *St Ignatius of Loyola.*

Considered the "Phidias of Seville", Juan Martínez Montañés undertook this sculpture for the beatification of St Ignatius Loyola in 1610. Creator of the head and hands, he managed to soften the energetic face of the founder of the Society of Jesus, who organised his order in militias, while nevertheless producing a portrait striking in its realism. The painter Pacheco undertook the polychromy of the work, which is in the chapel of the University of Seville.

Later, Juan Martínez Montañés made a sculpture of St Francis Borgia to balance the decoration of the chapel.

519. Jörg Zürn, *Altar of the Virgin.*

Conserved *in situ* in the parish church of Überlingen, this altarpiece of the Virgin Mary, conceived by Jörg Zürn at the beginning of the seventeenth century, is a beautiful example of the religious sculpture of southern Germany.

Produced in the vein of the great church altarpieces of northern Europe, in a case sheltering numerous figures, this work stands out from its predecessors thanks to decoration inspired by Mannerist motifs. In the same way, the posture of the figures illustrates the Baroque movement emerging throughout Europe at the beginning of the seventeenth century.

This well conserved work, rich in workmanship, perfectly illustrates the penetration of 'modern' motifs in a region where Gothic codes endured for a long time.

529. Gian Lorenzo Bernini, *David.*

A recurrent subject in sculpture since the beginning of the Renaissance, Bernini's *David* seems to terminate the cycle started by Donatello (see no. 365), Verrocchio (see no. 366) and Michelangelo (see no. 420). If his predecessors decided to sculpt the biblical hero before or after his defeat of Goliath, Bernini chose to present his subject during combat in order to work on the representation of movement, in which he never ceased to excel throughout his career.

Where Michelangelo succeeded thanks to the balance and monumental nature of his figure, Bernini chose to accentuate the dramatic tension in this biblical story by concentrating in this life-size work all the expressiveness of which a man is capable. On his face (considered by some as a self-portrait) David lets conviction show through his contorted concentration. In the same way, this tension can be seen in the sculpted limbs and the back of the figure in tense muscles vibrating underneath its marble skin.

Undertaken for the Borghese family, this work was also inspired by an Antique marble, the *Borghese Gladiator* (see no. 125), kept today in the Louvre Museum. The young artist found in this sculpture good examples of the expression of action (in the distance between the feet, for example) and also the underlying energy which would be seen in his future works.

530. Gian Lorenzo Bernini, *Apollo and Daphne*.

A dazzling symbol of the Roman Baroque, the sculpture *Apollo and Daphne* perfectly illustrates its subject in the majestic movement and emotion brought by the great master Bernini. Commissioned in 1622 by Cardinal Scipione Borghese, this sculpture of a mythological subject captivates by its grace and fluidity. Full of references to Antique sculpture comparable to the *Belvedere Apollo* (see no. 90), the group, based on curves, rises up with a weightlessness which manages to capture the instantaneousness of the transformation of the nymph. Distraught in her escape, Daphne's face expresses fear mixed with passive despair facing the fatality of her destiny; Apollo, portrayed as a young vigorous man, approaches with determination and confidence this young woman whom he cannot let escape.

Sculpted from one block of white Carrara marble, this work charms with the purity of its line and the mastery of its creator, who can model in his noble medium every human sentiment.

532. Alonso Cano, *St Teresa of Avila*.

Characteristic of Spanish sculpture of the seventeenth century, this work in polychrome wood illustrates the singularity of the sculpture created by Alonso Cano. St Teresa of Avila is represented here in a very sober manner, using both a classical style and the new concepts of Baroque sculpture: its delicate expression, showing a contained inner depth, is portrayed through a perfectly oval face, revealing the quest of the artist for refinement of form. The eyes of the saint express a melancholic concentration which opposes the usual hieratism of this type of work, which would have an important influence throughout the Iberian peninsula.

540. Alessandro Algardi, *Funeral Monument for Pope Leo XI*.

Pope for only twenty-seven days, Leo XI died in 1605 and had to wait until the middle of the seventeenth century for a commission entrusted to Algardi for the construction of his tomb in St Peter's Basilica. Influenced by Bernini, who was working on the tomb of Urban VIII, the tomb is in pyramid form, portraying three figures: Pope Leo sculpted by Algardi at the top, and on each side statues of Liberty and Majesty sculpted by Ercole Ferrata and Giuseppe Peroni.

A Baroque work, this group differentiates itself from the work of Bernini by its greater Classicism, owing to the teaching Algardi received in Carracci's studio.

A very beautiful portrait of the late pope, this work illustrates the attention to detail with which Algardi sculpted his portraits, keen to represent the merest psychological detail in an absolute quest for naturalism.

547. Francesco Mochi, *St Veronica*.

St Veronica was the woman who wiped the face of Christ during his walk to Golgotha, where he was crucified. This gesture of compassion led her to be canonised by the Church.

The cloth with which she touched Christ received the marks of the Holy Face, becoming a relic. This scene could only become a masterpiece of the Baroque period because of its dramatic intensity.

Placed in one of the niches of St Peter's Basilica, this masterpiece of Francesco Mochi surprises by its movement and by the large gestures of the saint. Criticised in the eighteenth century, when Baroque was considered a decadent style, the dramatisation of the work became its weak point, but the quality of the sculpted clothing by Mochi was never questioned.

554. Antonio Raggi, *Noli Me Tangere*.

A close collaborator of Bernini, who asked him to produce figures, notably the *Danube* (1650-1651) for the *Fountain of the Four Rivers*, Antonio Raggi had the qualities of a meticulous and attentive sculptor. The scene of the *Noli Me Tangere* is therefore integrated into a Bernini-like project. The composition can be compared to a true theatrical dramatisation characteristic of the Baroque period: the two figures sculpted in the round, facing each other and linked to each other by the placement of their gestures and by the glances they exchange, create their own narrative space. The finely-chiselled draped fabric floating in the air underlines the movement of the figures and the gesture of the hands that is at the heart of the subject: *Noli Me Tangere* (Do not touch me) are the words the risen Christ said to Mary Magdalene on Easter Sunday, before asking her to tell the good news to the apostles.

555. Pedro de Mena, *The Penitent Mary Magdalene*.

Undertaken for the Casa Profeda of the Society of Jesus in Madrid, this *Mary Magdalene* as a penitent is considered one of the major Spanish sculptures of the seventeenth century. Sculpted in wood then painted, the work strikes us by its realism. Dressed in a simple frock, her long hair falling down onto her chest, she is shown barefoot, having a silent dialogue with the crucifix she holds in her hand.

In this work, the artist's style seems to have evolved, highlighting the spiritual depth of the saint and somehow neglecting pure realistic representation.

568. Pierre Puget, *Milon of Croton*.

A masterpiece of the French Baroque, *Milon of Croton* surprised the whole court when it arrived in Versailles in 1683. Pierre Puget indeed differentiated himself from other sculptors by the Baroque training he received in Rome and by the subject he presented to the king.

Milon of Croton, who won the Olympic Games several times during Antiquity, decided to test his strength while walking in a forest by tearing apart a tree stump. As he was about to succeed, the stump closed itself around his hands. With his hands trapped in the tree trunk, he ended his life in exhaustion, devoured by wolves.

Even if Puget replaced the wolves by a lion, he nevertheless offered the court an allegory of Strength vanquished by Time that deeply influenced the art of the time.

Stunning in its strength and tension, this piece, based entirely upon opposed lines, was sculpted from one block of Carrara marble.

The virtuosity with which the sculptor translated Milon's pain is similar to the expertise he has shown by carving the base of his block in two points, increasing the intensity of the line and the powerful feelings represented by this monumental work.

569. François Girardon, *Apollo tended by Nymphs of Thetis*.

A former hunting lodge, the château of Versailles existed before the accession to the throne of Louis XIV, but it was during his reign that the château became the symbol of royal power. The château and the park were created and decorated with many sculptures affirming the power of the French sovereign, who was named the Sun King. The choice of Apollo was obvious, and the Sun, represented during its diurnal course and undertaken by Jean-Baptiste Tuby, was soon installed at the foot of the château in the great basin of the fountain.

This group created by François Girardon appears as the nocturnal counterpart of that episode. Set in the grotto of Thetis, the scene shows the nymphs taking care of the god after the course of the day. Monumental and imposing, this work perfectly illustrates the learned mix that French artists managed to create in order to distinguish their king from the rest of Europe. Drawing its dramatisation from the Baroque, the classical French style demands respect by its solemnity. The haughty figure of the god receives the care of the nymphs in an atmosphere of compliance worthy of a universal sovereign.

570. Gaspard and Balthasar Marsy, *Horses of the Sun*.

Created to complete the group *Apollo attended by the Nymphs* by François Girardon (see no. 569), *Horses of the Sun* was placed near the grotto, showing the care taken by the Tritons of the companions of the sun god before they start their diurnal course again.

Sculpted in Carrara marble like the two others, this group of animals charms us by its ardour and its dramatisation. However, one can also see here the solemnity present in the work of Girardon, which effects the style of this work, despite its unquestionable quality.

To balance the scene, another group undertaken by Guérin was placed on the other side of the central group. The artificial grotto of Thetis was demolished at the beginning of the eighteenth century for an extension to the château, and the sculptures were re-installed in a new artificial grotto, the grotto of Apollo.

A symbol of the strong bonds linking official art and royalty, *Apollo bathing* represents the synthesis of the assimilation of European artistic movements in the service of monarchy by its classical French style, which would soon extend throughout Europe.

571. Pierre Puget, *Alexander and Diogenes*.

When Pierre Puget received from Colbert the royal commission for this colossal bas relief, he could not guess that the work would only be delivered seventeen years later. This marble piece represents the encounter of Alexander the Great with the Greek philosopher Diogenes. The contrast between the posture of Alexander, victorious, riding his horse and surrounded by his soldiers, and that of the sitting philosopher who found refuge in his barrel, underlines the paradoxical aspect of the scene. When Alexander asks Diogenes what he wants, the philosopher answers 'Stand out of my sun!'

The powerful modelling of male figures, the description of the armour and lances, with an Antique city in the background, show the appropriation by Puget of the art he had for a long time studied in Rome with Pietro de Cortona. The success of this work by Puget is undoubtedly due to the presence of parts sculpted in the round which make the piece rise out of its original framing.

584. Antoine Coysevox (and Jean-Baptiste Tuby), *Tomb of Cardinal Mazarin*.

The Cardinal Mazarin planned the installation of his tomb in the chapel of the College of Four Nations, and ordered its construction of a short time before his death. Antoine Coysevox was charged with constructing the tomb from a drawing by Jules Hardouin Mansart. He created the statue of Mazarin, that of the angel and one of the Virtues, *Prudence*. Le Hongre and Tuby sculpted the two others, *Peace* (centre) and *Fidelity* (right). Dominating the space, Mazarin, whose draped cardinal's robes reveal movement, holds a hand on his heart and turns himself towards the spectator. Behind him, the angel holds a Roman column of light, symbol of the power of the late cardinal. Movement and emphasis, tinged with catholicism and Baroque art, dramatise the monument to reconcile death with life and underline their continuity. The contrast between the materials used for the lower part (bronze) and the upper part (marble) is another illustration of this approach. Highlighting the ambitions of Mazarin, the vast proportions of the tomb adapt themselves majestically to the architecture of the chapel and participate in the solemnity of the monument.

585. François Girardon, *Pluto abducting Proserpine*.

To decorate the gardens of Versailles, Louis XIV ordered statues of four mythological abductions: one was commissioned from François Girardon to decorate the water-basin designed by Charles Le Brun. The work presented here is a bronze copy of the preparatory piece.

With a subject drawn from Greek mythology, this group illustrates the abduction of Proserpine, daughter of Ceres, by Pluto, her uncle, god of the underworld, who wanted her for his wife.

Conceived in a spiral, the interlocking figures create a swirling effect accentuated by the draped fabric merging throughout the work. Monumental in its pose, the group rises to the sky, prolonging the line of the goddess' hands trying to escape her captor. Characteristic of the style of great French sculpture, this work differentiates itself from the Baroque style by an absence of expression on the faces of the figures.

588. Antoine Coysevox, *Fame Mounted on Pegasus*.

As the château of Versailles filled with courtiers, Louis XIV wished to escape, and commissioned in 1679 the construction of the château of Marly, a residence with more privacy, based on plans by Jules Hardouin

Mansart. Two sculpted groups were commissioned in 1699 to flank the 'trough' situated at the bottom of the gardens that would be visible from both inside and outside the property. Antoine Coysevox was charged with creating this artwork. He sculpted two equestrian groups: Mercury and Fame, each of them mounting Pegasus. Fame is shown with a laurel crown, standing victorious above military trophies. The corpse of a lion evokes Heracles and, on a shield, one can see Victory holding a palm and crown.

The challenge faced by the sculptor was to represent a rearing horse in one single block of marble. The imbalance thus created was then counterbalanced by the shields. The group can be appreciated from both front and back, the front being directed towards the interior of the park. This statue was dedicated to the glory of the king.

The château was deserted after the death of Louis XIV, when the sculptures were moved; the two groups have decorated the entrance of the gardens of the Tuileries in Paris since 1715.

599. Pierre Legros le Jeune, *Religion overthrowing Heresy and Hatred*.

Pierre Legros the Younger, a French sculptor living in Rome, undertook this allegory of triumphant religion to decorate the altar of the Church of the Gesu belonging to the Society of Jesus.

Perfectly Baroque, this work shows all the characteristics of the time: a religious subject with highly emotional potential, a large-scale representation, a dramatisation with the number of figures limited to bare necessities.

Here, Religion, represented as a young woman holding a cross in her hand, hurls lightning towards Hatred and Heresy, represented respectively by an old woman and an old man. Destabilised by Religion they collapse, and the figure of Heresy, represented by the old man, falls out of the strict framing of the composition. One can read anxiety and fear on their emaciated faces, while Religion, serene and determined, shows her perfect face under the veil covering her head.

To highlight the message transmitted by the work, the sculptor took the liberty of adding an angel at the feet of Religion, passionately tearing the pages of a book considered as heresy.

604. Paul Heermann, *Autumn*.

Having perfected his knowledge of Antique art in Italy, Paul Heermann, the brilliant sculptor of the Court of Saxe, undertook this marble bust on his return from Dresden. Heermann represents *Autumn* with the features of a Hellenistic Bacchus, draped in an Antique manner. A crown of vines with large grapes encircles his chubby face, animated by large smiling eyes, with a large grin enhancing his prominent and fleshy cheekbones. The autumn season was celebrated by the rejoicing of the wine harvest and the opulence of hunters' meals. The art of Paul Heerman was inspired by the works of Balthasar Permoser, who preceded him at the Court of Dresden. Awarded the title of Official Sculptor to the Elector after Balthasar Permoser, Heermann maintained his predecessor's style, which was both Baroque and Rococo.

606. Balthasar Permoser, *Apollo*.

When he sculpted this *Apollo* for his sovereign Augustus of Saxe, also known as Augustus the Strong, Balthasar Permoser placed his work in the European artistic movement of the time. His mythological subject was also the symbol of French absolutism. It is without doubt why it was commissioned by his sovereign who wanted, using the same themes, to compete with the greatness of Louis XIV. Permoser's style, although inspired by the Baroque style of Bernini, keeps a cold distance from the great Italian master: the floating draped fabric surrounding Apollo, carried away by his forward movement, seems counterbalanced by the impassive grace of his face.

An artist who collaborated on the creation of the Zwinger in Dresden, Balthasar Permoser represents perfectly the late German Baroque movement.

608. Narciso Tomé, *Altar "El Transparente"*.

The extraordinary *El Transparente* decorates the high altar of the cathedral of Toledo. This work was commissioned by the archbishop Diego de Astorga y Cespedes, who wanted to glorify the presence of the Holy Sacrament through a monumental sculpture. Narciso Tomé played with the chromatic variety of marble, bronze and stucco, and used an astonishing diversity of detail and complex forms to give his composition its impassioned vitality. The whole height of the front is animated by a tumultuous superimposition of figures and angels, symbols and vegetal scenes. The impression of chaos is however diverted by a skilful use of light that unifies the work. It cost 200,000 ducats, but the enthusiasm it provoked was worth the cost and effort required for such an endeavour. Narciso Tomé brought Baroque sculpture to its summit, giving the illusion of life to inanimate matter.

609. Egid Quirin Asam (and Kosmas Damian Asam), *Assumption of the Virgin*.

The church of the monastery of Rohr houses at its high altar a striking spectacle. Leaving the circle of the apostles, the Virgin is lifted into the sky by two angels, suspended between the massive marble tomb and the dome decorated with stucco clouds. This sculpted group is without doubt the best example of dramatic Baroque art in Germany; the statues respond to each other and participate in the same scene, composing an imaginary space vibrating with reality, whose only intent is to provoke the emotion of the faithful and revive faith. The 'Baroque dramatisation' illustrated by the direction of the gaze, the emphatic gestures and the draped effects reach their climax in the Virgin held weightless above the tabernacle. The execution of the work, which is testimony to the virtuosity of stucco, a practice coming from Italy, required the participation of many sculptors. The group of artists were supervised by the Asam brothers, architects, painters and sculptors, whose name is now closely associated with Bavarian Rococo of the eighteenth century.

610. Niccolò Salvi, *The Fountain of Trevi*.

Abutting onto the Palazzo Poli, the Trevi Fountain fills the small square in which it is situated. Both monumental, with its conception in a triumphal arch, and refined, with the lightness of waterfalls and the sparkling light, this work is an example of the durability of Baroque style in eighteenth-century Rome.

Started in 1732 by the architect Niccolò Salvi, it was completed eleven years after Salvi's death by Niccolò Pannini. Situated at the end of the Roman

aqueduct that brings water from a spring, the *Acqua Virgine*, the fountain celebrates the fertility of water. The main niche shelters Neptune on his shell chariot; the god of the ocean is surrounded by the figures of Abundance and Salubrity. These two sculptures in the round are overlooked by two reliefs: the young girl who discovered the spring on one side, the Roman Emperor Agrippa, who ordered the construction of the aqueduct, on the other.

615. Edme Bouchardon, *Cupid making a Bow out of the Club of Heracles.*

Specialists in classical art at the time considered this statue of Cupid a temporary error in the career of Bouchardon, professor, member of the Academy and sculptor to King Louis XV. Bouchardon intended to give his mythological figure the look of an adolescent, his angular figure, unformed musculature, slim legs and large feet lending a boyish appearance to the god of love. Resolutely true to the living model, the sculptor liberates himself here from the canon of beauty prescribed by the Academy. Some also found his attitude quite licentious: the malicious look and the way in which the young god holds his bow are too equivocal. The statue, installed in the Heracles room of the château of Versailles, displeased the king and the court, who did not approve of the sculptor's audacious style. Exiled in Choisy then in Saint-Cloud, the work was not accepted into the Louvre until the Restoration.

617. Michelangelo Slodtz, *Diana and Endymion.*

Michelangelo Slodtz has long occupied a rather ambiguous place in the historical panorama of eighteenth century French sculpture. Well known for his great Roman works like the statue of St Bruno in St Peter's and the Capponi Tomb at San Giovanni de' Fiorentini, his artistic personality remained somewhat torn between the Baroque, Rococo and Neoclassical idioms of the time. This small group, carved for a private collector, is inspired both by Bernini's works and *galant* French art. The subject belongs to Greek mythology: Endymion, sent to sleep forever at the command of Jupiter in return for being granted perpetual youth, was visited nightly by the goddess Diana.

The beautiful youth, Endymion, has captured poets' and artists' imagination as a symbol of the timelessness of beauty that is "a joy forever". The theme allowed the artist to display his talent by contrasting the amorous eagerness of the goddess with the torpor of the sleeping youth.

618. Guillaume Coustou the Elder, *Horse Restrained by a Groom,* called the *"Marly Horse".*

While nature was wresting back control in the domain of the château of Marly, King Louis XV decided to replace Antoine Coysevox' sculptures (see no. 588) that he had had moved to Paris by two other equestrian groups which he commissioned from Guillaume Coustou.

In these groups Guillaume Coustou tried to outperform his predecessor by sculpting escaped horses restrained by their grooms. The style of the sculpture is also different: the details are more refined, the figures more expressive and the groups more aerial, the base of sculpted rock opening the space below the body of the horse. Moreover, by placing the grooms at the side of the horses, the artist creates an imbalance in the composition, and allows the animals to rear in a higher movement and in a more natural manner.

At the French Revolution the château was destroyed and the gardens for evermore abandoned. In 1794 Coustou's groups joined those by Antoine Coysevox on the Place de la Concorde at the bottom of the Champs Elysées in Paris. Since 1984 the originals have been replaced by casts to protect them from pollution; they are now conserved in the Louvre.

622. Franz Xaver Messerschmidt, *An Arch-Villain.*

Suffering from mental illness, Messerschmidt, a German sculptor, was expelled from the Academy of Vienna and ended his life in Bratislava after having worked brilliantly at court. This work is part of the sixty-nine *Character Heads* undertaken after his retirement. All are variants of his self-portrait. The extremely convincing execution of his expressions, which go from triviality to morbidity, integrate only with difficulty into the art landscape of the eighteenth century. At a time when the Enlightenment raised man to the place of God, Messerschmidt gives a pitiless image of humanity, both formidably violent and infinitely vulnerable. A parallel can be made between his works and the *Essays on Physiognomy* (1775-1778) of Johann Kaspar Lavater, who referred to Messerschmidt several times in his book. The artist was also interested in working with metal alloys and exploring their various effects. Thanks to a combination of tin and lead, the sculptor gave to this head an illusory silver aspect.

626. Ignaz Günther, *Annunciation.*

Born in Altmannstein, the sculptor and architect Ignaz Günther studied under Straub and Donner and worked in Salzburg before becoming court sculptor in Munich in 1773. His works of 1763 in Weyarn are particularly interesting: like the *Pietà* in the same church, this *Annunciation* is a processional statue commissioned from the artist for Good Friday. The composition is a true painting in the round: between the two figures, Günther audaciously depicts divine intervention by means of a dove surrounded by a luminous halo. To amplify the immediacy of the scene, the wooden piece is painted to give a realistic complexion to the characters. But, beyond the impression of reality, this group invites the viewer into a mystical contemplation of the Mystery of the Annunciation, through its grace and the light curves of its ascending movements.

627. Etienne-Maurice Falconet, *Monument to Peter the Great* called the *"Bronze Horseman".*

Recommended by his friend Diderot to Empress Catherine II, Falconet received a commission for an equestrian statue in bronze, a monument dedicated to Peter the Great. Renowned Rococo sculptor and *protégé* of the Marquise de Pompadour, Falconet left behind his success in France to enter the service of the Russian Empress. The sculpture represents Peter the Great, with his left hand holding up his rearing horse, symbol of Russia, crushing a snake, symbol of the Swedish enemy, while his right hand points in the direction of Finland. The head of Peter the Great was made by Marie-Anne Collot, who came to St Petersburg with Falconet, from the death mask made by Rastrelli. The precipitous mound on which the statue is set is nothing but a granite rock extracted from the isthmus of Karelia, linked to the Tsar by legend; it is from this rock that, looking over the country, Peter the Great chose the location of his capital.

635. Augustin Pajou, *Monument to Georges Louis Leclerc de Buffon*.

Like Clodion and Houdon, Augustin Pajou sculpted a series of portraits of the great French personalities who constituted the major figures of the Century of Enlightenment. The *Monument to Georges Louis Leclerc de Buffon*, erected in 1776 in the Cabinet of Natural History, is conceived in the humanist spirit of the time. It pays tribute to Georges Louis-Leclerc, Comte de Buffon, who was the Keeper of the Jardin du Roi – now Jardin des Plantes (Paris). From an apothecary garden, he converted it into a research centre and museum, having planted numerous trees from many origins which were sent to him from around the world. The imposing marble monument is commensurate with the scope of the work left to science by Buffon. The thick coat that covers him makes his bearing even more imposing and powerful; the scientist becomes a hero in an Antique manner. This work perfectly illustrates the concept of the neoclassical portrait: art had to give to the contemporary figure a nobility and an authority which would make him one of the great names of History.

644. Jean-Antoine Houdon, *Seated Sculpture of Voltaire*.

This *Seated Sculpture of Voltaire* by Jean-Antoine Houdon triumphed at the Salon of 1781: it is an audacious work, without flattery. The statue had been commissioned by Madame Denis, the niece of Voltaire, who gave one of the marble versions to the Comédie Française. Through the subtlety of his chisel, Houdon highlights the merest smile and the finest wrinkle, transmitting the psychological depth of his model. A sarcastic smile and sparkling eyes animate the face of the old philosopher of Ferney, who sat for the sculptor during a visit to Paris in 1778. Writers, artists and people of note paraded through Houdon's studio: Diderot, Rousseau, Gluck or Turgot, the artist excelling in the sculpted portrait. Going beyond the Classicism of the time, the works of the 'Sculptor of the Age of Enlightenment' show his quest for a realism specific to his time.

645. Luigi Vanvitelli, *Diana and Actaeon Basin*.

When Luigi Vanvitelli was commissioned to construct the Royal Palace in Caserta (Italy) for Charles III Bourbon, great grandson of Louis XIV and future King of Spain, he surrounded the building with a park considered as one of the most striking Baroque gardens in Italy. In the manner of Versailles, Vanvitelli animated the park with sculpted scenes, surrounded by mineral and vegetal architecture. *Diana and Actaeon Basin*, whose myth is related to the theme of water, is situated in a basin of the great 78-metre high waterfall. Diana, surrounded by two nymphs, is surprised while she is bathing in the wood of Megara by the hunter Actaeon, son of Aristeo. Offended, the goddess transforms him into a stag and he dies, attacked and devoured by his own hounds. Vanvitelli died before completing this sculpted group. Although it was finished by a less talented sculptor, the work is an animated and harmonious group, faithful to the initial project of the eminent Neapolitan master.

648. Jean-Antoine Houdon, *Winter* or *The Chilly Woman*.

Winter is generally personified by an old man wrapped in a coat and close to a burning fire – like the statue of François Girardon in the park of Versailles. To respond to the amiable figure of *Summer* which was meant to be its counterpart, Houdon resolutely liberated himself from convention and represented *Winter* "under the guise of a young girl in marble, life-size and expressing the cold"

(catalogue of the 1783 Salon). The shawl into which she huddles covers only the top of her body, leaving her legs bare, and this led to the work being renamed *The Chilly Woman*. For the marble statue, a vase broken by the frost skilfully serves as a support for the figure; it disappears in the bronze version, shown at the Salon in 1791. Despite the scandal provoked on its exhibition, *The Chilly Woman* illustrates the virtuosity of the neoclassical sculptor at mastering a large statue; it is one of his most reproduced and most copied works.

649. Jean-Antoine Houdon, *Diana the Huntress*.

The bronze of *Diana the Huntress* in the Louvre reveals the qualities of Houdon's casting and his more and more obvious taste for refined forms. The artist had earlier executed this subject in marble quite primitively for the Prince of Saxe-Gotha in 1776. The use of bronze liberates the figure from the support (in the form of foliage) needed in the marble version. The goddess of hunting is seen walking lightly on the tips of her toes on which all the balance of the work is based. The neoclassical sculptor refined his statue even more by suppressing the quiver and the arrows. The gracious *Diana* in bronze, a rangy and elegant figure, refers to the sensuality and eroticism of the school of Fontainebleau. The light gilding on the polished bronze reveals all the grace of the modelling. Until 1796 this bronze was the other half of the *Apollo* installed in the gardens of Jean Girardot de Marigny, and is now in Lisbon.

650. Antonio Canova, *Psyche Awakened by Eros*.

As a commission from the English collector Campbell, Canova undertook one of his most famous sculpted groups, illustrating the myth of Psyche. The victim of Venus' jealousy because of her beauty, the mortal woman was bewitched in sleep from which only love could wake her. The artist chose the culminating part of the story, in which Cupid, recognisable by the quiver on his back, wakes up his beloved to marry her and raise her up to the rank of goddess. The expression of love is shown in its quintessence: the purity of contours, the elegance of form and the harmony of the composition in the shape of a pyramid transform the material of the marble into an angelic and weightless composition. If Canova inspired himself throughout his life with the Antiquity that he studied assiduously in Rome, he did not translate it by the vigorous anatomy and modelling of Greek art but by an elegant and gracious style: his refined reappropriation of Antique art is one of the most accomplished examples of neoclassical sculpture.

652. Johann Gottfried Schadow, *The Crown Princesses Louise and Friedrike of Prussia*.

From 1780 Schadow was a major figure of German art, producing for almost half a century a considerable amount of private portraits in busts, and various sculptures destined for public monuments – among them the famous quadriga on the Brandenburger Tor in Berlin. After the marriage of the Prussian Crown Prince Frederick William and his young brother Ludwig with the Princesses of Mecklenburg-Strelitz in December 1793, Schadow was commissioned to produce the bust portraits of the two sisters. While creating the work, Schadow opted for a double full-length portrait. A life-size plaster version was first exhibited in 1795, then Schadow started working on a marble version which was exhibited in 1797. However, following the early death of Frederick William II, these two gracious figures left Schadow's studio to be installed in an unused room of the Royal Palace in Berlin, hidden from public sight.

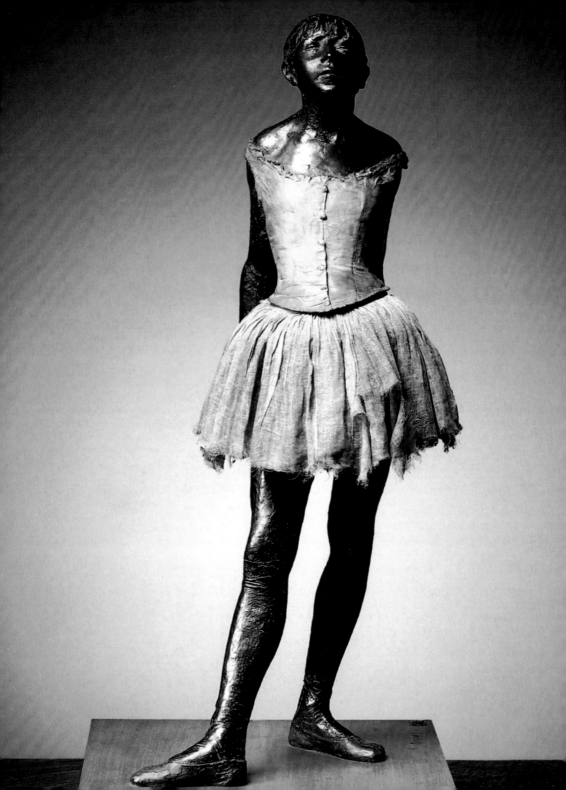

Modern

The shattering political events of the late eighteenth century and early nineteenth century occurred during the flowering of Neoclassicism, but the origins of that style preceded the revolutions in France and America. Flourishing, it is true, in America and France, Neoclassicism was equally at home in England, Russia, and Sweden, and it had reverberations in such places as Italy, Austria, Mexico, and elsewhere throughout the western world. It was manifested in all of the arts, including sculpture and its siblings architecture and the decorative arts. Neoclassicism had other more specific causes, including the rediscovery in the mid-eighteenth century of the ruins of the ancient cities of Herculaneum and Pompeii, and in the expanded popularity of the Grand Tour among the educated classes of Europe, a travel and learning experience particularly focused on the arts of Italy from antiquity and the Renaissance.

The Italian Antonio Canova, working for an international clientele, flattered Napoléon with his grand, ideal nude (now in the courtyard of the Brera Museum), and in a memorable image of Napoleon's sister, Pauline Borghese (see no. 660). The semi-nude Pauline, with Grecian profile reminiscent of a Venus, is recumbent on classical-revival furniture copied from ancient Roman design. The Englishman Joseph Wilton and the American Horatio Greenough contributed in their own ways to the same rediscovery of the ideals of classical sculpture, a movement that started as a slight on the frivolities of the rococo and ended as one of the continuing revival movements of the nineteenth century. The international quality of the style is shown in the works of Bertel Thorvaldsen, who, like most fellow neoclassical painters and sculptors of the time, rendered his subjects with gentle emotional sentiment and soft surface texture.

During the nineteenth century, feelings, nostalgia, and exoticism began to dominate the arts, in a style known as Romanticism. The passionate attitudes of Romanticism were expressed in the sculptures of Antoine-Louis Barye, who was fascinated by the power of animals and their inner life and strength, features that he captured most frequently in smallish bronzes. The violence in his scenes is widely found in romantic art. Jean-Baptiste Carpeaux best expressed the neo-baroque aspects of French Romanticism, and his sculptures' lively movement and what some contemporaries saw as unadorned naturalism had links to seventeenth-century art. Carpeaux' *Ugolino* (see no. 697), representing an imprisoned and starving father and his sons, draws on stylistic sources in the baroque, Michelangelo, and Hellenistic antiquity, but with a searing emphasis on horror that was modern for its time. Auguste Rodin dominated the field of sculpture in the late nineteenth century, bringing modernist strains to bear. Reaching back to the expressionism found in antiquity and the sixteenth century, his works are complex. He shared equally in the emotionalism of Romanticism and the bluntness of contemporary realism, and his rough surface articulations were influenced by impressionism and post-impressionist artistry. He embraced the *non finito* (unfinished) models of Michelangelo, but did so for the modernist ends of abstraction and fragmentation.

Whether fairly or unfairly, the nineteenth century is not usually seen as a great century of sculpture. The same cannot be said for the twentieth century, when the art form was often practised by those proficient in other artistic media, and when sculpture went hand in

hand with painting in finding expression in innovative styles. Pablo Picasso, having developed cubism in painting, soon applied similar principles of abstraction and deconstruction in his sculpture, as he did in his collages. The painter Henri Matisse also turned to sculpture to experiment with abstraction and geometricisation of figures. The Russian Aleksandr Archipenko, like the cubists, broke down the planes of his figures, which are smoothed out and abstracted with a smooth elegance. Jacques Lipschitz had also adapted cubism to sculpture by the second decade of the twentieth century, and he practised an angular, complex, and intertwined style in consonance with the paintings of Picasso and Georges Braque. Adumbrating a principle of fragmented movement that would be adopted by the futurists, Umberto Boccioni's famous *Unique Forms of Continuity in Space* of 1913 (see no. 657) represents, unlike the analytic cubist inspiration, rushing movement. Meanwhile, the twentieth-century penchant for purer abstraction was shared by the Romanian Constantin Brancusi, whose smooth and sometimes sensuous sculpture often reduced surface articulation to a minimum, while still maintaining meaningful subject matter.

The angst often associated with the early and mid twentieth-century art and culture found manifestation in the expressionistic works of Alberto Giacometti, the Swiss sculptor who crafted his human forms as isolated and thin figures that move in slow, dream-like fashion. Despite the sharp emotionalism of much modernist sculpture, a great strain of light-heartedness appears throughout the period. Picasso's wit appears often in his sculpture, whether in his *Baboon and Young* (the mother's head formed by the found object, namely, a toy car), or the *Bull's Head*, made of a bicycle wheel and handlebars. The practitioners of Dada, such as Marcel Duchamp, informed their works with an element of humour, as Duchamp did in his ready-mades the

Bicycle Wheel see no. 811) and *Fountain* (see no. 826), the latter a real urinal signed "R. Mutt". The surrealist contribution, exemplified by works like the famous *Fur Cup* of Meret Oppenheim (see no. 871), challenged authority in forms that nearly always had an underlying sense of humour. This attitude would be carried forward later in the century by the pop artists, who combined objects from daily use or crafted them, their works charged often charged with sexual innuendo and frequently embracing a light mocking of modern mass consumerism. Claes Oldenburg's public sculptural works, representing large-scale burgers (see no. 926) and clothes pegs, mock tradition by portraying everyday objects in monumental form. On a smaller scale, Swish sculptor Jean Tinguely's playful, colourful, and sometimes toy-like forms express the whimsy of the artist and take the form of kinetic art. Finally, postmodernism took humour to a new level, and based its very existence on the challenge, more often than not light-hearted, of stylistic and cultural traditions.

As in the nineteenth century, a number of sculptural works, often large in scale, caught the fancy of the public and have become icons of national landscapes. For example, sculptural monuments of the "American Century" are Gutzon Borglum's Mount Rushmore project in South Dakota (see no. 880), with US presidential portraits carried out on a mountainside in a spatially crowded style not unrelated to other works of modernism. The Finnish Eero Saarinen produced Saint Louis' *Gateway Arch*, offering a grand portal to the western United States, and bringing modernist abstraction to public attention. Similarly abstract is Maya Lin's *Vietnam Memorial*, its smooth surface and dark reflections casting a minor key, even as the maternal V-shape and earth-boundedness offer a kind of comfort. The unrelenting popularity of such monuments suggest that the future of sculpture as an art form is secure.

See next page:
657. Umberto Boccioni, 1882-1916, Italian.
Unique Forms of Continuity in Space, 1913.
Bronze, 111.2 x 88.5 x 40 cm.
The Museum of Modern Art, New York (United States). Futurism. (*)

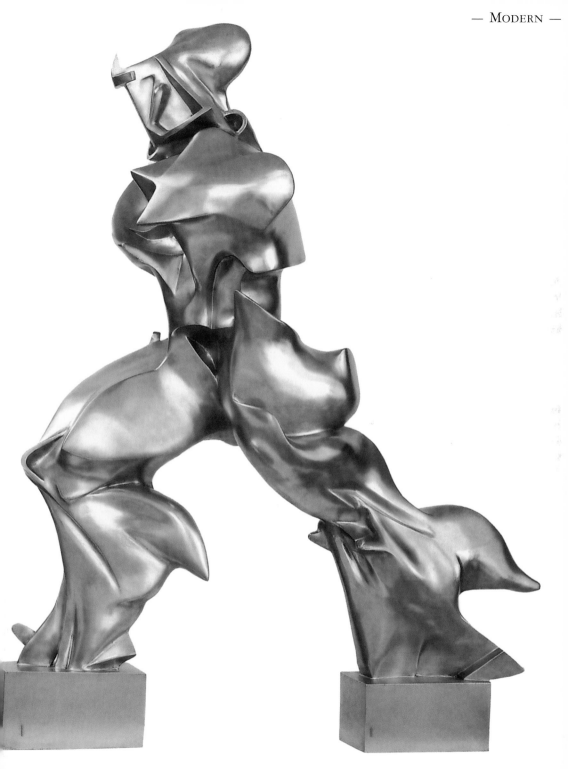

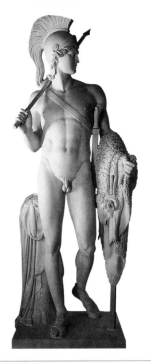

658. **Bertel Thorvaldsen**, 1770-1844, Danish.
Jason with the Golden Fleece, 1803-1828. Marble, h: 242 cm.
Thorvaldsens Museum, Copenhagen (Denmark). Neoclassicism. (*)

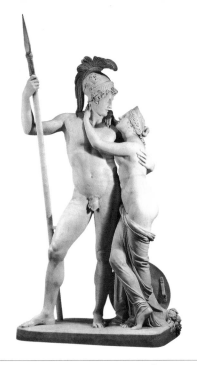

659. **Antonio Canova**, 1757-1822, Italian.
Venus and Mars, 1816-1822. Marble, h: 210 cm.
Buckingham Palace, London (United Kingdom). Neoclassicism.

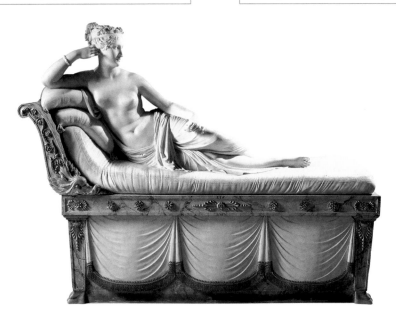

660. **Antonio Canova**, 1757-1822, Italian.
Pauline Bonaparte as Venus, 1805-1808. Marble, l: 200 cm.
Galleria Borghese, Rome (Italy). Neoclassicism. (*)

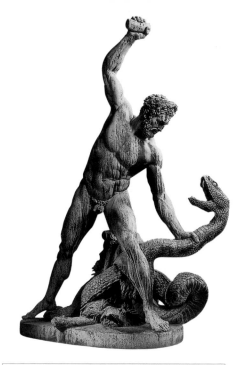

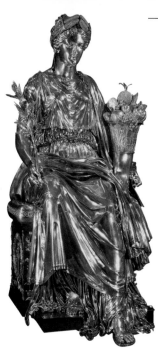

661. **François-Joseph Bosio**, 1768-1845, French.
Heracles fighting with Achelus Transformed into a Snake, 1814-1824.
Bronze, 260 x 210 x 95 cm.
Musée du Louvre, Paris (France). Neoclassicism.

662. **Antoine-Denis Chaudet**, 1763-1810, French.
Peace, 1806. Silver, silver gilt, bronze and gilded bronze, h: 167 cm.
Musée du Louvre, Paris (France). Neoclassicism.

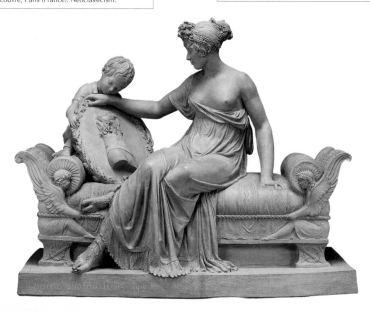

663. **Joseph Chinard**, 1756-1813, French.
The Family of General Philippe-Guillaume Duhesme, c. 1808.
Terracotta, h: 56 cm.
J. Paul Getty Museum, Los Angeles (United States). Neoclassicism.

See next page:
664. **François-Joseph Bosio**, 1768-1845, French.
Louis XIV, 1816-1822. Bronze.
Place des Victoires, Paris (France). Neoclassicism.

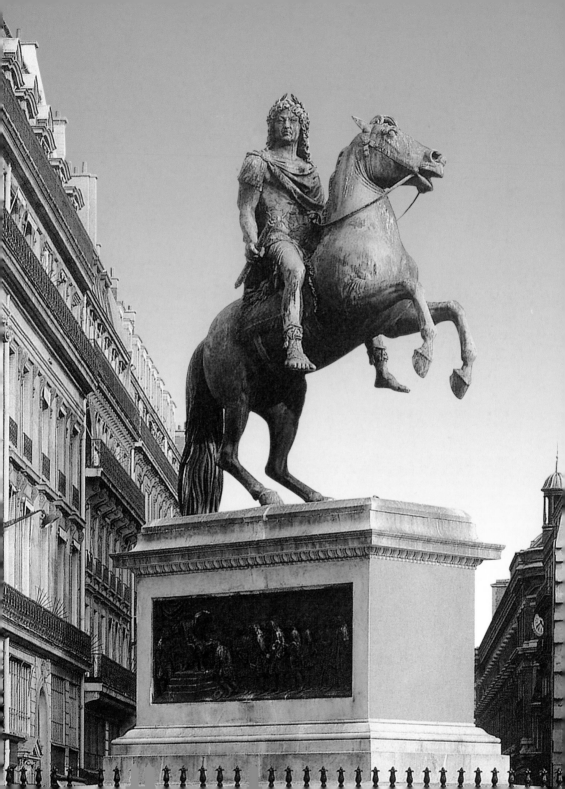

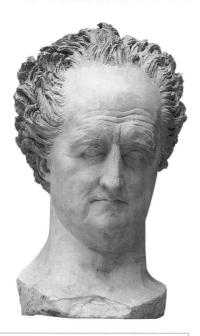

665. **Pierre Jean David d'Angers**, 1788-1856, French.
Johann Wolfgang von Goethe, 1829.
Plaster, 83 x 58 x 51 cm.
Musée d'Orsay, Paris (France). Neoclassicism.

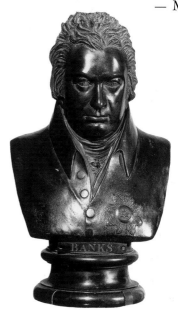

666. **Anne Seymour Damer**, 1748-1828, English.
Portrait Bust of Sir Joseph Banks, 1814. Bronze, h: 71 cm.
The British Museum, London (United Kingdom). Naturalism.

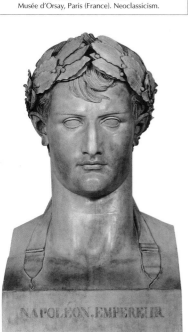

667. **Lorenzo Bartolini**, 1777-1850, Italian.
Napoléon I, c. 1805. Bronze, h: 155 cm.
Musée du Louvre, Paris (France). Neoclassicism.

668. **Pierre Jean David d'Angers**, 1788-1856, French.
Bust of Mary Robinson, 1824. Marble, h: 46.4 cm.
J. Paul Getty Museum, Los Angeles (United States). Neoclassicism.

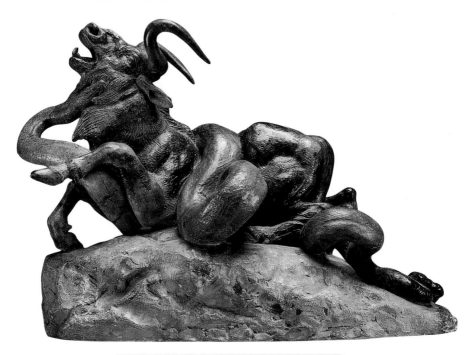

669. **Antoine-Louis Barye**, 1795-1875, French.
Python killing a Gnu, 1834-1835.
Red wax and plaster, 27.9 x 39 cm.
J. Paul Getty Museum, Los Angeles (United States). Romanticism.

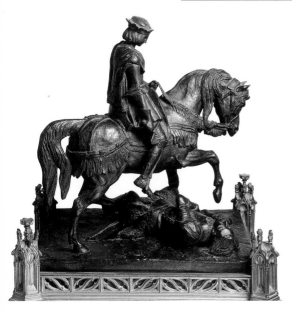

670. **Princess Marie d'Orléans**, 1813-1839, French.
Joan of Arc riding and crying at the Sight of a Wounded, 1833. Bronze, h: 49 cm.
Musée Condé, Chantilly (France). Romanticism.

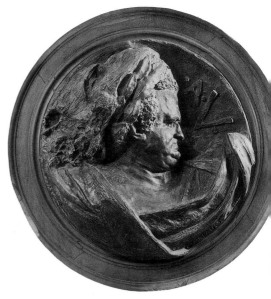

671. **Auguste Préault**, 1809-1879, French.
Aulus Vitellius, 1834-1870. Bronze, diameter: 75 cm.
Romanticism.

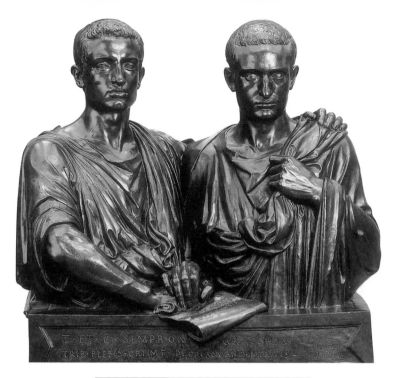

672. **Eugène Guillaume**, 1822-1905, French.
The Gracchi, 1847-1853. Bronze, 85.2 x 90.2 x 60.7 cm.
Musée d'Orsay, Paris (France). Neoclassicism.

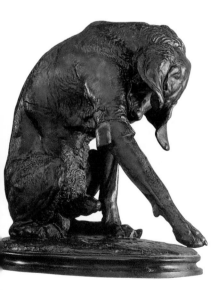

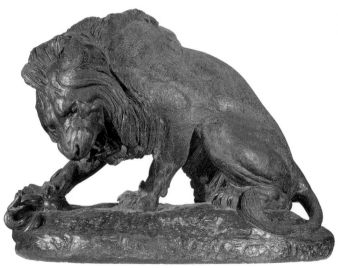

673. **Emmanuel Fremiet**, 1824-1910, French.
Wounded Dog, c. 1850. Bronze, 69 x 69 x 42.5 cm.
Musée d'Orsay, Paris (France). Neoclassicism/Naturalism.

674. **Antoine-Louis Barye**, 1795-1875, French.
Lion fighting a Serpent, 1835. Bronze, 135 x 178 x 96 cm.
Musée du Louvre, Paris (France). Romanticism. (*)

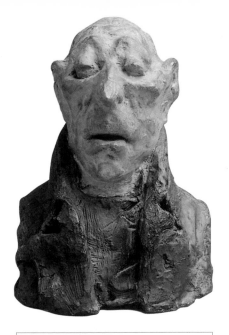

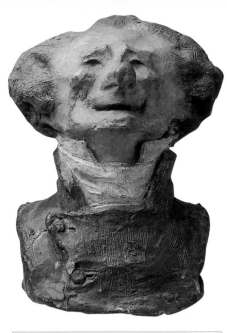

675. **Honoré Daumier**, 1808-1879, French.
Jean-Claude Fulchiron, Poet and Representative, c. 1832.
Painted clay, 17.3 x 12.9 x 11.8 cm.
Musée d'Orsay, Paris (France). Realism.

676. **Honoré Daumier**, 1808-1879, French.
Charles Philipon, Journalist, Creator and Newspaper Director,
c. 1832. Painted clay, h: 16.4 cm.
Musée d'Orsay, Paris (France). Realism. (*)

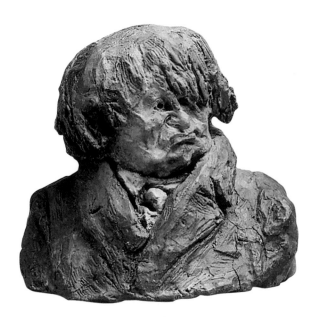

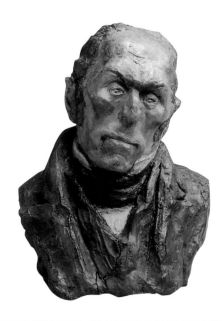

677. **Honoré Daumier**, 1808-1879, French.
Doctor Clément-François Victor Gabriel Prunelle, Representative,
c. 1832. Painted clay, 13.4 x 15.2 x 15.9 cm.
Musée d'Orsay, Paris (France). Realism.

678. **Honoré Daumier**, 1808-1879, French.
François-Pierre-Guillaume Guizot, Prime Minister, c. 1832.
Painted clay, 22 x 17 cm.
Musée d'Orsay, Paris (France). Realism.

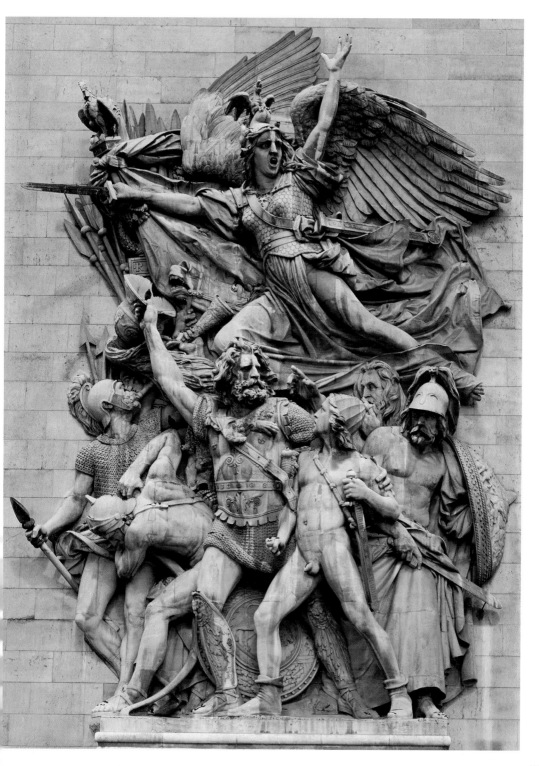

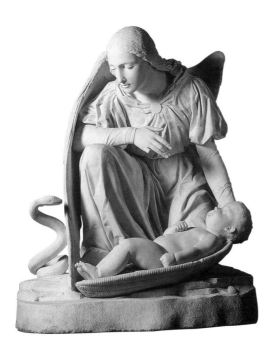

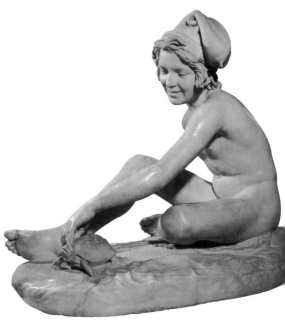

680. **Antoine Desbœufs**, 1793-1862, French.
The Guardian Angel, 1833. Marble, h: 100 cm.
Musée de Picardie, Amiens (France). Neoclassicism.

681. **François Rude**, 1784-1855, French.
Neapolitan Fisherman playing with a Tortoise, 1833.
Marble, 82 x 88 x 48 cm.
Musée du Louvre, Paris (France). Romanticism.

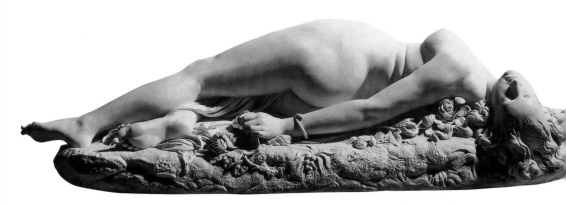

See previous page:
679. **François Rude**, 1784-1855, French.
La Marseillaise, 1833-1836. Bronze, 42.8 x 29 x 25 cm.
Musée des Beaux-Arts, Nice (France). Romanticism. (*)

682. **Auguste Clésinger**, 1814-1883, French.
Woman Bitten by a Snake, 1847. Marble, 56 x 180 x 70 cm.
Musée d'Orsay, Paris (France). Eclecticism. (*)

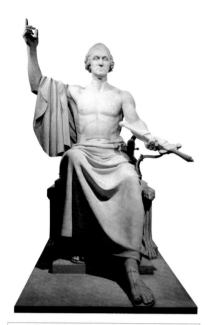

683. **Horatio Greenough**, 1805-1852, American.
George Washington, 1840. Marble, 345.4 x 259 x 209.5 cm.
Smithsonian American Art Museum, Washington, D.C.
(United States). Neoclassicism.

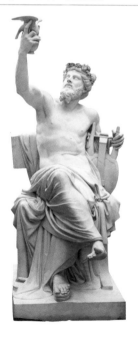

684. **Eugène Guillaume**, 1822-1905, French.
Anacreon, 1851. Marble, 185 x 80 x 122 cm.
Musée d'Orsay, Paris (France). Neoclassicism.

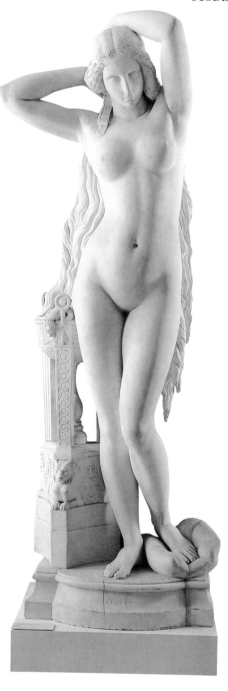

685. **Jean-Jacques Pradier (James Pradier)**, 1790-1852, Swiss.
Nyssia, 1848. Marble, h: 176 cm.
Musée Fabre, Montpellier (France). Neoclassicism.

686. **Auguste Préault**, 1809-1879, French.
Dante, 1852. Bronze, brown patina, 95 x 85.9 x 23 cm.
Musée d'Orsay, Paris (France). Romanticism.

687. **Auguste Préault**, 1809-1879, French.
Virgil, 1853. Bronze, brown patina, 95 x 85.5 x 23 cm.
Musée d'Orsay, Paris (France). Romanticism.

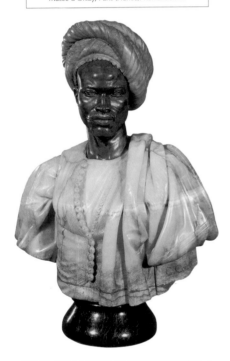

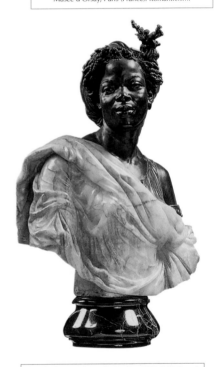

688. **Charles Henri Joseph Cordier**, 1827-1905, French.
Negro of the Sudan, 1856-1857.
Bronze, onyx and Vosges porphyre, h: 96 cm.
Musée d'Orsay, Paris (France). Realism. (*)

689. **Charles Henri Joseph Cordier**, 1827-1905, French.
"Capresse des Colonies" (Bust of a Negress), 1861.
Onyx, porphyre and bronze, 96.5 x 54 x 28 cm.
Musée d'Orsay, Paris (France). Realism.

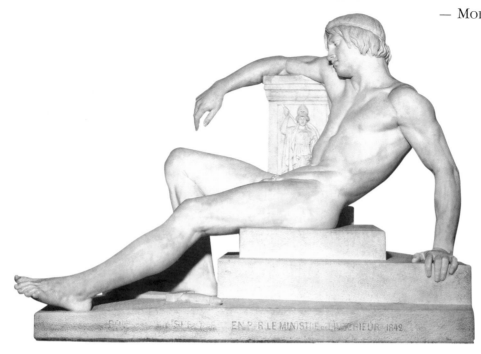

690. **Pierre-Charles Simart**, 1806-1857, French.
Orestes Sheltered in the Pallas Altar, 1839-1840.
White marble, 125 x 168 x 81 cm.
Musée des Beaux-Arts, Rouen (France). Neoclassicism.

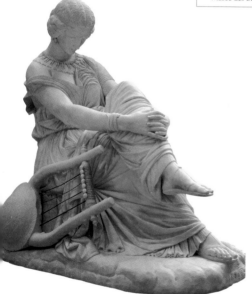

691. **Jean-Jacques Pradier (James Pradier)**, 1790-1852, Swiss.
Sappho, 1852. Marble, gilding, h: 118 cm.
Musée d'Orsay, Paris (France). Neoclassicism. (*)

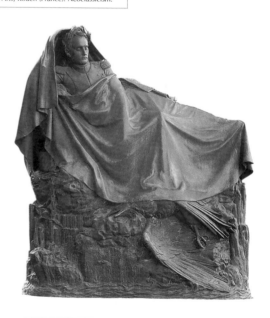

692. **François Rude**, 1784-1855, French.
Napoléon rising to Immortality, 1845-1847. Bronze, l: 251.5 cm.
Parc Noisot, Fixin-lés-Dijon (France). Romanticism. (*)

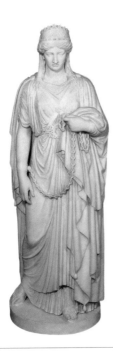

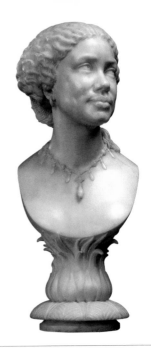

693. **Harriet Hosmer**, 1830-1908, American.
Xenobia in Chains, 1859. Marble, 124.4 x 40.6 x 53.3 cm.
Wadsworth Atheneum, Hartford (United States). Neoclassicism.

694. **Henry Weekes**, 1807-1877, English.
Bust of Mary Seacole, 1859. Marble, h: 66 cm.
J. Paul Getty Museum, Los Angeles (United States).
Neoclassicism/Historical Realism.

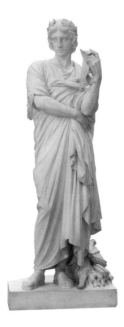

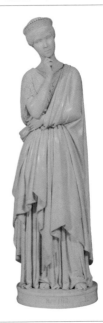

695. **Gabriel-Jules Thomas**, 1824-1905, French.
Virgil, 1861. Marble, 183 x 72 x 56 cm.
Musée d'Orsay, Paris (France). Neo-Baroque.

696. **Jean-Auguste Barre**, 1811-1896, French.
Rachel, 1848.
Ivory on a gilded bronze plinth, h: 46 cm.
Musée du Louvre, Paris (France). Neoclassicism.

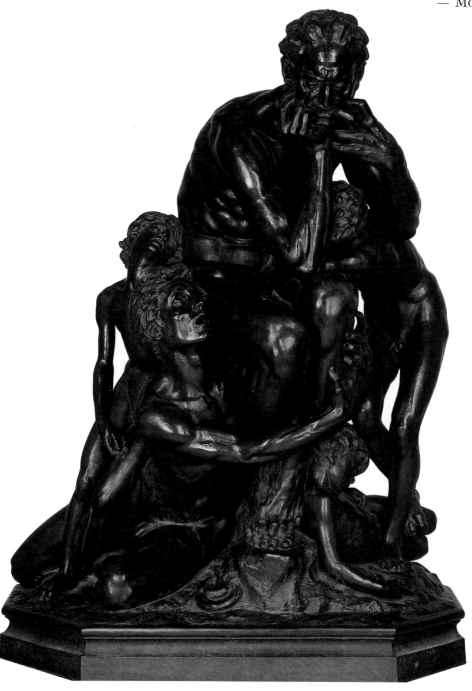

697. Jean-Baptiste Carpeaux, 1827-1875, French.
Ugolino, 1862. Bronze, cast iron, 194 x 148 x 119 cm.
Musée d'Orsay, Paris (France). Realism. (*)

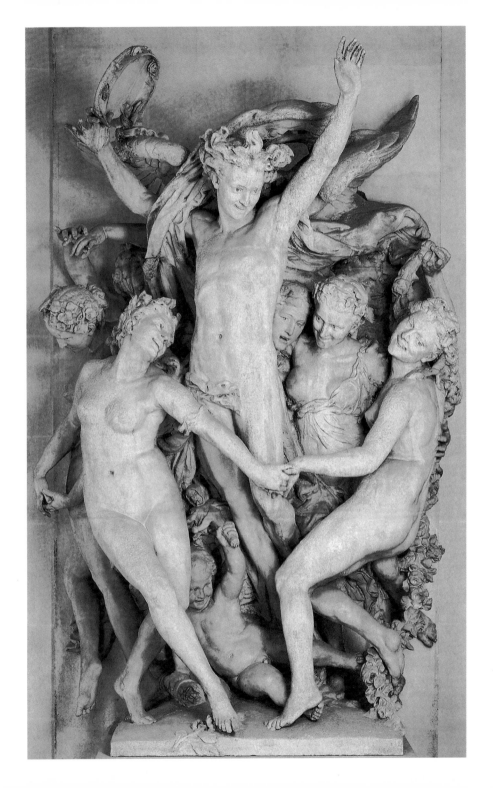

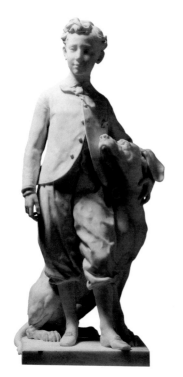

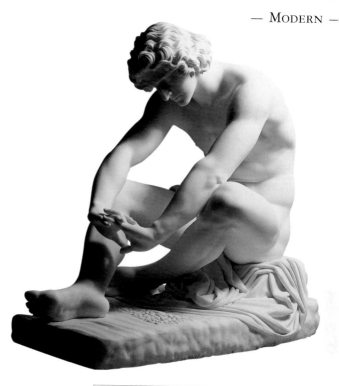

699. **Jean-Baptiste Carpeaux**, 1827-1875, French.
The Imperial Prince, c. 1865.
Plaster, 62 x 31.3 x 24.1 cm.
Musée d'Orsay, Paris (France). Realism.

700. **Jean-Joseph Perraud**, 1819-1876, French.
Despair, 1869. Marble, 108 x 68 x 118 cm.
Musée d'Orsay, Paris (France). Academicism.

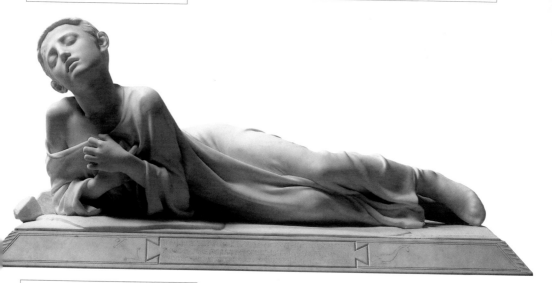

See previous page:
698. **Jean-Baptiste Carpeaux**, 1827-1875, French.
The Dance, 1865-1869. Stone, 420 x 298 x 145 cm.
Musée d'Orsay, Paris (France). Realism. (*)

701. **Jean-Alexandre-Joseph Falguière**, 1831-1900, French.
Tarcisius, Christian Martyr, 1868. Marble, 64 x 140 x 59.9 cm.
Musée d'Orsay, Paris (France). Academicism.

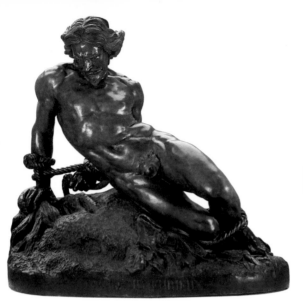

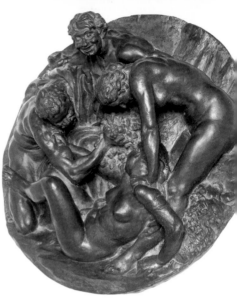

702. **Jehan Duseigneur**, 1808-1866, French.
Orlando Furioso, 1867. Bronze, 130 x 140 x 90 cm.
Musée du Louvre, Paris (France). Romanticism.

703. **Aimé-Jules Dalou**, 1838-1902, French.
Bacchanale, 1879-1899. Bronze, diameter: 59 cm.
Musée d'Orsay, Paris (France). Realism.

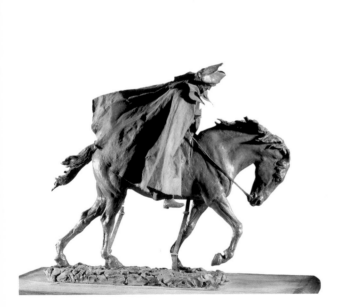

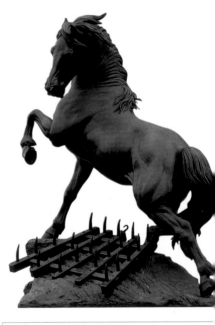

705. **Pierre-Louis Rouillard**, 1820-1881, French.
Horse with a Harrow, exhibited in front of the first Palace of Trocadéro
constructed for the Universal Exhibition in 1878, 1878.
Bronze, 350 x 223 x 220 cm.
Musée d'Orsay, Paris (France). Academicism/Naturalism.

704. **Jean-Louis-Ernest Meissonier**, 1815-1891, French.
The Traveller in the Wind, 1870-1880. Wax, 47.8 x 60 cm.
Musée d'Orsay, Paris (France). Academicism. (*)

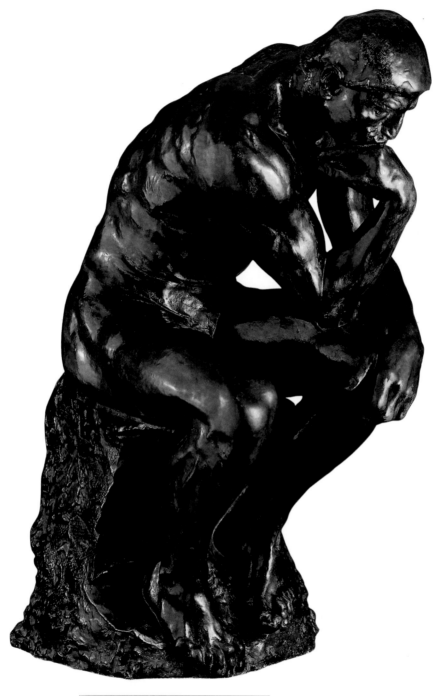

706. **Auguste Rodin**, 1840-1917, French.
The Thinker, 1881. Bronze, 71.5 x 40 x 58 cm.
Musée Rodin, Paris (France). Expressionism. (*)

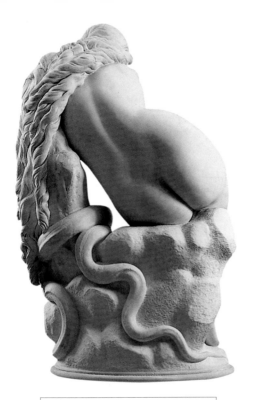

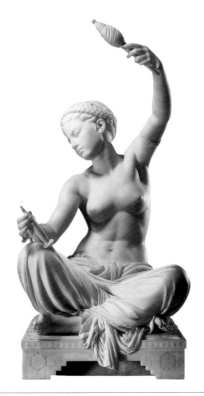

707. **Eugène Delaplanche**, 1836-1891, French.
Eva after the Sin, 1869. Marble, 152 x 105 x 89 cm.
Musée d'Orsay, Paris (France). Eclecticism.

708. **Louis-Ernest Barrias**, 1841-1905, French.
Young Girl from Megara, 1870. Marble, 126 x 63 x 66 cm.
Musée d'Orsay, Paris (France). Neoclassicism.

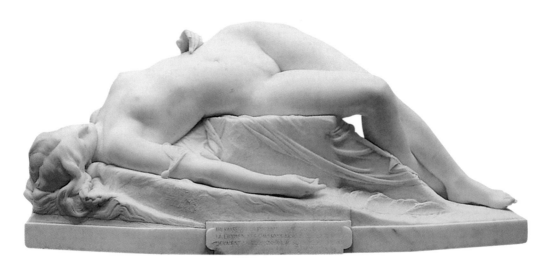

709. **Pierre-Alexandre Schoenewerk**, 1820-1885, French.
Young Tarentine, 1871. Marble, 74 x 171 x 68 cm.
Musée d'Orsay, Paris (France). Eclecticism.

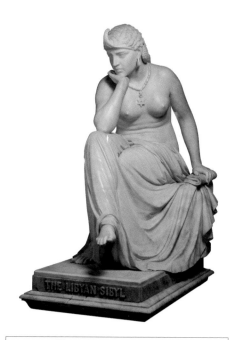

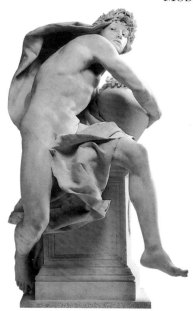

710. **William Wetmore Story**, 1819-1895, American.
The Libyan Sibyl, 1868. Marble, 144.8 x 78.4 x 111.1 cm.
Smithsonian American Art Museum, Washington, D.C.
(United States). Neoclassicism.

711. **René de Saint-Marceaux**, 1845-1915, French.
Genius keeping the Secret of the Tomb, 1879.
Marble, 168 x 95 x 119 cm.
Musée d'Orsay, Paris (France). Neoclassicism.

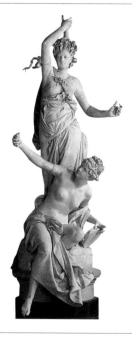

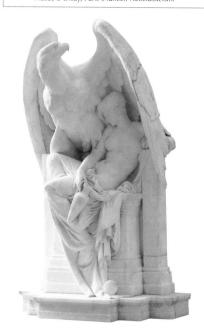

712. **Albert-Ernest Carrier-Belleuse**, 1824-1887, French.
Flare with a Tambourine, c. 1872. Plaster, 53.1 x 26.2 x 22 cm.
Musée d'Orsay, Paris (France). Neoclassicism.

713. **Albert-Ernest Carrier-Belleuse**, 1824-1887, French.
Hebe Asleep, 1869. Marble, 207 x 146 x 85 cm.
Musée d'Orsay, Paris (France). Neoclassicism.

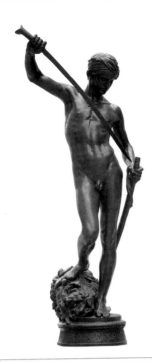

714. Marius-Jean-Antonin Mercier, 1845-1916, French.
David, 1872-1873. Bronze, 68 x 197 x 93 cm.
Musée d'Orsay, Paris (France). Academicism.

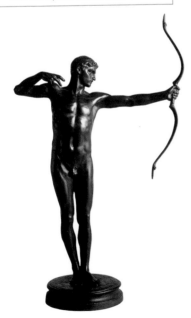

715. Sir Hamo Thornycroft, 1850-1925, English.
Teucer, 1881. Bronze, 44 x 30 cm.
Royal Academy of Arts, London (United Kingdom).
New Sculpture.

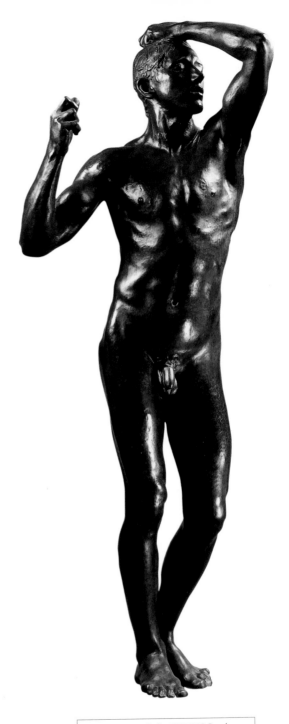

716. Auguste Rodin, 1840-1917, French.
The Age of Bronze, 1876. Bronze, 170.2 x 60 x 60 cm.
Musée d'Orsay, Paris (France). Expressionism.

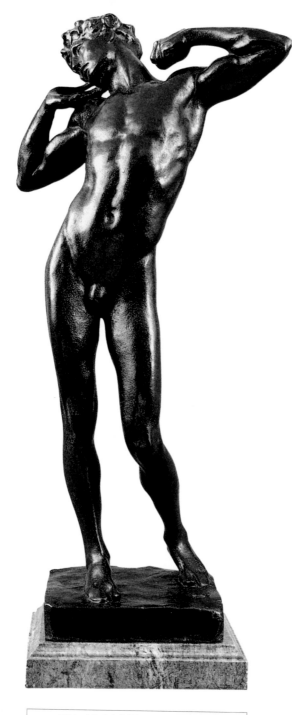

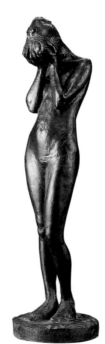

718. **Marie Bashkirtseff**, 1860-1884, Ukrainian.
The Pain of Nausicaa, 1884.
Bronze, dark patina, 83 x 23.7 x 23 cm.
Musée d'Orsay, Paris (France). Naturalism.

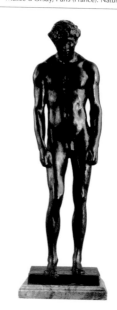

717. **Lord Frederic Leighton**, 1830-1896, English.
The Sluggard, 1885. Bronze, 190 x 94 cm.
Royal Academy of Arts, London (United Kingdom). Classicism.

719. **Lord Frederic Leighton**, 1830-1896, English.
Cymon, c. 1884. Bronze, 55 x 17.7 cm.
Royal Academy of Arts, London (United Kingdom). Classicism.

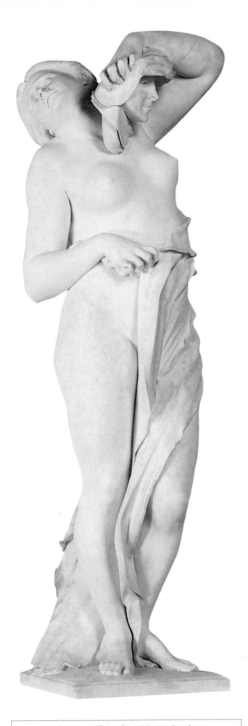

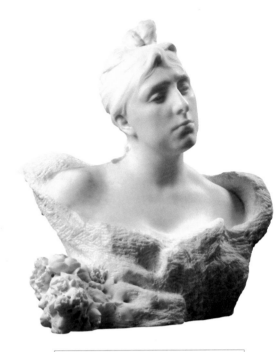

721. **Auguste Rodin**, 1840-1917, French.
Mrs Morla Vicuna, 1884. Marble, 47.2 x 34.5 x 25.1 cm.
Musée Rodin, Paris (France). Expressionism.

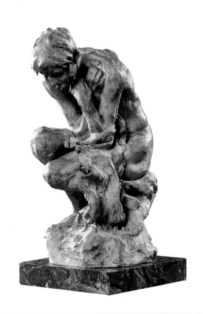

720. **Ernest Christophe**, 1827-1892, French.
La Comédie Humaine or *The Mask*, 1876. Marble, 245 x 85 x 72 cm.
Musée d'Orsay, Paris (France). Romanticism.

722. **Jules Desbois**, 1851-1935, French.
Old Woman (Poverty), 1884-1894. Terracotta, 37.5 x 17.7 x 24.6 cm.
Musée Rodin, Paris (France). Expressionism.

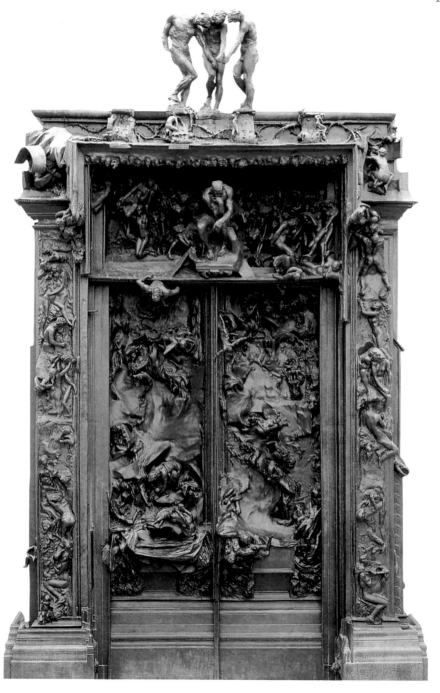

723. **Auguste Rodin**, 1840-1917, French.
The Gates of Hell, 1880-1917. Bronze, 636.9 x 401.3 x 84.8 cm.
Musée Rodin, Paris (France). Expressionism. (*)

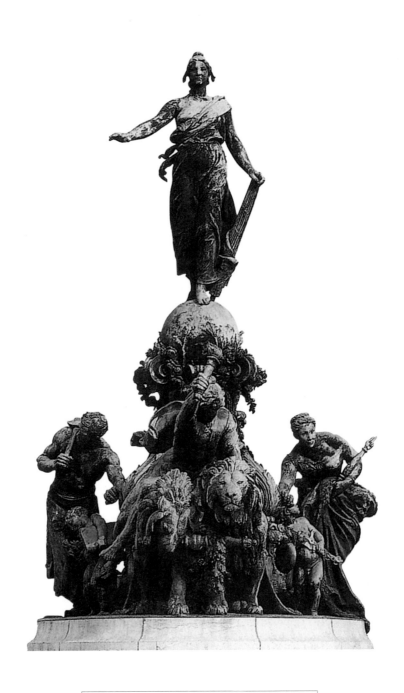

724. **Aimé-Jules Dalou**, 1838-1902, French.
The Triumph of the Republic, 1880-1899. Bronze, 12 x 6.5 x 12 m.
Place de la Nation, Paris (France). Realism. (*)

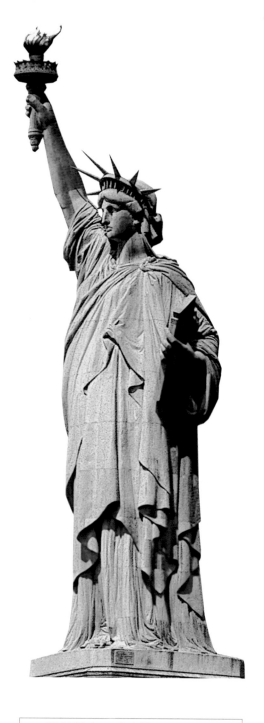

725. **Frédéric-Auguste Bartholdi**, 1834-1904, French.
The Statue of Liberty, 1886. Copper, h: 92.9 m.
Liberty Island, New York Harbor (United States). Academism. (*)

726. **Alfred Gilbert**, 1854-1934, English.
George Frederic Watts, 1889. Plaster, 55.9 x 60.3 cm.
Royal Academy of Arts, London (United Kingdom).
New Sculpture.

727. **Edward Onslow Ford**, 1852-1901, English.
Sir John Everett Millais, 1895. Bronze, 63.5 x 66 cm.
Royal Academy of Arts, London (United Kingdom). Neoclassicism.

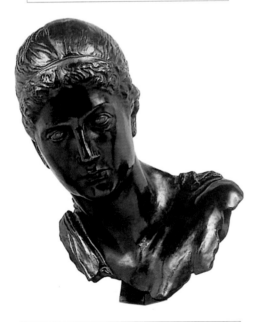

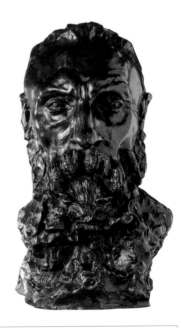

728. **Max Klinger**, 1857-1920, German.
Cassandra, c. 1903. Bronze with dark-brown patina, h: 59 cm.
Klaus Otto Preis Collection, Paris (France). Symbolism.

729. **Camille Claudel**, 1864-1943, French.
Auguste Rodin, 1888. Bronze, 40.7 x 25.7 x 28 cm.
Private collection. Expressionism. (*)

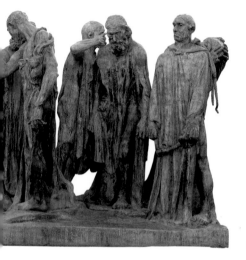

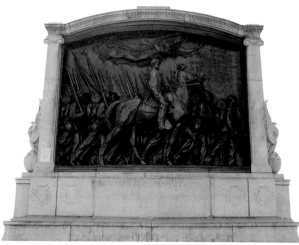

730. **Auguste Rodin**, 1840-1917, French.
The Burghers of Calais, 1889. Bronze, 217 x 255 x 177 cm.
Musée Rodin, Paris (France). Expressionism.

731. **Augustus Saint-Gaudens**, 1848-1907, American.
Colonel Robert Gould Shaw Memorial, 1883-1897.
Bronze, 335.3 x 426.7 cm.
Boston Commons, Boston (United States). Realism.

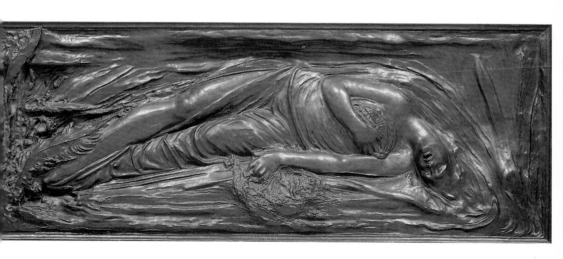

732. **Auguste Préault**, 1809-1879, French.
Ophelia, 1876. Bronze, cast iron, 75 x 200 x 20 cm.
Musée d'Orsay, Paris (France). Romanticism.

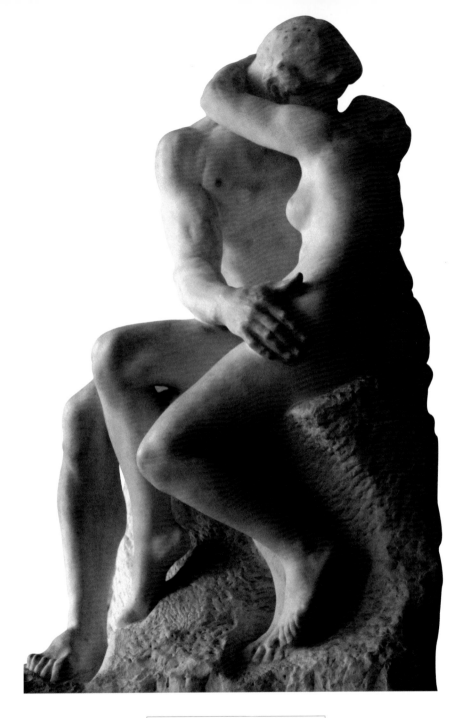

733. **Auguste Rodin**, 1840-1917, French.
The Kiss, 1888-1889. Marble, 181.5 x 112.3 x 117 cm.
Musée Rodin, Paris (France). Expressionism.

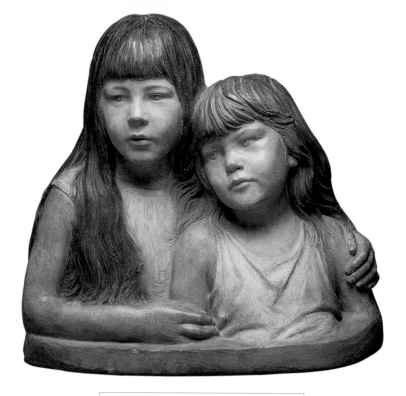

734. **Adolf von Hildebrand**, 1847-1921, German.
Double Portrait of the Artist's Daughters, 1889.
Painted terracotta, h: 50 cm.
J. Paul Getty Museum, Los Angeles (United States). Realism.

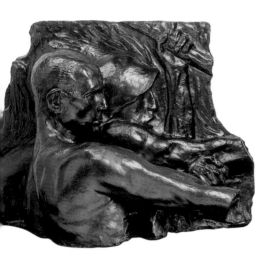

735. **Constantin Meunier**, 1831-1905, Belgian.
Industry, 1892-1896. Bronze, 68 x 91 x 36 cm.
Musée d'Orsay, Paris (France). Realism. (*)

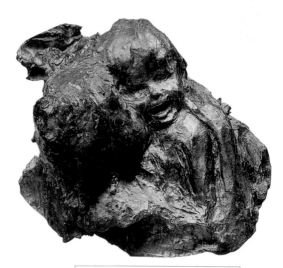

736. **Medardo Rosso**, 1858-1928, Italian.
Aetas Aurea or *The Golden Age*, 1886.
Bronze, 41.9 x 39.5 x 24.1 cm.
Musée d'Orsay, Paris (France). Impressionism. (*)

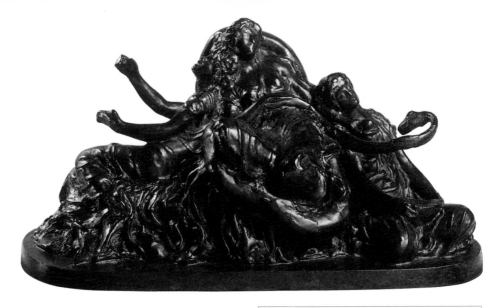

737. **Lord Frederic Leighton**, 1830-1896, English.
The Garden of the Hesperides, c. 1892. Bronze, 18 x 35 x 21 cm.
Royal Academy of Arts, London (United Kingdom). Classicism.

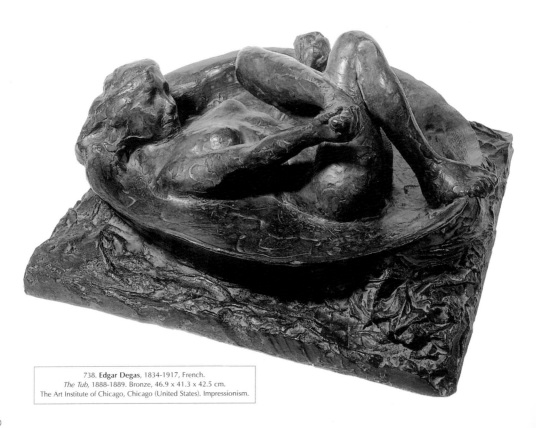

738. **Edgar Degas**, 1834-1917, French.
The Tub, 1888-1889. Bronze, 46.9 x 41.3 x 42.5 cm.
The Art Institute of Chicago, Chicago (United States). Impressionism.

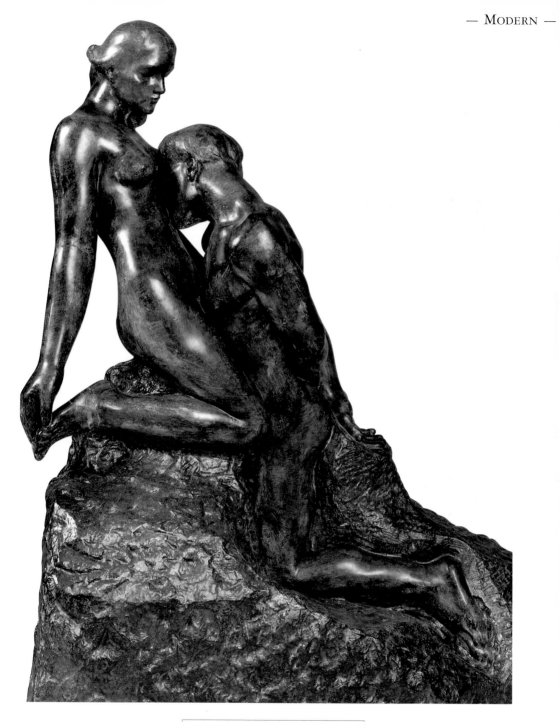

739. **Auguste Rodin**, 1840-1917, French.
The Eternal Idol, 1889. Bronze, 73.2 x 59.2 x 41.1 cm.
Musée Rodin, Paris (France). Expressionism.

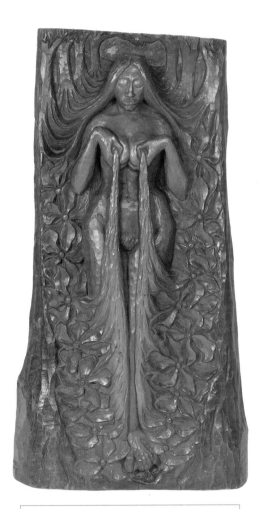

740. **Paul Lacombe**, dit **Georges Lacombe**, 1868-1916, French.
Isis, c. 1895. Painted wood.
Musée d'Orsay, Paris (France). Nabis.

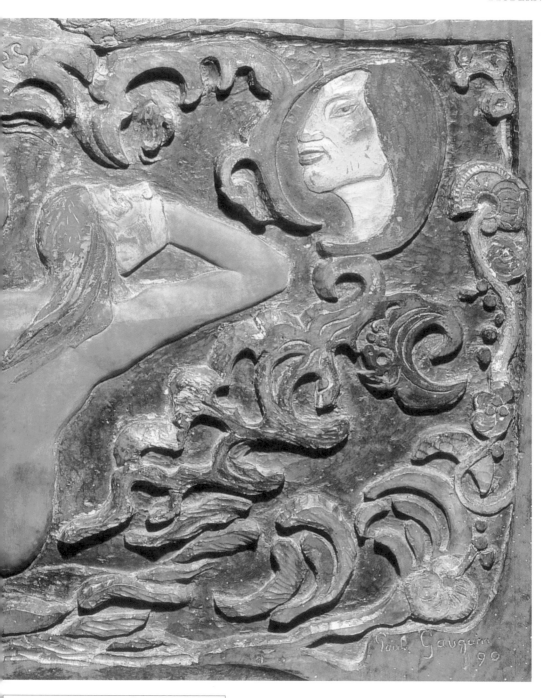

741. **Paul Gauguin**, 1848-1903, French.
Be Mysterious, 1890. Painted wood, 73 x 95 x 50 cm.
Musée d'Orsay, Paris (France). Post-Impressionism.

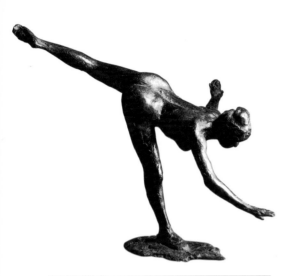

742. **Edgar Degas**, 1834-1917, French.
*Arabesque Over the Right Leg, Right Hand Near the Ground, Left Arm
Outstretched*, c. 1885. Bronze, 28.4 x 42.9 x 21 cm.
The Norton Simon Museum of Art, Pasadena (United States).
Impressionism. (*)

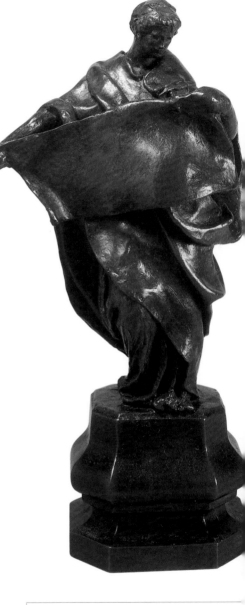

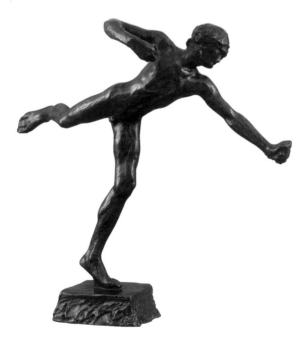

743. **Alfred Gilbert**, 1854-1934, English.
Sketch Model for Eros, 1893. Bronze, 62 x 27 cm.
Royal Academy of Arts, London (United Kingdom).
New Sculpture.

744. **Alfred Gilbert**, 1854-1934, English.
Sketch Model for a Symbolic Figure on the Queen Victoria Monume[nt]
Winchester, c. 1887. Bronze, 30.5 x 14.7 cm.
Royal Academy of Arts, London (United Kingdom). New Sculptur[e]

See next page:
745. **George Minne**, 1866-1941, Belgian.
Adolescent I, c. 1891. Marble, h: 42.9 cm.
J. Paul Getty Museum, Los Angeles (United States). Symbolism.

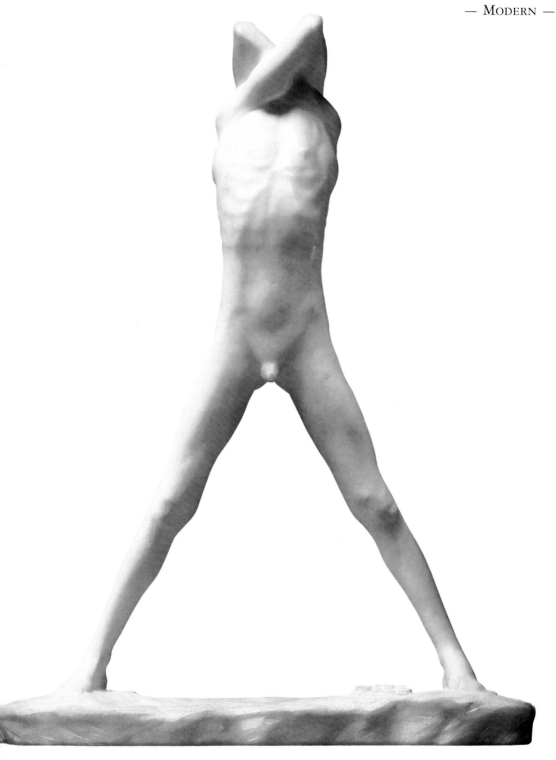

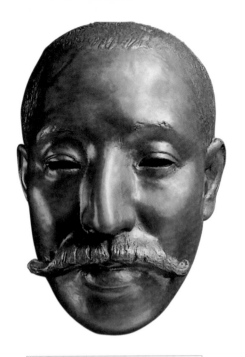

746. **Paul-Albert Bartholomé**, 1848-1928, French.
Mask of Tadamasa Hayashi, 1892.
Bronze, 25.5 x 19 x 13.5 cm.
Musée d'Orsay, Paris (France). Expressionism.

747. **Alexandre Charpentier**, 1856-1909, French.
Louis Welden Hawkins, Painter, 1893.
Bronze, h: 26 cm.
Musée d'Orsay, Paris (France). Symbolism.

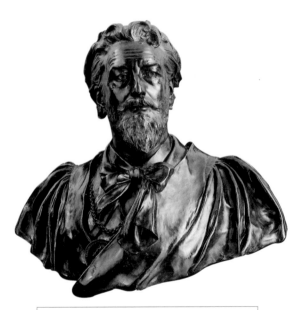

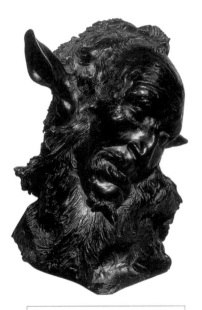

748. **Sir Thomas Brock**, 1847-1922, English.
Frederic, Lord Leighton, 1892. Bronze, 83 x 78 cm.
Royal Academy of Arts, London (United Kingdom). Realism.

749. **Jean Carriès**, 1855-1894, French.
Faun, 1893. Bronze, 34 x 35 x 24 cm.
Musée d'Orsay, Paris (France). Symbolism.

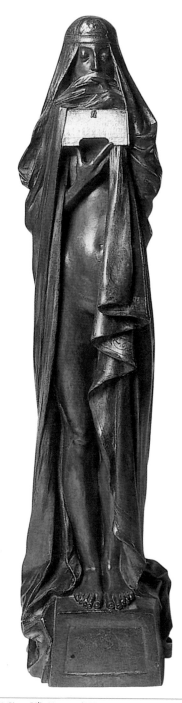

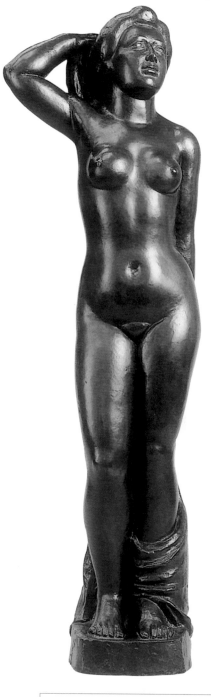

750. **Pierre-Félix Masseau**, dit **Fix-Masseau**, 1869-1937, French.
Secret, 1894.
Painted wood (mahogany), ivory, 76 x 17.5 x 18 cm.
Musée d'Orsay, Paris (France). Symbolism. (*)

751. **Aristide Maillol**, 1861-1944, French.
Standing Bather, 1898-1900. Bronze, h: 78 cm.
Musée d'Orsay, Paris (France). Art Nouveau/Nabis.

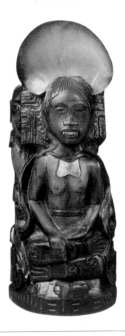

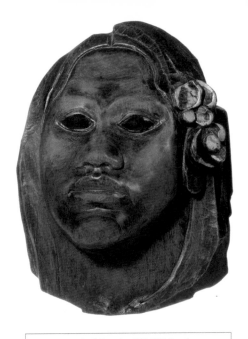

752. **Paul Gauguin**, 1848-1903, French.
Idol with a Shell, 1893. Wood, h: 27 cm.
Musée d'Orsay, Paris (France). Post-Impressionism. (*)

753. **Paul Gauguin**, 1848-1903, French.
Mask of Téha'amana, 1892. Painted wood (Pua), h: 22.2 cm.
Musée d'Orsay, Paris (France). Post-Impressionism.

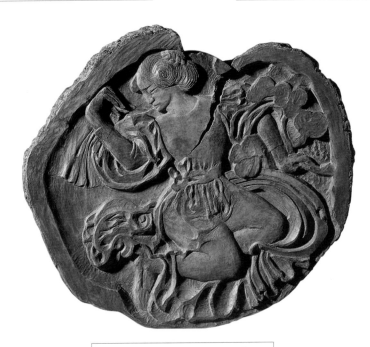

754. **Aristide Maillol**, 1861-1944, French.
Female Dancer, 1895. Wood, 22 x 24.5 cm.
Musée d'Orsay, Paris (France). Art Nouveau/Nabis.

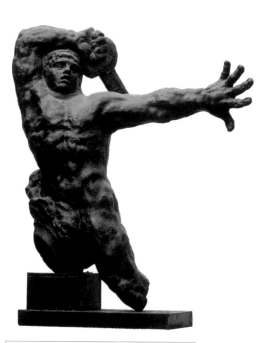

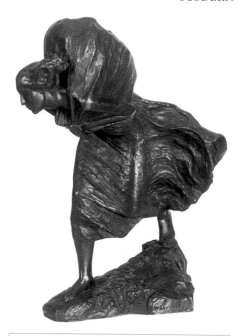

755. **Antoine Bourdelle**, 1861-1929, French.
The Great Warrior of Montauban, 1894-1900.
Bronze, 212 x 154 x 59 cm.
Musée Bourdelle, Paris (France). Expressionism. (*)

756. **Waclaw Szymanowski**, 1859-1930, Polish.
The Wind, 1899. Bronze.
Muzeum Mazowieckie, Plock (Poland). Symbolism.

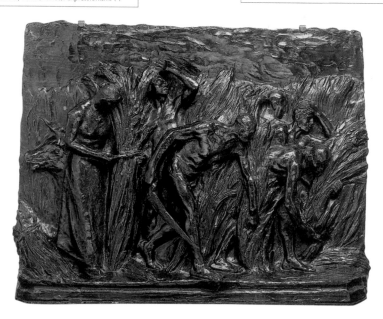

757. **Constantin Meunier**, 1831-1905, Belgian.
The Harvest, 1895-1896. Bronze, 63.5 x 85 x 17 cm.
Musée d'Orsay, Paris (France). Realism.

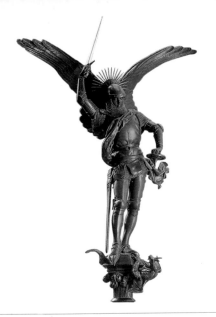

758. **Emmanuel Fremiet**, 1824-1910, French.
St Michael slaying the Dragon, 1897. Hammered copper, h: 617 cm.
Musée d'Orsay, Paris (France). Neoclassicism/Naturalism. (*)

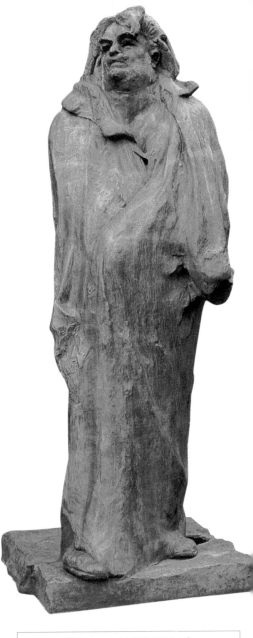

760. **Auguste Rodin**, 1840-1917, French.
Monument to Balzac, 1898. Bronze, 270 x 120 x 128 cm.
Musée Rodin, Paris (France). Expressionism. (*)

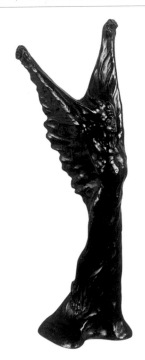

759. **Boleslas Biegas**, 1877-1954, Polish.
The Future, 1903. Bronze.
Zagrodzki Collection, Paris (France). Symbolism.

See next page:
761. **Augustus Saint-Gaudens**, 1848-1907, American.
General William Tecumseh Sherman Monument, 1897-1903.
Bronze, over lifesize.
Grand Army Plaza, New York (United States). Realism. (*)

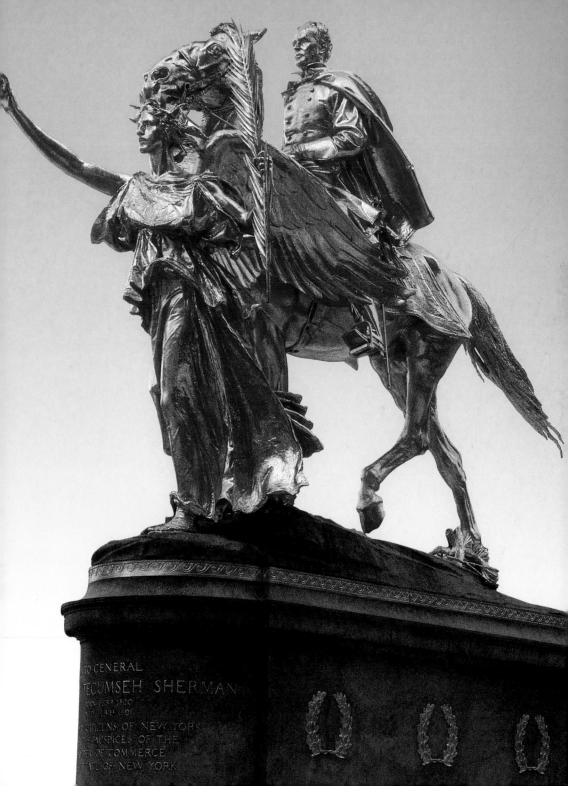

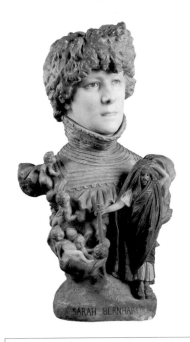

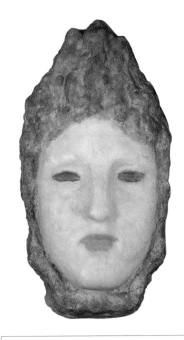

762. **Jean-Léon Gérôme**, 1824-1904, French.
Sarah Bernhardt, c. 1895. Coloured marble, 69 x 41 x 29 cm.
Musée d'Orsay, Paris (France). Academicism.

763. **Henri Cros**, 1840-1907, French.
Gold Mine, 1900. French *pâte de verre*, h: 31 cm.
Château-Musée, Boulogne-sur-mer (France). Art Nouveau.

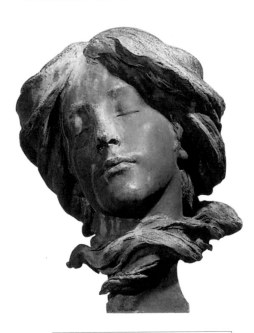

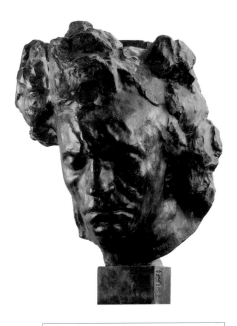

764. **Alfred Drury**, 1856-1944, English.
The Spirit of the Night, 1898-1905. Bronze, h: 57 cm.
Musée d'Orsay, Paris (France). Art Nouveau.

765. **Antoine Bourdelle**, 1861-1929, French.
Bust of Beethoven, 1901. Bronze, 109 x 60 x 53 cm.
Musée Bourdelle, Paris (France). Expressionism. (*)

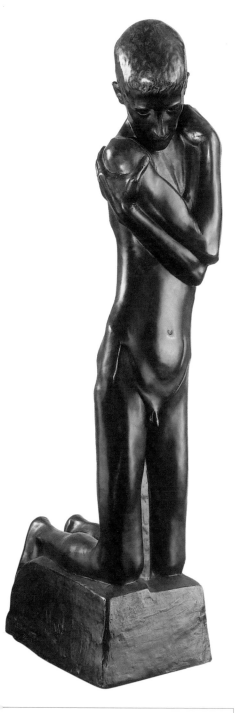

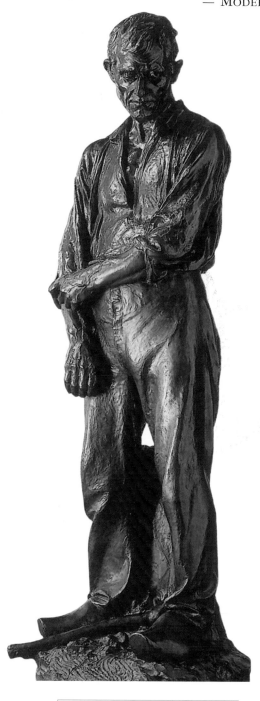

766. **George Minne**, 1866-1941, Belgian.
Kneeling Youth at the Fountain, 1898. Bronze, 78.5 x 19 x 43.5 cm.
Musée d'Orsay, Paris (France). Symbolism. (*)

767. **Aimé-Jules Dalou**, 1838-1902, French.
Large Peasant, 1898-1902. Bronze, 197 x 70 x 68 cm.
Musée d'Orsay, Paris (France). Realism.

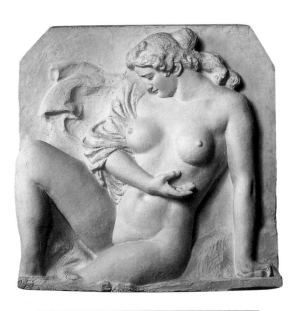

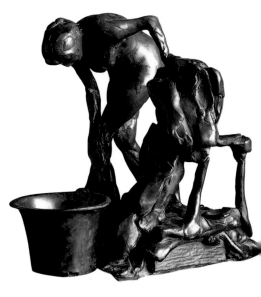

768. **Aristide Maillol**, 1861-1944, French.
Bather or *The Wave*, 1896-1900. Plaster, 93 x 10.3 x 25 cm.
Musée d'Orsay, Paris (France). Art Nouveau/Nabis. (*)

769. **Edgar Degas**, 1834-1917, French.
Woman washing her Left Leg, c. 1896-1911.
Bronze, 19.7 x 15.1 x 19.4 cm.
The Norton Simon Museum of Art, Pasadena (United States). Impressionism.

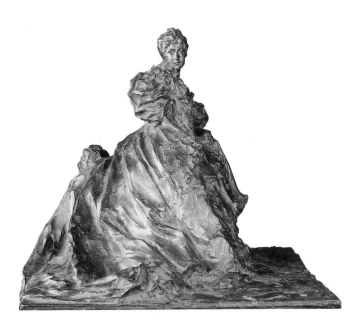

770. **Paul Troubetzkoy**, 1866-1938, Italian.
Geltrude Aurnheimer, 1898. Bronze, h: 53 cm.
Musée d'Orsay, Paris (France). Impressionism.

771. **Medardo Rosso**, 1858-1928, Italian.
The Bookmaker, 1894. Wax over plaster, 44.3 x 35.5 cm.
The Museum of Modern Art, New York (United States). Impression

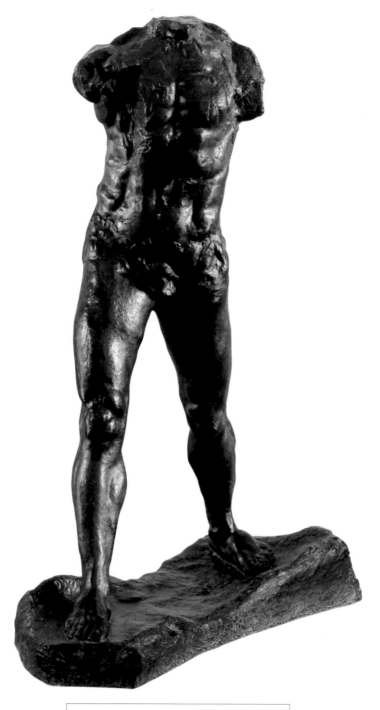

772. **Auguste Rodin**, 1840-1917, French.
The Walking Man, 1900-1907. Bronze, 213.5 x 71.7 x 156.5 cm.
Musée Rodin, Paris (France). Expressionism.

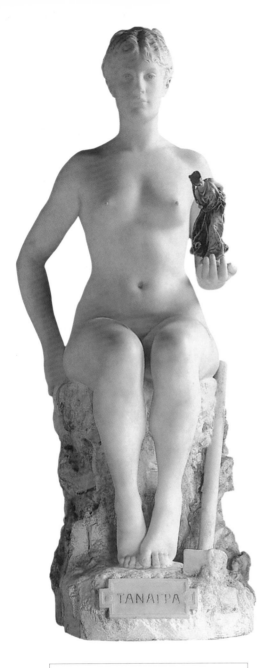

773. **Jean-Léon Gérôme**, 1824-1904, French.
Tanagra, 1890. Painted marble, 154.7 x 56 x 57.3 cm.
Musée d'Orsay, Paris (France). Academicism.

774. **Pierre Roche**, 1855-1922, French.
Morgan Le Fay, 1904. Bronze, lead and marble, 83 x 26.5 x 16 cm.
Musée d'Orsay, Paris (France). Academicism.

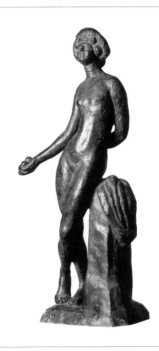

775. **Antoine Bourdelle**, 1861-1929, French.
Nude with Fruit, 1902-1911. Bronze, 226 x 104 x 58.5 cm.
Musée des Beaux-Arts, Rouen (France). Expressionism.

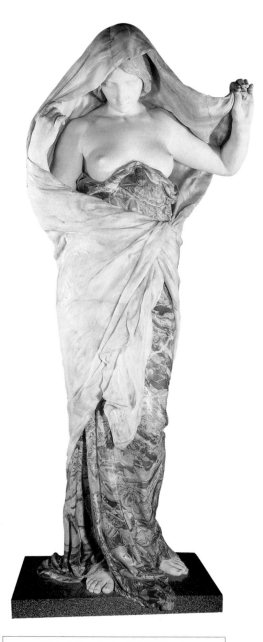

776. **Louis-Ernest Barrias**, 1841-1905, French.
Nature Unveiling Herself to Science, 1899. Marble, onyx, h: 200 cm.
Musée d'Orsay, Paris (France). Neoclassicism. (*)

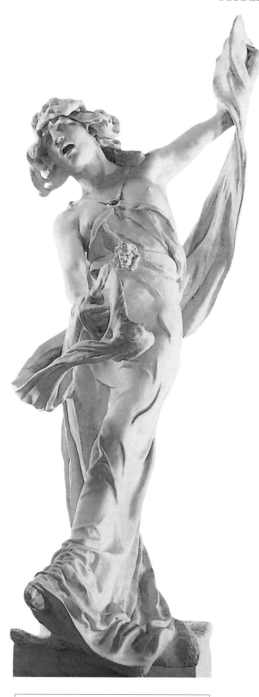

777. **Victor Ségoffin**, 1867-1925, French.
Warrior Dance, 1905. Marble, 250 x 140 x 80 cm.
Musée d'Orsay, Paris (France). Neoclassicism.

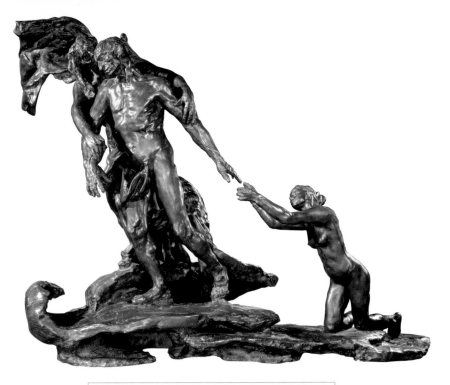

778. **Camille Claudel**, 1864-1943, French.
The Age of Maturity, 1902-1903. Bronze, cast iron, 114 x 163 x 72 cm.
Musée d'Orsay, Paris (France). Expressionism. (*)

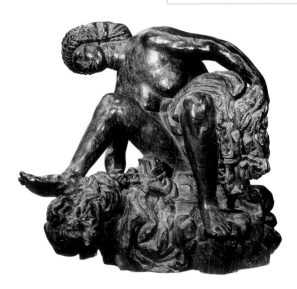

779. **Antoine Bourdelle**, 1861-1929, French.
Large Crouching Woman, 1906-1907.
Bronze, 101.6 x 76.8 x 116.2 cm.
Musée Bourdelle, Paris (France). Expressionism.

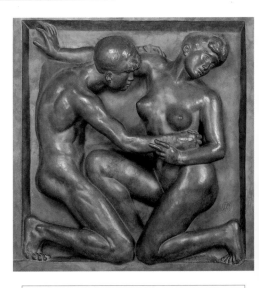

780. **Aristide Maillol**, 1861-1944, French.
Desire, 1906-1908. Tinted plastic, 119.1 x 114.3 x 12.1 cm.
The Museum of Modern Art, New York (United States).
Art Nouveau/Nabis.

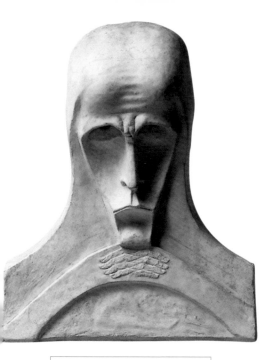

781. **Boleslas Biegas**, 1877-1954, Polish.
The Sphinx, 1902. Plaster; h: 46 cm.
Musée d'Orsay, Paris (France). Symbolism. (*)

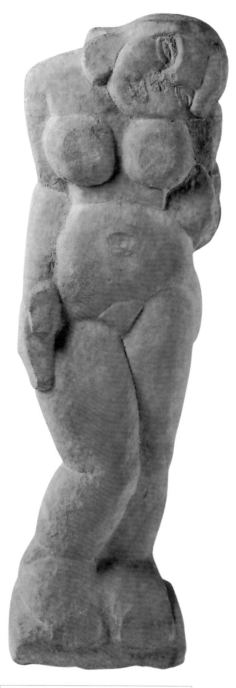

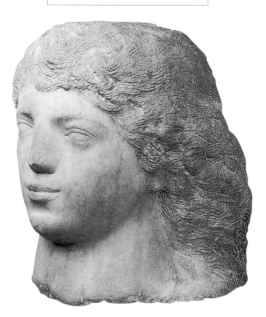

782. **Joseph Antoine Bernard**, 1866-1931, French.
Efforts Towards Nature, 1906-1907. Stone, 32 x 29 x 31 cm.
Musée d'Orsay, Paris (France). Fauvism.

783. **André Derain**, 1880-1954, French.
Standing Nude, 1907. Stone, 95 x 33 x 17 cm.
Musée national d'art moderne,
Centre Georges Pompidou, Paris (France). Fauvism. (*)

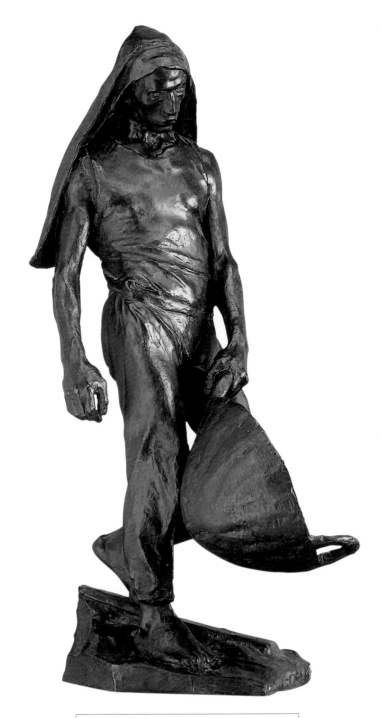

784. Henri Bouchard, 1875-1960, French.
The Docker, 1905. Bronze, patina: h: 71 x 28 x 39 cm.
Musée d'Orsay, Paris (France). Realism.

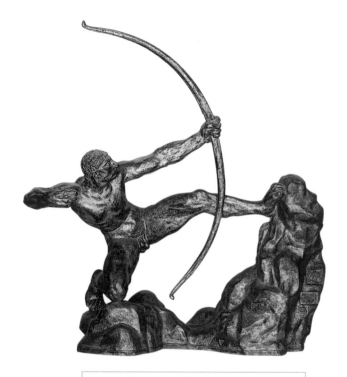

785. **Antoine Bourdelle**, 1861-1929, French.
Heracles the Archer, 1909. Bronze.
Musée d'Orsay, Paris (France). Expressionism. (*)

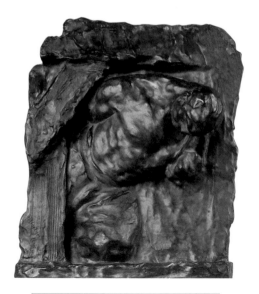

786. **Bernhard Hoetger**, 1874-1949, German.
The Human Machine, 1902.
Sand font, bronze and patine, 44 x 37 x 18 cm.
Musée d'Orsay, Paris (France). Expressionism.

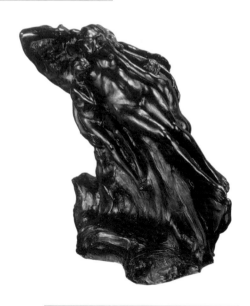

787. **Franciszek Flaum**, 1866-1917, Polish.
Vision. Prometheus, 1904. Bronze.
The National Museum in Poznań, Poznań (Poland). Symbolism.

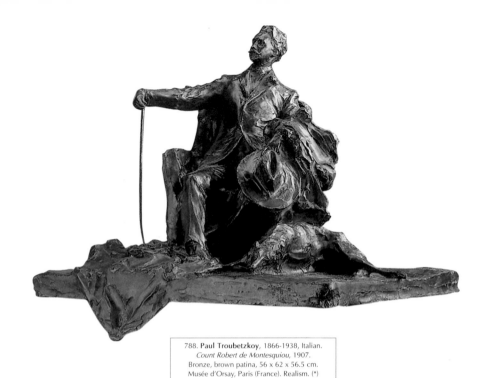

788. **Paul Troubetzkoy**, 1866-1938, Italian.
Count Robert de Montesquiou, 1907.
Bronze, brown patina, 56 x 62 x 56.5 cm.
Musée d'Orsay, Paris (France). Realism. (*)

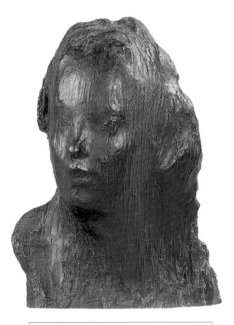

789. **Medardo Rosso**, 1858-1928, Italian.
Ecce Puer: A Portrait of Alfred Mond at the Age of Six,
1906-1907. Bronze, cast iron, 44 x 37 x 27 cm.
Musée d'Orsay, Paris (France). Impressionism. (*)

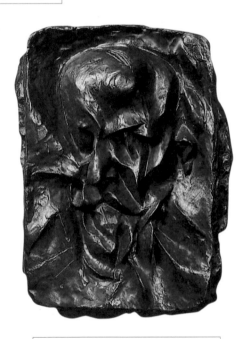

790. **Otto Gutfreund**, 1889-1927, Czech.
Father III, 1911. Bronze, h: 40 cm.
Národní Gallery, Prague (Czech Republic). Cubism. (*)

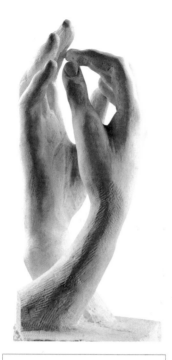

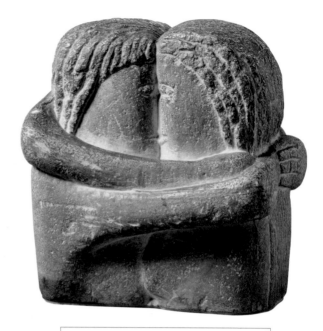

791. **Auguste Rodin**, 1840-1917, French.
The Cathedral, 1909. Stone, 64 x 34 x 32 cm.
Musée Rodin, Paris (France). Expressionism.

792. **Constantin Brancusi**, 1876-1957, Romanian.
The Kiss, 1907. Stone.
Hamburger Kunsthalle, Hamburg (Germany). Abstract art. (*)

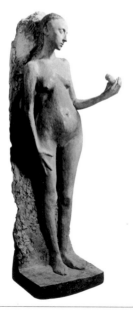

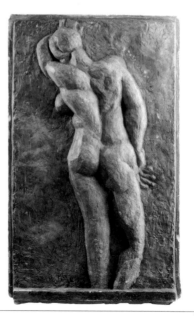

793. **Xawery Dunikowski**, 1875-1964, Polish.
Eve I, 1906. Reproduction in plaster.
Wawel Royal Castle, Wawel (Poland). Symbolism.

794. **Henri Matisse**, 1869-1954, French.
The Back I, 1909. Plaster with patina, h: 190 cm.
Musée Matisse, Le Château Cambrésis (France). Fauvism.

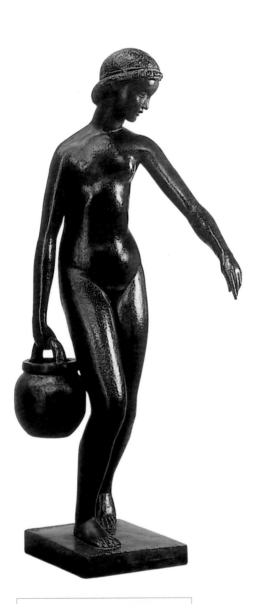

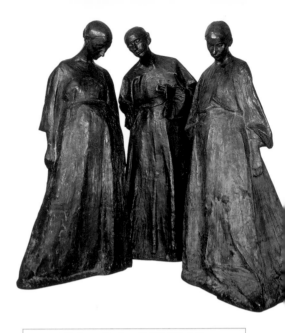

796. **Xawery Dunikowski**, 1875-1964, Polish.
Pregnant Women I-IV, 1906.
Reproduction in plaster, bronze, font.
MNW – Muzeum Narodowe Warszawie, Warsaw National Museum,
Warsaw (Poland). Symbolism.

795. **Joseph Antoine Bernard**, 1866-1931, French.
The Water-Carrier, 1912. Bronze, 175 x 40 x 52 cm.
Musée d'Orsay, Paris (France).

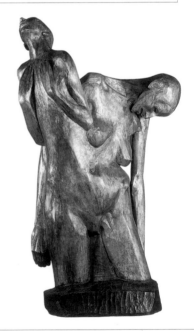

797. **Xawery Dunikowski**, 1875-1964, Polish.
Motherhood, 1908. Wood.
MNW – Muzeum Narodowe Warszawie, Warsaw National Museum,
Warsaw (Poland). Symbolism.

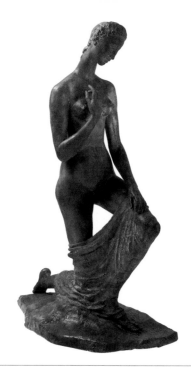

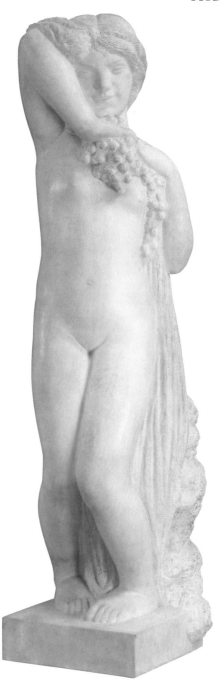

798. **Wilhelm Lehmbruck**, 1881-1919, German.
Kneeling Woman, 1911. Cast stone, 176.5 x 142.2 x 68.6 cm.
The Museum of Modern Art, New York (United States). Expressionism. (*)

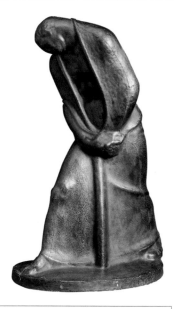

799. **Frantz Metzner**, 1870-1919, German.
The Sorrow Carrier (Der Leidtragende), c. 1912.
Plaster, black finish with graphite, h: 56 cm.
Musée d'Orsay, Paris (France). Symbolism. (*)

800. **Joseph Antoine Bernard**, 1866-1931, French.
Large Bacchante, 1912-1919. Stone, h: 173 cm.
Musée d'Orsay, Paris (France). Fauvism.

801. **Paul Dardé**, 1888-1963, French.
The Eternal Pain, 1913. Gypse, 49.5 x 44 x 38.2 cm.
Musée d'Orsay, Paris (France). Symbolism.

802. **Henri Gaudier-Brzeska**, 1891-1915, British.
Torso, 1914. Marble, 25.2 x 98.2 x 7.7 cm.
Tate Gallery, London (United Kingdom). Cubism.

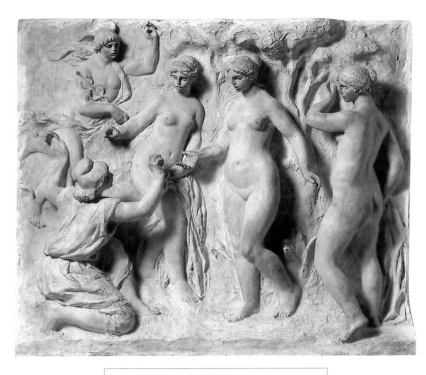

803. **Pierre-Auguste Renoir**, 1841-1919, French.
The Judgment of Paris, 1914. Plaster, patina, 76.2 x 94.5 x 10 cm.
Musée d'Orsay, Paris (France). Impressionism.

804. **Constantin Brancusi**, 1876-1957, Romanian.
Mlle Pogany, Version I, 1913.
Bronze with black patina, 43.8 x 21.5 x 31.7 cm.
The Museum of Modern Art, New York (United States). Abstract art.

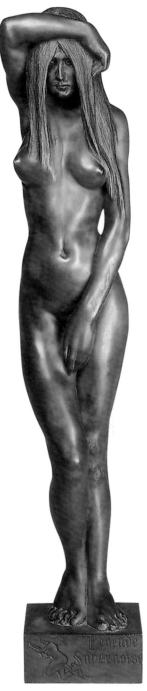

805. **Henri Matisse**, 1869-1954, French.
The Back II, 1913. Bronze, 188.5 x 121 x 15.2 cm.
The Museum of Modern Art, New York (United States). Fauvism. (*)

806. **Rupert Carabin**, 1862-1932, French.
Legend of Saverne, 1914. Wood, 82.9 x 17.4 x 18 cm.
Musée d'Orsay, Paris (France). Art Nouveau.

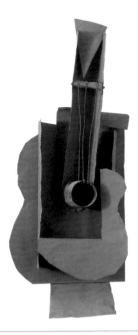

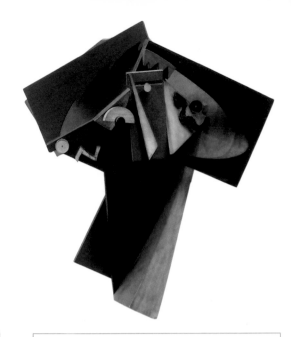

807. **Pablo Picasso**, 1881-1973, Spanish.
Guitar, 1912-1913. Sheet-metal and wire, 77.5 x 35 x 19.3 cm.
The Museum of Modern Art, New York (United States). Cubism.

808. **Henri Laurens**, 1885-1954, French.
Head of a Woman, 1915. Painted wood construction, 50.8 x 46.3 cm.
The Museum of Modern Art, New York (United States). Cubism.

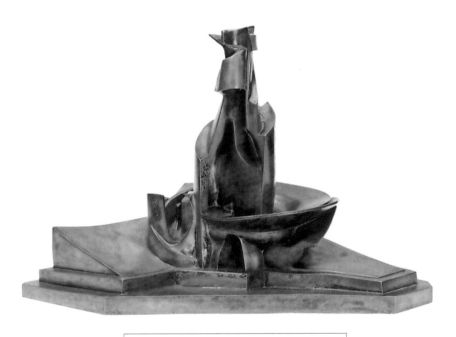

809. **Umberto Boccioni**, 1882-1916, Italian.
Development of a Bottle in Space, 1912.
Silvered bronze, 38.1 x 60.3 x 32.7 cm.
The Museum of Modern Art, New York (United States). Futurism.

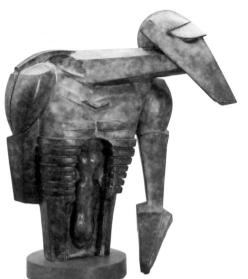

810. **Jacob Epstein**, 1880-1959, American/British.
The Rock Drill, 1913-1914.
Bronze on wooden base, 71 x 66 cm.
The Museum of Modern Art, New York (United States). Expressionism. (*)

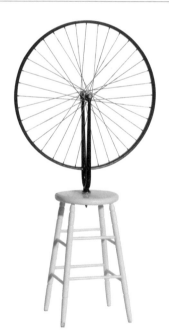

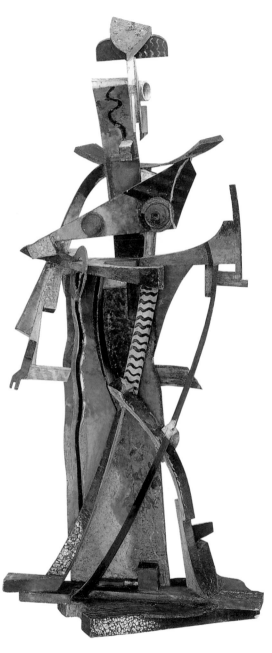

811. **Marcel Duchamp**, 1887-1968, French.
Bicycle Wheel, 1913. Ready-made: metal, painted wood,
126.5 x 31.5 x 63.5 cm.
Musée national d'art moderne, Centre Georges Pompidou,
Paris (France). Dada/Surrealism.

812. **Vladimir Baranoff-Rossiné**, 1888-1944, Ukranian.
Symphony No. 1, 1913. Painted wood, cardboard and crushed
eggshells, 161.1 x 72.2 x 63.4 cm.
The Museum of Modern Art, New York (United States). Cubism. (*)

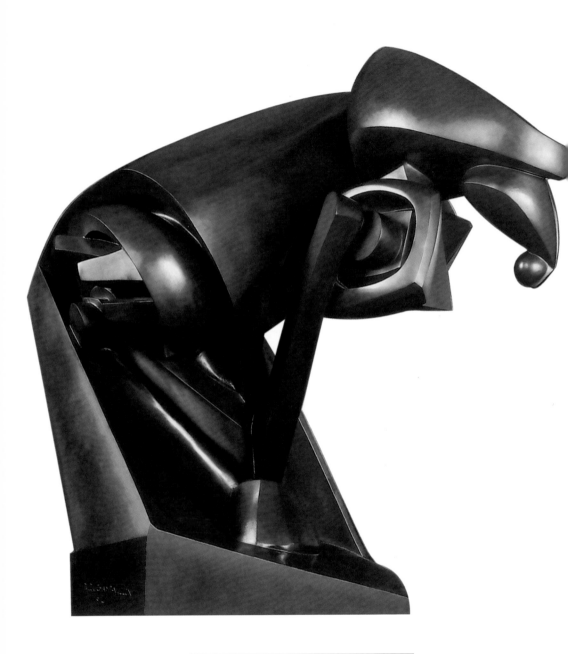

813. **Raymond Duchamp-Villon**, 1876-1918, French.
The Major Horse, 1914-1976.
Bronze with black patina, 150 x 97 x 153 cm.
Musée national d'art moderne,
Centre Georges Pompidou, Paris (France). Cubism. (*)

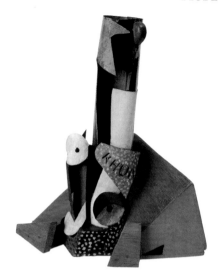

815. **Henri Laurens**, 1885-1954, French.
Rum Bottle, 1916-1917.
Painted wood, painted sheet iron, 28.5 x 25.5 x 19 cm.
Musée de Grenoble, Grenoble (France). Cubism.

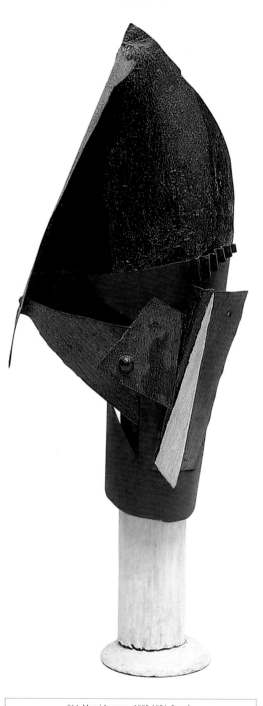

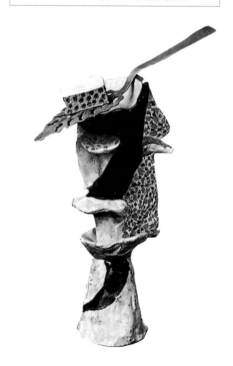

814. **Henri Laurens**, 1885-1954, French.
Construction, Small Head, 1915.
Wood and polychrome iron sheeting, 30 x 13 x 10 cm.
Musée national d'art moderne,
Centre Georges Pompidou, Paris (France). Cubism.

816. **Pablo Picasso**, 1881-1973, Spanish.
Glass of Absinthe, 1914. Painted bronze with absinthe spoon,
21.5 x 16.4 x 8.5 cm; diameter at base: 6.4 cm.
The Museum of Modern Art, New York (United States). Cubism.

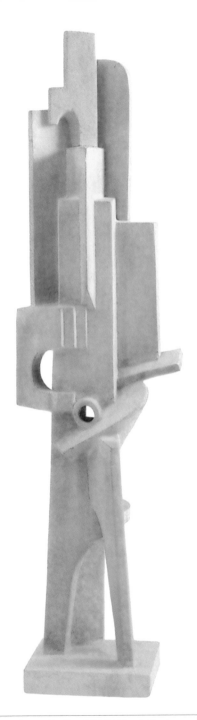

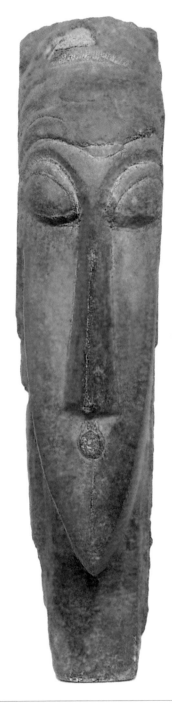

817. **Jacques Lipschitz**, 1891-1973, Lithuanian/French.
Man with a Guitar, 1915. Limestone, 97.2 x 26.7 x 19.5 cm.
The Museum of Modern Art, New York (United States). Cubism. (*)

818. **Amedeo Modigliani**, 1884-1920, Italian.
Head, 1915. Limestone, 56.5 x 12.7 x 37.4 cm.
The Museum of Modern Art, New York (United States). Expressionism. (*)

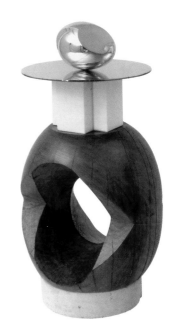

820. **Constantin Brancusi**, 1876-1957, Romanian.
Newborn II, c. 1923. Polished bronze, 17 x 25.5 x 17 cm.
Musée national d'art moderne,
Centre Georges Pompidou, Paris (France). Abstract art.

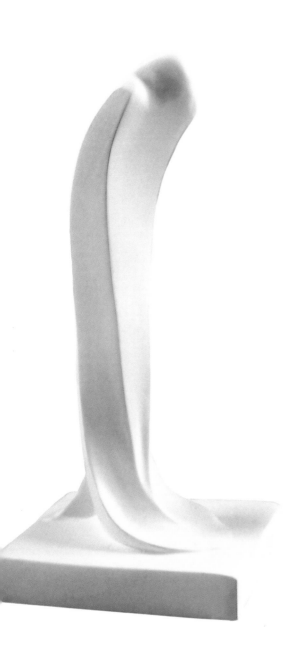

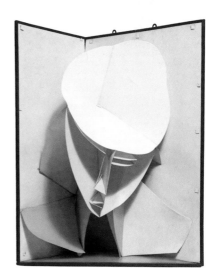

819. **Georgia O'Keeffe**, 1887-1986, American.
Abstraction, 1916 (1979-1980).
Bronze with white lacquer, h: 25.7 cm.
Georgia O'Keeffe Museum, Santa Fe (United States). Abstract art.

821. **Naum Gabo**, 1890-1977, Russian/American.
Head of a Woman, c. 1917-1920.
Celluloid and metal, 62.2 x 48.9 x 35.4 cm.
The Museum of Modern Art, New York (United States). Constructivism.

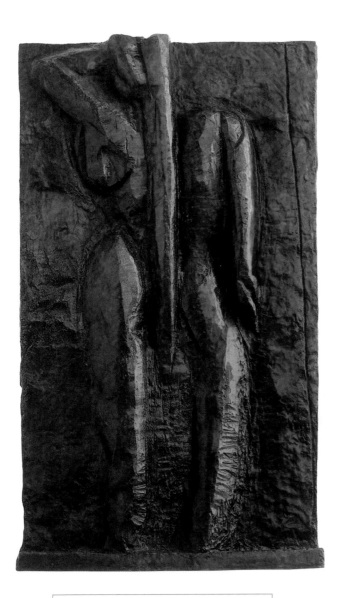

822. **Henri Matisse**, 1869-1954, French.
The Back III, 1916. Bronze, 189.2 x 112.4 x 15.2 cm.
The Museum of Modern Art, New York (United States). Fauvism.

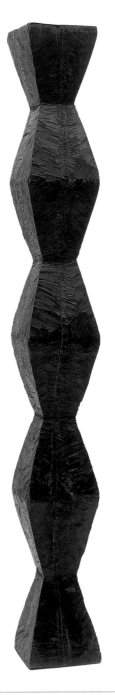

823. **Constantin Brancusi**, 1876-1957, Romanian.
Endless Column, version I, 1918. Oak, 203.2 x 25.1 x 24.5 cm.
The Museum of Modern Art, New York (United States).
Abstract art.

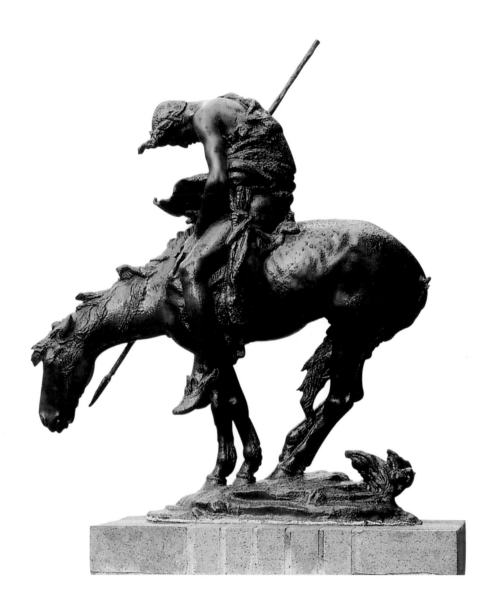

824. **James Earle Fraser**, 1876-1953, American.
End of the Trail, 1915. Bronze, over lifesize.
Brookgreen Gardens, Murrells Inlet (United States). Realism. (*)

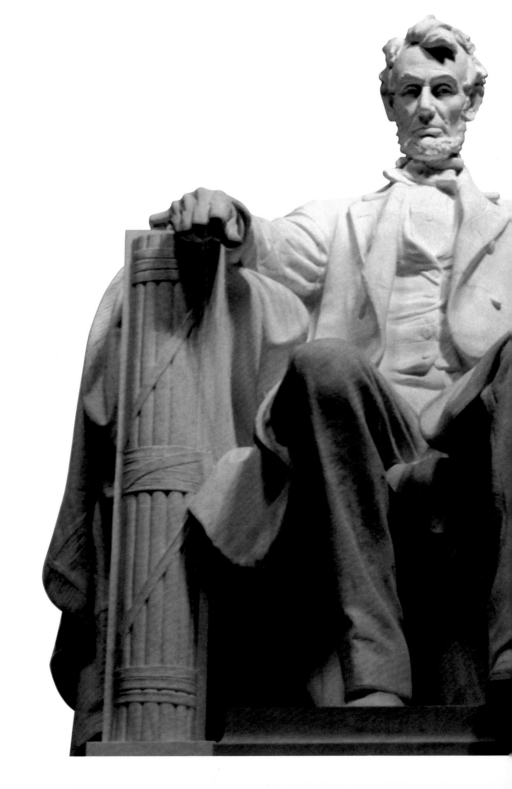

825. **Daniel Chester French**, 1850-1931, American.
Statue of Lincoln, Lincoln Memorial, 1922.
Washington, D.C. (United States). In situ. Realism.

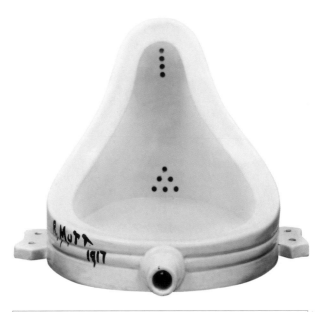

826. **Marcel Duchamp**, 1887-1968, French.
Fountain, copy of the original made in New York in 1917, 1917-1964.
White faience with ceramic glaze and paint, 63 x 48 x 35 cm.
Musée national d'art moderne, Centre Georges Pompidou, Paris (France). Dada/Surrealism. (*)

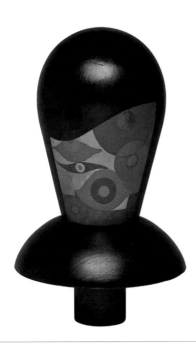

827. **Sophie Taeuber-Arp**, 1889-1943, Swiss.
Head (Dada Head), 1918. Painted wood, 34 x 20 x 20 cm.
Musée national d'art moderne,
Centre Georges Pompidou, Paris (France). Abstract art. (*)

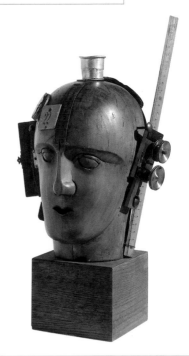

828. **Raoul Hausmann**, 1886-1971, German.
Mechanical Head (The Spirit of Our Age), c. 1920.
Wooden dummy head with various material, 32.5 x 21 x 20 cm.
Musée national d'art moderne, Centre Georges Pompidou, Paris (France). Dada. (*)

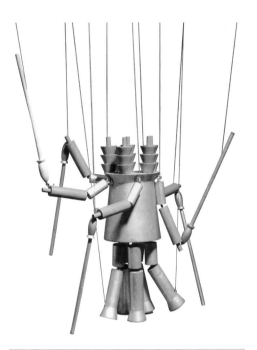

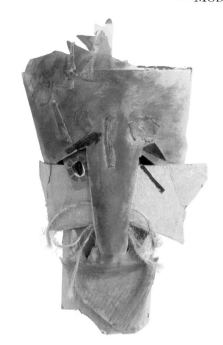

829. **Sophie Taeuber-Arp**, 1889-1943, Swiss.
The Guard, 1918.
Oil painted wood, metal fixtures, 40.5 x 18.5 x 13 cm.
Museum Bellerive, Zürich (Switzerland). Abstract art.

830. **Marcel Janco**, 1895-1984, Romanian. *Mask*, 1919.
Paper, cardboard, string, watercolour and pastel, 45 x 22 x 5 cm.
Musée national d'art moderne,
Centre Georges Pompidou, Paris (France). Dada.

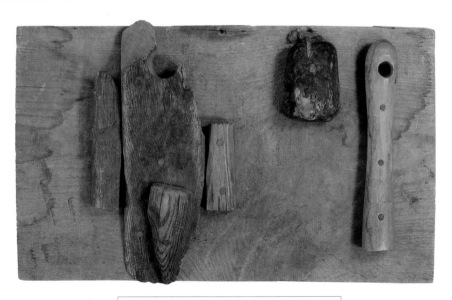

831. **Hans Arp**, 1886-1966, German/French.
Shipwreck Victim Kit, 1920-1921.
Assemblage of six pieces mounted on wood pannel, 19 x 32 x 4 cm.
Private collection. Surrealism/Dada.

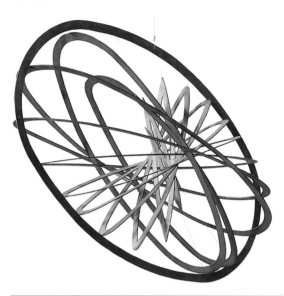

832. **Alexander Rodchenko**, 1891-1956, Russian.
Spacial Construction No. 12, c. 1920. Plywood, open construction partially painted
with aluminium paint and wire, 61 x 83.7 x 47 cm.
The Museum of Modern Art, New York (United States). Russian Constructivism.
Art © Estate of Alexander Rodchenko/RAO, Moscow/Licensed by VAGA, New York, NY

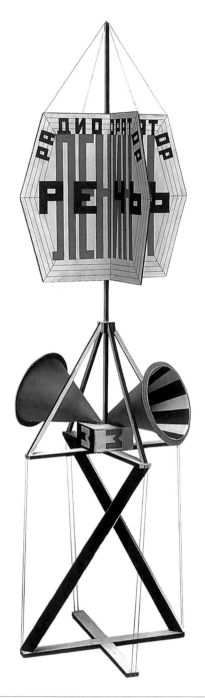

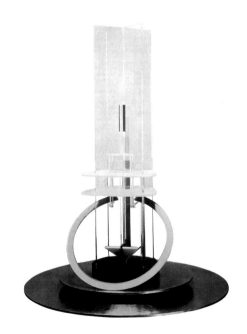

833. **Naum Gabo**, 1890-1977, Russian/American.
Model for Column, 1920-1921. Cellulose nitrate, 14.3 x 9.5 x 9.5 cm.
Tate Gallery, London (United Kingdom). Constructivism.

834. **Gustav Klucis**, 1895-1944, Latvian.
Maquette for Radio-Announcer, 1922. Painted cardboard, paper, wood
thread and metal brads, 106.1 x 36.8 x 36.8 cm.
The Museum of Modern Art, New York (United States). Constructivism.

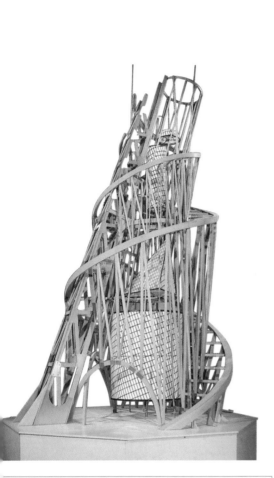

835. **Vladimir Tatlin**, 1885-1953, Russian.
Model for the Monument to the Third International, 1919-1979.
Wood, metal, h: 500 cm, diameter: 300 cm.
e national d'art moderne, Centre Georges Pompidou, Paris (France). Constructivism. (*)

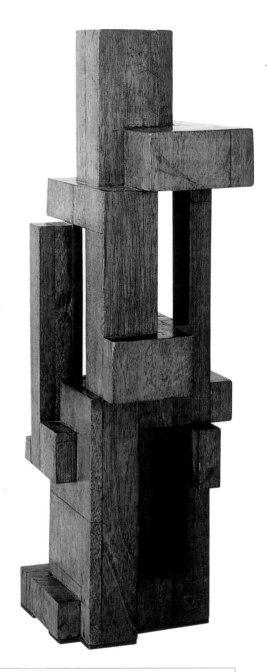

836. **Georges Vantongerloo**, 1886-1965, Belgian.
Construction of Volume Relations, 1921.
Wood (mahogany), 41 x 14.4 x 14.5 cm.
The Museum of Modern Art, New York (United States). Abstract art.

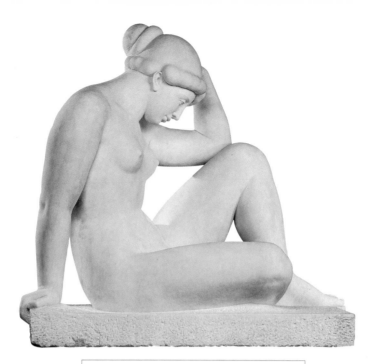

837. **Aristide Maillol**, 1861-1944, French.
Mediterranean or *Thought*, 1923. Marble, h: 110.5 cm.
Musée d'Orsay, Paris (France). Art Nouveau/Nabis.

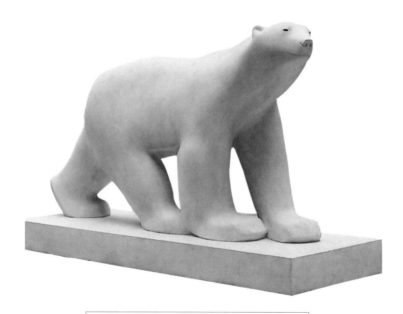

838. **François Pompon**, 1855-1933, French.
Polar Bear, 1922-1929. Lens Stone, 163 x 251 x 90 cm.
Musée d'Orsay, Paris (France). Minimalism. (*)

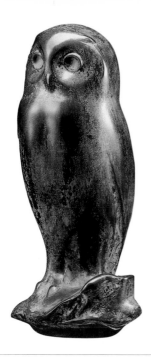

839. **François Pompon**, 1855-1933, French.
Young Owl, after 1918.
Bronze with green and brown patina, 19 x 8.5 x 8.2 cm.
Musée d'Orsay, Paris (France). Minimalism.

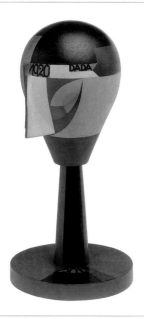

840. **Sophie Taeuber-Arp**, 1889-1943, Swiss.
Dada Head, 1920. Painted lathed wood, h: 29.4 cm.
Musée national d'art moderne,
Centre Georges Pompidou, Paris (France). Abstract art.

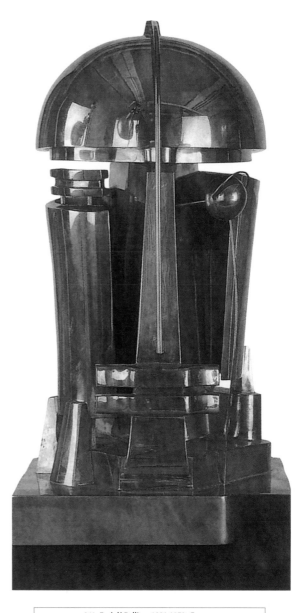

841. **Rudolf Belling**, 1886-1972, German.
Sculpture 23, 1923. Bronze, partially silvered, 48 x 19.7 x 21.5 cm.
The Museum of Modern Art, New York (United States).
Abstract art. (*)

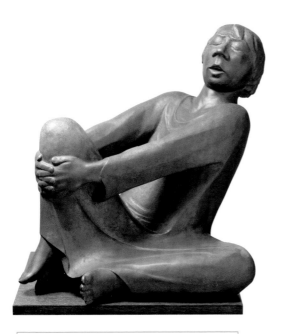

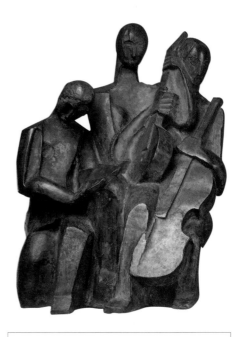

842. **Ernst Barlach**, 1870-1938, German.
The Singing Man, 1928. Bronze, 50.8 x 61 cm.
Indiana University Art Museum, Bloomington (United States).
Expressionism. (*)

843. **Ossip Zadkine**, 1890-1967, Russian/French.
Musicians, 1927. Bronze, h: 59 cm.
The Pushkin Museum of Fine Arts, Moscow (Russia). Cubism. (*)

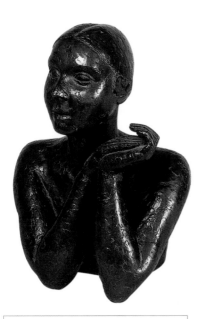

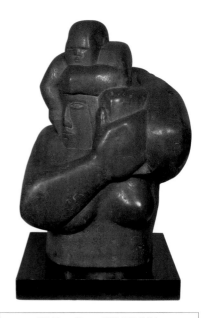

844. **Frank Dobson**, 1886-1963, British.
Portrait Bust of Lady Keynes (Lydia Lopokova), 1924.
Bronze, 47 x 36 x 35 cm.
Art Council Collection, Hayward Gallery,
London (United Kingdom). Realism.

845. **Henry Moore**, 1898-1986, British.
Mother and Child, 1924-1925.
Blue-brown Hornton stone, 63.5 x 40.5 x 35.5 cm.
Manchester Art Gallery, Manchester (United Kingdom).
Abstract art.

847. **Emmanuel Radnitszky**, called **Man Ray**, 1890-1976, American.
Metronome (Object to Be Destroyed), 1932 (destroyed 1957).
Wood, metal and paper, 21.5 x 11 x 11.5 cm.
Hamburger Kunsthalle, Hamburg (Germany). Surrealism/Dada.

846. **Constantin Brancusi**, 1876-1957, Romanian.
Bird in Space, c. 1925-1931. Grey marble, h: 134 cm.
Kunsthaus, Zürich (Switzerland). Abstract art. (*)

848. **Jacques Lipschitz**, 1891-1973, Lithuanian/French.
Figure, project for a monument to Apollinaire 1926-1930.
Bronze, 216.6 x 98.1 cm.
The Museum of Modern Art, New York (United States). Cubism. (*)

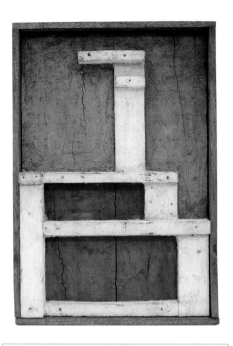

849. **Antoine Pevsner**, 1884-1962, Russian/French.
Mask, 1923. Celluloid, zinc, 33 x 20 x 20 cm.
Musée national d'art moderne,
Centre Georges Pompidou, Paris (France). Constructivism. (*)

850. **Joaquín Torrès-Garcia,** 1874-1949, Uruguayan.
Black and White Structure, 1930. Painted wood, 48.9 x 35.6 cm.
Colección Carmen Thyssen-Bornemisza en depósito en el Museo
Thyssen-Bornemisza, Madrid (Spain). Constructivism.

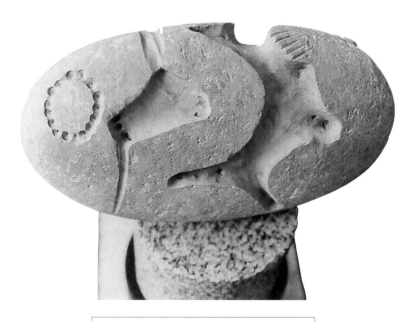

851. **Leon Underwood**, 1890-1975, British.
Embryo, c. 1925. Chalk, pebbles, 12 x 19 x 7 cm.
Private collection. Abstract art.

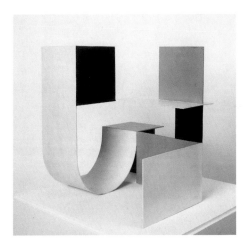

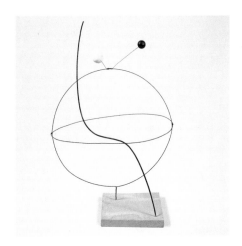

852. **Katarzyna Kobro**, 1898-1951, Russian.
Spatial Sculpture, 1928. Painted sheet-steel, 44.8 x 44.8 x 46.7 cm.
Musée national d'art moderne,
Centre Georges Pompidou, Paris (France). Abstract art. (*)

853. **Alexander Calder**, 1898-1976, American.
Cruise, 1931. Wire, wood and paint, 93.9 x 58.4 x 58.4 cm.
Calder Foundation, New York (United States). Abstract art.

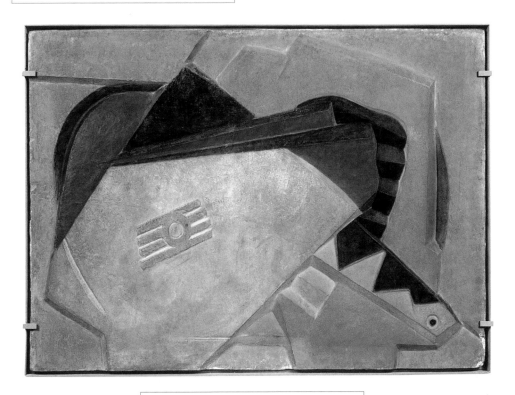

854. **Henri Laurens**, 1885-1954, French.
Low Relief, 1928. Painted terracotta, h: 93 cm.
Musée d'Art moderne, Villeneuve-d'Ascq (France). Cubism.

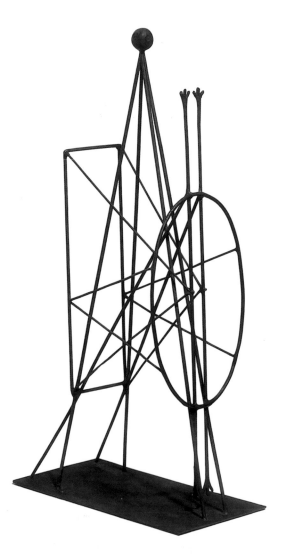

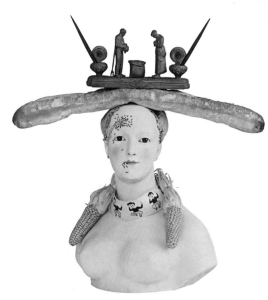

856. **Salvador Dalí**, 1904-1989, Spanish.
Retrospective Bust of a Woman, 1933.
Painted porcelain, bread, corn, feathers, paint on paper,
beads, ink stand, sand, two pens, 73.9 x 6.2 x 32 cm.
The Museum of Modern Art, New York (United States). Surrealism.

855. **Pablo Picasso**, 1881-1973, Spanish.
Figure, project for a monument to Apollinaire, 1928.
Sheet-metal and wire, 37.5 x 10 x 19.6 cm.
Musée national d'art moderne, Centre Georges Pompidou,
Paris (France). Cubism. (*)

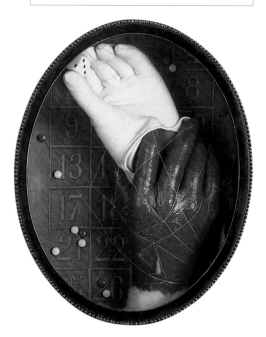

857. **Valentine Hugo**, 1887-1968, French.
Symbolic Functioning Object, 1931.
Assemblage of various objects on wood panel.
Private collection.

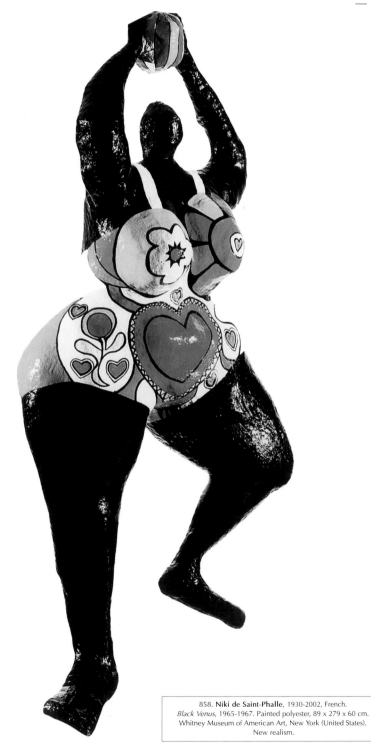

858. **Niki de Saint-Phalle**, 1930-2002, French.
Black Venus, 1965-1967. Painted polyester, 89 x 279 x 60 cm.
Whitney Museum of American Art, New York (United States).
New realism.

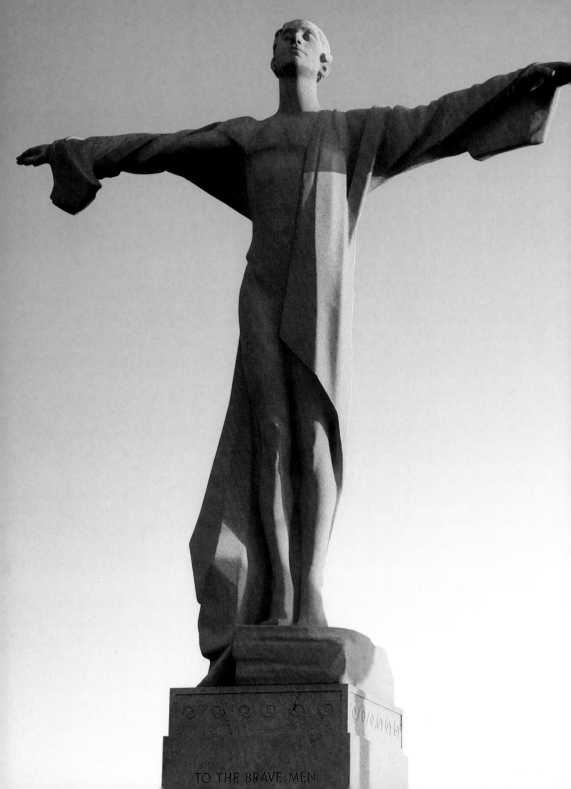

TO THE BRAVE MEN

860. **Jacob Epstein,** 1880-1959, American/British.
Genesis, 1929-1931. Marble (Seravezza), 162.5 x 83.8 x 78.7 cm.
Whitworth Art Gallery, University of Manchester,
Manchester (United Kingdom). Expressionism.

861. **Emmanuel Radnitzky,** called **Man Ray,** 1890-1976, American.
Restored Venus, 1936-1971.
Gypse and rope, h: 61 cm.
Private collection. Surrealism/Dada. (*)

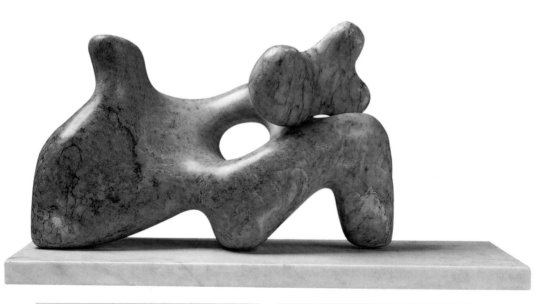

See previous page:
859. **Gertrude Vanderbilt Whitney,** 1877-1942, American.
Women's Titanic Memorial, 1931. Stone.
Fort McNair, Washington, D.C. (United States). Symbolism. (*)

862. **Barbara Hepworth,** 1903-1975, British.
Mother and Child, 1934.
Cumberland alabaster on marble base, 23 x 45.5 x 18.9 cm.
Tate Gallery, London (United Kingdom). Abstract art.

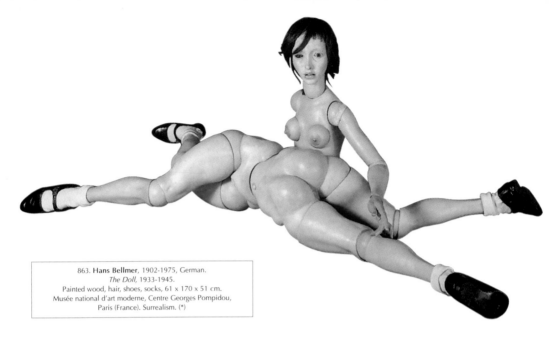

863. **Hans Bellmer**, 1902-1975, German.
The Doll, 1933-1945.
Painted wood, hair, shoes, socks, 61 x 170 x 51 cm.
Musée national d'art moderne, Centre Georges Pompidou,
Paris (France). Surrealism. (*)

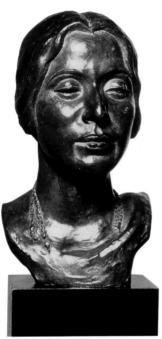

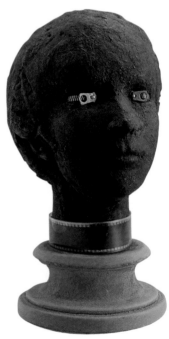

865. **Marcel Jean**, 1900-1993, French.
Spectre of the Gardenia, 1936.
Plaster head with painted black cloth, zippers and strip of film on
velvet-covered wood base, 35 x 17.6 x 25 cm.
The Museum of Modern Art, New York (United States).

864. **Malvina Hoffman**, 1885-1966, American.
Bengali Woman, 1933. Bronze, h: 34 cm.
Field Museum of Natural History, Chicago (United States). Realism.

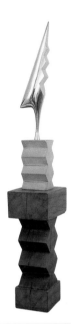

866. **Constantin Brancusi**, 1876-1957, Romanian.
The Cockerel, 1935.
Polished bronze, 103.4 x 12.1 x 29.9 cm.
Musée national d'art moderne,
Centre Georges Pompidou, Paris (France). Abstract art.

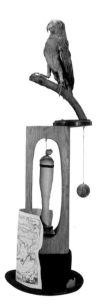

867. **Joan Miró**, 1893-1983, Spanish.
Object, 1936. Stuffed parrot on wood perch, stuffed silk stocking with velvet
garter and doll's paper shoe suspended in hollow wood frame, derby hat,
hanging cork ball, celluloid fish, and engraved map, 81 x 30.1 x 26 cm.
The Museum of Modern Art, New York (United States). Surrealism.

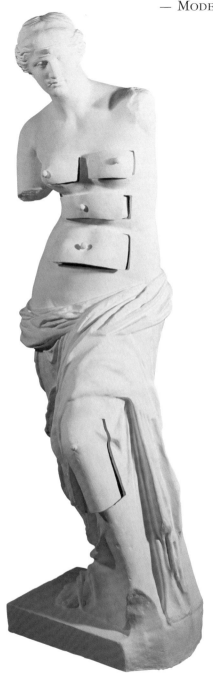

868. **Salvador Dalí** (and **Marcel Duchamp**), 1904-1989, Spanish.
Venus de Milo with Drawers, 1936.
Bronze on a plaster base.
Museum Boijmans van Beuningen, Rotterdam (Netherlands).
Surrealism.

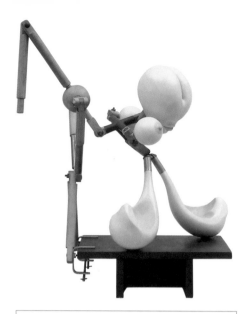

869. **Hans Bellmer**, 1902-1975, German.
The Machine-Gunneress in a State of Grace, 1937.
Construction of wood and metal, 78.5 x 75.5 x 34.5 cm;
on wood base: 12 x 40 x 29.9 cm.
The Museum of Modern Art, New York (United States). Surrealism.

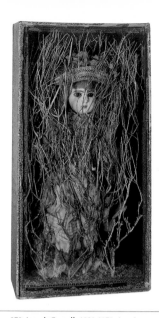

870. **Joseph Cornell**, 1903-1972, American.
Untitled (Bébé Marie), beginning 1940s. Papered and painted wooden bow, with p
corrugated cardboard floor, containing doll in cloth dress and straw hat with cloth f
dried flowers, twigs, flecked with paint, 59.7 x 31.5 x 13.3 cm.
The Museum of Modern Art, New York (United States). Assemblage art.
Art © The Joseph and Robert Cornell Memorial Foundation/Licensed by VAGA, New Yo

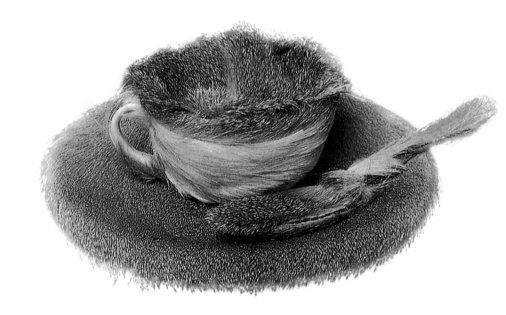

871. **Meret Oppenheim**, 1913-1985, German born/Swiss.
Fur Cup, 1936. Fur-covered cup, saucer, and spoon, cup: 10.9 cm;
saucer: 23.7 cm; spoon: 20.2 cm; overall height: 7.3 cm.
The Museum of Modern Art, New York (United States). Surrealism. (*)

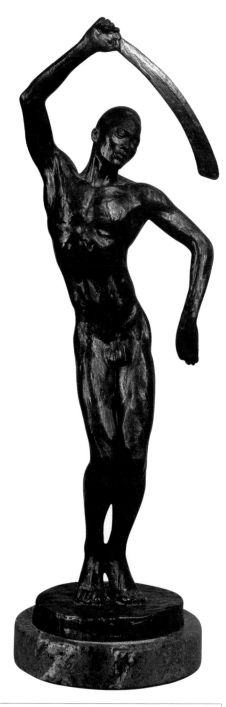

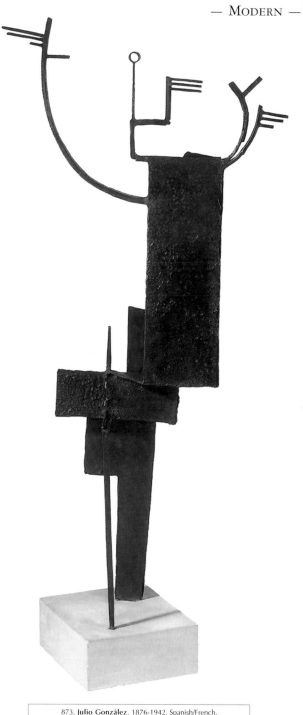

872. **Richmond Barthé**, 1901-1989, American.
Feral Benga, 1935. Bronze, h: 50.8 cm.
Museum of Fine Arts, Houston (United States).
Harlem-Renaissance.

873. **Julio González**, 1876-1942, Spanish/French.
Daphne, c. 1937. Bronze, 142 x 71 x 52 cm.
Musée national d'art moderne,
Centre Georges Pompidou, Paris (France). Abstract art.

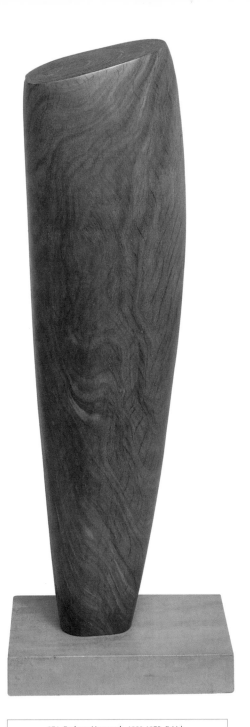

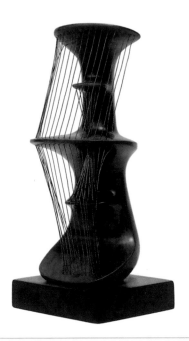

875. **Henry Moore**, 1898-1986, British.
The Bride, 1939-1940. Cast lead, copper wire, 23.8 x 10.3 x 10 cm.
The Museum of Modern Art, New York (United States). Abstract art.

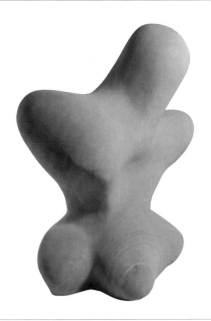

874. **Barbara Hepworth**, 1903-1975, British.
Single Form, 1937. Lignum vitae, h: 54.6 cm.
Private collection. Abstract art.

876. **Hans Arp**, 1886-1966, German/French.
Giant Pip, 1937. Stone, 162 x 125 x 77 cm.
Musée national d'art moderne,
Centre Georges Pompidou, Paris (France). Surrealism/Dada.

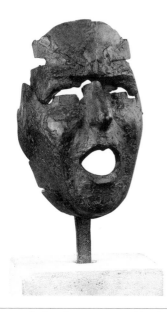

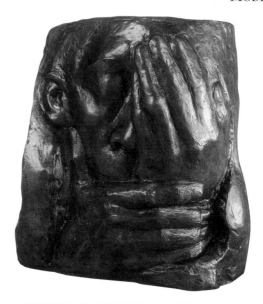

877. **Julio González**, 1876-1942, Spanish/French.
Mask of Montserrat shouting, c. 1938-1939.
Welded wrought iron, patina, 22 x 15.5 x 12 cm.
Musée national d'art moderne,
Centre Georges Pompidou, Paris (France). Abstract art.

878. **Käthe Kollwitz**, 1867-1945, German.
Lamentation: In Memory of Ernst Barlach, 1938.
Bronze, 26.6 x 26 x 10.1 cm.
Hirshhorn Museum and Sculpture Garden,
Washington, D.C. (United States). Expressionism. (*)

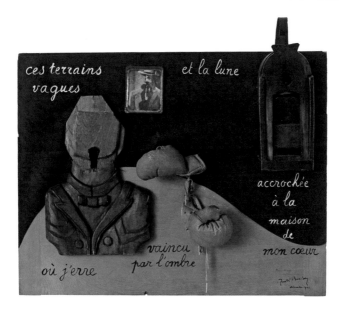

879. **André Breton**, 1896-1966, French.
Poem-Object, 1941. Assemblage mounted on drawing board:
carved wood bust of man, oil lantern, framed photograph, toy boxing
gloves, and paper, 45.8 x 53.2 x 10.9 cm.
The Museum of Modern Art, New York (United States). Surrealism.

See next page:
880. **Gutzon Borglum**, 1867-1941, American.
Presidential Portraits, 1941. Natural rock.
Mount Rushmore, South Dakota (United States). In situ. (*)

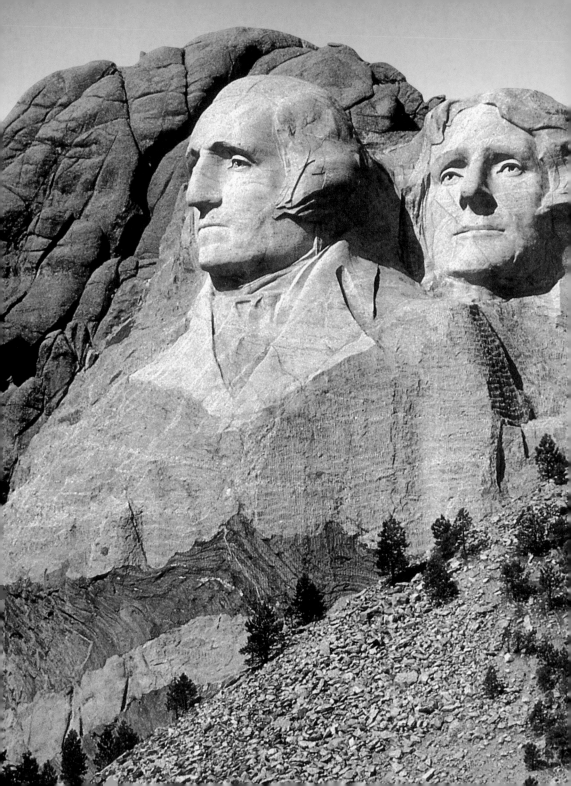

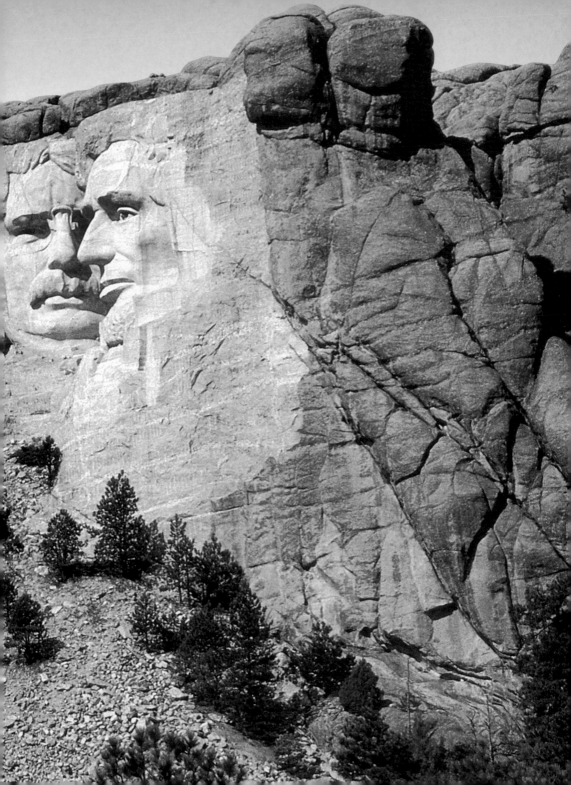

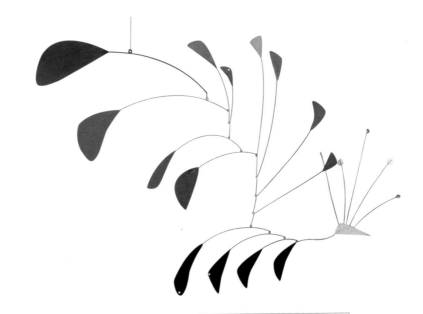

881. **Alexander Calder**, 1898-1976, American.
Untitled (Paon), 1941. Painted metal and aluminium, span: 125.7 cm.
Private collection, R. Kaller-Kimche Inc., New York (United States). Abstract art. (*)

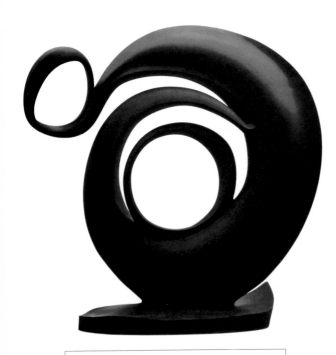

882. **Georgia O'Keeffe**, 1887-1986, American.
Abstraction, 1946. Cast aluminium, 299.7 x 299.7 x 146.7 cm.
Georgia O'Keeffe Museum, Santa Fe (United States). Abstract art.

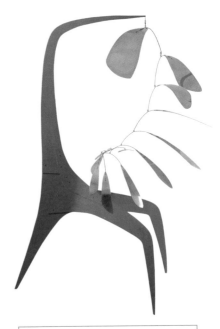

883. **Alexander Calder**, 1898-1976, American.
Aluminium Leaves, Red Post, 1941.
Sheet metal, wire and paint, 154.9 x 154.9 cm.
The Lipman Family Foundation. Abstract art.

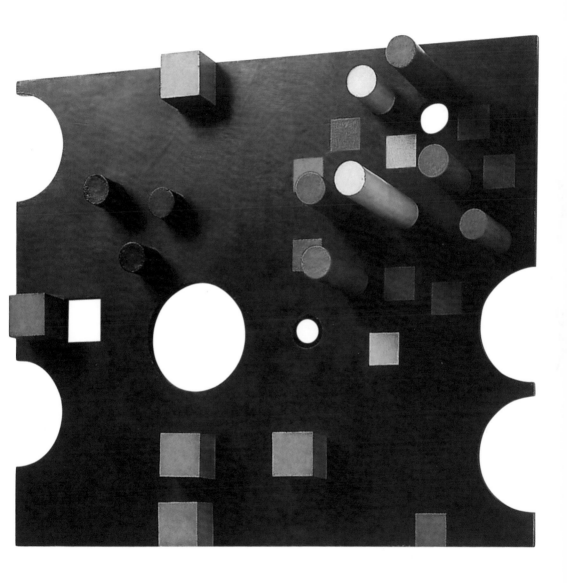

884. **Sophie Taeuber-Arp**, 1889-1943, Swiss.
Cut Reliefs, 1938. Oil on wood, 65 x 55 x 22 cm.
Kunstmuseum, Berne (Switzerland). Abstract art.

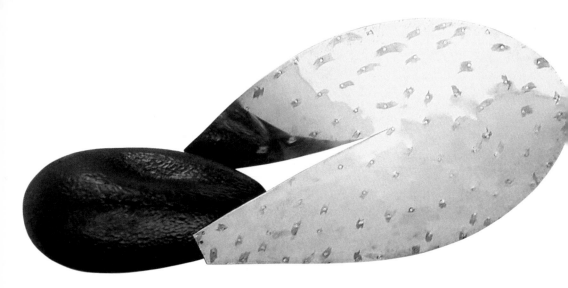

885. **Alison Wilding**, born 1948, English.
Nature – Blue and Gold, 1984.
Ash wood with pigment and brass, 47 x 103 x 31 cm.
British Council Arts Group, London (United Kingdom). Abstract art.

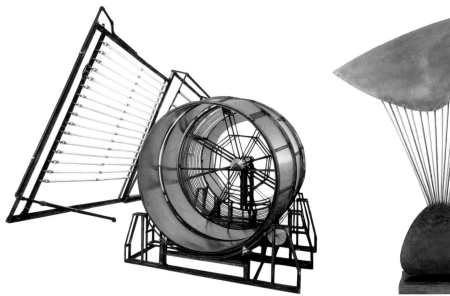

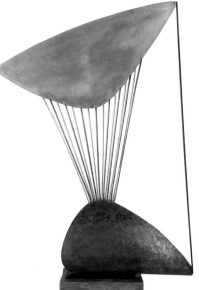

886. **Alice Aycock**, born 1946, American.
The Wild Diamond, 1946. Iron, metal leaves, heating resistor, neon tube,
engine and fan, 426 x 304 x 244 cm.
Plattsburgh State Art Museum, New York (United States). Land Art.

887. **Berto Lardera**, 1911-1989, Italian.
Two-Dimensional Sculpture, 1947.
Copper, aluminium and iron, 130 x 90 x 25 cm.
Musée national d'art moderne, Centre Georges Pompidou,
Paris (France). Abstract art.

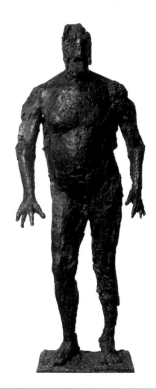

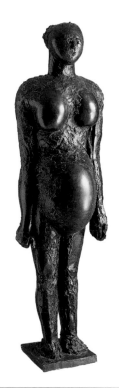

888. **Germaine Richier**, 1904-1959, French.
The Storm, 1947-1948. Bronze, h: 200 cm.
Musée national d'art moderne,
Centre Georges Pompidou, Paris (France). Surrealism.

889. **Pablo Picasso**, 1881-1973, Spanish.
Pregnant Woman, 1950. Plaster with metal armature, wood, ceramic,
large vessel and pottery jars, 110 x 22 x 32 cm.
The Museum of Modern Art, New York (United States). Cubism.

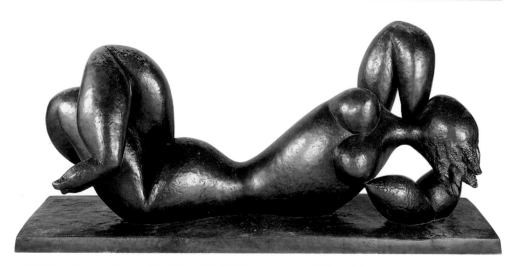

890. **Henri Laurens**, 1885-1954, French.
Autumn, 1948. Bronze, 80 x 103 x 22 cm.
Musée national d'art moderne,
Centre Georges Pompidou, Paris (France). Cubism. (*)

See next page:
891. **Henry Moore**, 1898-1986, British.
Draped Reclining Mother and Baby.
The Yorkshire Sculpture Park, Wakefield (United Kingdom).
Abstract art. (*)

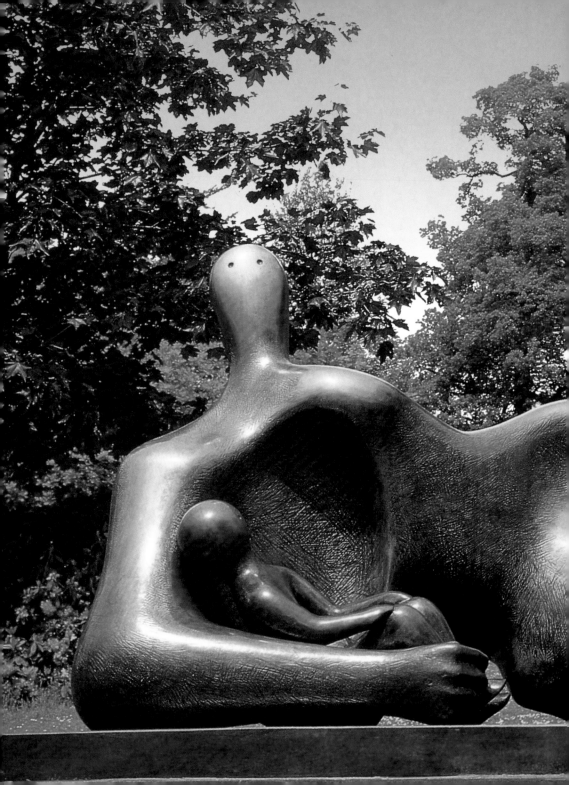

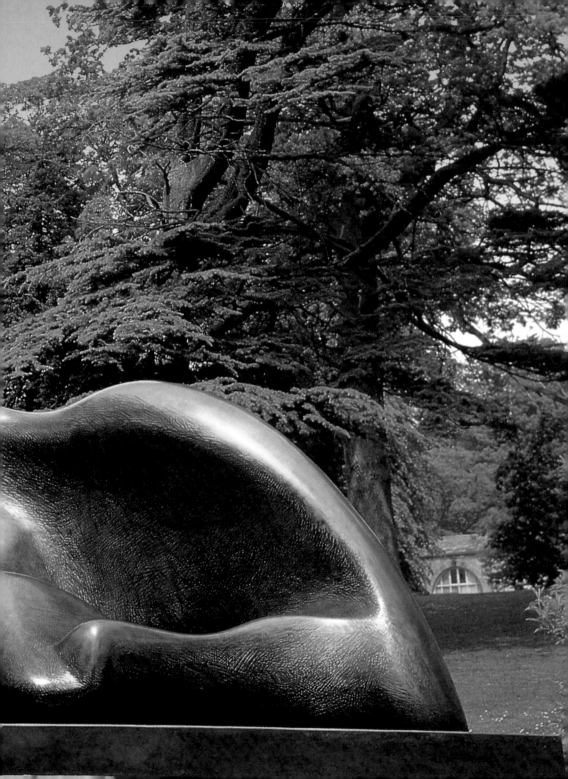

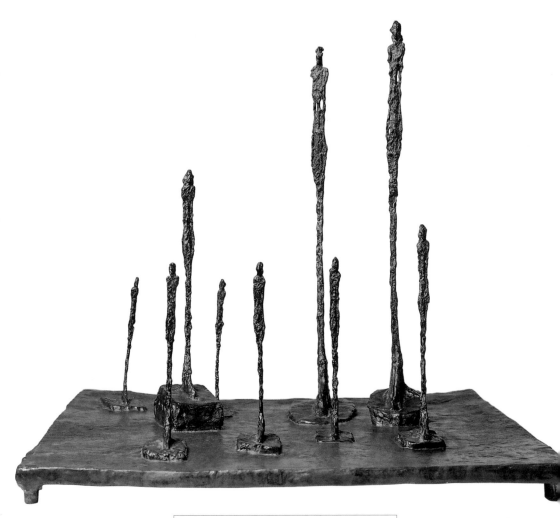

892. **Alberto Giacometti**, 1901-1966, Swiss.
The Glade, 1950. Bronze, 59.5 x 65.5 x 52 cm.
Kunsthaus Zürich, Zurich (Switzerland). Surrealism. (*)

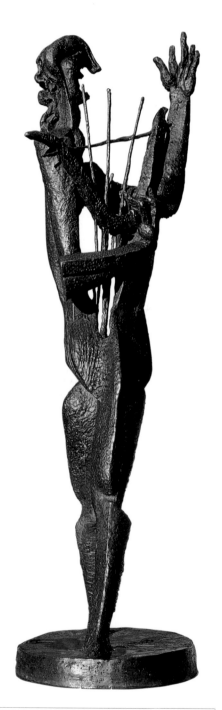

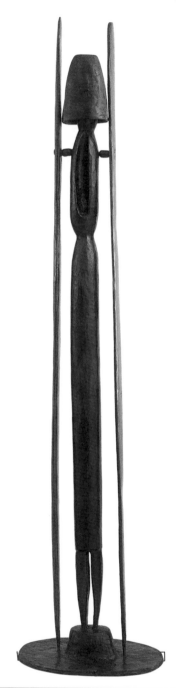

893. **Ossip Zadkine**, 1890-1967, Russian/French.
Orpheus, 1956. Bronze, h: 204 cm.
Antwerp Middelheim Museum, Antwerp (Belgium). Cubism.

894. **Louise Bourgeois**, born 1911, French/American.
Sleeping Figure, 1950. Painted balsa wood, 189.2 x 29.5 x 29.7 cm.
The Museum of Modern Art, New York (United States).
Abstract art/Expressionism. (*)
Art © Louise Bourgeois/Licensed by VAGA, New York, NY

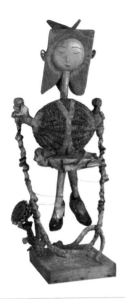

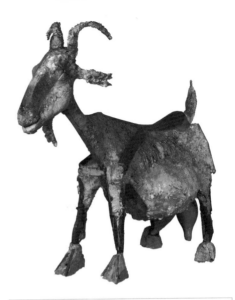

895. **Pablo Picasso**, 1881-1973, Spanish.
Little Girl with a Skipping Rope, 1950.
Plaster, ceramic, shoes, wood and iron, h: 152 cm.
Musée Picasso, Paris (France). Cubism.

896. **Pablo Picasso**, 1881-1973, Spanish.
She-Goat, 1950. Bronze (cast 1952), after an assemblage
of palm leaf, ceramic flower pots, wicker basket,
metal elements and plaster, 120.5 x 72 x 144 cm.
Museum of Fine Arts, Houston (United States). Cubism.

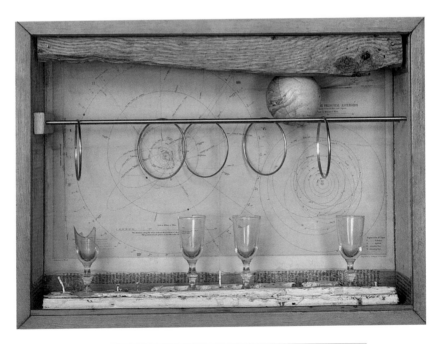

897. **Joseph Cornell**, 1903-1972, American.
Navigation Series Box, 1950-1952.
Wood, paper, metal and glass, 43.5 x 29.2 x 11.4 cm.
Private collection, New York (United States). Assemblage art.
Art © The Joseph and Robert Cornell Memorial Foundation/Licensed by VAGA, New York, NY

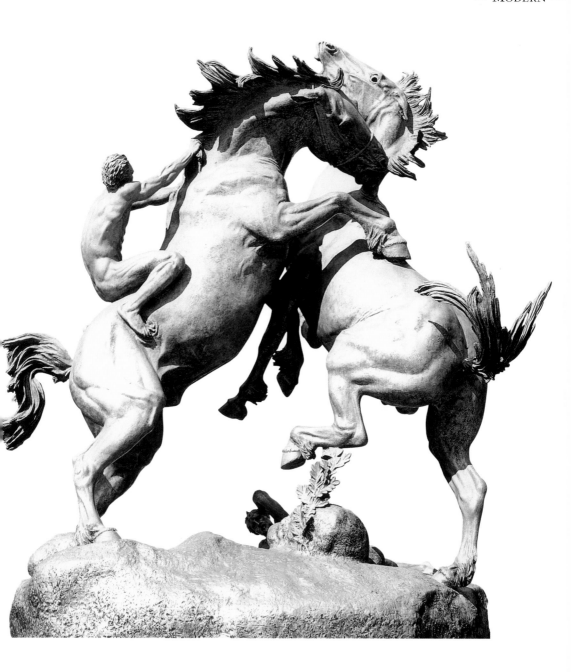

See next page:
898. **Anna V. Hyatt Huntington**, 1876-1973, American.
Fighting Stallions, 1950. Aluminium, 450 x 366 x 190 cm.
The Archer and Anna Hyatt Huntington Sculpture Garden, Brookgreen
Gardens, Murelles Inlet (South Carolina). Realism. (*)

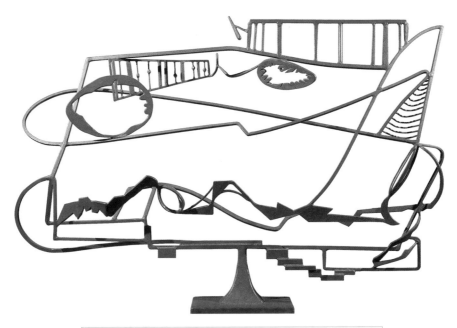

899. **David Smith**, 1906-1965, American.
Hudson River Landscape, 1951.
Welded painted steel and stainless steel, 125.7 x 190.5 x 42.5 cm.
Whitney Museum of American Art, New York (United States). Abstract art/Expressionism. (*)
Art © Estate of David Smith/Licensed by VAGA, New York, NY

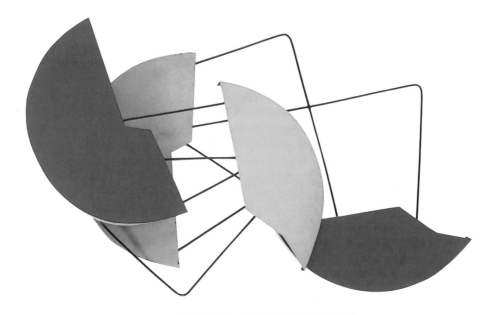

900. **Pol Bury**, 1922-2005, Belgian.
Relief Mobile 5, 1954. Painted metal, h: 44 cm.
Musée d'Art moderne, Saint-Etienne (France). Abstract art. (*)

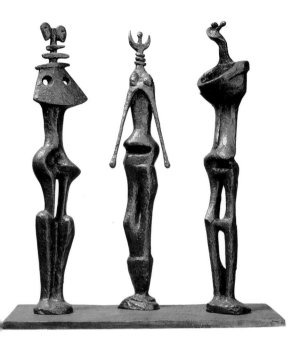

901. **Henry Moore**, 1898-1986, British.
Three Standing Figures, 1953.
Bronze, 73.2 x 68 x 29 cm (including base).
Peggy Guggenheim Collection, Venice (Italy). Abstract art.

902. **Marcel Duchamp**, 1887-1968, French.
Female Fig-Leaf, 1950-1951. Green-painted plaster, 8.5 x 13 x 11.5 cm.
Musée national d'art moderne, Centre Georges Pompidou, Paris (France).
Dada/Surrealism.

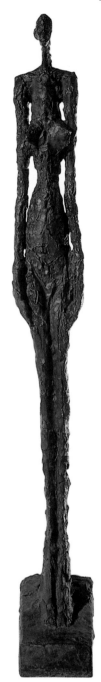

903. **Alberto Giacometti**, 1901-1966, Swiss.
Woman of Venice V, 1956. Bronze, 110.5 x 31.3 x 14 cm.
Musée national d'art moderne,
Centre Georges Pompidou, Paris (France). Surrealism.

904. **Marino Marini**, 1901-1980, Italian.
Horse, 1950. Bronze.
Hamburger Kunsthalle, Hamburg (Germany). Expressionism.

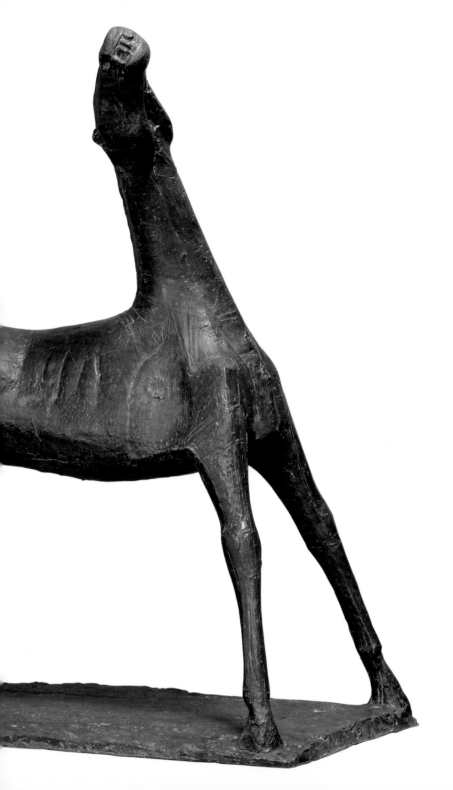

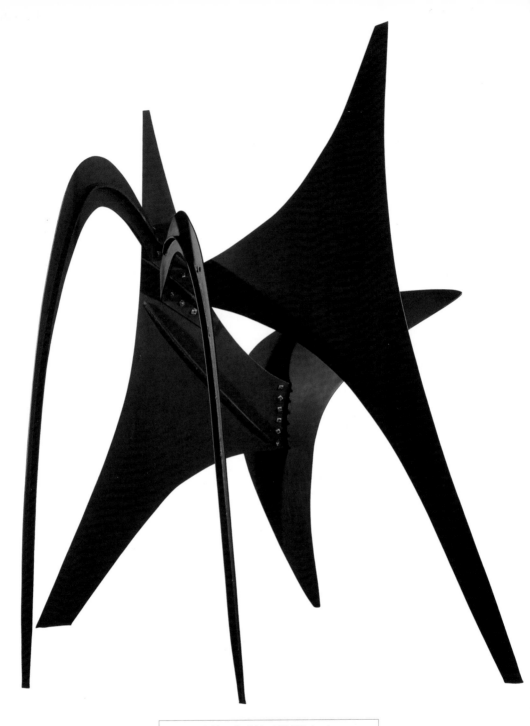

905. **Alexander Calder**, 1898-1976, American.
The Arches, 1959. Painted steel, 266.7 x 271.8 x 220.9 cm.
City Hall Park, New York (United States). Abstract art.

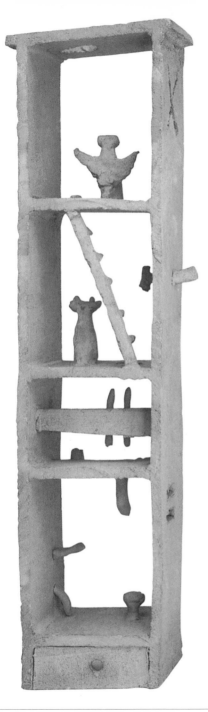

906. **Isamu Noguchi**, 1904-1988,
Japanese/American. *Apartment*, 1952.
Unglazed Seto red stoneware, 95.2 x 31.3 x 17 cm.
The Museum of Modern Art, New York (United States). Abstract art/Expressionism.

907. **Jesús Rafael Soto**, born 1923, Venezuelan.
Untitled, 1959-1960. Wood, painted wood,
metal and nails, 89.9 x 29.8 x 34 cm.
The Museum of Modern Art, New York (United States). Installation art.

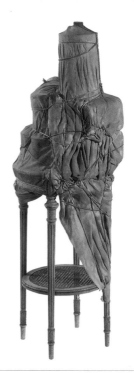

908. **Jean Dubuffet**, 1901-1985, French.
The Magician, from the series *Petites Statues de la vie précaire*, 1954.
Slag and roots, 109.8 x 48.2 x 21 cm.
The Museum of Modern Art, New York (United States). Pop Art.

909. **Christo**, born 1935, American.
Package on a Table, 1961. Pedestal table covered with wrapped up objects
in pink feutre and sackcloth, 134.5 x 43.5 x 44.5 cm.
Musée national d'art moderne,
Centre Georges Pompidou, Paris (France). Environmental art. (*)

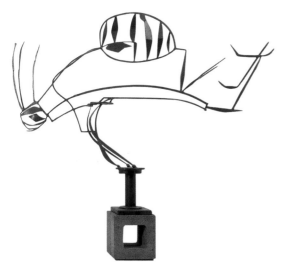

910. **David Smith**, 1906-1965, American.
Australia, 1951. Painted steel on cinder-block base,
202 x 274 x 41 cm; base: 44.5 x 42.5 x 38.7 cm.
The Museum of Modern Art, New York (United States). Abstract art/Expressionism.
Art © Estate of David Smith/Licensed by VAGA, New York, NY

911. **Jasper Johns**, born 1930, American.
Two Beer Cans, 1960. Oil on bronze, 14 x 20.3 x 12.1 cm.
Offentliche Kunstsammlung, Basel (Switzerland). Pop Art.
Art © Jasper Johns/Licensed by VAGA, New York, NY

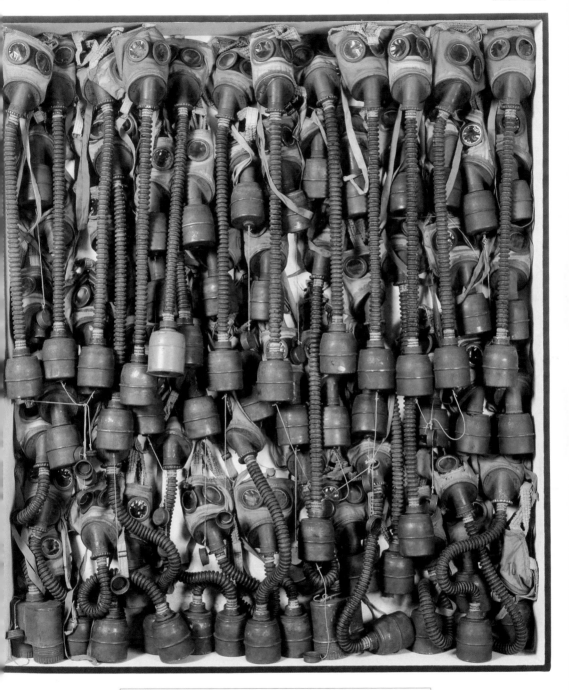

912. **Arman**, 1928-2005, French.
Home, Sweet Home, 1960.
Group of gasmasks in wooden box with plexiglass cover, 160 x 1405 x 20.3 cm.
Musée national d'art moderne, Centre Georges Pompidou, Paris (France). Assemblage art.

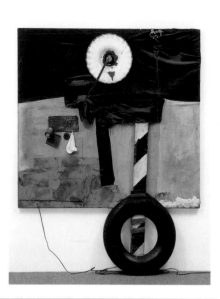

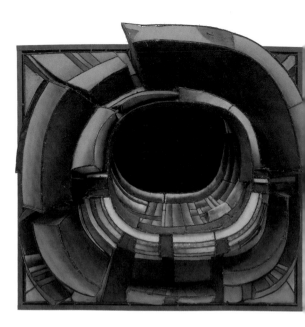

913. **Robert Rauschenberg**, born 1925, American.
First Landing Jump, 1961. Combine painting: cloth, metal, leather,
electric fixture, cable, and oil paint on composition board,
with automobile tire and wood plank, 226.3 x 182.8 x 22.5 cm.
The Museum of Modern Art, New York (United States). Pop Art.
Art © Robert Rauschenberg/Licensed by VAGA, New York, NY

914. **Lee Bontecou**, born 1931, American.
Untitled, 1961. Welded steel, canvas, black fabric,
copper wire and soot, 203.6 x 226 x 88 cm.
The Museum of Modern Art, New York (United States). Assemblage art.

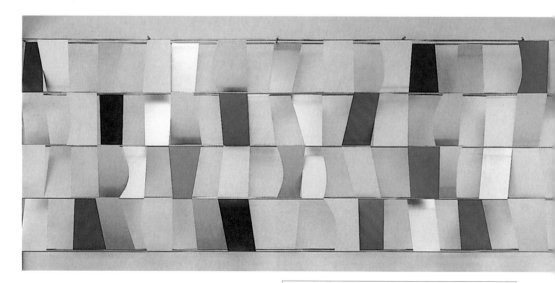

915. **Ellsworth Kelly**, born 1923, American.
Sculpture for a Large Wall, 1956-1957.
Anodised aluminium, one hundred and four panels, 348 x 1994 x 71.1 cm.
The Museum of Modern Art, New York (United States). Minimalism. (*)

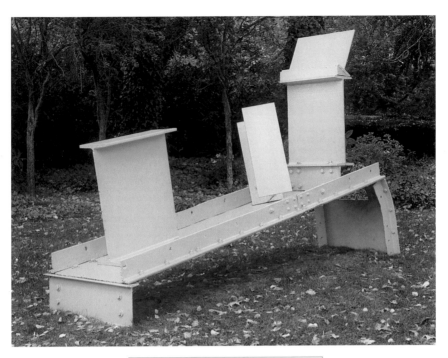

916. **Sir Anthony Caro**, born 1924, English.
Midday, 1960. Painted steel, 233.1 x 95 x 370.2 cm.
The Museum of Modern Art, New York (United States).
Abstract art. (*)

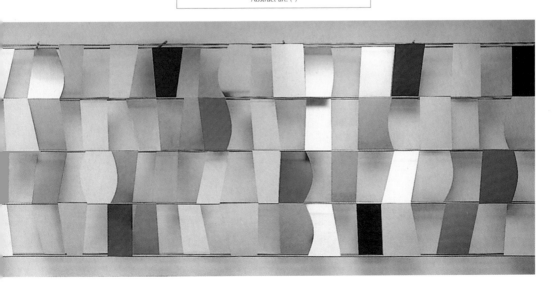

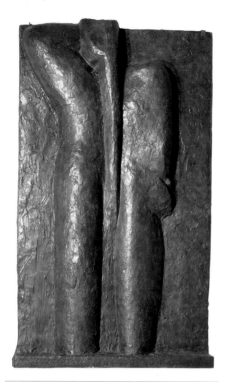

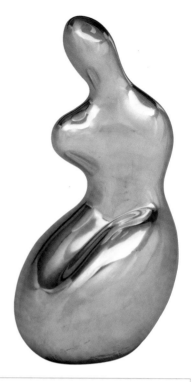

917. **Henri Matisse**, 1869-1954, French.
The Back IV, 1930. Low-wax process bronze, 190 x 114 x 16 cm.
Musée national d'art moderne, Centre Georges Pompidou,
Paris (France). Fauvism. (*)

918. **Hans Arp**, 1886-1966, German/French.
Demeter, 1961. Bronze, h: 59 cm.
The Israel Museum, Jerusalem (Israel). Surrealism/Dada. (*)

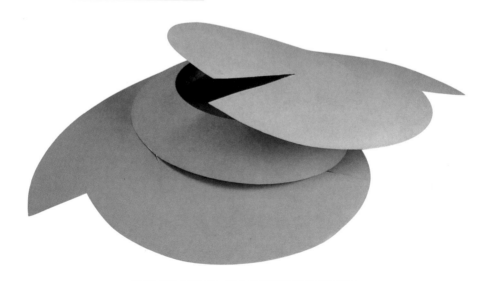

919. **Lygia Clark**, 1920-1988, Brazilian.
Poetic Shelter, 1960. Tin, 14 x 63 x 51 cm.
The Museum of Modern Art, New York (United States). Installation art.

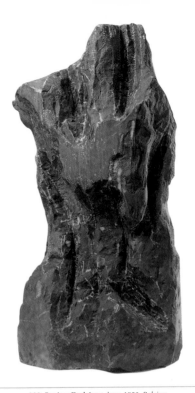

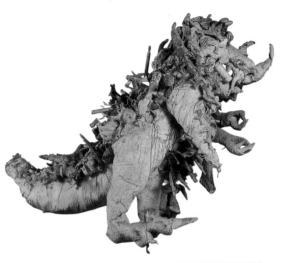

921. **Niki de Saint-Phalle**, 1930-2002, French.
The Monster of Soisy, c. 1962-1963. Paint and various objects on metal framework, 253 x 161 x 190 cm.
Musée national d'art moderne, Centre Georges Pompidou,
Paris (France). New realism.

920. **Eugène Dodeigne**, born 1923, Belgian.
Large Torso, 1960-1961. Black granit, 120 x 56 x 45 cm.
Musée national d'art moderne,
Centre Georges Pompidou, Paris (France). Abstract art.

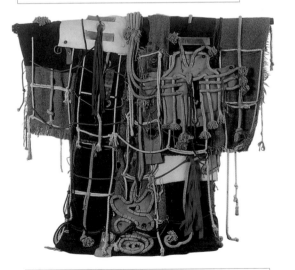

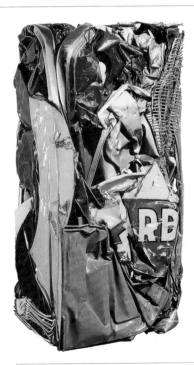

922. **Etienne Martin**, 1913-1995, French.
Coat (Dwelling 5), 1962.
Fabric, trimmings, rope, leather, metal, tarpaulin, 250 x 230 x 75 cm.
Musée national d'art moderne,
Centre Georges Pompidou, Paris (France). Abstract art.

923. **César**, 1921-1998, French.
Compression Ricard, 1962.
Compressed automobile parts, 153 x 73 x 65 cm.
Musée national d'art moderne,
Centre Georges Pompidou, Paris (France). Assemblage art.

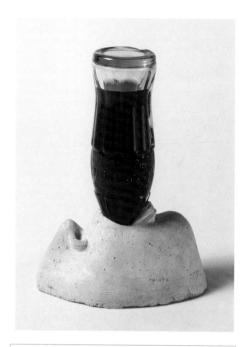

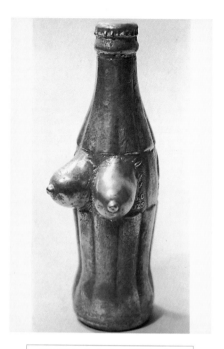

924. **Marisol**, born 1930, Venezuelan.
Love, 1962. Plaster and Coca-Cola bottle, 15.8 x 10.5 x 20.6 cm.
The Museum of Modern Art, New York (United States). Pop Art. (*)
Art © Marisol Escobar/ Licensed by VAGA, New York, NY

925. **Charles Frazier**, born 1930, American.
American Nude, 1963. Bronze, h: 19.6 cm.
Dr. and Mrs. Leonard Kornblee Collection,
New York (United States). Pop Art.

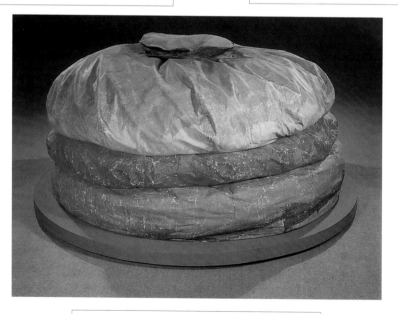

926. **Claes Oldenburg**, born 1929, Sweedish.
Floor Burger, 1962. Canvas filled with foam rubber and cardboard boxes,
painted with latex and Liquitex, diameter: 132.1 x 213.4 cm.
Art Gallery of Ontario, Toronto (Canada). Pop Art. (*)

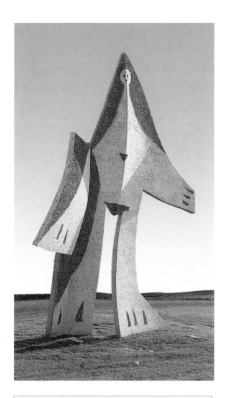

927. **Pablo Picasso**, 1881-1973, Spanish.
Woman with Outstretched Arms, 1961.
Painted iron and metal, h: 540 cm.
Museum of Fine Arts, Houston (United States). Cubism.

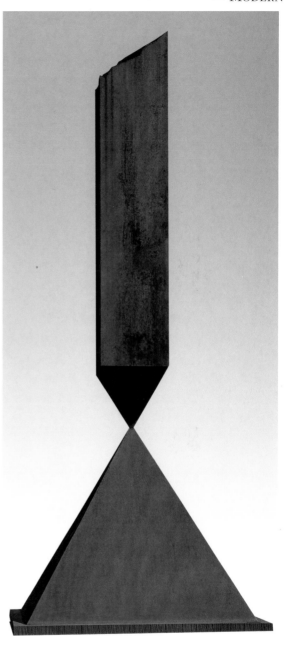

928. **Tony Smith**, 1912-1981, American.
Die, 1962. Steel, painted green and olive,
182.9 x 182.9 x 182.9 cm.
The Museum of Modern Art, New York (United States). Minimalism. (*)

929. **Barnett Newman**, 1905-1970, American.
Broken Obelisk, 1963-1969.
Cor-Ten steel, 749.9 x 318.8 x 318.8 cm.
The Museum of Modern Art, New York (United States).
Abstract art/Expressionism/Minimalism.

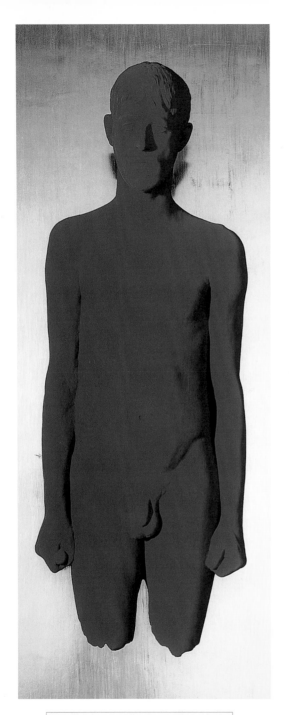

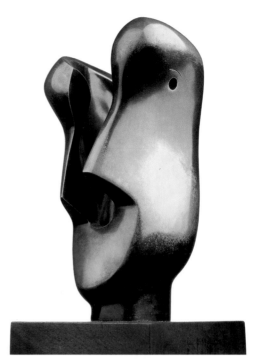

931. **César**, 1921-1998, French.
Divided Head, 1963. Bronze, h: 35 cm.
Fiorini, London (United Kingdom). Assemblage art.

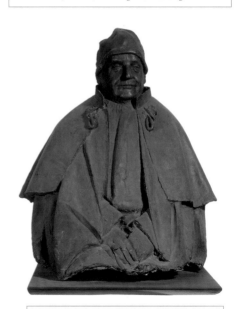

930. **Yves Klein**, 1928-1962, French.
Relief-Portrait of Martial Raysse, 1962. Painted bronze,
blue pigment on panel with gold paper, h: 178 cm.
Musée d'Art, Toulon (France). Conceptual art.

932. **Giacomo Manzù**, 1908-1991, Italian.
Bust of Pope John XXIII, 1962. Bronze, 105 x 79 x 75 cm.
Musei Vaticani, Vatican City (Italy).
Naturalism/Pre-Modernism. (*)

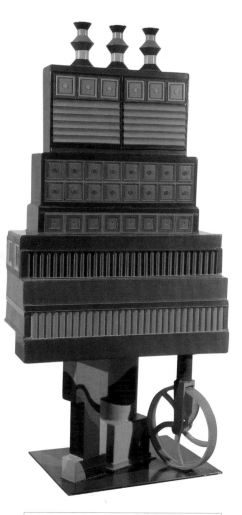

933. **Eduardo Paolozzi**, 1924-2005, English.
The City of the Circle and the Square, 1963-1966.
Painted aluminium, 210 x 102.2 x 66.7 cm.
Tate Gallery, London (United Kingdom). Surrealism. (*)

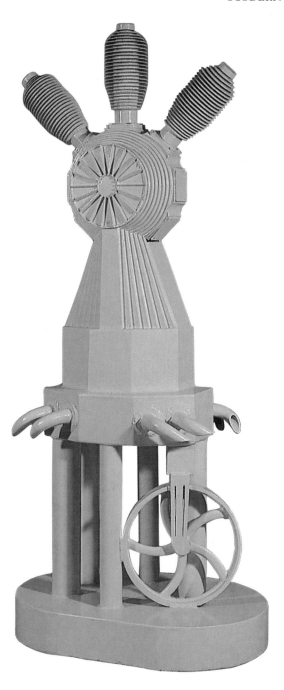

934. **Eduardo Paolozzi**, 1924-2005, English.
The Bishop of Kuban, 1962.
Private collection. Surrealism.

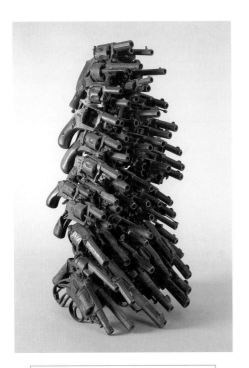

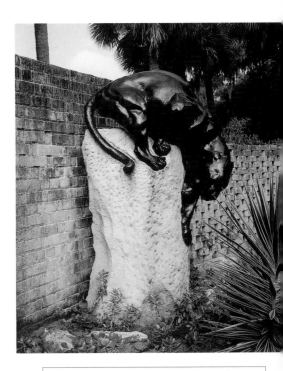

935. **Arman**, 1928-2005, French.
Nail Fetish, 1963. Group of revolvers glued together,
50.8 x 22.8 x 25.8 cm.
Private collection. Assemblage art.

936. **Anna V. Hyatt Huntington**, 1876-1973, American.
Panther ascending a Rock, 1964. Bronze, lifesize.
The Archer and Anna Hyatt Huntington Sculpture Garden,
Brookgreen Gardens, Murelles Inlet (United States). Realism.

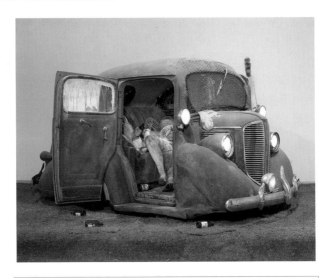

937. **Ed Kienholz**, 1927-1994, American.
Back Seat Dodge '38, 1964.
Polyester resin, paint, fiberglass, truncated 1938 Dodge automobile, clothing, chicken wire,
beer bottles, artificial grass and plaster cast, 167.6 x 609.6 x 365.8 cm.
Los Angeles County Museum of Art, Los Angeles (United States). Installation art.

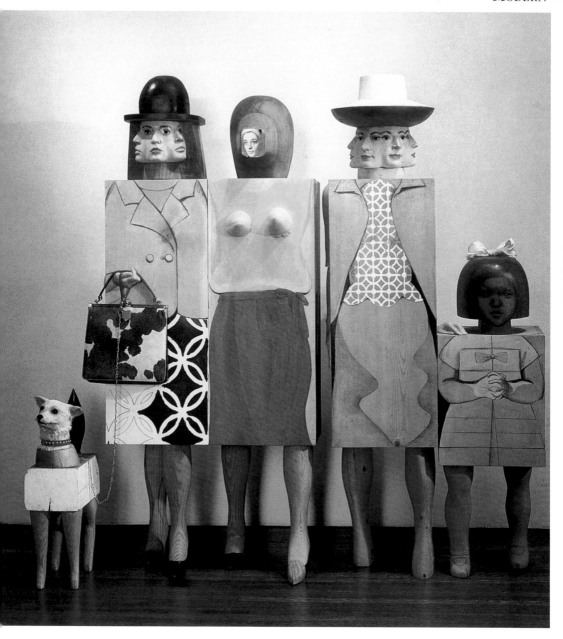

938. **Marisol**, born 1930, Venezuelan.
Women and Dog, 1964. Wood, plaster, synthetic polymer, taxidermied dog
head and miscellaneous items, 208 x 183 x 41 cm.
Whitney Museum of American Art, New York (United States). Pop Art.
Art © Marisol Escobar/Licensed by VAGA, New York, NY

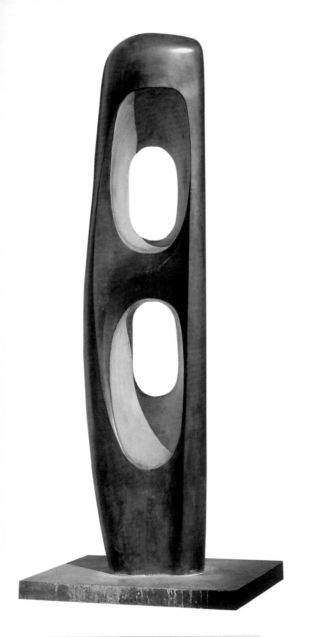

939. **Barbara Hepworth**, 1903-1975, British.
Figure Walnut, 1964. Bronze, h: 184 cm.
Fondation Maeght, Saint-Paul-de-Vence (France). Abstract art. (*)

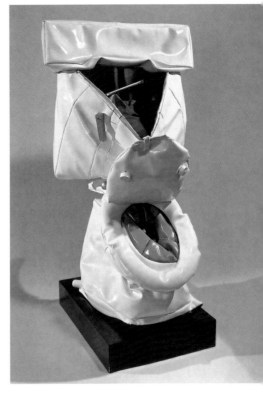

940. **Claes Oldenburg**, born 1929, Sweedish.
Soft Toilet, 1966. Vinyl, plexiglass and kapok on painted wood base,
144.9 x 70.2 x 71.3 cm.
Whitney Museum of American Art, New York (United States). Pop Art.

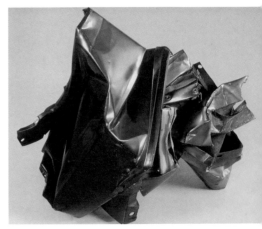

941. **John Chamberlain**, born 1927, American.
Untitled, 1964. Painted steel with chrome, 76 x 91.5 x 61 cm.
Musée d'Art moderne et contemporain, Nice (France). Pop Art.

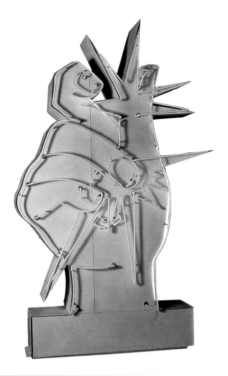

942. **Martial Raysse**, born 1936, French.
America America, 1964.
Neon lighting and metal paint, 240 x 165 x 45 cm.
Musée national d'art moderne, Centre Georges Pompidou, Paris (France). New realism.

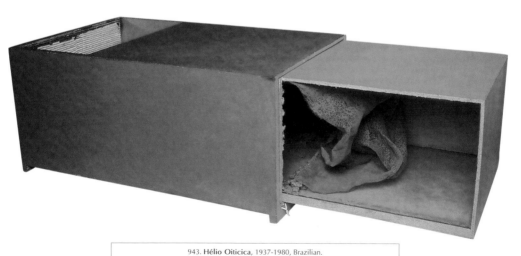

943. **Hélio Oiticica**, 1937-1980, Brazilian.
Box Bolide 12, "archeologic", 1964-1965.
Synthetic polymer paint with eath on wooden structure, nylon net, corrugated cardboard,
mirror, glass, rocks, earth, fluorescent lamp, 37 x 131.2 x 52.1 cm.
The Museum of Modern Art, New York (United States). Abstract art.

944. **Takis**, born 1925, Greek.
"Le Grand Signal", 1964. Metal and neon lighting, h: 499 cm.
Musée national d'art moderne,
Centre Georges Pompidou, Paris (France). Abstract art. (*)

945. **Walter de Maria**, born 1935, American.
Cage II, 1965. Stainless steel, 216.5 x 36.2 x 36.2 cm.
The Museum of Modern Art, New York (United States).
Dada/Minimalism.

946. **Marcel Broodthaers**, 1924-1976, Belgian.
White Cabinet and White Table, 1965. Painted cabinet, table and egg shells,
cabinet: 86 x 82 x 62 cm, table: 104 x 100 x 40 cm.
The Museum of Modern Art, New York (United States). Installation art.

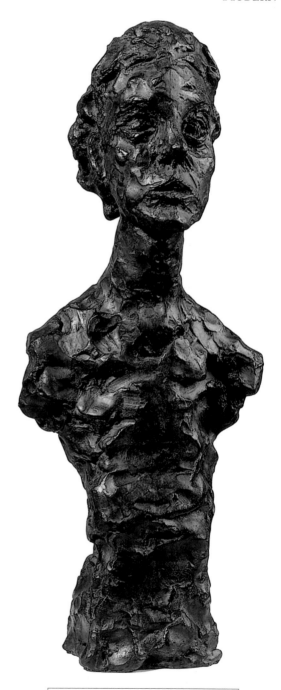

947. **Clive Barker**, born 1952, American.
Van Gogh's Chair, 1966. Chrome-plated steel, h: 86.4 cm
Sir Paul McCartney Collection. Installation art.

948. **Alberto Giacometti**, 1901-1966, Swiss.
Annette X, 1965. Bronze, 44 x 18.5 x 13.5 cm.
Musée national d'art moderne,
Centre Georges Pompidou, Paris (France). Surrealism.

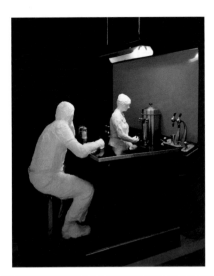

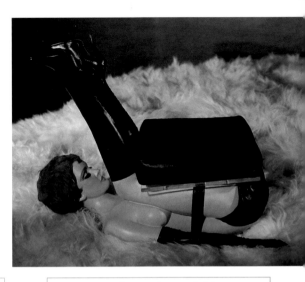

949. **George Segal**, 1924-2000, American.
The Diner, 1965. Plaster, wood, chrome, Formica,
Masonite and fluorescent light, 259 x 274.3 x 220.9 cm.
Walker Art Center, Minneapolis (United States). Pop Art.
Art © The George and Helen Segal Foundation/Licensed by VAGA, New York, NY

950. **Allen Jones**, born 1937, English.
Chair, 1969. Painted fiberglass, leather and hair, full-size.
Neue Galerie, collection Ludwig, Aachen (Germany). Pop Art.

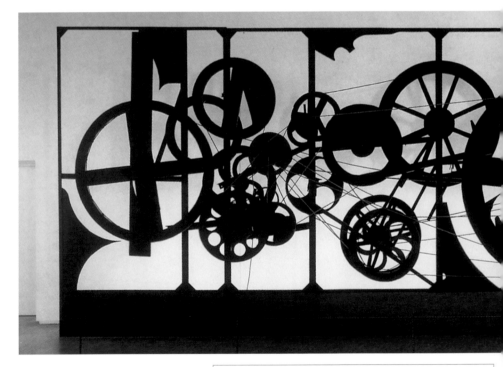

951. **Jean Tinguely**, 1925-1991 Swiss.
Requiem for a Dead Leaf, 1967.
Painted steel, wood, leather, 260 x 274.3 x 220.9 cm.
Musée national d'art moderne, Centre Georges Pompidou, Paris (France). Kinetic art. (*)

952. **Bruce Nauman**, born 1941, American.
Untitled, 1965. Fiberglass, polyester resin and light,
261 x 274.3 x 220.9 cm.
The Museum of Modern Art, New York (United States). Installation art.

953. **Joseph Beuys**, 1921-1986, German.
Eurasia Siberian Symphony 1963, 1966. Panel with chalk drawing, felt, fat,
hare and painted poles, 262 x 274.3 x 220.9 cm.
The Museum of Modern Art, New York (United States). Conceptual art.

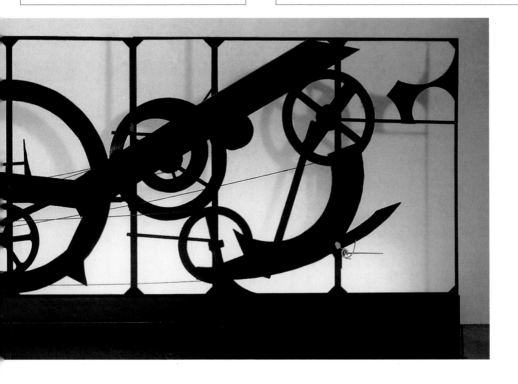

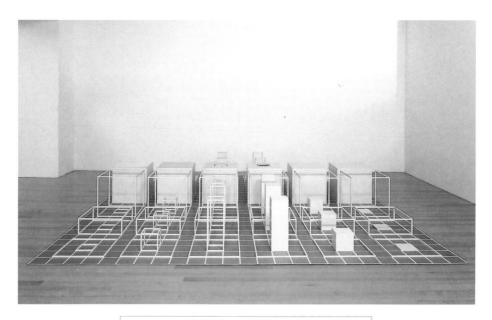

954. **Sol LeWitt**, 1928-2007, American.
Serial Project, I (ABCD), 1966. Baked enamel on steel units over baked enamel
on aluminium, 263 x 274.3 x 220.9 cm.
The Museum of Modern Art, New York (United States). Minimalism.

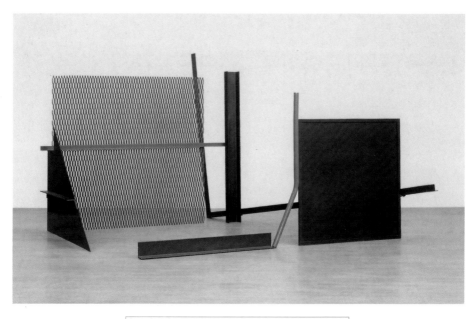

955. **Sir Anthony Caro**, born 1924, English.
The Window, 1966-1967. Steel, painted green and olive,
264 x 274.3 x 220.9 cm.
Private collection, London (United Kingdom). Abstract art.

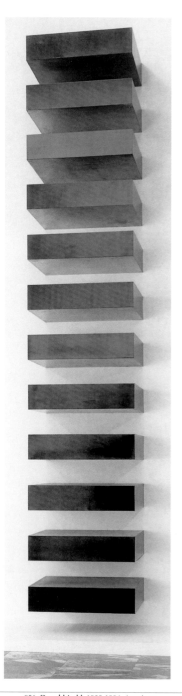

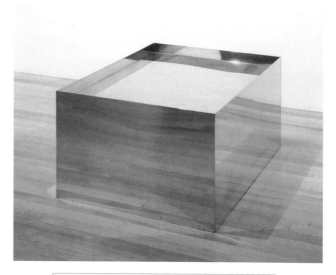

957. **Donald Judd**, 1928-1994, American.
Untitled, 1968. Brass, 266 x 274.3 x 220.9 cm.
The Museum of Modern Art, New York (United States). Minimalism.
Art © Donald Judd Foundation/Licensed by VAGA, New York, NY

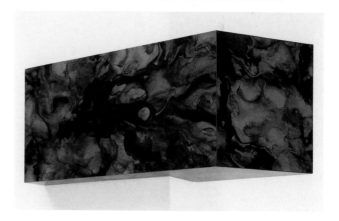

958. **Richard Artschwager**, born 1923, American.
Key Member, 1967.
Formica veneer and felt on wood, 267 x 274.3 x 220.9 cm.
The Museum of Modern Art, New York (United States). Pop Art.

959. **Ed Kienholz**, 1927-1994, American.
The Portable War Memorial, 1968.
Plaster casts, tombstone, blackboard, flag, poster, restaurant furniture, trash can,
photographs, working vending machine, stuffed dog, dog-leash, wood, metal,
fiberglass, chalk and string, 268 x 274.3 x 220.9 cm.
Museum Ludwig, Cologne (Germany). Installation art.

956. **Donald Judd**, 1928-1994, American.
Untitled (Stack), 1967. Lacquer on galvanised iron,
twelve units 265 x 274.3 x 220.9 cm.
e Museum of Modern Art, New York (United States). Minimalism. (*)
Art © Donald Judd Foundation/Licensed by VAGA, New York, NY

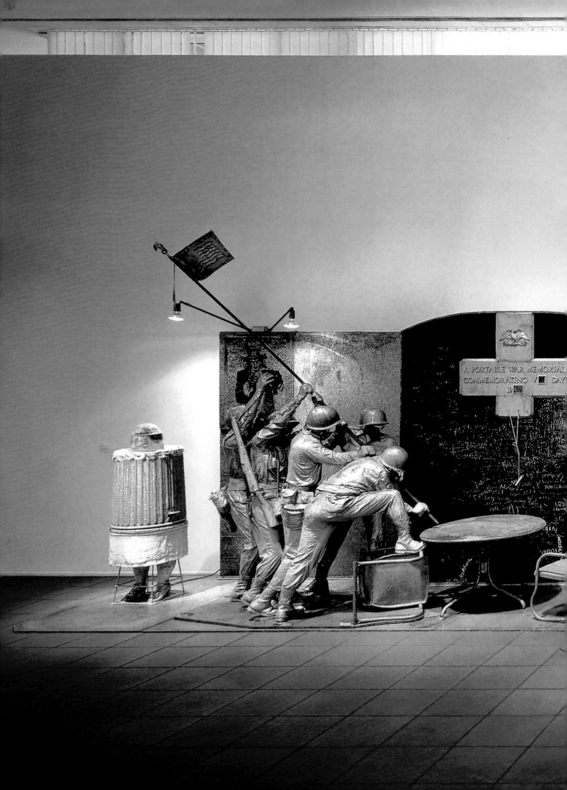

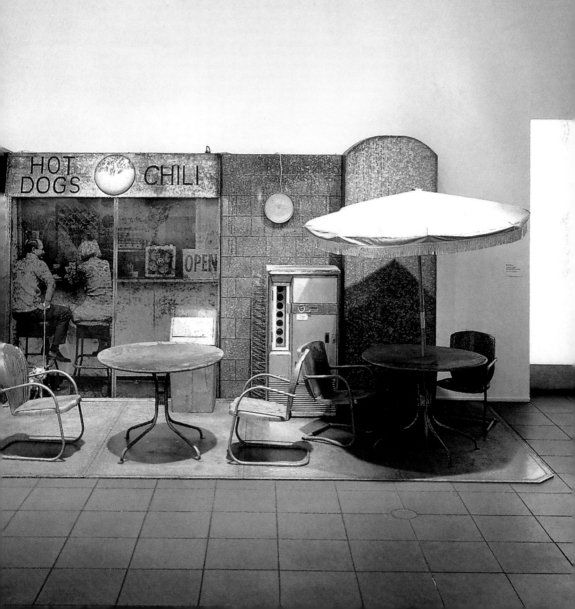

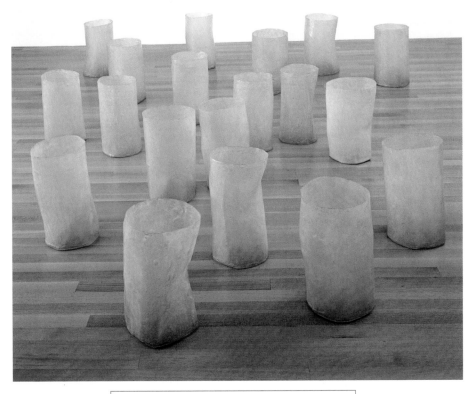

960. **Eva Hesse**, 1936-1970, German/American.
Repetition Nineteen III, 1968. Fiberglass and polyester resin,
19 units, each h: 48 to 51 cm; diameter: 27.8 to 32.2 cm.
The Museum of Modern Art, New York (United States). Minimalism. (*)

961. **Carl Andre**, born 1935, American.
144 Lead Square, 1969. Lead (144 units),
each unit: 1 x 367.8 x 367.8 cm.
The Museum of Modern Art, New York (United States). Minimalism. (*)
Art © Carl Andre/Licensed by VAGA, New York, NY

962. **Joseph Beuys**, 1921-1986, German.
Iron Chest from "Vacuum – Mass", 1968.
Iron, fat, bicycle pumps, 55.9 x 109.2 x 54 cm.
The Museum of Modern Art, New York (United States) Conceptual art. (*)

964. **Giovanni Anselmo**, born 1934, Italian.
Untitled, 1968. Granite, copper wire, lettuce, 70 x 23 x 37 cm.
Musée national d'art moderne,
Centre Georges Pompidou, Paris (France). Arte Povera. (*)

963. **Giovanni Anselmo**, born 1934, Italian.
Torsion, 1968. Cement, leather and wood,
132.1 x 287 x 147.3 cm.
The Museum of Modern Art, New York (United States). Arte Povera.

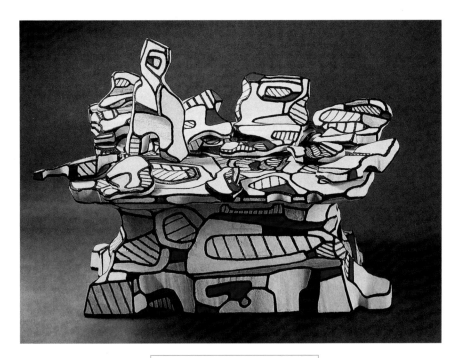

965. **Jean Dubuffet**, 1901-1985, French.
Portative Landscape, 1968.
Transfert on polyester, 80 x 130 x 75 cm.
Private collection. Pop Art.

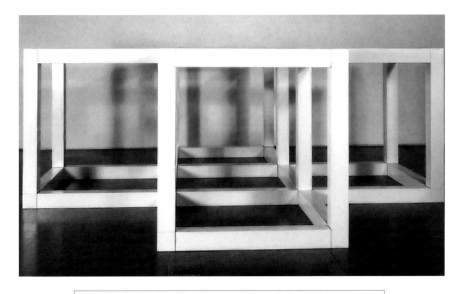

966. **Sol LeWitt**, 1928-2007, American.
5 Part Piece (Open Cubes) in Form of a Cross, 1966-1969.
Painted steel (enamelled lacquer), 160 x 450 x 450 cm.
Musée national d'art moderne, Centre Georges Pompidou, Paris (France). Minimalism. (*)

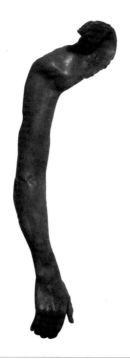

967. **Bruce Nauman**, born 1941, American.
From Hand to Mouth, 1967. Wax over cloth, 71.1 x 25.7 x 10.2 cm.
Hirshhorn Museum and Sculpture Garden, Washington, D.C.
(United States). Installation art.

968. **Pino Pascali**, 1935-1968, Italian.
Aesop's Feathers, 1968. Bird feathers, braided steel wool mounted
on a wooden plank, depth: 35 cm, diameter: 150 cm.
Musée national d'art moderne, Centre Georges Pompidou, Paris (France). Arte Povera.

969. **Luciano Fabro**, born 1936, Italian.
Foot, 1968-1972. Murano glass and silk, 333.5 x 108 x 79 cm.
Musée national d'art moderne,
Centre Georges Pompidou, Paris (France). Arte Povera.

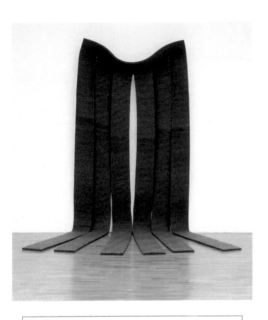

970. **Robert Morris**, born 1931, American.
Untitled, 1969. Felt, 459.2 x 184.1 x 2.5 cm.
The Museum of Modern Art, New York (United States). Minimalism. (*)

971. **Ed Kienholz**, 1927-1994, American.
Turgid TV, 1969. Television, plaster and paint, 51.4 x 25.4 x 57.2 cm.
Los Angeles County Museum of Art,
Los Angeles (United States). Installation art.

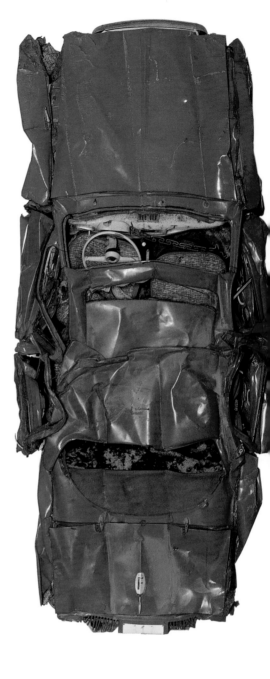

972. **César**, 1921-1998, French.
Dauphine, after 1959 (1970?). Flat red car compression on base,
licence plate 317 CE 91; compressed iron, 410 x 190 x 60 cm.
Musée d'Art moderne et contemporain, Nice (France). Assemblage art. (*)

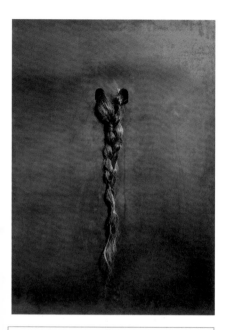

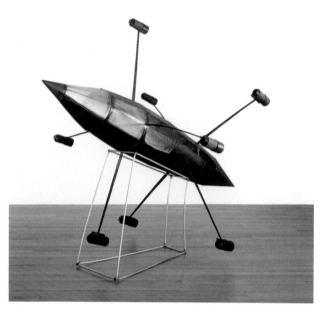

973. **Jannis Kounellis**, born 1936, Greek.
Untitled, 1969. Iron and hair, 100.5 x 70.5 x 5 cm.
Musée national d'art moderne,
Centre Georges Pompidou, Paris (France). Arte Povera.

974. **Panamarenko**, born 1940, Belgian.
Flying Object (Rocket), 1969. Balsa wood, cardboard, plastic, fabric, aluminium,
steel and synthetic polymer paint, 271.7 x 345.5 x 249 cm.
The Museum of Modern Art, New York (United States). Conceptual art.

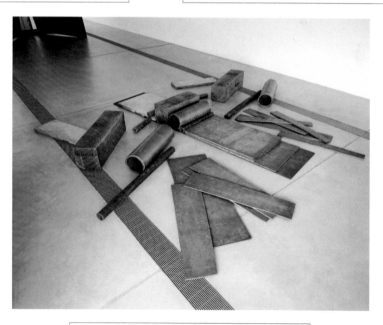

975. **Richard Serra**, born 1939, American.
Cutting Device: Base Plate-Measure, 1969.
Lead, wood, stone and steel, 30.5 x 549 x 498 cm.
The Museum of Modern Art, New York (United States). Minimalism. (*)

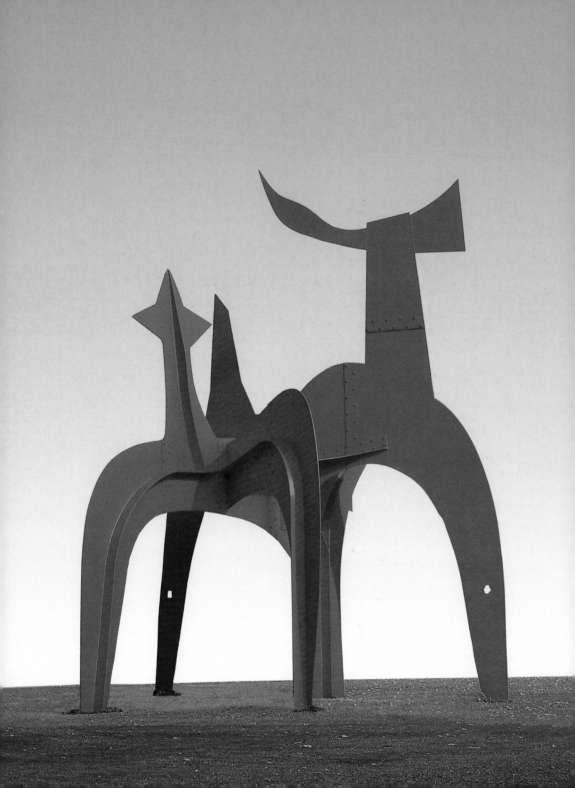

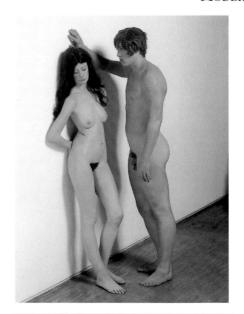

977. **Duane Hanson**, 1925-1996, American.
Supermarket Shopper, 1970.
Fiberglass, polychromed in oil, with clothing, accessories, supermarket packaging
and trolley, h: 166 cm (life-size).
Neue Galerie-Sammlung Ludwig, Aachen (Germany). Photorealism. (*)
Art © Estate of Duane Hanson/Licensed by VAGA, New York, NY

978. **John De Andrea**, born 1941, American.
Couple, 1971. Acrylic on polyester, hair, h: 173 cm.
Musée national d'art moderne,
Centre Georges Pompidou, Paris (France). Photorealism.

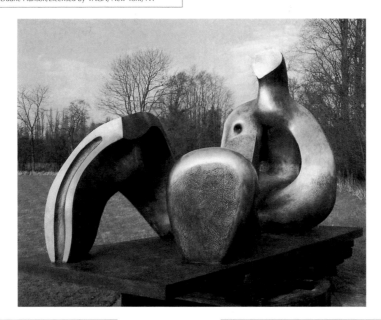

See previous page:
976. **Alexander Calder**, 1898-1976, American.
Le Hallebardier, 1971. Iron, painted over, h: 800 cm.
Sprengel Museum, Hanover (Germany). Abstract art.

979. **Henry Moore**, 1898-1986, British.
Three-Piece Reclining Figure: Draped, 1975.
Bronze, 264 x 427 cm.
Henry Moore Foundation, Perry Green (United Kingdom). Abstract art.

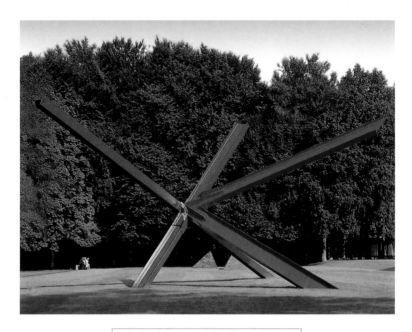

980. **Mark di Suvero**, born 1933, American.
K-Piece, 1933. Steel, 120 x 120 x 603 cm.
Rijkmuseum Kröller-Müller, Gelderland (Netherlands).
Abstract art/Expressionism. (*)

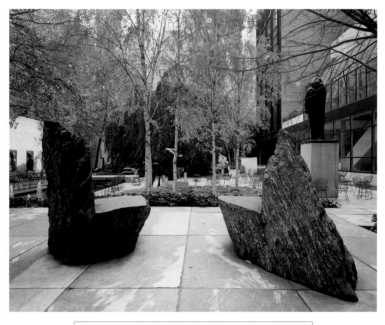

981. **Scott Burton**, 1939-1989, American.
Pair of Rock Chairs, 1980-1981.
Stone (Gneiss), 125.1 x 110.5 x 101.6 cm.
The Museum of Modern Art, New York (United States). Abstract art.

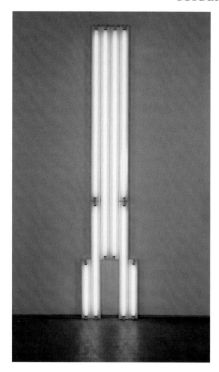

982. **Gilberto Zorio**, born 1944, Italian.
Phosphorescent Fist, 1971.
Phosphorescent wax, two wood lamps, 170 x 180 x 50 cm.
Musée national d'art moderne,
Centre Georges Pompidou, Paris (France). Arte Povera.

983. **Dan Flavin**, 1933-1996, American.
Monument for Vladimir Tatlin, 1975.
Fluorescent light tubes, metal, 304.5 x 62.5 x 12.5 cm.
Musée national d'art moderne,
Centre Georges Pompidou, Paris (France). Minimalism.

984. **César**, 1921-1998, French.
Expansion No. 14, 1970. Expanded polyurethane,
laminated and varnished, 100 x 270 x 220 cm.
Musée national d'art moderne, Centre Georges Pompidou,
Paris (France). Assemblage art.

985. **Wolfgang Laib**, born 1950, German.
Milk-Stone, 1977. Marble and milk, 143.5 x 139.5 cm.
Musée national d'art moderne,
Centre Georges Pompidou, Paris (France). Installation art.

986. **Giuseppe Penone**, born 1947, Italian.
Albero, 1973. Wood, 550 x 19.5 x 7.5 cm.
Musée national d'art moderne,
Centre Georges Pompidou, Paris (France). Arte Povera. (*)

987. **Toni Grand**, 1935-2005, French.
*Green, Squared Off then a Partial Notch,
Squarred Off then Two Partial Notches*, 1973. 160 x 180 cm.
Musée national d'art moderne, Centre Georges Pompidou,
Paris (France). Abstract art.

988. **Jackie Winsor**, born 1941, Canadian/American.
Bound Square, 1972. Wood and twine, 191.8 x 193 x 36.8 cm.
The Museum of Modern Art, New York (United States).
Abstract art.

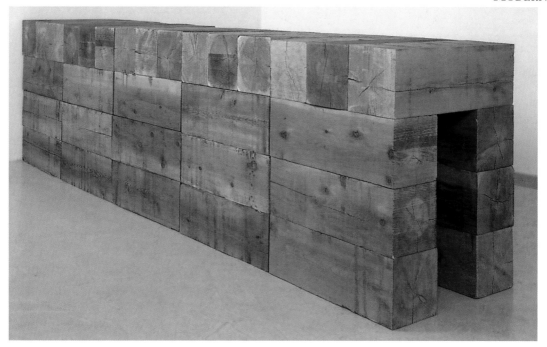

989. **Carl Andre**, born 1935, American.
Hearth, 1980. 45 cedarwood elements, 120 x 90 x 450 cm.
Musée national d'art moderne,
Centre Georges Pompidou, Paris (France). Minimalism.
Art © Carl Andre/Licensed by VAGA, New York, NY

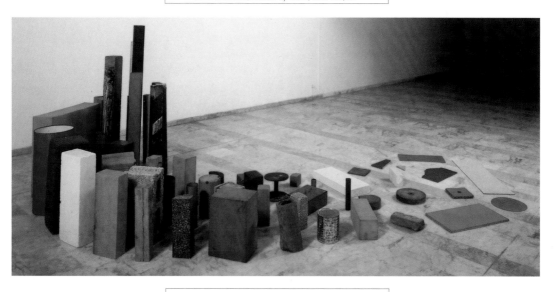

990. **Tony Cragg**, born 1949, English.
Opening Spiral, 1982. Mixed media, 152 x 260 x 366 cm.
Musée national d'art moderne,
Centre Georges Pompidou, Paris (France). Installation art.

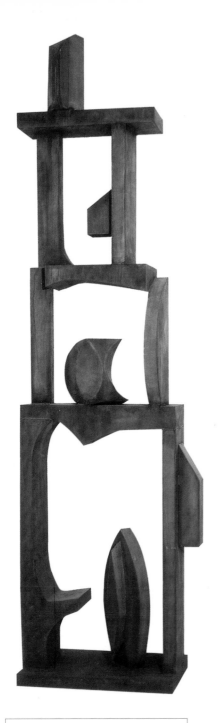

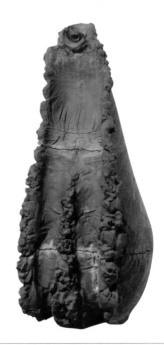

992. **Giuseppe Penone**, born 1947, Italian.
Soffio 6, 1978. Terracotta, 158 x 75 x 79 cm.
Musée national d'art moderne,
Centre Georges Pompidou, Paris (France). Arte Povera.

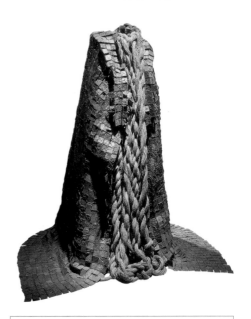

991. **Dorothy Dehner**, 1901-1994, American.
Scaffold, 1983. Fabricated Cor-Ten steel, h: 240 cm.
Twining Gallery, New York (United States). Abstract art.

993. **Barbara Chase-Riboud**, born 1939, American.
The Cape, 1973. Bronze, hemp, copper on base, 150 x 180 cm.
Lannan Foundation, Los Angeles (United States). Abstract art.

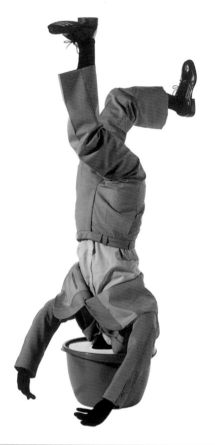

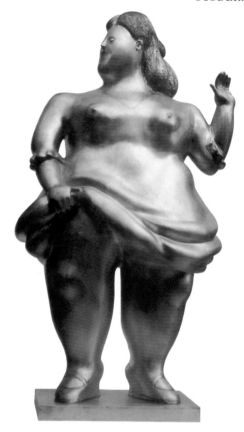

994. **Alain Séchas**, born 1955, French.
The Dummy, 1985. Rubber dummy, foam, clothes,
plastic basin and plaster, 185 x 130 x 76 cm.
Musée national d'art moderne, Centre Georges Pompidou, Paris (France).

995. **Fernando Botero**, born 1932, Colombian.
Woman, 1981. Bronze, 153 x 89 x 68 cm.
Private collection. Neo-Figurative art.

996. **Bruce Nauman**, born 1941, American.
Smoke Rings (Model for Underground Tunnels), 1979. White and green plaster
elements on wooden side pieces, diameter: 340 cm.
Musée national d'art moderne,
Centre Georges Pompidou, Paris (France). Installation art.

997. **Etienne Hajdu**, 1907-1996, French.
"Grandes Demoiselles", 1979-1982.
Bronze, 189 to 206 x 72 to 94 cm.
Musée national d'art moderne,
Centre Georges Pompidou, Paris (France). Abstract art.

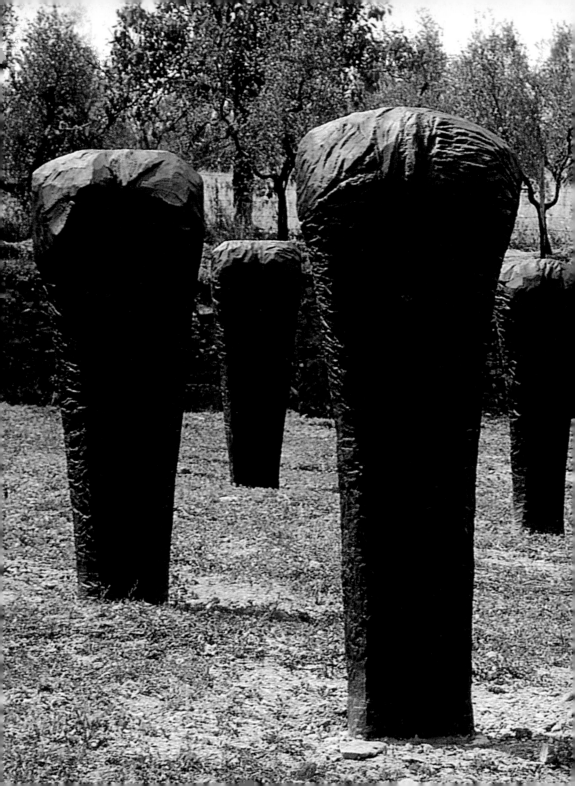

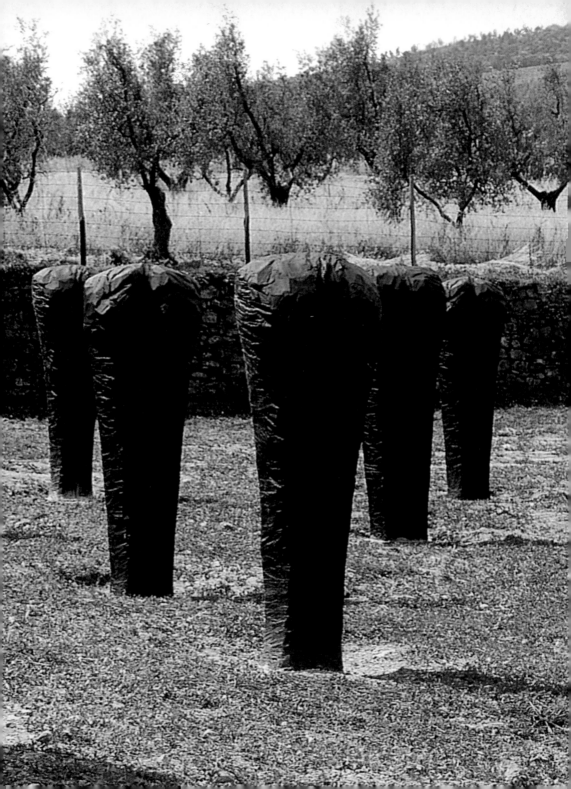

999. **Gina Pane**, 1939-1990, Italian.
Francis of Assisi Three Times with the Stigmata, 1985-1987.
Zinc-plated iron, iron, rust, frosted glass, 169.6 x 198 x 2.2 cm.
Musée national d'art moderne,
Centre Georges Pompidou, Paris (France). Performing art/Body art.

See previous page:
998. **Magdalena Abakanowicz**, born 1930, Polish.
Catharsis, 1985. Bronze, 33 figures, 270 x 100 x 50 cm each.
Giuliano Gori Collection, Fattoria di Celle, Pistoia (Italy). Abstract art. (*)

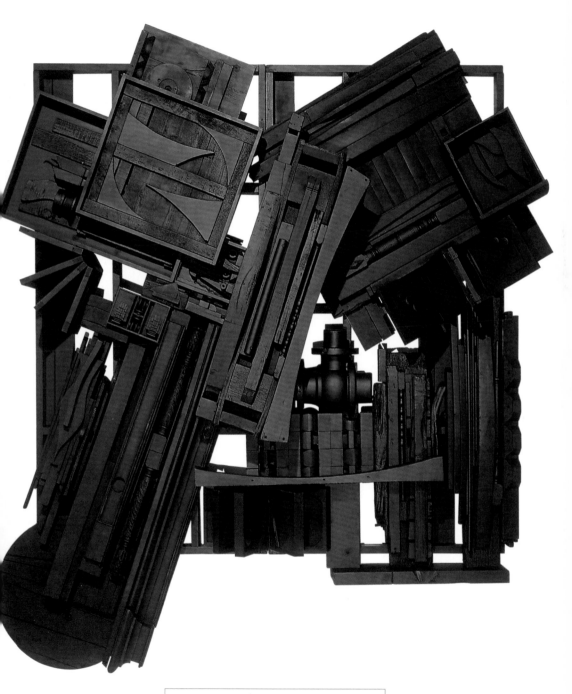

1000. **Louise Nevelson**, 1899-1988, Russian/American.
Reflected Shadow II, 1985. Painted wood, 300 x 360 cm.
Private collection. Abstract art/Expressionism.

MASTERWORKS COMMENTED

656. Edgar Degas, *Little Dancer Aged Fourteen.*

The unquestionable painter of dance, Edgar Degas created a sensation when he exhibited his *Little Dancer Aged Fourteen.* The young Marie van Goethem, *quadrille* at the Paris Opera, was his model. In the fourth position, her head up, her neck stretched to the extreme, the dancer is waiting, standing in a pose almost insolent. Nevertheless, it is more her ultra-real appearance than her pose that disturbed the public. Wearing a real pink tarlatan tutu, her hair tied up with a satin ribbon, her chest tightly enclosed in a rigid corset of bronze, like her ballet shoes, her skin is brownish in colour. Her tights are wrinkled at the knees, and in her hair, the ribbon, slightly untied, suggests she has been exercising. The public, used to white marble, was not confronted by a sculpture any more but by a genuine young girl, whose size, slightly smaller than life, is the only thing that reminds us that she is not real. It is precisely this extreme realism that disturbed the audience. The critic Huysmans considered this figure the "only modern attempt" in sculpture.

657. Umberto Boccioni, *Unique Forms of Continuity in Space.*

One of the most powerful monuments of early modernism, this is the signature piece of the Futurist movements. Like his fellow Futurists, Boccioni embraced the speed and dynamism, as they called of the machine age. They looked forward to industrialisation as capable of reviving the moribund society of Europe and Italy in particular. The Futurists were exposed by 1910 to the formal innovations of Cubism and saw that language as a means to express their enthusiasm, which bordered on nihilism, for the velocity of the machine age. Boccioni's figure embodies the new man, at one with this new world, powerfully striding through space. Like a Cubist painting, the sculpture is able to portray movement through space as the figure and the void around move together. With his chest thrown powerfully forward, the striding man seems to be a revision of the *Nike of Samothrace* (see no. 106), symbolising the triumph of technological man over both nature and the past.

658. Bertel Thorvaldsen, *Jason with the Golden Fleece.*

Under the direction of his father, a sculptor himself, Thorvaldsen began his art training at an early age and entered the Academy of Fine Arts in Copenhagen. Awarded the Academy's prize for his bas relief of *St Peter Healing a Lame Man*, he was sent to Rome in 1797. Thorvaldsen immediately dedicated himself to a meticulous and systematic study of the works of classical Antiquity. In Rome he was under the influence of his rival Canova, imitating him in the creation of his groups with mythological subjects, such as *Jason* (1803), *Amour and Psyche* (1804) or *Venus Victrix* (1805). This life-size statue of *Jason* could on its own stand for the art of Thorvaldsen. The virile and archaic figure is the image of his quest for the perfect Antique canon. The soldier turns his head to better underline the ideal line of his profile; his swaying posture highlights the contraction of his muscles and the curve of his inguinal triangle. The chisel of the Danish sculptor competes here with the art of the Antique sculptor Polykleitos.

660. Antonio Canova, *Pauline Bonaparte as Venus.*

Sister of Napoléon Bonaparte, Pauline was thirty-two when she posed for Canova. Widow at twenty-two of General Leclerc, victim of yellow fever, in 1803 she married Prince Camille Camille Borghese, heir to the noble Roman family. Pauline Borghese was one of the most beautiful women in Rome and led a free and independent life. The statue was commissioned by her husband, who wished to immortalise the beauty of his wife in the guise of Venus, holding in her hands the apple given to her by Paris. For his composition, Canova drew his inspiration from the *Venus* by the Antique sculptor Praxiteles. Reclining on a couch, the young woman is covered only by a sheet over her legs. The sensuality of the pose,

underlined by the finely-chiselled folds of the draped fabric and the noble posture of her head, give Pauline a timeless and majestic beauty. To highlight the shine of the marble even more, Canova coated it with a thin layer of slightly pink wax.

674. Antoine-Louis Barye, *Lion fighting a Serpent.*

"The bronze lion of M. Barye is as frightening as Nature. What vigour and what truth! This lion does roar, this snake does hiss." This comment by Alfred de Musset in front of the *Lion fighting a Serpent* remarkably defines the sculpture of Antoine-Louis Barye. An unquestioned master of animal sculpture to which he gives, for the first time, a real natural strength, the sculptor suspends this work in time. He fixes forever this crucial moment in the fight during which the opponents evaluate each other, each of them waiting for the first sign of weakness in the other. The muscles of the beasts are stretched in the extreme, and the tension of the scene is tangible. A perfect alchemy between Naturalism and Romanticism, this work, commissioned by King Louis-Philippe to decorate the gardens of the Tuileries, also appears as an allegory of monarchist power, the lion remaining its major symbol. And, like the king, whose accession to the throne followed the repression of the insurrection of the 'Three Glorious Days' (*Les Trois Glorieuses*) (July 1830), Barye's lion is going to master its prey.

676. Honoré Daumier, *Charles Philipon, Journalist, Creator and Newspaper Director.*

The unequalled caricaturist Honoré Daumier was censored and sent to prison several times under the July monarchy because of his unflattering representations of King Louis-Philippe published in the satirical and Republican journals of Charles Philipon, *La Caricature* and *Le Charivari*. It seems that it was at Philipon's request that Daumier undertook his series of terracotta busts known as *Members of Parliament*. Critical portraits of certain politicians, the artist's friends or Republican sympathisers, these busts in painted clay, including one of Philipon himself, qualified by the artist as a 'toothless laugher', were successfully exhibited in the window of the journal's offices. Sold to Philipon, then bought by his grandson, some of these works would be copied after having been restored and cast in bronze during the first half of the twentieth century. The originals are now at the Musée d'Orsay. In 2004, the French National Assembly bought thirty-two of the bronzes during a public sale.

679. François Rude, *La Marseillaise.*

To complete the decoration of the Arc de Triomphe in Paris, commissioned almost thirty years before by Napoléon, Thiers, Minister of King Louis-Philippe, asked François Rude to undertake a bas relief to decorate the right abutment of the monument. In the name of the king of the French and not that of the King of France, he chose the most patriotic subject, the French Revolution. Entitled *The Departure of the Volunteers* or *La Marseillaise*, the work shows, in the Romantic style as only Rude knew how, the departure of the patriots for the capital under the encouraging and benevolent protection of the figure of Victory. The artist's wife, here forever immortalised, gave her face to this allegoric representation, and the whole work is oriented around this powerful figure, her face distorted in exaltation. Vigorously holding her broadsword, she drags the combatants along with her and towards her, therefore becoming the symbolic figure of Romantic sculpture.

682. Auguste Clésinger, *Woman Bitten by a Snake.*

Commissioned by the Belgian financier Alfred Mosselman, Clésinger's *Woman Bitten by a Snake* provoked a scandal the Salon of 1847. This nude woman, meant to resemble Michelangelo's *Madonna*, but whose form is far too contemporary, was judged provoking because of its unashamedly sexual character. Beyond this eclecticism, the critic Théophile Gautier agreed with the public by suggesting the idea of a body cast; so this modern woman, with her well-endowed forms, was not a sculpture anymore but a genuine body.

However, paradoxically, the criticism made against Clésinger only increased his popularity and that of his work among a public who could not deny its irremediable attraction.

688. Charles Henri Joseph Cordier, *Negro of the Sudan*.

A student of François Rude, Charles Cordier occupies a specific place among the sculptors of the second half of the nineteenth century. For ethnographic purposes he undertook for the anthropology gallery of the Natural History Museum in Paris a series of busts to illustrate "the history of the races". He exhibited his *Negro of the Sudan* at the 1857 Salon, then at the Universal Exhibition of 1889. Mixing different coloured materials, his busts, particularly expressive, contrasted with the white marbles of the Salon. It was his encounter with Seid Enkess, a former black slave who became a model, which orientated the art of Cordier towards the representation of the diversity of peoples of the world. True portraits of human beings whom he sometimes met during his voyages, Cordier's busts show a quest both for realism and for aesthetics through the natural polychromy of the different marbles. Moreover, these pieces are the witnesses of a time which, thanks to archaeological digging, finally rediscovered polychrome sculpture.

691. Jean-Jacques Pradier (James Pradier), *Sappho*.

At the Salon des Artistes Français of 1852, Jean-Jacques Pradier exhibited this marble sculpture of *Sappho*. Despite the neoclassicism of its subject, Sappho being a lyric poet of the seventh century B.C.E., the representation created by the sculptor did not obey the rules of an Antique composition, but used a contemporary pose. Only her attributes, the lyre, added later, and her clothing, link the work to the neoclassical movement. Bought at the Salon by the State, the sculpture was first placed, at the request of Napoléon III, in the entrance hall of the Palais de Saint-Cloud before entering the sculpture department of the Louvre. Later it was installed at the Musée d'Orsay. A major work of the sculptor, it is linked to him forever: an exact copy can be seen on a bas relief on his grave in the Père-Lachaise cemetery in Paris.

692. François Rude, *Napoléon rising to Immortality*.

Captain Noisot, a former soldier of the Empire, having retired to Burgundy, commissioned a monument to the glory of his hero, whose ashes had been brought back from Saint-Helena in 1840. The title chosen for this tribute to the deposed emperor is, in addition to the workmanship of the piece, a true testimony to the Romantic movement, of which Rude is the greatest sculptor. It is in death that the artist chose to represent the awakening of the departed. Draped in a shroud, eyes closed and with a peaceful face, Napoléon seems to breathe his last breath in front of our eyes. A symbol of power, the eagle lying next to him accentuates the Romanticism of the work. Nevertheless, under a July monarchy that did not hesitate to use censorship, the features of the exiled emperor are rejuvenated to be closer to those of the General or of the First Consul Bonaparte.

697. Jean-Baptiste Carpeaux, *Ugolino*.

To create this group Jean-Baptiste Carpeaux found inspiration in his reading of *The Divine Comedy* by Dante. Combining the influence of various works he discovered during a visit to Rome, such as the Antique *Laocoön* (see no. 112) or *Damned* by Michelangelo, the sculptor presented to the academic jury of the Fine Arts School a sculpture far too modern for the time.

In a composition whose density is almost oppressive, Carpeaux represents Ugolino dell Gherardesca, the tyrant of Pisa, condemned to die of starvation after having devoured his children, at the exact moment when he makes his choice. His face is pulled about by the tensions caused by the horror of his situation. At his feet, his begging children transmit their despair to the viewer. The work of the sculptor is not moralistic or paternalistic; like the *Raft of the Medusa* by Géricault, it is a most arresting testimony of pure horror.

698. Jean-Baptiste Carpeaux, *The Dance*.

At the request of the architect Charles Garnier, Jean-Baptiste Carpeaux undertook in 1865 a high relief to decorate the right side of the new Opera House in Paris.

While the specifications showed a group of three or four figures, Carpeaux created a real dancing circle of six bacchantes, one faun, the figure of Love and that of Genius. In this work, so rightly entitled *The Dance*, the composition, largely inspired by *La Marseillaise* (see no. 679) by Rude, takes the viewer into the whirling movement of its figures, symbols of the pleasures of the Opera. However, the expressivity of the relief and the pleasure and the joy shown by these naked and moving figures bothered the public. Judged obscene, the sculpture was criticised by the Parisians and, in 1869, another group was commissioned from Charles Gumery to replace this work, by then seen as offending public decency. The War of 1870 prevented the achievement of the project and, on the death of Carpeaux, his work was considered differently by a public which finally saw it as wonderful proof of the sculptor's virtuosity. For preservation purposes the work was moved to the Louvre in 1964. *The Dance* now on the front of the Palais Garnier is a copy produced by the sculptor Paul Belmondo.

704. Jean-Louis-Ernest Meissonnier, *The Traveller in the Wind*.

A major academic painter of the nineteenth century, regularly exhibiting in the Salons and President of the National Society of Fine Arts, Jean-Louis Ernest Meissonnier is mainly renowned for his paintings. However, the artist was also a sculptor, notably creating models he used in the numerous battle scenes of his paintings. *The Traveller in the Wind* is a study for several paintings and drawings undertaken by the artist between 1878 and 1890. For this piece, a kind of 'model', Meissonnier mixed materials for better realism. To a basis of wax, the artist added black and greenish fabric to represent the cape of the traveller and the saddle, while the reins and the bit of the horse are made of leather and bronze. In Meissonnier's paintings, the anonymous *Traveller in the Wind* then becomes Napoléon during the Russian campaign, Marshal Ney or any other officer of the Empire in the storm. In this version, the sculpture presents itself only as a study; it would be cast in bronze to become a work in its own right.

706. Auguste Rodin, *The Thinker*.

A part of the *Gates of Hell* (see no. 723), *The Thinker* was situated at the centre of the lintel in the original project. Like his creator, be it Dante or Rodin, he was watching the degradation of the inferior world. His prominent muscles are tensed in the extreme and his concentration is highly visible. However, the *Gates of Hell* remaining uncompleted, *The Thinker* became, like most other sculptures, an independent work. Cast on a larger scale in 1902, it was exhibited at the Salon de la Société Nationale in 1904. The work was placed in front of the Panthéon on 21st April 1906 and became the first sculpture by Rodin to be erected in the French capital. In 1922 *The Thinker* was transferred to the gardens of the Hôtel Biron, former residence of the sculptor and transformed into the Rodin Museum in 1919.

723. Auguste Rodin, *The Gates of Hell*.

After the destruction of the Cour des Comptes in Paris in 1871, the Directorate of Fine Arts wanted to build in the same location a Decorative Arts Museum. On this occasion, the Directorate commissioned from Rodin, through a by-law on 16th August 1880, a monumental and decorative door. Inspired by the *The Divine Comedy* of Dante, Rodin started working on his *Gates of Hell*. In response to *The Gates of Paradise* by Lorenzo Ghiberti erected between 1425 and 1452 (see no. 346), Rodin planned to undertake his door with a number of panels, each of them illustrating an extract from the *Inferno*. As the project was evolving, however, this plan was abandoned for a profusion

of figures drowning in the torments of hell. Rodin did not exhibit his door at the Universal Exhibition in 1889 and the public would only see it in 1900 during the sculptor's one-man show. As the idea of a Decorative Arts Museum was abandoned, the gates were never in fact needed, but Rodin worked on his *Gates of Hell* throughout his life. From the characters invented for this work, Rodin created new independent works, *Ugolino* (see no. 697), *The Thinker* (see no. 706), *Paolo and Francesca* etc. *The Gates of Hell* therefore became the greatest testimony to the sculptural assembly that is characteristic of his work. Still uncompleted, this work of the great sculptor would be first cast in bronze in 1917.

724. Aimé-Jules Dalou, *The Triumph of the Republic*.

To celebrate the advent of the Third Republic and decorate the Place de la Nation, the City of Paris commissioned from Aimé-Jules Dalou a monumental bronze in 1880. In line with the new aspirations of Realism, the artist offered the public a truly educational work. Led by the genius of Liberty, on a chariot pulled by four powerful lions, the figure of the Republic stands up, victorious, on the globe. In her triumphant march she is attended by allegorical representations of Justice, Labour and Peace, while two children, symbols of the future, carry Education and Abundance. The model in plaster was installed in 1889 and the bronze was inaugurated ten years later. In this monumental work, made with a realistic workmanship that Dalou mastered better than any other artist, he summarised the aspirations of the Republic which the French longed for, and fixed them in the people's imaginations for ever.

725. Frédéric-Auguste Bartholdi, *The Statue of Liberty*.

While the Suez canal was being built in Egypt, Bartholdi was working on the monumental lighthouse of *Egypt enlightening Asia*. With this project going nowhere, the sculptor proposed a variant as the gift of France to the United States for the centenary of its independence.

In 1870, he created the first model of *The Statue of Liberty enlightening the World*, but the project lacked finance. Travelling to the United States to promote his idea and consolidate the Franco-American friendship, Bartholdi found in New York a suitable location for the realisation of his project. Back in France the plans raised technical issues, and to resolve them the sculptor worked in collaboration with Eugène Viollet-le-Duc and, later, Gustave Eiffel. But in 1876, with the torch completed, the work was far from being finished, and financial backing was still not assured. During the Universal Exhibition of 1878 Bartholdi unveiled the head of the statue and the following five years were dedicated to raising funds. *The Statue of Liberty* would finally be completed in 1884, being then transported to the United States on board the French frigate *Isère*. The inauguration took place in New York on 28th October 1886. Holding in her right hand the flame of Liberty and with the Declaration of Independence in her left hand, this monumental copper sculpture, more than ninety-two metres tall, stands on a pedestal as high as the statue itself. The first sight of the United States for arriving immigrants, it became a major symbol of liberty and of the United States itself.

729. Camille Claudel, *Auguste Rodin*.

In 1888 Camille Claudel created her portrait of Auguste Rodin. With a piercing and particularly expressive gaze, the master's face seems to emerge from the bronze in which it is cast. Like the figures that Rodin loved sculpting, untangling themselves from the blocks of marble, his beard totally merges with the base of the work, eliminating any idea of a pedestal. A true psychological portrait of the artist, notably in its strength, this bust of Rodin had a great success and added to the fame of the young artist in her early career. To meet the large number of orders up until 1905, several versions of the work were produced.

735. Constantin Meunier, *Industry*.

Painter and sculptor of the daily life of the Belgian worker, Constantin Meunier started working in 1890 on figures for the *Monument to Labour* in Brussels. The piece *Industry* conserved at the Musée d'Orsay is a study for the eponymous relief, destined to decorate one side of the monument. However the mound, to which the industrial Belgium of the nineteenth century gives its theme, would be erected only after the death of the sculptor by the architect Mario Knauer in 1930. It highlights five sculptures in the round and four bas reliefs sculpted by Meunier. The definitive version of *Industry* shows a group of eight men at work. The bronze from the Orsay corresponds to the detail of the two men who, in the foreground, maintain the wheel. Meunier treats his subject in a style combining Naturalism and the expertise of the nineteenth-century avant-garde. Struck by the difficulty of working conditions of the time, Meunier exalts here not only the physical but also spiritual strength of his subjects. Labour is idealised and the workers are seen as heroes, inspiring deep respect from the spectator.

736. Medardo Rosso, *Aetas Aurea* or *The Golden Age*.

An original artist, notably in his utilisation of wax, Medardo Rosso created his *Aetas Aurea* in 1886. Insisting more on the energy of his models than on the realism of form, the work of Rosso is in many aspects close to that of the Impressionists. The work, undertaken as a whole, was first cast in wax. This representation of the artist's wife kissing their young son plunges the viewer into a true moment of great intimacy. If the bodies are only suggested, the love expressed in this sculpture is perfectly tangible; emotion surpasses figuration. An evocation of motherly love, a recurring theme in the work of the artist, this sculpture, with the *Ecce Puer* (see no. 789) he created twenty years later, is one his major works.

742. Edgar Degas, *Arabesque Over the Right Leg, Right Hand Near the Ground, Left Arm Outstretched*.

In contrast to his *Little Dancer Aged Fourteen* (see no. 656), forever fixed in a waiting position, the series of *Dancers*, and notably the *Great Arabesque* that Degas undertook in the 1890s are an evocation of movement. With the true technical prowess that only bronze can offer to sculpture, these works seem to be posing for one of the paintings by the artist. Shown naked, the figures are often only drafted, the modelled heads remaining faceless. The treatment of the work is rough, only the gesture, the position of the arms, the legs or the hips being important. After the scandal he provoked in 1879, Degas does not try here to transcribe the realism of a body anymore, but the essence of dance itself, a theme forever linked to his work.

750. Pierre-Felix Masseau, dit Fix-Masseau, *Secret*.

In 1894 the Lyon artist Pierre-Felix Masseau exhibited his *Secret* at the Salon de la Société Nationale des Beaux-Arts. Representing a naked woman, draped in a long veil falling to the ground and presenting to the public a mysterious little box, the title given to this work could not have been better chosen. Acquired at the Salon by the Department of Fine Arts, a body dedicated to the purchase of works by living artists, this sculpture would also be exhibited at the Universal Exhibition of 1900. By choosing mahogany, a particularly colourful wood, to undertake this sculpture, Masseau only increased its mystery, while the polychromy due to the contrast between the ivory of the casket, the body and the green tone of the veil gives even more realism to the piece. A true enigma for the viewer, the *Secret* is undeniably one of the most beautiful works undertaken by Masseau, whose strength makes us forget it is only a statuette and gives it the feeling of a life-size sculpture.

752. Paul Gauguin, *Idol with a Shell*.

Escaping from the West and its civilisation, Paul Gauguin moved to Tahiti in 1891 and, inspired by the landscapes and the people he met, started creating his exotic works. Integrating the culture of these foreign civilisations

with which he merged, Gauguin would undertake several paintings and sculptures in wood. Tinged with deep mysticism and determined to rediscover the origins of the world, he often tries to represent in his works the traces of local beliefs. Inspired by *Travels to the Islands of the Pacific Ocean* by Moerenhout, he composed his *Idol with a Shell*. Representing the supreme god in the Polynesian pantheon, Taaroa, the artist, by syncretism, associates it with Hindu divinities by showing Taaroa in the position of Buddha, while the pearly shell that overhangs the work is the symbol of the Earth he created. With its pure form but fancy details, this statuette constitutes today one of the most beautiful testimonies to the sculpture that Gauguin liked to qualify as "ultra wild".

755. Antoine Bourdelle, *The Great Warrior of Montauban*.

In April 1895 Antoine Bourdelle won the competition launched for the building of the *Monument to the Warriors of 1870* in Montauban, his native town. For this work the artist undertook multiple studies which he assembled in various compositions, and went beyond the academicism in his subject with a fiery use of the material. The massiveness and the concentration of forms, praised by Rodin, give the work its strength and expressivity. One of these studies, *The Great Warrior of Montauban* represents a young man whose elbow is folded behind his head brandishing a sword, while he seems to fight off an invisible enemy with his robust left hand. The body is powerful, the bronze vibrates under the hand of the master and the hand of the warrior itself is a masterpiece. The monument was cast in 1901 and inaugurated the following year. As in Rodin's work, Bourdelle's studies are rightly considered independent pieces.

758. Emmanuel Fremiet, *St Michael slaying the Dragon*.

This statue depicts the battle between the archangel St Michael and the dragon. According to the book of Revelation in the New Testament, St Michael and the other angels fought with the dragon and his angels. The dragon, a symbol of Satan, lost, and the rebel angels were banished to Hell. The story is seen as an allegory of the triumph of Christianity over evil, or of the new faith replacing the old.

760. Auguste Rodin, *Monument to Balzac*.

Since the death of Balzac in 1851, the Société des Gens de Lettres had wanted to have a monument erected in his honour. The project was first commissioned from Chapu, but he died before completing it. The idea of the monument would finally be resurrected at the end of the century and commissioned, through Zola, from Auguste Rodin. In 1891, the sculptor was working on a *Balzac in a Frock Coat*, then, using the composition of his *Walking Man* (see no. 772), on a *Walking Balzac*. Five years later Rodin represented the writer naked and standing, and it was by draping this work that the sculptor obtained its definitive version. But Rodin's message was not understood, and the work, seen as a "menhir", was refused by the commissioners. Beyond any Realism, and announcing what Impressionism in sculpture would be, Rodin created here a monument to Balzac's spirit. A monumental piece for a monument to French literature, the massiveness of the sculpture therefore became an echo of the strength of Balzac's work.

761. Augustus Saint-Gaudens, *General William Tecumseh Sherman Monument*.

General Tecumseh Sherman was a hero of the American Civil War, defeating the Confederacy in his Great March to the Sea. In this monument to General Tecumseh Sherman, the artist Augustus Saint-Gaudens brought realism to the piece by first sculpting a portrait bust of the General from life, capturing every detail of his face. He used that bust as a model for the statue. The result is a life-like image of the General, who rides a powerful horse. The strength and vitality of the horse and rider is matched by a dynamism and energy, thanks to the windswept drapery of the winged figure that precedes

them, an allegory of Victory. The statue group was placed at Fifth Avenue and 59th Street in Manhattan, at the south end of Central Park, in 1903. It is thought that it was originally gilded with a bright gold, and that it how it has been recently restored.

765. Antoine Bourdelle, *Bust of Beethoven*.

Antoine Bourdelle created many portraits of Beethoven during his career, including busts, paintings, masks, and figurines. This bust shows the composer as emerging from the roughly-hewn stone, the smooth shape of his face contrasting with the rougher contours of the stone. At the same time, however, his face echoes the form of the stone, his eyes, nose, cheeks and chin appearing swollen and slightly misshapen. The artist often added a quote by Beethoven to his portraits, tying the composer's image to his ideas. Beethoven was much admired at the time, and in his portraits of the composer, Bourdelle sought to portray the strength and heroism of the man, rather than simply a realistic rendering of his appearance.

766. George Minne, *Kneeling Youth at the Fountain*.

George Minne was a Belgian sculptor working in the late nineteenth and early twentieth centuries. He was associated with the Symbolist movement in Europe, concerned with the experience and deeper meaning of what could be seen on the surface. In pursuit of this deeper truth, he created figures out of simple, almost abstracted shapes, but imbued them with strong emotion. His sculptures have a mournful, even injured feeling. He created several versions of kneeling figures, such as this one. The kneeling pose adds a spiritual dimension to the figure.

768. Aristide Maillol, *Bather* or *The Wave*.

In a letter to Antoine Bourdelle, Aristide Maillol, who began as a painter, wrote: "I'm making studies of the sea. It feels very strange to paint the sea; one never knows which colours it is." Achieving a brilliant result in a canvas named *The Wave*, now in the Museum of the Petit Palais in Paris, the artist also used this theme in his sculpted work. If Maillol is mainly known for his sculptures in the round, he also sporadically undertook sculptures in high relief such as the plaster entitled *The Wave* or the *Bather* now at the Musée d'Orsay. Cast of a ceramic piece now lost, the work uses rounded lines, inspired by Art Nouveau and characteristic of other work of the sculptor, while, by choosing to make a relief of this theme, the artist illustrates the perfect transition between his painted *Wave* and his *Bathers* of the Jardins du Carousel.

776. Louis-Ernest Barrias, *Nature Unveiling Herself to Science*.

In this life-size marble statue, an image of a woman removing her cloak symbolises Nature revealing herself to Science. At once erotic and allegorical, the piece is a commentary on the promise of nature, and the ability of science to discern truth. The figure has not removed her veil entirely, she only reveals part of herself. Barrias thus poses a symbolic question with the piece, asking if science will be able to understand nature. Barrias used a neoclassical style for the figure, which has a softly modelled face and a round, full body. The smooth, white marble of her body contrasts with the richly-toned stone of her patterned veil.

778. Camille Claudel, *The Age of Maturity*.

In 1893 Camille Claudel created a first plaster version of *The Age of Maturity*. In this initial version, the man torn between old age and youth still holds the hand of the young implorer, which was different in the definitive version. As in the teachings of Rodin, *The Implorer*, *God flown away* or *Clotho*, earlier works of Camille Claudel lend their features and forms to the representations of Youth and Old Age. With this oblique composition that stresses the imbalance of the work, Camille Claudel produced an autobiographical sculpture. Illustrating the abandonment of the young woman by her master and lover, Auguste Rodin, her brother, the poet Paul

Claudel, who would however always support her, said about this work: "Imploring, humiliated, on her knees, her so superb, so proud, it is how she has represented herself. Imploring, humiliated, on her knees, and naked! Everything is over! It is this and forever that she leaves us to look at!" Nevertheless, Camille Claudel created here one of her most beautiful works, in the pain she transmits so well to the bronze, striking the spectator anew at every viewing.

781. Boleslas Biegas, *The Sphinx.*

Biegas, a Polish artist of the Symbolist school, created this image as a ideational representation of the mystical sphinx. Instead of representing a sphinx as it would actually appear, Biegas suggests the idea of a sphinx, showing a human face with a slightly leonine appearance, in a contemplative pose, chin resting on interlaced fingers. The furrowed brow suggests a challenge, perhaps an illusion to the riddles with which the sphinx would challenge men. The deeply carved eyes stand in contrast to the low relief of the hands, and underscore the psychological element of the piece. In this piece, Biegas combines the curved lines of the Art Nouveau style with a symbolic primitivism.

783. André Derain, *Standing Nude.*

As a member of the Fauvist group in Paris, Derain sought to dispense with rules and conventional approaches to composition in favour of a hitherto-unknown directness of emotional expression. Like a number of artists in the first decade of the twentieth century, Derain also looked to primitive art as a source for this immediacy of feeling. In the *Standing Nude*, Derain reveals a certain classical impulse, using the traditional form of the female nude, conceived here as a monumental form. Derain eliminates classical perspective, however, and exaggerates the *contrapposto* to create a set of flowing curves that take precedence over any anatomical concerns. These curves also provide a sense of movement and primal energy that is typical of the youthful spirit of Fauvism, which took its name from the French term for a "wild beast". The movement was primarily associated with painting, and the frontal quality of the *Standing Nude* suggests a certain pictorial conception of the relief sculpture.

785. Antoine Bourdelle, *Heracles the Archer.*

The Greek hero Heracles had to perform twelve labours for Eurystheus, the King of Tiryns and Mycenae, as penance for having killed his family in a state of temporary insanity. His sixth labour is depicted in this statue. For that task, Heracles had to drive away a large flock of birds that had taken up residence at a lake deep in the woods. The birds, known as the Stymphalian birds after the nearby town of Stymphalos, were vicious and intractable. Heracles was only able to complete the task with Athena's help. The goddess gave him castanet-like clappers made by the god Hephaistos. Heracles used these to startle the birds into flight, then shot them down, one by one, with a bow and arrow. In this statue, Heracles is shown with the bow, poised to shoot a bird. His super-human strength is illustrated through the tense, bulging muscles that strain against the bow and the rock on which he anchors himself. Like the vase painters of the Archaic age in Greece, Bourdelle has chosen to show the pregnant moment before the action. The outcome is known, of course – Heracles will successfully shoot the birds and complete the task. But in this moment, all outcomes are still possible, and the tension and anticipation are at their height.

788. Paul Troubetzkoy, *Count Robert de Montesquiou.*

Paul Troubetzkoy was a prince, the son of a Russian nobleman. He is best known for his small bronze portraits. The sketchy, unfinished appearance of his work links him to the Impressionist school. This portrait is of Count Robert de Montesquiou, a vain dandy who loved to have his portrait done. Known for his carefully staged appearance, elaborate outfits, and desire to be always at the centre of attention, Montesquiou was the inspiration for several fictional

characters, including Marcel Proust's Baron de Charlus in his *Remembrance of Things Past*. His highly-styled appearance is portrayed in this bronze portrait, which shows his elaborate costume, careful hairstyle, and directorial gesture, commanding the attention and action of all those around him.

789. Medardo Rosso, *Ecce Puer: A Portrait of Alfred Mond at the Age of Six.*

Like Impressionist painters, Medardo Rosso sought to capture the illusive qualities of light and atmosphere, not in paint, but in the more challenging media of stone, wax, and plaster. In this piece, his last work, Rosso depicts a young boy, Alfred Mond, as he appeared for an instant in a quick glimpse. Hence the title, *Ecce Puer*, or "Behold the Boy." The acts of looking, seeing, and remembering are materialised in the portrait. Rosso does not attempt to recreate a physical account of the boy's appearance, instead he constructs a representation of the figure fused with the transitory moment in which he was sighted.

790. Otto Gutfreund, *Father III.*

The Czech sculptor Gutfreund was a student of Bourdelle but worked more in the Expressionist and Cubist styles, influenced especially by Picasso. He produced Cubist sketches in ink, pencil and crayon, but is best known for his bronze sculpture. In this example, the face of a man is presented as warped and abstracted. The principles of Cubism, in which forms are dissected, taken apart, and reassembled in an analytical way, have been applied here, although the work represents Gutfreund's later, more expressionist work. Thus, instead of cubic forms, the face retains its naturalistic contours. Those contours, however, have been exaggerated to express the emotionality of the subject.

792. Constantin Brancusi, *The Kiss.*

A vital member of the early twentieth-century avant-garde, the Romanian Brancusi stands apart from so many of his radical peers for his ongoing faith in an organic, healing conception of art. Ever simplifying his forms into a set of elemental shapes, Brancusi sought to connect his work to the natural world, and so to reintegrate humans with their spiritual essence and themselves. In *The Kiss* we already see Brancusi sharing the primitivising impulse of artists like Picasso, creating a form that seems to mimic some of the static monumentality of archaic sculpture. But whereas Picasso's citations of archaic and non-Western art created a heightened sense of the alienation of modern existence, Brancusi uses it to express profound connection between Self and Other. Far from any anecdotal expression of bourgeois sentimentality, *The Kiss* is a statement of profound faith in the plenitude of pure human emotion.

798. Wilhelm Lehmbruck, *Kneeling Woman.*

Though he associated with the spiritual goals and drive to go beyond naturalism that characterises German Expressionism, his work is characterised by a greater delicacy and focus on silhouette. While the form of the woman is pronounced, the body has become elongated and attenuated in manner that would be typical of Lehmbruck's work for the rest of his life. Deeply aware of the compositional possibilities of lines, Lehmbruck's works are surprisingly complex and often reveal very different characters and formal dynamics when viewed from different angles. As often, there is little anecdotal information here, and the artist instead focus on the interior spirituality suggested by the down-turned angle of the head, the raised arm and hand and the posture of kneeling. Indeed, Lehmbruck acknowledged the source of this pose in the imagery of the kneeling Madonna, her pressed into service to suggest a more universal sense of meditation.

799. Frantz Metzner, *The Sorrow Carrier (Der Leidtragende).*

Metzner was trained as a stone cutter with Christian Behrens. Working in Vienna in 1903 he became associated with the developing Vienna Secession, or *Jugendstil* movement, which sought to bring crafts, decoration and

architecture together in works that would bridge the divide between nature and man in the modern world, creating all-encompassing artistic environments. Many of Metzner's sculptures were executed for inclusion in architectural and interior design schemes. In this case, the universal nature of the subject and lack of anecdotal detail tie Metzner to the developing Expressionist movement. Metzner remains tied to a smoothness of surface that is closer to the *Jugendstil* aesthetic, but his focus on a powerfully massed, central point to Expressionism. The overall theme is also typical of the northern focus on *sturm-und-drang*, or storm and stress, which expresses a sense of anguish about humankind's position in the world.

805. Henri Matisse, *The Back II.*

Although he never conceived of them as a series, Matisse did a series of *Backs* between 1909 and 1931, moving away from detailed perceptions of a specific body into ever-greater generalisation of a monumental form in this, the second of the series. As a modernist, Matisse was interested in creating visual expression without recourse to story or narrative. By turning the figure away from the viewer, Matisse has no recourse to facial expression and must rely instead on the interaction of the lines and masses of the body. Choosing to work in relief, Matisse here challenges himself, as he would do in painting to adapt his figure to the shape of the support, carefully balancing its proportions and lines against the rectangular background. Created from the same cast as the first in the series, this version shows Matisse concentrating on the monumentality of the increasingly blocky figure and resolving the complexity of the body into a few simple curves.

810. Jacob Epstein, *The Rock Drill.*

Born in the United States, Jacob Epstein moved to Europe in his early twenties and became a pioneering figure in the development of modern sculpture in Britain. In *The Rock Drill*, one of his most well-known works, Epstein treats the theme of the mechanisation of modern life. Associated with the short-lived movement of Vorticism, Epstein shared a general early twentieth-century fascination with the speed and dynamism of the industrial age. Looking off to the side like an industrial version of Michelangelo's *David* (see no. 420), Epstein's figure is a symbol of the new age, evoking as Epstein described it, "the terrible Frankenstein's monster we have made ourselves into." Originally set atop an actual rock drill, Epstein removed it from this base after World War I, stripping the figure of some of its destructive power.

812. Vladimir Baranoff-Rossiné, *Symphony No. 1.*

A Ukrainian artist, educated in Moscow, Vladimir Baranoff-Rossiné moved to Paris in 1910 at precisely the moment when the Cubist movement was transforming the very basis of Western art. *Symphony No. 1* is indicative of his immersion in that *avant-garde*. In the first place the sculptural form is opened to the space around it, as in a Cubist painting, suggesting the duration of vision and movement. Reacting specifically to Synthetic Cubism, Baranoff-Rossiné creates his form in additive process, and with the use of ordinary, found materials like cardboard and eggshells. Typically these materials both announce themselves for what they are and serve a representative function, forming the various parts of the figure. One would be mistaken to attribute too much representative function to the sculpture, however, since based on the title we should focus more on the formal interaction of the parts, than what they may depict. The title also points to Baranoff-Rossiné's familiarity with the music of Russian composers who were also a part of this milieu like Igor Stravinsky.

813. Raymond Duchamp-Villon, *The Major Horse.*

Like his well-known brother Marcel Duchamp, Raymond Duchamp-Villon emerged from the Cubist movement in Paris in the early years of the twentieth century. In particular he was able to bring the Cubist approach to space and form, so geared to the contradictions of the two-dimensional medium of painting, into play in sculptural form, a medium in which he was essentially

self-taught. *The Major Horse*, however, reveals the extent of Duchamp-Villon's technical skill as the complex forms twist and turn and fold back on each other with extraordinary complexity. Here the solid mass of the form seems to have blown apart. The Cubists were reacting to the changes brought about by modern technology and modern philosophy in which the unitary status of the body had been in question. While parts of the animal are recognisable here, the bodily unity of the horse is undermined as it is caught in a moment that suggests movement and dynamism.

817. Jacques Lipschitz, *Man with a Guitar.*

Sculptors, like Jacques Lipschitz, who were captivated by the revolutionary innovations of the Cubism of Pablo Picasso and Georges Braque, were faced with a particular challenge. Cubism's critique of Western traditions of illusionism were based on teasing out the tension between the two-dimensional nature of the medium and its task of representing a three-dimensional world. In *Man with a Guitar*, Lipschitz manages to introduce the spatial ambiguities of Cubist paintings, opening the form up to space so that form and void interpenetrate to suggest movement through space and time. Lipschitz's subject is a typically mundane Cubist one and his use of grey stone mimics the muted colour scheme of so much Cubist painting. Perhaps the most wonderful aspect of Lipschitz's work, however, is that he maintains the three-dimensional status of sculpture, working in the round rather than reducing sculpture to a relief to imitate the effects of painting.

818. Amadeo Modigliani, *Head.*

While he is largely known as a painter, sculpture was a primary concern for Amadeo Modigliani. In both painting and sculpture, however, his chief subject was the human head and body. Like so many other members of the early twentieth-century Parisian *avant-garde*, Modigliani was fascinated by the primitivism of tribal African sculptures and masks, incorporating here its stylised, geometric features. Just as primitivism was a means for artists to bypass what they viewed as the corrupted sophistication of Western art, so too, did Modigliani eschewed the malleability of making casts in the Western tradition, as exemplified by Auguste Rodin. As Brancusi had in these years, Modigliani preferred to carve directly in stone, which he took to be a more purely artistic activity, with greater spiritual immediacy.

824. James Earle Fraser, *End of the Trail.*

James Earle Fraser was a child of the American West. Raised in South Dakota and son to a railroad engineer, Fraser saw first hand the expansion of the United States and the resulting displacement of Native Americans. He began his career working on architectural sculpture at the Chicago World's Fair, conceived as an homage to Neoclassicism. That classicising style informed his later work, which was imbued with the realism and plasticity of form of the classical ideal. His subject matter, however, was purely American. In this, his most famous piece, the artist portrays a trail-weary Native American on an equally exhausted horse. The horse and rider have not only reached the end of the trail, but the end of a way of life for the American Indian. Defeated and despairing, the horse and rider hang their heads. The rider's arms have fallen limp, his spear has dropped from his grasp. The dynamic, impressionistic depiction of the horse's mane and tail, and of the rider's garment, add energy to the otherwise forlorn work.

826. Marcel Duchamp, *Fountain.*

Fountain, a ceramic urinal purchased from a hardware store, is the object Duchamp exhibited in a vast New York exhibition he had been instrumental in setting up in 1917. A major motivation underlying this show was democratic access (all the thousands of works submitted to it were automatically displayed), and this at a time when democracy was very much in the news because of impending American entry into World War I. Ultimately Duchamp's wittily-titled pisspot made a wholly valid point about

shared human activity, for all people everywhere have need of urinals from time-to-time. According to Duchamp (or initially at least), a major reason he had chosen to exhibit such an article was to raise it to the status of an art-object by forcing us to recognise the inherent beauty of a mass-produced artefact which normally provokes no aesthetic response whatsoever. Ultimately Duchamp's *Fountain*, like his other "ready-made", completely broke down the distinction between the work of art as crafted object and the work of art as mass-produced artefact. In doing so it necessarily democratised the entire notion of being an artist, for by means of the selfsame process by which a urinal became *Fountain* – "it is a work of art simply because I proclaim it to be such".

827. Sophie Taeuber-Arp, *Head (Dada Head).*

The wife of artist Hans Arp, Sophie Taeuber-Arp was a major figure in radical art circles in the first half of the twentieth century. Taeuber-Arp participated in the Zürich Dada movement. An international phenomenon, Dada reacted to the horror and destruction of World War I by preaching the value of the absurd and the nonsensical in a world where reason seemed to have led only to destruction and chaos. The word Dada was essentially nonsense: in Russian it was a repeated "yes, yes," in French it is a term for a child's horse and the artists certainly valued this international quality. But even more importantly Dada suggests a kind of pre-lingual utterance, something uncorrupted by reason and science. The *Dada Head*, therefore must stand as a kind of counterpoint to the traditional portrait bust. Instead of a face, Taeuber-Arp used abstract designs. The lyrical flowing quality, as well as the saturated colour, may stem from Taeuber-Arp's interest in textiles and decorative arts. The *Dada Head* then also reads as a kind of manifesto for a new head that will perceive the world in terms of artistic vision.

828. Raoul Haussmann, *Mechanical Head (The Spirit of Our Age).*

A key member of the Dada movement in Berlin, Raoul Haussmann's work sought to undermine the rational basis of Western art as a part of a broader critique of society. In particular, Haussmann often critiqued the elevated pretensions of "high" art by incorporating found elements from everyday life to create surprising and politically challenging new meanings. Here Haussmann brings the aesthetic of this "photomontage" method, which he claimed to have invented, to sculpture. The head is a simple artist's dummy to which he has attached various found materials including a ruler and dials. Haussmann here comments on the mental emptiness of the modern bourgeoisie, unable to see or hear; the modern rational man has become an automaton here, guided only by the tools of technology that have been affixed to him. The cup at the top of the head is a kind of funnel through which anything may be poured to fill the empty brain.

835. Vladimir Tatlin, *Model for the Monument to the Third International.*

Tatlin's model for a monument to communism that would have been over 450 m – dwarfing the Eiffel Tower – the West's monument to capitalism, captures all of the frenzied optimism of the first years after the Bolshevik Revolution, in which it was hoped art could play an active role in redefining society. The monument, which could never have been built at the time, was meant to express the dynamism of the Communist Revolution and link its material connection to the people with its highest utopian aspirations. Its intended steel superstructure would have spiralled into the sky with a set of sweeping curves that were also made reference to the masts of a ship. Inside, the tower housed four cylinders that turned at different rates, according to their function. The lowest for instance, turned at the rate of one revolution per year and was to house annual meetings of a legislative body. The highest was a telegraph station that would revolve once a day and broadcast the message of the Revolution through the air.

838. François Pompon, *Polar Bear.*

Pompon's majestic *Polar Bear* is universally appealing, an image of natural strength and beauty. Although Pompon was an assistant to the sculptor Rodin, known for his emotional realism, Pompon does not employ that realism to portray the creature's strength. The artist does not present a detailed depiction of the muscled anatomy, nor a craggy, textured fur coat. Instead, the form is simplified, the details sparse. The large scale of the sculpture, as well as the massive paws, long stride, and piercing expression suggest the power of the animal. The highly-polished surface of the stone reflects light, and the resulting play of colour, shadow, and reflection add vitality to the spare form.

841. Rudolf Belling, *Sculpture 23.*

Rudolf Belling was a major proponent of modernism in Germany and is credited with producing the first completely abstract sculpture in that country in 1919. *Sculpture 23* reveals Belling's sophisticated incorporation of the principles of Cubism and Futurism. The head is created by the combination of a different geometric forms, each of which has a machine-like precision and efficiency. Radically, Belling allows part of the head to be a void, pointing to his association with the developments in both modern sculpture and architecture in which the artist does not so much build form as define volumes of space. Always active in organising and helping to spread modernism in the German-speaking countries, Belling was labelled a "degenerate" artist by the Nazi regime, and first forced out of his teaching position, and finally into exile.

842. Ernst Barlach, *The Singing Man.*

Ernst Barlach was associated with the Expressionist movement in Germany, which sought to restore to art its spiritual function, often by employing the materials and methods of artisan traditions. While Barlach courted this image of the artist/worker, and even playfully referred to himself as a "barbarian," he was also astonishingly well read and knowledgeable about the history and philosophy of art. As did many of the Expressionists, Barlach chose to work in the traditional craft material of wood. Barlach's figures appropriately are meant to stand for larger aspects of the human experience and spirituality, suggested here by the closed eyes and the rocking motion implied by the figure's posture. While the work has the direct emotional impact typical of Expressionism, there is also a delicacy to his work that is visible in the smooth surface and gentle curves that dominate this work.

843. Ossip Zadkine, *Musicians.*

Zadkine came to France in 1909 and like a number of young Russians, including Alexander Archipenko and Marc Chagall, was attracted to the developing Cubist movement. *Musicians* treats a common theme of Cubism: a single or group of figures with instruments, and he may in part be reprising Picasso's famous paintings of *Three Musicians* from earlier in the decade. By placing the musicians on a sharp diagonal, Zadkine gives the composition a dynamism difficult to achieve in the static medium of cast bronze. He adds to this by creating a complex play of light and dark by means of varying the convexity and concavity of the forms, in typical Cubist fashion. All of these give the group a sense of light, counterpoised rhythm that seems to stem from the very music they are producing. The generalised features of the figures and use of fragmentary elements to comprise the whole also reveals a sophisticated incorporation of Cubist logic.

846. Constantin Brancusi, *Bird in Space.*

Coming from a peasant village in Romania, Brancusi celebrated the natural metaphors of folk art in a language of high modernist form. Birds had been a constant source of interest for Brancusi for most of his life, as their ability to soar into the air stood for humankind's spiritual and bodily aspirations. On the one hand Brancusi seems to work like Michelangelo, seeking out the pure Platonic form that lies within the material, eliminating all extraneous details. The narrow form seems in no way to reference the form of

a bird in flight but merely the very idea of flight and all the metaphysical associations it carries. On the other hand, Brancusi had an abiding love of surface. For *Bird in Space* he polished the brass to high glow, as if the form came from another, more perfect world or spiritual plane.

848. Jacques Lipschitz, *Figure*.

As one of the primary sculptors associated with Cubist movement, Jacques Lipschitz opens the vertical form of the sculpture here, allowing void and negative space to play a primary role in visual effect. As Pablo Picasso had also done, Lipschitz here clearly works from the example of African sculptures which had become known in the West in the early years of the twentieth century. Lipschitz thus stylises the features into simple geometric shapes, which lends a totemic quality to the figure. He also creates a formal play between the convex and the concave, as the sculptor reverse the expected relationships between face, eyes and nose. By this means Lipschitz wonderfully incorporates the two-dimensional effects of Cubist painting, while retaining a vivid sense of the sculpture as an object in three-dimensional space.

849. Antoine Pevsner, *Mask*.

Along with Naum Gabo, Antoine Pevsner helped bring the *avant-garde* ideas of Cubism into post-Revolutionary Russia. In the immediate aftermath of the Bolshevik revolution radical art flourished in Russia, bolstered by a sense of optimism about the new Communist world and a belief in art's desire to create that world. Adapting the formal innovations to the Russian *avant-garde* concern for bringing out the inherent structural and visual properties of industrial materials, Pevsner's series of masks and heads brought an unprecedented sense of openness to sculpture. Here the sculpture is defined not by its form but the space created by the interpenetrating planes. Updating the traditional form of the Orthodox religious icon, Pevsner's heads seem to be in motion, monuments perhaps to a brief moment of optimism about the possibility of a new, dynamic form of society.

852. Katarzyna Kobro, *Spatial Sculpture*.

Born in Poland, Katarzyna Kobro came to Moscow to study sculpture in 1915 and was there when the Bolshevik Revolution took place. In the heady days after the Revolution *avant-garde* art flourished in Russia and Kobro was in close contact with Kasimir Malevich, the innovator of Suprematism, and El Lissitsky and Vladimir Tatlin who adapted the formal innovations to social utility in the Constructivist movement. After working with these artists in the burgeoning artistic communities of Smolensk and Vitebsk, Kobro and husband Wodzimierz Strzemiński, a painter, were forced to flee for Western Europe when official Communist policy turned against modernism. Back in Poland Kobro was central in promoting modernism through groups like "Blok," and "a.r." As the title indicates, in *Spatial Structure*, Kobro elaborates her theory that sculpture is an art of defining space rather than form. Her abstractions in these years were often based on a precise set of arithmetic relationships.

855. Pablo Picasso, *Figure*, project for a monument to Apollinaire.

In this work of the 1920s, Picasso revisits the geometric conception of the figure from his Cubist years. As in a Cubist painting, the figure is indicated here only by a roughly centralised triangular form. Radically opening sculpture to space, rather than conceiving of it as solid form, Picasso allows the figure to interpenetrate with the lines of the space surrounding it. While the late 1920s were the years of Picasso's greatest affiliation with the psychological dynamism of Surrealism, this piece is coolly formal, indicative of the extraordinary range of modes in which Picasso was capable of working at any one time. Here he focuses on the complex formal relationships created by the interpenetration of lines and planes. The sculpture is likely related to a elaborate series of works Picasso did in this period around the theme of the artist's studio.

859. Gertrude Vanderbilt Whitney, *Women's Titanic Memorial*.

Located in South-West Washington, D.C., Whitney's monument to the *Titanic*, which sank during her maiden voyage on 15 April 1912, takes the form of the Christian imagery. With its arms spread the figure, of course, makes reference to the sacrifice of Christ, a tribute to the many acts of heroism that took place during the sinking. The form also appears poised to take flight, however, suggestive of both the soul leaving its bodily prison and Christ rebirth in spiritual form. As iconic as the central form is, Whitney provides a sense of gentle movement, perhaps like that of a ship cutting through the wind, by twisting the drapery into soft spirals. With its arms thrown out and chest forward, the figure also evokes the *Nike of Samothrace* (see no. 106), providing an additional level of resonance.

861. Emmanuel Radnitszky, called **Man Ray**, *Restored Venus*.

Man Ray was a key innovator in the international Surrealist movement. In this typically subversive work, Man Ray transforms a familiar image of Western art and reinvests it not only with eroticism, but a sense of Freud ambivalence. The armless torso of the Venus de Milo is of course a cherished representation of the goddess of chastity and love. But Man Ray wraps her in cord, making it appear that this hasty "restoration" is all that holds her together. Seeming to return her to her pure form, Man Ray of course draws attention to the fallen state of humankind, when its idols are in danger of falling apart. The Surrealists were well-versed in Freudian theories of the dynamic unconscious and there is a certain violence present in Man Ray's treatment of the Venus, suggestive of the linkage between the sex and death urges, discussed by Freud as Eros and Thanatos.

863. Hans Bellmer, *The Doll*.

Bellmer's grotesque, life-sized female images were his expression of opposition to the Nazi Party, which had recently gained power in his native Germany. The Nazis supported a particular idealised human appearance, and instituted eugenic policies to encourage that ideal. By creating representations of the human form that were so far from the Nazi ideal, Bellmer was expressing his refusal to create art for the state. Protest was not the only force motivating his work, however. The explicit sexuality of the doll and the poses in which he photographed it gåve his work a broader resonance than the political message alone could. He was forced to leave Germany in 1938, and the distorted, sexual nature of his work was welcomed by the surrealist circle in Paris.

871. Meret Oppenheim, *Fur Cup*.

In many ways, Oppenheim's tea cup and spoon, covered in Chinese gazelle fur, is the prototypical Surrealist object. Surrealism, as espoused especially by writer Andre Breton, sought to revolutionise the world by tapping into the energy of the human subconscious. Inspired by a the study of dream images, much surrealist art functioned by transforming the most ordinary aspects of everyday life into something strange and suddenly unfamiliar. Here Oppenheim reverses all of the typical properties associated with a cup of tea – warmth, comfort and domesticity – and turns it into a viscerally disturbing sensual experience. One can imagine, for instance, putting the cup to one's mouth, expecting the smoothness of porcelain and feeling instead fur sticking to the lips and tongue. Interestingly, Oppenheim may also be subtly critiquing the phallic nature of so much Surrealist imagery here, offering instead a reference to feminine sexuality in the air-lined void of the cup.

878. Käthe Kollwitz, *Lamentation: In Memory of Ernst Barlach*.

Themes of grief and human sorrow informed the work of Käthe Kollwitz throughout her career. In this memorial to her friend and fellow artist Ernst Barlach, Kollwitz typically avoids any specific reference, preferring to allow the sculpture to function as a universal statement of grief. Barlach was a central figure in the German Expressionist movement, and an artist who

inspired deep respect and affection among his peers, including Kollwitz, with who he was close. Kollwitz also worked as a painter and printmaker, and her work in these media often creates a sense of pictorial composition in her sculptures, visible here in the way the hands and one side of the face create a powerful, but organic, geometry. Similarly her sculptural work informed her two-dimensional art, often lending it a sense of solidity and massed form. The contrast of the dark background with the lighter tones of the emerging space add an element of primal drama to the work.

880. Gutzon Borglum, *Presidential Portraits*.

Cut directly into the granite of the Black Hills of South Dakota, Borglum's monument has become one of the most recognisable icons of American identity. Conceived originally in 1923 as a means to promote tourism in the remote area, the portraits were carved onto a geological formation that was a part of a spiritual pathway for the Lakota tribe, and known as the "Six Grandfathers". Borglum worked on the portraits for some fourteen years, utilising a team of 400 workers to create 18 metres high likenesses of George Washington, Thomas Jefferson, Theodore Roosevelt and Abraham Lincoln. Borglum, a member of the Ku Klux Klan, who had been long fascinated by monumental scale and patriotic subject matter, chose the four presidents and particularly liked this site because its southeast facing meant that it would receive good light throughout the day. The features were created by first dynamiting the rock and then using a tool to remove smaller areas of rock and smooth the surface.

881. Alexander Calder, *Untitled (Paon)*.

Very large, this work by Alexander Calder takes us into a world where Abstraction is close to a poetic vision of the real world. *Untitled (Paon)* is a work which is characteristic of his series of "mobiles". Oscillating in the wind, this composition seems as fragile as it is graceful. Fascinated by the endless potential of metal wire, Calder created numerous pieces in metallic materials painted in primary colours. Renewed harmony emerges from them, allowing many interpretations regarding their source of inspiration.

For an exhibition of the artist, Jean-Paul Sartre wrote: "His mobiles do not mean anything; they refer to nothing but themselves… They are absolute."

890. Henri Laurens, *Autumn*.

An influential Cubist sculptor, Henri Laurens brought the Cubist project of examining form to three dimensions. In this piece, the female body is broken up into a series of volumetric forms. The relationships among the rounded, football-shaped parts become as important as the vision of the whole figure. It is exactly that breaking apart that signifies the Cubist pursuit. Laurens borrows on a common theme from Western art, the Odalisque, or reclining female slave in a harem, as seen in the paintings of artists such as Boucher, Ingres, Matisse, and Renoir. This type of figure, as seen in two-dimensional painting, is a powerless object of desire. By disassembling the figure and abstracting the parts of the body, Laurens adds a modern, critical element to the tradition.

891. Henry Moore, *Draped Reclining Mother and Baby*.

Draped Reclining Mother and Baby is a later, more abstract variation on the theme of Madonna and Child by Henry Moore. A bronze sculpture, it was cast in 1985. Moore preferred to sculpt reclining figures because they gave him more freedom in dealing with his compositional space. This figure is inspired not only by Mary but also by other godly personages, such as Gaia, the Earth Mother of ancient Greece, a Creator goddess who also gave birth to the sun and the moon. The artist here conveys a message about the deep relationship between the mother and her child. The figure of the mother mimics the contours of rolling hills, an appropriate symbol of Mother Earth.

892. Alberto Giacometti, *The Glade*.

Although he had been an associate of the Surrealists for much of the 1920s, in 1934 Alberto Giacometti decisively rejected their interior directed methods in favour of returning to the study of the live model. For the rest of his life Giacometti would be exclusively concerned with the attempt to find an adequate form to render his acute perception of the human figure in space. After the war Giacometti's sculpted figures became increasingly frail and elongated. The artist frequently worked away at the plaster casts for these figures until they disintegrated, so that the figures which were actually cast in bronze represent only a part of his output. Giacometti was an associate of the philosopher Jean-Paul Sartre multi-figure compositions like *The Glade* seem to express a particular sense of existential anguish. United by proximity but forever divided by the nothingness that surrounds them, they are a powerful representation expression of existence in the modern city.

894. Louise Bourgeois, *Sleeping Figure*.

As an expatriate working in New York during World War II, Louise Bourgeois associated closely with Surrealists including Joan Miró and André Masson. Indeed, like the Abstract Expressionist painters, Bourgeois drew heavily on subconscious imagery, but she did so without losing contact with representational form. Her sleeping figure here, of course, is upright, suggestive then not so much of quiet slumber, but instead an alternate state of active consciousness. With its stylised features and stick-like form, separated into four component parts, the figure also stands for a kind of collective identity rather than any specific person, suggestive of a shared level of human experience. There is no sense of the absolute freedom of the ego here, however, as the two poles which ostensibly support the figure also constrict it and hem it in.

898. Anna V. Hyatt Huntington, *Fighting Stallions*.

An American sculptor, Anna V. Hyatt Huntington mainly depicted animals. She spent a great deal of time in the study of horses and other animals, attention that resulted in detailed and accurate depictions of their anatomy in her sculpture. In this highly-charged work, two stallions are shown rearing in combat, one attacking the other. The horse under attack is losing balance, his weight supported entirely by one leg. His rider has fallen and is at risk of being trampled. Both horses are shown with their muscles straining and their manes flying wildly, their energy heightened by the circular, spiralling composition of the piece. Bernini-esque in its compositional torsion, the piece retains a distinctly American style thanks to the sensitively-wrought realism of the animals.

899. David Smith, *Hudson River Landscape*.

As an associate of the Abstraction Expressionist group in New York during the 1940s and 1950s, David Smith was a key figure in bringing that language into the three-dimensional. *Hudson River Landscape*, one of a number of sculptures that are free-standing but occupy a broad plane perpendicular to the viewer, shows the influence of the loose, gestural approach to form taken by artists like Jackson Pollock. Smith's line squiggles and masses in irregular fashion, belying the seemingly static quality of the steel and creating something that looks almost improvised. The natural forms of his native Hudson Valley were always important to Smith are echoed here in diagonal forms that evoke low mountains, clouds and the movement of the environment. Smith's sculptures also make wonderful effects of their transparency, and he photographed it silhouetted against the landscape itself so that natural and artistic form merged.

900. Pol Bury, *Relief Mobile 5*.

Pol Bury was a member of the Surrealist "Rupture," and would remain influenced by Surrealism throughout his career. In the period immediately after the war, however, he came under the influence of the COBRA group, an international association of artists more interested in abstraction. *Relief Mobile 5* displays the influence of the bright colours and abstraction of COBRA, but also is the result of Bury's exposure in 1953 to the mobiles of Alexander Calder. Bury's mobile is more oriented to the wall than Calder's

work, exploring a set of tensions between two and three dimensions, void and solid and movement and stillness. The presence of a Surrealist interest in frustrated eroticism is also visible here. The circular forms are partially complementary, making the eye seek to put them back together. The taut wires keep them apart, forever suspended and neither fully united nor separated.

909. Christo, *Package on a Table*.

While he painted portraits to make a living in Paris in the late 1950s, Christo also immersed himself in *avant-garde* circles in Paris in which artists like Yves Klein and Jean Tinguely were reassessing the very nature of what constituted art. In 1958, Christo began his *Inventory* which marked the appearance of the act of wrapping which would become the defining characteristic of his career. The project consisted of groups of cans, bottles and crates which he wrapped in canvas and painted in dull colours. This process emerged out of his experimentation with varied, rough surfaces in his paintings, but quickly took on a life of its own. In wrapping things, Christo took ordinary objects establishing a connection with the everyday world even as he transfigured them, separating them from the flow of modern life. *Package on a Table* is an extension of this project, which dated from a period just before Christo began wrapping on a much larger, architectural scale. Here the objects are more fully covered by the wrapping, adding a level of mystery, mixing the expectation of opening with a darker sense of entombment.

915. Ellsworth Kelly, *Sculpture for a Large Wall*.

Ellsworth Kelly rejected the grand metaphysical yearnings and intense interiority of the Abstract Expressionist movement that preceded him. Instead, Kelly takes simple geometric shapes culled from the ordinary visual stimuli of the everyday and transforms them into powerful abstractions. Kelly's intense preparation and delicate sense of composition balance is belied by the apparently random quality of the final works. Here the colour and shapes were worked out through a series of preparatory drawings, which allowed Kelly to subtly modulate between the appearance of flatness and depth, testing the boundaries between painting and sculpture. As massive as it is, there is a flickering sense of movement to the *Sculpture for a Large Wall*.

916. Sir Anthony Caro, *Midday*.

In the early 1960s Sir Anthony Caro abandoned the figural style in which he had been working and in so doing became one of the crucial figures in the development of abstract sculpture in the last half of the twentieth century. Eschewing traditional materials such as bronze, wood and stone, Caro began working with industrial materials and techniques, welding large slabs of steel together. Placed directly on the ground, with no pedestal to separate it from the everyday world of the spectator, *Midday* powerfully asserts itself with the spectator's world. Dominated by a diagonal tilt contrasted with vertical elements the sculpture evokes the movement of the sun across the sky and is also reminiscent of a sundial. The bright yellow industrial paint finally may be another reference to the pervasive tones of the daytime sun.

917. Henri Matisse, *The Back IV*.

The final statement in the series of *Backs*, this relief sculpture shows the mature Matisse able to create a powerfully expressive form with an absolute economy of means. The figure has become a set of interlocking cylinders which are aligned with the vertical rectangle of the background to become stable and permanent. Almost all anecdotal reference to the original subject, a woman with a long pony-tail, leaning against a fence, has been eliminated here. Throughout his career Matisse sought to create forms that would be both monumental and elegant, expressive yet simple. This last instalment of the *Backs*, done some twenty years after the first, represents an important moment in Matisse's realisation of his particular form of modernism.

918. Hans Arp, *Demeter*.

A foundational member of the Zürich Dada movement, Hans Arp helped introduce notions of the absurd into art as part of a critique of the rational basis of Western culture. In the years between the world wars, Arp developed a playful style of biomorphic abstraction. Reminiscent of the organicism of Brancusi, Arp, like many artists of the twentieth century sought a simplicity of form and expression in past art. Along with the reference to the Greek goddess, Arp form evokes the single-breasted form of ancient goddess figurines, here transformed to a large scale. Arp also transforms the hard stone into a seemingly malleable, warm inviting material, echoing the maternal associations of the iconic form. The pristine whiteness of the stone amplifies the idea of a pure, vital natural form, uncorrupted by modern civilisation and rationalism.

924. Marisol, *Love*.

For all its simplicity this is one of the most immediate and wittiest sculptures of the entire Pop/Mass-Culture Art tradition. As well as commenting upon the enthusiastic intake of a beverage that has come to symbolise consumer culture, it also tellingly points up the inherent sexuality of objects and the fetishisation of those artefacts that underlies our society.

926. Claes Oldenburg, *Floor Burger*.

Oldenburg once stated, "I have always been fascinated by the values attached to size", and the enhancement of normal dimensions has been a constant factor within his mature work, rendering the familiar unfamiliar and thus forcing us to question what we usually take for granted. Naturally, because of the sheer physical immensity of the United States and its grandiose political and materialistic aspirations, Oldenburg's enlargements of common things have consistently paralleled a very deep vein within that nation's psyche. And because of his conversion of familiar articles into other materials, he has always stressed the inherent formal qualities of both the items he replicated and of the representations themselves.

928. Tony Smith, *Die*.

Trained as an architect, Tony Smith brought a constructive, modernist inspired approach to sculpture. *Die* was his first sculpture in steel and was central to his overall development of his career. The apparent simplicity of Smith's steel box belies its complex commentary on the very conditions that comprise both art making and viewing. Smith's box was constructed according to his specifications by a welding company, thus calling into question the role of the artist in creating the physical form of the work of art. Despite the initially austere appearance of the box, Smith carefully calibrated its proportions to those of the human body, so that it would be neither overwhelming, nor dwarfed by the viewer. The very name, a simple world, suggests a multiplicity of meanings from a metal cast, to a cube for gambling to a simple command for death.

932. Giacomo Manzù, *Bust of Pope John XXIII*.

Giacomo Manzoni, called Manzù created a number of religious sculptures in the twentieth century and so was an appropriate choice for the official portrait of Pope John XXIII, the 261st pope. Born Angelo Roncalli to a family of sharecroppers near Bergamo, Italy, John XXIII was pope for five years until his death in 1963 and is known in part for the controversy surrounding the papal election of 1958 in which it is thought the conservative Cardinal Siri declined the papacy. Manzù's rendering of John XXIII is reminiscent of the directness of High Renaissance painted portraits of popes by Raphael and Titian. The Pope is shown frontally wearing the relative simple garments of the *mozzetta*, or cape, and the red velvet cap, the *camauro*, which went out of usage after John XXIII's death. The firm solidity of the form is also reminiscent of the Early Renaissance sculptor Donatello.

933. Eduardo Paolozzi, *The City of the Circle and the Square.*

Eduardo Paolozzi worked in a wide range of styles from Surrealism to an early Pop Art aesthetic. His work was marked, however, by a pervasive interest in the modern city and machinery. He combines these in this polychrome sculpture, which is a kind of three-dimensional collage that he referred to as an urban image. Paolozzi designed each element of the work and then had assistants execute them to his design and weld them together. Various parts of the work make reference to buildings, the smokestacks of factories and perhaps the gridded structure. The traditional pedestal of a sculpture has been incorporated into the work and is partly comprised of a wheel, which Paolozzi often used to symbolise technology.

939. Barbara Hepworth, *Figure Walnut.*

Along with Henry Moore, Barbara Hepworth is a central figure in twentieth-century British sculpture and the inheritor of Brancusi's tradition of organic abstraction. Deeply sensitive to her materials, Hepworth created fluid, curving forms that were richly evocative while avoiding specific references. Here she takes the traditional vertical format of sculpture but pierces it with two irregular holes. Indeed, while she often shares the flowing lines of Brancusi and Moore, she avoids the powerful unity that so often characterised their solid forms. Instead, she opens the form open, acknowledging the spatial complexity of Cubism and bringing in a play of solid and void.

944. Takis, *"Le Grand Signal".*

Working in Paris after the war, Takis was a key figure in the development of kinetic art, utilising in particular magnetism to create dynamic, ever-changing works of art that challenged traditional definitions of sculptures. He had made his first "signal" sculptures in the mid-1950s, works of flexible iron that swayed and moved gently. The vertical forms of *Le Grand Signal* resonate with heroic associations of sculptures of the human form, but here they have become frail, subject to the forces of nature, which themselves become the subject of the work. Undoubtedly these are also "signals" in that declare themselves to have urgent communicative value. But these values must remain intuitive and non-specific, rather than depict any specific form or message, urging the viewer instead to immerse him- or herself with invisible but powerful forces that surround us.

951. Jean Tinguely, *Requiem for a Dead Leaf.*

A member of the post-war Parisian *avant-garde*, Swiss-born Tinguely is a pioneer of kinetic art. Often featuring high-speed motors and whirring, noisy parts, Tinguely's sculpture/machines are more poetic than mechanistic and offer a fantasy-based, deeply ambivalent response to the age of technology. With parts moving simultaneously, and yet automatically, works like *Requiem for a Dead Leaf* seem like parodies of the modern, industrial world, mimicking the chaos created by so many rational processes. In this way, they are late twentieth-century responses to the nihilistic optimism and faith in industrialisation that characterised early European avant-garde movements such as the Futurists. At once powerful and movingly fragile, Tinguely's moving sculptures offer the absurd as an antidote to the alienation of modern life.

956. Donald Judd, *Untitled (Stack).*

As one of the key figures in the development of Minimalism, Donald Judd's work engages with sculpture at its most fundamental levels. On the one hand, Judd's Stack evokes the traditional upright format of sculpture's most noble subject: the human figure. At the same time, this association is undermined on numerous levels. The rigid, precise geometry of the industrially produced boxes is anything but organic, and Judd is careful to avoid any hint of symbolism or metaphor. Judd also anchors his piece to the

wall, rather than placing it on a pedestal, evocative of a painting, and also suggesting that it may continue through the wall. As much as it may deny the humanist aspects of artistic creation, however, Judd's work is undeniably visually compelling in its combination of sharp formal lines with lush, green lacquer, applied with slight variations of hue.

960. Eva Hesse, *Repetition Nineteen III.*

Eva Hesse shares Minimalism's insistence on an abstract formal language, as well as its insistence on bringing sculpture directly into contact with the space of the viewer. Here the cylindrical forms, all variants of a basic geometrical unit, are placed on the floor of the space, without pedestal or other means of establishing distance between object and audience. Hesse's work, however, admits a greater possibility for metaphor and reference. In particular, her skein-like, semi-opaque materials often seem to suggest organic, even bodily forms. Where Minimalist is often monumental and forbidding in its formal precision, Hesse's abstractions address the viewer on a much more intimate scale. Further, where Minimalist works are typically formed of industrial materials, Hesse's works are clearly organic with an almost visceral sense of bodily presence. Huddled together on the on the floor the decidedly anthropomorphic cylinders are clearly related, suggesting some communal life, but are also hopelessly immobile and thus separated from each other.

961. Carl Andre, *144 Lead Square.*

Carl Andre's floor pieces are typical of Minimalism's extreme, almost unforgiving, formal austerity. Just as rigorously as Andre's use of industrial materials such as lead, aluminium, copper and zinc denies any possibility of artistic flourish, so too does the geometric arrangement negate narrative, symbolism or figural reference. Resolutely tied to the floor, and denying even the possibility of a pedestal, *144 Lead Square* directly refuses the elevated status of sculpture's traditional format, preferring to impact the viewer simply by means of its material and its effect on the space around it. Indeed, Andre figures his audience more as participants than viewers: the visitor is forced to cope with the sculpture as object and decide whether to walk around or over it (Andre encourages the latter). In this way, Andre both critiques fundamental aspects of sculpture's traditional functions while exploiting one of its most basic qualities: three-dimensional presence.

962. Joseph Beuys, *Iron Chest from "Vacuum – Mass".*

Working in the wake of world war, genocide and economic hardship in Europe, Joseph Beuys adopted a deeply utopian view of creativity, in which art could transform society. To do so, however, Beuys felt that art had to be come all-encompassing so that every aspect of his life became art. Acting as a kind of priest for a new spirituality Beuys held ritualistic performances in which materials took on important symbolic meanings. Iron and fat, for instance, were two of the most important materials for Beuys; the former, hard, unyielding and associated with Mars, stands for masculinity, while the latter, soft, malleable and nurturing symbolised femininity. The Iron Chest here has some of the monumental geometry of Minimalism, but here this is harnessed not in pursuit of literalness but instead for a kind primal simplicity, like a sort of altar.

964. Giovanni Anselmo, *Untitled.*

Like the other artists associated with the Arte Povera group, Giovanni Anselmo employs non-traditional artistic materials to create sculptures with intense metaphysical yearnings. In particular Anselmo has sought to place his work within a vast continuum of natural forces, incorporating, for instance, gravity and complex tensional relationships between parts of the sculpture. Here two blocks of granite are held in taut fragile balance by the copper wire and a head of fresh lettuce. When the lettuce dries the balance will be lost and the smaller block will fall. Thus the most permanent of

natural forms comes to rely on the most ephemeral. Anselmo's sculpture itself comes to embody this dichotomy of the ephemeral and the permanent, tapping into these larger, defining forces, but doing so in a contingent, fragile way.

966. Sol LeWitt, *5 Part Piece (Open Cubes) in Form of a Cross.*

In part critiquing in the intensely personal nature of the art of Abstract Expressionism, which had become dominant in the 1950s, Sol LeWitt espoused a form of art from which all artistic flourish and improvisation had been banished. Describing what he called "Conceptual Art," LeWitt wrote in 1967: "When an artist uses a conceptual form of art, it means that all of the planning and decisions are made beforehand and the execution is a perfunctory affair. The idea becomes a machine that makes the art." Thus LeWitt's works are not so much sculpted, but rather assembled; a set of pre-produced geometric forms are placed together in a prescribed manner. Both components and placement are described matter-of-factly in the title here. But the apparent directness of the process of creation here belies the visual complexity that LeWitt's work often creates. Placed sometimes in the middle of the room other times against a wall, the open cubes create a dynamic sense of space and form as the viewer moves around. The distinction that LeWitt would make here is that the subtlety and sophistication of the work must be a result of its original idea rather than its execution.

970. Robert Morris, *Untitled.*

In *Untitled* Robert Morris moves away from the formal austerity and extreme narrative avoidance of the Minimalist language he had helped to create. Morris explores here the non-traditional material of felt, both for its ability to evoke a more rich range of ideas and associations, and its unpredictability. Thus, while Morris's cuts follow predetermined intervals and regular paths, the final form is determined by the material's response to its position on the wall rather than the will of the artist. Vaguely anthropomorphic, soft and yielding yet at the same time monumental in its physical presences, *Untitled* is undeniably psychologically suggestive, but is also non-specific enough to allow the viewer to bring his or her associations to the work. *Untitled* thus posits the work of art as existing at the intersection of artist, viewer and material with none of these terms playing a more dominant role than the others.

972. César, *Dauphine.*

César is one of France's most important and popular sculptors of the post-war period. Cars have been an persistent fascination for César throughout his career and art indicative of his own ambivalent relationship with popular culture. Part of a series in which he took Peugeot race cars that had been rendered useless by crashes, the crushed form of the car seems to make reference to the enduring attraction of the car as a source of speed and excitement, making reference perhaps to early modernism's embrace of the automobile, as in the work of the Futurists. Here, however, the mechanical utopia of early modernism has become a scene of violence and destruction, suggestive perhaps of the effect of commodity culture on Western society. The car, isolated in its destruction, collapses in on itself, a metaphor perhaps for the alienating effects of modern capitalism.

975. Richard Serra, *Cutting Device: Base Plate-Measure.*

Of the generation that immediately followed the Minimalists, Richard Serra takes much from the movement, including its focus on monumental geometry and an awareness of the effect of sculpture on its environment and the viewer. In *Cutting Device: Base Plate-Measure*, however, Serra focuses on the process of art as well, however, and in the process leaves his work more open-ended more available to associative meaning and metaphor. While the various natural and man-made woods have been exposed to two parallel cuts, they are scattered in apparently random pattern across the floor. The work

becomes increasingly complex then as we note a intricate set of relationships between the various textures of the materials as well as their shapes and the effects of the cuts. Thus, in a work about the effect of the man-made (sculpture) on the space around, Serra's work also points richly to the effect of man on the natural environment.

977. Duane Hanson, *Supermarket Shopper.*

Hanson was a highly realistic sculptor, as this work demonstrates. What differentiates him from most equally representational sculptors, however, is that he never used his mature work simply to replicate appearances; instead, he employed it to isolate particular social types, such as the supermarket shopper (as here) or the gawping tourist. Usually the sculptures are life-sized and always they were cast from life, with Hanson looking out for models whose physiognomies and build would best stand for the social types he wished to personify. By holding up such an accurate mirror to reality, Hanson forces us to a renewed awareness of the values such people represent.

980. Mark di Suvero, *K-Piece.*

One of the key figures in American sculpture in the later twentieth century, Mark di Suvero's work is characterised by a rich set of contradictions. Having been injured in an elevator accident in 1960, in which he lost the use of his legs, di Suvero responded by increasing the size of his work and employing a crane in its construction. Often monumental in scale, they are nonetheless held together in the most delicate balances. Works like *K-Piece* are powerful, sometimes overwhelming artistic statements that are nonetheless capable of great playfulness. Here the industrial steel that di Suvero uses seems to defy gravity, as di Suvero uses its inherent structural possibilities to create something that seems contrary to the density and heaviness usually associated with steel. Similarly, di Suvero uses the structural capacity of I-beam to carve out space, working with complex juxtapositions of void and solid that change dynamically as one encounters the work.

986. Giuseppe Penone, *Albero.*

Giuseppe Penone was a central member of the Arte Povera group that emerged in Italy in the late 1960s. "Povera," Italian for poor, refers here to the humble materials many of the members of the group chose, consciously rejecting traditional high art materials of painting and sculpture. *Albero* is part of a series of works Penone has done on the theme of trees, in which he attempts to carve a wood beam as a means of bringing it back to its source as a tree and thus connecting his own work with the growth and life cycles of nature. This in turn relates to the meditative, painstaking process of Penone's own work. As Penone has said: "What I find even more fascinating, what I feel to be an ever present aspect of my work, is the time it takes me to carve in relation to the time it takes the tree to grow. I am driven by the curiosity to discover a tree each time around and with it a new story."

998. Magdalena Abakanowicz, *Catharsis.*

Working in the tradition of artists like Brancusi, Magdalena Abakanowicz seeks to use sculpture to promote spiritual contemplation and to speak to elemental issues of the human condition. Designed for a non-descript site near a sculpture garden in Celle, Italy, *Catharsis* consists of thirty-three vertical bronze figures, each about 2.5 metres high. In creating the mottled, rough surface of the forms Abakanowicz allowed the inside surface of the mould, normally invisible once something is cast in bronze. She also left the bronze unfinished so that it would continue to be affected by the natural environment, of which the sculptures were meant to be a permanent part. Interested in creating a "sacred space" Abakanowicz's title refers to the role of catharsis in Greek tragedy: a collective, rather than individual purging of feelings of pity in fear. Coming in the wake of the genocide and world war in Europe, Abakanowicz uses art to attempt to place man back into spiritual harmony with nature.

GLOSSARY

Term	Definition	
Alabaster	Name applied to two distinct mineral substances, the one a hydrous sulphate of lime and the other a carbonate lime. The former is the alabaster of the present day, the latter is generally the alabaster of the ancients. The two kinds are readily distinguished from each other by their relative hardness (the ancient alabaster being harder than the modern one). Highly estimed in the ancient times, it was used for perfume-bottles, sculptures and even sarcophagus. (see no. 360)	56. Bronze
Aluminium	Most abundant metal in the earth's crust where it always occurs in combination, malleable, ductile, light, with high resistance to oxidation. It has a bluish silver-white colour. (see no. 883)	
Armature	Iron skeleton with stout bars for the arms and legs fixed in the pose of the future figure.	
Baptismal font	Vessel used in churches to hold the water for the Christian baptism. Located in a baptistery (separate hall or chapel where baptisms occur), baptismal fonts belong to a period when adults were baptised by immersion. (see no. 194)	
Bronze	Alloy formed wholly or chiefly of copper and tin in variable proportions. In sculpture, it can be treated in various ways, the chief of which are casting in a mould and treatment by hammering and punching. (see no. 56)	
Cameo	Term applied to engraved works executed in relief on hard or precious stones. (see no. 134)	60. Metope in high relief
Capital	In architecture, crowning member of the column, which projects on its side as it rises, in order to support the abacus and unite the square form of the latter with the circular shaft. (see no. 222)	
Caryatid	Term given to the draped female figures used for piers of supports, as found in the portico of the Erectheum in Athens. (see no. 71)	
Cast	Mould for the casting of metals, and more particularly for the copy of original statue of relief taken from a mould. Cast *à la cire perdue* ("lost wax"): way of casting, where the figure is first roughly modelled in clay, then a skin of wax is applied that is worked by the sculptor and requires form and finish. The next phase is to cover it with a coating of refractory plaster to form a mould. Once heated, the wax melts and runs out of the mould thanks to holes made for that purpose. Then, the metal can be poured into the vacant mould. Once cooled, the mould has to be broken to free the metal sculpture.	88. Contrapposto
Chassis	Stand with a revolving top, where a sculpture is placed, so that the sculptor can easily turn the whole model round.	
Chisel	Sharp-edged tool for cutting metal, wood or stone. There are numerous varieties of chisels used in different trades: the carpenter's chisel is wooden-handled with a straight edge, transverse to the axis and bevelled on one side; stone mason's chisels are bevelled on both sides and others have oblique, concave and convex edges. A chisel with a semicircular blade is called a "gouge". The tool is worked either by hand-presssure or by blows from a hammer or mallet.	
Clay	Fine-grained, almost impalpable substance, very soft, more or less coherent when dry, plastic and retentive of water when wet. It consists essentially of hydrous aluminium silicate with various impurities. Modelled to make a sculpture, it can also be used for casts. (see no. 676)	134. Cameo
Cloister	Four-sided enclosure, surrounded with covered ambulatories, usually attached to conventual and cathedral churches.	
Contrapposto	Term describing a human figure throwing the weight of the body on one leg so that its shoulders and arms twist off-axis from the hips and legs. (see no. 88)	
Fiberglass	Type of glass in fibrous form made of plastic and glass. (see no. 950)	
Files	Tools that can be classed with scrapes, for although the points are keen, there is never any front rake. Collectively there is a shearing action because the rows of teeth are cut diagonally. Files include parallel or blunt files, tapered square files or parallel half-round files.	181. Ivory
Hammer	Tool consisting of a handle with a head, usually of metal, fixed transversely to it. The head has one flat face while the other may be shape to various purposes.	
Hammered work	Plates of bronze hammered over a wooden core, rudely cut into the required shape, the core serving the double purpose of giving shape and strenghtening the thin metal. (see no. 198)	
Hieratic	Term used in the arts for figures represented in a certain way that is set by religious codes and traditions. (see no. 229)	
High relief	See **Relief**.	
Ivory	Term confined to the material represented by the tusk of the elephant. (see no. 181)	
Jamb	In architecture, the side-post or lining of a doorway or other aperture. (see no. 213)	
Kore (Korai)	Statue of a female youth, offered to the deities in the archaic sanctuaries in Greece. (see no. 32)	
Kouros (Kouroi)	Statue of a male youth commonly naked, offered to the deities in the archaic sanctuaries in Greece. (see no. 6)	
Limestone	Rock consisting essentially of carbonate lime. (see no. 817)	
Low relief	See **Relief**.	198. Hammered gold
Mallets	Wooden hammer used to avoid bruising tools or the surfaces of a work.	
Marble	Term applied to any limestone or dolomite which is sufficiently close in texture to admit of being polished. Famous quality marble are Pentelic marble in Ancient Greece sculptures or Carrara marble from the Renaissance period until now. (see no. 420)	

Term	Definition
Metal-work	Gold, silver and bronze may be treated in various ways, the chiefs of which are: casting in a mould and treatment by hammering and punching ("repoussé").
Metope	In architecture, term for the square recess between the triglyphs (vertically channelled tables) in a Doric frieze, which is sometimes filled with sculpures. (see no. 60)
Modelling	Preliminary sculpture made in malleable material (wax,clay, plaster).
Original bronze work	Sait of the eight first cast of a bronze sculpture.
Patina	Brownish green film that appears on copper and bronze sculptures after a long exposure. It can be made artificially with acids. (see no. 672)
Pediment	In classic architecture, the triangular-shaped portion of the wall above the cornice which formed the termination of the roof above it. The projecting mouldings of the cornice which surround it enclose the tympanum, which is sometimes decorated with sculpture. (see no. 45)
Piece-mould	Mould formed by applying patches of wet plaster all over the clay statue in such a way that they can be removed piecemeal from the model, and then be fitted together again, forming a complete hollow mould.
Pietà	Representation of the dead Christ resting on the lap of the Virgin who laments the death of her child. This sombre image of the grieving Virgin was popular at the end of the Middle Ages due to devastation caused by the plague epidemic and was widely reproduced during the Middle Ages and the Renaissance, the most famous example being that of Michelangelo, dating of 1498-1499. (see no. 340)
Plaster	Fine white calcinated gypsum which forms a hard cement when treated with water. (see no. 665)
Portal	In architecture, the word "portal" designates an elevated structure serving as a facade or as a main entrance to a large building in front of the door. It often takes the form of a splay in front of the main doors of an edifice, forming an overhanging shelter. The portal is built around the doors themselves. This distinguishes it from a porch, which extends outward from the building. The portal is the frame of the door and the arch which extends from it, either corbelled or supported by buttresses or columns. (see no. 234)
Ready-made	Name given to sculptures that appropriated industrially mass-produced objects. (see no. 826)
Relief	Term in sculpture signifying ornament, a figure or figures raised from the ground of a flat surface of which the sculptured portion forms an inherent part of the body of the whole. The design may be in high relief , "alto relievo" (see no. 60), or low relief , "basso relievo" (see no. 222). High relief means that the design is almost wholly detached from the ground, the attachment, though "under-cutting" remaining only here and there. Low relief means that the relief is wholly attached and may scarcely rise above the surface, or it may exceed in projection to about a half the proportionate depth (or thickness) of the figure or object represented.
Sandstone	Consolidated sand rock built up of sand grains held together by a cementing substance. (see no. 195)
Sarcophagus	Name given to a coffin in stone, which, on account of its caustic qualities, according to Pliny, consumed the body forty days; also by the Greeks to a sepulchral chest, in stone or other material, which was more or less enriched with ornaments and sculptures. (see no. 26)
Scale stone	Large block covered with a series of points, corresponding to a series of marks placed on all the most salient parts of the clay model, in order to use a "pointing machine" which has arms ending in metal points or needles, that will make holes in the block helping the sculptor to copy the clay model into marble.
Scrapes	Tools which operate by scaping including many of the broad finishing tools of the turner in wood and metal, and the scrape of the wood worker and the fitter. Scrapes include round-nosed tools or diamond points used by wood turners.
Spoil-moulds	Moulds made in one or few pieces, from which the cast can only be extracted by destroying the mould.
Stucco	Term loosely applied to nearly all kinds of external plastering, whether composed of lime or of cement used in sculpture for architectural decorations or for casts. (see no. 460)
Terracotta	Originally used to define clay sculptures "sun-dried" only. Can also be used to define fired clay. This word comes from the Italian "terra cotta", literally "baked earth". (see no. 621)
Tympanum	In architecture this term is given to the triangular space enclosed between the horizontal cornice of the entablature and the sloping cornice of the pediment. Though sometimes left plain, in the most celebrated Greek temples, it was filled with sculptures of the highest standard ever attained. In Romanesque and Gothic work, the term is applied to the space above the lintel or architrave of a door and the discharging arch over it, which was also enriched with groups of figures. (see no. 202)
Wax	Solid fatty substance of animal and vegetable origin, allied to the fixed oils and fats. From these it is distinguished by the fact that while oils and facts are glycerides, a true wax contains no glycerin, but is a combination of fatty acids with solid monatomic alcohols. Wax is a convenient medium for preparing figures and models, either by modelling or by casting in moulds. (see no. 704)
Wood	Solid compact or fibrous substance forming the trunk, branches and roots of voluminous plants. Lighter and more malleable than stone, it was often used for sculptures of small scale or in regions where sculptural stone was not easy to find. (see no. 447)

222. Capital in low relief

621. Terracotta

447. Wood

650. Marble

817. Limestone

883. Aluminium

950. Fiberglass

BIOGRAPHIES

Magdalena ABAKANOWICZ
(Felenty, near Warsaw, born 1930)

The Polish artist Magdalena Abakanowicz broke down traditional barriers between textiles and sculpture. After studying at the College of Fine Arts in Sopot, she graduated from the Academy of Fine Arts in Warsaw in 1955. Abakanowicz first made a name for herself at the 1962 Beiennale Internationale de la Tapisserie in Lausanne with a composition made out of white fabrics. Over the rest of the decade Abakanowicz developed the idea of three-dimensional textiles and fabrics. In the early 1970s, she entered the realm of "happenings" by entwining first Edinburgh Cathedral and then a fountain in Bordeaux in rope and began to use such non-traditional materials (both in terms of textiles and fine arts) as string, burlap and cotton gauze. In the 1970s and 1980s Magdalena Abakanowicz became increasingly pre-occupied with the human body, often from a medical or scientific point of view. As artists have done since the Renaissance, she visited dissecting rooms and she made casts of real human beings. This interest was expressed in series such as Human Backs of 1980 which consisted of eighty figures, Syndromes (clay simulations of human brains) and the Androgyn series of 1985 depicting human torsos.

Alessandro ALGARDI
(Bologna, 1598 – Rome, 1654)

Italian sculptor, Alessandro Algardi started his training as a painter, and while attending the Carracci school his preference for plastic art became evident. He placed himself under the instruction of the sculptor Conventi. At the age of twenty he was brought to the notice of Duke Ferdinand of Mantua, who gave him several commissions. About the same period he was also much employed by jewellers and others for modelling in gold, silver, and ivory. After a short residence in Venice he went to Rome in 1625, with an introduction from the Duke of Mantua to the pope's nephew, Cardinal Ludovisi, who employed him for a time in the restoration of ancient statues. The death of the Duke of Mantua left him to his own resources, and for several years he earned a precarious maintenance from these restorations and the commissions of goldsmiths and jewellers. In 1640 he executed for Pietro Buoncompagni his first work in marble, a colossal statue of San Filippo Neri, with kneeling angels. Immediately after, he produced a similar group, representing the execution of St Paul, for the church of the Barnabite Fathers in Bologna. These works, displaying great technical skill though with considerable exaggeration of expression and attitude, at once established Algardi's reputation, and other commissions followed in rapid succession. The turning point in Algardi's fortune was the accession of Innocent X, of the Bolognese house of Panfili, to the papal throne in 1644. Camillo Panfili, nephew of the pontiff, employed him to design the Villa Doria Panfili outside the San Pancrazio gate. The most important of Algardi's other works were the monument of Leo XI, a bronze statue of Innocent X for the capitol, and, above all, *Pope Leo XI repulsing Attila* (see no. 548), the largest alto-relievo in the world, the two principal figures being about three metres high. In 1650 Algardi met Velázquez who obtained some interesting orders for his Italian companion in Spain. Thus, four chimneys by Algardi stand in the palace of Aranjuez, where he also executed the figures on the fountain of Neptune.

Carl ANDRE
(Quincy, Massachusetts, born 1935)

Carl Andre was one of the best-known artists associated with the Minimalist movement in the 1970s. Andre studied at the Phillips Academy, Andover, Massachusetts between 1951 and 1953. The following year he crossed the Atlantic to visit Britain where he was profoundly impressed by the great monoliths of Stonehenge. After

military service (1955-56) he moved to New York and formed a close working relationship with the painter Frank Stella, with whom he shared a studio in 1959. In the early 1960s Andre worked on the railways, an experience that influenced his future choice of industrial materials in interchangeable units like railway tracks and also the tendency to horizontality in his works that are, as he put it, "more like roads than buildings". In an exhibition catalogue of 1978 he elaborated "The railway completely tore me away from the pretensions of art, even my own, and I was back on the horizontal lines of steel and rust and great masses of coal and material, timber, with all kinds of hides and glue and the burdens and weights of the cars themselves."

The acquisition in 1972 by the Tate Gallery in London of *Equivalent VIII* which consisted of 120 bricks arranged in a rectangle, gave rise to one of the regular scandals that have punctuated the history of modern art in Britain.

Benedetto ANTELAMI
(Parma, active 1178-1196)

The Italian architect and sculptor Benedetto Antelami is considered one of the most important sculptors of the period preceding that of Nicola Pisano. His Roman-style work, with its long figures and compact composition, was popular in Parma towards the end of the twelfth century. The cathedral of this city is adorned with his *Crucifixion* and *Deposition from the Cross* (see no. 259) – a marble bas-relief of remarkable quality. Antelami was probably the builder of the Baptistery, which is decorated with fourteen of his allegorical statues.

Hans ARP
(Strasbourg, 1886 – Basel, 1966)

The French sculptor Hans Arp was born to a German father and a French mother. As a child he fashioned sculptures out of wood, but in 1902 he gained recognition for his poetry. All of his work, whether in sculpture or in literature, was guided by a poetic sensibility expressed in all forms of art. In 1914 he left for Paris, where he met, among others, Delaunay and Picasso. As a refugee in Switzerland, he met Sophie Taeuber, whom he married in 1921. Upon his return to France, Arp settled in Meudon, Seine et Oise. He was an adherent of Dadaism, a period during which he ordered his works according to "the law of chance," similar to the order of nature, as well as of surrealism. Eventually, he returned to concrete art, rejecting the label of abstraction for his works. In 1940, out of fear of the Nazis, he fled to Grasse with his wife, and it was during this period that he gallicised his name to "Jean." His work was particularly fruitful during this period and he sculpted a great number of statues. Having returned to Switzerland in 1942, he lost his wife in an accident, but continued to enjoy great success after the Liberation.

Egid Quirin ASAM
(Tegernsee, 1692 – Mannheim, 1750)

The remarkably versatile Egid Quirin Asam was active as an architect, sculptor, stuccoist and occasionally as a painter. He was a member of the Asam family who collectively produced several of the supreme masterpieces of South German Baroque. Founded by Hans Georg Asam (born Rott am Inn, 10 October 1649, died Sulzbach 7 March 1741), this artistic dynasty included Hans Georg's wife Maria Theresia, his sons Kosmas Damian (chiefly active as a painter apart from his work as an architect), and Egid Quirin and his daughter Maria Salome. Egid Quirin was apprenticed to the sculptor Anton Faistenberger in Munich. It is likely that he accompanied his brother Cosmas Damian to Rome from 1711 to 1713. Both brothers were strongly imbued with the Roman Baroque and in particular based their own fusion of architecture, sculpture and painting on that of Bernini.

The development of the Baroque style in Bavaria was retarded by disastrous defeats in the War of the Spanish Succession (1701-1714). With the resumption of peace and the return of the ruling Wittelsbach family, Bavaria saw a late flowering of the Baroque style of unparalleled splendour in which the Asams played a leading role. The first great masterpiece of the Asam brothers (assisted by their sister) was the monastic church of Weltenburg. So successful is the fusion of visual arts at Weltenburg that it is hard to separate the various contributions of the two brothers. Egid Quirin's individual genius is more readily appreciable in the monastic church of Rohr (rebuilt 1717-1723) where his spectacularly operatic, larger than life-sized sculptural group portraying the Assumption of the Virgin forms the focal point of the building (see no. 609).

A final masterpiece was the jewel-like church of St John Nepomuk (known as the Asamkirche) in Munich created by Egid Quirin (initially with the help of his brother) between 1729 and 1746. Inspired by Borromini's example in the Roman church of S. Carlo alle Quattro Fontane, Egid Quirin was able to turn the urban setting's constricted inelegance to brilliant advantage.

César BALDACCINI, called CESAR
(Marseille, 1921 – Paris, 1998)

"César" achieved a scandalous success and international notoriety with the sculptures made from crushed cars that he exhibited at the Salon de Mai in 1960. However these spectacular and apparently iconoclastic works represented only a short phase in a varied career. César first studied at the Ecole des beaux-arts in Marseille where he learned the most traditional methods from a sculptor who had worked in Rodin's studio as a stone-cutter, methods that he would later completely reject. In 1943, at the height of the German occupation, César moved to Paris, where he studied at the Ecole des beaux-arts until 1950. In the post-war years he was principally influenced by Alberto Giacometti, Constantin Brancusi, Germaine Richier and by the iron sculptures of Pablo Gargallo and Picasso. César's own first sculptures were made in the non-traditional materials of iron and plaster, beaten lead and soldered wire and various kinds of industrial scrap metal. These works were still figurative, representing animals, insects and humans as well as fantastic winged creatures. In his best known works, César reduced crushed cars and other industrial scrap material to simple block like forms. While seemingly in the subversive anti-art tradition of Dadaism, these works also display an interest in formal and aesthetic concerns. In the late 1960s César began to use polyurethane foam in a series of biomorphic sculptures entitled *Expansions*.

Nanni di BANCO
(Florence, c. 1375-1421)

The Italian sculptor and architect Nanni di Banco was the son of a Florentine artist named Antonio. He was among Donatello's best disciples and friends. Among his statues, he is especially praised for the *Santi Quattro Coronati* (see no. 355), created around 1410, and for his *St Phillip*, which adorns the Orsanmichele church in Florence. As an architect, he worked on the Duomo of Florence, where he made the statue of *St Luke*, executed in 1408 (see no. 351). Considered one of the major figures in the transition from the Gothic style to that of the Renaissance, his sculptures inspire admiration for their Gothic elegance, but also for the Greek and Roman influence on the *Santi Quattro Coronati* (see no. 355) Orsanmichele.

Ernst BARLACH
(Wedel near Hamburg, 1870 – Rostock, 1938)

Ernst Barlach was a German sculptor, printmaker and playwright whose work represented characteristic aesthetic and political tendencies in the Weimar Republic of 1919-1933.

Barlach studied sculpture at the Kunstgewerbeschule in Hamburg (1888-91) and later at the Dresden Academy. He also studied (like so many

German, British and American artists of the day) at the Académie Julian in Paris, where he would have come into contact with the simplified and flattened forms associated with Gauguin and the Nabis group.

Barlach's early work shows the influence of the curvilinear and decorative forms of the Art Nouveau style. A decisive change was brought about by a visit to Russia in 1906 where Barlach was profoundly impressed by the earthy and austere grandeur of the Russian peasantry. Ceramic pieces produced on his return from Russia such as *Blind Beggar* and *Russian Beggar-woman with Bowl* show the features that were to characterise his work from now on – bold, even crude simplification of form, concentration on the expressive power of faces and hands, with the figure swathed in bulky drapery, that as in medieval sculpture had a powerful expressiveness in itself.

Much of Barlach's mature work was carved in wood, a material largely ignored by leading European sculptors since the Renaissance, but which delighted Barlach on account of its inherent texture and roughness.

A highly-successful exhibition of thirty-seven wooden sculptures at the Paul Cassirer Gallery in Berlin in 1926 established Barlach as one of the leading cultural figures of the Weimar Republic. Many honours followed, culminating in the award of the Prussian Order of Merit in 1933.

Barlach's brief experience of military service in World War I led to a detestation of war that made him a highly suitable sculptor for the creation of war memorials. The most famous of these was the "Hovering Angel" suspended inside Gustrow Cathedral in 1927.

Barlach's pacifist and left-wing political views as well as the primitivism of his work made him an inevitable target of Nazi wrath after 1933. His work was included alongside that of Oskar Kokoschka as primary exhibits in the notorious exhibition of "Degenerate Art", organised by the Nazis in order to discredit modern art.

Richmond BARTHE
(Bay St Louis, Mississippi, 1901 – Pasadena, 1989)

Born in 1901, Richmond Barthé is today recognised as one of the leading artists of the twentieth century. Despite a lack of formal training in art, the African-American Barthé was admitted to the Art Institute of Chicago. Initially a painter, Barthé started modelling in clay to allow him a better understanding of the third dimension as a way of broadening his painting. This experience proved to be the turning point of his career as Barthé gave up painting and began experimenting with sculpture. His first success came in 1928 from an exhibition at the Chicago Art League where he showed two busts that excited great interest and admiration. In 1929 Barthé established himself in Harlem. His first solo exhibition took place in the Caz Delbo galleries and was an immense success, gaining him recognition and celebrity. However, New York proved to be a dangerous and often violent place to live, and Barthé decided to settle down in Jamaica. There he also felt uncomfortable and so moved to Italy and then on to Spain, before finally settling in Switzerland for five years. Barthé finished his rich life in Pasedena, California. His most famous works include the Toussaint L'Ouverture Monument in Port-au-Prince, Haiti, in front of the Palace, the *Walls of Jericho* in Harlem and the garden sculpture for the Edgar Kaufman house, *Falling Water*, designed for F. Lloyd. Many of his works have been acquired by public collections including museums such as the Metropolitan Museum in New York, the Whitney Museum of Art or the Art Institute of Chicago.

Frédéric-Auguste BARTHOLDI
(Colmar, 1834 – Paris, 1904)

The French sculptor Frédéric-Auguste Bartholdi, born in Colmar in 1834, was a student of the painter Ary Scherffer. Bartholdi's robust talent had already been manifested in a colossal statue of *Général Rapp*, unveiled

in 1855. In the course of his long and brilliant career, the artist successfully tried his hand in various genres. Colmar, his home town, possesses some good specimens of his work, including the *Bruat*, the *Monument of Martin Schön*, and the *Jeune Vigneron alsacien (Young Alsatian Vintner)*. He seems to have had the least success with allegory, with the exception of patriotic allegory. In this area, Bartholdi's rich talent brought him success with the public. The monumental *Lion of Belfort* (1880) is among his very best patriotic works, as well as the famous and colossal *Liberty Enlightening the World (The Statue of Liberty)* in New York (1886), given by France to the United States during the centenary celebrations of American independence (see no. 725).

Gian Lorenzo BERNINI
(Naples, 1598 – Rome, 1680)

The Italian sculptor, painter, and architect Gian Lorenzo Bernini took his first lessons in sculpture from his father Pietro Bernini, a mediocre artist. Bernini's first works testify to his rare talent. *David Fighting Goliath* that he allegedly created at the age of fifteen demonstrates the exactitude of his studies and the taste from which he had yet to depart. Cardinal Barberini, who became Pope under the name Urban VIII (1623), entrusted him with the execution of the embellishments planned for St Peter's Basilica in Rome. The first work Bernini put his hands to was the famous canopy or *baldacchino* of gilded bronze, placed over the tomb of St Peter beneath the immense dome. Next, he made niches in the four pillars which supported this dome and placed four statues there, one of which, *St Longinus* (see no. 539), he sculpted himself. The artist then built the Palazzo Barberini, one of the most beautiful modern buildings in Rome. Bernini was less happy with the project he took on to complete the facade of St Peter's, which, according to the sketches of Carlo Maderna, was to be accompanied by two bell towers. One of the towers partly fell when a part of the portico that served as a foundation for it collapsed in several places. Thereafter, the towers were totally demolished. This incident had no effect other than to stimulate Bernini's ardour. It was during this time that he completed the sketches of the chapel of Cardinal Cornaro in the Church of Santa Maria della Vittoria, where he installed the famous group *The Ecstasy of St Teresa* (see no. 502).

Pope Alexander VII commissioned him to decorate the porticos of the avenues of the Vatican basilica. After the *baldacchino*, the Throne of St Peter, completed next, is the most significant work in gilded bronze. The artist's least successful work was the grand stairway of the Vatican, built on an unsightly foundation. Bernini's various works spread his reputation throughout Europe. Louis XIV ordered Colbert to invite Bernini to come and take charge of the completion of the Louvre. The plan he proposed for the Louvre involved the complete destruction of what had already been constructed, despite Colbert's wishes. Nevertheless, the first stone of the new building was placed in a grand ceremony on 17 October 1665. However, in the end Bernini became so tormented that he declared that he wanted to leave and construction of the facade fell to Claude Perrault instead.

The works Bernini created at the end of his life are overshadowed by the grandeur of his work on St Peter's in Rome. However, there are two groups that he completed for the Chigi Chapel between 1655 and 1661, as well as the tomb of the Blessed Ludovica Albertoni (see no. 574) (c. 1671), that stand out in contrast to his later work.

The extraordinary eulogies Bernini received from his contemporaries have not been confirmed by posterity. Criticism has gone to the extreme in this regard. His great faults were remembered and not his enormous qualities; this exceptional artist worked for eight popes and up to his death was considered one of Europe's best artists and best men.

Umberto BOCCIONI
(Reggio Calabria, 1882 – Verona, 1916)

Though primarily active as a painter for much of his short career, it was as a sculptor that Umberto Boccioni made his most important artistic contribution through his exploration of dynamic form. Frustrated by the limitations of the derivative Post-Impressionist and Divisionist techniques that passed for modernism in the Italy of the early 1900s, Boccioni found the means to develop his ideas of modernity through his encounter with Marinetti, whose celebrated *Futurist Manifesto* had been published in February 1909, and above all through his discovery of Cubism in 1911. Boccioni used Cubist fragmentation of form in his paintings (and still more fruitfully in his sculptures) to express dynamic energy and movement.

From 1910 onwards Boccioni was a leading member of the Futurist movement, co-signing the *Manifest of Futurist Painting* in February 1910 with Carlo Carra, Luigi Russolo, Gino Severini and Giacomo Balla and writing the *Manifest of Futurist Sculpture* in 1912.

Boccioni's early death in World War I prevented him from following up his ideas for motorised sculpture, but in his *Unique Forms of Continuity in Space* (see no. 657) of 1913 he created an updated version of the *Nike of Samothrace* (see no. 106) for the machine age and one of the iconic sculptures of the twentieth century.

Giovanni BOLOGNA called GIAMBOLOGNA
(Douai, 1529 – Florence, 1608)

Giambologna was the most celebrated and successful sculptor working in Italy between Michelangelo and Bernini. There is little trace of his northern origins to be seen in his work, and he may be regarded as the most representative sculptor in the Mannerist style in Italy. Giambologna was apprenticed to the Flemish sculptor Jacques Du Broecq who had been to Italy and was open to Italianate influences. Giambologna also travelled to Rome, where he spent two years absorbing the lessons of the High Renaissance and where he was able to study first hand re-discovered Antique sculptures. On his return journey to Flanders in 1552 Giambologna stopped in Florence, where he was persuaded to stay and eventually became court sculptor to the Medici Dukes of Tuscany. The Medici courts were highly influential in matters of taste, and through his position there Giambologna's fame spread through the courts of Europe.

With its complex balletic poses, its spiralling composition and virtuoso cutting of marble, Giambologna's three figure sculpture, *The Rape of the Sabine* of 1581-1583 (see no. 493) in the Loggia dei Lanzi can be seen as a defining example of the Mannerist style in sculpture.

Among Giambologna's other major achievements are the graceful airborne bronze of *Mercury* (in several versions) (see no. 481), the over life-sized marble of *Samson slaying a Philistine* (1560-1562), Victoria and Albert Museum, London), the vast but playful Neptune fountain in Bologna (completed 1566), and numerous exquisite small scale bronzes produced by his workshop and sometimes used a diplomatic gifts.

Fernando BOTERO
(Medellin, born 1932)

Fernando Botero is one of the few twentieth-century artists who has been able to win critical acclaim and at the same time exercise a broad popular appeal with his paintings and sculptures of enormously inflated, volumetric figures both human and animal. After training as a matador, he worked as a newspaper illustrator. An early and crucial influence was that of the Mexican muralist Diego Rivera. The 1950s brought Botero to Europe, where he worked and studied in Barcelona, Madrid, Paris and Florence. During this period he developed a passion

for the Old Masters from Giotto, Uccello and Piero della Francesca, with their emphasis on simplified and sculptural form, through to the more painterly Velázquez and Goya. In the 1960s Botero was based in New York. In 1961 he painted his hugely popular *Mona Lisa, Age Twelve*, subsequently acquired by the Museum of Modern Art in New York. By the mid 1960s Botero's highly individual and instantly recognisable style with its smoothly-applied paint and inflated and rounded forms was fully developed. In the 1970s Botero moved to Paris, where he began to concentrate on sculpture. Amongst his better-known public sculptures are the *Broadgate Venus* in London and a giant male cat who menaces the new Ramblas in Barcelona.

Edmé BOUCHARDON

(Chaumont, 1698 – Paris, 1762)

French sculptor, Edmé Bouchardon was esteemed in his day the greatest sculptor of his time. Born at Chaumont, he became the pupil of Guillaume Coustou and gained the *Prix de Rome* in 1722. Resisting the tendency of the day, he was classic in his taste, pure, chaste, and always correct, charming and distinguished, a stickler for all the finish that sand-paper could give. During the ten years he remained at Rome, Bouchardon made a striking bust of Pope Benedict XIII (1730). In 1746 he produced his first acclaimed masterpiece, *Cupid making a Bow out of the Club of Heracles* (see no. 615), perfect in its grace, but cold in the purity of its classic design. His two other leading *chefs-d'œuvre* are the fountain in the rue de Grenelle in Paris, the first portions of which had been finished and exhibited in 1740, and the equestrian statue of Louis XV, a commission from the city of Paris. When the model was produced, this superb work was declared the finest of its kind ever produced in France. Bouchardon did not live to its finish, but left its completion to Pigalle. It was destroyed during the Revolution.

Louise BOURGEOIS

(Paris, born 1911)

Louise Bourgeois is a very long-lived artist who has received popular and critical acclaim in the latter part of her life. After helping in her parents' tapestry restoration workshop, she studied mathematics at the Sorbonne before turning to art. In 1938 she married the noted American art historian Robert Goldwater and moved to New York, where she studied painting at the Arts Students' League. The war years brought her into contact with refugee Europeans such as Joan Miró and André Masson, both Surrealists for whom she felt an affinity. Using both traditional materials (wood, bronze and marble) and non-traditional ones, Bourgeois created works which in their disturbing and often sexually explicit symbolism belong in the Surrealist tradition, but also reflect her shared preoccupations with the Feminist movement.

Constantin BRANCUSI

(Hobita, 1876 – Paris, 1957)

The Romanian sculptor Brancusi lived in Paris from 1904 and worked in series, returning to a small number of motifs time and time again in order to develop and reinterpret his vision of a subject. He was a highly-skilled craftsman who evolved artistically very rapidly. His early influences included African as well as Oriental art. Although Rodin was another early influence, Brancusi decided he wished to make much simpler pieces, and began an evolutionary search for pure form. He reduced his work to a few basic elements. Paradoxically, this process also tended to highlight the complexity of thought that had gone into its making. Monumental, subtle and intimate, Brancusi's sculptures are rightly now considered to be the work of a modern master.

Michelangelo BUONARROTI, called MICHELANGELO

(Caprese, 1475 – Rome, 1564)

The name "Michelangelo" has come to mean "genius." Firstly because his talents spanned sculpture, painting, architecture, army engineering and even poetry. Secondly, because he was the artist through whom Humanism found full expression.

Son of a minor civil servant from the minor nobility of Florence, Michelangelo was sent to study under Francesco d'Urbino, who opened Michelangelo's eyes to the beauties of Renaissance art. He was subsequently enrolled in Ghirlandaio's workshop (*bottega*) as an "apprentice or valet."

It was through Ghirlandaio that Michelangelo met Lorenzo de' Medici, also known as "Il Magnifico", a patron of art and literature who, inside his own palace, founded a school chaired by Bertoldo, a student of Donatello's. Through that school, Michelangelo met the Medici family and was greatly impressed by their fabulous collection of sculptural works.

By age sixteen, Michelangelo had achieved many works, including *The Battle of the (Lapiths and) Centaurs*, an allusion to the sarcophagi of Late Antiquity, and the *Madonna of the Stairs* (see no. 416). Around 1495, the cardinal Lorenzo di Pierfrancesco de' Medici invited the artist to Rome. Thus began Michelangelo's first period in Rome where he could explore even more of the splendours of the Antiquity he had first encountered in the Medici gardens. Here he did *Bacchus* (see no. 421) and in 1499, he finished the *Pietà* (see no. 340), one of his most beautiful accomplishments. The French ambassador to the Vatican under King Charles VIII commissioned it for his own tomb. Now in St Peter's Basilica in Rome, it is the perfect depiction of God's sacrifice and inner beauty. Michelangelo was then twenty-two. Soon, Michelangelo became one of the most influential artists of his era. Nicknamed "Il Divino", his genius moved art forward by drawing inspiration from Antiquity and reshaping it for the greater glorification of Man. The apogee of Michelangelo's youth was his 4.34 metres *David* in marble, now at the Académia of Florence (see no. 420). First sketched in 1501, it was completed in 1504. It was a break with tradition to show David without Goliath's head in hand.

In November 1503, Pope Pius III died, ceding the papal throne to Julius II. His Holiness persuaded Michelangelo to return to Rome where he commissioned a majestic tomb for himself along with other monuments. With influences from Classicism, it ranks among works the artist intended as monumental and representative of all the power and sensual delight that gives marble its unique nobility among stone. Finally completed in 1545, the tomb of Julius II faithfully reflects the pope's love of Antiquity. Then in 1520, Michelangelo was appointed for the creation of the Medici funerary chapel. This architectural gem contains the tombs of Giuliano de' Medici, Duke of Nemours, and Lorenzo, Duke of Urbino. The overall mood is like a scene from informal daily life rather than one of rigorous piety, thus demonstrating Michelangelo's ability to rise above his rebellious temperament and attain true freedom of artistic expression.

The pursuit of excellence haunted Michelangelo all his life, aggravated by an oversized ego and stamina superior to that of his contemporaries.

Pol BURY

(Haine-Saint-Pierre, near La Louvière, 1922 – Paris, 2005)

Pol Bury has been one of the leading twentieth-century exponents of kinetic or moving sculpture. Bury began his career as a painter strongly influenced by the Surrealists René Magritte and Yves Tanguy. In 1939 he joined the Surrealist group "Rupture", and in 1947 the Jeune Peinture Belge group, at which time he was also close to the Cobra group. His encounter with the mobile sculptures of Alexander Calder at the beginning of the 1950s was an important catalyst for Bury. He began to create moving

sculptures, such as *Mobile Planes* of 1953 and *Multiplanes* of 1957, that were powered by electric motors. Bury became increasingly fascinated by slow and imperceptible movement, and explored other means of creating movement such as magnetism and the weight of water. Notable examples of the latter were the fountains installed in the courtyard of the Palais Royal in Paris in 1985.

Melchiore CAFFA
(Vittoriosa, 1638 – Rome, 1667)

Melchiore Caffà was born on the island of Malta when it was the last bastion of Christendom against the encroaching Ottoman Empire and a centre of great counter-reformationary fervour. Moving to Italy, he followed in the footsteps of Gian Lorenzo Bernini as a brilliant exponent of the highly theatrical and dazzlingly virtuoso late Baroque style. Though he was trained by Ercole Ferrata who was himself a pupil of Bernini's greatest rival Alessandro Algardi, it was the more flamboyant and expressive Baroque of Bernini himself that influenced Caffà rather than the more restrained version of the Baroque style practised by Algardi and Ferrata. Caffà's agitated, operatically emotional Baroque derives from Bernini but also looks forward to final development of the style north of the Alps in the following century. Unfortunately, Caffà's early death in a foundry accident prevented him from fulfilling the brilliant promise of his few completed works, such as the astonishing *Ecstasy of St Catherine of Siena* made for the church of S. Caterina da Siena a Monte Magnanapoli in Rome. The numerous projects Caffà had undertaken before his death were completed by others – often by the workshop of his own teacher, Ercole Ferrata.

Jean-Jacques CAFFIERI
(Paris, 1725-1792)

Jean-Jacques Caffiéri is the most celebrated member of a family of French sculptors, metal smiths, and engravers, from which six members have achieved certain recognition. He began his education under his father and later studied art under Jean-Baptiste Lemoyne II. In 1748, he received the *Prix de Rome* for a bas-relief representing Cain killing Abel. The Royal Academy admitted him as a member in 1759. His most noteworthy works are: the *Holy Trinity* (Saint Louis des Français church in Rome), the statues of Pierre and Thomas Corneille, and, finally, that of Moliere. Several theatres in Paris, the Saint Genevieve library, and Versailles possess busts of famous people created by him.

Alexander CALDER
(Lawton, Pennsylvania, 1898 – New York, 1976)

The American sculptor Alexander Calder was the second child of Nanette Lederer Calder, a painter, and Alexander Stirling Calder, a sculptor. In his early youth he showed interest in scultpure, creating tiny sculptures made from brass wire. After graduating from the Stevens Institute of Technology with a degree in Mechanical Engineering, he began, in 1923, to take classes at the Art Students' League in New York. During the summer of 1926 Calder travelled to France where he started drawing at the Académie de la Grande Chaumière in Paris. There he began to give performances of his miniature *Cirque Calder*. It was at the beginning of the 1930s that a visit to Piet Mondrian's studio inspired him to create completely abstract works. The next year he began to introduce moving parts into his sculptures, later named "mobiles" by Marcel Duchamp. After going back to America, Calder started to design sets for ballets by Martha Graham and Eric Satie. In 1937, *Devilfish,* Calder's first large-scale stabile, was completed, after which he continued to concentrate on similar large-scale works.

The work of Alexander Calder was part of kinetic art, a movement concerned with movement, objects in actual motion. With his mobiles, made of wire and pieces of wood, his genius changed these ordinary materials into abstract universes.

CALLIMACHUS
(Active c. 432 – c. 408 B.C.E.)

An ancient sculptor and engraver, Callimachus was nicknamed *"katatxitechnos"* – "the perfectionist." He left behind no writings, but we know his life through the works of Pausanias and Vitruvius, although today certain of their accounts seem doubtful. It is known that he contributed to the decoration of the Erechtheion. For this temple he created, among other things, a magnificent golden lamp, above which was mounted a bronze palm branch, which trapped the smoke. Several beautiful sculptures were also ascribed to him: a group of Lacedemonian dancers and a statue of the seated Hera made for the Heraion of Plataea. What characterises Callimachus more than anything else is his painstaking attention to detail; hence the nickname. Purportedly, he was the first to use a drill for shaping marble. He modelled his work on the tradition of the old masters and pioneered the Archaic style.

Callimachus also has a place in the history of architecture. He is considered the inventor of the Corinthian capital. According to the legend told by Vitruvius, he got the idea while looking at the acanthus blossom wrapped around a basket which had been placed on a child's tomb.

Alonzo CANO
(Granada, 1601-1667)

Spanish painter, architect, and sculptor, Alonzo Cano's genius left Spain with a large number of works, which display boldness of design, flair with pencil, purity of flesh-tints and knowledge of chiaroscuro. He learned architecture from his father, Miguel Cano, painting from Pacheco and sculpture from Juan Martínez Montañes. As statuary, his most famous works are the *Madonna and Child* in the church of Nebrissa, and the colossal figures of San Pedro and San Pablo. As an architect he indulged in profuse ornamentation and too often yielded to the fancies of his day. Philip IV appointed him royal architect and the king's painter, and gave him the church preferment of a canon. His principal pictures hang in Madrid. Notorious for his ungovernable temper, it is said that, when in a rage with the purchaser who grudged his asking price, he once risked his life by committing the then capital offence of dashing to pieces the statue of a saint. According to another story, his well-known outbursts also caused him to be suspected, and even tortured, for the murder of his wife, although all evidence pointed to his servant as being the culprit.

Antonio CANOVA
(Possagno, 1757 – Venice, 1822)

Italian sculptor, Antonio Canova was the grandson of a talented stonemason and spent his early life with him modelling in clay. His talent was obvious; the influential Senator Falieri noticed the young boy and had him placed with the sculptor Torretto, to learn his art. At the age of sixteen, he created his first work, Eurydice, followed by Orpheus, Daedalus and Icarus. Canova went to Rome in 1780, where he was strongly influenced by classical Antiquity. During this time, he modelled a masterpiece called *Theseus and the Minotaur* which is today in Vienna. He produced many other admirable works in Rome, including *Psyche Awakened by Eros* (see no. 650) in the Louvre, and *Creugas and Damoxenus* in the Vatican Gallery. He was admired by Napoléon I from whom he received an important commission to execute a colossal statue of him.

He became the imperial sculptor and portraitist of Napoléon's mother, Marie-Louise, Pauline Bonaparte and many other members of the court. In Vienna, he was charged with the creation of a monument for Maria Christina, the Archduchess. His most famous portrait is probably the *Bust of Pius VII*, created in 1807. Promoted by the Pope, given the title of Marquis of Ischia, Canova made a huge statue named *Religion*. Many other commissions followed, among which feature famous masterpieces such as *Infant St John*, *The Recumbent Magdalena*, a statue of Washington and his *Pietà*. Other important commissions include the tombs of two popes, Clement XIII and Clement XIV. Buried in Possagno, where he was born sixty-five years earlier, Canova is considered the artist who defined classical, elegant sculpture and was of primary importance in the development of the neoclassical style.

Sir Anthony CARO
(New Malden, born 1924)

Sir Anthony Caro was initially trained as an engineer before attending the Royal Academy Schools in London from 1947 to 1952. From 1951 to 1953 he worked as an assistant to Henry Moore, then very much the most admired and influential of British sculptors. Moore undoubtedly helped Caro move beyond the parochial standards of the Royal Academy, but Moore's art eventually proved more significant for Caro's development in a negative sense as something against which he needed to react. In the 1950s Caro created freely and expressively modelled figures influenced by Dubuffet, Picasso and De Kooning. After a period of dissatisfaction and experimentation at the end of the 1950s, and a trip to America from 1959 to 1960, during which he was influenced by the writings of Clement Greenberg and the welded metal sculptures of David Smith, there was a decisive change of direction in Caro's work. He began to produce abstract sculptures in welded metal painted in single primary colours that were placed directly on the ground without plinths, producing an impression of airy lightness and energy. In the 1970s Caro stopped painting his sculptures and instead adopted raw and rusted surfaces that emphasised the nature of the material. A major 1975 exhibition at the Museum of Modern Art in New York established his international reputation.

Jean-Baptiste CARPEAUX
(Valenciennes, 1827 – Courbevoie, 1875)

The French sculptor Jean-Baptiste Carpeaux was the son a stonemason, and his family lived in great poverty. At the age of fifteen he moved to Paris and two years later he was admitted to the Ecole des beaux-arts. He executed the much admired statue of *Hector and Astyanax* for which he was awarded the *Grand Prix de Rome* in 1854. Disagreeing with the French Academy and fascinated by the works of Michelangelo and Donatello, he decided to move to Rome in 1856. There he created, amongst others, his masterpiece, a dramatic group based on Dante's inferno, *Ugolino* (see no. 697). Although it gained him only a second-class medal at the Salon, it was admired by Napoléon and the court assuring him permanent success as well as notoriety. The imperial prince commissioned a statue from Carpeaux. Among other famous works, he decorated the Pavillon de Flore and designed the frontispiece of the town hall of Valenciennes. In 1869 the group he made for the Opera Garnier, *The Dance* (see no. 698), created a scandal with its freedom of movement and laughing characters.

Another of his later masterpieces was the Parisian fountain, *The Four Quarters of the World*, featuring a globe which is held by four female sculptures representing the four continents. Carpeaux received many honours during his life. His best sculptures are noble in conception, his style naturalistic and full of emotion.

Benvenutto CELLINI
(Florence, 1500-1571)

Italian artist, metalworker, and sculptor, Benvenuto Cellini was the third child of Giovanni Cellini, a musician and artificer of musical instruments. When he reached the age of fifteen his father reluctantly consented to his being apprenticed to a goldsmith. He had already attracted notice in his native area when he was banished for six months in Siena, where he worked for a goldsmith; from there he moved to Bologna, where he made progress as a goldsmith. After visiting Pisa and after twice resetting from a short time in Florence, he left for Rome. He was nineteen. His first attempt at his craft there was a silver casket, followed by some silver candlesticks, and later by a vase for the bishop of Salamanca, which introduced him to the favourable notice of Pope Clement VII. In the attack upon Rome by the constable de Bourbon, which occurred immediately after, in 1527, the bravery and address of Cellini proved of particular service to the pontiff. His exploits paved the way for reconciliation with the Florentine magistrates, and he returned shortly after to his native place. Here he assiduously devoted himself to the execution of medals, the most famous of which are *Heracles and the Nemean Lion*, in gold repoussé work, and *Atlas supporting the Sphere*, in chased gold. From Florence he went to the court of the Duke of Mantua, and then again to Florence and Rome, where he was employed not only in the working of jewellery, but also in the execution of dies for private medals and for the papal mint.

Between 1540 and 1545 he worked at the court of Francis I at Fontainebleau and in Paris, where he created his famous saltcellar of gold enriched with enamel (see no. 458). After approximately five years of laborious and sumptuous work, the intrigues of the king's favourites led him to retire to Florence, where he employed his time in works of art, and exasperated his temper in rivalries with the uneasy natured sculptor Vaccio Bandinelli. During the war with Siena, Cellini was appointed to strengthen the defences of his native city, and, though rather shabbily treated by his ducal patrons, he continued to gain the admiration of fellow citizens by the magnificent works he produced. He died in Florence in 1571, unmarried, leaving no posterity, and was buried with great pomp in the church of Annunziata.

Besides the works in gold and silver, previously mentioned, Cellini executed several pieces of sculpture on a grander scale. The most distinguished of these is the bronze *Perseus* (see no. 465), a work (first suggested by Duke Cosimo de' Medici) now in the Loggia dei Lanzi at Florence, full of fiery genius and the grandeur of terrible beauty, one of the most typical and unforgettable monuments of the Italian Renaissance. The casting of this great work gave Cellini the utmost trouble and anxiety; and its completion was hailed with rapturous homage from all parts of Italy.

Camille CLAUDEL
(Fère-en-Tardenois, 1864 – Villeneuve-les-Avignon, 1943)

It is still hard to separate the achievements of Camille Claudel from that of her lover and mentor Auguste Rodin. Both as a model and as an assistant she helped to create many of his masterpieces. It is even possible that he appropriated some of her own creative ideas. Like many artists who worked with him it was difficult for her to escape from his giant shadow. However suggestions that she was exploited by him have certainly been exaggerated, and she worked throughout her career in a style that was essentially created by Rodin. Claudel's earliest teacher was Alfred Boucher and her skills as a sculptor were well-developed before she met Rodin in the early 1880s. Claudel's intense creative and personal relationship with Rodin lasted until 1898 but eventually foundered upon the fact that he refused to abandon his older mistress Rose Beuron and

commit himself to Claudel. Her bitterness was expressed in the transparently autobiographical three-figure group entitled *The Age of Maturity* (see no. 778). Rodin continued to offer what support he could to Claudel's career after the end of their affair. Her deteriorating mental health and the death of her father enabled her brother, the Catholic writer Paul Claudel, to have her placed in an asylum in 1913. She remained institutionalised for the rest of her life.

Michel COLOMBE
(Bourges (?) c. 1430 – Tours, c. 1512)

The name of this French sculptor was buried in oblivion until 1727, when the magnificent tomb of Francis II, the last Duke of Brittany, was discovered. Mellier, the magistrate from Nantes who presided over the ceremony, discovered the following inscription: *The pure art and industry of Michel Colombe, the first sculptor of our time native to the viscounty of Leon.* Today, two works are attributed with certainty to this master: the tomb of Francis II, in which Michel Colombe was assisted by Jean Perreal and Girolamo da Fiesole, and *St George and the Dragon* (see no. 437) (formerly at the Château de Gaillon), displayed in the Louvre. It is the quality of this bas-relief that is responsible for Michel Colombe's fame, due to its captivating and vigorous style, combined with elements of French Gothic art and influences of the Italian Renaissance, which had begun to pour into the south of France, without, however, relying on a specific iconographic model.

Charles Henri Joseph CORDIER
(Cambrai, 1827 – Algeria, 1905)

The French sculptor Charles Cordier was a student of Fauginet and Rude. His work was first displayed at the 1844 Salon. His goal was to study the different races of mankind. Having visited North Africa a number of times, as well as Greece and Italy, he returned armed with material that allowed him to found his anthropological and ethnographic gallery. His works, more remarkable for their force than for their grace, exhibit both a genuine scientific understanding and a true originality. He excelled at producing the various racial types in their intimate character, giving them a palpable life force. Many of his busts, in particular his *Capresse des Colonies* (see no. 689) and his *Negro of the Sudan* (see no. 688) are pieces in which he succeeded in reviving the art of polychrome sculpture.

Nicolas and Guillaume COUSTOU
Nicolas (Lyon, 1658 – Paris, 1733) – Guillaume (Lyon, 1677 – Paris, 1746)

French sculptors, Nicolas and Guillaume Coustou were the sons of a wood-carver in Lyon. At eighteen Nicolas moved to Paris to study under Antoine Coysevox, his mother's brother, who presided over the recently-established Academy of Painting and Sculpture; at twenty-three he won the Colbert prize, which entitled him to four years education at the French Academy of Rome. He subsequently became rector and chancellor of the Academy of Painting and Sculpture. From the year 1700 he was an active collaborator with Coysevox at the palaces of Marly and Versailles. His ability was remarkable, and though especially influenced by Michelangelo and Algardi, his numerous works are among the most representative samples of his age existing today.

His younger brother, Guillaume Coustou, was a sculptor of still greater merit. He also gained the Colbert prize, but refused to submit to the Academy's rules, and soon left it. For some time he wandered homeless through the streets of Rome. At length the sculptor Legros, under whom he studied for some time, befriended him. Returning to Paris, in 1704 he was admitted into the Academy of Painting and Sculpture, of which he later became director; like his brother, he was employed by Louis XIV. His finest work is the famous group of the *Horse restrained by a Groom* (see no. 618), originally at Marly, now in the Champs Elysées at Paris.

Elegance, liberty, and the life of these groups ranks their creators high in the French school.

Charles-Antoine COYSEVOX
(Lyon, 1640 – Paris, 1720)

French sculptor, Charles-Antoine Coysevox came from a family of Spanish origin. His artistic talent developed early and by the time he was seventeen, he modelled his first statue, an admirable Madonna. In 1671, by special request of Louis XIV, the young sculptor executed various monuments in Versailles and Marly. He also made decorative sculptures for the royal gardens and many interior designs. In 1676, in acknowledgement of his art, he was selected a member of the Academy, a great honour for an artist. He was commissioned to make bronze statues of Louis XIV and Charlemagne, which can be admired at Saint-Louis-des-Invalides, a church in Paris. His most notable achievement is probably *Fame Mounted on Pegasus* (see no. 588), which embellishes the entrance of the Tuileries, representing a winged horse, bearing Mercury and Fame. The exquisite lines of some of the church monuments in Paris come from his hands and are among the most notable artistic achievements of the city, where he died at the age of eighty.

Honoré DAUMIER
(Marseille, 1808 – Valmondois, 1879)

French caricaturist, printer and sculptor Honoré Daumier showed in his earliest youth an irresistible inclination towards the artistic profession. Having mastered the technique of lithography, Daumier started his artistic career by producing plates for music publishers and illustrations for advertisements. When, in the reign of Louis Philippe, Philipon launched the comic journal *La Caricature*, Daumier joined its staff and embarked on his pictorial campaign of scathing satire upon the foibles of the bourgeoisie, the corruption of the law and the incompetence of a blundering government. His caricature of the king as "Gargantua" led to Daumier's imprisonment for six months at Sainte-Pélagie in 1832. The publication of *La Caricature* discontinued soon after, but Philipon provided a new field for Daumier's activity when he founded *Charivari*. For this journal Daumier produced his famous social caricatures, in which bourgeois society is held up to ridicule in the figure of Robert Macaire, the hero of a then-popular melodrama. In 1848 Daumier re-embarked on his political campaign, still in the service of *Charivari*, which he left in 1860 and rejoined in 1864.

It is while working for this journal that Daumier made his thirty-six busts of legislators in coloured terracotta (see nos. 675, 676, 677, 678). It has often been said that he had made them directly in the Chamber, but it is most likely that he only made sketches there before working on his sculptures in his studio.

In spite of his prodigious activity in the field of caricature, he still found time for painting. One of the pioneers of naturalism, Daumier was before his time, and did not meet with success until in 1878, a year before his death, when M. Durand-Ruel collected his works for an exhibition at his gallery.

Hilaire-Germain-Edgar DEGAS
(Paris, 1834-1917)

Painter, sculptor and etcher, Edgar Degas was originally from a well-to-do family. As a child, he studied at the Parisian secondary school, Louis-le-Grand, and then at the Faculty of Law. However, with

his parents' backing, he soon dedicated himself to art, his true vocation. Contrary to a great number of artists, the wealth of the Degas family freed him from having to make a living from his art. While he was linked to the Impressionist group, Degas worked in the studio in a realistic style. In painting, as in sculpture, the artist liked to transpose themes that were dear to him. Dancers, young women bathing and even portraits were equally undertaken in painting or in bronze. Even if he was one of the least controversial artists of his time, the modernism of his work was largely criticised. Objecting to an art which hypocritically offered the images that the public expected, Degas chose to attach himself, at the risk of shocking, to the representation of reality. This search attained its zenith when he exhibited *Little Dancer Aged Fourteen* (see no. 656), an actual little girl in bronze. Edgar Degas died in Paris in 1917 and remains today one of the greatest artists of the nineteenth century.

Andrea DELLA ROBBIA
(Florence, 1435-1525)

Italian sculptor, Andrea della Robbia was the nephew and pupil of Luca della Robbia. He carried on the production of the enamelled reliefs on a much larger scale than his uncle had ever done; he also extended its application to various architectural uses, such as friezes, fountains, and large retables. The result of this was that, though the finest reliefs from the workshop of Andrea were little if at all inferior to those by the hand of Luca, others produced by pupils and assistants achieved only a lower standard of merit. One method introduced by Andrea in his enamelled work was to omit the enamel on the face and hands (nude parts) of his figures, especially in those cases where he had treated the heads in a realistic manner, as, for example, in the noble tympanum relief of the meeting of St Domenic and St Francis in the loggia of the Florentine hospital of San Paolo, a design suggested by a fresco of Fra Angelico's in the cloister of San Marco. One of the most remarkable works by Andrea is the series of medallions with reliefs of Infants in white on blue ground set on the front of the foundling hospital at Florence. No two alike, these lovely child-figures are modelled with wonderful skill and variety. For guilds and private persons, Andrea produced a large number of reliefs of the Madonna and Child varied with much invention (see no. 382); all possess extreme beauty of pose and sweetness of expression. While the main relief is left white, these are frequently framed with realistic yet decorative garlands of fruit and flowers painted with coloured enamels.

Luca DELLA ROBBIA
(Florence, 1400-1482)

Italian sculptor, Luca della Robbia was the son of a Florentine named Simone di Marco della Robbia. During the early part of his life Luca executed many important and exceedingly beautiful pieces of sculpture in marble and bronze. In technical skill he was quite the equal of Ghiberti, and, while possessing all Donatello's vigour, dramatic power and originality, he frequently excelled him in grace of attitude and soft beauty of expression. No sculptured work of the great fifteenth century ever surpassed the singing gallery, which Luca made for the cathedral at Florence between 1431 and 1440, with its ten magnificent panels of singing angels and dancing boys.

The most important existing work in marble by Luca (executed in 1454-1456) is the tomb of Benozzo Federighi, bishop of Fiesole. A beautiful effigy of the bishop in a restful pose lies on a sarcophagus sculptured with graceful reliefs of angels holding a wreath containing the inscription. A rectangular frame formed of painted tiles of exquisite beauty, though out of keeping with the memorial, surrounds the effigy.

The few other works of this class that exist do not approach the beauty of this early essay in tile painting, on which Luca evidently put forth his utmost skill and patience.

In the latter part of his life Luca was mainly occupied with the production of terracotta reliefs covered with enamel, a process that he improved upon, but did not invent, as Vasari asserts. The *rationale* of this process was to cover the clay relief with enamel formed of the ordinary ingredients of glass *(marzacotto)*, made white and opaque by tin oxide. In 1471 Luca was elected president of the Florentine Guild of Sculptors, but he refused this great honour on account of his age and infirmity. It demonstrates, however, the high estimation in which his contemporaries held him.

DONATELLO
(Florence, c. 1386-1466)

Donatello, an Italian sculptor, was born in Florence, and received his initial training in a goldsmith's workshop; he worked for a short time in Ghiberti's studio. Too young to enter the competition for the baptistery gates in 1402, the young Donatello accompanied Brunelleschi when, in disappointment, he left Florence and went to Rome to study the remains of classical art. During this period Brunelleschi undertook his measurements of the Pantheon dome, which enabled him to construct the noble cupola of Santa Maria del Fiore in Florence, while Donatello acquired his knowledge of classic forms and ornamentation. The two masters, each in his own sphere, were to become the leading spirits in the art movement of the fifteenth century.

Back in Florence around 1405, he was entrusted with the important commissions for the marble *David* and for the colossal seated figure of *St John the Evangelist*. We find him next employed at Orsanmichele. Between 1412 and 1415, Donatello completed the *St Peter*, the *St George* (see no. 358) and the *St Mark* (see no. 356).

Between the completion of the niches for Orsanmichele and his second journey to Rome in 1433, Donatello was chiefly occupied with statuary work for the campanile and the cathedral. Among the marble statues for the campanile are the *St John the Baptist*, *Habakkuk* (see no. 359), the so-called "Il Zuccone" (Jonah?) and *Jeremiah*.

During this period Donatello executed some work for the baptismal font at San Giovanni in Siena, which Jacopo della Quercia and his assistants had begun in 1416. The relief, *Feast of Herod* (see no. 344), already illustrates the power of dramatic narration and the skill of expressing depth of space by varying the treatment from plastic roundness to the finest *stiacciato*.

In May 1434, Donatello was back in Florence and immediately signed a contract for the marble pulpit on the facade of the Prato cathedral, a veritable bacchanalian dance of half-nude *putti*, the forerunner of the "singing tribune" for the Florence cathedral, on which he worked intermittently from 1433 to 1440.

But Donatello's greatest achievement of his "classic period" is the bronze *David* (see no. 365), the first nude statue of the Renaissance, well-proportioned, superbly balanced, suggestive of Greek art in the simplification of form, and yet realistic, without any striving after ideal proportions.

In 1443 Donatello was invited to Padua to undertake the decoration of the high altar of San Antonio. In that year the famous Condottiere Erasmo de' Narni, known as Gattamelata, had died, and it was decided to honour his memory with an equestrian statue. This commission, and the reliefs and figures for the high altar, kept Donatello in Padua for ten years. The Gattamelata was finished and unveiled in 1453, a powerful and majestic work.

Donatello spent the remaining years of his life in Florence.

Jean DUBUFFET
(Le Havre, 1901 – Paris, 1985)

The French sculptor, Jean Dubuffet, was born into a family of wine merchants. After an evening course at the Ecole des beaux-arts in Le Havre, he went to Paris in 1918, where he attended the Académie Julian, leaving after only six months. Friend of numerous artists and writers, he traveled to Algeria, Lausanne and in Italy but in 1924, he stopped painting for eight years, in order to take over his father's business.

In 1942, after many interruptions, he decided to concentrate totally on painting. His works were exhibited in Paris, New York and Basle, creating great controversy. In 1965 he began to create sculptures in expanded polystyrene, painted in vinyl. From 1969 these works were the object of several public commissions, such as *The Group of Four Trees* on Chase Manhattan Plaza in New York in 1969 and the *Tower with Figures* in 1983 for the French state (erected on the Ile Saint-Germain, close to the capital). Jean Dubuffet considered these monumental sculptures as proliferations of cells, a continuity in space between sites, objects and figures. In giving three dimensions to his paintings, he allowed his graphics to escape the paper and invade space with monumental elements.

Marcel DUCHAMP
(Balinville, 1887 – Neuilly-sur-Seine, 1968)

Despite a relatively small œuvre as a painter and sculptor, Marcel Duchamp exercised a powerful and enduring influence on the art of the twentieth century, primarily as a theorist. He was the brother of the sculptor Raymond Duchamp-Villon and the half-brother of Jacques and Suzanne Villon. Along with his two brothers he was involved with the sub-cubist Section d'Or group in the years before the outbreak of World War I. At this time he painted his notorious *Nude descending a Staircase* (1911-12) which provoked a scandal at the New York Armory show in 1913 and which anticipated the Futurist use of Cubist fragmentation to express movement. His most ambitious work was *The Bride Stripped Bare by her Bachelors, Even* (1915-23) executed on glass and incorporating a coffee-grinder as a sexual metaphor. But perhaps Duchamp's most influential contribution to twentieth-century art was the introduction of the notion of "ready-made" or found object. *Bicycle Wheel* (see no. 811) was exhibited in 1913, followed by *The Bottlerack* in 1914, and the urinal signed "R. Mutt" and exhibited under the title of *Fountain* in 1917 (see no. 826).

Raymond DUCHAMP-VILLON
(Damville, 1876 – Cannes, 1918)

Raymond Duchamp-Villon was one of the most talented and tragic casualties of World War I in the arts. He died in the final weeks of the war from septicaemia which he contracted while serving as a voluntary auxiliary doctor. Duchamp-Villon was the middle of three artist brothers, the eldest being Jacques Villon and the youngest Marcel Duchamp. Duchamp-Villon's studies at the Faculte de Medicine in Paris were interrupted by illness in 1898, and it was while convalescing that he discovered his vocation for sculpture. Though largely self-taught, he soon attained considerable technical mastery, exhibiting at the fairly traditionalist Salon National and later at the more adventurous Salon d'Automne in a style initially much influenced by Rodin. As with so many artists of his generation, Duchamp-Villon needed to throw off this influence, and Cubism eventually provided the means to do so.

In 1906 Duchamp-Villon moved to the district of Puteaux, west of central Paris, where he shared a studio with his brother, Jacques Villon, and with the Czech artist Frank Kupka. After 1910 these studios became a magnet for a group of artists that included Jean Metzinger, Albert Gleizes, Roger de la Frenaye, Henri le Fauconnier and Fernand Léger. These young artists were all keen to explore the exciting possibilities opened up by the advent of Cubism. They exhibited together at the Salon d'Automne of 1911 and under the group title of Section d'Or at the Galerie La Boetie in 1912. In the two years that remained to him before the outbreak of war, Duchamp-Villon produced his most innovative and original works. In many ways these works paralleled contemporary work by the Italian Futurists. Like the Futurists, Duchamp-Villon used Cubist devices to represent movement and the dynamism of modern life. His best-known work entitled *Horse* (see no. 813) was completed while on leave from military service, and was cast in bronze after his death.

François DUQUESNOY
(Brussels, c. 1597 – Leghorn, 1643)

The Belgian sculptor François Duquesnoy is best known in France under the name of François Flamand, or, in Italy, where he arrived in 1618, under the name of Francesco Fiamingo. A friend of Poussin, he is considered an equal of Francesco Algardi. He took his first lessons in art from his father, an accomplished sculptor, and was sent by Archduke Albert to Rome to study classical art. There, Pope Urban VIII commissioned him to create a *St Andrew* for St Peter's Basilica. This artist especially excelled in the representation of graceful themes.

Gregor ERHART
(Ulm (?), c. 1460/79 – Augsburg, 1540)

Gregor Erhart was born into an important and prolific family of German late Gothic sculptors. His father Michael Erhart ran a successful sculpture workshop in the city of Ulm. Gregor Erhart's early work is difficult to distinguish from that of his father and attributions are much disputed by experts. Gregor Erhart was granted citizenship of the prosperous mercantile city of Augsburg in 1494. Augsburg was one of the first cities north of the Alps to open to Renaissance influence. This influence showed itself in Gregor Erhart's work. He moved beyond the constrictions of late gothic work. His figures exhibit a new freedom and plasticity. Especially remarkable is an extraordinarily life like, full-length, polychrome wooden sculpture of the *St Mary Magdalene* in the Louvre (see no. 423).

Etienne Maurice FALCONET
(Paris, 1716-1791)

A French sculptor whose parents were poor, Etienne Maurice Falconet was at first apprenticed to a carpenter, but some of his clay-figures, which he made during leisure time, attracted the notice of the sculptor Lemoyne, who took him as his pupil. He found time to study Greek and Latin, and also wrote several *brochures* on art. His artistic productions are characterised by the same defects as his writings, for though manifesting considerable cleverness and some power of imagination, they display in many cases a false and fantastic taste, probably the result of excessive striving for originality. One of his most successful statues was *Milon of Croton*, which secured his admission to the membership of the Academy of Fine Arts in 1754. At the invitation of the Empress Catherine he went in 1766 to St Petersburg, where he executed a colossal statue of *Peter the Great* in bronze (see no. 627). In 1788 he became director of the French Academy of Painting. Many of Falconet's works, being placed in churches, were destroyed at the time of the French Revolution.

Armand FERNANDEZ, called ARMAN
(Nice, 1928 – New York, 2005)

The French sculptor "Arman" owes his commonly-used name to a printer's error that led him to drop the last letter of his forename in 1958; later, in 1967, he abandoned his surname altogether. Between 1946 and 1951 he studied art in Nice and Paris, and in 1960 he became a founding member of the Nouveaux Réalistes group of artists in Paris. Some members of this group shared his interest in popular culture and its artefacts and, like him, they exhibited in the "New Realists" exhibition held in New York in 1962, the show that provided the ultimate breakthrough for Pop/Mass-Culture Art. Arman settled in New York in 1963, and in the following year he held his first museum exhibition at the Walker Art Center in Minneapolis. He has shown widely ever since, and a major retrospective of his work was mounted in Paris in 1998.

Naum GABO
(Don Klimovichi, 1890 – Waterbury, 1977)

Born Naum Borisovich Pevzner, the sculptor known as Naum Gabo changed his name to avoid confusion with his brother Antoine Pevsner, also a distinguished sculptor. Gabo moved to Munich in 1910, initially to study medicine and then, from 1912-14, to study engineering at the prestigious Technische Hochschule, which no doubt provided him with many of the techniques he used later in innovative constructed sculptures. While in Munich, which was second only to Paris at the time as a centre for contemporary art, he began to develop an interest in the visual arts. At the outbreak of World War I Gabo was forced to leave Germany and seek refuge in Norway. Here he began to experiment with materials such as cardboard, plywood and galvanised iron that were more associated with industry and the construction of buildings than with traditional fine arts. In 1916 he was joined in Norway by his brother Antoine Pevsner. The two brothers returned to Russia in 1917, where they exchanged ideas with Vladimir Tatlin and Kasimir Malevich at the Moscow College of Art. In 1920, together with his brother, he published his *Realist Manifesto* in which he postulated his ideas for a constructivist and kinetic art. These ideas were given radical expression in his *Kinetic Construction (Standing Wave)* of 1919-20, a vibrating vertical wire powered by an electric motor. In 1922, finding himself out of sympathy with the materialist direction taken by Constructivism in Soviet Russia, he left for Berlin, where he exhibited alongside Kurt Schwitters, Hugo Haring and artists associated with the Bauhaus. In 1927 Gabo produced controversial constructivist designs for Diaghilev's ballet *La Chatte*. After the rise of the Nazis in 1933, Gabo settled in Paris, but then moved on to England, where he found a sympathetic response from the art critic Herbert Read and artists such as Ben Nicholson and Barbara Hepworth. Gabo took refuge in Cornwall from 1939-1946, after which he moved on to the United States. There he received considerable recognition and major public commissions in the latter part of his life.

Lorenzo GHIBERTI
(Florence, c. 1378-1455)

Italian sculptor, Lorenzo Ghiberti learned the trade of a goldsmith under his father Ugoccione, and his stepfather Bartoluccio. In the early stages of his artistic career Ghiberti was best known as a painter in fresco. In Rimini, he executed a highly prized fresco in the palace of the sovereign Pandolfo Malatesta.

Informed that a competition was to be opened for designs of a second bronze gate in the baptistery, Ghiberti returned to Florence to participate in this famous artistic competition. The subject for the artists was the sacrifice of Isaac, and the competitors were required to observe in their work a certain conformity to the first bronze gate of the baptistery,

executed about 100 years before by Andrea Pisano. Of the six designs presented by Italian artists, those of Donatello, Brunellesehi and Ghiberti were pronounced the best; Brunelleschi and Ghiberti tied for first. The thirty-four judges entrusted the execution of the work to the two friends. Brunelleschi, however withdrew from the contest. The first of his two bronze gates for the baptistery occupied Ghiberti twenty years (see no. 343).

To his task Ghiberti brought deep religious feeling and a striving for a high poetical ideal absent from the works of Donatello. The unbounded admiration called forth by Ghiberti's first bronze gate led to his receiving from the chiefs of the Florentine guilds the order for the second gate, of which the subjects were likewise taken from the Old Testament. The Florentines gazed with special pride on these magnificent creations. Even a century later they must still have shone with all the brightness of their original gilding when Michelangelo pronounced them worthy to be the gates of paradise (see no. 346). Next to the gates of the baptistery Ghiberti's chief works are his three statues of St John the Baptist, St Matthew, and St Stephen, executed for the church of Orsanmichele. He died at the age of seventy-seven.

Alberto GIACOMETTI
(Borgonovo, near Stampa, 1901 – Chur, 1966)

Albert Giacometti was one of most highly-respected and influential European sculptors of the twentieth century. He was the son of the painter Giovanni Giacometti, the nephew of the painter and decorative artist Augusto Giacometti, and the older brother of the furniture maker and sculptor Diego Giacometti. Alberto began his painting studies at the Ecole des beaux-arts and his sculptural studies at the Ecole des arts et métiers in Geneva immediately after World War I. In 1922 he moved to Paris, where he studied under the sculptor Antoine Bourdelle. From 1925 he broke with academic techniques and began to explore the new sculptural possibilities raised by Cubism. From 1927 to 1934 Giacometti was heavily influenced by the Surrealist movement, and it was at this time that he produced his first mature and highly-original works. Turning to the characteristically surrealist themes of the dream and the unexpected juxtaposition (*The Palace at 4 a.m.*) and sexuality and violence (*Woman with her Throat cut*) Giacometti produced sculptures which, though cast in bronze, have the look of assemblages. In the first half of the 1930s Giacometti participated in several important Surrealist group exhibitions.

A creative crisis in 1935 caused Giacometti to reject Surrealism and to return to an art based on the study of reality, though not to any kind of academic naturalism. This period of creative block lasted a decade, and was only resolved after Giacometti's return to Paris from Switzerland at the end of World War II. In the immediate post-war years Giacometti evolved his late style of elongated and emaciated figures and busts upon which his fame largely rests. These skeletal figures were perceived as expressing a post-war mood of existential angst, and it was no coincidence that they were particularly admired by the philosopher Jean Paul Sartre, who wrote two essays on the sculptor's work. After a renewed crisis of confidence in the mid 1950s Giacometti continued to work prolifically and obsessively until his death in 1965.

François GIRARDON
(Troyes, 1628 – Paris, 1715)

French sculptor, François Girardon had a joiner and wood-carver master under whom he is said to have worked at the château of Liébault, where he attracted the notice of Chancellor Séguier. Under the chancellor's influence Girardon first moved to Paris and was placed in the studio of François Anguier, and afterwards sent to Rome. In 1652

he was back in France, and seems at once to have addressed himself with something like ignoble subservience to the task of conciliating the court painter Charles Le Brun. Indeed, a very large proportion of his work was carried out from designs by Le Brun, and shows the merits and defects of Le Brun's manner (a great command of ceremonial pomp in presenting his subject coupled with a large treatment of forms which, if it were more expressive, might be imposing). The court Girardon paid to the "premier peintre du roi" was rewarded. An immense quantity of work at Versailles was entrusted to him, and in recognition of the successful execution of four figures for the *Apollo tented by Nymphs of Thetis* (see no. 569), Le Brun induced the king to present his protégé personally with a purse of 300 louis, as a distinguishing mark of royal favour. In 1650 Girardon was made a member of the Academy, in 1659 professor, in 1674 "adjoint au recteur", and finally in 1695 chancellor. Five years earlier (1690), on the death of Le Brun, he had also been appointed "inspecteur général des ouvrages de sculpture" – a place of power and profit. In 1699 he completed the bronze equestrian statue of Louis XIV, erected by the town of Paris on the Place Louis le Grand. This statue was melted down during the Revolution, and is only known to us by a small bronze model finished by Girardon himself. His Tomb of Richelieu was saved from destruction by Alexandre Lenoir, who received a bayonet thrust in protecting the head of the cardinal from mutilation (see no. 578). It is a major example of Girardon's work, and the theatrical pomp of its style is typical of the funeral sculpture of the reigns of Louis XIV and XV. Although chiefly occupied at Paris Girardon never forgot his native Troyes, the museum of which town contains some of his best works, including the marble busts of Louis XIV and Maria Theresa. In the hôtel de ville is still shown a medallion of Louis XIV, and in the church of Saint-Rémy a bronze crucifix of some importance, both works by his hand.

Jean GOUJON
(Active 1540-1563)

French sculptor of the sixteenth century. The first mention of his name occurs in the accounts of the church of Saint-Maclou at Rouen in the year 1540. On leaving Rouen, Goujon was employed by Pierre Lescot, the celebrated architect of the Louvre, on the restorations of Saint-Germain l'Auxerrois. In 1547 appeared Martin's French translation of Vitruvius, the illustrations of which were due, the translator tells us in his "Dedication to the King," to Goujon, "naguères architecte de Monseigneur le Connétable et maintenant un des vôtres." We learn from this statement not only that Goujon had been taken into the royal service on the accession of Henry II, but also that he had been previously employed under Bullant on the Château of Ecouen. Between 1547 and 1549 he was employed in the decoration of the Loggia ordered from Lescot for the entry of Henry II into Paris, which took place on June 16, 1549. In the late eighteenth century Bernard Poyet reconstructed Lescot's edifice into the Fontaine des Innocents, a considerable variation from the original design. At the Louvre, Goujon, under the direction of Lescot, executed the carvings of the southwest angle of the court, the reliefs of the Escalier Henri II, and the Tribune des Caryatides (see no. 479). Associated with Philibert Delorme in the service of Diana of Poitiers, Goujon worked on the embellishment of the Château d'Anet, which rose between 1548 and 1554. Unfortunately, the building accounts for Anet disappeared. Goujon executed a vast number of other works of equal importance destroyed or lost in the great Revolution. In 1555 his name appears again in the Louvre accounts, and continues to do so every succeeding year up to 1562, when all trace of him is lost. In the course of that year an attempt was made to release from royal employment all those suspected of Huguenot tendencies. Goujon has always been claimed a Reformer; consequently, it is possible he fell victim to this attack.

Horatio GREENOUGH
(Boston, 1805 – Somerville, 1852)

The American sculptor, Horatio Greenough, was the son of a merchant. At the age of sixteen he entered Harvard University, but he devoted his principal attention to art, and in the autumn of 1825 he went to Rome, where he studied under Thorvaldsen. After a short visit in 1826 to Boston, where he executed busts of John Quincy Adams and other people of distinction, he returned to Italy and took up residence in Florence. Here one of his first commissions was from James Fenimore Cooper for a group of Chanting Cherubs, and he was chosen by the American government to execute the colossal statue of George Washington for the national capital. It was unveiled in 1843, and was really a fine piece of work for its day; in modern times, however, it has been sharply criticised as unworthy and incongruous. Shortly afterwards he received a second government commission for a colossal group, *Rescue*, intended to represent the conflict between the Anglo-Saxon and Indian races. In 1851 he returned to Washington to superintend its erection, and in the autumn of 1852 he was attacked by brain fever, of which he died.

Dame Barbara HEPWORTH
(Wakefield, 1903 – St Ives, 1975)

Dame Barbara Hepworth was initially trained at the Leeds School of Art. She moved on to the Royal College of Art in London from 1920-23, where she was the contemporary of another Yorkshire sculptor with whom she had often been compared, Henry Moore. In 1925 she married the sculptor John Skeaping and moved with him to Rome when he won a scholarship. In the 1920s, working in a powerfully simplified but still basically figurative style, she was committed to the currently fashionable doctrine of truth to materials and direct carving.

In the 1930s, together with her second husband, Ben Nicholson, she was part of the first generation of British artists to espouse abstraction, and formed links with leading continental artists, notably Constantin Brancusi and Hans Arp. After the rise of Hitler brought a flood of refugee artists to Britain, Hepworth and Nicholson were briefly a part of a cosmopolitan British-based avant garde that included Naum Gabo, Piet Mondrian and Lazlo Moholy-Nagy. It was also at this time that Hepworth developed the pierced and hollowed out forms and the use of tautly-stretched strings for which she is best known. Shortly before the outbreak of World War II, Hepworth went to St Ives in Cornwall where she eventually settled, becoming a leading figure in the thriving artistic community that developed there. After the war, Hepworth relaxed her earlier devotion to direct carving and began to produce sculpture in bronze. This enabled her to fulfil large-scale commissions such as the Dag Hammerskjold Memorial *Single Form* (1963, United Nations, New York). After her death in a fire in 1975, her St Ives studio and garden opened to the public as a museum.

Jean Antoine HOUDON
(Versailles, 1741 – Paris, 1828)

French sculptor, Jean Antoine Houdon entered the Ecole Royale de Sculpture at the age of twelve, and at twenty, having learnt all he could from Michelangelo Slodtz and Jean-Baptiste Pigalle, won the *Prix de Rome* and left France for Italy, where he spent the next ten years. His brilliant talent delighted Pope Clement XIV, who on seeing the *St Bruno* executed by Houdon for the church of Santa Maria degli Angeli, said "he would speak, were it not that the rules of his order impose silence." In 1771, he sent *Morpheus* to the Salon and this work procured him his "agrégation" to the Academy of Painting and Sculpture, of which he was made a full member in 1775. Between these dates Houdon had not been idle; busts of Catherine II, Diderot and Prince Galitzin were observed at the

Salon of 1773. At the 1775 Salon he produced not only his *Morpheus* in marble, but busts of Turgot, Gluck and Sophie Arnould as Iphigeneia, together with his well known marble relief, "Grive suspendue par les pattes." He also took an active part in teaching at the academy, executing for the instruction of his pupils the celebrated *Ecorché* still in use. To every salons Houdon was a chief contributor; most of the leading men of the day were his sitters. His busts are remarkable portraits, and in 1778, when news of Rousseau's death reached him, Houdon set out at once for Ermenonville, and there took a cast of the dead man's face, from which he produced the grand and life like head now in the Louvre. In 1779 his bust of Molière at the Comédie Française won universal praise, and the celebrated draped statue of Voltaire, in the vestibule of the same theatre, was exhibited at the Salon of 1781, to which Houdon also sent a statue of Marshal de Tourville, commissioned by the King. Three years later he went to America, to carry out the statue of Washington. Houdon left France in 1785 with Benjamin Franklin, whose bust he had recently executed. Staying some time with Washington at Mount Vernon, he modelled the bust with which he decided to return to Paris. There, he completed the statue destined for the capital of the State of Virginia. After his return to his native country, Houdon executed for the king of Prussia, as a companion to a statue of *Summer*, *The Chilly Woman* (see no. 648), a naïf embodiment of shivering cold, which is one of his best as well as one of his best known works. The Revolution interrupted the busy flow of commissions. Under Napoléon, Houdon received little employment; he was, however, commissioned to execute the colossal relief's intended for the decoration of the column of the "Grand Army" at Boulogne, and various busts, among which may be cited those of Marshal Ney, Joséphine and Napoléon himself, by whom Houdon was rewarded with the Legion of Honour.

Donald JUDD
(Excelsior Springs, 1928 – New York, 1994)

Donald Judd was one of the principal practitioners and theorists of the Minimalist movement that developed in the 1960s in reaction at what were seen as the excesses of Abtract Expressionism.

After studying Philosophy and Art History at the Art Students' League and later at Columbia University, Judd began his career as an abstract painter. Between 1959 and 1965 he wrote for *Arts Magazine* and other periodicals, championing the work of Claes Oldenburg, Frank Stella, John Chamberlain and the artist with whom he is most frequently associated, Don Flavin. Around the same time Judd turned to sculpture. Preferring industrial materials such as aluminium, painted steel, galvanised iron, perspex, unpolished wood and concrete for sculptures to be situated out of doors, Judd sought a neutral industrial finish and reduced the elements of sculpture to simple box-like forms that were exhibited on the ground or attached to walls without plinths or framing.

Judd presented his theories in a article entitled *Specific Objects*, published in 1965.

Juan de JUNI
(Joigny, 1506 – Valladolid, 1577)

Juan de Juní was a sculptor of Burgundian origin who spent most of his career in Spain. Elements in his work suggest that like many northern artists of his day, he visited Italy where he was impressed by the work of Michelangelo and by the newly discovered Antique sculptural group of the *Laocoön* (see no. 112). By 1533 Juní is known to have been working in Leon. In 1540 he moved to Salamanca and from there to Valladolid. In 1545 he carved an Entombment for the funerary chapel of Bishop Fray Antonio de Guevara in the monastery of S. Francisco in Valladolid and the following year won the commission to create the high altar of Valladolid Cathedral.

Amongst his other notable works was a magnificent funerary chapel for the banker Alvaro de Benavente that he was commissioned to design in 1557 and the high altar of the cathedral of Burgo de Osma. Like El Greco, who arrived in Spain around the time of Juní's death, Juní adapted extraordinarily well to the very special religious and emotional fervour that permeated sixteenth-century Spain.

Katarzyna KOBRO
(Moscow, 1898 – Lodz, 1951)

Katarzyna Kobro was an artist whose career was much bound up with and affected by the political convulsions of the first half of the twentieth century, from the Russian Revolution through to World War II and the post war division of Europe. Of Latvian origin, Kobro studied art in Moscow in the heady atmosphere of the immediate post-revolutionary period (1917-20). In 1920 she moved to Smolensk, and the following year married the Polish artist and theorist Wladyslaw Strzeminski. By moving to Poland, Kobro and Strzeminski were able to escape the clampdown that inhibited the development of the avant garde in Soviet Russia, and were free to carry on their own experimental projects until the outbreak of World War II. They belonged in turn to a succession of Polish avant garde groupings, including Block from 1924, Praesens from 1926 and A.R. from 1929. By the 1920s Kobro had moved on from her early Cubist nude studies to abstract kinetic forms hanging in space. From 1924 she restricted the colour of her forms to white, grey and primary colours. From 1928 Kobro and Strzeminski based their works on the Pythagorean Golden Section, with elements organised according to the fixed proportions of 8:5:3. These ideas were elaborated by the couple in a book entitled *Kompozycja Przestrzeni* (*The Composition of Space*) published in 1931. Kobro's career was interrupted in 1939 by the German invasion of Poland, and much of her work was destroyed during the war. Surviving works were presented by the artist to the Museum of Art in Lodz in 1945. Both Kobro and Strzeminski lived just long enough to experience a renewed clampdown on artistic freedom under the new post-war Stalinist regime.

Henri LAURENS
(Paris, 1885-1954)

Henri Laurens was one of the first sculptors to exploit and develop the innovations of Cubism. His early work, like so much sculpture produced in the early 1900s, was heavily under the influence of Rodin. He turned initially to French Romanesque and Gothic sculpture as a means of escaping the pervasive pathos of Rodin, but a close friendship formed with Georges Braque in 1911, just as Analytical Cubism was giving way to Synthetic Cubism with the introduction of collage, provided a more effective way forward. As one of his legs had been amputated in 1909, Laurens was exempt from the military service that interrupted the career of Braque. During World War I he expressed his new-found cubist ideas in a series of sculptures entitled "constructions", made in wood and in polychrome plaster, in which he explored the typically Cubist subject matter of fragmented nudes and still-lives of studio clutter (*Bottle and Glass*, 1917 and *Guitar*, 1917-18). At this time Laurens was represented by the dealer Léonce Rosenberg, along with Picasso, Braque, Gris and Léger. Like most of these he defected from Rosenberg at the end of the war, and moved for a while to the dealer Daniel-Henry Kahnweiler. It was a mark of Laurens' recognition and fashionable status when in 1924 the Russian impresario Serge Diaghilev commissioned him to design the sets for the ballet *Le Train bleu*, set on a beach in the South of France, that combined the music of Darius Milhaud, costumes by Coco Chanel and a curtain by Picasso.

From the mid 1920s Laurens moved away from the angularity of his Cubist style and adopted a softer, more sensuous and organic style, concentrating on the subject of the female nude.

Lord Frederick LEIGHTON
(Scarborough, 1830 – London, 1896)

English painter and sculptor, the son of a physician, Frederick Leighton was taken abroad at a very early age. In 1840 he learnt drawing at Rome. Then the family moved to Dresden and Berlin, where he attended classes at the Academy. In 1843 he was sent to school at Frankfurt, and in the winter of 1844 accompanied his family to Florence, where his future career as an artist was decided. In 1849 he studied for a few months in Paris, where he copied Titian and Correggio in the Louvre. He loved Italy and Italian art, and the first picture by which he became known to the British public was *Cimabue's Madonna carried in Procession through the Streets of Florence*, which appeared at the Royal Academy in 1855. This painting created such a sensation that it was purchased by Queen Victoria. It was not until 1860 that he settled in London, and in 1864 he was elected an Associate of the Royal Academy. After this, the main effort of his life was to realise visions of beauty suggested by classical myth and history. Leighton was one of the most thorough draughtsmen of his day. The sketches and studies for his pictures are numerous and very highly esteemed. Like other painters of the day, notably G.F. Watts, Lord Leighton executed a few pieces of sculpture. His *Athlete struggling with a Python* was exhibited at the Royal Academy in 1877. Another statue, *The Sluggard*, of equal merit, was exhibited in 1886, and a charming statuette of a nude figure of a girl looking over her shoulder at a frog, called *Needless Alarms*, was completed in the same year, and presented by the artist to Sir John Millais in acknowledgement of the gift by the latter of his picture *Shelling Peas*. He made the beautiful design for the reverse of the Jubilee Medal of 1887. It was also his habit to make sketch models in wax for the figures in his pictures, many of which are in the possession of the Royal Academy. In 1878 he became president of the Royal Academy and was created baronet in 1886.

LEOCHARES
(Active, 340 – 320 B.C.E.)

A Greek sculptor who worked with Skopas on the Mausoleum around 350 B.C.E. Leochares executed statues in gold and ivory of Philip of Macedon's family; the king placed them in the Philippeum at Olympia. Along with Lysippos, he made a group in bronze at Delphi representing a lion-hunt of Alexander. We hear of other statues by Leochares of Zeus, Apollo and Ares. The statuette in the Vatican, representing Ganymede being carried away by an eagle, originally poorly executed, though considerably restored, corresponds closely with Pliny's description of a group by Leochares.

Sol LEWITT
(Hartford, 1928 – New York, 2007)

Sol LeWitt is noted for his coolly cerebral minimalist and conceptual art. From 1945 to 1949 he studied at Syracuse University, before his military service took him to Japan and Korea. This proved to be happy and useful experience, as he was profoundly impressed by the ascetic and spiritual qualities of the temples and gardens he was able to visit in these countries. After training at the Cartoonists' and Illustrators' School in New York he worked as a graphic designer in the office of the architect I. M. Pei from 1955 to 1956, and at the same time pursued his development as an artist, initially as a painter. In 1962 he took up sculpture and began to make black and white reliefs. From 1965 LeWitt was primarily concerned with serial

and modular works and with creating systems, though he insisted that his work was not determined by theory and was in fact intuitive. As he put it "... it is involved with all types of mental processes and it is purposeless." Using abstract and neutral elements, he radically reduced and simplified his formal vocabulary in works that consisted of complexes of box or table-like structures. His sculptures were made of painted wood or white baked enamel, and from the late 1970s they were not simply coloured black, grey and white but also incorporated the three primary colours.

Jacques LIPSCHITZ
(Druskieniki, 1891 – Capri, 1973)

Jacques (Chaim Jacob) Lipschitz was the son of a Jewish building contractor in Lithuania. After initially studying engineering, he was able, with the support of his mother, to move to Paris in 1909 and to devote himself to art, studying at the Ecole des beaux-arts and the Académie Julian. Forming friendships with Constantin Brancusi, Amedeo Modigliani, Chaim Soutine, Alexander Archipenko and Diego Rivera, he also met and developed an intense creative relationship with Picasso and Juan Gris. He remained a central figure of the thoroughly international Ecole de Paris until his enforced exile to America in 1941.

Like many artists of his generation he was attracted to non-European sculptural traditions, and made a study of Scythian sculpture in the Hermitage during a visit to St Petersburg in 1911. But it was his encounter with Picasso in 1913 and his discovery of Cubism that were to provide the decisive impetus for the direction his work was to take. From 1916 Lipschitz was represented by the dealer Léonce Rosenberg, who also showed the work of Picasso, Braque, Rivera and Gris. Towards the end of World War I, like Léger and indeed like Picasso himself, he began to feel that experimentation with Cubist form had led him too close to abstraction, and he returned to a more figurative and easily comprehensible, though still Cubist, style. From the mid 1920s Lipschitz developed a more open and linear style in which voids played an important role. From this time, too, the influence of Surrealism became apparent in his work. After the German invasion of 1940, Lipschitz, like many French-based Modernists, both Jewish and non-Jewish, fled to the South of France and then to America.

Lipschitz was well received in America and gained many important commissions there. Though he returned to France in 1946, he continued to be active in America in the post-war years. The events of World War II and the Holocaust quickened his sense of Jewishness, and he was buried in Israel, which he came to regard as his spiritual home.

LYSIPPOS
(c. 395 – c. 305 B.C.E.)

The Greek sculptor, Lysippos, was head of the school of Argos and Sicyon in the time of Philip and Alexander of Macedon. His works, some colossal, are said to have numbered 1500. Certain accounts have him continuing the school of Polykleitos; others represent him as self-taught. He was especially innovative regarding the proportions of the human male body; in contrast to his predecessors, he reduced the head size and made the body harder and more slender, producing the impression of greater height. He also took great pains with hair and other details. Pliny and other writers mention many of his statues. Among the gods he seems to have produced new and striking types of Zeus, the Sun-god and others; many of these were colossal figures in bronze. Among heroes he was particularly attracted by the mighty physique of Heracles. The *Heracles Farnese* of Naples, though signed by Glycon of Athens, and a later and exaggerated transcript, owes something, including the motive of rest after labour, to Lysippos. Lysippos made many statues of Alexander the Great, and so satisfied his patron, no doubt by idealising him, that he became the king's

court sculptor; the king and his generals provided numerous commissions. Portraits of Alexander vary greatly, and it is impossible to determine which among them go back to Lysippos.

As head of the great athletic school of Peloponnese, Lysippos naturally sculptured many athletes; a figure by him of a man scraping himself with a strigil was a great favourite of the Romans in the time of Tiberius; it has usually been regarded as the original copied in the *Apoxyomenos* of the Vatican (see no. 88).

Stefano MADERNO
(Rome (?), 1576-1636)

In his time the Roman sculptor Stefano Maderno was successful and prolific. His subsequent reputation and popular fame, however, depended almost entirely upon one work – the marble statue of *St Cecilia* (see no. 505) in the church of St Cecilia in Trastevere. The fame of this sculpture derived as much from the extraordinary circumstances of its commission as from its moving simplicity and exquisitely fine execution.

An apparently uncorrupted body, believed to be that of St Cecilia was discovered on October 20, 1599 during excavations under the high altar of the church dedicated to the saint. Cardinal Paolo Emilio Sfondrato commissioned the statue to be placed upon the altar. Widely believed to have been based directly on the re-discovered body, Maderno's statue certainly follows verbal descriptions of its pose, clothing and appearance, though his carefully balanced combination of the real and the ideal shows a clear debt to well known sculptures surviving from Antiquity. Indeed Maderno's *St Cecilia* may be regarded as a virtuoso study in the way classical drapery can be used simultaneously to mask and reveal the body underneath.

Belonging to the generation immediately before Bernini, Maderno is sometimes seen as a transitional figure between Mannerism and Baroque. In fact, his sober Classicism has little in common with the artifice of Mannerism or the theatricality of Baroque and probably owes more to his early experience of the thriving Roman trade in "restoring" (and no doubt faking) re-discovered ancient sculptures.

Apart from the *St Cecilia*, Maderno's important commissions included a marble figure of Prudence for the tomb of Cardinal Alessandrino in the church of S. Maria sopra Minerva in Rome and a large scale marble relief of *Rudolf II of Hungary attacking the Turks* for the tomb of Pope Paul V in the church of S. Maria Maggiore.

Aristide Joseph-Bonaventura MAILLOL
(Banyuls-sur-Mer, 1861 – Perpignan, 1944)

Aristide Joseph-Bonaventura Maillol began his career as a painter and as a decorative artist making tapestries and ceramics, before problems with his sight turned him towards sculpture. He enrolled at the Ecole des beaux-arts in 1884 where he was a pupil of the academic painter Alexandre Cabanel. Maillol's painting in the 1890s combined a flat linearity, borrowed from Puvis de Chavannes, with a sunlit palette and sweetness that shows his enthusiasm for Renoir. His early wooden sculptures have a curvilinear decorativeness that shows the influence of Art Nouveau. The pivotal work of Maillol's career was a monumental seated female nude entitled *The Mediterranean* (see no. 837), begun in 1900 and exhibited in its final form at the Salon d'Automne of 1905. This exhibition owed its fame to the explosive debut of Fauvism, but it could be argued that the kind of monumental Classicism announced by *The Mediterranean* had a far more widespread and long-lasting impact than the brightly coloured French expressionism of Derain and Vlaminck. Maillol's brand of simplified Classicism became an international style in the interwar period. It is a style that came to be particularly associated with fascism, though in fact it was widespread across the political spectrum. Amongst Maillol's pupils was

Arno Breker the leading sculptor of Nazi Germany. It is deeply ironic that it was Maillol's connection with Breker that saved the life of Maillol's final model, Dina Vierny, who subsequently did so much to promote Maillol's work, not least by creating the Musée Maillol in Paris.

Maillol himself died in disputed circumstances at the moment of France's liberation from German occupation in September 1944.

MARISOL
(Paris, born 1930)

Marisol was born Marisol Escobar of Venezuelan parents in Paris. After studying at the Ecole des beaux-arts and the Académie Julian in Paris, she moved in 1960 to New York, where she continued her studies at the Hans Hofmann School and the Art Students' League. Influenced by folk art, she began making sculptures in metal and wood, and first exhibited at the Leo Castelli Gallery in New York in 1958. From about 1960 onwards her work became more straight forwardly figurative, often representing people with sharply defined heads and other parts of the body; these effigies were frequently arranged in groups. In 1961 her work was shown in the influential *Art of Assemblage* exhibition held at the Museum of Modern Art in New York, and important one-person shows later followed in New York, London, Rotterdam, Venice (the 1968 Biennale), Philadelphia and Worcester, Massachusetts. A show dedicated to her many portrait sculptures was held in Washington, D.C. in 1991.

Gaspard and Balthazar MARSY
Gaspard (Cambrai, 1624 – Paris, 1681).
Balthazar (Cambrai, 1628 – Paris, 1674).

The French sculptor Gaspard Marsy was the son of a mediocre sculptor. At an early age he moved to Paris with his brother Balthazar. In 1657, Gaspard was accepted as a member of the Academy of Sculpture and Painting, later becoming a professor (1659), and finally an adjunct rector. The works he completed on his own include *Diligence* and *Celerity,* for the Tuileries, and, for Versailles, a *Venus* and a figure of *Daybreak*; the *Month of February, Mars,* and a *Victory,* for Colbert in his castel of Sceaux. Marsy also made a bas-relief of the gate of Saint Martin (Paris). The works created by both Marsy brothers include in Versailles, *Venus and Amour, The Aurora, Latone and Her Children,* and the famous *Horses of the Sun* (see no. 570), a superb group adorning the Baths of Apollo. The harmony, elegance, and originality of the idea and of the rendering are especially remarkable in these sculptures, which resulted from the collaboration of the two brothers. Balthazar, in turn, also became a member of the Academy in 1673 and an adjunct professor at the same time.

Juan MARTINES MONTANES
(Alcala-la-real, 1568 – 1649)

Spanish sculptor, Juan Martínez Montañez was the pupil of Pablo de Roxas. His first known work (1607) is a boy Christ, now in the sacristy of the *capella antigua* in the Seville cathedral. Montañes executed most of his sculpture in wood, coloured, and covered with a surface of polished gold. Other works were the great altars at Santa Clara in Seville and at San Miguel in Jerez, the Conception and the realistic figure of Christ crucified, in the Seville cathedral; the figure of St John the Baptist, and the St Bruno (1620); a tomb for Don Perez de Guzman and his wife (1619); the St Ignatius and the St Francis of Borja in the university church of Seville. Montañes died in 1649, leaving a large family. His works are more realistic than imaginative, but this, allied with an impeccable taste, produced remarkable results. Montañes modelled the equestrian statue of King Philip IV, cast in bronze by Pietro Tacca in Florence and now in Madrid. He had many imitators, his son Alonso Martínez, who died in 1668, among them.

Henri MATISSE
(Cateau-Cambrésis, 1869 – Nice, 1954)

It was during the last decade of the nineteenth century that Henri Matisse chose to dedicate himself to art. Living in Paris, he abandoned his law studies and first attended the studio of the academic painter William Bouguereau, then that of the symbolist Gustave Moreau. Visiting exhibitions, he discovered Corot and Cézanne, then during his travels, the Impressionism of Turner, the art of Gauguin and Van Gogh. He was also inspired by the Divisionism of Paul Signac. All these encounters led Matisse to paint using areas of flat colour. Giving rise to the Fauve movement, his canvases characterised themselves with juxtapositions of violent tones, making the bright colours vibrate and, in turn, provoking the public. He was engaged in a perpetual artistic dialogue with Picasso, who he met at this time, at the house of their patron Gertrude Stein. He progressively simplified his forms, approaching Abstraction and, starting in the 1930s, dedicated himself to his gouache collages. At the same time, Matisse made sculptures, models in the round and low-reliefs working on his *Naked Back* (see nos. 794, 805, 822, 917) series, from 1909 to 1930. This way, he confronted different problems, the rendering of form, the tracing of line, the link with background and base, etc. Echoing his paintings, his Fauvist sculptures use pure form and simplified line, often reminding one of Primitive art. In his series, each work is created from the preceding one and offers a perfect illustration of the evolution of the master's work. In sculpture, as well as in his painting, Matisse remains one of the major references of Avant-garde art from the beginning of the twentieth century.

Guido MAZZONI
(Modena, 1450-1518)

Nicknamed Paganino or Modanino, the Italian sculptor Guido Mazzoni, lived in Naples when Charles VIII seized the city in 1494 and annexed it to France, where Mazzoni also resided for twenty years. He is credited with the *Tomb of Charles VIII*, which was destroyed at the time of the French Revolution. The majority of his works, having been made from terracotta or other fragile materials, were destroyed or have deteriorated. The main surviving piece of his work is the *Holy Sepulchre*, a group of nine figures that can be seen in the Monteoliveto church in Naples. His wife, Isabella Discalzi, as well as his daughter, collaborated with him on many of his works.

Pedro de MENA
(Adra, 1628-1688)

Spanish sculptor, Pedro de Mena was a pupil of his father as well as Alonzo Cano. His first conspicuous success was achieved in work for the convent El Angel at Granada, including figures of St Joseph, St Anthony of Padua, St Diego, St Pedro Meantara, St Franciscus and Santa Clara. In 1658 he signed a contract for sculptural work on the choir stalls of the cathedral at Malaga – this work extending over four years. Between 1673 and 1679 Mena worked at Cordova. About 1680 he was in Granada, where he executed a half-length of Madonna and child (seated) for St Dominicos.

Mena may be regarded as the artistic descendant of Montañes and Alonzo Cano, but in technical skill and the expression of religious motive his statues are unsurpassed in the sculpture of Spain. His feeling for the nude was remarkable. Like his immediate predecessors, he excelled in the portrayal of contemplative figures and scenes.

Franz Xavier MESSERSCHMIDT
(Weissenberg, near Ulm, 1736 – Pressburg (now Bratislava), 1783)

Franz Xavier Messerschmidt was a highly accomplished practitioner of the late Baroque and early neoclassical styles. What separates him from the numerous other skilled sculptors in southern Germany and the Habsburg Empire in the mid to late eighteenth century was the onset of mental illness in the 1770s, which gave his late work a startlingly timeless and modern quality. Descended from a family of craftsmen on his mother's side, he was first trained by two of his maternal uncles before going in 1746 to the fine late baroque Johann Baptist Straub in Munich for training and then on to Philipp Jacob Straub in Graz and finally to the Akademie in Vienna where he would be based for the following twenty years. Though he occasionally produced religious works, Messerschmidt was principally active as a portraitist. Splendid larger than life statues of the Empress Maria Theresia and her consort Franz I of Lothringen, now in the Belvedere in Vienna, are characteristic examples of Messerschmidt's work in a lively and highly animated late Baroque style.

In 1765 he spent several months in Rome at the time that the Neo-classical style was developing under the aegis of Johann Joachim Winckelmann (1717-1768). His subsequent work with its smooth surfaces and crisper modelling was influenced by this style.

By the end of the 1760s Messerschmidt was at the height of his success and a member of the Vienna Akademie, where he also taught. In the early years of the 1770s his increasingly eccentric behaviour led to his dismissal from the Akademie. Messerschmidt returned first to his birthplace of Weissenberg, then moved to Munich and finally to Pressburg, where his brother was also active as a sculptor. It was here that he produced the extraordinary series of grimacing, distorted, and blankly staring "character heads" upon which his subsequent fame has rested. These were partly inspired by the then fashionable theories of physiognomist Lavater and partly as a result of his own persecution mania. Messerschmidt apparently believed that the heads were an effective means of controlling the malevolent spirits that tormented him.

Constantin MEUNIER
(Brussels, 1831-1905)

Constantin Meunier, the Belgian painter and sculptor, attended the Academy in Brussels and was appointed professor at Louvain in 1882. He is known as one of the masters of the Belgian school as a sculptor. Living in a coal mining region, his favourite artistic subject was the miner's life, and drew from this inspiration throughout his life. Exhausted by work, bony, with muscled arms and neck; here is the miner by Constantin Meunier. These crushed profiles, these expressions of sadness and resignation, these silent parades that the artist aligns in his low-reliefs, his workers and his puddlers are remarkable. Meunier obtained the Grand Prix at the Universal Exhibitions of 1889 and 1890. He ended his life sculpting a low-relief for the *Monument au travail* in Brussels, dedicated to industrial Belgium at the end of the nineteenth century, which was erected after his death.

Claude MICHEL, called CLODION
(Nancy, 1738 – Paris, 1814)

French sculptor Clodion spent the earlier years of his life in Nancy and probably in Lille. In 1755 he went to Paris and entered the workshop of Lambert Sigisbert Adam, his maternal uncle, a clever sculptor. He remained four years in this workshop, and on the death of his uncle became a pupil of J.B. Pigalle. In 1759 he obtained the grand prize for sculpture at the Académie Royale; in 1761 he obtained the first silver medal for studies from models; and in 1762 he went to Rome. Here his activity was considerable between 1767 and 1771. Catherine II was eager to secure his presence in St Petersburg, but he returned to Paris.

Among his numerous patrons were the chapter of Rouen, the states of Languedoc, and the *Direction générale*. His works were frequently exhibited at the Salon. In 1782 he married Catherine Flore, a daughter of the sculptor Augustin Pajou, who subsequently obtained a divorce from him. The agitation caused by the Revolution drove Clodion in 1792 to Nancy, where he remained until 1798, his energies being spent in the decoration of houses. On March 29, 1814 Clodion died in Paris, on the eve of the invasion of Paris by the allies.

George MINNE
(Ghent, 1866 – Laethem-Saint-Martin, 1941)

Though an artist of limited range, the Belgian sculptor and illustrator George Minne achieved a personal and highly expressive style that broke with nineteenth-century academicism, but also remained independent of the influence of Rodin that overwhelmed so many of his contemporaries. After studying at the Académie Royale des beaux-arts in Ghent (1879-86) he worked in that city (1886-95) before moving to Brussels where he undertook a further year of study at the Académie Royale. At the turn of the century Minne settled in the village of Laethem-Saint-Martin where, apart from four years' enforced exile during World War I, he remained for the rest of his life.

In the mid to late 1890s Minne created highly-stylised sculptures of emaciated and pathetic figures that are amongst the most characteristic expressions of the Belgian *fin-de-siècle*. These won the enthusiastic endorsement of the Symbolist poets Emile Verhaeren and Maurice Maeterlinck (whose *Serres chaudes* Minne had illustrated in 1889) as well as the influential support of the Art Nouveau architect and designer Henry van de Velde and the critic and art dealer Julius Meier-Graefe. Through lavishly-illustrated art magazines of the period and exhibitions in Vienna, Berlin, Venice and elsewhere, Minne won an international reputation and exercised considerable influence on the art of his time and later.

Minne's most celebrated and frequently illustrated work, the *Kneeling Youth* (see no. 766), was developed in the late 1890s and made a powerful impact on Gustave Klimt, Oskar Kokoschka and Egon Schiele when it was exhibited at the Vienna Secession. The figure was repeated in marble around a circular basin for his most ambitious work, the *Fountain of kneeling Figures* completed for the Folkwang Museum in Essen, Germany in 1905.

Minne followed traditional methods of modelling figures in clay, before they were cast in plaster and then either cast in bronze or carved in stone.

Francesco MOCHI
(Montevarchi, 1580 – Rome, 1654)

Francesco Mochi, just five years younger than Stefano Maderno and a full eighteen years older than Gian Lorenzo Bernini, may be regarded as the first Baroque sculptor and the sculptural equal of Caravaggio and Annibale Carracci, who pioneered the style in painting.

Mochi studied initially in Florence with Santi di Tito, then, around 1600, moved to Rome, to work with the Venetian sculptor Amillo Mariani.

The dynamism and theatricality of Mochi's *Annunciation* (see no. 514) produced for the Orvieto cathedral (c. 1603-1609), with the two free-standing figures intended to interact with one another across the space of the high altar, marked the beginning of a new phase in Italian sculpture and anticipated the full-blown Baroque of Bernini.

Equally innovatory were the two monumental statues of Alessandro and Ranuccio Farnese commissioned for the central piazza of Piacenza. That of Alessandro Farnese, with its billowing drapery and dynamic movement, broke with the static type of equestrian monument favoured in Antiquity and the Renaissance.

The most significant work of Mochi's later career was the vast *St Veronica* (see no. 547), commissioned by Pope Urban VIII for one of the four niches at the crossing of St Peter's in Rome. Mochi was forced to compete with Bernini and two other leading sculptors of the new generation, François du Quesnoy and Andrea Bolgi. The extremely agitated pose and excessive emotionalism of Mochi's *St Veronica* may have resulted from a desire to outdo the more operatic qualities of Bernini. Mochi's *St Veronica* did not find favour with his contemporaries and from that time on he found himself eclipsed by the younger Bernini.

Henry MOORE
(Castleford, 1898 – Hertfordshire, 1986)

The British sculptor Henry Moore is considered one of the most important sculptors of the twentieth-century. His bronze and stone sculptures constitute the major twentieth-century manifestation of the humanist tradition in sculpture. The son of a Yorkshire coal miner, he was enabled to study at the Royal College of Art by a rehabilitation grant after being wounded in World War I. His early works were strongly influenced by the Mayan sculpture he saw in a Paris museum. From around 1931 onwards, he experimented with abstract art, combining abstract shapes with human figures, at times leaving the human figure behind altogether. Much of his work is monumental, and he is particularly well known for a series of reclining nudes. These female figures, echoing the forms of mountains, valleys, cliffs and caves (see no. 891), extended and enriched the landscape tradition which he embraced as part of his English artistic heritage.

Hans MULTSCHER
(Reichenhofen, 1400 – Ulm, 1467)

The southern German sculptor Hans Multscher was both relatively long-lived and well documented for an artist of his time. His birthplace is recorded in inscriptions on two of his works. Surviving documents record his marriage to Adelheid Kitzin, in Ulm in 1427, and payment for various commissions and properties that show he became a man of substance.

Stylistic elements in his early work suggest that he travelled in the Netherlands, Burgundy, and France before settling in the city of Ulm where he is recorded as having been admitted as a freeman in 1427 and where he eventually developed a workshop employing as many as sixteen assistants, including his own brother Heinrich.

Multscher's historical importance lays in his move away from the so-called "soft-style" towards a greater degree of realism with drapery related more to the underlying body and its movement.

In 1456 Multscher received a down payment for an elaborate altarpiece for the Frauenkirche in the town of Vipiteno in the South Tyrol. This altarpiece, which combined figures in the round and reliefs in wood with painted wings, is one of his most significant surviving works and represents the ultimate development of Multscher's style.

MYRON
(Active during the first half of the 5th century B.C.E.)

Mid-fifth century B.C.E. Greek sculptor, Myron worked almost exclusively in bronze. Though he made some statues of gods and heroes, his fame rested primarily upon his representations of athletes, for which he proved revolutionary by introducing greater boldness of pose and a more ideal rhythm. His most famous works, according to Pliny, were a cow, Ladas the runner, who fell dead at the moment of victory, and a discus-thrower, *Discobolus* (see no. 53). The cow seems to have earned its fame largely by serving as a peg on which to hang epigrams, which tells us nothing of the animal's pose. Of the Ladas, there is no known copy; we are fortunate, however, in possessing several copies of the *Discobolus*.

The athlete is represented at the moment he has swung back the discus with the full stretch of his arm, ready to hurl it with all the weight of his body. His face is calm and untroubled, but every muscle in his body is focused in effort.

Another marble figure, almost certainly a copy of a work of Myron's, is a Marsyas eager to pick up the flutes Athena had thrown away (see no. 55). The full group is copied on coins of Athens, on a vase and in a relief representing Marsyas as oscillating between curiosity and fear of Athena's displeasure. His face of the Marsyas is almost a mask; but from the attitude we gain a vivid impression of the passions affecting him.

The ancient critics say of Myron that, while he succeeded admirably in giving life and motion to his figures, he failed in rendering the mind's emotions. To a certain degree this agrees with the existing evidence, although not perfectly. The bodies of his men are of far greater excellence than the heads.

He was a somewhat older contemporary of Phidias and Polykleitos.

Bruce NAUMANN
(Fort Wayne, born 1941)

The American sculptor Bruce Naumann went to the University of Wisconsin, where he studied music on an informal basis together with mathematics, physics and art as well as philosophy. Naumann was initially a painter but gave up this medium in 1964 to concentrate his time and talent on experimenting with sculpture and performing arts as well as film holograms, photographs, films and research. Until 1970 he divided his life between teaching (in order to earn a living) and his conceptual art work. His first solo exhibition took place in 1966 at the Nicholas Wilder Gallery in Los Angeles, followed two years later in New York by a solo exhibition at the Leo Castelli Gallery. These two shows were the beginning of a long series of solo exhibitions in America and Europe. He received much admiration from critics and public alike, and participated in *Documenta 4* in Kassel, Germany. Naumann experienced success after success and his exhibitions travelled widely in Europe and the United States. In 1979 he settled in New Mexico. His work is focused mainly on the medium of neon and around video installations and sculpture. His themes and imagery revolve around animal parts, particularly horse and human body parts.

Claes OLDENBURG
(Stockholm, born 1929)

The Swedish sculptor Claes Oldenburg was taken to the United States when his father was appointed Swedish Consul-General there in 1930. Initially Oldenburg lived in New York City and Rye, New York, and then mostly in Chicago between 1936 and 1956. Since the latter date he has lived almost continuously in New York City. Between 1946 and 1950 he studied at Yale University, and between 1950 and 1954 at the Art Institute of Chicago. His early works were influenced by Abstract Expressionism. After moving to New York in 1956, Oldenburg came into contact with the highly experimental artist Allan Kaprow, following whose example Oldenburg mounted a number of "Happenings" around 1958. He held his first one-man exhibition at the Judson Gallery in New York in 1959. As touched on above, in 1961 and 1962 Oldenburg aped the marketing processes of capitalism by holding two exhibitions on the subject of retail stores, for the second of which he created his first batch of larger-than-life emulations of everyday consumer objects and foodstuffs. In 1976 he worked for the first time with the Dutch artist and curator Coosje van Bruggen, whom he married in 1977, and with whom he has collaborated on all subsequent projects. Since 1964 major exhibitions of his works have been held in Venice, Kassel, New York, Amsterdam, Stockholm, Tübingen, Cologne, Krefeld, Duisberg and London.

Augustin PAJOU
(Paris, 1730-1809)

French sculptor, Augustin Pajou won the *Prix de Rome* at eighteen; he was a pupil of Lemoyne and went to Rome between 1752 and 1756. At thirty he exhibited his *Pluton tenant Cerbère enchaîné*. His portrait busts of Buffon and of Madame Du Barry (1773), and his statuette of Bossuet, are among his best works. When B. Poyet constructed the Fontaine des Innocents from the earlier edifice of P. Lescot (see Goujon), Pajou provided a number of new figures for the work.

Augustin Pajou is also known for his role in the conservation of works of arts: in 1777 he became Keeper of the King's Antiquities, and in 1792 he served on a Revolutionary Committee for the Conservation of Works of Art.

Eduardo PAOLOZZI
(Edinburgh, 1924 – London, 2005)

The Scottish sculptor Eduardo Paolozzi was of Italian origin. After attending Edinburgh College of Art and St Martin's School of Art in London between 1943 and 1945, he studied sculpture at London's Slade School of Art, then temporarily based in Oxford. He first exhibited at the Mayor Gallery in London in 1947, and that same year moved to Paris where he met Brancusi, Arp, Giacometti, Hélion, Tzara, Braque and Léger among others. Following his return to London in 1949, he taught at the Central School of Art and Design until 1955, and at St Martin's School of Art between 1955 and 1958. In 1952 he was one of the founding members of the Independent Group at the Institute of Contemporary Arts (ICA) in London, which was a forum for debate about the relationship of art and popular culture. This interest found expression in Paolozzi's organisational contribution to the *Parallel of Life and Art* exhibition mounted at the ICA in 1953, as well as his participation in the *This is Tomorrow* show put on at the Whitechapel Art Gallery in 1956. After 1960 he taught in Hamburg, Berkeley, London, Berlin, Cologne and Munich. He exhibited at the Venice Biennale in 1952 and again in 1960, in which year he also displayed work at the Betty Parsons Gallery in New York. Four years later his work was exhibited at the Museum of Modern Art, New York. In 1967 he received the First Prize for Sculpture at the Carnegie International Exhibition in Pittsburgh. A major retrospective of his output was mounted at the Tate Gallery, London in 1971. Eduardo Paolozzi was knighted in 1989.

Giuseppe PENONE
(Turin, born 1947)

Giuseppe Penone was representative of the art movement known as Arte Povera, which developed in the 1960s in reaction to what was seen as the excessive commercialism of the art world. Interested in exploring the interaction between man and nature and the connections between natural and cultural forms, Penone first made a name for himself with works created in a forest near Garessio in Northern Italy, marking his presence with an iron hand attached to a tree trunk, and piercing trees with nails and wrapping them with metal wire. In the 1970s Penone created art based on images drawn from his own body, going so far as to cast in bronze the shapes of vegetables reminiscent of his own face.

PHIDIAS
(Athens, c. 488 B.C.E. – Olympia, c. 431 B.C.E.)

Son of Charmides, universally regarded as the greatest of Greek sculptors, Phidias was born in Athens. We have varying accounts of his training. Hegias of Athens, Ageladas of Argos, and the Thasian painter Polygnotus, have all been regarded as his teachers.

The earliest of his great works were dedications in memory of Marathon, from the spoils of the victory. On the Acropolis of Athens he erected a colossal bronze image of Athena, visible far out at sea. Other works at Delphi, at Pellene in Achaea, and at Plataea were appreciated; among the Greeks themselves, however, the two works of Phidias which far outstripped all others – providing the basis of his fame – were the colossal figures in gold and ivory of Zeus at Olympia and of Athena Parthenos at Athens, both of which belong to about the middle of the fifth century.

Plutarch gives in his life of Perikles a charming account of the vast artistic activity that went on at Athens while that statesman was in power. For the decoration of his own city he used the money furnished by the Athenian allies for defence against Persia. "In all these works," says Plutarch, "Phidias was the adviser and overseer of Perikles." Phidias introduced his own portrait and that of Perikles on the shield of his Parthenos statue. And it was through Phidias that the political enemies of Perikles struck at him.

It is important to observe that in resting the fame of Phidias upon the sculptures of the Parthenon we proceed with little evidence. What he was celebrated for in antiquity was his statues in bronze or gold and ivory. If Plutarch tells us that he superintended the great works of Perikles on the Acropolis, this phrase is very vague.

Of his death we have two discrepant accounts. According to Plutarch he was made an object of attack by the political enemies of Perikles, and died in prison at Athens. According to Philochorus, he fled to Elis, where he made the great statue of Zeus for the Eleans, and was afterwards put to death by them. For several reasons the first of these tales is preferable.

Ancient critics take a high view of the merits of Phidias. What they especially praise is the ethos or permanent moral level of his works as compared with those of the later "pathetic" school. Demetrius calls his statues sublime and at the same time precise.

Pablo Ruiz PICASSO
(Málaga, 1881 – Mougins, 1973)

"Picasso always considered himself a poet who was more prone to express himself through drawings, paintings and sculptures."(Pierre Daix). The great Spanish artist learned from his father, painter and professor at the School of Fine Art and Crafts, the basics of formal academic art training. Then he studied at the Academy of Arts in Madrid, but when he was not yet eighteen, he joined the ranks of those who called themselves modernists, the non-conformist artists and writers. His early works were grouped into the so-called "Blue Period" (1901-1904), but towards the end of 1901 the desire to express these feelings of sadness more directly motivated Picasso to turn to sculpture. The predominance of form in his paintings undeniably testifies to this interest; Picasso began to sculpt because it corresponded to his need to impose strict limits on himself, to achieve the most ascetic means of expression.

Between 1905 and 1907 Picasso entered a new phase, the "Rose Period". In 1907 nude females that had become really important for him were the object of the composition of the large painting, Les Demoiselles d'Avignon. By that time Picasso had already discovered African wooden sculpture in the ethnographic museum at the Palais du Trocadero and, like many other artists, had bought several statues and masks. During the autumn of 1907 the artist spent long hours carving strange, fetish-like figurines and primitive dolls, and making sketches for future sculptures.

Just as African art is usually considered a factor leading to the development of Picasso's classic aesthetics in 1907, the lessons of Cézanne are perceived as the cornerstone of this new progression. Painter Georges Braque explained that: "Cubism's main direction was the materialisation of space." In the autumn of 1912, in Paris, Picasso, attempting to realise his

new vision, again turned to three-dimensional sculptural forms to create a family of spatial constructions in the shape of guitars. Made of grey cardboard, these new "sculptures" did not even pretend to imitate real instruments, but recreated their images through spatially-linked and partially-overlapping flat silhouettes of planes that form open volumes. After his Cubist period in the 1920s, Picasso returned to a more figurative style and got closer to the Surrealist movement. He represented distorted and monstrous bodies but in a very personal style. Picasso's final works were in a mixture of styles, becoming ever more colourful, expressive and optimistic.

Perceiving painting as sculpture, Picasso approached the subject as a sculptor, and saw human anatomy as a plastic construction. His true sculptor's temperament, recognised by Julio González, caused him to be very laconic and to reject incidental features in order to lay bare the plastic essence of the image and emphasise its reality. Picasso called such an approach "surreality" and, even in the days of Cubism, considered himself a Realist artist. For Picasso, sculpture also served to verify the feeling of reality, in the sense of physical validity, since for him "sculpture is the best comment that a painter can make on painting."

Jean-Baptiste PIGALLE
(Paris, 1714-1785)

The French sculptor Jean-Baptiste Pigalle was the son of the king's furniture maker. A neighbour and relative of Allegrain, he became an apprentice of Robert le Lorrain, the creator of the Horses of the Sun of the Hôtel de Rohan, and later of Lemoyne. He was unsuccessful in the Rome competition. He subsequently travelled on foot to Italy, where he nearly died of poverty. A guest of the king, Guillaume II Coustou, saved him. Pigalle's work was so successful that the French ambassador bought his first work from him – a copy of the Player of Jacks. He later lived in Lyon for several years, and, upon returning to Paris, created his charming statuette of Mercury attaching His Winged Sandals (1744), the work he presented at the time of acceptance by the Academy. The king bought a larger reproduction of it and commissioned a second piece, the Venus (1748). In addition, the favour of Madame de Pompadour secured him numerous orders. The King's mistress herself commissioned the pedestrian Louis XV at Bellevue (destroyed) as well as Love and Friendship.

Pigalle portrayed his patroness in the allegorical statue of Friendship (see no. 636). The favour of Marquise de Marigny won him a commission for the mausoleum of Maurice de Saxe. Pigalle presented his model in 1756 to the Salon. However, the Monument to Maurice de Saxe was not opened in Strasbourg until 1777. Among his important works, mention must also be made of the Tomb of Marshal d'Harcourt.

Along with monumental sculpture, Pigalle also distinguished himself in figures of style, in fantasy, and in portraiture. He displayed a highly original realist style. His figures of children are superb, with the most famous being his Child with a Cage.

Germain PILON
(Paris, c. 1529-1590)

Germain Pilon was a French sculptor. He worked with his father, also a sculptor, at the Solesmes abbey and returned to Paris around 1550. Charles IX then named him controller general of currencies. His works are numerous and of high style. His oldest known work is the decoration of Henri II and Catherine Medici in the Saint-Denis abbey finished in 1558. There one can also see the magnificent tomb of Henri II, upon which Pilon worked from 1564 to 1583. He was the author of the famous group of The Three Graces (see no. 119), today in the Louvre. The statue was to hold a funeral urn in which the heart of Henri II lay. Many of his works have disappeared. However, a good number of authors

agree that he belongs to the great French Renaissance School, even if his works, by a certain languid grace, forshadowing decadence, are different from those of Jean Goujon.

Andrea PISANO
(Pisa, c. 1295 – Orvieto, 1348)

Italian sculptor, Andrea Pisano first learned the trade of a goldsmith. It is at Florence that his chief works were executed, and the formation of his mature style was due rather to Giotto than to his earlier master. Of the three world-famed bronze doors of the Florentine baptistery, the earliest one – the one on the south side – was the work of Andrea; he spent many years on it, and it was finally installed in 1336 (see no. 319). It consists of a number of small quatrefoil panels – the lower eight containing single figures of the Virtues, and the rest scenes from the life of St John the Baptist. While living in Florence Andrea Pisano also produced many important works of marble sculpture, all of which strongly demonstrate Giotto's influence. In some cases the artist probably designed them as, for instance, the double band of beautiful panel-reliefs, which Andrea executed for the great campanile. Their subjects are the Four Great Prophets, the Seven Virtues, the Seven Sacraments, the Seven Works of Mercy and the Seven Planets. The duomo contains the chief of Andrea's other Florentine works in marble. In 1347 he was appointed architect to the duomo of Orvieto, which had already been designed and begun by Lorenzo Maitani.

Nicola PISANO
(Apulia, 1206 – Pisa, 1278)

Italian sculptor and architect, Nicola Pisano heads the tradition of Italian sculpture. As early as 1221 he is said to have been summoned to Naples by Frederick II, to do work in the new Castel del l'Uovo. In 1260, as an incised inscription records, he finished the marble pulpit for the Pisan baptistery (see no. 302); on the whole this is the finest of his works.

The next important work of Nicola in date is the Area di San Domenico, in the church at Bologna consecrated to that saint, who died in 1221. Only the main section, the actual sarcophagus covered with sculptured reliefs of St Dominic's life, is the work of Nicola and his pupils. The sculptured base and curved roof with its fanciful ornaments are later additions. It was finished in 1267, not by Nicola himself, but by his pupils.

The most magnificent, though not the most beautiful, of Nicola's works is the great pulpit in Siena cathedral (1268) (see no. 301). It is much larger than that at Pisa, though somewhat similar in general design, being an octagon on cusped arches and columns.

Nicola's last great work of sculpture was the fountain in the piazza opposite the west end of the cathedral at Perugia. This is a series of basins rising one above another, each with sculptured bas-reliefs; it was begun in 1274, and completed, except the topmost basin, which is of bronze, by Nicola's son and pupil Giovanni.

Nicola Pisano was not only pre-eminent as a sculptor but was also a skilled engineer, and was compelled by the Florentines to destroy the great tower, called the Guardamorto, which overshadowed the baptistery at Florence. He managed skilfully, causing it to fall without damaging the baptistery. Nicola Pisano died at Pisa, leaving his son Giovanni, a worthy successor to his great talents both as an architect and sculptor.

POLYKLEITOS
(Active during the 5th century B.C.E.)

Polykleitos was a contemporary of Phidias, and in the opinion of the Greeks his equal. He made a figure of an Amazon for Ephesus regarded as superior to the Amazon of Phidias made at the same time; and his colossal Hera of gold and ivory, which stood in the temple near Argos, was considered worthy to rank with the Zeus of Phidias.

It would be hard for a modern critic to rate Polykleitos so high, for reasons of balance, rhythm, and minute perfection of bodily form, the great merits of this sculptor, which appeal less to us than they did to the fifth century Greeks. He worked mainly in bronze.

His artistic activity must thus have been long and prolific.

Copies of his spearman (*Doryphorus*) and his victor winding a ribbon round his head (*Diadoumenos* (see no. 69)) have long been recognised in galleries. While we understand their excellence, they inspire no enthusiasm; they are fleshier than modern athletic figures and lack charm. They are chiefly valuable for showing us the square forms of body affected by Polykleitos, and the scheme he adopted, for throwing the body's weight (as Pliny says of him) onto one leg.

The Amazon of Polykleitos survives in several copies (see no. 72). Here again we find a certain hardness, and the Amazon's womanly character scarcely appears through her robust limbs.

The masterpiece of Polykleitos, his Hera of gold and ivory, has of course totally disappeared. The Argos coins give us only the general type. Ancient critics reproached Polykleitos for the lack of variety in his works. We have already observed the slight variety in their attitudes. Except for the statue of Hera, which was the work of his old age, he produced hardly any notable statue of a deity. His field was narrowly limited; but in that field he was unsurpassed.

Jean-Jacques PRADIER (James PRADIER)
(Geneva, 1792 – Paris, 1852)

The Swiss-born French sculptor, James Pradier, was a member of the French Academy, and a popular sculptor of the pre-Romantic period, representing in France the drawing-room Classicism which Canova illustrated at Rome.

After spending four years in Rome, from 1814 to 1818, he studied with Jean-Auguste-Dominique Ingres in Paris, and soon became a friend of the Romantic poets Alfred de Musset, Victor Hugo and Théophile Gautier. His works, showing neoclassical influence, are filled with an eroticism that made his *Satyr and Bacchante* the centre of a scandal during the Salon in 1834. He also provided official works such as figures for the Arc de Triomphe, the church of the Madeleine and the Invalides.

His work, very famous in his time, has now been largely forgotten. However, in 1846 Gustave Flaubert wrote: "This is a great artist, a true Greek, the most antique of all the moderns."

PRAXITELES
(Active between c. 375 – c. 335 B.C.E.)

Greek sculptor, Praxiteles of Athens, the son of Cephissodotus, is considered the greatest of the fourth century B.C.E. Attic sculptors. He left an imperishable mark on the history of art.

Our knowledge of Praxiteles received a significant contribution, and was placed on a satisfactory basis with the discovery at Olympia in 1877 of his statue of *Hermes with the Infant Dionysos* (see no. 100), a statue that has become world famous, but which is now regarded as a copy. Full and solid without being fleshy, at once strong and active, the *Hermes* is a masterpiece and the surface play astonishing. In the head we have a remarkably rounded and intelligent shape, and the face expresses the perfection of health and enjoyment.

Among the numerous copies that came to us, perhaps the most notable is the *Apollo Sauroktonos*, or the lizard-slayer (see no. 86), a youth leaning against a tree and idly striking with an arrow at a lizard, and the *Aphrodite of Knidos* of the Vatican (see no. 87), which is a copy of the statue made by Praxiteles for the people of Knidos; they valued it so highly they refused to sell it to King Nicomedes, who was willing in return to discharge the city's entire debt, which, according to Pliny, was enormous.

The subjects chosen by Praxiteles were either human or the less elderly and dignified deities. Apollo, Hermes and Aphrodite rather than Zeus, Poseidon or Athena attracted him. Under his hands the deities descend to human level; indeed, sometimes almost below it. They possess grace and charm to a supreme degree, though the element of awe and reverence is wanting.

Praxiteles and his school worked almost entirely in marble. At the time the marble quarries of Paros were at their best; for the sculptor's purpose no marble could be finer than that of which the Hermes is made.

Antoine-Auguste PREAULT
(Paris, 1809-1879)

A student under the neoclassical sculptor David d'Angers, Antoine-Auguste Préault first exhibited two low-reliefs at the Salon in 1833 . Of a violent nature, these works were immediately hailed by the Romantics. However, the work undertaken during the revolutions of July 1830 was not well accepted in the art world. Over several years, Préault was completely rejected by the official exhibitions' network, whose doors would not open again for him until 1839. His return was largely celebrated, notably by the critic Théophile Gautier: "Regarding Préault, he is a sculptor full of life and movement, audacious, and following his idea until the end, a man of energy who understands statue making in a great manner and who, after a most brilliant beginning, has seen the doors of the Salon closed to him for five or six years..." Attracted by pathetic subjects, lending themselves perfectly to the Romantic treatment which allows translation of emotions with emphasis, the style of Préault is characterised by incomparable vigour and warmth. Inspired by the works of Shakespeare, in 1842 he started working on a representation of Ophelia, who drowned herself after being rejected by Hamlet (see no. 732). Préault represented the depth of the stream, the hair swirling in the fleetingness of the moment which carries her away forever. Refused by the Salon of 1849, the low-relief in plaster was exhibited the following year and the work was cast in bronze at the order of the state in 1876. A sincere artist with an instinct for drama, abiding close to the convictions of his youth, Antoine-Auguste Préault died in Paris in 1879.

Barthelemy PRIEUR
(Berzieux, 1536 – Paris, 1611)

This French sculptor died in Paris in 1611. From the little known of his life, it is certain he worked in Turin for the Duke Emmanuel-Philibert of Savoy between 1564 and 1567. Having arrived in Paris in 1571, he found a patron in the constable Anne de Montmorency, who employed him at the Chateau d'Ecouen. Prieur was the creator of two sacred monuments dedicated to the constable: a tomb at the Montmorency church and a funerary column in the Celestine Church in Paris. For the funerary column, a monument to the heart of Anne de Montmorency, he was commissioned to create three allegorical life size sculptures, displayed today in the Louvre. The original monument had been demounted during the French Revolution. The statues represent *Peace*, *Justice* (see no. 490), and *Abundance* (see no. 491). In 1573, Prieur worked for Catherine de' Medici on the decoration of the Tuileries Palace. Finally, beginning in 1576, he created the funeral monument of Madeleine de Savoy, the wife of constable Anne de Montmorency, based on the sketches of Bullant. Since the demolition of the monument in 1793, all that remains of those monuments are recumbent statues and some fragments displayed in the Louvre.

Francesco PRIMATICCIO
(Bologna, 1504 – Paris, 1570)

The Italian painter and architect Francesco Primaticcio was a student of Giulio Romano, whom he assisted in his works on the Palazzo del Te in Mantua. It is there that he established his reputation by executing grand decorative compositions under the direction of Romano, often together with Il Rosso, and at the same time learned how to model and sculpt. Summoned to France in 1531 by Francis I to decorate the Fontainebleau Palace, he created admirable works of decoration in stucco and painting in the form of mythological frescos in the gallery of Henri II.

Aside from his paintings, Primaticcio provided sketches and plans for an infinite number of works of sculpture, ornamentation, furniture, silversmithing, etc. His works are distinguished by their elegance, grace, and finesse, brought together with the most brilliant execution. However, his drawings are often incorrect: his elegance is mannered, and his figures lack character and energy. In this way, he was an early representative of decadence in Italian art. The patronage of the Duchess of Etampes, the king's mistress, sheltered him from the attacks by Cellini. During a trip to Italy which Primaticcio made on the orders of Francis I in 1540, he acquired and brought to France a considerable number of classical statues and sculptures, along with casts of Trajan's Column, the *Laocoön* (see no. 112), the *Venus de' Medici*, and others. Appointed as superintendent of royal construction by Francis II in 1559 and showered with riches and favours by four consecutive kings, he exercised something of an artistic dictatorship during that era.

Pierre PUGET
(Marseille, 1620-1694)

Though an artist of genius, French sculptor Pierre Puget was difficult and kept away from court, then under the artistic influence of Le Brun. Puget's work was considered too personal and too impassioned to find favour there. His work was greeted with indignant protests, not because of any fault but rather because it exceeded prescribed limitations. In 1640, he left Marseille for Rome, where he stayed until 1643. Puget worked in Rome with Pietro da Cortona, to whom he owes his Baroque Style. Back in Marseille, full of energy after having travelled around Italy, he produced some of his major works, including two remarkable Atlas figures that embellish the entrance of the Forum Hall. His next notable work is his famous *Milon of Croton* (see no. 568), which can be admired in the Louvre in Paris. Puget died in Marseille in 1694, embittered and discouraged by the lack of recognition from the king and his court.

Tilman RIEMENSCHNEIDER
(Heiligenstadt, c. 1460 – Wurzburg, 1531)

Despite the fact that his career coincided with the High Renaissance in Italy, the German sculptor Tilman Riemenschneider remained an essentially medieval artist working in a late Gothic style, entirely unaffected by the innovations taking place south of the Alps.

Riemenschneider's earliest works were carved in the relatively soft medium of alabaster. Later he carved in stone as well as wood, but has been most admired for his virtuosity in the carving of wood and especially for the elaborate and exquisite rendering of surface detail and textures. Riemenschneider was always more interested in surface realism than in the volumetric weightiness and anatomical accuracy of his Italian contemporaries. The complex and angular folds of his draperies have an expressive life of their own and tend to disguise rather than to reveal the body underneath.

Riemenschneider was a successful and prolific sculptor whose workshop at one time employed as many as forty assistants. As a result of changing tastes, fires and wars, much of his work was altered, damaged, or lost.

His finest qualities may be judged from the Holy Blood altarpiece that remains in the Jacobskirche in Rothenburg ob der Tauber for which it was carved between 1501 and 1505 (see no. 411).

After completing his apprenticeship with Michel Erhart in Ulm, Riemenschneider moved to the prosperous Franconian city of Wurzburg where he was based until the end of his life. Riemenschneider was a successful and respected citizen of Wurzburg, becoming a member of the town council and the cathedral chapter. In 1505 he was among a group of councillors who greeted the Emperor Maximilian I at the city gate of Wurzburg. All this changed in the mid 1520s during the Peasant's Revolt when Riemenschneider sided with the peasants against Prince Bishop of Wurzburg. After the revolt had been put down Riemenschneider was imprisoned, heavily fined and, it seems, tortured. Though there is no evidence for the legend that his right hand was amputated, he seems to have executed little work in the last six years of his life.

Auguste RODIN
(Paris, 1840 – Meudon, 1917)

French sculptor, Auguste Rodin took classes at the School of Decorative Arts, also called the 'Little School.' After failing the entrance exam three times, he was unable to attend the School of Fine Art. As if in revenge against the establishment, he became one of the greatest sculptors of the century. In 1864, Rodin became a student of Carrier-Belleuse, first a master, then friend, of whom he made a bust of, almost twenty years later. In 1877, Rodin exhibited at the 'Cercle de Bruxelles' his plaster work, the *Defeated*, then at the Salon des Artistes Français under the title of *Age of Bronze*. The work provoked a real scandal, because the modelling appeared to be alive.

Accused of moulding from a cast, Rodin was finally cleared of all suspicion, notably as a result of the support of Carrier-Belleuse, and the affair finally allowed the genius of the sculptor to be revealed to the public. Now a recognised artist, he worked in a studio, in a marble works, on the rue de l'Université in Paris. In 1880, the state commissioned a cast of his *Age of Bronze* and a monumental door, for the future Museum of Decorative Arts. It is the beginning of public commissions which, until the death of the artist, never ceased and always ended, paradoxically, in scandal. Revolutionising sculpture by liberating the form, the work of Rodin was also marked by his admiration for Michelangelo whose *non finito* method he utilised in his own way, by letting his figures appear from blocks of marble in which they are kept prisoner.

Pedro ROLDAN
(Seville, 1624-1699)

Spanish sculptor, Pedro Roldán was the founder of a dynasty of sculptors that included four of his own children – notably his daughter Luisa Roldán who pursued a successful independent career that was quite exceptional for a woman of her day, eventually becoming court sculptor to Kings Charles II and Phillip V of Spain. The Roldán family practised the art of polychrome woodcarving that continued to thrive in Spain long after it had come to seem anachronistic or provincial in more economically and culturally "advanced" parts of Europe.

Pedro Roldán trained in Granada under Alonso de Mena, moving to Seville after his master's death in 1647. In Seville, Roldán was influenced by the work of the sculptor and painter Alonso Cano (1601-1667) and collaborated with the painter Juan de Valdes Leal (1622-1690) Roldán is particularly known for the polychromed sculptural groups he carved for retables which are remarkable for their combination of theatricality and realism. Among Roldán's finest existing works are a figure of St Joseph made for Seville Cathedral in 1664, a retable group depicting the Descent from the Cross, now in the Sagrario of Seville Cathedral but made for the chapel of the Biscayans in the Convent of St Francisco, in Seville and another depicting the Entombment made for the Hospital de la Caridad, Seville. Roldán worked in other Andalusian towns, notably Cadiz, Jerez and Jaen.

After Pedro Roldán's death in 1699, his sculptural workshop was continued for some time by his son Marcelino Roldán (1662-1706).

Antonio ROSSELLINO
(Settignano, c. 1427 – Florence, 1479)

Florentine sculptor, Antonio Rosselino was the son of Matteo di Domenico Gamberelli, and had four brothers, who all practised some branch of the fine arts. Almost nothing is known about the life of Antonio, but many of his works still exist, and are full of religious sentiment and executed with the utmost delicacy of touch and technical skill. The style of Antonio and his brother Bernardo is a development of that of Donatello and Ghiberti; it possesses all the refinement and sweetness of the earlier masters, but is not equal to them in vigour or originality. Antonio's chief work, still perfectly preserved, is the lovely tomb of a young cardinal prince of Portugal, who died in 1459. It occupies one side of a small chapel, also built by Rossellino, on the north side of the nave of San Miniato al Monte. The recumbent effigy of the cardinal rests on a handsome sarcophagus and over it, under the arch framing the ensemble, is a beautiful relief of the Madonna between two flying angels. The tomb was begun in 1461 and finished in 1466. A reproduction of this tomb with slight alterations, and of course a different effigy, was made by Antonio for the wife of Antonio Piccolomini, Duke of Amalfi, in the church of S. Maria del Monte at Naples, where it still exists.

Medardo ROSSO
(Turin, 1858 – Milan, 1928)

Medardo Rosso was an ambitious and highly-original sculptor whose work did not entirely fulfil its extraordinary promise. Rosso's studies at the Accademia de Belle Arti di Brera, starting in 1875, were interrupted by military service and then terminated in 1882 when he was expelled for protesting against the conservative teaching methods. In the 1880s he was primarily influenced by the literary and artistic group known as *Gli Scapigliati*, which promoted naturalism and a commitment to modern-life subject matter and whose ideas bear richest fruit in the verist operas of Mascagni and Leoncavallo. Increasingly Rosso attempted to imbue his sculpture with what might be regarded as painterly qualities. He set himself the task of fusing figures with their surroundings, dissolving contours and depicting atmosphere and light in the manner of an Impressionist painting. Works such as *Impression of an Omnibus* (1883-4) and *Conversation in a Garden* (c. 1896) were remarkable experiments, but given Rosso's commitment to naturalism and his use of traditional sculptural methods, the pursuit of such painterly qualities in sculpture was an enterprise doomed to failure. Rosso's experiments were later enthusiastically praised by the Futurists, who themselves pursued similar aims but who had been liberated from the constraints of naturalism by the innovations of Cubism.

In 1889 Rosso moved to Paris where he won the admiration of the naturalist writer Emile Zola and also of Auguste Rodin, with whom he exchanged works. Rosso and his supporters would later accuse Rodin of plagiarising Rosso's work, and indeed the odd backward tilt of Rodin's Balzac monument may possibly have been borrowed from Rosso's *The Bookmaker* (see no. 771).

Though Rosso lived well into the twentieth century and was taken up by such influential figures as the critic and painter Ardengo Soffici and Mussolini's long term mistress Margherita Sarfatti, he produced little of significance after 1900.

François RUDE
(Dijon, 1784 – Paris, 1855)

The French sculptor François Rude, the son of a locksmith, received only the most elementary instruction and was not able to attend the Dijon Free School of Drawing, Painting, and Modelling. After several difficult years of manual labour, in 1807 he decided to move to Paris. The superintendent of fine arts, Baron Denon, having seen Rude's statuette of *Theseus Picking up a Discus*, which he had brought from Dijon, recommended him as an assistant to the sculptor Gaulle, commissioned to do a section of a bas-relief for the restoration of the Column of the Grand Army. Rude assisted Gaulle with the execution of this commission and was admitted at the same time as a student of Cartellier. In 1812 he received the *Prix de Rome* for a bas-relief of *Le Berger Aristée pleurant la perte de ses abeilles* (*Berger Aristée weeping for the Loss of his Bees*), which he destroyed himself in 1843. Financial difficulties postponed his departure for Italy. During the Hundred Days, Rude joined the Bonapartist movement in his home-town. After his benefactor had been forced to flee following the restoration of the Bourbons, Rude had to leave for Brussels, where he became known as a sculptor and opened a school. In 1827, following the advice of the painter Gros and the sculptors Cartellier and Roman, he returned to Paris.

In 1828 he unveiled an *Immaculate Virgin* at the Salon, created in plaster and commissioned by the Saint-Gervais church, as well as the model of *Mercury attaching his Winged Sandals*.

Between 1833 and 1835 he created the *Departure of the Volunteers of 1792* (see no. 679), a high relief on the *Arc de Triomphe*, one of the most celebrated pieces in modern French Art.

Rude presented himself before the Institute four times without success. In 1855 his name was entered on the jury list for prizes at the World's Fair, and his peers awarded him the first medal of honour of the section. The great sculptor enjoyed as much respect for the dignity of his character as he did for his talent as an artist.

Auguste SAINT-GAUDENS
(Dublin, 1848 – Cornish, 1907)

An American sculptor born in Dublin, Auguste Saint-Gaudens began his artistic studies in Paris, where he attended the School of Fine Art. In 1870, he moved to Rome, where the neoclassical American William Wetmore Story was already working, and made his first sculpture in marble: *Hiawatha*, representing a young Indian (inspired by the writing of Henry Wadsworth Longfellow) in a neoclassical style, inspired by the art which surrounded him in Rome. On his return to the United States, he made portraits, in busts and medallions. He returned regularly to Paris and Rome.

For over thirty years, Saint-Gaudens undertook numerous private commissions or commissions for public monuments (the statue of General Sherman on horseback), in a naturalistic style which differentiated itself from Neoclassicism and was about to trigger the renaissance of American sculpture. In 1905, he had the privilege of redesigning the ten- and twenty-cent coins, these coins becoming an example of American numismatics.

Professor and model, Saint-Gaudens is considered first on the list of American artists who managed to integrate their Parisian training into a true "American" style.

Niki de SAINT-PHALLE
(Paris, 1930 – San Diego, 2002)

The French sculptor Niki de Saint-Phalle spent her childhood in New York. Self-taught as an artist, she took up painting in 1950. In 1952 she returned to Paris, and after 1960 she lived with the sculptor Jean Tinguely. In 1961 she began creating "shot-reliefs", works in which she used a rifle to pierce receptacles of paint suspended above relief assemblages of found

materials; as the paint spilt from the bags it completed the works beneath. She held her first solo exhibition at the Alexander Iolas Gallery in New York in 1961. By that time she had joined the Nouveaux Réalistes group of artists in Paris, and also begun making slightly more conventional sculptures, many of which employ a politicised bias. She went on to create some extremely large works, including the 1966 *She*, a reclining female whose innards contained film-shows, installations and machines, and which was entered through an aperture between its legs. Subsequently de Saint-Phalle wrote plays, made films, created architectural projects and continued to sculpt. A large retrospective of her work was mounted in Munich in 1987.

Johann Gottfried SCHADOW
(Berlin, 1764-1850)

German sculptor, Johann Gottfried Schadow was the son of a poor tailor. His first teacher was an inferior sculptor, Tassaert, patronised by Frederick the Great; the master offered his daughter in marriage, but the pupil preferred to elope with a girl to Vienna, and the father-in-law not only condoned the offence but furnished money with which to visit Italy. Three years study in Rome influenced his style, and in 1788 he returned to Berlin to succeed Tassaert as sculptor to the court and secretary to the Academy. Over half a century he produced upwards of two hundred works, as varied in style as in subject.

Among his ambitious efforts were Frederick the Great in Stettin, Blücher in Rostock, and Luther in Wittenberg. His portrait statues include Frederick the Great playing the flute, *The Crown Princesses Louise and Friedrike of Prussia* (see no. 652). His busts, which reach a total of more than one hundred, comprise seventeen colossal heads in the Walhalla, Ratisbon; from the life were modelled Goethe, Wieland and Fichte. Of church monuments and memorial works thirty are enumerated, yet Schadow hardly ranks among Christian sculptors. He is claimed by classicists and idealists. The quadriga on the Brandenburger Tor and the allegorical frieze on the facade of the Royal Mint, both in Berlin, are judged among the happiest studies from the antique. Schadow, as director of the Berlin Academy, had great influence. He wrote on the proportions of the human figure, on national physiognomy, etc.; and many volumes by him and others describe and illustrate his method and work.

Andreas SCHLUTER
(Hamburg, c. 1660 – St Petersburg, 1714)

German sculptor and architect, Andreas Schlüter exercised much of his activity as a sculptor in Warsaw, but in 1694 he was summoned to Berlin. Two years later he began his designs for the rebuilding of the royal palace. The execution of these occupied him from 1699 to 1706, and the palace became a conspicuous example of Baroque style in Germany. In 1713 Schlüter went to St Petersburg, where he did architectural work for Peter the Great. His principal works in Berlin are the monument of the great elector Frederick William and the twenty-one masks of dying warriors in the courtyard of the arsenal, the tombs of King Frederick I and his wife, and the marble pulpit in the Marienkirche.

SKOPAS
(Active during first half of the 4th century B.C.E.)

Probably of Parian origin, Skopas was the son of Aristander, a great Greek sculptor of the fourth century B.C.E. Although classed as an Athenian, and similar in tendency to Praxiteles, he was really a cosmopolitan artist, working largely in Asia and Peloponnesos. The existing works with which he is associated are the Mausoleum of Halicarnassos, and the temple of Athena Alea at Tegea. In the case of the Mausoleum, though no doubt the sculpture generally belongs to his school,

we are unable to single out any specific part of it as his own. We have, however, good reason to think that the pedimental figures from Tegea are Skopas' own work. They are, unfortunately, all in extremely poor condition, but appear to be our best evidence for his style.

While in general style Skopas approached Praxiteles, he differed from him in preferring strong expression and vigorous action to repose and sentiment.

Early writers give us a good deal of information as to works of Scopas. For the people of Elis he made a bronze Aphrodite riding on a goat (copied on the coins of Elis); a *Maenad* (see no. 85) at Athens, running with head thrown back and a torn kid in her hands, was ascribed to him. Another type of his was Apollo as leader of the Muses, singing to the lyre. The most elaborate of his works was a great group representing Achilles being conveyed over the sea to the island of Leuce by his mother Thetis, accompanied by Nereids.

Jointly with his contemporaries Praxiteles and Lysippos, Skopas may be considered to have completely changed the character of Greek sculpture; they initiated the lines of development that culminated in the schools of Pergamum, Rhodes and other great cities of later Greece. In most modern museums of ancient art their influence may be seen in three-fourths of the works exhibited. At the Renaissance it was especially their influence which dominated Italian painting, and through it, modern art.

Claus SLUTER
(Haarlem, c. 1340 – Dijon, c. 1406)

The Flemish sculptor Claus Sluter was the primary representative of the Dijon school in the late fourteenth and the early fifteenth centuries. In 1385 he became the *"ymaigier"* of Philippe le Hardi, Duke of Burgundy, and was commissioned to create the main statues of the Chartreuse de Champmol. He sculpted the statues and portraits on the portal of the chapel (see no. 339): the Virgin with the Duke Philippe and his wife, Margaret of Flanders, kneeling at her side, created between 1387 and 1393, on which he undoubtedly collaborated with Jean de Marville; and, in the same place, the famous well of Moses, created between 1395 and 1403, with statues of the prophets Moses, David, Jeremiah, Zachariah, Daniel, and Esau, a powerful and expressive masterpiece. The tomb of Philippe le Hardi is credited to Claus Sluter as well.

David SMITH
(Decatur, 1906 – near Bennington, 1965)

David Smith was undoubtedly the most influential and highly-regarded American sculptor of the period after World War II. In 1925 Smith was employed for a time in the car industry and acquired skills in the welding of metal that would later prove useful. In 1927, after moving to New York, Smith enrolled at the Art Students' League, where he initially concentrated on painting and drawing. Through the artist, collector and connoisseur John Graham, who acted as a mentor, Smith was introduced to the latest innovations of the European avant garde at a time when they were little known in America, as well as to other young and progressive artists such as Arshile Gorky, Stuart Davis and Willem De Kooning. As with so many twentieth-century sculptors, the discovery of African art proved a liberating experience for Smith. Still more important for his development as an artist was his discovery around 1930 of welded metal sculptures by Pablo Picasso and Julio Gonzalez, illustrated in the magazine *Cahiers d'Art*. From 1933 he began to make his own welded metal sculptures utilising the skills he had picked up earlier while working on cars. Incorporating found objects and machine parts as well as industrial metal elements, this work exhibits various textured and coloured surfaces, painted, polished and rough. In the post-war period, with the enthusiastic support of the influential critic Clement Greenberg, Smith was accorded recognition and success, and was able to

work on a larger scale. In the final years of his life he worked on his well-known *Cubi* series, made from stainless steel. He was killed in a car accident in 1966.

William Wetmore STORY
(Salem, 1819 – Vallombroso, 1895)

The American sculptor and poet William Wetmore Story was the son of the jurist Joseph Story. He graduated from Harvard University in 1838 and from the Harvard Law School in 1840, continued his law studies under his father and was admitted to the Massachusetts bar. Abandoning the law, he devoted himself to sculpture, and after 1850 lived in Rome, where he had first gone in 1848, and where he was intimate with the Brownings and with Landor. He was a man of rare social cultivation and charm of manner, and his studio in Rome was a centre for the gathering of distinguished English and American literary, musical and artistic people. During the American Civil War his letters to the *Daily News* in December 1861, and his articles in *Blackwood's*, had considerable influence on English opinion. One of his earliest sculptures was a statue of his father. His most famous, *Cleopatra*, was enthusiastically described in *The Marble Faun*, a romance by Nathaniel Hawthorne. Among his writings, in addition to legal and artistic treatises, he wrote a novel and several volumes of poems of considerable merit.

Veit STOSS
(Horb, c. 1447 – Nuremberg, 1533)

German sculptor and wood carver, Veit Stoss is considered, with Tilman Riemenschneider, as the greatest wood carver of his age. In 1477 he went to Cracow, where he was actively engaged until the end of the century. It was here that he carved the high altar for the Marienkirche (see no. 393), between 1477 and 1489. On the death of King Kasimir IV in 1492, Stoss carved his tomb in red marble for the cathedral in Cracow. To the same date is ascribed the marble tombstone of the archbishop Zbigniew Ollsnicki in the cathedral at Gnesen (Giezno). In 1496 he returned to Nuremberg, where he did a great deal of work completing altars. His best-known sculpture is the *Annunciation* for the Church of St Lorenz in Nuremberg, from 1518, carved in wood on a heroic scale and suspended from the vault.

Sophie TAEUBER-ARP
(Davos, 1889 – Zurich, 1943)

The Swiss sculptor Sophie Taueber-Arp began her career as a teacher of clothing design at the School of Arts and Crafts in Zurich. In 1915 she met Hans Arp, whom she married in 1921. It was with him that she participated in the activities of the Zurich Dadaist group. These *Dada Heads* (see nos. 827, 840) had already used motifs that she included in her elaborate paintings of 1915: abstract compositions, multi-coloured juxtapositions of geometrical figures animated by lively and luminous shades. Influenced by the principles of the Bauhaus school, it was Sophie who completed the plans for the house she shared with Hans in Meudon.

In 1933, she used nothing except circles on monochromatic black and white backgrounds. During that time she participated in expositions of the Abstraction-Création group, in which she and Hans Arp participated after abandoning the Surrealist movement.

In Grasse, Sophie Taueber worked with the theme of the line, free and open, which developed into a motif in itself. During 1941, having suffered the hardships caused by the war, her state of health became poor. In 1942, while a refugee in Switzerland awaiting departure to the United States, she died of suffocation by the fumes of a coal stove. Rediscovered during the 1960s, she is today considered one of the precursors of Concrete art.

TAKIS
(Panayiotis Vassilakis, 1925)

"Takis" achieved an international reputation from the late 1950s as one of the most inventive proponents of Kinetic art. Based primarily in Paris, Takis experimented from 1958 with the use of magnetism and electromagnetic fields to create movement and the effect of objects floating in air. The series entitled *Signals* (see no. 944) consisted of slender and flexible vibrating rods. In 1960 Takis staged a spectacular happening at the Galerie Iris Clert in Paris, in which the poet Sinclair Beiles read poems aloud while suspended in mid-air with the aid of magnetism.

Takis later incorporated light and sound into his sculptures. In *Tele-lumiere II* (1963) light was made to dance by means of electromagnets. In his *Tele-sculpture musicale* sound was produced by needles vibrating against a length of piano wire.

Jean TINGUELY
(Friburg, 1925 – Bern, 1991)

With great wit, irony and ingenuity, the Swiss sculptor Jean Tinguely explored and developed ideas and themes produced by earlier twentieth-century avant-garde movements such as Constructivism, Keneticism, Dada and Surrealism. In so doing he won exceptional popular fame and acceptance.

As early as the 1930s, when barely into his teens, Tinguely began experimenting with moving and mechanically-powered objects. There remained a childlike sense of mischief in his work for the rest of his career. During the war years he studied at the Allgemeine Gewerbeschule in Basle. It was around this time that he discovered the anarchic work of Kurt Schwitters. After a brief phase in which he painted in a Surrealist manner, he turned to sculpture. In 1953 Tinguely moved to Paris and began producing what he called "meta-mechanical devices" – abstract constructions with mechanical elements that could be activated by viewers. In the late 1950s he produced mechanical sculptures that when operated by viewers could make abstract paintings. In 1960 Tinguely co-founded Nouveau Realisme, along with Yves Klein, Arman, César and others. Tinguely anticipated the anarchic tendencies of the 1960s and looked back to the cultural anarchy of Dada as well in works that self-destructed such as the famous *Homage to New York* which burst into flames outside MOMA in 1960. From 1961 Tinguely lived and collaborated with Niki de Saint-Phalle.

Andrea del VERROCCHIO
(Florence, c. 1435 – Venice, 1488)

Italian goldsmith, sculptor and painter, Andrea del Verrocchio took his name from his master, the goldsmith Giuliano Verocchi. Except through his works, little is known of his life. As a painter he occupies an important position, for Leonardo da Vinci and Lorenzo di Credi worked for many years in his *bottega* as pupils and assistants. Only one existing painting can be attributed with absolute certainty to Verrocchio's hand, the celebrated *Baptism of Christ*.

As a sculptor, one of his earliest works was the beautiful marble medallion of the Madonna over the tomb of Leonardo Bruni of Arezzo in the church of Santa Croce at Florence. In 1476, Verrocchio modelled and cast the fine but too realistic bronze statue of *David* (see no. 366), and in the following year he completed one of the reliefs of the magnificent silver altar-frontal of the Florentine baptistery, representing the "Beheading of St John." Between 1478 and 1483, he was occupied in making the bronze group of the *Unbelief of St Thomas* (see no. 385), which stands in one of the external niches of Orsanmichele. Verrocchio's chief masterpiece was the colossal bronze equestrian statue of the Venetian general Bartollomeo Colleoni, which stands in the piazza of SS. Giovanni Paolo at Venice.

Verrocchio received the order for this statue in 1479, but had only completed the model when he died in 1488. In spite of his request that the casting be entrusted to his pupil Lorenzo di Credi, the Venetian senate gave the work to Alessandro Loepardi, and the statue was gilt and unveiled in 1506. This is perhaps the noblest equestrian statue in the world, being in some respects superior to the antique bronze of Marcus Aurelius in Rome and equal to the Gattamelata at Padua by Donatello. The horse is designed with wonderful nobility and spirit, and the easy pose of the great general, combining perfect balance with absolute ease and security in the saddle, is a marvel of sculpturesque ability.

According to Vasari, Verrocchio was one of the first sculptors who made practical use of casts from living and dead subjects. He is now considered among the greatest sculptors between Donatello and Michelangelo.

Adriaen de VRIES
(The Hague, c. 1560 – Prague, 1626)

The Dutch sculptor Adriaen de Vries played a major role in the development of mannerism in Northern Europe. During the 1580s, he resided in Italy and was a student of Giambologna in Florence, where he made copies for the Emperor Rudolf II. The sculptors first known work is his *Mercury and Psyche* (see no. 494), displayed in the Louvre, which was inspired by the style of Giambologna. Recalled to Prague, he was then sent to Augsburg where he lived for a number of years and created significant works, most notably, the *Fountain of Mercury* in 1599 and the *Fountain of Heracles* in 1602. Most of his works, made in bronze, benefited considerably from the nature of their medium, which lends character and curve to compositions. Paradoxically, none of the commissions he carried out ever made it to the Netherlands.

Ossip ZADKINE
(Vitebsk, 1890 – Paris, 1967)

Ossip Zadkine was born in the same city and three years after Marc Chagall, an artist whose career path would cross with his own at many points. Both were of Jewish origin, though Zadkine's father was a convert to Christianity and his mother of Scottish descent. It was while living with maternal relatives in the north of England that he had his first artistic training at a local art school. At the age of sixteen he moved to London to continue his studies and met there another artist of Russian Jewish origin, David Bomberg, one of the very few British artists who was not only open to the latest continental avant garde tendencies but capable of contributing to them.

In 1909 Zadkine moved to Paris. From this time on he may be regarded as a Parisian artist, taking French nationality in 1921. He returned to Paris as soon as possible after his exile in America during World War II.

In 1910 he moved into the famous studio complex of La Rouche where he mixed with Chagall, Léger and Archipenko amongst others. From 1912 he lived in Montparnasse, becoming a familiar figure in a lively community of avant garde artists and writers that included Picasso, Max Jacob and Apollinaire. As with so many artists of his generation, the most important formative experiences on his art were the impact of World War I during which he served as a volunteer medical orderly, and his encounter with Cubism.

The first monograph on Zadkine (by Maurice Raynal) appeared as early as 1921, and by the end of that decade his reputation was well established. At the 1937 Paris World Exhibition forty seven of Zadkine's sculptures were on display.

Zadkine's most important post-war commission – and perhaps his best known sculpture altogether – was the monumental bronze *Destroyed City* commemorating the destruction of Rotterdam by German bombs in 1940.

CHRONOLOGY

		– ANTIQUITY –	
Archaic Period	800 B.C.E.:	Intensification of greek trade towards Middle East, then Italy. Beginning of the Etruscan civilisation in Tuscany.	Homer: *Iliad* and *Odyssey*
	753 B.C.E.:	Foundation of Rome.	
	750 B.C.E.:	Beginning of Greek colonisation towards the East.	
	660 B.C.E.:	Foundation of Byzance. Splendour of Ninive.	
	597 B.C.E.:	Destruction of the Temple of Jerusalem by Nabuchodonosorus.	Temples of Jupiter, Junon and Minerva on the
	575 B.C.E.:	Height of the power of the Estruscan kings upon Rome. Tarquin the Elder imposes himself on the Latins and dries the site and installs the forum. Servius Tullius gives the city fortifications.	Capitole, Rome
			Beginning of dramatic arts in Greece
	561 B.C.E.:	Pisitratus becomes the tyrant of Athens. Autocracy in all the Cities of Greece.	
	510 B.C.E.:	Pisitratides are chased out of Athens. Installation of Roman Republic.	Temple of Zeus, Olympia
Classic Period	508 B.C.E.:	Installation of democracy in Athens by Clysthen.	Temple of Aphaia, Aegina
	490-479 B.C.E.:	Medic War. Destruction of the Acropolis by the Persians. Victory of the Greeks. Athens becomes the most powerful city of the Greek Republic.	Parthenon, Athens
	449 B.C.E.:	Ratification of peace with Persia.	Sophocles: *Antigone*
	443-429 B.C.E.:	Perikles in Athens rebuilds the Acropolis.	Plato: *Symposium*
	431-404 B.C.E.:	War of the Peloponese: Sparta beats Athens.	Plato founds a school of philosophy in Athens, the "Academy"
	399 B.C.E.:	Trial and death of Socrates.	
Hellenistic Period	338 B.C.E.:	Defeat of Athens and its last allies to Philip II of Macedonia.	Aristotle funds the Lycee of Athens
	336-323 B.C.E.:	Reign of Alexander the Great. Conquest of Greece and Persia.	Theatre of Epidauria
	331 B.C.E.:	Foundation of Alexandria.	
	264-241 B.C.E.:	First Punic War: Rome takes Carthage from Sicily, Sardinia and Corsica. Foundation of Cartagena in the Iberian Peninsula.	
	218-201 B.C.E.:	Second Punic War: Hannibal crosses the Alps and threatens Rome, which finally spreads its control all the way to the Iberian Peninsula and Northern Africa.	
	168 B.C.E.:	Rome triumphs over Macedonia.	Lighthouse of Alexandria
	166 B.C.E.:	Overthrow of the last Macedonian king by the Romans. Rome dominates the entire Mediterranean region.	Library of Alexandria
	150 B.C.E.:	Sack of Corinth by the Romans.	Colossus of Rhodes
	149-146 B.C.E.:	Third Punic War: destruction of Carthage.	Julius Caesar: *Commentarii de Bello Gallico*
	52 B.C.E.:	Victory of Caesar over the people of Gaul in Alesia.	(*Commentaries on the Gallic War*)
	44 B.C.E.:	Murder of Caesar in Rome.	
	31 B.C.E.:	Battle of Actium: defeat of Mark-Anthony and Cleopatra.	*Julian Calendar*
Hegemony of the Roman Empire	27 B.C.E.:	Octavius is proclaimed Augustus. Beginning of the Roman Empire.	Virgil: *Aeneid*
	0:	Birth of Jesus Christ.	Ovid: *Metamorphoses*
	64:	Great Fire of Rome and first Christian persecutions by Nero.	Livy: *History of Rome*
	70:	Destruction of the Jerusalem Temple by Titus.	
	79:	Disappearance of the cities of Herculaneum and Pompeii after the eruption of Vesuvius.	Plinis the Elder: *Naturalis Historia*
			Colosseum and Pantheon, Rome
	293:	Diocletian establishes the Tetrarchy, dividing the government of the Empire between West and East.	Tacitus: *Histories*
			Marcus Aurelius: *Meditations*
	306-337:	Reign of Emperor Constantine. Unity of Empire established.	
	313:	Edict of Milan authorises Christians to celebrate their cult.	Basilica of San Pietro, San Giovanni Fuoricivitas
	330:	Constantine I founds Constantinople.	and San Giovanni in Laterano, Rome
	406:	Beginning of the Great Invasion in Gaul after the freeze of the Rhine.	Church of the Holy Apostles, Constantinople
	410:	Sack of Rome by the Visigoths.	
	451:	Invasion of Gaul by Attila the Hun.	Church of the Holy Sepulchre, Jerusalem
	455:	Invasions of the Vandals. Sack of Rome.	
	476:	Emperor Romulus Augustus abdicates in favour of the German vassal chieftain Odoacer – end of the Roman Empire.	

Early Middle Ages	496:	Clovis I, King of the Francs (480-511), converts to Christianity.	529: *Corpus Juris Civilis*
	532:	Reconquering of the Roman Empire by the Emperor Justinian (527-565). Ravenna is the capital.	529: Rule of St Benedict
	568-572:	Invasion of the Italian peninsula by the Lombards.	532-537: Hagia Sophia, Constantinople
	596:	Toledo becomes the capital of the Visigoth kingdom.	644: Caliph Uthman establishes a definitive version of the Koran
	610:	Beginning of Mahomet's predication at Mecca.	785: Beginning of the construction of the Mezquita in Córdoba
	634:	Umar unifies Araby and launches the first wave of Muslim conquest (Hijra).	c. 800: First known treaty of chemistry
	711:	Arab conquest of the Visigoth kingdom.	8th century-10th century: Pre-roman architecture in Lombardy and Catalonia (Church of San Pedro de Roda)
	715:	St Boniface evangelises Frisia (Northern Europe).	
	718:	Creation of the Christian kingdom of the Asturias (Spain).	
	730-787:	First iconoclasm in the Byzantine Empire.	9th century: Creation of the Cyrillic alphabet
	732:	Charles Martel halts the Arab invasion in Poitiers.	909: Fundation of the Cluny Abbey in Bourgogne
	756:	Abd-ar-Rahman founds the Umayyad dynasty of the Cordova emirate. Pippin the Younger delivers Rome from the Lombard Siege. Creation of Church States.	
High Middle Ages	800:	Charlemagne (768-814) is crowned emperor of the Holy Roman Empire.	c. 976: Arabic numbers are introduced in the Western world
	825:	First unification of the Christian-anglo-saxon kingdoms.	10th century: Avicenna: *The Canon of Medicine*
	834-841:	Settlement of the Normans in Frisia.	10th century: Roman Churches, known as "pilgrimage churches" (Santiago de Compostella, Saint Sernin of Toulouse)
	846:	Sack of St Peter in Rome by the Saracens. Pope Leon IV builds the fortifications of the Vatican.	
	866-910:	Reign of Alfonso the Great, King of Asturias and León.	1065: Consecration of the Westminster Abbey
	887:	Abdication of Charles III, end of Carolingian Empire.	1066-1082: Bayeux tapestry
	919-936:	Reign of Henri I, King of Germany.	1088: Creation of the first university in Bologna
	926:	Raids of the Magyards, halted in Lechfeld (955) by Otto.	End of the 11th century: *Song of Roland*
	962-973:	Reign of Otto I, crowned in Rome, first emperor of the Holy Roman Empire.	12th century: Choir of the Saint-Denis Basilica under Abbot Suger: birth of Gothic architecture
	976-1025:	Reign of Basil II, golden age of the Byzantine Empire.	1163: Beginning of the construction of Notre-Dame Cathedral in Paris
	987-996:	Reign of Hugh Capet, King of France, founder of the Capetian dynasty.	1167: Foundation of the University of Oxford
	1054:	Schism between the churches of Rome and Constantinople. Birth of Orthodoxy.	1170: Béroul: *Tristan and Iseult*
	1066:	Battle of Hastings: conquest of England by William the Conqueror, Duke of Normandy.	c. 1177: Chrétien de Troyes: *The Knights of the Round Table*
	1099:	Sack of Jerusalem by Godefroi de Bouillon.	1208-1216: Foundation of Fransiscans and Dominicans Orders
	1138-1152:	Reign of Conrad III, King of Germany. Dynasty of the Hohenstaufen.	1248: Beginning of the construction of the Cologne Cathedral
	1146:	Second crusade preached by St Bernard of Clairvaux, with Louis VII.	1257: Foundation of the Sorbonne in Paris
	1152-1190:	Reign of Frederick I, called Barbarossa, King of Germany.	1267-1273: St Thomas Aquinas: *Summas*
	1190:	Third Crusade with Philippe Auguste, Frederick I, called Barbarossa and Richard the Lionheart.	1297-1300: Giotto di Bondone: Frescos of the Life of St Francis, Basilica of San Francesco de Assisi
	1199-1216:	Reign of John Lackland, King of England.	1314-1321: Dante: *The Divine Comedy*
	1200:	Venice, Pisa and Genoa dominate trade with the east.	
	1204:	Sack of Constantinople by the crusaders.	
	1215:	John Lackland signs the Magna Carta. Council of the Lateran.	
	1226-1270:	Reign of St Louis (Louis IX), King of France.	
	1242:	Alexandre Nevski begins unification of Russia.	
	1275:	Marco Polo arrives in China.	
Late Middle Ages	1337-1453:	Hundred Years War between England and France.	1349-1353: Boccaccio: *The Decameron*
	1348:	The Plague (known as the Black Death) arrives in Europe.	15th-16th century: Navigation with caravels
	1378:	Beginning of the Great Schism: Pope Urban VI reigns in Italy and Pope Clement VII in France.	1432-1436: Brunelleschi: Dome of the Cathedral of Florence
	1384:	Creation of the Burgundy states by Philip the Bold.	1434: Van Eyck: *The Arnolfini Portrait*
	1385:	Victory of Juan I of Portugal over the Castilians.	1436: Alberti: *De Pictura*
	1431:	Joan of Arc is burned alive in Rouen.	1437-1440: Fra Angelico: *The Descent of the Cross*
	1453:	Turkish conquest of Constantinople, end of the Byzantine Empire.	

	– RENAISSANCE –	
Early Renaissance	1455-1485: War of the Roses in England between the Houses of York and Lancaster. 1456: The Portuguese discover the Cape Verde. 1478: Sixtus IV issues the Bull establishing the Spanish Inquisition. 1479: The Treaty of Alcáçovas settles the union of Ferdinand of Aragon and Isabelle of Castile: beginning of the reign of Catholic Monarchs. 1480: Ivan III Vasilevich frees Russia from Mongol domination. 1485-1509: Reign of Henri VII Tudor, King of England. 1487: Bartolomeu Dias sails around the Cape of Good Hope. 1492: Moors are driven out of Grenada and Spain, ending 800 years of Islamic presence in Spain. Christoper Columbus discovers the Americas. 1494: Beginning of Italian Wars with the expedition of Charles VIII, King of France. 1498: Vasco de Gama arrives in India.	1452: Hopfer invents engraving 1457: *Mainz Psaulter*, first book printed by Gutenberg 1476-1478: Van der Goes: *The Adoration of the Shepherds* 1478: Botticelli: *Spring* 1485: Reconstruction of the Moscow Kremlin 1490: Mantegna: *Dead Christ*
High Renaissance	1500: Pedro Alvares Cabral discovers Brazil. 1508-1519: Reign of Maximilan I, emperor of the Holy Roman Empire. Spreads the Habsburgs' reign to Burgundy, the Netherlands, Franche-Comté, Hungary and Bohemia. 1515-1547: Reign of Francis I, King of France. 1515: Battle of Marignan, victory of France against the Swiss. 1517: Martin Luther posts his 95 theses: Protestant Revolt and beginning of the Reformation. 1519-1555: Reign of Charles V, emperor of the Holy Roman Empire. 1520: Magellan discovers a strait and names it after himself. 1520: Revolt of Gustave Vasa, King of Sweden (1523-1560), against Denmark. 1521-1557: Reign of Juan III, King of Portugal. The conquistador Hernán Cortés defeats the Aztecs: beginning of three centuries of Spanish colonisation. 1526: Victory of the Turks in Mohács, Hungary. 1527: Sack of Rome by the troops of Charles V. 1529: Ottoman siege of Vienna. 1530: End of the Florence Republic (1500-1530). Under the reign of Cosimo de' Medici, Tuscany acquires the title of Grand Duchy.	1500: Dürer: *Self-portrait in a Fur-Collared Robe* 1503-1506: Leonardo da Vinci: *Mona Lisa* c. 1504: Bosch: *The Garden of Earthly Delights* 1506: The statue of *Laocoön* unearthed in Rome 1506-1614: Sangallo, Bramante and Michelangelo: St Peter's Basilica 1509: Erasmus: *In Praise of Folly* 1509-1510: Raphael: *School of Athens* c. 1515: Nicolaus Copernicus theorises the theory of heliocentrism 1519-1547: Château de Chambord
Late Renaissance	1531: Francisco Pizarro conquers the Inca Empire. 1534: Adoption of the Act of Supremacy by England: birth of the Anglican Church. 1545-1563: Council of Trent and Counter-Reformation. 1547-1584: Reign of Ivan IV, the Terrible, first ruler of Russia to assume the title of tsar. 1549: Francis-Xavier is designated to carry on the first Christian mission to Japan. 1553-1558: Reign of Marie Tudor, Queen of England. Return to Catholicism. 1555: Abdication of Charles V. His son, Philippe II, is crowned King of Spain and Sicily (1555-1598). Ferdinand I, his brother, becomes emperor of the Holy Roman Empire. 1559-1603: Reign of Elizabeth I, Queen of England. Anglicanism becomes the official religion of the kingdom. 1568: General revolt in the Netherlands. 1571: Battle of Lepanto, victory of the Venetians and Spaniards over the Ottomans: end of the Ottoman hegemony on the Mediterranean Sea 1572: St Bartholomew's Day massacre: massive, brutal killings of Protestants in France during the night of the St Bartholomew. 1579: Union of Utrecht: creation of the Dutch Republic (Independence of the Northern provinces from Spain). 1588: The Spanish Armada defeated by England: end of Spanish commercial supremacy. 1598: Henri IV, King of France (1589-1610), proclaims the Edict of Nantes: end of the French Wars of Religion.	1532: Rabelais: *Pantagruel* 1533: Holbein the Younger: *The Ambassadors* 1536-1541: Michelangelo: *The Last Judgment*, decoration of the Sistine Chapel 1538: Titian: *Venus of Urbino* 1543: Andreas Vesalius realises the first anatomical study 1557: Herrera: beginning of the construction of the Monastery of San Lorenzo de El Escorial 1562-1563: Veronese: *The Wedding of Cana* 1563: Bruegel the Elder: *Babel Tower* 1566-1570: Palladio: La Villa Rotonda 1582: The Gregorian Calender 1595: Shakespeare: *Romeo and Juliet*

17th century, the great European monarchies	1600: Founding of the British East India Company. 1608: Beginning of British colonisation in Northern America. Samuel de Champlain founds Québec. 1609: Twelve Years Truce, Spain acknowledges the Independence of the United Provinces. 1613-1645: Reign of Michel III, Tsar. Romanov Dynasty (1613-1917). 1619-1637: Reign of Ferdinand II, emperor of Holy Roman Empire. 1621-1665: Reign of Philippe IV, King of Spain. 1625: Dutch settle in Manhattan and establish New York. 1642-1649: English Revolution, led by Oliver Cromwell. 1648: Defeat of Spain against France, peace of Westphalia, concession of the Flanders' territories. 1649: Death of Charles I of England. 1653: Oliver Cromwell, Lord Protector of England. 1660-1685: Reign of Charles II Stuart, King of England. 1661-1715: Reign of Louis XIV, the "Sun King", King of France. 1666: Great Fire of London. 1668: Spain acknowledges Portugal's independence. 1672-1678: Dutch War comes to an end with the Treaty of Nijmegen; Louis XIV becomes the Europe "arbiter". 1675-1700: Charles II of Spain, last Spanish king from the House of the Habsburgs. 1683: Last siege of Vienna by the Ottomans. 1685: Revocation of the Edict of Nantes and Protestant exodus from France. 1688-1697: War of the "Augsburger Allianz". 1697-1718: Reign of Charles XII, King of Sweden.	1599-1600: Caravage: *Calling of St Matthew* 1605: Cervantès: *Don Quichotte* 1609: Galileo invents the astronomical telescope 1610-1611: Rubens: *Descent of the Cross* 1636: Corneille: *Le Cid* 1637: Descartes: *The Discourse on Method* 1638-1639: Poussin: *The Shepherds of Arcadia* 1638-1641: Borromini: San Carlo alle quattro fontane, Rome 1642: Rembrandt: the *Night Watch* 1656: Velázquez: *Las Meninas* 1687: Newton: Theory of universal gravitation 1664: Molière: first performance of *Tartuffe* 1670: Wren: St Paul's Cathedral, London 1677: Racine: *Phaedra* 1678-1684: Hardouin-Mansart and Le Brun: the Hall of Mirrors, Château de Versailles 1690: Locke: *An Essay Concerning Human Understanding* 1696: Fischer von Erlach: Castle of Schonbrunn, Vienna 1698: Thomas Savery invents the steam engine
18th century, the Enlightments time	1700-1746: Reign of Philippe V, King of Spain. 1701-1714: Spanish War Succession. 1703: Uprising of Hungary, which breaks free from the Habsburgs. Foundation of St Petersburg by Peter the Great. 1707: Acts of Union merges the Kingdom of England and the Kingdom of Scotland in the "United Kingdom." 1714-1727: Reign of George I, first Hanoverian King of England. 1721-1725: Reign of Peter I of Russia, first emperor of the Russian Empire. 1740-1786: Frederic II, King of Prussia. 1741: Beginning of the Austrian War of Succession. 1756-1763: Seven Years War between Europe and the Americans colonies. 1759-1788: Reign of Charles III, King of Spain. 1762-1796: Reign of Catherine II, Empress of Russia. 1763: Treaty of Paris: France cedes Canada and all its territories east of the Mississippi River to England. 1764-1795: Reign of Stanislaw August Poniatowski, King of Poland. 1765-1790: Reign of Joseph II, emperor of the Holy Roman Empire. 1774-1792: Reign of Louis XVI, King of France. 1775-1783: American War of independence from Great Britain. 1776: Declaration of Independence of the United States. 1780-1810: First Industrial Revolution in England. 1788: Colonisation of Australia by the United Kingdom. 1789: French Revolution. Election of George Washington as the first President of the United States of America (1789-1797). 1793: Louis XVI, King of France, is beheaded. Opening of the Louvre Museum. 1796: Italy Campaign of Bonaparte.	1709: Pöppelmann: Zwinger Palace, Dresden 1721: Montesquieu: *Persian Letters* – Vivaldi: *The Four Seasons* 1727: Bach: *St Matthew Passion* 1734: Voltaire: *Philosophical Letters* 1738: Zimmermann: Pilgrimage Church of Wies 1748: Discovery of the ruins of Herculaneum and Pompeii 1750-1753: Tiepolo decorates Wurtzburg, Germany 1751: Publishing of the first volume of the Encyclopaedia by Diderot 1764: Winckelmann: *History of Art in Antiquity* 1760-1763: Macpherson publishes the poems of Ossian (3rd century) 1781: Kant: *The Critique of Pure Reason* 1791: Mozart: *The Enchanted Flute* 1794: Blake: *Ancient of Days* (God as an Architect) 1800-1801: Goya: *Family of Charles VI*

19th century	1804: Civil War in France. 1804-1815: Reign of Napoléon I, French emperor. 1805: Victory of Nelson at Trafalgar. Victory of Napoléon at Austerlitz. 1806: Dissolution of the Holy Roman Empire. 1810-1826: Independence of the Spanish colonies (with the exception of Cuba and Puerto Rico). 1814: Vienna Congress. Restoration of the Bourbons in Spain. 1815-1848: Restoration of the French Monarchy with Louis XVIII (1814-1824) and Charles X (1824-1830). 1837-1901: Reign of Victoria I, Queen of the United Kingdom of Great Britain and Ireland and the first Empress of India (1876-1901). 1848: Year of revolutions: revolts in France, Italy, Austria and Hungary. 1852-1870: Reign of Napoléon III, French emperor. 1853-1856: War of Crimea. Japan opens its borders to Westerners. 1860: Beginning of the Second Industrial Revolution. 1861-1865: American Civil War. 1861-1878: Reign of Victor-Emmanuel II, King of Italy. 1864: Founding in London of the First International Social Conference by Marx and Engels. 1866: Battle of Sadowa: Prussia excludes Austria from the new German Confederation. 1867: Bismarck becomes Chancellor of the North German Confederation. 1870-1871: Franco-Prussian War. Fall of the Second Empire in France. 1871: Proclamation of the German Empire (II Reich). 1888-1918: Reign of William II, German emperor and King of Prussia.	1804: First steam locomotive 1806-1807: David: *The Crowning of Napoléon* 1808: Goethe: *Faust I* 1822: Champollion deciphers hieroglyphs 1824: Beethoven: *9th symphony* 1830: Delacroix: *Liberty Leading the People* 1839: Nicéphore Niepce and Louis Daguerre invent the daguerreotype c. 1844: Turner: *Rain, Steam and Speed* 1844: Dumas, father: *The Three Musketeers* 1851: Crystal Palace, Great Exhibition of London 1859: Darwin: *On the Origin of Species* 1862: Hugo: *The Miserables Ones* 1863: Manet: *Luncheon on the Grass* 1867: Marx: *Capital* 1869: Inauguration of the Suez canal 1873: Monet: *Impression, Sunrise* 1883: Nietzsche: *Thus Spoke Zarathustra* 1884-1926: Gaudí: Sagrada Familia, Barcelona 1888: Van Gogh: *Vincent's Room* 1889: Eiffel Tower, Paris
20th century	1905: First Russian revolution. 1914-1918: World War I. 1917: October Revolution in Russia, the Bolsheviks take power. 1919: Treaty of Versailles. Creation of the League of Nations in Geneva. 1922: Benito Mussolini's march on Rome. Creation of the U.S.S.R, Joseph Stalin becomes General Secretary of the Communist Party. 1929: "Great Crash" on Wall Street. 1933: Adolf Hitler, Chancellor of Germany. Franklin Roosevelt launches the "New Deal". 1936: Beginning of the Civil War in Spain. 1938: Annexation of Austria by Germany (Anschluss). 1939-1945: World War II. 1945: Yalta Conference. Atomic bombs dropped on Hiroshima/Nagasaki. Untited Nations Charter. 1946: Beginning of the Cold War/Indochina War. 1947: Independence of India. 1948: Establishment of the Marshall Plan. Israel declares itself a state. 1949: North Atlantic Treaty (NATO). Republic of China declared. 1959: Revolution of Fidel Castro in Cuba. 1960-1963: John Fitzgerald Kennedy, President of the United States. 1962: Evian Accords: independence of Algeria. Cuban missile crisis. Second Vatican Council. 1963: Martin Luther King's "March on Washington". 1964: Guerrilla war lead by par Ernesto Che Guevara in Latin America. 1966: Great Proletarian Cultural Revolution. 1968: Student revolts in Paris, Los Angeles and Berlin. Prague Spring. 1972: Strategic Arms Limitation Treaty between the United States and Soviet Union. 1973: Oil Crisis. Military Coup in Chile. 1978: Election of Pope John Paul II. 1980: Outbreak of Iran-Iraq War. 1985: Schengen Agreement. 1986: Beginning of Perestroika in the Soviet Union. Explosion at the Tchernobyl nuclear power plant. 1989: Berlin Wall falls. Collapse of communism. Ceausescu is overthrown in Romania.	1890: First flight of the Ader Eole (Clément Ader) 1890: Wilde: *The Portrait of Dorian Gray* 1895: Auguste and Louis Lumière invent the cinématographe 1898: Pierre and Marie Curie discover radium 1901: Creation of the Nobel Prize 1901: Rachmaninov: *Concerto for piano n° 2* 1904: Cézanne: *Mount Sainte-Victoire* 1905: Einstein: Theory of special relativity 1906-1907: Picasso: *Les Demoiselles d'Avignon* 1917: Freud: *Introduction to Psychoanalysis* 1931: Empire State Building, New York 1942: First nuclear reactor 1952: Creation of the first computer IBM 701 1953: Discovery of the DNA structure 1964: Warhol: *Shot Blue Marilyn* 1969: Neil Armstrong, first man to walk on the moon 1978: First babies from an in vitro fertilisation 1983: Identification of the AIDS virus 1983: First flight with space shuttle Challenger

INDEX